DADA AND SURREALISM

BARRON'S
Woodbury, New York

Text filmset by Keyspools Ltd, Warrington, Lancs.
Litho origination by Paramount Litho Ltd, Wickford, Essex
Printed in Great Britain by Cox and Wyman Ltd,
London, Fakenham and Reading

Library of Congress Catalog Card No. 77–76765
International Standard Book No. 0–8120–0877–4

Printed in Great Britain

Dada

The bourgeois regarded the Dadaist as a dissolute monster, a revolutionary villain, a barbarous Asiatic, plotting against his bells, his safe-deposits, his honours list. The Dadaist thought up tricks to rob the bourgeois of his sleep. . . . The Dadaist gave the bourgeois a sense of confusion and distant, yet mighty rumbling, so that his bells began to buzz, his safes frowned, and his honours list broke out in spots.

(*The Navel Bottle* by Hans Arp.)

TO THE PUBLIC

Before going down among you to pull out your decaying teeth, your running ears, your tongues full of sores,

Before breaking your putrid bones,

Before opening your cholera-infested belly and taking out for use as fertilizer your too fatted liver, your ignoble spleen and your diabetic kidneys,

Before tearing out your ugly sexual organ, incontinent and slimy,

Before extinguishing your appetite for beauty, ecstasy, sugar, philosophy, mathematical and poetic metaphysical pepper and cucumbers,

Before disinfecting you with vitriol, cleansing you and shellacking you with passion,

Before all that,

We shall take a big antiseptic bath,

And we warn you

We are murderers.

(Manifesto signed by Ribemont-Dessaignes and read by seven people at the demonstration at the Grand Palais des Champs Elysées, Paris, 5 February 1920.)

You are all indicted; stand up! Stand up as you would for the *Marseillaise* or *God Save the King*. . . .

Dada alone does not smell: it is nothing, nothing, nothing.

It is like your hopes: nothing.
like your paradise: nothing.
like your idols: nothing.
like your politicians: nothing.
like your·heroes: nothing.
like your artists: nothing.
like your religions: nothing.

Hiss, shout, kick my teeth in, so what? I shall still tell you that you are half-wits. In three months my friends and I will be selling you our pictures for a few francs.

(*Manifeste cannibale dada* by Francis Picabia, read at the Dada soirée at the Théâtre de la Maison de l'Œuvre, Paris, 27 March 1920.)

The Dadaists believed that the artist was the product, and, traditionally, the prop, of bourgeois society, itself anachronistic and doomed. The war finally demonstrated its rottenness, but instead of being able to join in the construction of something new, the artist was still trapped in that society's death throes. He was thus an anachronism whose work was totally irrelevant, and the Dadaists wanted to prove its irrelevance in public. Dada was an expression of frustration and anger. But the Dadaists were after all painters and poets, and they subsisted in a state of complex irony, calling for the collapse of a society and its art on which they themselves were still in many ways dependent, and which, to compound the irony, has shown itself masochistically eager to embrace Dada and pay a few sous for its works in order to turn them into Art too.

The Dadaists wrote innumerable manifestos, each one colouring the concept of Dada according to his temperament. But how else can you express frustration and anger? Dada turned in two directions, on the one hand to a nihilistic and violent attack on art, and on the other to games, masks, buffoonery. 'What we

4

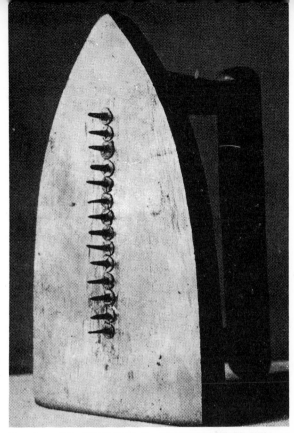

Man Ray. *Gift,* (1921) 1963. Readymade. Collection Mr and Mrs Morton G. Neumann.

call Dada is a harlequinade made of nothingness in which all higher questions are involved, a gladiator's gesture, a play with shabby debris, an execution of postured morality and plenitude', Hugo Ball wrote in his diary, *Die Flucht aus der Zeit.* Picabia and Man Ray produced perfect Dada works of aggression in objects like Picabia's *Portrait of Cézanne,* a stuffed monkey, or Man Ray's *Gift,* an ordinary flat iron with sharp tacks stuck on the bottom, which, combined

with Duchamp's suggestion for a Reciprocal Ready-made: 'Use a Rembrandt as an ironing board', functions as a metaphor for Dada.

Art had become a debased currency, just a matter for the connoisseur, whose taste was merely dependent on habit. Jacques Vaché, who died of an overdose of opium in 1918 before he had even heard of Dada, but whose flamboyant character and letters full of ironic despair, and humour, were powerful influences on the future Paris Dadaists, wrote to his friend André Breton in 1917: 'ART does not exist, of course – so it is useless to sing – however! we make art because it is thus and not otherwise – . . . So we like neither ART, nor artists (down with Apollinaire) AND HOW RIGHT TOGRATH WAS TO ASSASSINATE THE POET!' Picabia wrote disrespectfully in *Jésus-Christ Rastaquouère*: 'You are always looking for already-felt emotions, just as you like to get an old pair of trousers back from the cleaners, which seem new when you don't look too closely. Artists are cleaners, don't let yourself be taken in by them. True modern works of art are made not by artists but quite simply by men.' Or even, he might have said, by machines.

1 When Marcel Duchamp in 1913 mounted a bicycle wheel upside down on a stool, and in 1914 chose the first readymade, a bottle-rack, from the Bazaar de l'Hôtel de Ville, it was the first step in a debate that Dada was to do much to foster – did this gesture of the artist elevate the ordinary mass-produced object into a work of art, or was it like a Trojan Horse, penetrating the ranks of art in order to reduce all objects and works of art to the same level? Of course these are really two sides of the same coin. Anyway, at first the readymades just lay around in his studio, and when he moved to New York in 1915 his sister threw away the *Bottlerack* with the rest of his accumulated rubbish. (He chose another one later.) He only gave them the name Readymade in America, where he began to 'designate' more manufactured objects. Du-

champ himself was quite clear that the point was not to turn them into works of art. He explained that the choice of readymade 'depended on the object in general. It was necessary to resist the "look". It is very difficult to choose an object because after a couple of weeks you begin to like it or hate it. You must reach something like such indifference that you have no aesthetic emotion. The choice of readymades is always based on visual indifference at the same time as a total absence of good or bad taste. . . . [Taste is] habit: the repetition of something already accepted.' So they were exercises in the avoidance of art (habit). Yet Duchamp did intervene too. In shifting objects out of their normal contexts (nailing a coat-rack, *Trap,* to the floor, tipping the urinal on its back, suspending the hat-stand from the ceiling) Duchamp suggested that a 'new thought' was being created for them, and the 'assisted' Readymades can be strange combinations – a bird cage filled with marble 'sugar-cubes'.

Duchamp also interprets his mechanical drawings and paintings (at first paintings depicting machine-like organs, such as *The Passage from the Virgin to the Bride,* and then increasingly mechanical in execution, eliminating any interest in sensuous paint sur-face, texture, etc., like *Chocolate Grinder No. 2,* 1914 as ways of escaping the tyranny of taste. These cul-minate in one of the most deliberately obscure, eso-teric paintings of the century, *The Bride Stripped Bare by her Bachelors, Even,* executed on glass between 1915 and 1923 when he abandoned it 'definitively unfinished'. It is accompanied by a number of notes by Duchamp, which reveal that it is a 'love machine', consisting of two parts, the upper one, the domain of the Bride, the lower one, the Bachelors. Each part was scrupulously planned beforehand (many studies for the individual elements exist), and then placed within a very rigid if idiosyncratic perspective, which has the disturbing effect, in the lower half of the work, of making parts of the machine look literally

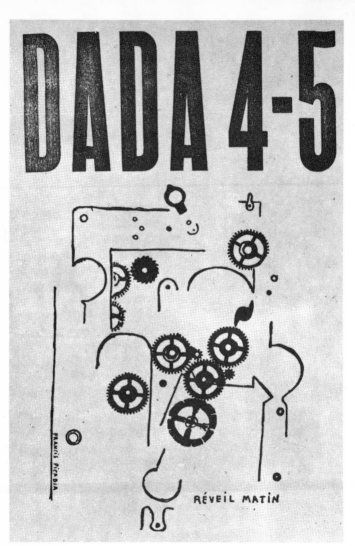

Francis Picabia. Titlepage for *Dada,* 4/5, Zurich, 1919.

three-dimensional while at the same time enforcing the flatness and transparency of the glass surface. Duchamp then incorporated several experiments with chance. For example, he left the glass by the open window of his New York studio for several months to gather dust, then wiped away the dust (after it had been photographed by Man Ray), leaving it only on the 'Sieves', the conical shapes arranged in a half circle, where he fixed the dust with glue.

After 1913, except for the single 'record of the readymades', *Tu m'* of 1918, Duchamp abandoned conventional oil painting on canvas for good. In 1923 he apparently abandoned all artistic activity (apart from isolated objects such as *Female Fig Leaf*, and installing exhibitions), preferring to play chess. His silence was perhaps the most forceful and disquieting of all Dada myths. However, after his death in 1968, it was revealed that he had spent over twenty years, 1944–66, secretly working on an assemblage, a room called *Etant donnés: 1 La chute d'eau, 2 Le gaz d'éclairage,* also traceable back to the *Large Glass* notes.

Duchamp and Francis Picabia had met and immediately became close friends at the end of 1910. Picabia was ebullient, rich and totally nihilistic, and liked the grotesque humour of Alfred Jarry. Duchamp was withdrawn, ironical and esoteric in his tastes. Both were looking for a way out of being trapped and type-cast among the Paris avant-garde, which was predominantly Cubist, and both had an extreme distaste for reverential attitudes towards the 'special nature' of the artist. In 1911, shortly after making contact with the avant-garde's chief spokesman, the poet Guillaume Apollinaire, they attended a performance of Raymond Roussel's *Impressions d'Afrique* which seemed to them a monument of absurd humour. Among the incredible collection of objects and machines (which foreshadow the best Surrealist objects) is a painting machine, activated by rays of sunlight, which of its own accord paints a masterpiece. Roussel's demystifi-

cation of the work of art, and his systematic destruction of order by pursuit of the absurd, strengthened their own similar aims, while the bizarre linguistic games which Roussel describes as the genesis of many of his ideas and objects in *Comment j'ai écrit certains de mes livres* are not unlike the esoteric way in which Duchamp set about constructing his works.

18, 19 Francis Picabia began making machine drawings under the influence of Duchamp, developing the blasphemous potential of the sex/machine metaphor. He carried the machine drawing to its logical conclusion in 1919 in Zurich when, fittingly, he dismembered a watch, dipped the parts in ink and printed them (title page of *Dada* 4–5). Picabia first published works based on mechanical objects in 1915 in the New York proto-Dada review *291*, named after Alfred Stieglitz's avant-garde gallery. He had visited New York before in 1913 on the occasion of the Armory Show – the first taste of advanced European art for the American public – where Duchamp's painting *Nude Descending a Staircase* caused the greatest scandal. Both men were already notorious when they arrived from Europe in 1915. Picabia was furnished with a military commission and money to buy molasses from Cuba, which he immediately put out of his mind. They joined a group of equally insurrectionary poets and painters including

8 John Covert and Man Ray. Arthur Cravan was there intermittently. He had been, in Paris, author of some vitriolic pamphlets, *Maintenant,* and once challenged the ex-heavyweight champion of the world, Jack Johnson, to a disastrous fight in Barcelona, and escaped with his fee. Duchamp and his friends arranged for Cravan to lecture to a glossy New York audience on modern art, but he arrived drunk, and, unsure what he was there for, began undressing on the platform. He finally disappeared while trying to row across the shark-infested Gulf of Mexico.

This group remained ignorant of the European 'movement' Dada, which had been given a name in

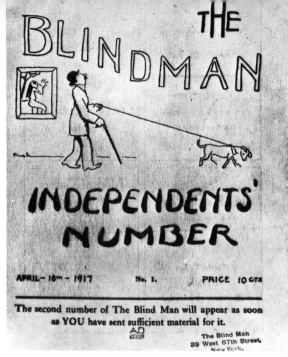

The Blind Man, 1, New York, 10 April 1917.

Zurich in 1916. Picabia went to Barcelona for a few months, to recover from excesses of alcohol and opium, and there in 1917 produced the first numbers of his itinerant review *391*, best and longest lived of the many periodicals informed with a Dada spirit. The activities of the New York group culminated in the publication of the New York issues of *391* in 1917, which coincided with a spectacular gesture of Duchamp's. Invited to serve on the jury of an exhibition at the Grand Central Gallery, which, modelled on the lines of the Indépendants in Paris, gave anyone the right to exhibit, Duchamp sent in a white porcelain urinal with the pseudonym R. Mutt roughly painted on the side. When it was not shown, he resigned from the jury, and the incident was publicized in the broadsheets *The Blind Man* and *Rongwrong*.

Dada in Zurich

Many people were momentarily Dada, and Dada itself varied widely according to place, time and the people involved. It was essentially a state of mind, focused by the war from discontent into disgust. This disgust was directed at the society responsible for the terrifying waste of that war, and at the art and philosophy which appeared so enmeshed with bourgeois rationalism that they were incapable of giving birth to new forms through which any kind of protest could be made. In place of the paralysis to which this situation seemed to lead, Dada turned to the absurd, to the primitive, or to the elemental.

Dada was christened in Zurich in 1916, although the circumstances – and the intended meaning of the name – are still disputed. Richard Huelsenbeck, then a young refugee poet, says that he and Ball discovered the word by accident in a German–French dictionary, and that the child's word (meaning hobby-horse), 'expresses the primitiveness, the beginning at zero, the new in our art'. It was adopted by the group of young exiles, mostly painters and poets, who had come to Switzerland to take refuge from the war on neutral ground, and gathered at the Cabaret Voltaire, a 'literary nightclub' organized by Hugo Ball at the beginning of 1916. There was for a while much discussion of a new art, and a new poetry, which would revitalize a worn-out and debased language. A member of the group who was both painter and poet, Hans Arp, described the situation: 'In Zurich in 1915, losing interest in the slaughterhouses of the world war, we turned to the Fine Arts. While the thunder of the batteries rumbled in the distance, we pasted, we recited, we versified, we sang with all our soul. We searched for an elementary art that would, we thought, save mankind from the furious folly of these times. We aspired to a new order that might restore the balance between heaven and hell. This art gradually became an object of general reprobation. Is it sur-

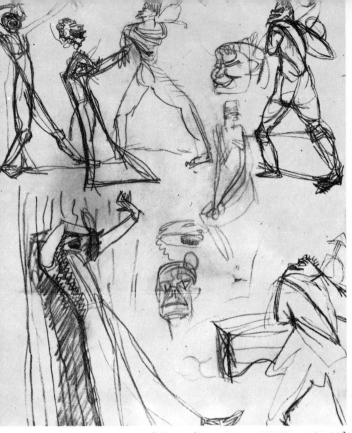

Marcel Janco. *Cabaret Voltaire*, 1916. Drawing, $12 \times 11\frac{3}{4}$ (33 × 30). Galleria Schwarz, Milan.

prising that the "bandits" could not understand us? Their puerile mania for authoritarianism expects art itself to serve the stultification of mankind.'

The Zurich Dadaists included Hugo Ball, Emmy Hennings, Hans Richter and Richard Huelsenbeck, from Germany, Hans Arp from Alsace, Marcel Janco and Tristan Tzara from Romania, and occasionally the enigmatic Dr Walter Serner. Dada's public manifestations took place in riotous evenings at the Cabaret Voltaire. Tzara describes one in his *Dada diary*:

'1916 July 14 – For the first time anywhere. Waag Hall.
'1st Dada night
(Music, dances, theories, manifestos, poems, paint-
ings, costumes, masks)
'In the presence of a compact crowd Tzara demon-
strates, we demand we demand the right to piss in
different colours, Huelsenbeck demonstrates, Ball
demonstrates, Arp *Erklärung* [Statement], Janco
meine Bilder [my pictures], Heusser *eigene Komposi-
tionen* [original compositions], the dogs bay and the
dissection of Panama on the piano and dock – shouted
poem – shouting and fighting in the hall, first row
approves second row declares itself incompetent to
judge the rest shout who is the strongest. . . . Boxing
resumed: Cubist dance, costumes by Janco, each man
his own big drum on his head, noise, Negro music/tra-
batgea bonooooo oo ooooo/ 5 literary experiments:
Tzara in tails stands before the curtain . . . and
explains the new aesthetic: gymnastic poem, concert
of vowels, bruitist poem, static poem chemical
arrangement of ideas, 'Biriboom, biriboom . . . vowel
poem a a ò, i e o, a i i. . . .'

A similar evening culminated in Ball's reading of his
new abstract phonetic poem, *O Gadji Beri Bimba*.
Encased in a tight-fitting cylinder of shiny blue card-
board, with a high blue and white striped 'witch-
doctor's hat', he had to be carried up to the platform.
As he began to declaim the sonorous sounds, the
audience exploded in laughing, clapping, cat-calls.
Ball stood his ground, and, raising his voice above the
uproar, began to intone, 'taking on the age-old
cadence of priestly lamentation: *zimzim uralalla
zimzim urallala zimzim zanzibar zimzalla zam.*'

It was as if he were illustrating his description of
Dada in his diary *Die Flucht aus der Zeit*: 'What we are
celebrating is at once a buffoonery and a requiem
mass. . . . The bankruptcy of ideas having destroyed
the concept of humanity to its very innermost strata,
the instincts and hereditary backgrounds are now

14

emerging pathologically. Since no art, politics or religious faith seems adequate to dam this torrent, there remain only the *blague* and the bleeding pose.'

Dada works have their only real existence as gestures, public statements of provocation. Whether at exhibitions or demonstrations (and the distinction between them as far as Dada was concerned was deliberately blurred), the Dada object, painting or construction was an act which expected a definite reaction.

Inevitably, some of the experiments of the Dadaists in poetry and the plastic arts seem to some extent to be borrowing the voices of other movements. Hans Richter's *Visionary Self-portrait* is an Expressionist work. Above all, Dada is full of echoes of Italian Futurism, in the violent language of its manifestos, and in its experiments with noise (bruitism) and with simultaneity. George Grosz's Dadaist *Funeral Procession, Dedicated to Oscar Panizza* of 1917, like the

7 Futurist Carlo Carrà's painting *Funeral of the Anarchist Galli* (1910–11), suggests a funeral that has become a riot. Its dynamic criss-crossing lines and the inter-penetrating houses, lights and people also owe a great deal to Umberto Boccioni's more sophisticated concept of simultaneity. Arp referred, in Futurist terms, to the 'dynamic boomboom' of the strong diagonals in his

6 early abstract collages. Arthur Segal's hectic *Harbour,* with its parodied Cubist facets, owes a great deal to Futurism. Very often a style, a device is borrowed in order to satirize itself, to be turned into a grotesque parody. Tzara's 'Simultaneist Poem' is an example – a poem composed of banal verses in three languages, read simultaneously to the accompaniment of noises offstage, mimicking the idea of expressing simultan-eous impressions. The Futurists' serious and optimistic attempts at portraying the dynamism, or heroism, of modern life were easy prey for the Dadaists, who regarded this particular branch of artistic activity as the most futile of all.

There was, however, a gulf between the artist in the privacy of his studio and the same person joining in Dada's public activities. Marcel Janco, for instance, was experimenting with purely abstract plaster reliefs and at the same time making masks for the Dada demonstrations, which Arp remembers happily in 'Dadaland': 'They were terrifying, most of them daubed with bloody red. Out of cardboard, paper, horsehair, wire and cloth, you made your languorous foetuses, your lesbian sardines, your ecstatic mice.'

Arp was one of the group's most loyal members; although he had little taste for the violence and noise of the Cabaret, he had a very definite idea of the value and meaning of Dada. In this respect he was very close to Hugo Ball. In an essay called 'I become more and more removed from aesthetics' he wrote, 'Dada aimed to destroy the reasonable deceptions of man and recover the natural and unreasonable order. Dada wanted to replace the logical nonsense of the men of today by the illogically senseless. That is why we pounded with all our might on the big drum of Dada and trumpeted the praises of unreason. Dada gave the Venus de Milo an enema and permitted Laocoon and his sons to relieve themselves after thousands of years of struggle with the good sausage Python. Philosophies have less value for Dada than an old abandoned toothbrush, and Dada abandons them to the great world leaders. Dada denounced the infernal ruses of the official vocabulary of wisdom. Dada is for the senseless, which does not mean nonsense. Dada is senseless like nature. Dada is for nature and against art. Dada is direct like nature. Dada is for infinite sense and definite means.'

Dissatisfied with the 'fat texture of expressionist paintings', Arp began constructing works with simple lines and structures. He made severely geometric collages, and also abstract designs which Sophie Taeuber (later his wife) executed in tapestry or embroidery. He and Sophie were working in ignorance

16

Jean (Hans) Arp. Illustration for *Dada,* 1, Zurich, 1917. Woodcut $4\frac{1}{16} \times 5\frac{1}{8}$ (10.5 × 13).

of Mondrian's similar experiments with straight lines and coloured squares and rectangles, and it was only in 1919 that they saw reproductions of them in the Dutch magazine *De Stijl*.

Perhaps one of the reasons why Dada in Zurich came close to being a modern art movement was that Zurich, unlike Paris, was shocked and horrified by all new art. Richter remembers the occasion when Arp and Otto van Rees were asked to paint the entrance to a girls' school: 'On either side of the school entrance appeared two large abstract frescoes (the first to be seen so near the Alps) intended to be a feast for the eyes of the little girls and a glorious sign to the citizens of Zurich of the progressiveness of their city. Unfortunately all this was fearfully misunderstood. The parents of the little girls were incensed, the city fathers enraged, by the blobs of colour, representing nothing, with which the walls, and possibly the little girls' minds, were sullied. They ordered that the frescoes should at once be painted over with 'proper' pictures. This was done, and *Mothers, Leading Children*

by the Hand lived on the walls where the work of Arp and Van Rees died.'

Arp soon abandoned oil painting on canvas in favour of using other materials like wood, embroidery, cut-out paper, newspaper, often collaborating with Sophie in his desire to get away from the 'monstrous egoism' of the artist to an ideal of communal work. He described some of these works as 'arranged according to the laws of chance' (although compared with torn papers of the 1930s they look carefully planned). 'We rejected everything that was copy or description, and allowed the Elementary and Spontaneous to react in full freedom. Since the disposition of planes, and the proportions and colours of these planes, seemed to depend purely on chance, I declared that these works, like nature, were ordered "according to the law of chance", chance being for me merely a limited part of an unfathomable *raison d'être*, of an order inaccessible in its totality.'

In his poetry at this time Arp used chance in a more radical, Dada-like, manner, taking words and phrases at random from newspapers and building them into a poem. Some of his wood reliefs were made from bits of rotten wood that look like flotsam and jetsam. Many of the reliefs of 1916–17 are deliberately left with the wood rough and unpainted, and nail heads protruding. Other wood reliefs, like the *Forest* or *Egg Board,* are brightly painted and made up of highly concentrated forms which later open out into the biomorphic abstraction of his sculptures. It was a flexible morphology. Richter remembers painting an enormous backcloth with Arp for a Dada demonstration. Starting at opposite ends, he says, they covered the roll of paper with yards of 'giant cucumber plantations'. Arp's development towards organic abstraction was helped by the automatic drawings he was experimenting with at this time, a technique later to be taken up and systematized, for rather different reasons, by the Surrealists.

Jean (Hans) Arp. Illustration from *Onze peintres vus par Arp,* Zurich, 1949. Woodcut.

For the first couple of years in Zurich Dada was thus still seen, particularly by Ball and Arp, as offering possibilities of a new artistic direction. Ball's desire to restore magic to language, Arp's search for directness in art, can be seen in this way. Ball said: 'The direct and the primitive appear to [the Dadaist] in the midst of this huge anti-nature as being the supernatural itself'. It was even presented publicly in this light; Tzara was to describe the Zurich review *Dada,* when he introduced it to Picabia, as a 'modern art publication'. But with Picabia's arrival in Zurich in August 1918, there was a radical change. The Dadaists had never experienced anyone with such a total disbelief in art, and such an acute sense of the meaninglessness of life. Richter says that meeting him was like an experience of death, and that after such meetings

his feelings of despair were so intense that he went round his studio kicking holes in his paintings.

Tzara, the chief impresario and publicist of Zurich Dada, immediately fell under the spell of Picabia's overpowering and magnetic personality; and in his famous *Dada Manifesto 1918* he harnesses his extreme verbal agility to the service of nihilism.

'Philosophy is this question: from which side shall we look at life, God, the idea or other phenomena? Everything one looks at is false. I do not consider the relative result more important than the choice between cake and cherries after dinner. The system of quickly looking at the other side of a thing in order to impose your opinion indirectly is called dialectics, in other words, haggling over the spirit of fried potatoes while dancing method around it.

'If I cry out:

Ideal, ideal, ideal,
Knowledge, knowledge, knowledge,
Boomboom, boomboom, boomboom,

'I have given a pretty faithful version of progress, law, morality and all the other fine qualities that various highly intelligent men have discussed in so many books.'

Dada in Paris
It was Tzara's 1918 Manifesto ('I write a manifesto and I want nothing, yet I say certain things, and in principle I am against manifestos as I am also against principles') that seduced André Breton and other members of the Parisian *Littérature* group. Tzara reached Paris at the very beginning of 1920, and immediately, with the help of Picabia, Breton, the poets Louis Aragon, Philippe Soupault and Georges Ribemont-Dessaignes, and others, set about making the Dada revolt public through outrageous works such as Picabia's *Feathers*. On 23 January the first Dada demonstration took place at the Palais des Fêtes,

20

and as it set the tone for subsequent manifestations it is worth describing in some detail. A talk billed as 'La crise du change' ('The Exchange Crisis') by André Salmon, which had attracted the small shopkeepers of the *quartier* in expectation of financial enlightenment, turned out to be about the overturning of literary values since Symbolism. The audience began to melt away. But Breton's presentation of some Picabia paintings (Picabia never liked to present himself on the stage) began the real event. A large canvas was wheeled on, covered with inscriptions: 'top' at the bottom, 'bottom' at the top, and underneath in large red letters the obscene pun *L.H.O.O.Q. (Elle a chaud au cul).* As the insult began to sink in, the audience started to shout back at the stage, and with a second 'work' there was uproar. A blackboard appeared, covered with more inscriptions, under the title *Riz au nez,* which Breton immediately rubbed out with a duster. Not only was this not a work of art; it was destroyed before the audience's very eyes. The culmination of the evening was the arrival on stage of Monsieur Dada from Zurich, Tristan Tzara, to present one of his works. He immediately began to read Léon Daudet's latest speech from the Chamber of Deputies, accompanied in the wings by Breton and Aragon energetically ringing bells. The audience, which included figures like Juan Gris who had come to encourage the younger generation, reacted violently. One avant-garde editor began to shout 'Back to Zurich! To the stake!' Dada had set a fine trap, and after this its audience came prepared.

Dada in Germany

After the war Dada spread with the dispersal of the Zurich Dadaists to other places in Europe, where often only the name was needed to consecrate already proto-Dada activities. In Cologne, in 1919, Johannes Baargeld and Max Ernst were joined by Arp, whereupon, as Arp put it, they produced 'the finest fruits on the

Max Ernst. *Here Everything is still Floating. Fatagaga: The Third Gazometric Picture*, 1920. Photomontage, $4\frac{1}{4} \times 4\frac{7}{8}$ (10.7 × 12.3). The Museum of Modern Art, New York. (Title by Arp.)

Dada tree', fruits, which included the *Fatagagas*, collages made by Arp and Ernst in collaboration. Baargeld distributed his anti-patriotic radical periodical *Der Ventilator* at factory gates: and in the atmosphere of post-war Germany, already showing signs of a new, militaristic nationalism, Dada took on a more obviously political role. One of the most successful Dada events in Cologne was an exhibition at a beerhall, the Bräuhaus Winter, held in a small courtyard reached through the lavatory, where on the opening day a young girl dressed in a white first-communion dress recited obscene poems. At the entrance stood a wooden 'sculpture' by Max Ernst, with an axe attached and the invitation to destroy it. Some of the

22

objects in the exhibition had the enigmatic quality of later Surrealist objects — for instance Baargeld's *Fluidoskeptrick der Rotzwitha van Gandersheim,* a fish tank filled with red-stained water, with an alarm clock at the bottom, a fine head of hair floating on the top, and a wooden dummy's hand sticking out. In the course of the exhibition this was destroyed.

Ernst and Baargeld were summoned to police head-quarters and charged with fraud, on the grounds that they had demanded an entrance fee for an art exhibition that manifestly had nothing to do with art. Ernst replied, 'We said quite plainly that it is a Dada exhibition. Dada never claimed to have anything to do with art. If the public confuses the two that is no fault of ours.'

It was in Berlin that Dada's potential for political action came nearest to being fulfilled. Huelsenbeck arrived, in pursuance of his medical studies, in 1917. Berlin at that time, its people half-starved and desperate, near to defeat, where 'men's minds were concentrating more and more on questions of naked existence', was very different from the 'smug, fat idyll' of Zurich that he had left behind.

He immediately wrote a strident manifesto to re-direct Dada: 'The highest art will be that which in its conscious content presents the thousandfold problems of the day, the art which has been visibly shattered by the explosions of last week, which is forever trying to collect its limbs after yesterday's crash. The best and most extraordinary artists will be those who every hour snatch the tatters of their bodies out of the frenzied cataract of life, who with bleeding hands and hearts hold fast to the intelligence of their time. Has Expressionism fulfilled our expectations of such an art, which should be an expression of our most vital concerns? No! No! No!'

A Club Dada was formed, its members including Hannah Höch, Johannes Baader, George Grosz, Wieland Herzfelde and his brother John Heartfield

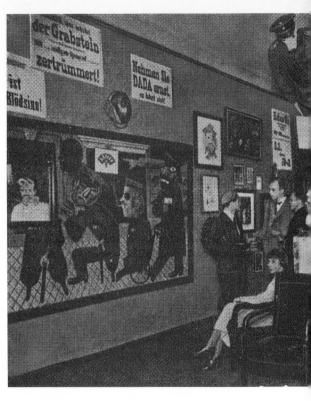

(who had Anglicized his name during the war), Raoul
23 Hausmann, and Huelsenbeck. Numerous periodicals
appeared under the Dada flag, were banned and
reappeared under a new name. The 'First International
Dada Fair' was held in 1920, and homage was paid
to the new revolutionary art in Russia: 'Art is dead.
Long live the new machine art of Tatlin.' From the
ceiling hung a dummy dressed in a German officer's
uniform, with the head of a pig and a placard, 'Hanged
by the Revolution'.

Dada was presented in Berlin with a real problem
of identity. It had in a sense to compete directly

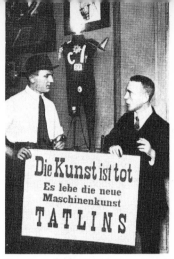

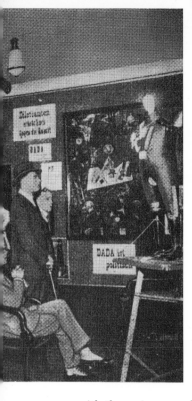

Opening of the 'First International Dada Fair' at Dr Otto Burchard's gallery, Berlin, June 1920. Left to right: Raoul Hausmann, Hannah Höch, Dr Burchard, Johannes Baader, Wieland Herzfelde, Mrs Herzfelde, Otto Schmalhausen, George Grosz and John Heartfield.

George Grosz and John Heartfield at the 'First International Dada Fair', Berlin, 1920.

with the serious revolutionary fervour of the activist wing of the literary Expressionists. The Dadaists immediately singled them out as their enemy, hating their lofty and pompous rhetoric about the Value of Art, which they treated as a kind of social therapy. On the other hand, although actively involved in the post-war social upheavals, in the brief occupation of Berlin by the Communists in November 1918 (though it is a myth that Huelsenbeck held an official post), and later in unceasing propaganda against the Weimar Republic, the Dadaists kept their Dada autonomy. The Communists mistrusted them as dilettante anti-

artists, and the bourgeoisie inevitably saw them as Bolshevik monsters.

Partly as a reaction to this position, they wrenched their work forcibly back into contact with real life in the transformation of collage into photomontage, creating a unique weapon for visual polemics. The Berlin Dadaists called themselves *Monteure* – fitters or assemblers, as opposed to artists. After Dada had ceased to exist in Germany, Heartfield went on using pure photographic montage to attack the growing power of Nazism (*Das ist das Heil, das sie bringen*).

The Berlin group were critical of Zurich Dada. Huelsenbeck wrote, 'I find in the Dadaism of Tzara and his friends, who made abstract art the cornerstone of their new wisdom, no new idea deserving of very strenuous propaganda. They failed to advance along the abstract road, which ultimately leads from the painted surface to the reality of the post office form.' But the manifesto he and Hausmann drew up, 'What is Dadaism and what it wants in Germany', in its violent swings from rational to extravagant demands, mirrors Dada's uneasy position. '*Dadaism demands:* the international revolutionary union of all creative and intellectual men and women on the basis of radical Communism. . . . The Central Council demands the introduction of the simultaneist poem as a communist state prayer.'

Kurt Schwitters, who operated 'merz', a one-man movement with Dada leanings, in Hanover, tried to join the Berlin group but was rejected. He had, in fact, more in common with those Zurich Dadaists like Arp whom he called 'kernel' Dadaists as opposed to 'husk' Dadaists. These 'kernel' Dadaists include Arp, Picabia, and rather surprisingly, the sculptor Alexandre Archipenko, an indication that the range of Dada sympathizers and friends was much wider than the handful of names usually associated with the movement would lead one to expect. Unembarrassed at calling himself an artist, Schwitters was looking for

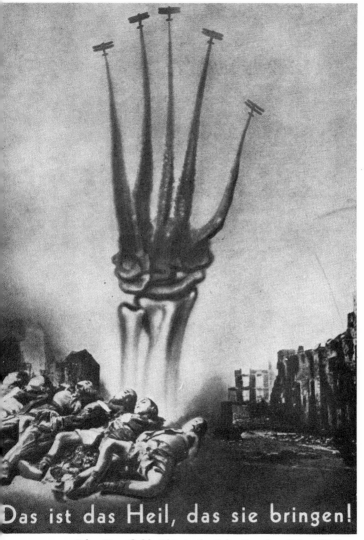

Das ist das Heil, das sie bringen!

John Heartfield. *This is the Salvation they Bring,* 29 June 1938. Photomontage.

a renewal of the springs of artistic creation, outside conventional means. He nailed or glued his pictures together from scraps of material, string, wood, bus tickets, chicken-wire and odds and ends he picked up in the street, and then painted them. The result, as in his apparently irrational poems like *Anna Blume,* was an almost lyrical beauty. 'Every artist must be allowed to mould a picture out of nothing but blotting paper, for example, provided he is capable of moulding a picture.'

Dada was a genuinely international event, not just because it operated across political frontiers, but because it consciously attacked patriotic nationalism. Its total effect was far in excess of the energy any individual Dadaist put into it. Each Dadaist brought something different to it and came out with a different idea of what Dada was. The splinters from the bombshell altered the face of art for good.

The 'Sleep Period'

Dada in Paris lasted two years. In 1922 it collapsed in a series of internal quarrels which laid bare the differences between the old Dadaists, Tzara and Picabia, and the younger French group, including Breton. Perhaps the latter were never really Dadaists at all: Breton had certainly attempted to organize several grand projects which had little or nothing to do with Dada. The 'Trial of Maurice Barrès', patriot and man of letters, whom Breton could not forgive for the early fascination he had exercised over him, took place in 1921; it disgusted Ribemont-Dessaignes, who said, 'Dada could be criminal, coward, plunderer, or thief, but not judge.' Breton, acting as judge, sternly brought back 'witnesses' when they strayed into irrelevances or Dada irrationalities, and the interrogations produced a mingled philosophical quest and painful truth game, of a kind which was to be characteristic of Surrealism. With Jacques Rigaut,

who was to kill himself in 1929, Breton had the following conversation:

BRETON: 'According to you, nothing is possible. How do you manage to live, why haven't you committed suicide?'

RIGAUT: 'Nothing is possible, not even suicide. . . . Suicide is, whether you like it or not, a despair-act or a dignity-act. To kill yourself is to admit that there are terrifying obstacles, things to fear, or just to take into consideration.'

There was a gap of two years between the dissolution of Dada in Paris in 1922 and the publication of the first *Surrealist Manifesto* by André Breton in the autumn of 1924. The interlude, 1922 to 1924, was spent in a series of experiments, a tentative search for something positive that could lead out of the Dada *impasse*. Breton wrote:

> Leave everything.
> Leave Dada.
> Leave your wife leave your mistress.
> Leave your hopes and your fears.
> Sow your children in the corner of a wood.
> Leave the substance for the shadow. . . .
> Set out on the road.

One event that falls historically within Dada in Paris was of great importance for the future development of Surrealism. This was an exhibition of collages by Max Ernst, which was planned for the summer of 1920 but did not in fact take place until 1921. As they unpacked the collages, Breton, Aragon and the other Dadaists felt an overpowering excitement, seeing a new kind of poetic image in key with their own ideas. Also, probably, they saw in Ernst an artist capable of challenging Picabia, who as far as the Paris public was concerned was the incarnation of Dada, but whose mixture of nihilism and cynical worldliness disturbed Breton, who was already searching for a positive formula to escape from Dada's death grip.

Max Ernst. *The Orator*, 1920.
Collage, $9\frac{3}{4} \times 7\frac{1}{2}$ (24.6 × 18.9).
Galleria Schwarz, Milan and
Galerie Krugier, Geneva.

Breton wrote a preface to the exhibition in which
he defines the collages in terms that are almost
identical to his later definition of the Surrealist poetic
image: 'It is the marvellous faculty of attaining two
widely separate realities without departing from the
realm of our experience, of bringing them together
and drawing a spark from their contact; of gathering
within reach of our senses abstract figures endowed
with the same intensity, the same relief as other
figures; and of disorienting us in our own memory by
depriving us of a frame of reference – it is this faculty
which for the present sustains Dada. Can such a gift
not make the man whom it fills something better than
a poet?' In the Surrealist manifesto of 1924 he uses the
same electrical metaphor of the spark to describe the
bringing together of 'two distant realities', although
this time he lays emphasis on the necessarily un-
premeditated nature of the image. What he saw in
Ernst's collages was the visual equivalent of Lautréa-
mont's famous phrase, 'as beautiful as the chance

encounter on a dissecting-table of a sewing-machine and an umbrella'. The collages, small in format, use old engravings, pieces cut out of old magazines (often geological ones showing sections of rock formations which exercised a special fascination for Ernst), and photographs, to create a scene in which the spectator, deprived of a frame of reference, is disoriented.

The disorientation of the spectator is a step towards the destruction of his conventional ways of apprehending the world and dealing with his own experiences according to preconceived patterns. The Surrealists believed man had shut himself into a strait-jacket of logic and rationalism which crippled his liberty and stultified his imagination. Inheriting this attitude from Dada, Breton found in the revelations of Sigmund Freud about the unconscious a possible guideline for the liberation of the imagination. Without too much respect for the detail of Freud's model of the mental processes, he seized on the idea that there is a vast untapped reservoir of experience, thought and desire, hidden away from conscious, everyday living. Through dreams (whose direct connection with the unconscious Freud had proved in *The Interpretation of Dreams,* published in 1900), and through automatic writing (the equivalent of the free-associative monologue of psychoanalysis), Breton believed that access could be gained to the unconscious, and the barrier between the conscious and the unconscious, maintained in the interests of order and reason, could eventually, in a sense, be broken down. 'Man proposes and disposes. It is up to him to belong to himself altogether, that is to say to maintain in an anarchic state the band, every day more powerful, of his desires.' This was, of course, to ignore the whole point of Freud's psychoanalytic theory, which was to *cure* disturbances in the psyche and enable the patient to lead an ordinary, orderly life. Many of the Surrealists, including Aragon, thought Freud was a bourgeois reactionary; and Freud for his part had

little sympathy or understanding for the young Surrealists and the curious use to which they were putting his discoveries. 'I believe,' Breton said, 'in the future resolution of the two states, apparently so contradictory, of dream and reality, in a sort of absolute reality, of *surreality*.'

By 1922 Breton was already using the term 'Surrealist' – originally coined by Apollinaire, probably by analogy with Nietzsche's superman (*Surhomme*) and Jarry's *Surmâle,* and used to describe his play *Les Mamelles de Tiresias* – to mean 'a certain psychic automatism which corresponds quite well to the state of dream'. But he believed at this time that 'psychic automatism' could be produced through hypnotic sleep, and this is the source of the term *période des sommeils.* The future Surrealists, including Breton, Aragon, Soupault, René Crevel, Robert Desnos and Max Ernst, experimented with group and individual hypnosis. Breton himself never succeeded in becoming hypnotized. Desnos was the most adept at falling into a self-induced sleep, and in this state produced monologues and drawings that he felt he would not have been capable of in ordinary waking life. Hypnotic sleep seemed to offer a direct source of poetic imagery from the unconscious. But after a series of disturbing incidents it became clear that these experiments were dangerous and could become uncontrollable; also, perhaps, the results, after the initial excitement at the mysterious phenomenon, were not as spectacular or as sustained as originally expected. The 'Sleep Period' brought out too clearly a tension always inherent in Surrealism, between the idea of artists or poets as unconscious transmitters, 'modest recording devices', of images, and that of their status as conscious creators with a predetermined sense of what is beautiful. The balance between the two shifted, with Breton periodically reaffirming the necessity for the springs of Surrealist activity to remain unconscious, to flow underground. The

problem was greatest for the painters, many of whom refused to submerge their creative, active personality by using exclusively those automatic techniques proposed by Breton. It was not a question of the self-important, egoistic artist intervening. Arp, for instance, always longed for an anonymous collective art; and yet, the most naturally 'unconscious' artist, he did not really like Surrealist theories of automatism: 'I am no longer doing the forming' (*Ce n'est plus moi qui forme'*).

Surrealism and Painting

The definition of Surrealism given in the First Manifesto of 1924 was intended to be conclusive.

'SURREALISM, noun. Pure psychic automatism by which it is intended to express, either verbally or in writing, the true function of thought. Thought dictated in the absence of all control exerted by reason, and outside all aesthetic or moral preoccupations.

'*Encycl. Philos.* Surrealism is based on the belief in the superior reality of certain forms of association heretofore neglected, in the omnipotence of the dream, and in the disinterested play of thought. It leads to the permanent destruction of all other psychic mechanisms and to its substitution for them in the solution of the principal problems of life.'

This certainly makes the scope of surrealism clear. Although Breton was later to describe it as fundamentally an attack on language in the interests of poetry, this was on the natural understanding that language is fundamental to our knowledge of the world, and that poetry is not just the printed word on the page but a state of mental 'availability', an openness to all new experience. Jacques Baron, a schoolboy at the time, remembered the overwhelming experience of walking the Paris streets with Aragon or Breton, and the intense relationships between the Surrealists which he called *poésie-amitié*.

Painting was mentioned in the Manifesto only in a footnote, and in spite of one or two close friendships between poets and painters, notably between Breton and Masson, and Eluard and Ernst, the painters kept themselves a little apart from the group. This was to maintain their independence, for Breton had an intense desire to control everything that went on around him, and although he wrote many articles which try to define the Surrealist nature of the paintings, they seldom fit neatly into his rather rigid definition, and to describe them in terms of Surrealism is often inadequate. Significantly, the title of the most important series of articles was 'Surrealism and Painting' (1927), not 'Surrealist Painting'. Painting had a tangential relationship with the core of Surrealist activity. However, in *Artistic Genesis and Perspective of Surrealism,* Breton does define two major routes open to the Surrealist artist: firstly automatism, and secondly 'the *trompe-l'œil* fixation of dream images'. This serves to establish broad categories for the paintings, although individual painters, and even individual paintings, by no means stick rigidly to one or the other.

In the winter of 1922–23 Joan Miró and André Masson met at a party and discovered that they had adjoining studios in an old building on the rue Blomet (where Arp later came to join them). They immediately became close friends, and a little later Miró asked Masson whether he should go to see Picabia or Breton. 'Picabia is already the past,' Masson replied; 'Breton is the future.' The atmosphere of excitement and constant ferment of new ideas generated by the Surrealists were much more stimulating to them than the various groups of painters in Paris who still seemed to be locked in an increasingly unprofitable relationship with Cubism. 'I'll smash their guitar,' Miró once said. By 1924 Miró, Masson and the young writers who had gathered round Masson including Michel Leiris, Antonin Artaud and Georges Limbour,

André Masson. *Dreamed Embraces,* 1927. Indian ink, $25\frac{3}{8} \times 19\frac{5}{8}$ (64.2 × 50).

had become part of the Surrealist movement, part of a 'moral community', as Leiris describes it.

At first, although in different ways, it was the ideas behind the principle of automatism that attracted Miró and Masson. In the First Manifesto Breton describes his first attempts, as early as 1919 and influenced by Freud, to write down 'a monologue delivered as rapidly as possible, on which the critical mind of the subject should make no judgment, which should not, consequently, be hampered by any reticence, and which should be as nearly as possible *spoken thought*'. He and Philippe Soupault, who joined in the experiment, were astonished at the result, 'a considerable choice of images of a quality such that we would have been incapable of producing a single one in the normal way of writing'. These pages were published in 1919 under the title *Les Champs magnétiques,* Magnetic Fields.

In 1924 Masson began to make automatic drawings. Using a pen and Indian ink he let his hand travel rapidly over the paper, forming a web of lines from which images began to emerge, which Masson then either develops or leaves in a suggestive state. In the best of these drawings there is an extraordinary coherence, a textural unity, which in for instance the horse's head suggests water, pebbles, seaweed, fishes, behind the dominant image of the horse. Others have suggestions of obsessive sexual imagery, twined bodies and clasped hands. Masson was interested in the moment of metamorphosis, when a line was in the process of *becoming* something else. The effect of these drawings on his paintings, hitherto sombre, rather inflexible and heavily influenced by Cubism, was an immediate loosening-up; but working in oil paint he could never achieve the same fluidity. Connected with the automatic drawings were a series of sand paintings he began in 1927. Roughly spreading a canvas with glue, he then sprinkled or threw handfuls of sand on it, tipping the canvas to retain sand

41

only on the glued bits. He then added a few lines or patches of colour, which, as in the drawings, would evoke the image he found there. One of his most radical acts was in the ironically named *Painting,* 1927, where the thick coloured lines have been applied direct from the tube of paint. An exchange between Masson and Matisse in 1932 exemplifies the fundamental difference between Surrealism and other modernist traditions.

42

Masson explained : 'I begin without an image or plan in mind, but just draw or paint rapidly according to my impulses. Gradually, in the marks I make, I see suggestions of figures or objects. I encourage these to emerge, trying to bring out their implications even as I now consciously try to give order to the composition.'

'That's curious,' Matisse replied. 'With me it's just the reverse. I always start with something – a chair, a table – but as the work progresses I become less conscious of it. By the end, I am hardly aware of the subject with which I started.'

Whatever the influence certain Surrealist techniques (such as Masson's use of paint direct from the tube) may have had on subsequent abstract artists, such as the Action Painters, the end result for Masson, as for Ernst in his frottages, was fundamentally different, the move being, in Breton's phrase, 'towards the object'.

40

Max Ernst made his first frottage in 1921, but did not develop the idea any further until 1925, when he took it up as a direct answer to the poets' automatic writing. 'The procedure of frottage, resting thus upon nothing more than the intensification of the irritability of the mind's faculties by appropriate technical means, excluding all conscious mental guidance (of reason, taste, morals), reducing to the extreme the active part of that one whom we have called up to now the "author" of the work, this procedure is revealed to be the exact equivalent of

Max Ernst. *Head,* 1925. Frottage, $17\frac{3}{4} \times 13$ (45 × 33). Galerie Alexandre Iolas, Paris.

that which is already known by the term *automatic writing*.' Becoming obsessed by the cracks in some floorboards, he decided 'to examine the symbolism of this obsession and, to assist my meditative and hallucinatory powers, I obtained from the floorboards a series of drawings by dropping on them at random pieces of paper I then rubbed with black lead.' So far the technique is not new, but in Ernst's hands the 'drawings steadily lose, thanks to a series of suggestions and transmutations occurring to one spontaneously . . . the character of the material being studied – wood – and assume the aspect of unbelievably clear images of a nature probably able to reveal the first cause of the obession'. Ernst began to include other materials, sacking, leaves, thread, and other things, and their transformation in the final frottage, worked now into a harmonious and balanced picture, sometimes makes the original material unrecognizable.

Ernst adapted this technique to oil painting, by scraping a canvas, previously spread with pigments, when it was placed on an uneven surface, enabling, in his words, 'painting to travel with seven-league boots a long way from Renoir's three apples, Manet's four sticks of asparagus, Derain's little chocolate women, and the Cubist's tobacco packet, and to open up for it a field of *vision* limited only by the "irritability" capacity of the mind's powers. Needless to say this has been a great blow to art critics who are terrified to see the importance of the "author" being reduced to a minimum and the conception of "talent" abolished.' Ernst's *Forest and Dove* of 1927 uses this *grattage* technique to build up an evocative image of the forests that had haunted him since his childhood at Brühl, near Cologne, when he used to accompany his father into the forest to paint.

Miró, although he too used automatic procedures to a certain extent, treated them more cavalierly than Ernst or Masson, focusing far more intently on the work itself and less on any theoretical overtones such

procedures might have. But there is no doubt that the Surrealists were responsible for the flowering of a fantastic imagination in the *Tilled Field* (1923–24). Basically the same subject as *The Farm,* painted a year earlier, his family's farm in Catalonia, in place of the delicate and precise illusionism, with every detail of the tufts of grass on the farm wall painted in almost like a Douanier Rousseau, the landscape is suddenly filled with extraordinary creatures (some with an ancestry going back to Bosch), and the man-and-plough on the right reappears grotesquely as a bull-man with all its sexual connotations (Minotaur?) on the left. The technique, although flatter, is still fairly illusionistic, but in 1925 he began to cover his canvases freely with great waves of colour, sometimes with a brush, sometimes rubbing with a rag. On this background, now floating in a space which has nothing to do with perspectival space and the horizon line, he places forms and lines from his developing language of signs (*The Birth of the World*). It was of paintings like these that Miró wrote: 'I begin painting, and as I paint the picture begins to assert itself, or suggest itself, under my brush. The form becomes a sign for a woman or a bird as I work. The first stage is free, unconscious.' But, he added, 'the second stage is carefully calculated.'

Breton expressed reservations about these paintings in *Le Surréalisme et la peinture*: 'Of the thousands of problems which preoccupy him to no degree at all, even though they are the ones which trouble the human spirit, there is only one perhaps towards which Miró has any inclination: to abandon himself to painting, and only to painting (which is to restrict himself to the one domain in which we may be sure he has the means), to give himself over to pure auto-matism to which, for my part, I have never ceased to appeal, but of which I fear that Miró has come too summarily to the proof of its worth and its deep rationale. Perhaps, it is true, for that reason, that he

will pass for the most "Surrealist" of us all. But how far we are in his work from that "chemistry of the intellect" of which we had been speaking!'

This 'chemistry of the intellect' which Breton praised was Masson's work. Aragon was to criticize Miró in the same spirit when he talked of his 'imbecile harmonies'. Criticism like this does little but rebound upon the critic; however it does demonstrate the kind of demand Surrealism made of painting: that its interest should not lie in the sensuous pleasure of the paint surface, but in the enigmatic, hallucinatory or revalatory power of the image. 'Only the marvellous is beautiful,' wrote Breton in the First Manifesto, and in *Le Surréalisme et la peinture* he says: 'It is impossible for me to consider a painting in any other way than as a window, and my first concern is to know what it looks out on to.'

After 1924 Miró's painting became intricately linked in various ways with the poetry of the Surrealists and of those poets they admired, like Rimbaud and Saint-Pol-Roux. *Portrait of a Dancer* is a mono-
37 syllabic evocation; *Smile of my Blonde* is an emblem of Miró's beloved, her hair bearing symbols, sexual attributes, in a way similar to Rimbaud's poem 'Voyelles', where each vowel is associated with a colour and a series of esoteric metaphors for parts of the female body:

A, black corset hairy with glittering flies
that buzz around cruel smells
Gulfs of darkness . . .

The 'trompe-l'œil fixation of dream images' which Breton defines as the other route open to Surrealist painters, is perhaps a misleading term. The illusion-istic 'hand-painted dream picture' is not necessarily dealing specifically with symbolic dream images, and one should be careful of treating it as an entity open, as dreams may be, for analysis. It *may* be using dream images; it may use images culled from different

dreams; it may merely remind us of certain general characteristics of dreams. It is illusionistic painting, but not of the external world – the model is an interior world.

Tanguy's visionary paintings are based on a deep space in which strange objects float or stand, casting black shadows. In a general way they are like dreams, or the state of mind immediately before sleep which gives an internal sensation of endless space. Tanguy was one of the few self-taught Surrealist painters. He was fascinated by Giorgio de Chirico, and in *Mama, Papa is Wounded* (a title apparently taken from a psychiatric case history) the diagrammatic lines leading back to the enigmatic structure in the background perhaps refer to De Chirico's meta-physical paintings which contain blackboards covered with diagrams and equations, or to Ernst's *Of This Men Shall Know Nothing*. *A Large Painting which is a Land-scape* of 1927 also has echoes of De Chirico, but the disorientation of the spectator is peculiar to Tanguy. An endless desert stretches out to the horizon, but is covered with wisps that suggest seaweed and the bottom of the sea. The spiky sculpture in *Infinite Divisibility* casts a deep shadow back into pure space, into what appears to be sky, and little shells, or bowls of water reflect the sky but are placed where the sky itself should be. Tanguy's later paintings become increasingly crowded with rock-like shapes that bear an affinity to the rocky beaches of his native Brittany.

Ernst, Tanguy and Magritte were all deeply in-fluenced by De Chirico. It was the sight of one of his paintings in a gallery window that persuaded Tanguy to become a painter. But De Chirico himself was never a Surrealist. After 1917 his paintings reverted to academicism and held no more interest for the Surrealists – they felt he had betrayed himself. But from about 1910 to 1917 his enigmatic paintings of arcaded Italian squares, statues, railway stations, towers have a hallucinatory and dream-like intensity,

filled with a potent and unconscious sexual imagery. Unseen objects cast menacing shadows, and the clock 27 in the *Conquest of the Philosopher* suggests the anguish of departure – the train is perhaps a memory of his engineer father, building railways in Greece where De Chirico spent his childhood. De Chirico might be celebrating the end of the domination of the ideal of classical beauty – an ideal being violently challenged in 1910 in Italy, where De Chirico was living, by the Futurists. But while they sought to substitute the beauty of the modern mechanical world of speed and power, De Chirico painted forgotten Greek statues, empty, bleached towns. He remembers sitting in a square in an Italian town staring at a statue, very weak after a long illness, and suddenly seeing the whole scene in an extraordinarily clear, hallucinatory light, with an enigmatic intensity which he wanted to reproduce in his paintings. Sometimes objects appear, disconnected, as though surfacing from a dream. In 25 *The Song of Love* the green ball, red glove and classical mask are coupled, like an Ernst collage. The paintings are almost always empty of human beings, but after a 26 while manikins enter to inhabit the increasingly stage-like settings.

In 1921–24 Max Ernst did a series of paintings, including *Elephant Celebes, Oedipus Rex* and *Pietà or Revolution by Night,* which are strongly influenced by De Chirico in their structure and cool intense light as well as in their actual imagery. They remain very obscure in meaning; if they are dream images, it is necessary to remember Freud's warning, when he was asked to contribute to a Surrealist anthology of dreams: 'a mere collection of dreams, without the dreamer's associations, without knowledge of the circumstances in which they occurred, tells me nothing, and I can hardly imagine what it would tell anyone'.

Wary of psychoanalysis in the absence of the conditions required by Freud, we may still suggest, in

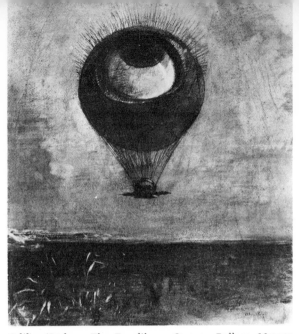

Odilon Redon, *The Eye like a Strange Balloon Mounts Towards Infinity*, 1882. Charcoal, $16\frac{5}{8} \times 13\frac{1}{8}$ (43.5 × 33.5). The Museum of Modern Art, New York, Gift of Larry Aldrich.

28 *Oedipus Rex*, bearing in mind Ernst's frequent and ambiguous references to his father, that the Oedipus legend as interpreted by Freud, whom Ernst had read, bore a personal significance for him. Oedipus blinded himself, and the references to eyes in the painting are disturbingly underlined by the balloon in the background, which is a quotation from Odilon Redon's *The Eye like a Strange Balloon*.

Ernst shared the Surrealists' taste for exotic and
29 primitive art. In *Elephant Celebes* the elephant itself is based on a photograph of an African corn bin transformed in Ernst's imagination into this grotesque animal, and a bull's head, reminiscent of an African mask, is suspended on the end of its pipe-trunk. One
31 of his most striking paintings is *The Robing of the*

44

Bride, where the figure of the bride is clothed only in a magnificent cloak inspired by Breton's description of a 'splendid and convulsive mantle made of the infinite repetition of the unique little red feathers of a rare bird, which is worn by Hawaiian chieftains'. Driven out by this overpowering and youthful primitive figure is a little cowering creature, a grotesque parody of the old hermaphrodite Tiresias of Greek legend. Ernst has also made a number of sculptures, above all while he lived in Arizona after the Second World War, inspired by American Indian, African and Oceanic art. Breton himself owned a superb collection of primitive sculpture, objects and masks. Wifredo Lam, the Cuban painter who joined the Surrealists in 1938, painted a number of pictures which are poetic evocations of the voodoo masks and totemic objects with which he was familiar. It was in objects such as these that the Surrealists found directness of vision, an escape from the rational and the stereotyped hierarchies of Western thought, and above all that element of the marvellous that alone for them constituted beauty.

58

Among the most disturbing of all Surrealist works are the series of collage novels Ernst made, *La Femme 100 têtes* (1929) and *Une Semaine de bonté* (1934). Constructed almost entirely of old engravings, they consist of disorienting scenes in which often the scale is completely disrupted. In one scene from *Une Semaine de bonté* a man with a bird's head is seated in a railway carriage, and looking through the window is what at first appears to be the gigantic head of the Sphinx of Gizeh. There is a kind of delayed action in the effect of these collages; often after the immediate shock one becomes aware of more disturbing details, ambiguous textures, double images. Paul Eluard wrote about Ernst in *Beyond Painting*: 'It is not far – through the bird – from the cloud to the man; it is not far – through the images – from the man to his visions, from the nature of real things to the nature of imagined

things. Their value is equal. Matter, movement, need, desire, are inseparable. Think yourself a flower, a fruit or the heart of a tree, since they wear your colours, since they are necessary signs of your presence, since your privilege is in believing that everything is transmutable into something else.'

Of the other makers of the 'hand-painted dream picture', the former Dadaist Man Ray produced perhaps the most spectacular images, such as *Observatory Time – The Lovers*. Victor Brauner's paintings, such as *The Philosopher's Stone,* are metamorphoses, evoking magical icons. In the work of Pierre Roy, and above all in that of René Magritte, the image is fixed in a flat, dead paint surface.

Some Magritte paintings may really be memories of dreams. *The Lovers*, with their heads swathed in cloth, could be a dream transformation of his terrible memories of his mother's death, when he was a child; she was found drowned with her white gown wrapped round her head. It is impossible to know. But most of his paintings take the form of a dialogue with the world, a questioning of the reality of real phenomena, and their relation with their painted image (*The Human Condition*). Sometimes by disruption of the scale of objects he can turn something harmless into something menacing (like the monstrous Alice-through-the-looking-glass apple in *The Listening Room*) or puzzling (*Personal Values*). Often, although the image exists – there it is in the painting – it is impossible to grasp it because it is beyond our logical understanding: in *The Field-Glass* a window opens onto blackness beyond. Clouds are reflected in the shut casement, but the other casement is open, revealing an empty frame. *On the Threshold of Liberty* is a room panelled with motifs from Magritte's own paintings, with a cannon threatening violence or rape. Again he assembles disturbing objects from other pictures in his cover for the Surrealist periodical *Minotaure,* with the Minotaur's skeleton shrouded like a de Chirico figure.

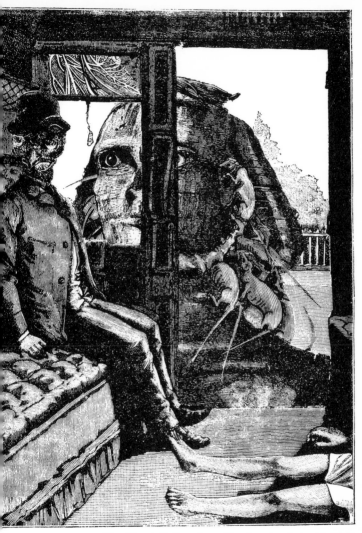

Max Ernst. Collage from *Une Semaine de bonté,* 1934.

In 1949 Magritte wrote a manifesto, *Le Vrai Art de la peinture* (which incidentally contains an attack on the 'magnetic fields of chance', an allusion to Breton and Soupault's early work), to explain his idea of the true function of painting, as opposed to its real rival, the cinema. 'The art of painting is an art of thinking, whose existence underlines the importance of the role held in life by the eyes of the human body.' He goes on to state something that is in fundamental opposition to our conception of a kind of immortality granted to art: 'The perfect painting produces an intense effect only for a very short time, and emotions resembling the first emotion felt are to a greater or lesser extent soiled by habit. . . . The true art of painting is to conceive and realize paintings capable of giving the spectator a pure visual perception of the external world.' It is not beyond the technical powers of a moderately skilful artist to evoke on canvas a blue sky – 'but this poses a psychological problem . . . what do you do with the sky?' Magritte's process is to make us aware, by contradiction ('in full obscurity', he says), of the appearance of a sky, a pipe, a woman, a tree. 'This is not a pipe', he writes underneath a perfectly banal painting of a pipe.

Magritte belonged to the Belgian Surrealist group, together with Paul Nougé and E. L. T. Mesens. They kept their distance from the Paris Surrealists. Paul Delvaux, also a Belgian, participated in Surrealist exhibitions while, like Magritte, keeping a certain distance between himself and the 'arbiter' of Surrealism, André Breton. Delvaux's often large canvases are of silent cities, sometimes entered by a train from a De Chirico painting, and peopled with sleep-walking nudes. Dream-like (it is usually night), they seem really to be the dreams of the figures themselves 56 (*Sleeping Venus*), therefore curiously self-contained.

Salvador Dali, who met and immediately joined the Surrealist movement in 1928, provokes the most difficult questions about the possible realization of

dreams on canvas, and hence about the symbolic function of the imagery.

First, one must remember that the dream for Freud, and also for Breton, was a direct path to the unconscious; the way in which a dream deals with its subject, condensing, distorting, allowing contradictory facts or impressions to exist side by side without any conflict – what Freud calls dream-work – is characteristic of the processes of the unconscious. The manifest content of the dream, what we remember when we wake up, probably masks latent, hidden meanings, which may be revealed by the dreamer's associations, achieved through analysis. For most of the Surrealists dreams were valuable simply for their poetic content, as documents from a marvellous world, whose hidden sexual symbolism nonetheless filled them with delight. The first number of the Surrealist periodical *La Révolution surréaliste* contained simple accounts of dreams by Breton, De Chirico, Renée Gauthier; 'Only the dream leaves man with all his rights to liberty.' Dali, on the other hand, especially in the late 1920s and early 1930s, presents dream images whose content is made manifest. Freud, who met Dali, and found him infinitely more interesting than the other Surrealists, immediately understood what Dali was doing. 'It is not the unconscious I seek in your pictures, but the conscious. While in the pictures of the masters – Leonardo or Ingres – that which interests me, that which seems mysterious and troubling to me, is precisely the search for unconscious ideas, of an enigmatic order, hidden in the picture. Your mystery is manifested outright. The picture is but a mechanism to reveal itself.' Dali had read Freud, as well as Krafft-Ebing on the psychopathology of sex, and his 'vice of self-interpretation, not only of my dreams but of everything that happened to me, however accidental it might seem at first glance', is clear not only in his paintings but in books like *Le Mythe tragique de l'Angélus de Millet,* in which

the hidden content of Millet's painting, and hence the cause of Dali's obsession with it, reveals itself to him through a series of associations, coincidences and dreams.

47 *The Dismal Sport* (*Le Jeu lugubre*), a painting which made the Surrealists hesitate before admitting Dali to their group, fearing it revealed coprophiliac tendencies in Dali, swarms (as does *Illumined Pleasures*) with examples of symbols straight from the pages of text-books of psycho-analysis. It is impossible to tell what may be a dream image, and what Dali's analysis of it. Certainly the images make perfectly clear Dali's fear of sex, guilt about masturbatory fantasies, and consequent castration fears. In another series of paintings Dali interprets the legend of William Tell as a kind of reversed Oedipal myth about castration.

48 Like *The Dismal Sport,* the *Giraffe in Flames* bunches its matter into concentrated areas of canvas, a deliberate analogy with Freud's description of dream-work.

'The only difference between myself and a madman is that I am not mad,' Dali once said. He turned his willed paranoia into a system that he called 'paranoiac critical activity', defined as 'a spontaneous method of irrational knowledge based upon the interpretive-critical association of delirious phenomena'. 'Paranoiac-critical activity discovers new and objective significances in the irrational; it makes the world of delirium pass tangibly on to the plane of reality.' Paranoiac phenomena are 'common images having a double figuration'. In other words one object can be read as itself and as another quite different object, and so on; in theory the ability to continue to see double or treble figuration depended, like Ernst's frottage technique, on the spectator's powers of 50 voluntary hallucination. *Impressions of Africa* (1936) has a whole train of double images, becoming increasingly minute, in the top left-hand corner, starting from Gala's eyes, which are also the arcades in the building behind. On the right, curious rock forma-

Luis Buñuel and Salvador Dali. Still from *L'Age d'or,* 1930.

tions, inspired by the volcanic rocks near his home at Port Lligat, in Catalonia, turn into human figures. In fact Dali is fixing and making visible for us his own double images, rather than inviting us to read into it what we will.

Dali deliberately used an ultra-illusionistic technique, a 'return to Meissonier' (a much-abused nineteenth-century academic painter), as a kind of anti-art. 'The illusionism of the most abjectly *arriviste* and irresistible imitative art, the usual paralysing tricks of *trompe-l'œil,* the most analytically narrative and discredited academicism, can all become sublime hierarchies of thought and the means of approach to new exactitudes of concrete irrationality.' He describes works like *Six Apparitions of Lenin* . . . as 'instantaneous and hand-done colour photography'.

In 1928 Dali collaborated with Luis Buñuel on the film *Un Chien andalou,* and in 1930 they made *L'Age d'or,* whose more openly sacrilegious and political themes in fact are predominantly the work of Buñuel.

49

51

A manifesto written by the Surrealists was included in the programme of *L'Age d'or,* together with drawings by Dali, Miró, Ernst, Man Ray and Tanguy. It included the following passage:

'All those who are not yet alarmed by what the censorship allows them to read in the newspapers must go and see *L'Age d'or.* It complements the present stock exchange crisis perfectly, and its impact is all the more direct just because it is Surrealistic . . . just as in everyday life, accidents occur in bourgeois society while that society pays no attention whatsoever. But such accidents (and it must be noted that in Buñuel's film they remain uncorrupted by plausibility) further debilitate an already rotting society that tries to prolong its existence artificially by the use of priests and policemen. The final pessimism born within that society as its optimism begins to wane, becomes a powerful virus that hastens the process of disintegration. That pessimism takes on the value of negation and is immediately translated into anticlericalism; it thus becomes revolutionary, since the fight against religion is also the fight against the world as it is.

'But it is *love* [*l'amour*, or desire] which brings about the transition from pessimism to action; Love, denounced in the bourgeois demonology as the root of all evil. For love demands the sacrifice of every other value: status, family and honour. And the failure of love within the social framework leads to Revolt.'

In the work of some artists Surrealism avowed a perverse kinship (as in Ernst and Lam) to religion. Picasso's most Surrealist work is a violent *Crucifixion*.

The Surrealist Object

At the International Exhibition of Surrealism in Paris in 1938, the emphasis was not so much on paintings as on objects and the creation of a whole environment. Duchamp conjured up the installation of the exhibi-

Salvador Dali. *Rainy Taxi*, 1938.

tion. The main hall had a thousand sacks of coal
hanging from the ceiling, with leaves and twigs
littering the ground, a grass-bordered pool, and a
large double bed in one corner. The corridor leading
to the hall was bordered with manikins or dummies,
embellished in various ways – Masson's wore a
G-string covered with glass eyes, had its head in a
cage and was gagged with a black band, with a pansy
where the mouth should have been. In the courtyard
at the entrace stood Dali's *Rainy Taxi*, dripping with
water, with live snails crawling all over it and a
hysterical blonde passenger.

53

Many 'made' Surrealist objects are essentially an extension of the Surrealist collage – itself the visual equivalent of the Surrealist poetic image – into three
51 dimensions. In·Arrival of the Belle Epoque Dominguez slices in half a fin-de-siècle statuette and inserts an empty frame with two cones in it, wrapping her hand, which might once have held a torch, with cotton wool. Breton considered the 'hold' of Lautréamont's image (see above, p. 30) to be obviously sexual, and the majority of Surrealist objects share, consciously or unconsciously, erotic interest. Hans Bellmer visited Paris and joined the Surrealists in 1936, but his
46 poupées had been planned much earlier, and are perhaps the strongest example of the Surrealist erotic object. Here, rather than bringing together things dissimilar, Bellmer perversely rearranges (with almost infinite possibilities) the doll's anatomy.

In the third issue of Le Surréalisme au service de la révolution of 1931, Dali proposed making moving erotic objects 'of symbolic functioning'; he instanced
45 Giacometti's Suspended Ball (made when Giacometti was close to the Surrealists in the early 1930s and described by him as 'mobile and mute') as an example, together with more complex and baroque fabrications of found and interpreted objects by himself, his wife Gala and Breton. Dali intended these to procure a particular sexual emotion by indirect means; Breton later in 'The Communicating Vessels' felt they were less effective than objects 'less systematically determined'. They lacked, he felt, the 'astonishing power of suggestion of the gold leaf electroscope' (two sheets of gold which spring apart when approached by a metal rod). However, Giacometti's Ball is I think instinct with the 'indefinable sexual emotion' of the best unconsciously determined Surrealist objects.

In Breton's essay 'Beauty Will Be Convulsive', its title taken from the last words of his extraordinary novel Nadja, 'La beauté sera CONVULSIVE ou ne sera pas', he discusses more precisely the nature of that

which he finds beautiful. He remains, he says, profoundly insensible to natural spectacles and works of art that do not *'immediately produce in me a state of physical disturbance* characterized by the sensation of a wind brushing across my forehead and capable of causing me really to shiver. . . . *I have never been able to help relating this sensation to erotic pleasure and can discover between them only differences of degree.'* By 'convulsive', Breton understands not movement but 'expiration of movement' (a locomotive abandoned to virgin forest, the red feathers of the Hawaiian chieftain's cloak). He compares the work of art to a crystal, both as regards appearance, 'same hardness, rigidity, regularity and lustre on all its surfaces, both inside and out, as the crystal', and the *spontaneous* method of its creation. It is impossible to create this beauty by logical means. Clearly it is a matter of indifference whether the object that produces this sensation is made or found. What matters is the spectator's power to 'recognize the marvellous precipitate of desire'.

Postscript

I have severely limited this essay in several directions. Firstly, rather than directly discuss the relationship between Dada and Surrealism, I have by implication stressed the differences rather than the similarities. They were of course sufficiently alike for many former Dadaists like Ernst, Man Ray, Arp, to join the Surrealists without making any radical changes in their work. As Arp said, 'I exhibited with the Surrealists because their rebellious attitude towards "art" and their direct attitude to life were wise, like Dada.' Surrealism inherited the same political enemies. But, clearly, it was a less anarchic, generous movement than Dada, erecting rigid rules and principles based on carefully formulated theories.

Secondly, painting is only one, and even a rather ancillary Surrealist activity. Much more of its energy was spent in the fields of poetry, philosophy, and

politics. But for rather crucial reasons Surrealism became best known through its plastic works, because they proved to be the most direct way of *imposing* Surrealist vision.

Because the discussion has been confined more or less to the 1920s and 1930s it has been necessary to omit painters like Matta, who, joining the movement in 1937, was the last new recruit to have a powerful effect on the visual expression of Surrealism.

Roberto Matta Echaurren, a Chilean who began his career studying architecture in Le Corbusier's office, joined the Surrealists in 1937 and began painting in 1938. He and Arshile Gorky, an Armenian-American, were really the last painters to offer new paths towards the visual expression of Surrealist thought. Paintings by Matta like *Inscape* (*Psychological Morphology No. 104*), 1939, and *The Earth is a Man,* 1942, are like metaphors for an inner landscape, with small, brightly lit cells appearing in places, giving a sensation of superimposed layers of matter which can peel away to reveal other worlds inside; these works were a strong influence on Gorky.

The presence of many of the Surrealists in America during the War, including Breton, Ernst, Matta, and Dali, confirmed several young painters in one of the directions indicated by Surrealism – that of spontaneous automatic execution. As Jackson Pollock said in 1944: 'I am particularly impressed with their concept of the source of art being the unconscious. The idea interests me more than the specific painters do, for the two artists I admire most, Picasso and Miró, are still abroad.'

Gorky, a painter whom Breton admired, had also served an apprenticeship to Picasso, Miró and Kandinsky. In paintings like *How my Mother's Embroidered Apron Unfolds in my Life* (1944) and *The Leaf of the Artichoke is an Owl* (1944), paint is allowed to drip and run freely on the canvas. Gorky opened up new possibilities for expressing spontaneous and

simultaneous impressions and perceptions. Breton wrote of him in *Le Surréalisme et la peinture*: 'By hybrid I mean the results produced by the contemplation of a natural spectacle in compounding itself with the flux of childhood memories that the extreme concentration before this spectacle provokes in an observer who possesses in the highest degree the gift of emotion. It is important to underline that Gorky is, of all Surrealist artists, the only one who keeps in direct contact with nature, in placing himself to paint *in front of it*. It is no longer a question, however, with him, of taking the expression of that nature for an *end,* but rather of summoning up from it feelings that can act as a springboard towards the deepening, in knowledge as much as in pleasure, of certain states of mind.'

Finally, I have not discussed in any detail the various techniques invented by the Surrealists to explore automatism further, like decalcomania, which involved spreading a sheet of paper with gouache or oil, laying another sheet of paper, on top, and peeling this off when the paint was nearly dry to reveal strange cavernous landscapes in the resulting configurations; or to invoke chance, like *Cadavre Exquis,* the child's game of head, body and legs. They were, as Breton said, only techniques, 'lamentable expedients', in the Surrealists' fight to conquer the imagination.

Surrealism was not a style of painting. As Breton said of poetry in 1923, 'It is not where you think it is. It exists outside words, style etc. . . . I cannot acknowledge any value in any means of expression.' The Surrealist painters illustrated here are those who, by their relationship with the core of Surrealist thought, demonstrate most clearly the vision the Surrealists wanted to impose on the world.

'Surrealism has suppressed the word "like". . . .

'He who fails to see a horse galloping on a tomato is a fool. A tomato is also a child's balloon.'

Chronology

1913 Duchamp renounces painting makes first readymade.

1915 Picabia and Duchamp arrive in New York. Picabia executes series of machine drawings; Duchamp begins the *Large Glass* and meets Man Ray.

1916 Cabaret Voltaire opens in Zurich on 5 February, and in April its participants adopt the name 'Dada'.

1917 Publication of first issues of *Dada* in Zurich. Picabia publishes nos. 1–4 of *391* in Barcelona. Duchamp sends *Fountain* to the Independents in New York; Man Ray and Duchamp edit *The Blind Man* and *Rongwrong*. Première of Apollinaire's 'Surrealist drama' *Les Mamelles de Tirésias* in Paris. Galerie Dada in Zurich.

1918 Breton, Eluard, Soupault, Aragon see *Dada*. Tzara's *Manifeste Dada 1918* published in *Dada, 3*. Club Dada in Berlin; Hausmann and others start using photomontage.

1919 *Littérature,* edited by Breton, Aragon, Soupault, appears in Paris, publishes Lautréamont, and serializes *Les Champs magnétiques.* Jacques Vaché commits suicide. Ernst and Baargeld found 'Dada conspiracy of the Rhineland' in Cologne. Schwitters makes first *Merz* works.

1920 Tzara arrives in Paris. Dada tour in Germany by Huelsenbeck, Hausmann and Baader. In Berlin *Dada Almanach;* 'Dada Fair'. Dada exhibition in Cologne.

1921 Publication of *New York Dada,* edited by Duchamp and Man Ray. Exhibition of Ernst in Paris; Dada stages 'trial of Barrès', loses Picabia's support.

1923 Duchamp leaves *Large Glass.* Masson makes first automatic drawings, Miró paints *Tilled Field.*

1924 Breton publishes first *Manifeste du Surréalisme.*

1925 'Exposition, La Peinture Surréaliste' at Galerie Pierre.

1926 Galerie Surréaliste opens with Man Ray exhibition. Arp settles in Paris. Publication of Ernst's frottages *Histoire naturelle.*

1927 Masson makes first sand paintings.

1928 Breton publishes *Nadja* and *Le Surréalisme et la peinture.* Dali makes *Un Chien andalou* with Bunuel.

1929 Breton publishes *Second Manifeste du Surréalisme,* purging dissidents and calling for political action.

1930 Bunuel and Dali make *L'Age D'Or.*

1932 Breton publishes *Les Vases communicants.* Group exhibition of Surrealists at Julien Levy Gallery in New York.

1933 Victor Brauner joins Surrealists.

1934 Dali visits America. Dominguez joins Surrealists.

1936 Exhibition 'Fantastic Art, Dada, Surrealism' at the Museum of Modern Art in New York. First exhibition of Surrealist objects in Paris. Exhibition in London. Dali censured for support of Fascism.

1937 Breton opens Galerie Gradiva. Matta joins Surrealists.

1938 Breton meets Trotsky, and they write manifesto *Pour un art révolutionnaire indépendant*. Eluard and Ernst break with Surrealism. Wifredo Lam and Hans Bellmer meet the Surrealists.

1940 Many Surrealists, including Breton, Masson, Lam and Ernst, meet in Marseilles *en route* for New York.

1942 'First Papers of Surrealism' exhibition in New York.

1944 Breton meets Gorky.

1947 'Exposition Internationale du Surréalisme' at Galerie Maeght: last major group exhibition.

1966 Breton's death effectively ends movement.

Further Reading

The most complete anthology of Dada writings is Robert Motherwell's *Dada Painters and Poets* (New York, 1951). A blow-by-blow history of Dada in Paris has been written by Michel Sanouillet, *Dada à Paris* (Paris, 1965). Sanouillet has also re-edited Picabia's review *391* (Paris, 1965). A facsimile of Duchamp's notes to accompany *The Bride Stripped Bare by her Bachelors, Even* was published in 1960 (London and New York). Arp's collection of essays and poems *On My Way* (New York, 1948) contains, as well as essays on his own work of the period, a brief view of Dada in Zurich. Hans Richter's *Dada: Art and Anti-art* (London and New York, 1965) is one of the best general histories of Dada. Hugo Ball's diary *Flight out of Time* has been translated (New York, 1974).

The *Surrealist Manifestos* by André Breton (Ann Arbor, 1970) are essential. The Surrealist periodicals, *la Révolution Surréaliste* and *le Surréalisme au service de la Révolution*, have been issued in facsimile. Good commentaries include *The History of Surrealism* by Maurice Nadeau (London, 1968), *An Introduction to Surrealism* by J. H. Matthews (Pennsylvania, 1965) and *A Short Survey of Surrealism* by David Gascoyne (London, 1935). The most comprehensive work on Dada and Surrealist painting is William Rubin's

Dada and Surrealist Art (London and New York, 1969); Rubin devotes time to post-1945 Surrealism, and Surrealism's extensions in America, which have been virtually excluded from this book. Breton's *Surrealism and Painting* (New York, 1972) is invaluable for understanding the relationship between Surrealist painting and theory.

List of Illustrations

Measurements are given in inches and centimetres, height first

10 Jean (Hans) Arp (1887–1966). *Trousse d'un Da,* 1920. Painted wood, $10\frac{3}{4} \times 15\frac{3}{8}$ (27.5 × 39). Late collection of Tristan Tzara, Paris. See p. 18.

11 Jean (Hans) Arp (1887–1966). *Forest,* 1916. Painted wood, $12\frac{1}{2} \times 8\frac{1}{4}$ (31.5 × 21). Penrose Collection, London. See p. 18.

12 Jean (Hans) Arp (1887–1966). *Egg Board,* 1917. Painted wood relief, $39\frac{1}{4} \times 29$ (99.5 × 73.5). Graindorge Collection, Liège. See p. 18.

13 Jean (Hans) Arp (1887–1966). *Head,* 1926. Collage and relief on oil painting, $14\frac{5}{8} \times 14\frac{1}{8}$ (37 × 36). Private Collection. See p. 18.

14 Jean (Hans) Arp (1887–1966). *Geometric Collage,* 1916. Paper on cardboard, $13 \times 9\frac{1}{2}$ (33 × 24). Collection François Arp. See p. 16.

15 Sophie Taeuber-Arp (1889–1943). *Composition with triangles, rectangles and circles,* 1916. Tapestry, $16\frac{1}{8} \times 16\frac{1}{8}$ (41 × 41). Private Collection, Paris. See p. 16.

16 Kurt Schwitters (1887–1948). *Merzpicture 25A. The Star Picture,* 1920. Assemblage, $41\frac{3}{8} \times 31\frac{3}{8}$ (105 × 79). Kunstsammlung Nordrhein-Westfalen, Düsseldorf. See p. 26.

17 Kurt Schwitters (1887–1948). *Mz 26, 41. okola,* 1926. Collage, $7 \times 5\frac{1}{2}$ (17.5 × 14). Collection Mr and Mrs Fred Shore, New York. See p. 26.

18 Francis Picabia (1879–1953). *L'Enfant Carburateur.* Mixed media on panel, $39 \times 41\frac{1}{4}$ (99.5 × 104.5). The Solomon R. Guggenheim Museum, New York. See p. 20.

19 Francis Picabia (1879–1953). *Parade amoureuse,* 1917. Oil on cardboard $28\frac{3}{4} \times 37\frac{3}{4}$ (73 × 96). Private Collection, Chicago. See p. 10.

20 Francis Picabia (1879–1953). *Feathers,* 1921. Oil and collage, $46\frac{7}{8} \times 30\frac{3}{4}$ (119 × 78). Private Collection, Paris. See p. 20.

21 Marcel Duchamp (1887–1968). *Female Fig Leaf,* 1950. Painted plaster, h. $3\frac{1}{2}$ (9). Collection Madame Marcel Duchamp, Villiers-sous-Grez. See p. 9.

22 Hannah Höch (1889–). *Collage,* 1920. Collage, $11\frac{3}{4} \times 13\frac{3}{4}$ (30 × 35). Morton G. Neumann Collection, Chicago. See p. 23.

23 Raoul Hausmann (1886–1971). *Mechanical Head,* 1919–20. Wood, leather and aluminium, h. 13 (33). Collection Hannah Höch, Berlin. See p. 24.

24 Man Ray (1890–1976). *Observatory Time – The Lovers,* 1932–34. Oil on canvas, $98\frac{3}{8} \times 39\frac{3}{8}$ (250 × 100). Collection William N. Copley, Longpont-sur-Orge. See p. 46.

25 Giorgio de Chirico (1888–). *The Song of Love,* 1914. Oil on canvas, $28\frac{3}{8} \times 23\frac{1}{2}$ (71 × 59.5). Private Collection, New York. See p. 43.

26 Giorgio de Chirico (1888–). *Disquieting Muses,* 1917. Oil on canvas, $26 \times 38\frac{1}{8}$ (66 × 97). Private Collection of Modern Art, Milan. See p. 43.

27 Giorgio de Chirico (1888–). *Conquest of the Philosopher,* 1912. Oil on canvas, 39 × 48 (99 × 122.5). The Art Institute of Chicago. See p. 43.

28 Max Ernst (1891–1976). *Oedipus Rex,* 1922. Oil on canvas, 35 × 46 (89 × 117). Private Collection.

29 Max Ernst (1891–1976). *Elephant Celebes,* 1921. Oil on canvas, $51\frac{1}{8} \times 43\frac{1}{4}$ (130 × 110). Tate Gallery, London.

30 Max Ernst (1891–1976). *Of This Men Shall Know Nothing,* 1923. Oil on canvas, $31\frac{5}{8} \times 25\frac{1}{8}$ (80.5 × 63.5). Tate Gallery, London. See p. 42.

31 Max Ernst (1891–1976). *The Robing of the Bride,* 1939–40. Oil on canvas, $37\frac{3}{4} \times 51\frac{1}{8}$ (96 × 130). Collection Peggy Guggenheim, Venice. See p. 44.

32 Max Ernst (1891–1976). *Forest and Dove,* 1927. Oil on canvas, $39\frac{1}{2} \times 32$ (100.5 × 81.5). Tate Gallery, London. See p. 39.

33 Joan Miró (1893–). *The Farm,* 1921–22. Oil on canvas, $48\frac{1}{4} \times 55\frac{1}{4}$ (132 × 147). Collection Mrs Ernest Hemingway, New York. See p. 40.

34 Joan Miró (1893–). *The Tilled Field,* 1923–24. Oil on canvas, 26 × 37 (66 × 94). Collection Mr and Mrs Henry Clifford, Radnor, Pennsylvania. See p. 40.

35 Joan Miró (1893–). *Maternity,* 1924. Oil on canvas, $35\frac{7}{8} \times 29\frac{1}{8}$ (91 × 74). Private Collection, London. See p. 39.

36 Joan Miró (1893–). *The Birth of the World,* 1925. Oil on canvas, $96\frac{1}{2} \times 76\frac{3}{4}$ (245 × 195). Private Collection. See p. 40.

37 Joan Miró (1893–). *Smile of My Blonde,* 1925. Oil on canvas, $34\frac{5}{8} \times 44\frac{7}{8}$ (114 × 88). Private Collection, Paris. See p. 41.

38 Joan Miró (1893–). *Portrait of a Dancer,* 1928. Object on frame, $31\frac{7}{8} \times 39\frac{3}{8}$ (81 × 100). Collection André Breton, Paris. See p. 41.

39 Pablo Picasso (1881–1973). *Crucifixion,* 1930. Oil on wood, 20 × 26 (50.5 × 66). Private Collection. See p. 52.

40 André Masson (1896–). *The Painter and Time,* 1938. Oil on canvas, $28\frac{3}{4} \times 45\frac{1}{4}$ (73 × 115). Private Collection. See p. 40.

41 André Masson (1896–). *Armour,* 1925. Oil on canvas, $21\frac{1}{4} \times 33\frac{1}{2}$ (54 × 80). Collection Peggy Guggenheim, Venice. See p. 36.

42 André Masson (1896–). *Painting (Figure),* 1927. Oil and sand on canvas, $18 \times 10\frac{1}{2}$ (45.5 × 26.5). Private Collection, New York. See p. 36.

43 Yves Tanguy (1900–55). *A Large Painting Which is a Landscape,* 1927. Oil on canvas, $46 \times 35\frac{3}{4}$ (116.5 × 90.5). Collection Mr and Mrs William Mazer, New York. See p. 42.

44 Yves Tanguy (1900–55). *Infinite Divisibility,* 1942. Oil on canvas, 40 × 35 (101.5 × 89). Albright-Knox Art Gallery, Buffalo, New York. See p. 42.

45 Alberto Giacometti (1901–66). *Suspended Ball (The Hour of the Traces),* 1930. Plaster and metal, $24 \times 14\frac{1}{4} \times 13\frac{1}{4}$ (61 × 36 × 33.5). Kunsthaus, Zurich, Alberto Giacometti Foundation. See p. 54.

46 Hans Bellmer (1902–). *Ball Joint,* 1936. Object. Shown at 1936 Paris exhibition. See p. 54.

47 Salvador Dali (1904–). *The Dismal Sport,* 1929. Oil and collage on panel, $18\frac{1}{8} \times 15$ (46 × 38). Private Collection, Paris. See p. 50.

48 Salvador Dali (1904–). *Giraffe in Flames,* 1935. Oil on canvas, $13\frac{3}{4} \times 10\frac{3}{4}$ (35 × 27). Kunstmuseum, Basle, Emanuel Hoffmann Foundation. See p. 50.

49 Salvador Dali (1904–). *Six Apparitions of Lenin on a Piano,* 1931. Oil on canvas, $57\frac{1}{2} \times 44\frac{7}{8}$ (146 × 114). Musée National d'Art Moderne, Paris. See p. 51.

50 Salvador Dali (1904–). *Impressions of Africa*, 1938. Oil on canvas, $36 \times 46\frac{3}{8}$ (91.5 × 117.5). Tate Gallery, London, Edward James Foundation. See p. 50.

51 Oscar Dominguez (1906–58). *Arrival of the Belle Epoque*, 1936. Wood and lead, h. $17\frac{3}{4}$ (45). Collection Marcel Jean, Paris. See p. 54.

52 René Magritte (1898–1967). *Personal Values*, 1952. Oil on canvas, $31\frac{5}{8} \times 39\frac{1}{2}$ (80.5 × 100). Collection Jan-Albert Goris, Brussels. See p. 46.

53 René Magritte (1898–1967). *The Human Condition I*, 1933. Oil on canvas, $39\frac{3}{8} \times 31\frac{7}{8}$ (100 × 81). Collection Claude Spaak, Choisel. See p. 46.

54 René Magritte (1898–1967). *On the Threshold of Liberty*, 1929. Oil on canvas, $44 \times 57\frac{5}{8}$ (11.5 × 146.5). Museum Boymans-van Beuningen, Rotterdam. See p. 46.

55 René Magritte (1898–1967). Cover of *Minotaure*, No. 10, 1937. Gouache. See p. 46.

56 Paul Delvaux (1897–). *Sleeping Venus*, 1944. Oil on canvas, $68 \times 78\frac{3}{8}$ (172.5 × 200). Tate Gallery, London. See p. 48.

57 Pierre Roy (1880–1950). *Invitation to a Journey*, 1929. Oil on canvas, $25\frac{5}{8} \times 36\frac{1}{4}$ (65 × 92). See p. 46.

58 Wifredo Lam (1902–). *Figure*, 1938. Oil on canvas $29\frac{1}{2} \times 39\frac{5}{8}$ (75 × 100). Collection the artist, Paris. See p. 52.

59 Arshile Gorky (1904–48). *The Leaf of the Artichoke is an Owl*, 1944. Oil on canvas, 28×36 (71 × 91.5). Collection Ethel K. Schaubacher, New York. See p. 56.

60 Matta (Roberto Sebastiano Matta Echaurren), (1912–). *The Earth is a Man*, 1942. Oil on canvas, $72\frac{1}{4} \times 96\frac{1}{2}$ (183.5 × 245). Collection Mr and Mrs Joseph Shapiro, Oak Park, Illinois. See p. 56.

61 Matta (Roberto Sebastiano Matta Echaurren), (1912–). *Inscape (Psychological Morphology No. 104)*, 1939. Oil on canvas, $28\frac{1}{8} \times 36\frac{3}{8}$ (71.5 × 92.5). Collection Gordon Onslow-Ford, Inverness, California. See p. 56.

62 André Breton (1896–1966), Paul Eluard (1895–1952) and Valentine Hugo. *Cadavre Exquis, c.* 1930. Coloured chalk on black paper, $8\frac{5}{8} \times 11$ (22 × 28). Collection Graindorge, Liège. See p. 57.

COVER René Magritte (1898–1967). *Reproduction Prohibited (Portrait of Mr James)*, 1937. Edward James Foundation.

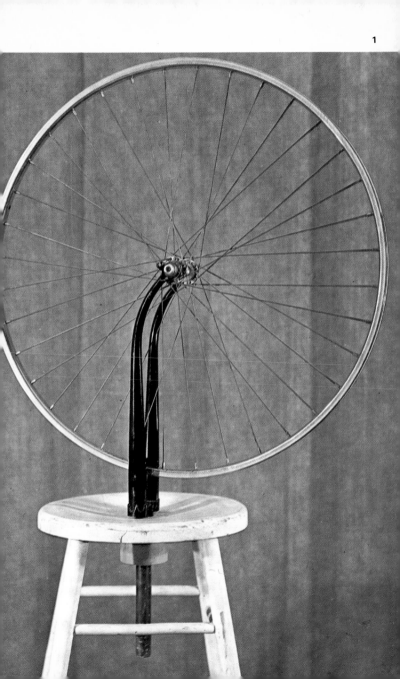

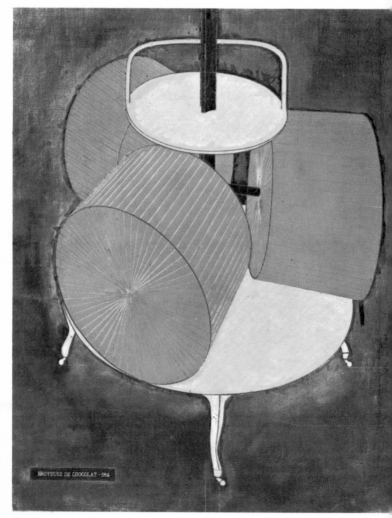

BROYEUSE DE CHOCOLAT · 1914

2

4

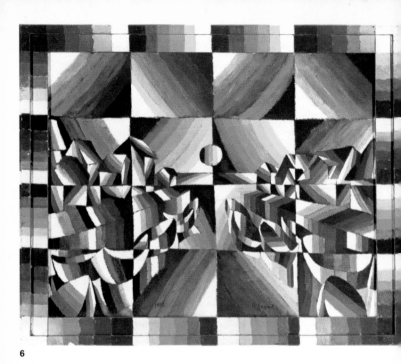

6

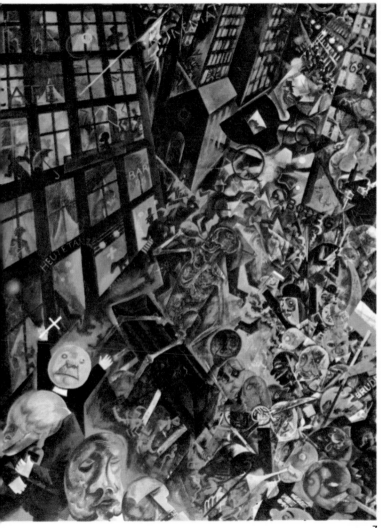

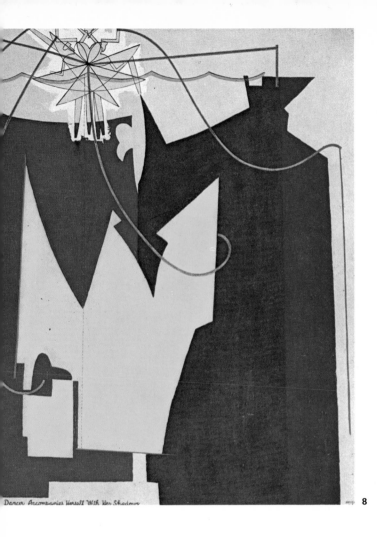

Dancer Accompanies Herself With Her Shadow

8

9

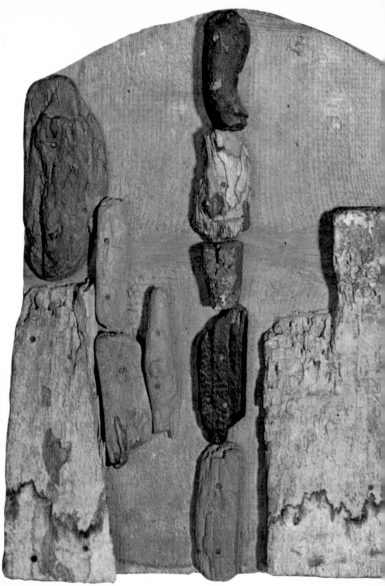

10

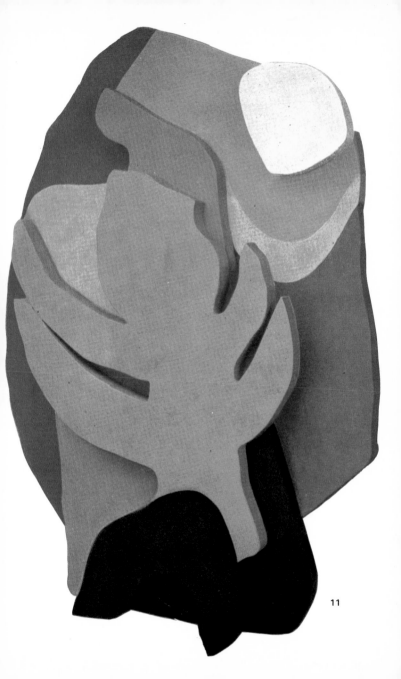

11

12

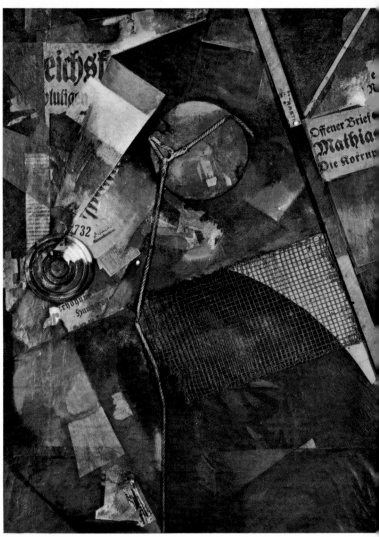

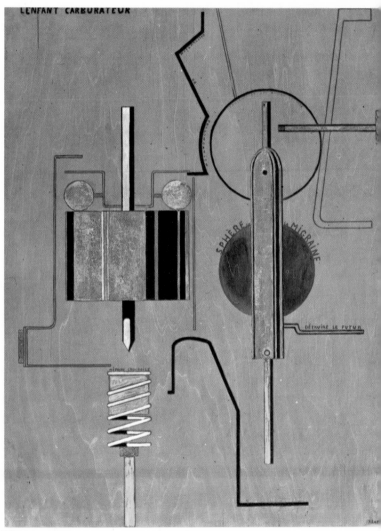

L'ENFANT CARBURATEUR

SPHÈRE MIGRAINE

DÉTRUIRE LE FUTUR

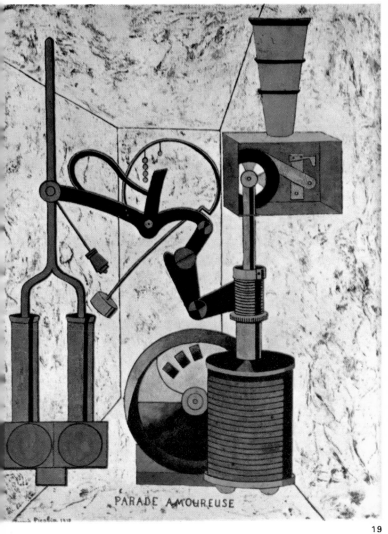

PARADE AMOUREUSE

22

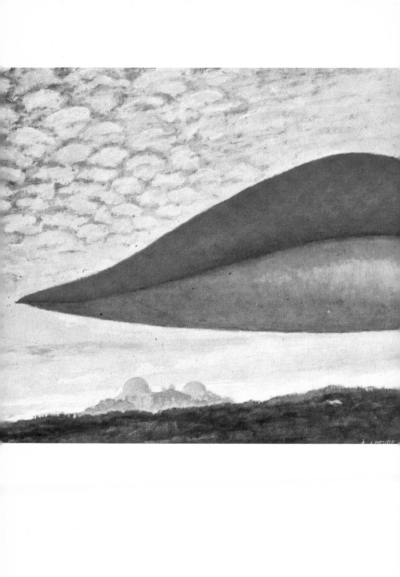

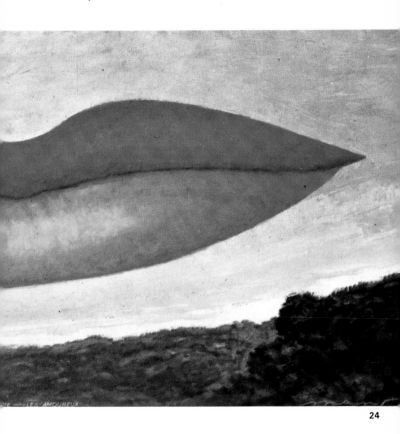

LES AMOUREUX

24

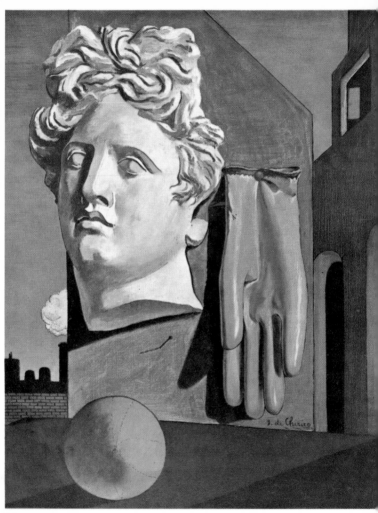

25

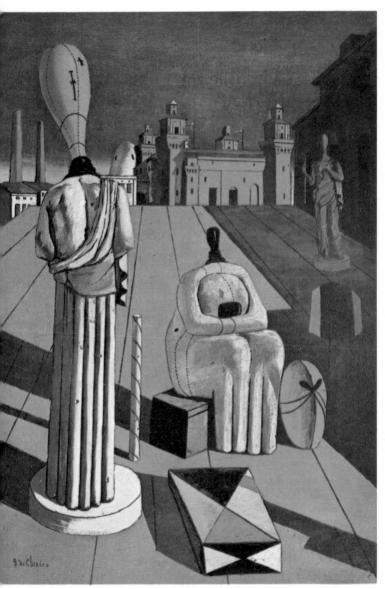

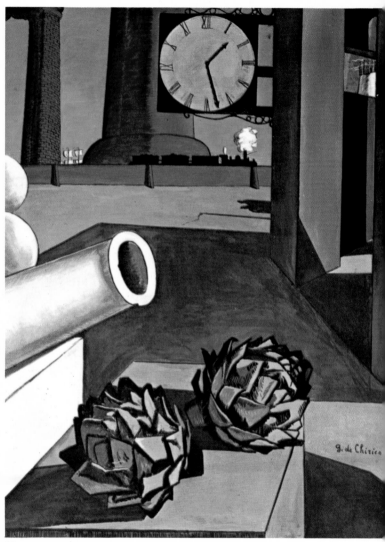

27

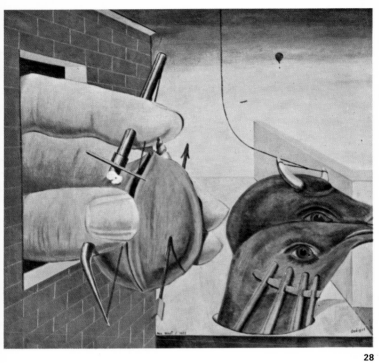

28

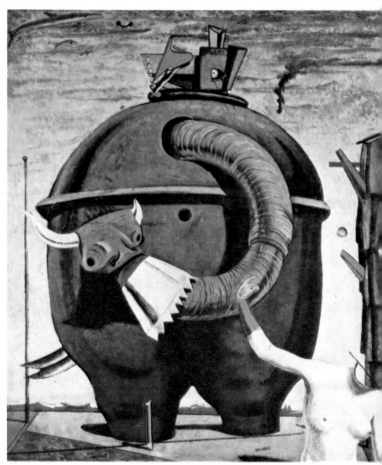

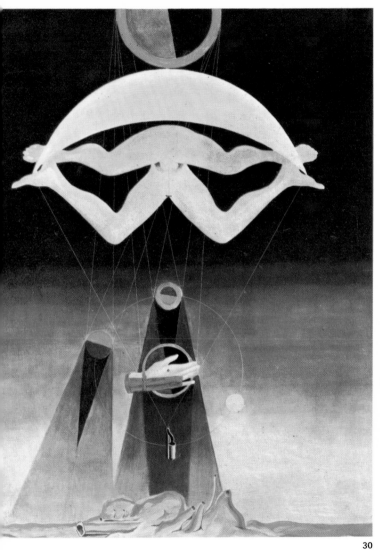

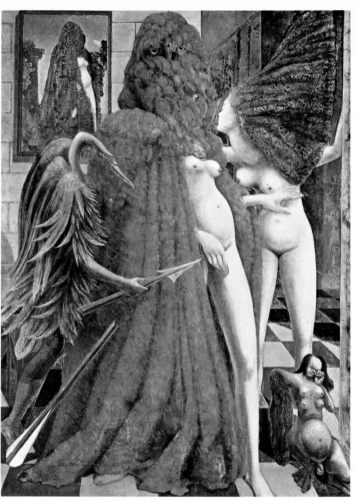

31

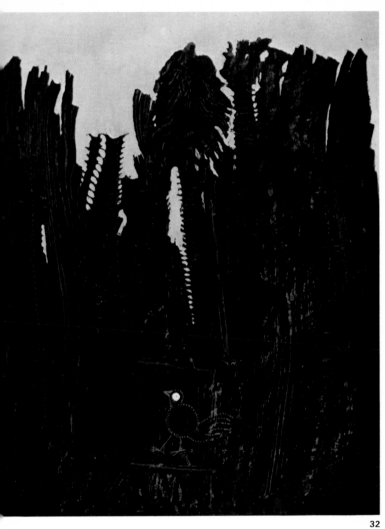

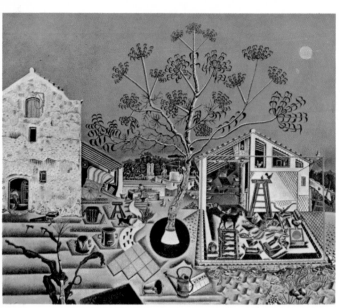

33

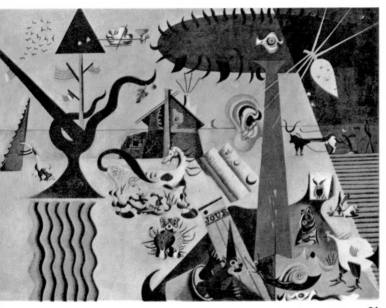

34

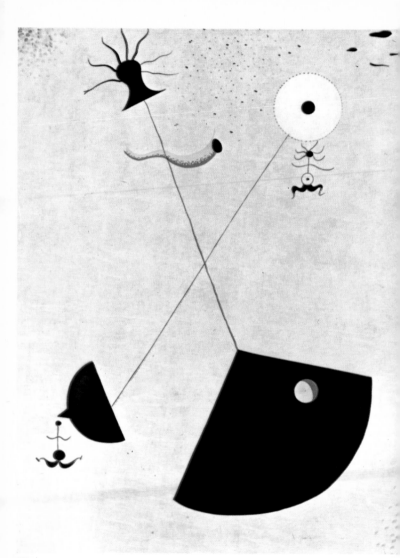

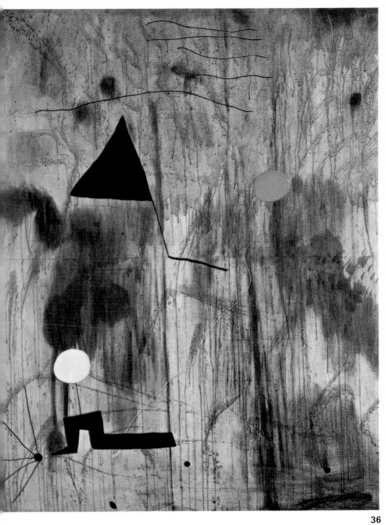

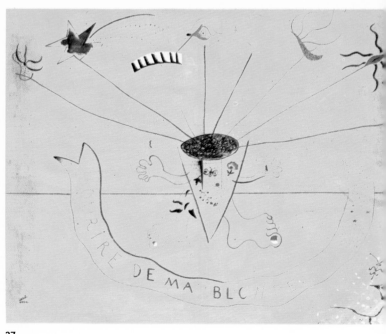

37

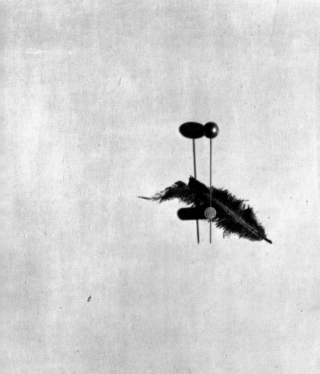

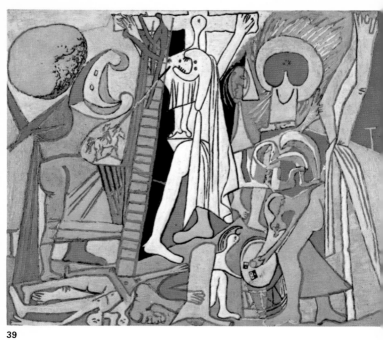

39

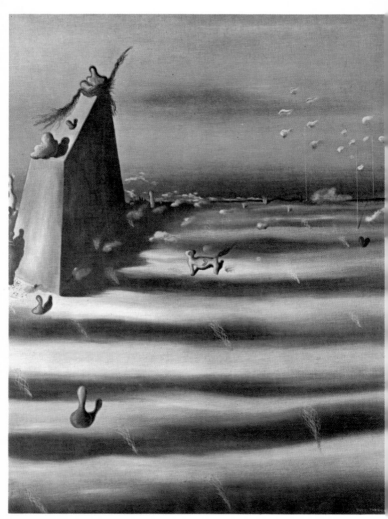

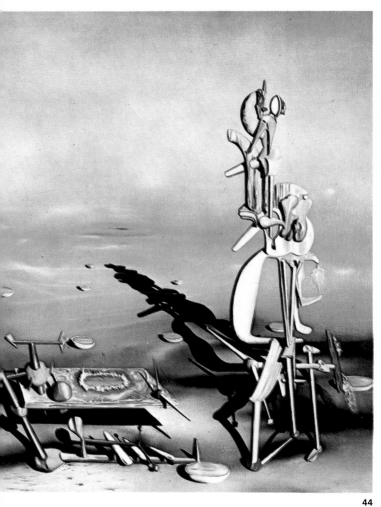

44

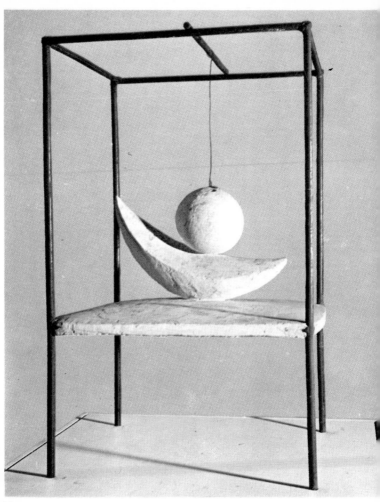

45

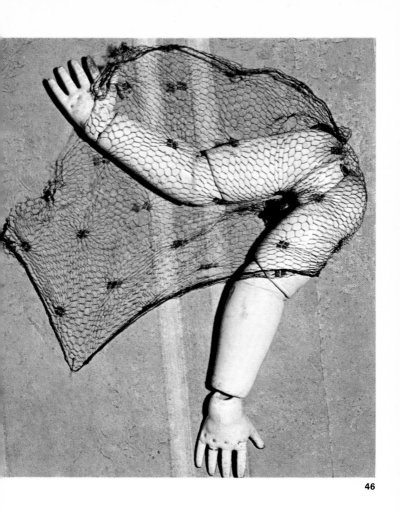

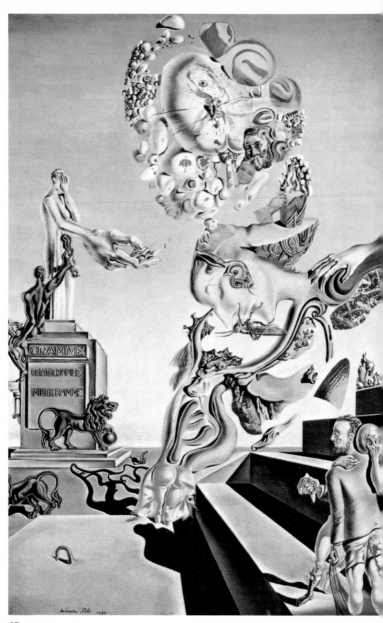

47

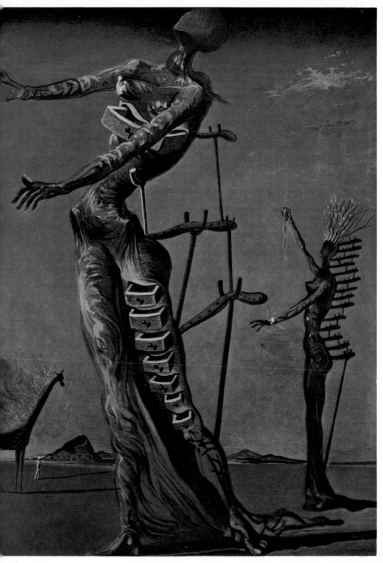

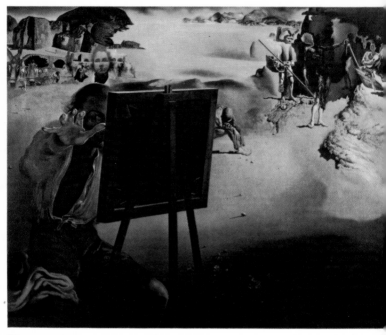

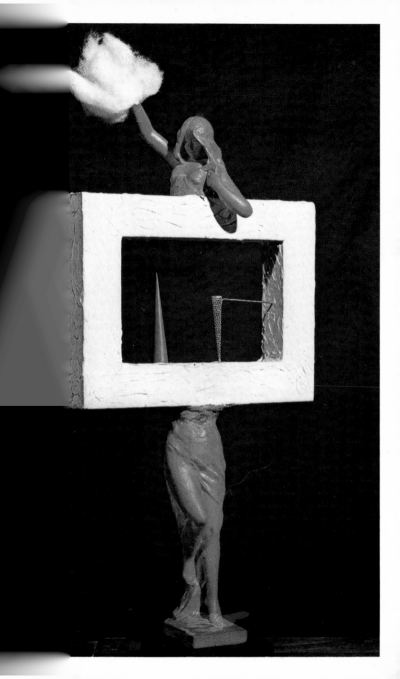

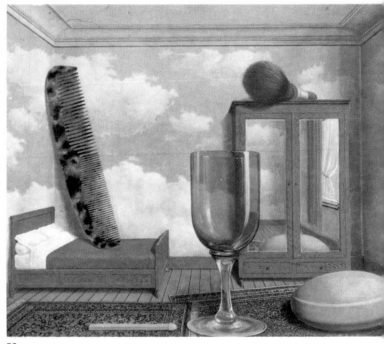

52

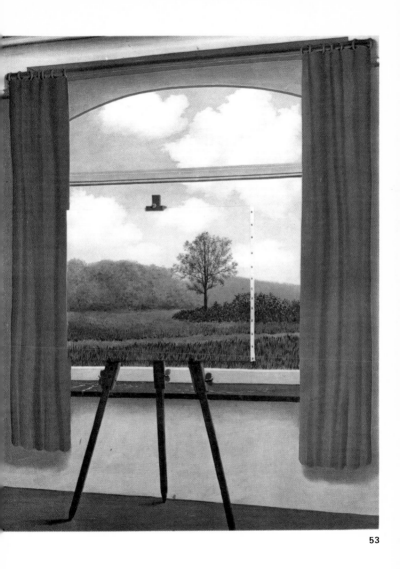

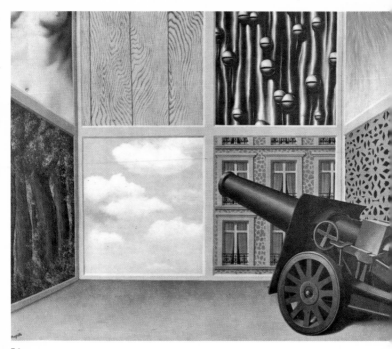

54

MINOTAURE

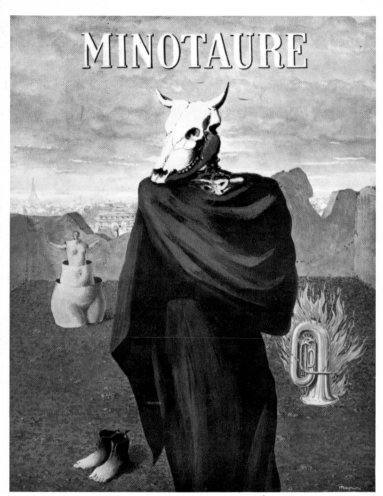

57

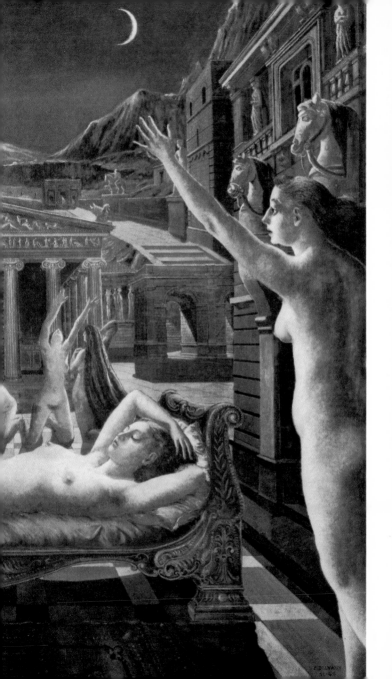

59

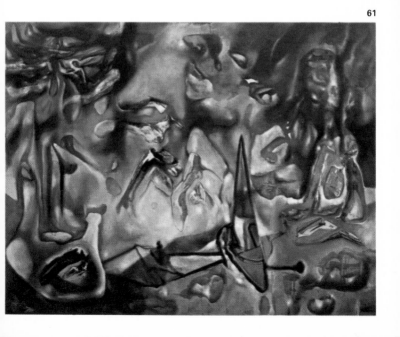

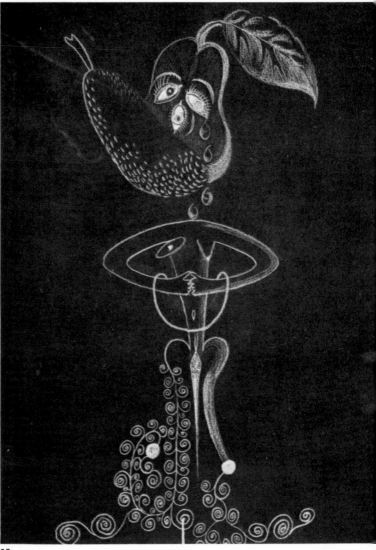

THE STRAIGHT DOPE

"A living monument to the indomitable power of human curiosity and the lengths to which people will go to get to the bottom of things."

Ed Zotti, editor

"Combines the knowledge of the Library of Congress with the charm of a Marine drill sergeant."

The Washington Post

"Deals almost exclusively with cosmic questions."

St. Louis Post-Dispatch

"A goldmine for trivia enthusiasts."

Newsday

More of
THE STRAIGHT DOPE

Cecil Adams

Edited and with an Introduction by
Ed Zotti

Illustrated by Slug Signorino

BALLANTINE BOOKS ■ NEW YORK

DEDICATION

To Ann and Laurie, who didn't deserve it; to Ed and Sluggo, who did; to Tom, Dan, Terry, Clark, Eli, Ken, and the other members of the Straight Dope advisory panel; to Ed Walters, for being a good guy; to Mary, one half of the world's cutest couple; to all those people who patiently answered questions on the telephone that if somebody asked you on the bus you'd have the guy arrested; and finally, to the nation's irrepressible talk show hosts: I love you, you're beautiful, and let's do lunch.

Library of Congress Catalog Card Number: 87-91358

ISBN: 0-345-35145-2

Cover design by James R. Harris
Illustrations by Slug Signorino
Text design by Mary A. Wirth

Manufactured in the United States of America

First Edition: July 1988
10 9 8 7 6

Contents

Introduction

We are pleased to present this second volume of *The Straight Dope*, the first one having done well enough to warrant an encore. (In answer to the obvious question, no, we haven't equaled Garrison Keillor's 3.5 million copies, but we're breathing down his neck.) Cecil and I hope to continue this series as long as we both shall live, or at least until we've got that condo in the Virgin Islands paid for.

We had a bit of a discussion about the title. As you can see, we wound up with *More of the Straight Dope*. This is descriptive, I suppose, but also a bit . . . well, "vapid" was one expression that was mentioned, and I think "unbelievably lame" also came up. Cecil and I were plumping for STRAIGHT DOPE 3-D, which we felt had a certain ring to it. But the publisher wouldn't go for it. We are surrounded by cretins. It is fortunate Keats wasn't thus afflicted, or we'd have wound up with "Poem to a Greek Pot."

We've done a few things differently this time. For one thing, at Cecil's insistence, we have included some quiz questions for the Teeming Millions to answer—a pleasant turnabout from the usual routine. Cecil has been on the firing line for more than 15 years now, answering some of the most off-the-wall questions the mind of man can conceive, and he feels it only fair that the Teeming Millions have an opportunity to share the experience. But never fear. For you, if not for Cecil, the answers are in the back of the book.

We have also included a section called "Feedback," which consists of letters from various rash individuals taking issue with points raised in Volume One. Cecil, of course, responds with his customary restraint. In a few cases, the Teeming Millions have uncovered anomalous situations that to the casual observer might appear to be "mistakes." These are largely the work of saboteurs. However, Cecil's name was on the book's cover, and he takes responsibility, as he always does when compelled by the lack of any plausible alternative.

We have been more forthcoming in supplying references for many of Cecil's answers, particularly when we rely heavily on a single source. Some have criticized us for this practice, on the grounds that Cecil is supposed to know everything. Well, Cecil does know everything. However, he is not going to kid you that he has simply absorbed this knowledge out of the rocks. We have tried to give credit where it's due. In those cases where we forgot, have the decency to keep quiet and we'll slip you a tenner when we get a chance.

The most substantial change in this volume is that we have decided to preserve the Hegelian character, as it were, of the dialogue between Cecil and his readers as it emerges in the weekly *Straight Dope* column. This consists of Cecil making some innocuous assertion and the Teeming Millions responding with clouds of lamebrained and distracting objections. We do this partly because the exchanges are entertaining (Cecil always likes it when he wins), partly because we wish to foreclose future correspondence along the same lines from readers of this book, and partly because it pads out the word count. Once in a while, however, an additional nugget of human knowledge is unearthed, and we wish to pass these along.

In other respects, the book is similar to Volume One, and we hope it meets with a similar response. We were fortunate enough to receive very favorable reviews of Volume One, which shows you how much mileage you can get these days out of a roll of twenties and a case of Chivas. We were particularly taken with the remarks of Larry Kart, a writer for the *Chicago Tribune*. Larry, gifted with a wisdom beyond his years, declared that Cecil was a "direct descendant" of Oscar Wilde and Max Beerbohm. This is not literally true, of course. So far as we know, Max and Oscar were not even acquainted. However, from the point of view of properly fixing Cecil in the pantheon of immortals, it is definitely in the ball park. We humbly suggest that thinking about Mark Twain, Finley Peter Dunne, and S.J. Perelman might also help you get a bead on the situation. Not that we want to put words in your mouth, but I must say that if someone from a large daily newspaper or news magazine were to use the expression "MAMMOTH BLOCKBUSTER" in the course of his or her remarks, it would definitely look nice on the cover when we prepare the mass market edition.

It has been suggested that this might be an appropriate place

to speculate on the Meaning of It All—It, naturally, being the pursuit of human knowledge. We resisted this temptation in Volume One, largely because we felt that It didn't necessarily Mean anything, beyond the obvious fact that people were curious. However, we have reconsidered, largely because the question seems to come up so often. Maria Shriver—a lovely girl, really, but a little low on the glial cell count—once asked us plaintively on the "CBS Morning News," "But why do people care about this stuff, anyway?" We had to confess that we didn't know. We still don't. We find it interesting to note, however, that a field Cecil once had entirely to himself has now become almost crowded.

There are any number of books out now—many of them very good books—that attempt to track down rumors, unearth big secrets, suppress misinformation, and solve the imponderable mysteries of life. Perhaps in some small way we enable people to feel they know what is Really Going On. Perhaps we merely give them something to read in the bathroom now that *Modern Bride* has gotten too thick. We cannot say. All Cecil and I know is that every six months we get a very tasty royalty check, and we'd like to keep it that way. Keep reading, and thanks for your support.

—Ed Zotti

Comments, testimonials, and contributions to the STRAIGHT DOPE Research & Entertainment Fund may be sent to:

Cecil Adams
c/o Chicago Reader
Box 11101
Chicago, IL 60611

More of
THE STRAIGHT DOPE

Chapter 1

The Birds and the Beasts

I've wondered about this for years, ever since I heard it in the third grade from Steve Revoi. He said brontosauri had a brain in their butt. Is this true? What did it control? Was it part of the central nervous system or an entity unto itself? Did it have angst or did it feel integrated into the whole being of the brontosaurus? How about its sex life? As you can tell, I am very curious about this topic.—Ruth M., Alhambra, California

Your feelings are understandable, Ruth; there's no question that the phenomenon of creatures with their brains up their butts has acquired a certain desperate relevance today. But let's start with dinosaurs. Actually, it wasn't the brontosaurus that supposedly had two brains, it was the stegosaurus, the one with the spikes running up and down its back. Archaeologists found there was a big enlargement in the stegosaurus's spinal cord at the point where it passed through the pelvis. Since the stegosaurus had a pretty poor excuse for a brain in its head—the thing was about the size of a walnut, only one twentieth the size of the mysterious butt organ—speculation arose that the giant reptile needed some auxiliary gray matter to mind its rump while the forward brain handled business up front. Naturally, this idea provoked a certain amount of merriment amongst the more disreputable elements of the popular press. In 1912, columnist Bert Taylor of the *Chicago Tribune* penned the following ode on the subject:

Behold the mighty dinosaur / Famous in prehistoric lore, / Not only for his power and strength / But for his intellectual length. / You will observe by these remains / The creature had two sets

3

of brains— / One in his head (the usual place), / The other in his spinal base. / Thus he could reason "A priori" / As well as "A posteriori." / No problem bothered him a bit / He made both head and tail of it. / So wise was he, so wise and solemn, / Each thought filled just a spinal column. / If one brain found the pressure strong / It passed a few ideas along. / If something slipped his forward mind / 'Twas rescued by the one behind. / And if in error he was caught / He had a saving afterthought. / As he thought twice before he spoke / He had no judgment to revoke. / Thus he could think without congestion / Upon both sides of every question. / Oh, gaze upon this model beast; / Defunct ten million years at least.

Alas, it was too good to be true. Later scholars decided that the putative afterbrain was just a neural junction where a lot of nerves happened to enter the spinal cord. Such junctions are found in many lizards, as well as in the ostrich. Dinosaurs may have been stupid, but they weren't schizo.

Are or are not cats and dogs really color-blind? How do they know?—Jim L., Chicago

You ever see a cat who could pick out a tie? Believe me, cats'll wear things you wouldn't put on a dog. Scientists, however, are not content with anecdotal evidence. They often test animal color sensitivity by trying to link color with food. One such experiment was conducted in 1915 by two scientists at the

University of Colorado, J.C. DeVoss and Rose Ganson. They put fish in two jelly jars and then lined both with paper, one gray and one colored. If a cat picked the colored jar, it got to eat the fish. Nine cats, 18 months, and 100,000 tries later, the researchers established that cats picked the right jar only half the time—the level of pure chance. On the other hand, cats could readily distinguish between different shades of gray. Ergo, cats are color-blind.

Doubts about this conclusion arose some years later, however. Cats have cones as well as rod-type vision receptors in their retinas, and cones have long been associated with color vision in humans. Neurologists who wired up feline brains with electrodes discovered that, on laboratory instruments at least, cats responded to light of different wavelengths—which is to say, color. So researchers went back for another round of fish experiments. Finally, in the 1960s, they managed to teach the cats to discriminate between colors. But it took some doing—one group found it took their cats between 1,350 and 1,750 tries before they got the hang of it.

From this one might deduce one of two things: either cats are exceptionally dense, a proposition Cecil has no trouble buying, or else they just don't give a hoot about color. Most cat scholars have opted for choice number 2, saying that the ability to distinguish colors is obviously of no importance to cats and hence not something they learn readily.

Less work has been done on dogs than on cats, but what there is suggests canine color sensitivity isn't very good either. Much the same can be said for mammals in general, with the exception of primates. In contrast, some of your supposedly lower order creatures, such as fish, turtles, and especially birds, can distinguish color with ease. The fact that these primitive beasties should have more advanced visual abilities than their mammalian betters has always struck observers as a little odd; clearly the evolutionary progress of color vision has been more erratic than one might expect.

While watching TV the other night I saw a commercial that repeated the old saying, "An elephant never forgets." Never forgets what? Is it true that pachyderms have unparalleled powers of recollection?—Carlos M., Chicago.

You will be happy to know, Carlos, this being the age of

science and all, that the claims made for elephants and their memories have been subjected to rigorous analysis. In an experiment reported in 1957, Professor B. Rensch of Munster University in Germany attempted to teach a five-year-old Asiatic elephant to differentiate between two wooden boxes, one marked with a square, the other with a circle. The former contained food, the latter nothing. The elephant, obviously no Einstein, needed 330 tries before he grasped the concept. Different pairs of symbols were then used, with the elephant making (for an elephant) remarkable progress. By the time the fourth pair rolled around, the elephant needed only 10 tries before he figured out where the food was, and by the twentieth, he had it down solid.

Professor Rensch then bided his time for a year, following which he subjected the hapless elephant to further tests with 13 of the original pairs. On all except one (the toughest), the elephant scored between 73 and 100 percent correct. From this the professor concluded that while elephants were not what you could call quick, once you got an idea pounded into them, it was well nigh impossible to get it out again.

This finding generally accords with the experience of elephant trainers. With patience—a lot of patience—elephants can be taught an amazing array of tricks, ranging from the mundane perching on a ball to such feats as driving a jeep, playing cricket, and who knows, maybe even balancing the federal budget. If only we could get the rest of Congress to cooperate.

I want the dirt. *Is Mrs. Mantis really guilty of biting off Mr. Mantis's head immediately after they consummate their mantis marriage? I hear it's only a vicious rumor and that Mrs. Mantis is getting a bad rap.—Victois M., Chandler, Arizona*

The stories about Mrs. M are a little exaggerated, but they're no rumor. And believe me, you ain't heard the half of it. Not only is Mrs. Mantis notorious for chowing down on her man *après* romance, sometimes she bites his head off *during the act.* What's more, it doesn't discourage him in the slightest—if anything, it inspires him to greater heights.

In fairness to Mrs. Mantis, she doesn't always have her mate for lunch. In most of the 1,500 species of mantis, in fact, cannibalism is fairly rare. Past reports of mass slaughter were based on observations in the lab, a stressful environment that apparently brought out the female mantis's bad side.

But even in the field, male manticide occurs "more often than not" in *Mantis religiosa*, the one type of praying mantis "from which the whole group gets its bad reputation," according to one researcher. Here's the scenario: "The male usually tries to approach the female undetected, to seize her unawares, but often he is seen, and the female then catches and eats him, usually beginning at the head. The loss of his head, however, galvanizes the male into action, and he can successfully complete copulation without it. [The male climbs on the female's back and assumes the position before his partner starts to dig in.] This behaviour pattern, in which she devours the male, is of obvious advantage to the female, and to the species, because she is able to put to good use an otherwise worthless mass of protein."

Another writer notes, "If a male praying mantis is decapitated the body will immediately assume the reflex attitudes which are characteristic of copulation." In other words, we are talking about a species that has become dependent not just on cannibalism but on S&M to perpetuate itself.

The spectacle of *M. religiosa* mating is something no human male can contemplate without emotion. On the one hand, you have to admire a lad who can do his connubial duty under what must be described as very trying circumstances. On the other hand—let us speak frankly here—it is wounding to have a member of the sex described as a "worthless mass of protein." One weeps to think what it does to the ego of Mr. Mantis. Not only

does the female of the species not value you for your mind; by the time she gets done with you you don't even *have* a mind.

Sexual cannibalism is not confined to the mantis. A type of fly known as *Serromyia femorata* mates by snuggling up to its partner and engaging in what sounds like an exceptionally vigorous french kiss: "At the end of mating," it says here, "the female sucks out the body content of the male through the mouth." Believe me, I'll never complain about a lack of female aggressiveness again.

Female spiders also eat their mates on occasion, although contrary to popular belief the black widow spider (*Latrodectus mactans*, et al.) is not conspicuously energetic in this regard. On the other hand, black widows do have a tendency to nibble on their kiddies . . . but let's take this up later.

Why Do I Encourage These People?

Your article on Mr. and Mrs. Mantis caught my eye. I'm interested in the subject of peculiar sexual habits, particularly the deadly ones, found within the animal and insect kingdoms. I enclose an article I thought you might get a chuckle out of. —Chris S., Santa Monica, California

The article, clipped from the *Los Angeles Times*, discusses the mating habits of the ant:

"When the mating urge comes, something pretty stupendous happens—by human standards. 'Both the queen [female] and the prince [male] have wings,' Levine [ant tycoon] said. 'They fly 100 feet straight up in the air and mate.' After the quick tryst, several things happen, all bad in the case of the male. 'His wings fall off and he drops dead,' Levine said. 'The female also sheds her wings and falls to the ground. Then she begins laying eggs almost immediately. For possibly as long as the next 15 years after that single mating, she lays eggs almost continuously. Hundreds of thousands of them. The survivors become her colony.' "

And you thought *your* pregnancy was rough.

It being spring and all, we would like to know what the connection is between Easter and rabbits, and for that matter between rabbits and eggs. My uncle told me that when the West was in the progress of being won, trappers knew it was Easter when the first rabbits of the season appeared. That explains things logically, I guess, but does it mean they don't have chocolate Easter bunnies in Paris?—Ed Y., Chicago

I realize we're getting to this one a little late, gang, but I feel the Easter bunny is one of those subjects with year-round relevance. Many stories have been told to explain the EB's origin. There's the one about the rich lady in medieval times who hid eggs around the backyard as a springtime treat for the neighborhood urchins. Seeing a wild hare or two bounding about the premises and then finding a mysterious egg a short time later, the kids supposedly concluded that the former had laid the latter. Charming, sure, but woefully lacking in explanatory power.

In reality the association of Easter, eggs, and rabbits dates back to the early Christian era, when the celebration of the Resurrection became conflated with traditional spring fertility rites. Eggs and rabbits, for obvious reasons, are fertility symbols of long standing. Indeed, in the eighth century, the Venerable Bede speculated that the word "Easter" was originally the name of an Anglo-Saxon goddess of spring/dawn/fertility (although this has since been disputed). Once again we find that one of our sacred days is tainted with lust. Incidentally, the usual symbol in Europe, where this all got started, is actually the hare. The rela-

tively hare-starved U.S. was obliged to substitute the smaller but infinitely cuter bunny rabbit.

Is it true that turkeys are so stupid they will look up in the sky when it rains and thereby drown?—Jim G., Park Ridge, Illinois

Fortunately, no, Jim, or the godforsaken Chicago Cubs would never be able to field a team. (Sorry, but my feelings on this subject run deep.) However, while turkeys don't literally drown in the rain, there is a grain of truth to the idea that they do. Until they're about eight or nine weeks old, baby turkeys are covered with down rather than feathers and consequently are quite vulnerable to the effects of weather. In the wild, the baby turkeys' mommas hustle them out of harm's way when a storm blows up, but domesticated turkey mothers, having been rendered spineless by generations of welfare, are apparently too indolent to do so. (In fairness, modern poultry raising being what it is, Mom may no longer even be on the scene.) As a result, the chicks get cold and wet and often die of exposure when it rains.

Former farm kids from back in the days when every homestead had a few gobblers out back will tell you of being sent out into the barnyard after a downpour looking for small huddled bodies, in hopes that a few might be saved. Many will insist that the little clucks really did drown. But those I have quizzed about it admit they didn't actually stand out there in the rain and watch.

Now, it's true turkeys (and chickens) do a lot of things that don't exactly qualify as brilliant. When they get into a panic, for example, they'll all crowd into a corner trying to get away, and the sap on the bottom sometimes suffocates. But should we blame the poor turkeys for that? For shame—the real fault lies with the farmer, for failing to instruct his birds in proper evacuation procedures. In short, I don't think we should be so quick to write turkeys off as "stupid." Rather, let us recognize them for the tragic victims of society that they are.

Every year we hear the Alpo man claim his 14-year-old dog is actually 98 years old in human years. Yet I remember reading in some journal that the seven-years-for-every-one-dog-year rule is only applicable to dogs under 10 years old. After a certain age the conversion factor reduces considerably, so that a 98-year-old

Alpo dog is really in his mid-seventies. I need the Straight Dope so I can get the candles right for my hound.—Michael L., Bethesda, Maryland

I've seen various formulations for this over the years. One of the simplest and most sensible goes like this: The first year of canine life is equal to 21 years of human life—in other words, the puppy grows to adulthood. Every additional dog year is equivalent to four human years. Thus a 10-year-old mutt is the equivalent of 57 human years old ($9 \times 4 + 21$). Likewise, the Alpo dog is not 98 (14×7) but 73 in human terms ($13 \times 4 + 21$).

The formula jibes reasonably well with the known landmarks of canine life. Dogs reach middle age when they're 6 or 7, which works out to 41–45 in HY. Life expectancy for most is 12–15 years (65–77 HY); occasionally one manages to creak along until age 20 (97 HY). That makes a lot more sense than saying a 20-year-old dog is 140, and it sure saves on the candles too.

What happened to the brontosaurus? Number-one son (pre-literate) recently acquired a major case of dinosaur love, so I've been spending a lot of time lately reading about prehistoric life in books with large type, lotsa pictures, and a sketchy sense of detail. In the course of this I've noticed there's something cooking with my favorite sauropod. There seems to be three possibilities: (1) The brontosaurus has been renamed the apatosaurus. (2) The brontosaurus was never really called the brontosaurus; that was just its popular name, and the dinosaur establishment for unspecified reasons is now cracking down and insisting on the scientific name Apatosaurus ajax. *(3) There was never any such thing as a brontosaurus; there was only the apatosaurus, but nobody knew it until recently. What's the truth? Does this have anything to do with the story I heard that all the heads on the brontos in all the museums everywhere had to be knocked off some years ago and changed?—Clint P., Chicago*

This is going to be a world-class bummer for all you Dino the Dinosaur fans out there, but it seems there's been a little mistake. A couple mistakes, actually. First, Othniel Charles Marsh, the distinguished paleontologist who discovered the so-called brontosaurus, somehow managed to get the heads mixed up. Second, what he thought was a new species in reality was just another specimen of a previously discovered lizard called the

apatosaurus. Since the name that comes first gets priority, apatosaurus stayed, and brontosaurus got the hook. Thus, officially speaking, there is no such thing as a brontosaurus, and what's worse, what you thought was a brontosaurus actually doesn't look like what you thought it looked like.

Now, admittedly, I'm exaggerating things a bit here. The apatosaurus really isn't that much different from the brontosaurus. Basically, it has a longer snout, with more delicate teeth. It also has similar habits, including a moral commitment to vegetarianism. And no doubt the name brontosaurus will continue to be used by laymen. For we purists, though, it just won't be the same.

Here's what happened. In the late 1800s, O.C. Marsh was feverishly scouring the American West looking for new dinosaur species, lest he be beaten to the punch by his archrival, Edward Drinker Cope. Between the two of them, Cope and Marsh discovered half the vertebrate fossils known as of 1900. Unfortunately, what was popularly known as the "Dinosaur Wars" occasionally resulted in slipshod work. In 1879 O.C. dug up the skeleton of a jumbo-sized critter that was complete in every respect except one—it didn't have a head. Never one to get hung up on details, O.C. rummaged around in the veld until he found a couple skulls that looked like they might fit the bill. Voila, the brontosaurus.

There was just one problem: one head was found four miles

away from the main skeleton, the other one 400 miles away. Moreover, the skulls were found near the skeletons of another type of dinosaur called the camarasaurus, and in fact looked an awful lot like camarasaurus skulls. O.C. was thus asking the world to believe, in essence, that a whole passel of camarasauruses came along, spied Mr. Bronto, noticed how much he looked like themselves, slipped him a mickey, sawed off his noodle, and dragged it along with them until such time as they too departed this vale of tears. Needless to say, O.C. kept mum about this in his scientific paper on the subject. His colleagues bought his story, and the paleontological equivalent of the unicorn was born.

Questions about the brontosaurus began to surface fairly early on. The problem with the name got straightened out in 1903, at least for scientists, when it was pretty firmly established that the brontosaurus was the same species as the apatosaurus, which Marsh had discovered in 1877. The term "brontosaurus" thus lost its official standing. Nonetheless, the name has always stuck in people's minds, and chances are it'll survive in popular usage for a long time.

The business with the head is a bit more complicated. In 1909 researchers for the Carnegie Museum of Natural History began digging up what turned out to be a pair of apatosauruses in Utah. Near the neck of one, but detached from it, was a skull. It was not, however, a camarasaurus-type skull, but rather looked like that of another big lizard, the diplodocus. In a 1915 paper, Carnegie Museum director William Holland hinted that perhaps O.C. Marsh had messed up and given the apatosaurus the wrong skull. But nobody believed him, since Marsh was still held in high esteem. In 1936 another paleontologist named Charles Gilmore reviewed Holland's claim. Unfortunately, by this time the original diplodocus-type skull had gotten mixed up with a smaller skull that probably belonged to an actual diplodocus. (Paleontologists seem to have a real problem with skulls.) Since the second skull was obviously too small, Gilmore dismissed the idea that it belonged to the apatosaurus.

It wasn't until the 1970s that two researchers, Wesleyan University physicist John McIntosh and Carnegie Museum associate curator David Berman, were finally able to get all the heads straightened out. They assembled enough evidence to convince the scientific community to accept the real (we hope) story, namely that the apatosaurus had a diplodocus-type head rather

than a camarasaurus-type head. Museums around the country subsequently began modifying their skeletons accordingly— although I'm told that the apatosaurus at Yale's museum still has camarasaurus *feet*. But let's take one thing at a time.

Why do worms crawl out onto the sidewalk after it rains?—Gregory S., Evanston, Illinois

Because otherwise they'd drown when their holes filled up with water. Who says there ain't no simple answers?

Chapter 2

That's Entertainment?

For some time now my wife and I have pondered a question about the old "Clutch Cargo" cartoon series. The mouths of Clutch and his pals, Spinner and Paddlefoot, seemed almost life-like—much different from the characters' other movements. Were actual lips somehow superimposed on the faces of the animated characters? We cannot recall seeing this technique used in any other cartoon shows—and we watched our share of them.—Victor S., Oak Park, Illinois

I remember "Clutch Cargo" well—especially Spinner, the teenage castrato. That kid's squeak was like chalk on a blackboard. You apparently never saw "Space Angel," released in 1964 by TV Comic Strips, Inc., which also produced "Clutch Cargo." Both series made use of a technique known as "syncro-vox," in which, as you correctly surmise, film of actors with everything masked out but the lips was superimposed over the animation. (The actors actually spoke their lines through a black megaphone.) The idea, not surprisingly, was to conserve bucks, since lip movements are a hassle to draw. In "Space Angel" they often used to draw microphones in front of the characters' mouths to save even the minimal expense of syncro-voxing. The technique was also used for things like flame. Little else in the scene moved, with the exception of the occasional plane, train, or extraterrestrial vehicle, which more or less slid across the screen. The contrast of the totally wooden action with the luridly lifelike lips was bizarre even by the relaxed standards of kidvid, and the producers wisely deep-sixed the technique after a short time.

My girlfriend says that half of the film crew and eight of the cast of the movie The Conqueror *starring John Wayne died of cancer after an A-bomb test in Nevada. It can't be the truth— that many people—can it? Please, Cecil, give us the Straight Dope.—John L., Santa Monica, California*

I am horrified to have to report this, John, but your girlfriend's claim is only slightly exaggerated. Of the 220 persons who worked on *The Conqueror* on location in Utah in 1955, 91 have contracted cancer to date and 46 have died of it, including stars John Wayne, Susan Hayward, and Agnes Moorehead and director Dick Powell. Experts say under ordinary circumstances only 30 people out of a group of that size should have gotten cancer. The cause? No one can say for sure, but many attribute the cancers to radioactive fallout from U.S. atom bomb tests in nearby Nevada. The whole ghastly story is told in *The Hollywood Hall of Shame*, by Harry and Michael Medved. But let's start at the beginning.

The Conqueror, a putative love story involving Genghis Khan's lust for the beautiful princess Bortai (Hayward), was a classic Hollywood big budget fiasco, one of many financed by would-be movie mogul Howard Hughes. Originally, director Powell wanted to get Marlon Brando for the lead, but John Wayne, then at the height of his popularity, happened to see the script one day and decided he and Genghis were meant for each other.

Unfortunately, the script was written in a cornball style that was made even more ludicrous by the Duke's wooden line readings. In the following sample, Wayne/Genghis has just been urged by his sidekick Jamuga not to attack the caravan carrying Princess Bortai: "There are moments fer wisdom, Juh-mooga, then I listen to you—and there are moments fer action—then I listen to my blood. I feel this Tartar wuh-man is fer me, and my blood says, "TAKE HER!" In the words of one writer, it was the world's "most improbable piece of casting unless Mickey Rooney were to play Jesus in *The King of Kings*."

The movie was shot in the canyonlands around the Utah town of St. George. Filming was chaotic. The actors suffered in 120 degree heat, a black panther attempted to take a bite out of Susan Hayward, and a flash flood at one point just missed wiping out everybody. But the worst didn't become apparent until long afterward. In 1953, the military had tested 11 atomic bombs at Yucca Flats, Nevada, which resulted in immense clouds of fallout floating downwind. Much of the deadly dust funneled into Snow Canyon, Utah, where a lot of *The Conqueror* was shot. The actors and crew were exposed to the stuff for 13 weeks, no doubt inhaling a fair amount of it in the process. Hughes later shipped 60 tons of hot dirt back to Hollywood to use on a

set for retakes, thus making things even worse. Many people involved in the production knew about the radiation (there's a picture of Wayne himself operating a Geiger counter during the filming), but no one took the threat seriously at the time. Thirty years later, however, half the residents of St. George had contracted cancer, and veterans of the production began to realize they were in trouble. Actor Pedro Armendariz developed cancer of the kidney only four years after the movie was completed, and later shot himself when he learned his condition was terminal. Howard Hughes was said to have felt "guilty as hell" about the whole affair, although as far as I can tell it never occurred to anyone to sue him. For various reasons he withdrew *The Conqueror* from circulation, and for years thereafter the only person who saw it was Hughes himself, who screened it night after night during his paranoid last years.

As you can see from our Index page, we at Harper's *are fascinated by facts. But even our crack research team is occasionally stumped. And so, with our resources exhausted, we turn to you, hoping you can rescue us from this dark night of our inquisitive souls. We have heard that Mr. Greenjeans, Captain Kangaroo's faithful sidekick, is, in real life, Frank Zappa's father. Is this true, or just another rumor perpetuated by a myth-hungry nation?—Will D., Alan B., Molly W.*

One of the advantages of the fast-paced world we live in, gang, is that there are many technological marvels that make the job of the investigative reporter easier. One of these is called the telephone. Give it a whiz next time you're in a jam. Hugh "Lumpy" Brannum, aka Mr. Greenjeans, recently died, but the folks at Bob Keeshan Associates, which produced the old "Captain Kangaroo" show, tell me he had one son, whose name, suffice it say, is not Frank. Frank Zappa, the well-known president of Pumpko Industries, Ltd., and founder of the Mothers of Invention, is the son of Francis Vincent Zappa Senior, a research scientist now retired from Lockheed. Frank Junior was born in Baltimore, but when he was still a kid Dad moved the family out to California, where for all I know they live to this day. The whole story is told in Zappa's biography, *No Commercial Potential* by David Walley (1972), which features pictures of Papa Zappa and the rest of the Zappa clan. The origin of the Mr. Greenjeans rumor is shrouded in obscurity, but I note that an

instrumental tune on Zappa's 1969 *Hot Rats* LP is named "Son of Mr. Green Genes." Make of it what you will.

More On the Zappa–Greenjeans Connection

As long as you're running barefaced plugs for other organizations, I'm a writer for Jeopardy! *Like* Harper's *and their index, we too are fascinated by facts (preferably in groups of five, having something in common), and I have another fact or two regarding the Frank Zappa–Mr. Green Genes connection.*

The song "Son of Mr. Green Genes" on 1969's Hot Rats *album is a theme-and-variations offshoot of a song called—can you guess?—"Mr. Green Genes" on a 1968 album called* Uncle Meat. *Zappa did it again later: the 1970 album* Weasels Ripped My Flesh *had a song called "The Orange County Lumber Truck" that resurfaced on the 1974* Roxy and Elsewhere *album under the name "Son of Orange County." So brace yourself for questions about where he (and his dad) grew up.—Carlo P., Burbank, California*

In the movie In Old Chicago, *the role of the Stuttering Clerk is played (according to the credits) by Joe Twerp. Was that his real name or even his actual stage name, or was it a made-up name such as W.C. Fields used as a writer on some of his movies (e.g.,* Mahatma Kane Jeeves)?—J.K., Chicago*

I hope this doesn't come as a disappointment, but Joe Twerp was no more or less than Joe Twerp, a bit-part actor in the late thirties. In addition to *In Old Chicago*, his credits include *The Woman I Love*, directed by Anatol Litvak in 1937, and *Mary Burns, Fugitive*, a 1935 gun-moll story directed by William K. Howard.

As I sit here watching Saturday-morning cartoons with my kids, an old, nagging question resurfaces, to wit: How are the harmonious, perfectly pitched voices of Alvin and the Chipmunks created? Eunuchs? The Mandrell sisters on helium? I breathlessly await your reply.—Earl B., Acton, Texas

Obviously, Earl, you never spent much time horsing around with the speed control on your tape recorder to make goofy high-pitched voices. As kids, my brothers and I found this to be a

source of endless amusement, and if we'd been smarter and about 20 years older, we'd be millionaires today. Unfortunately, we were beaten to the punch by California songwriter Ross Bagdasarian.

Bagdasarian, who used the stage name David Seville, showed early signs of genius in 1951, when he and his cousin, the playwright William Saroyan, wrote a number-one hit for Rosemary Clooney called "Come On-a My House." But he didn't really hit his stride until 1958, when he recorded the immortal tune "Witch Doctor." By singing at a very . . . deliberate . . . pace into a tape recorder running at half speed, and then replaying the tape at normal speed, Bagdasarian was able to create the unforgettable proto-chipmunk chorus line, "Oo Ee Oo Ah Ah, Ting, Tang, Walla Walla Bing Bang." (Bagdasarian used Walla Walla because he had an uncle who moved to Washington State. If the uncle had moved to Chicago, the whole course of musical history might have been different.)

The record sold 1.5 million copies. Realizing he was onto something big, Bagdasarian followed up seven months later with "The Chipmunk Song," a Christmas tune featuring the now-famous trio of Theodore, Simon, and the obstreperous Alvin. Alvin was loosely based on Bagdasarian's equally obstreperous four-year-old son Adam, who, according to *Life* magazine writer

Shana Alexander, was given to engaging his father in such implausibly precocious dialogue as the following:

ADAM: I made a valentine for you in school today.
Ross: Adam, I told you not to come in here when I'm . . .
ADAM: But I didn't bring it because it's not finished.
Ross: Adam, didn't you hear me?
ADAM: You see, I only made the valen today.
Ross (*voice rising*): Shut up, Adam . . .
ADAM: I'm making the tine tomorrow.
Ross: A-A-A-A-DAM! (Slow fade.)

Sure, Shana. Adam apparently inspired his father to write "The Chipmunk Song" by pestering him about Christmas in September. (The song, you may remember, is a child's timeless lament about the slow passage of time before the holidays, sung about 23 octaves above high C.) Bagdasarian did all the voices himself, a tedious process that took three days and nine tape tracks in a recording studio. He named the chipmunks after Al Bennett and Si Warnoker, the heads of his record company, Liberty, and Ted Keep, the recording engineer for the session. (I learned this, incidentally, from Norm N. Nite's music encyclopedia *Rock On*, which notes that Bagdasarian "played the tape back at a faster speed to mimic the voices of tiny animals." From this we deduce that Norm N. Nite thinks *tiny animals actually talk*.) "The Chipmunk Song" sold four million copies, and in 1961 CBS broadcast an animated prime-time version called *The Alvin Show*. Bagdasarian again did all the voices. The show bombed, but was moved to Saturday mornings and aired there for several seasons. In 1979 NBC picked up the show for its own kidvid lineup, retitling it "Alvin and the Chipmunks." This was produced by Bagdasarian's eldest son, Ross Junior—Ross Senior, God rest his soul, kicked the bucket in 1972. I, for one, am inconsolable. Truly, the old man was one of the giants.

On the Origin of Chipmunks

I can't vouch for anything Ross Bagdasarian has or hasn't done, but I can absolutely assure you that the "Chipmunks," under that name, "vocalized" by sped-up records, and with "conversational" personalities, were regular daily guests in the late

1940s on Trafton Robertson's "Sunrise Serenade" program on radio station WTAR, Norfolk, Virginia—Lance T., Munster, Indiana

Re The Straight Dope *book, page 359: OK, I give up. Where did* Bullwinkle *go to college?—Robert L., New York*

It's about time one of you guys took the bait on this. Bullwinkle's alma mater, as every cartoon connoisseur knows, was the immortal Wassamatta U.

I was watching this great Greta Garbo movie on TV the other day and wondered . . . what movies did she win the Academy Award for?—J.L., Chicago

Not a one. She did win a special Oscar in 1954 for her "unforgettable screen performances." Usually when the Academy makes an award of this type the word "unforgettable" can be translated to "numerous, but, indeed, forgettable."

Years ago, British television produced a brilliant series called The Prisoner. *It starred Patrick McGoohan as a recently resigned secret agent. He is kidnapped and taken to a place called "the Village" where some apparently evil-minded no-gooders try and tap the knowledge he has acquired in his years as a spy. What I want to know is, what exactly was the show all about? What exactly was the Village? Who was Number One, the Village's top man? What were they trying to get out of McGoohan? And most of all, what the hell was going on in that crazy final episode that sees the escape of McGoohan and the demise of the Village?—Tony B., Washington, D.C.*

Why people get worked up over this absurd show I will never know, but it has attracted a cult following since it first aired as a summer replacement on CBS in 1968.

The purpose of the Village (in reality the Welsh resort town of Portmeirion), who operated it, and what exactly they were trying to pry out of McGoohan were kept purposely vague in order to heighten the Kafkaesque quality of the show. Apparently it was some sort of halfway house for former secret agents and other government officials who Knew Too Much, run by the mysterious, unseen Number One. (McGoohan is Number Six.) Life in the Village is pleasant, if a bit eerie, but it is still a prison and McGoohan is continually trying to escape. He is thwarted

by, among other things, the Big Bubbles, more commonly known as "rovers" (actually they were weather balloons), which apparently suffocate their victims. The rovers and various other bad guys are directed by a series of characters—there was a new one each week—known as Number Two. The different Number Twos went through various machinations trying to get McG to divulge "information."

The series ran 17 episodes, and mixed James Bond–type thriller elements with a half-baked allegory on The Role of the Individual in Mass Society. The show is confusing partly because there was a struggle between McGoohan and story editor George Markstein for creative control. Markstein wanted to keep the show fairly rational, while McGoohan preferred to indulge his penchant for two-bit surrealism. Markstein finally quit, and McGoohan wrote and directed the last two episodes himself, with bizarre results. The plot of the finale defies quick summary, but the drift of it is that the Village's head honchos are so impressed by McGoohan's indomitable will that they want to make him head dude (or something like that—nothing in this show is very clear). A long hallucinatory sequence in the Village's underground HQ transpires in which Beatles tunes, the song "Dem Dry Bones," and a gallery of weird geeks in white cloaks and face masks are prominently featured. Finally, McGoohan is taken to see Number One. He pulls off Number One's mask to reveal

an ape mask, which he also pulls off, only to find that Number One is . . . McGoohan himself. No kidding. While McGoohan-as-Number-One escapes, McGoohan-as-Number-Six finds his way to the control room, where he triggers a missile countdown. Panic breaks out among the Villagers. McGoohan and several confederates escape in what looks like a big moving van. Just as they get past the gates, a rocket blasts off out of the center of the Village containing who knows what and heading God knows where, while the Village itself is abandoned (I guess). McGoohan and friends then cheerfully drive to London, where he resumes residence in the apartment from which he had originally been kidnapped.

And that, incredibly enough, is it. No explanations, no nothing. Baffled viewers jammed the switchboards when the show was first aired and wrote irate letters to the newspapers. Critics and even people involved in the show's production agreed that the last episode had gotten totally out of hand, although ironically the widespread bewilderment it created helped the show attain the underground status it enjoys today. People have tried to tell me the whole thing is some sort of allegory for the 60s, but you couldn't prove it by me. The series is available on videocassette if you want to check it out for yourself.

I heard a cute tale about how Groucho Marx supposedly got the hook while hosting a live broadcast of his famous TV quiz show, You Bet Your Life. *As this microlegend has it, Groucho was small-talking with a female contestant when the following exchange took place:*

GROUCHO: *So, you got any kids?*
FEMALE CONTESTANT: *Yes, Groucho, I have 11 children.*
GROUCHO: *Eleven?! Did you say 11 kids?*
FEMALE CONTESTANT: *Well, I love my husband.*
GROUCHO: *Lady, I love my cigar but I take it out of my mouth once in a while.*

Supposedly, the program's censors immediately stopped the broadcast and never let Mr. Marx do the show again.

I'll admit the story does sound a little contrived. Still, as a hunter of truth in the forest of deceit, do you find any droppings of plausibility? More important, can I get it on VHS?—William S., Arlington, Virginia

I've had to strangle so many show-biz myths in their cradles, it's a pleasure to report on one that actually has some basis in fact. Groucho Marx, who regularly did for the airwaves what Cecil humbly endeavors to do for the newspapers, really did pull off the amazing exchange quoted above. In fact, he mentions it in a book he wrote with Hector Arce about his broadcast experiences called *The Secret Word Is Groucho*. But it didn't happen at the end of his network career, it happened at the beginning, in 1947 or '48, when "You Bet Your Life" was still on the radio. The censors didn't stop the show, either, they just prevented the exchange from getting on the air. Groucho's producers knew about his penchant for ribald humor, so they took the precaution of recording all his shows and cutting out the dirty parts before airtime.

The name of the female contestant was Mrs. Story. She lived in Bakersfield, California, and she had 19 children, all of whom came down for the show. Groucho says he asked Mrs. Story, "Why do you have so many children? That's a big responsibility and a big burden." Mrs. Story responded as indicated above, and Groucho then unloaded his 50-megaton zinger. The studio audience roared, but censor Robert Dwan gave it the ax, so you're not going to find it on VHS or anywhere else.

The Secret Word Is Groucho quotes a lot of the repartee from the show, including some stuff that didn't make it onto the air. Most of the censored material is tame by today's standards but still pretty funny, such as when Groucho said, "I had never seen anybody dressed in evening clothes, except my father when he got married." My personal favorite, which did get broadcast, was the time Groucho asked a tree surgeon, "So, did you ever fall out of one of your patients?"

There are dozens of legends about dirty jokes that famous personalities have allegedly told on the air, and believe me, there's no way I'm going to track them all down, so don't anybody out there get any ideas. One yarn has it that Soupy Sales was trying to teach the alphabet to White Fang the dog. Soupy would point at an *x*, say, and ask, "OK, Fang, what letter is that?" Fang would grunt something, and Soupy would say, "Very good. And what letter is that?" This continued until they got to *f*. When Fang grunted his answer, Soupy said, "No, no, it's not *k*, it's *f*." They went on to some other letters, and then came back to *f*. Fang again grunted an answer, and Soupy said in an exasperated

tone, "No, Fang, I told you, it's not *k*. What gives? Every time I show you an *f*, you see *k*!"

Then there was the joke that supposedly got a well-known Chicago DJ yanked off the air years ago. (Actually, there are several versions of this.) This couple was making out in the upper deck at a baseball game, see, until finally the guy comes up for air. "Listen," he says, "we gotta get organized. Tell you what, I'll kiss you on the strikes, you kiss me on the . . ." But heck, you've probably already heard that one.

Memo to History, Part One

I personally heard Dick Biondi [the Chicago DJ] tell the infamous "baseball joke." Showing an unusual brevity of expression, he merely exclaimed: "Hey, everybody, let's go out to the baseball game. The boys kiss the girls on the strikes and . . ." Years later, I was told this joke originated with Dizzy Dean during his time as a radio broadcaster.

By the way, Biondi says he was not *fired for telling dirty jokes. He claimed he was fired for starting a fistfight with the advertising director over the number of commercials on his program.*

As for Soupy Sales, probably his most infamous stunt was the time he said: "Hey, kids! Go into your parents' dresser, take out all those pictures of dead presidents, and mail them to: Soupy, WXYZ-TV, Detroit . . ."—Steven S., Skokie, Illinois

Memo to History, Part Two

Inspired by this column's recent mention of Soupy Sales, Cecil's buddies at WMAQ radio in Chicago have done some further checking on the famous story that Soupy supposedly got fired when he told his youthful audience to go into their parents' dresser drawers and send him all those little pieces of paper with pictures of dead presidents on them. A spokesman for Soupy says he wasn't fired, he was only suspended for a week. We're happy to set the record straight, and hope this puts an end to all those vicious show-biz rumors.

Please answer a question I've been pondering for years. Why are we movie patrons handed back half our tickets after passing the ticket taker?—H.J.N., Chicago

For the patron, the stub is a simple receipt that works more or less like a rain check does at the ballpark. In case of a major disaster (e.g., a projection breakdown) or personal problem (you become nauseated during *You Light Up My Life*), most theater managers will happily hand out passes for another night. But lest you take advantage of their good nature, the managers record, every hour on the hour, the number of the most recent ticket sold. By checking the number on your stub against the time you claim to have entered, the manager can tell whether or not you sat through *You Light Up My Life* twice before you decided you didn't like it. The returned stubs are kept as a record of how many passes are handed out.

For the theater owner, his half of the ticket serves as a sort of inventory control. Every night the stubs are taken out of the ticket taker's stand, sealed in a bag, and stored. This protects the owner against one of the oldest scams in the movie game: the usher who periodically palms an untorn ticket and resells it himself. Periodically, the sealed stubs are counted and checked against the box office records. If the numbers don't match, the owner calls out the dogs.

With all the recent furor over the location of the Rock 'n' Roll Hall of Fame, we all need to know: when, where, and by whom was the term "rock 'n' roll music" invented?—DMc, Alexandria, Virginia

Depends what you mean by "invent." The term was first used to describe a particular kind of music by Alan Freed, the legendary Cleveland disc jockey who was among the first to introduce black rhythm-and-blues music to a white audience. But the roots of the term go back much earlier.

In the 1920s the words "rock" and "roll," used separately or together, were employed by blacks to mean partying, carrying on, and/or having sex. According to rock historian Nick Tosches, blues singer Trixie Smith recorded a tune in 1922 called "My Daddy Rocks Me (With One Steady Roll)" for Black Swan Records. "Daddy," suffice it to say, was not trying to rock little Trixie to sleep. This song inspired such variations as "Rock That Thing" by Lil Johnson and "Rock Me Mama" by Ikey Robinson.

By the 1930s the term had begun to be associated with the idea of music with a good beat to it. In 1931 Duke Ellington did "Rockin' in Rhythm" for Victor. The Boswell Sisters did a song called "Rock and Roll" in the 1934 United Artists flick *Transatlantic Merry-Go-Round*. In 1939 Buddy Jones recorded "Rockin' Rollin' Mama" (String), in which he soulfully shouted, "I love the way you rock and roll!" But rockin' and rollin' did not really catch on until 1948, when Wynonie Harris released "Good Rockin' Tonight" (King). An earlier version by Roy Brown (Deluxe, 1947) had bombed, but Wynonie's cover became a number one hit. That was the beginning of a flood of tunes that worked "rock" into the title, such as Bill Haley's "Rock-a-Beatin' Boogie" (1952), which contained the deathless words "Rock, rock, rock, everybody/Roll, roll, roll, everybody."

In 1952 Alan Freed visited a Cleveland record store and learned that R&B records were being snapped up by white teenagers. Immediately sensing the makings of Something Big, he changed the name of his popular music show on radio station WJW from the lame "Record Rendezvous" to "Moon Dog's Rock 'n' Roll House Party" and began playing R&B tunes. Freed apparently used the term "rock 'n' roll" to describe the music because he thought the racial connotation of "rhythm and blues" might turn off the white audience. In any case, the term stuck.

Freed was the original high-energy, shout-along-with-the-record AM screamer, and his show, along with rock 'n' roll music, attracted a huge following. A rock 'n' roll show Freed promoted at Cleveland Stadium had to be canceled when the joint was overrun by something like 80,000 fans. By 1954 Freed had moved to a late-night show on WINS in New York City, where he duplicated his earlier success. On April 12, 1954, Bill Haley and the Comets recorded "Rock Around the Clock," a teen anthem that is generally credited with making rock 'n' roll a worldwide phenomenon. Initially the tune did poorly, but when it was chosen as the theme for the film *Blackboard Jungle*, it became a monster smash in just about every country where the movie played, selling 22 million copies in all. Meanwhile, down in Memphis, a redneck by the name of Elvis Aron Presley . . . but the rest you know.

·　　·　　·　　·

A Correction

Bill Haley did not record "Rock-a-Beatin' Boogie" in 1952. "Rock Around the Clock" was the first song he recorded for Decca Records (now MCA) in 1954. (I was there.) He recorded "Rock-a-Beatin' Boogie" for Decca a year later.

According to Alan Freed, the first time he used the term "rock 'n' roll" was when he first played RATC on his radio show at NYC station WINS.

Haley's recording of RATC is still selling over a million copies a year worldwide, and has sold more than 40 million copies to date. It has been recorded over 500 times by other artists such as Chubby Checker, Mae West, Pat Boone, and several of the Beatles. Total sales have passed the one hundred million mark, making it the best-selling song of all time.

Anyhoo, thanks for the plug on my song.—James E. Myers, aka Jimmy DeKnight, composer (with Max Freedman) of "Rock Around the Clock."

I've just noticed a dumb new commercial with one redeeming feature: it heralds the return of Mr. Ed, the most debonair actor on four legs. Since I was a child, I've always wondered how they got that horse to "talk." Did they keep a camera trained on him until he yawned or something? I've been watching police horses lately, but they don't waggle their lips around like Mr. Ed. My own theory is that he has pieces of apple skin stuck between his teeth.—Judy H., Chicago

P.S.: This question doesn't apply to Francis the Talking Mule, because I have it on good authority that he always read his own lines.

Cecil will have you know, Judy, that he has this one straight from the horse's . . . Lordy, for a second there I was about to commit a pun too horrible for words. Anyway, I did get this from the horse's *buddy's* mouth, namely, the guy who played Wilbur Post, or, if you prefer, "Wi-i-illlbu-u-urrrr," Ed's owner and putative master. The role was created by show-biz legend Alan Young, whom Cecil was lucky enough to run into in the studio of would-be show-biz legend Drew Hayes of WMAQ radio in Chicago. Never one for whom opportunity needed to knock twice, I immediately grilled him, and this is the result.

You'd think that playing opposite a talking horse for five years would have to make the rest of your career seem like an anticlimax, but Young has been plugging away like the trouper that he is in the years since, doing a stint on "General Hospital" and most recently supplying the voice of Scrooge McDuck on "Ducktales," a new Disney animated TV series. (He was making the rounds promoting the Disney series when Cecil found him.) There is no question, however, that "Mr. Ed" remains his chief claim to glory. Although initially reluctant to reveal trade secrets, after a heartfelt plea he consented to explain how the trick was done. No special photography was involved. Before a scene, Mr. Ed's trainer merely fed him a wad of a mysterious substance akin to peanut butter, which sat between cheek and gum. (Ed's trainer, by the way, was the late Lester Hylton, who also trained Francis the Talking Mule, eponymous star—and don't think I haven't thirsted for years to use *that* word in a column—of the 1950s movie series. Just in case you were wondering about certain suspicious conceptual similarities here, the first six F the TM films were directed by Arthur Lubin, coexecutive producer of the "Mr. Ed" series.) Now, where was I? . . . Ah, right. Though the wad of quasi peanut butter was harmless, Ed, being a horse (of course), naturally wanted to get rid of it, which he did by working his lips. When this was synched up with a voice-over by the inimitable Allan "Rocky" Lane, Ed looked like he was talking.

Young reports that the real problem wasn't getting Ed to talk, it was getting him to *stop* talking. After a while the horse apparently tumbled to the idea that the humans wanted him to move his lips on camera, and thereafter every time Young would finish saying his lines Ed would commence to orating whether the script called for it or not. Eventually Hylton worked out a system whereby a crop placed against Ed's foreleg was the signal for him to clam up.

The original Mr. Ed was a gelding ("It happens to all of us in show business," Young avers) whose real name, believe it or not, was Bamboo Harvester. Sad to say, he died about a dozen years ago, followed a short time later by the heartbroken Hylton. Allan Lane has also departed this vale of sorrow. However, talking-horse buffs who feel they have pretty much plumbed the depths of nuance to be found in "Mr. Ed" reruns need not depair. Young tells me a Mr. Ed TV special is currently in the talking stage.

(Presumably a nationwide talent search will be conducted to find replacements for the missing members of the original team.) I think this is a fitting tribute to the staying power of an animal who has become one of the leading cultural icons of our time, right up there with Elvis—and hey, Ed didn't go in for drugs, gluttony, or tacky interior decorating. I don't know about you, but I know who I want *my* kids to grow up to be like.

• • •

QUIZ #1

1. Three of the following have something in common. Pick the one that doesn't:
 a. Mark Twain's demise (the unexaggerated version)
 b. The defeat of the Huns by Roman forces in A.D. 451
 c. The Battle of Hastings
 d. The coronation of Victoria

2. The name of the Six Flags Over Texas amusement park supposedly refers to the six national flags that have flown over that state at various points in its history. Which U.S. state has *never* had a foreign flag flying over it?
 a. Idaho
 b. Minnesota
 c. Nevada
 d. Tennessee

3. It wasn't always customary to say "hello" when answering the telephone. When the industry was in its infancy, the standard greeting was:
 a. Ahoy
 b. Yowsah
 c. Hey dere
 d. Wop bop a loo bop, a wop bam boom

4. If you can find a reasonably detailed map of the U.S., you shouldn't have any trouble figuring out which of the following possesses a very unusual characteristic:
 a. the Willamette River
 b. the Humboldt River
 c. the Rio Grande
 d. the Connecticut River

5. The original Brooklyn Dodgers baseball team got its name because:
 a. Most Brooklynites were thieves who spent much of their time dodging the law.
 b. Augustus Dodge owned the auto factory that originally sponsored the team.
 c. The pitchers were so awful that the infielders were constantly dodging ricocheting baseballs.
 d. Brooklyn was overrun with trolley cars and the residents were always dodging out of the way.

6. The Earp brothers' disreputable buddy Doc Holliday (of O.K. Corral fame) was in fact a:
 a. medical doctor
 b. bartender
 c. dentist
 d. veterinarian

Answers on pages 467–68.

Chapter 3

Food Stuff

News accounts of Coca-Cola's change in its legendary flavor formula said the change was the first in Coke's 99-year history. But back when Coke got started, the company led the public to believe that the coca shrub—the source of cocaine—provided one of the ingredients, giving consumers that extra lift that we now associate with mirrors, tiny spoons, and rolled-up hundred-dollar bills. Of course back then cocaine was legal and sold over the counter. So how can Coke say the formula hasn't changed in 99 years? Has cocaine been part of their formula up till now? Or were they misleading the public back in 1886? Did they change the formula when cocaine became illegal? Personally I don't particularly care about cocaine one way or the other. All I want to know is if Coke was then or is now fibbing.—Phillip F., Los Angeles

Depends on your definition of fibbing, Felipe. But here, let me tell the whole sorry tale:

Coke was originally formulated in 1886 by one John Styth Pemberton, an Atlanta druggist and former Confederate army officer. Among other things it contained (and presumably still contains) three parts coca leaves to one part cola nut. The new soft drink was one of many concoctions in that era containing cocaine, which was being touted as a benign substitute for alcohol. Coke, in fact, was promoted as a patent medicine, which would "cure all nervous afflictions—Sick Headache, Neuralgia, Hysteria, Melancholy, Etc. . . ." How much cocaine Coke actually contained and how much kick you got from it is not known (a Coke spokesman today says the amount was "trivial"). But for

33

years Southerners called the stuff "dope" or "a shot in the arm," while soda fountains were called "hop joints" and Coke delivery trucks "dope wagons."

In the 1890s, however, public sentiment began to turn against cocaine, which among other things was believed to be a cause of racial violence by drug-crazed blacks. In 1903 the *New York Tribune* published an article linking cocaine with black crime and calling for legal action against Coca-Cola. Shortly thereafter Coke quietly switched from fresh to "spent" coca leaves (i.e., what's left over after the cocaine has been removed). It also stopped advertising Coke as a cure for what ails you and instead promoted it simply as a refreshing beverage.

Does the substitution of denatured coca for The Real Thing constitute a change in the magic Coke formula? Not according to Coke. The true source of Coke's unique flavor, the company contends, lies not in the coca/cola combination but in the special mix of oils and flavorings added thereto, including the mysterious ingredient known as Merchandise 7X. The formula is kept in a bank vault and known to only a handful of Coke employees (in addition to me, of course—but I'll never tell). It was this formula that Coke changed when it introduced the infamous New Coke, replacing Merchandise 7X with an updated Merchandise 7X-100.

There are those who say that Asa Candler, who bought the

infant Coke company from Pemberton, tinkered with the formula a fair bit before settling on a version that he liked; and these folks claim that the formula thus cannot truly be said to be 99 years old. Others regard this as contemptible nitpicking. Still, whatever may be said about the formula, Coke's taste has certainly altered over the years. The most radical (and to serious Coke aficionados, most upsetting) change came in 1980, when Coke, in an effort to control costs, permitted its bottlers to substitute high-fructose corn sweetener for the beet and cane sugar once used in the product. The result was that Coke's previously crisp and bracing taste was sadly blunted. For that reason I didn't share the feelings of the fanatics who stocked up on "old" Coke when the new version was first introduced. The regrettable fact is that Coke hasn't been It for many years.

Further Insight from the Teeming Millions

Regarding your column about Coca-Cola, did you know that in 1912 D.W. Griffith directed a short film called For His Son *that featured a soft drink spiked with drugs? The hero is a small-town district attorney who learns that a popular beverage concocted by the town druggist called Dopokoke is aptly named because it contains a good dose of cocaine. Of course, all the town's housewives and young people become addicted to the stuff, and the DA has a devil of a time shutting production down.*

When I first saw the film about 15 years ago I thought it had probably been financed by the beer industry in a laughable effort to discredit a fast-rising competitor (which, come to think of it, may still have been true). At the time I didn't know about Coke's original formula.—Bob S., North Hollywood, California

Thanks for the info, Bert. Speaking of original formulas, it seems I'm not the only one to complain about the substitution of corn sweetener for syrup in "old" (now "classic") Coke. I have here a full-page ad placed by the Sugar Association, a trade group, that mentions an organization called the Old Coke Drinkers of America. At a 1985 press conference the OCDA criticized the Coca-Cola folks for not restoring sugar to their product when they came out with Classic Coke. The leader of the group is quoted as saying, "It is not the original formula; it is not the Coke of my youth." The ad goes on to claim that the use of sugar

substitute contributed to Coke's decline in market share in the early 80s.

I never heard of the Old Cola Drinkers before, and for all I know they're on the payroll of the sugar barons, but I'm totally in accord with their sentiments. For what it's worth, you can still get Coke made with sugar in parts of Mexico, Canada, Hawaii, and Europe.

Recently some friends and I were puzzling over various questions of great ontological import, such as the Meaning of Life and What Is Time?, and reached satisfying conclusions on all except the following, which proved to be a real stumper: If spaghetti is a dish of Italian descent, so to speak, then to what or to whom does the "Franco-" in "Franco-American" brand refer?—Emily L., Washington, D.C.

When I was younger and had not yet achieved Buddha nature, Emily, this question used to haunt me, along with whether your Louisville Slugger would really splinter if you swung it with the trademark toward the front. My theory at the time (honest) was that Franco-American spaghetti was the last vestige of a native Gallic pasta that had been brutally suppressed by the Italian macaroni barons. Alas, the truth is disappointingly mundane. It seems that Franco-American was the invention of one Alphonse Biardot, who emigrated from France around 1880 or so.

Evidently of a musical nature (he named one of his sons Oc-

tave), Biardot's real forte proved to be in the prepared foods biz. In 1886 he established Biardot's Franco-American Food Company in Jersey City, New Jersey, and began churning out a line of soups of such quality that he soon became the dominant force in U.S. soupmaking. Eventually he branched out into consummés and bouillons and something called "spaghetti à la milanaise," all of which were doing a pretty brisk business when the company was bought out by Campbell Soup in 1921. Franco-American soups were sold as late as the 1950s, but eventually they bit the dust, leaving F-A (which is no longer a separate company but merely a brand name used by Campbell's "grocery business unit") with a line of pasta products and a somewhat incongruous name.

In my day the F-A mainstay was straightforward spaghetti, albeit spaghetti that had been doused with sugar and dyed an improbable Day-Glo orange. But in later years Franco-American introduced the unforgettable SpaghettiOs, which did for the eating experience what Grant did for Vicksburg. Recently even greater heights were reached with the appearance of Spaghetti UFOs, which are shaped like little space vehicles, demonstrating yet again the vast cultural chasm that separates me from the coming generation.

Tradition has it (has it incorrectly, too, but let's not get ahead of ourselves) that pasta first reached Europe when Marco Polo brought noodles from China early in the fourteenth century—which implies that America's favorite lunchtime dish should really be called Sino-American spaghetti. In fact, however, this seems to be a baseless slander against the inventiveness of the Italian people. Pasta was well known during the time of the Roman empire; Cicero loved the stuff. Whether he would approve of what Franco-American has done with it we can only guess. But I suspect that as a loyal son of Italy (and a big-hearted guy to boot), he'd be only too happy to give the credit to the French.

• • • •

One Reason Why "You Say To-may-to, I Say To-mah-to" Could Not Have Been a Hit Record in First-Century Rome

While you did a neat job of debunking the myth that Marco Polo dragged noodles to Genoa in the fourteenth century, you might also have mentioned that the red goop (or, in the case of F-A, orange goop) one traditionally associates with Italian spaghetti is made from tomatoes, a native of the New World that wasn't introduced to Europe until after the conquest of Mexico in 1522. So what did the Italians do with their noodles before tomatoes? I suspect they messed with those whitish clam sauces, creams, butter, etc. I am quite sure they at no time entertained the use of cornstarch, probably the grossest culinary sin committed upon spaghetti sauce in Los Angeles today. Regardless, it is interesting to think that all the red things we associate with Italian food today, including pizza, couldn't have existed had it not been for that contact between Spain and the Aztec empire more than 400 years ago.

Now it's my turn to ask a question. I'll readily admit you may be the F. Bacon of our age, but you must, in fact, resort to regular research from time to time. What are your most frequently used sources?—Sean M., Los Angeles

The Lord and I chat frequently. She's a font of information, but the phone bills are murder.

Why is it that sugar in restaurants no longer comes in individually wrapped cubes as it used to? Now it's usually bagged.— Marcia W., Chicago

You still see cubes occasionally, but they're vastly outnumbered by sugar packets, which are a lot cheaper. Last time I checked, a one sixth-ounce packet cost about half as much as an individually wrapped one sixth-ounce cube. Cubes were the sugar industry's first effort at dispensing their product in premeasured, mess-free portions, and they were an improvement over the community sugar bowl. However, you have to go to a fair amount of trouble to make them, and they're only good for dumping into a beverage—you can't spread them on your Post Toasties with optimum results. Consequently, when automatic bagging equipment was developed after World War II, packet sugar began to

take over the market. Some people, though, still like cubes—sucking on them is an indescribable rush—and in some quarters they're considered to be more elegant. So the sugar companies continue to make them. Personally, I like a good cube when I can get one, but I am resigned to the inexorable advance of progress.

Your astuteness and tenacity in searching out and serving up some fine answers to weirdo questions have led me to hope you will be able to illuminate for me a present puzzling mystery in my life. What's the scoop on coconuts? Fresh coconuts. In particular, when are they in season and is there any way to judge which one to bring home? A really bad coconut is soooo yukky. But a really good coconut is so celestial. Thanks for your help and thanks for the great job you do in the quest for truth and straightness for the edification of us, your faithful readers. Carry on!—Sadie, Chicago

(Note to the Teeming Millions: She wrote it all, I swear to God.)

There is no real season for coconuts, since they grow in tropical regions where there is no real season for anything. The most common cause of yukkiness is a crack in the shell, which (1) either admits enough air to dry out the fruit or (2) admits enough bacteria to precipitate the formation of a light gray mold between fruit and shell. Small, barely visible cracks are enough to cause trouble, so the best way to select a coconut is to pick one up and shake it. If you can hear the milk sloshing inside, odds are you've got a celestial coconut rather than a yukky one. Some yukky coconuts also slosh, but the coincident occurrence of yukkiness and sloshiness is extremely rare.

About eight years ago I read somewhere that the state of Wisconsin accounts for 75 percent of total U.S. consumption of brandy. Having mentioned this in conversation, I now find my credibility (not to mention a fair amount of money) hinging on my coming up with proof. The library and the newspapers have been no help. Do you have any information?—John M., Madison, Wisconsin

The library? The *newspapers?* When are you Teeming Millions going to learn? For starters, never put money on things you read "somewhere," as opposed to right here in the Straight Dope.

Wisconsin's percentage of U.S. brandy consumption is nowhere near 75 percent. In the mid-70s I'm told it was around 39 percent, but it's since dropped to 14 percent (2.8 million gallons out of 20.9 million). That's still a pretty impressive figure—only California, with five times the population, drinks more (4.0 million gallons). You may be interested to know that in taverns per capita, seven of the top eight U.S. cities are located in the great state of Wisconsin. When it comes to those long winters, Wisconsinites obviously don't believe in going gently into that good night.

I suppose this is water under the bridge now, but it's something I've always wondered about. For at least 10 or 15 years cans of frozen orange juice concentrate have had those handy plastic strips around the lid to help you open them. But until just recently you had to open lemonade cans with an old-fashioned can opener, not a job for the faint of heart. Why were they so late in putting the plastic strips on lemonade? Is the diffusion of new technology in our society so slow that the lemonade division of Minute Maid just found out about this new breakthrough? Or did they just figure lemonade drinkers were so tough they could tear the cans open with their teeth (which, believe me, I was more than once tempted to do)?—Rick M., Dallas

Now, Rick, let's not get excited. The difference in packaging had to do with the physical characteristics of the two products. As OJ gets colder, it just gets gradually thicker. Lemonade, on the other hand, is more like water—it remains liquid as it gets colder until all of a sudden it freezes over. The temperature in grocery freezers, it turns out, is notoriously variable. If it gets too warm, OJ will get mushy, but it'll remain pretty viscous. Lemonade, however (along with apple and grape juice), will become completely liquid. Since early tearstrips didn't seal as well as conventional double-seam cans, lemonade in tearstrip containers tended to leak, making them impractical. Fortunately, a better sealing tearstrip was developed that could be used with lemonade, and this unseemly form of discrimination was stamped out at last.

After viewing millions of beer commercials, we find ourselves asking the same question again and again. TV commercials show people slugging down soda, piggin' on pizza, and yes,

even making mustaches with milk. But the commercials never show people drinking beer—even though alcohol consumption during TV programs (as opposed to TV commercials) is commonplace. Please tell us why the people in commercials refuse to be seen in public drinking the product they're plugging.—Gary O. and Kate J., Chicago

Mainly because of a voluntary beer industry code that's either hypocritical or merely irrational, depending on how you look at it. Booze makers—and, for that matter, the media—have always been touchy about the suggestion that they encourage moral turpitude, so long ago they established codes to regulate advertising, lest the government step in and do it for them. These codes vary in their degree of strictness. For instance, the Distilled Spirits Council of the U.S. (DISCUS) prohibits any broadcast advertising for hard liquor at all. For many years the National Association of Broadcasters (NAB) had a similar policy.

The NAB allowed beer and wine makers to advertise, but until recently neither group could depict someone actually consuming the product on camera. You would thus see some guy gazing longingly at a frosty glass of Shyster Brau, say, and a little while later you might see the glass empty, but what happened in the meantime was a deep and abiding mystery. Did the stuff evaporate? Did the guy pour it on his plants? Millions went to their graves without a clue. At the same time, of course, the commer-

cial was pulling out all the stops to convince you that the product would transform your ratty life-style, demonstrate your patriotism, and make you an all-around superior human being, in hopes that you would immediately run down to the corner and buy cartloads of the stuff. There were (and are) two possible explanations for this apparently contradictory policy: (1) the manufacturers wanted you to buy what they were selling (preferably two six-packs at a time), but not to actually *drink* it; or (2) the whole thing was a ploy to appease temperance advocates while minimizing the impact on sales.

The situation changed a bit when the NAB code was abolished in 1982 as a result of a challenge on an unrelated issue by the Justice Department. There was initially some fear that this would open the floodgates, and in fact one Boston radio station began airing commercials for vodka during Red Sox games. (The vodka company didn't belong to DISCUS, and thus didn't subscribe to the code.) Public outcry, however, soon forced the ads off the air, and most broadcasters today refuse to accept hard liquor commercials. The brewers' code remains in force, so beer drinking still isn't graphically depicted. But the wine industry has never had any scruples about such things, and in 1983 CBS, conceding that the old policy "defied logic," began accepting ads from Taylor California Cellars showing people drinking vino. CBS's standards now allow tasteful sipping in an appropriate context—i.e., the next scene can't depict some demanding activity like driving or boating and imply that booze will give you an edge. ABC and NBC, however, continue to prohibit on-camera drinking.

Your comment about "commonplace" depictions of booze consumption on prime-time programs raises an interesting point. In recent years public interest groups have made a real stink about the glorification of alcohol on TV, and the result is that while there is no formal prohibition against on-air drinking, you see a lot fewer scenes in which characters at a party, say, are given cocktails simply in order to have something to do with their hands. At the same time there has been an effort to give some serious attention to the problem of excess drinking, with stories about alcoholism turning up in such unlikely settings as "Love Boat." These treatments typically are pretty superficial, but Cecil is prepared to concede that they are a step in the right direction.

NutraSweet artificial sweetener has, in my humble opinion, brought an improved taste to diet drinks. But additionally, it seems to me that the chemical has also increased the volume of foam produced, compared to other, non-NutraSweet diet drinks when the drink is poured into a glass of ice. This is also welcome, as I greatly enjoy sucking up as much froth as can be produced. But am I just imagining these greater suds, or are they actually caused by NutraSweet?—Ken Z., Chicago

You may not believe this, Ken, but Coke, Pepsi, and the G.D. Searle company, the maker of NutraSweet, all deny any knowledge of the foam-producing properties you describe. However, scientific tests conducted at the legendary Straight Dope labs have proved conclusively that they do in fact exist. Moreover, it is clear that not only do NutraSweetened beverages produce *more* foam, but the foam *lasts longer*. The ecological significance of this development is too awful to contemplate.

We began by comparing Diet Coke to regular Coca-Cola. Uncapping a bottle of each, we let them molder in the fridge overnight. Next morning we poured an equal volume of each product into a pair of genuine sculpted Coca-Cola soda fountain glasses, which we got at a local hot dog parlor two summers ago. (We feel these little touches are important.) The results were dramatic. Not only did Diet Coke produce substantially more foam (in some cases two or three times as much), but the foam proved to be amazingly durable. While the regular Coke froth dissipated in a few seconds, fully two minutes went by before you could see the top surface of the Diet Coke underneath the bubbles. Moreover, even *half an hour later* there was still a significant amount of foam left around the edge of the Diet Coke glass, whereas the regular Coke had all boiled down to nothing. Cecil attributes this partly to the fact that the products had been chilled, since the Diet Coke head didn't last anywhere near as long when it had warmed up to room temperature. But even when warm, Diet Coke showed more vigor than the regular stuff.

Unfortunately, we were not able to compare a Nutra-Sweetened beverage directly with the saccharin-sweetened version of the same product, because the former has generally chased the latter out of the marketplace. However, we were able to obtain several cans of a Brand X cola that is still sweetened with saccharin. In a head-to-head (heh-heh) foam-off between Brand X and Diet Coke, the latter easily trounced its low-rent compet-

itor. Whether this was due to the presence of NutraSweet or simply to the superior quality of Coca-Cola manufacturing is hard to say. Still, we may note that when sugar-sweetened Brand X and Coke were compared, they both fizzed out in approximately the same amount of time.

Finally, we performed the well-know "squirt" test, which consists of going out in the alley behind the house and shaking up the bottles with your thumb held over the top. The intention here was to determine which product would produce a greater volume of liberated CO_2 gas—i.e., which one would squirt farthest. Unfortunately, the results were inconclusive, mainly because the damn foam got all over everything, forcing Cecil to call a halt to the proceedings while he changed his shirt. The path to progress is never smooth.

Since research is still in the preliminary stages, Cecil does not feel it would be appropriate to offer a theory on the cause of Diet Coke foam at this time. In the meantime, however, the makers of NutraSweetened soft drinks are clearly missing the boat in not touting the longevity of their carbonation, e.g., "Sticks to your lips, not to your hips." I guarantee you, sales would skyrocket.

The Teeming Millions Get the Right Idea

What is the protocol for when you actually respond to a reader's quest for knowledge? I ask this because I was pleased to note that you confirmed my observation about Diet Coke some weeks back. Was I supposed to call you up? Send you a present? Is there an expected bribe? I know you are not Miss Manners, but nevertheless you probably have as good a handle on the appropriate behavior in this situation as anyone.—Anonymous, Chicago

The satisfaction of a job well done is all I require, along with $100 in an unmarked envelope by five o'clock or you'll never get your garbage collected again. I thought Chicagoans understood things like this.

The other day my friends and I were sitting around knocking back a few beers when we came upon a question we realized only you can answer: Why does it say "33" on the back of the labels of Rolling Rock beer? We all know it's brewed from pure artesian well water in the glass-lined tanks of Latrobe, Pennsyl-

vania, hometown of Arnold Palmer and all that. But what does the number mean? I remember seeing it on the pony bottles ("a little nip") I drank in the Philadelphia of my college youth, and it's also on cans and the long-neck returnables. One of the assembled good ol' persons pointed out there's a French (formerly Vietnamese, he claims) beer called "33," which may have something to do with it.—Stephanie F., Washington, D.C.

I would venture to say, Stefania, that there are still one or two persons in this country who are unacquainted with Rolling Rock beer. Too bad. It is a brave little brew, with many shining qualities to recommend it, among them: (1) it's got a taste with a little gravel to it, at least on occasion—the flavor is notoriously variable; (2) they print the ingredients on the label, unlike most brewers (they use water, malt, rice, corn, hops, and brewer's yeast, in case you're interested); and (3) it's got an undeniable mystique, which derives largely from the enigmatic 33. Now, the *official* explanation for the number, which is not entirely coterminous with the *real* explanation, is that 33 signifies two things: the year Prohibition was repealed (1933), and the number of words in the legend printed above the 33 on cans and returnable bottles, to wit: "Rolling Rock from glass lined tanks in the Laurel Highlands. We tender this premium beer for your enjoyment as a tribute to your good taste. It comes from the mountain springs to you."

Now, this is a touching sentiment, and there is no question that there are 33 words in it, but from the point of view of being intellectually satisfying, it sucks. Therefore, I hunted up James L. Tito, who until recently was chief executive officer of Latrobe Brewing, the maker of Rolling Rock beer. Mr. Tito's family owned Latrobe from the end of Prohibition until the company was sold to an outfit in Connecticut in 1985. After some prompting, he told me the sordid truth. Based on some notes and discussions with family members now dead, Mr. Tito believes that putting the 33 on the label was nothing more or less than a horrible accident. It happened like this:

When the Titos decided to introduce the Rolling Rock brand around 1939, they couldn't agree on a slogan for the back of the bottle. Some favored a long one, some a short one. At length somebody came up with the 33-word beauty quoted above, and to indicate its modest length, scribbled a big "33" on it. More argument ensued, until finally somebody said, dadgummit, boys,

let's just use this one and be done with it, and sent the 33-word version off to the bottle maker. Unfotunately, no one realized that the big 33 wasn't supposed to be part of the design until 50 jillion returnable bottles had been made up with the errant label painted permanently on their backsides. (I suppose this bespeaks a certain inattentiveness on the part of the Tito family, but I am telling you this story just as it was told to me.) This being the Depression and all, the Titos were in no position to throw out a lot of perfectly good bottles. So they decided to make the best of things by concocting a yarn about how the 33 stood for the year Prohibition was repealed.

In retrospect, this was a stroke of marketing genius. Next to cereal boxes, beer labels are probably the most thoroughly scrutinized artifacts in all of civilization, owing to the propensity of beer drinkers to stare morosely at them at three o'clock in the morning. The Rolling Rock "33" has baffled beer lovers for generations, and accordingly has become the stuff of barroom legend. I have letters claiming that the number has something to do with a satanic ritual, that it was the age of Christ when he died, even that it signifies the number of glass-lined tanks in the Latrobe plant. *Très* bizarre, but if M. Tito is to be believed, not quite as bizarre as the truth.

Why is it that the food-processing industry can get away with peddling their products as "natural"? Seems to me nothing that's stuffed into a can, box, bag, or bottle is "natural." Yet walk down the supermarket aisles these days and you'll see all kinds of food products that don't exist in nature labeled "natural," "all natural ingredients," some even "100% natural." They don't call the waxed, artificially ripened fruit and pesticide-soaked vegetables in the produce department "natural." So how can a carton full of white sugar and raspberry paste be called "100% natural"? In fact, there are many so-called "natural" products that include refined sugar. If you've ever visited a sugar mill, you know that the process they use to turn cane into powder is, well, unnatural.—Dirk W., Tucson, Arizona

When the revolution comes, Dirk, there is no question that the heads of the food companies will be put on trial by the dictatorship of the proletariat. However, we must recognize that the current shabby state of affairs owes almost as much to the

gullibility and ignorance of consumers, including food zealots such as yourself.

From both a legal and a nutritional point of view, "natural" is a meaningless term. A few years ago the staff of the Federal Trade Commission wanted to issue a rule defining "natural" foods, but the commission nixed the idea. As a result, according to ex-FTC chairman James Miller, the terms "natural" and "organic" could probably be applied to Coca-Cola.

Now, admittedly, this was a hard-core Reaganista talking here, but you can understand his reasoning. Horrifying though the thought may be to health food buffs, there is no way that even refined white sugar, aka sucrose ($C_{12}H_{22}O_{11}$), can be considered an "unnatural" product, strictly speaking. Sucrose is found in many plants, including cane, beets, and maples. It is removed by a relatively simple mechanical process that does not chemically alter the final product, and it is not doped up with additives. This is not to say it's *good* for you, but that's a different story.

Even if we were to accept an extreme definition of "natural"— e.g., not subjected to any process invented since 1812—the word still doesn't tell you anything useful. Many "natural" substitutes for common consumer products—honey for sugar, sea salt for ordinary salt, carob candies for chocolate—are essentially equiv-

alent to the foods they're supposed to replace. Furthermore, there are many naturally occurring substances, such as the cyanide precursors found in some fruit pits, that are dangerous. The fact that something is "natural" doesn't necessarily mean it's healthful.

It's true, of course, that if you eat lots of fresh fruits and vegetables, you'll be better off than if your diet consists solely of TV dinners. That's because processed foods tend to heavy up on the fat, sugar, and salt. You'll also be eating a lot fewer food additives—although, except for occasional wrong numbers like sulfites, certain uses of which were recently banned by the FDA, additives are not the major health threat facing Americans. The real dietary problem these days is the consumption of too much fat and cholesterol, which are found in both processed and "natural" foods, such as milk and eggs.

If it's any comfort, there is at least one context in which "natural" does have legal meaning. The U.S. Department of Agriculture, which regulates meat and poultry, has decreed that "natural" may only be used to describe products that are free of artificial additives and subjected to minimal processing. "Natural" meat may still contain drug residues, though.

Whatever the merits of "natural," there are certain terms of which one has a right to expect more. One of these is "light" (or, as some prefer in this postliterate age, "lite"). To innocent minds, "light" suggests that the product is low-calorie, low-fat, or at least low-salt, all of which have health benefits. In reality, however, it may simply mean that the product is (tee-hee) light in color or texture. Or light compared to a banana split, as in the case of Michelob Light, which checks in at 134 calories per 12-ounce serving, more than some regular beers. As with "natural," the gummint has never gotten around to establishing a legal definition. Fortunately, in 1988 U.S. Representative Jim Cooper (D-Tennessee) will be introducing the Fair Food Labeling and Advertising Act, which sets strict legal guidelines. An earlier version of the bill didn't make it out of committee, so if you're in favor, you might want to so signify in a letter to Cooper or your local rep, care of the House of same, Washington, D.C. 20515.

Here it is, autumn. The leaves are turning colors—I don't care why. The insects are going off to wherever it is they go all winter—don't bother explaining where. The roadside stands are

filled with Indian corn, which I probably wouldn't like even if I knew whether it was edible. Oh, yes, and cider.

About that cider. Indifferent though I am to most manifestations of the changing seasons, there is one thing I have always wondered about: what makes cider different from apple juice? I mean, you never see those big sludgy jugs sold as apple juice, and you never see the little cans of frozen concentrate sold as cider. Is it all just marketing? Legal terminology—i.e., if you freeze it, it's not cider? It seems to me that the two things taste different. Is this all in my head? Please answer before the snow flies.—Will C., Baltimore.

Science tells us, William, that there are limits to what we can hope to know about the cosmos. Offhand you wouldn't think the cider/juice dichotomy would present a particularly compelling demonstration of this fact, but think again. I have checked around with most of the major manufacturers and with various reference books, and the end result is that I have come up with three logical, plausible, but totally contradictory explanations of the difference between cider and apple juice. Take your pick:

1. *There is no difference at all.* (Source: large Midwestern bottler.) Uncle Sam confirms that there is no legal distinction. In other words, it is all marketing booshwa. But see below.
2. *The store-bought stuff is juice; the homemade stuff is cider.* (Source: East Coast conglomerate; also, the old edition of the *Encyclopedia Britannica*.) The product you buy from roadside stands usually has not been pasteurized. Consequently, it ferments over time, giving it a mildly alcoholic kick. What you buy in the store, in contrast, is pasteurized soon after crushing, preventing fermentation and resulting in a pleasant but kickless taste. The manufacturers call their product cider in the fall for marketing purposes.
3. *Cider is made from apples that are picked early.* (Source: Washington State outfit that claims to be the country's largest maker of juice and cider.) Early harvest apples supposedly have higher acid and lower sugar content, producing a drink with a tangier taste. Thus true cider remains cider after processing because pasteurization doesn't affect the acid/sugar content. Therefore, the company claims, it's possible to make not only frozen cider concentrate, contrary to your assertion, but also "sludgy"—i.e., unfiltered, hence cloudy—apple juice.

The guy I got all this from says his company is quite scrupulous about monitoring the acidity of its product and changing the labels accordingly.

OK, so there I am. Weeping with frustration. Suspicious events then begin to transpire. A letter arrives from informant number 2 (true cider is unpasteurized). It includes some photocopied pages from the *American Cider Book* essentially confirming our conversation about pasteurization. However, in the letter itself, my informant blithely states, "We use the first season apples to provide a sharp, tart taste. The main difference between the two products is the amount of clarification done in the processing." Immediately dismissing the distracting second sentence as the product of an unsound mind, I focus on the first. Clearly something is afoot. I call back the Midwestern bottler (cider = juice). My original informant is out, but another spokesperson, obviously reading from a prepared statement (and no doubt with armed representatives of the Cider Control Board standing beside her), states that her company too makes cider from early harvest apples, contrary to earlier reports. Juice, on the other hand, is a blend of fresh apple squeezin's and concentrate.

Two explanations for all this confusion come to mind—either apple processors truly do not know the difference between cider and juice, or, more likely, have decided to line up behind a wimp definition that enables them to flog off sterile juice in the place of genuine, raw, unpasteurized cider. Neither redounds to the industry's credit.

My husband and I moved to the U.S. from Canada three years ago. The last thing my sister said to me before we left was, "My condolences on the American beer." At the time I thought she was being funny, but after sampling several of the local varieties of what passes for beer around here, I began to realize what she meant. Finally, in a fit of nostalgia, I bought some Molson's Canadian, at twice the price of American domestic. You can imagine my disappointment at the discovery that it did not taste the same as the Molson's Canadian I had known and loved at home. The same thing seemed to hold true for European beers. So my question is this: Does my jaded palate deceive me, or is the beer exported to the U.S. by Canada and other countries in fact different from what they sell at home under the same

label? I am sure you can appreciate the international significance of this issue.—Mr. and Mrs. Puzzled Canuck, Chicago

Listen, acid rain is nothing compared to this. For what it's worth, a taste panel organized by James Robertson, author of *The Great American Beer Book*, agreed with your low opinion of the Molson sold in the U.S. When asked about this, Martlet Importing Company, which handles Molson's U.S. sales, claimed the American and Canadian versions were identical when brewed, and said that any differences arose from the fact that beer is perishable, and can go stale in the time it takes to reach American supermarket shelves. To check this, Robertson procured samples of Molson Ale, Golden Ale, and Canadian in Montreal and had them shipped to the U.S. by air freight. The taste panel then compared the Montreal brew to samples of the same Molson products that had been purchased in New Jersey. Except for one batch of U.S. Molson Ale, which was described as "skunky," the panelists agreed the fresh U.S. and Canadian versions were virtually identical, the one difference being that the Canadian stuff, which came in cans, was more carbonated than the bottled U.S. variety. Seems to me we can draw one of two lessons from this: either there's something about merely living in the U.S. that dulls the taste buds, or else your memory of the beer you drank in Canada is a little rosier than the reality warrants.

We have been puzzled for a while about how salt and ground black pepper became the standard spices on the American dinner table. Why don't we use cinnamon or oregano or something else instead?—Joe and Fern S., Beverly Hills, California

This is just the kind of thing that fascinates historians, gang, something you may want to consider next time a historian asks you out for a date. Actually, the popularity of common salt (sodium chloride, or NaCl) is pretty easy to account for. It stimulates one of the primary sensations of taste, via the salt-sensing taste buds at the tip of the tongue. (The other primary tastes, of course, are sweet, bitter, and sour.) It has long been used to preserve meat and fish, obviously a matter of considerable importance in the days before mechanical refrigeration. It is essential in humans and animals, playing a vital role in body heat regulation, among other things; to maintain health you must consume between three and eight grams a day. Salt's popularity,

therefore, is not surprising. Every major civilization has cherished it. It has always been an important object of trade and at times has been a medium of exchange. Roman soldiers, among others, were paid in salt, which gave rise to the English word "salary."

Pepper is a different story. In terms of total volume, it isn't even in the same league with salt. Every year Americans douse their food with a staggering 6.5 million tons of sodium chloride, whereas during the same period they use a measly 27,000 tons of pepper. (That is to say, black pepper, the fruit of the plant *Piper nigrum*. Red pepper adds another few thousand tons.) Pepper nonetheless is among the most popular of all the spices, and always has been. (Salt, strictly speaking, is not a spice.) In terms of total tonnage, it lags behind sesame seed and mustard consumption in the U.S. But whereas the latter two are largely confined to the hot dog and hamburger biz, pepper you can cheerfully dump on nearly anything.

Indigenous to India, pepper came to the Romans around the first century B.C. They became so fond of it that they established special pepper storehouses (*horrea piperataria*). Partly because of its scarcity, the stuff became extremely valuable; it's said Alaric the Goth demanded the Romans give him a ransom of 5,000 pounds of gold, 30,000 pounds of silver, and 3,000 pounds of pepper.

But it was only in the late Middle Ages that pepper got really hot, so to speak. After centuries of tasteless gruel, Europeans developed a craving for certain spices that could be obtained chiefly from the East, among them pepper, cinnamon, cloves, nutmeg, and ginger. Pepper, being pungent, became particularly popular, since it could be used to disguise the taste of semirotten meat, a commodity then in abundant supply. So precious did pepper become that at times, like salt, it was used as money. The popularity of pepper dropped off a bit after 1650, partly because the European diet became more varied and there was less need for it, but it remains an extremely common seasoning today.

What exactly accounts for pepper's popularity, apart from its evident versatility, is hard to say. Given its usefulness in decayed beef, we may speculate that the rise of the fast food industry has done much to prop up the market. More generally, I would say that pepper's macho fieriness gives it a broad cross-cultural ap-

peal that must forever elude such justifiably obscure herbs as fennel, which sounds like something out of *Rosemary's Baby*. Cecil's own researches in the kitchen (he is to spaghetti what Mozart is to music) persuade him that pepper plays a vital if indefinable role in the human diet. Many are the hours I have sweated over that damn pot trying to get the proportions of salt, pepper, and garlic—the Magic Triumvirate—exactly right. But it's been worth it, needless to say; we're talking about a dish that will heal the sick and raise the dead. Play your cards right and I'll invite you over for a plateful.

While eating graham crackers recently, we were discussing the myth that they were invented to keep girls from engaging in, uh, self-abuse. Is this true? How were they supposed to work? Didn't Graham realize he might frustrate an entire generation?—Chris C. and Frank L., Washington, D.C.

Frustrate, nothing. Health lecturer Sylvester Graham (1794–1851) was trying to save shattered lives—not just of women, but everybody who suffered from what Graham referred to variously as "venereal excess" or "aching sensibility." Graham thought intense sexual desire, no matter how expressed and regardless of whether you were married or not, was guaranteed to have dire physiological consequences.

A forebear of the hairy-palms-and-blindness school of moral instruction, Graham said excessive carnal exercise would cause indigestion, headache, feebleness of circulation, pulmonary consumption, spinal diseases, epilepsy, insanity, and early death of

offspring, among other things. He thought men should remain virgins until age 30 and then should have sex only once a month—not at all if they were sickly.

To cool the dread fever of lust, he prescribed a special vegetarian diet, the centerpiece of which was "Graham bread," made from whole wheat flour. Graham crackers, which Graham invented in 1829, were another manifestation of the same idea.

Graham attracted a fair number of followers, who opened Graham boardinghouses in New York and Boston where his dietary regimen was observed. But most people regarded him as a nut. He was assaulted by mobs on at least three occasions, once by butchers and bakers who thought he was going to drive them out of business. He was cranky and aloof and alienated even those who admired him, so much so that he gave up the lecture business in 1839 and lived out the last years of his life in relative obscurity.

His saving grace was that in many important respects he was right. Although he was a little goofy on the question of sex, many of his ideas about health were sound. He advocated daily toothbrushing, once considered a revolutionary idea, as well as fresh air, regular bathing, exercise, and seven hours of sleep. During an era of recurring cholera epidemics he urged people to drink pure water.

Most important, we now know the diet he recommended to be vastly more healthy than the one Americans were eating at the time, or for that matter today. He railed against commercial bakers who used refined flour devoid of dietary fiber. He urged the consumption of fresh fruits, vegetables, grains, and seeds. Strictly verboten were fat, salt, sugar, tobacco, alcohol, and stimulants. Modern dietitians aren't as strongly opposed to meat as he was (although they'd certainly advise fish and poultry rather than red meat), and they'd go easy on the fat- and cholesterol-laden milk, cheese, and eggs he recommended. But by and large "the prophet of bran bread and pumpkins" was right on the money.

One more thing: if you were starting to feel virtuous because you eat graham crackers, don't. Despite the name, most brands of "graham cracker" today use refined white flour. If you want the real thing (more or less), try the Health Valley or New Morning brands, which can be found in health food stores. They

use whole wheat flour, soy oil, unsulfured molasses, and no preservatives.

We were all sitting around lunch the other day and the question of what sweetbreads are came up. I voted for the thymus gland, but I was tremendously outnumbered by votes for the pancreas. Other suggestions include the brain, salivary gland, and even some sort of reproductive organ. I won't comment on the mental status of the person giving the latter suggestion, but you may feel free to do so.—M.K., Baltimore

Boy, nothing like a little light conversation to improve the digestion. As it happens, you and the pancreas bloc are both right. There are two kinds of sweetbreads: stomach sweetbreads (also known as heart or belly sweetbreads), which are an animal's pancreas, and neck (aka throat or gullet) sweetbreads, an animal's thymus gland. (The animal in question can be a hog or calf or just about any other large mammal, I gather.) They're called sweetbreads for the obvious reason that if you called them thymus glands or whatever you couldn't give the damn things away. The art of euphemism goes back a long way.

Every now and then I find a green potato chip in with the normal potato chips. Now, I have never seen a green potato (except on Saint Patrick's Day at a diner, the chef of which had a questionable sense of humor, and it was mashed), so I assume that something happens to the chips during the chipping process to inadvertently color certain of their number a virulent verte. Why?—Carole F., Alexandria, Virginia

Green (or brown) chips come from potatoes that have been kept in storage so long that the sugar in them has caramelized. A percentage of taters picked in the fall is stored for use during March through May, when the supply of fresh potatoes is at its lowest. Quality control is supposed to catch the greenies, but some sneak by. I'm told they're harmless. However, I make no promises.

• • •

Oops

After reading your discussion of green potato chips, which you described as harmless, I would like to offer the following comments. When I was a boy back on the family farm in Minnesota, we always raised our own potatoes. Sometimes the potatoes protruded above the ground, and when that happened, the exposed portion turned green as a result of the formation of chlorophyll. We called it "sun scald." My mother always removed the spots of sun scald when preparing the potatoes for the table because it was common knowledge among farm people that the spots contained a poison, the same as the leaves did.

Potatoes belong to the nightshade family, and most green portions of plants in this family contain an alkaloid poison called solanine. While it is unlikely that anyone has ever become seriously ill from eating the small portions of green sometimes found on potato chips or french fries, some tummy aches could probably have been prevented. They definitely are not good for you!—Donald L., technical information specialist, U.S. Department of Agriculture, Washington, D.C.

Well, OK. Maybe I shouldn't have said green potato chips are "harmless." Maybe I should have said they were "harmless compared to getting hit by a truck," just to put things in perspective. But let's get serious. Do you know how many green potato chips you'd have to eat to kill yourself? Fifty kajillion, that's how many. You could get killed if fifty kajillion potato chips *fell* on you. So let's not get too excited here.

Just to clarify: green potatoes result from excessive exposure to light, whether natural or artificial. The green itself is chlorophyll, which is not harmful. However, the same process of photosynthesis that produces chlorophyll also produces compounds called *glycoalkaloids*, such as solanine, that can cause headaches, nausea, and diarrhea if eaten in sufficient quantity.

In a normal potato plant, the glycoalkaloids are concentrated in the leaves and the sprouts. The story is told that during World War II some refugees broke into an abandoned house and found a quantity of old sprouted potatoes in the basement. The potatoes themselves were too dried out to eat, so the refugees made a stew out of the sprouts—and got incredibly sick as a result. Thus Mom's injunction never to eat the eyes in a potato, eyes, of course, being sprouts as yet unborn.

Green potatoes and green potato chips are to be distinguished from *brown* potato chips, which are a different matter entirely. Brown potato chips result when potatoes are stored too long at low temperatures, causing them to accumulate excessive sugar. When sugar is present in normal amounts, it combines with amino acids during cooking to produce the potato chip's characteristic yellow-brown color. A chip with too much sugar, on the other hand, takes on a dark brown, almost burned appearance, even though it wasn't in the oven any longer than usual. This phenomenon is commonly but inaccurately known as "caramelization." (True caramelization occurs when water is removed from sugar.)

Brown chips are harmless. Green ones won't kill you in small amounts, but in the words of one authority, "You should not deliberately go around trying to find green potato chips just so you can eat them." Which pretty much kills *that* party idea. Do the sensible thing and stick to the ones you know are safe.

Granted you're no Galloping Gourmet, but this question has psychological as well as nutritional implications. (Catholic mothers are quite underrated when it comes to instilling childhood neuroses.) Is it really true that potato skins, apple peels,

and carrot outsides are good for you? What value do they have? According to my mom, peeling apples, carrots, potatoes, and the like leads to vitamin and fiber deficiencies and, worse, spiritual laxity. As a result I suffer pangs of conscience every time I peel a carrot, spit out an apple peel, or leave behind a potato skin. But ever since I discovered all that stuff she told me about sex was wrong, I've been suspicious. Just what are the dire consequences of peeling one's fruits and vegetables?—Rita H., Washington, D.C.

A complicated story, my little muskrat, even if we leave your tortured psyche out of it. Generally speaking it's a good idea to keep the skins on your fruits and vegetables, but not because they're a great source of vitamins and minerals—quite the contrary. In potatoes, for instance, the skin, which is a dark corky layer called the "periderm," consists mostly of dead cells filled with a waxy, largely vitaminless substance whose chief function is to protect the potato's insides. However, skin does keep vitamins from being boiled off during cooking. A baked potato with skin intact has almost all its original vitamin C, whereas a potato that has been peeled and boiled retains only 50–80 percent. (There's even less if the potatoes have been mashed up and left to sit around for a while.)

So, just leave the potato skins on while cooking and peel them afterward, right? Not so fast. It turns out that glycoalkaloids, the toxic compounds found in potato leaves and sprouts, are also present to some degree in potato skins. Researchers Nell Mondy and Barry Gosselin of Cornell say boiling potatoes in their skins can cause the toxins to migrate into the vegetables' flesh. Frying the skins is even worse since it eliminates water and concentrates the poison. Seventeen English schoolboys reportedly were hospitalized in 1979 after eating glycoalkaloid-laden spuds.

So what's a mother to do? Beats me—maybe you should just give up and feed the kids Snickers bars. Personally, though, I think Mondy and Gosselin are exaggerating the dangers a bit. If the potato hasn't sprouted or turned green inside, two definite danger signs, I'd advise leaving the skins on.

Things get a little simpler when we turn to other fruits and vegetables. Skin is a good source of dietary fiber, something most Americans could use a lot more of. One medium apple with peel, for instance, contains about 3.3 grams of fiber, while a peeled apple contains only 1.5 grams. Although there are no official

daily fiber requirements, authorities say most people get only 10–20 grams per day, even though they could use 20–35.

There are several types of dietary fiber. The one abundant in apples, and to some extent in all fruits and vegetables, is called pectin. It's water soluble, and water-soluble fiber has been shown to reduce blood cholesterol levels. What happens apparently is that each particle of fiber grabs an armful of bile salts on its way through the intestine (a process called "binding") and carries it out of the body during excretion. The body then has to make new bile salts and evidently uses cholesterol as the raw material, thus keeping the blood cholesterol level down.

It has not been shown conclusively that an apple a day keeps the heart specialist away, which is to say they haven't proven that eating apples and other pectin-rich fruits and vegetables reduces heart disease. It's also true that if you eat too much water-soluble fiber it'll bind with (and subsequently carry away) micronutrients your body needs. But since most people could stand to double their dietary fiber intake, it's probably a good idea to leave your apples and other fruits and vegetables (except taters) unpeeled . . . unless of course the whole idea just grosses you out of existence. Nutritionists would rather have you peel your veggies and at least get the benefit of the complex carbohydrates and starches than not peel and consequently not eat them at all.

My friends at work were amazed when I mentioned that on the average I chew 8 to 10 sticks of gum each day. But when I said that I always swallow it they were horrified and seemed shocked that I lived to tell about it. Please tell me—is there any danger in swallowing chewing gum?—Patrick T., Milwaukee

Cecil has heard numerous theories on this subject over the years, each one more knuckleheaded than the last. One version has it that the gum stays in your stomach for seven years; another says it winds up in your appendix, along with your fingernail nubs, should you happen to be addicted to nail biting. All of these ideas, needless to say, are jive. It's true that chewing gum base is indigestible, but humans consume a great many things that are indigestible. (You ever try Crispy Critters?) All such roughage is simply eliminated from the body after the usual jog down the alimentary canal.

My wife loves sushi. Sushi is just raw fish. Raw fish is full of deadly contaminants. Is she doomed? Pull no punches. —Mike M., Chicago

Disaster shudders on the horizon, Mike. Grab the little lady and pour a quart of Lysol down her pronto, or the dread roundworms'll ventilate her bowels in no time. I kid but little. Eating raw fish can result in *anisakiasis*, an infection caused by an infestation of *Anisakis* worm larvae. These little guys, who under other circumstances might make charming pets, can grow up to one inch in length. If you're lucky, they'll wind up in your stomach, where the chief symptom is generally a sudden attack of intolerable pain. It starts within 12 hours after eating the affected fish and continues for two or three days, until the worms expire. If you're not as fortunate, the larvae head down to your intestines, where they can take up permanent residence, opening small grocery stores and carrying on until all hours of the night, making your life miserable in the process.

Cases of anisakiasis turn up from time to time in Japan and the Netherlands, where raw fish eating is common. Here the disorder is often misdiagnosed as appendicitis, peptic ulcer, or stomach cancer. The only treatment is to poke a tube down your craw and remove the larvae one by one. The only preventive measure is to cook the fish or else freeze it at least three days. (Mercifully, many Japanese restaurants purchase squid and whatnot frozen; shrimp, eel, and octopus are often cooked.) Some of the assassins who run sushi bars will tell you they can check for worms by "candling," holding the fish up to the light and cutting out the larvae before slapping what's left on your platter. The Centers for Disease Control, however, say the efficacy of this method is on a par with rain dancing. Now understand, I'm not saying you're *guaranteed* to get worms if you eat sushi, or, for that matter, sashimi, ceviche, or some other type of raw fish cuisine. Think of it as kind of a remote threat, like nuclear war. Or else stick to Chicken McNuggets.

The Raw Fish Lobby Wishes to Register a Complaint

You recently carried an item about sushi in which your querent (nice terms, n'-est-ce pas? Got it from a tarot card reader) says "sushi is just raw fish." I am tired of hearing this.

Sushi is not just raw fish. Not even sashimi is just raw fish, although it's a hell of a lot closer than sushi is. Many sushi dishes contain cooked fish and/or vegetables. You can start with kappa-maki, which generally contains seaweed, sushi-rice, cucumber, and wasabi. (Wasabi, incidentally, is not horseradish, or mustard either. It's Wasabi japonica, and is sui generis as far as I'm concerned.) Then there is a salmon-skin handroll, for which they carefully cook the fish so you needn't worry about it. A good place will put such goodies as gobo (pickled Burdock root) into this, and it becomes a major delight. Also there is "tiger eye," which is cooked, as is most eel sushi. I generally end with ume-jiso-maki, which contains umeboshi plum paste, shiso, leaves, rice, and seaweed, and is a bit salty but wonderful. There are plenty more where these came from.—John S., Boulder, Colorado

You recently recommended that people avoid sushi, since raw fish is prone to parasitic infestation. Unfortunately, the issue is not that clear cut. Hours after reading your column, I sat through a pathology lecture in which the professor described the risks associated with eating cooked fish. Sugimura has demonstrated that certain compounds in cooked fish protein are strongly mutagenic and carcinogenic. So maybe we should avoid fish altogether. On the other hand, fish is very high in monounsaturated fats, and in this respect it seems to be one of the best dietary interventions for preventing coronary heart disease, the nation's leading cause of death. What to do?—Keith B., Chicago

I'd say the benefits of fish clearly outweigh the risks, even though I'm not at all crazy about the raw version (and I say this as much from an aesthetic standpoint as anything else; the actual danger of parasite infestation is pretty low). Here's a quick rundown on what researchers have found: (1) Greenland Eskimos, who eat a high-fish diet, rarely die of heart disease. (2) In a 20-year study of 852 men conducted by the University of Leiden in the Netherlands, men who ate one ounce of fish a day were half as likely to suffer a heart attack. Studies also show a low heart-disease rate among Japanese fish-lovers. (3) According to researchers at Oregon Health Sciences University, a high fish-oil diet reduced dangerous triglyceride ("bad fat") levels. Triglycerides are thought to increase the risk of heart disease. Pass the fish cakes, pal.

As I write this letter, I am staring at a box of candy, the contents of which are basically a total mystery. It shouldn't be that way, I understand, because supposedly the chocolate-dipped candy industry adopted a not-so-secret "squiggle code" many years ago. In other words, the squiggly lines of chocolate on the pieces of candy are supposed to indicate if the contents are nougat, vanilla cream, marshmallow, etc. But my tidbits are mostly covered in smooth, plain, unsquiggled dark or milk chocolate, which means I must resort to the notorious "pinch test" to discover the contents. What's going on here?—N.G., Chicago

Just to give you an idea of the nightmarish conditions I endure on this job, N., I had to buy (and eat, of course—you can't just take some clerk's word on these things) literally dozens of pieces of candy in order to crack the squiggle code—risking insulin shock, acne, and my svelte physique in the process. Luckily, you are dealing here with the Chuck Yeager of modern candy testing. My efforts have turned up the following facts:

Once upon a time there was a universal candy code, but it went out the window in the 1940s. Apparently this was due to increasing mechanization in candy manufacture, which made the use of identifying letters on each candy, as the code required, rather problematic. Codes are still used by some manufacturers, particularly those who sell chocolates by the piece (as opposed to strictly by the box), so that clerks can identify the goods in the store. But each firm seems to have adopted its own code, usually a series of abstract designs that can readily be done by machine. Happily, the traditional *shapes* of candies, plus a few of the codes used for the more common types, have remained relatively constant over the years. A single stripe on a rectangle, for example, usually means nougat. However, if you're into the more exotic varieties, or if the maker of your candy has eschewed markings altogether, you're pretty much out of luck.

Here's a list of selected candies comparing the old codes with those of two present-day firms, Chicago-based Fannie May and Massachusetts-based Fanny Farmer. (And no, I'm not going to speculate on why candy makers tend to be named Fanny. I've got enough problems already.)

• • •

Type	Universal code	Fannie May	Fanny Farmer
Vanilla cream	Round with "V" on top	Round with straight line	Round with single "arrow"
Chocolate cream	Round, open "C" on top	Round with 2 curved lines (light inside)	Round with 2 straight lines (dark inside)
Cherry cordial	Round with closed "C"	Round with circular hieroglyphic	Round with closed "C"
Vanilla caramel	Square with "V" on top	Square with straight line	Square with V-like zigzags
Peppermint	Round, flat, unmarked	Round, flat, wavy stripes	Discontinued
Nougat	Rectangle, straight line	Rectangle, straight line	Rectangle, 1 or 2 straight lines
Orange cream	Round with "O" on top	Oval, slanted "Hostess cupcake" swirls	Oval with narrow zigzags
Shredded coconut	Not listed	Round, wide zigzags	Round, lumpy, one arrow
Marshmallow	Not listed	Square, 2 or 4 "peaks"	Round, random peak pattern

Cecil advises keeping this list with you always, so you can be prepared next time the ticklish task of candy picking presents itself. (Some candy makers also supply their own lists.) If that isn't practical, you might try memorizing the ones you find particularly loathsome (e.g., the dread coconut), the better to dodge them in the future. So many chocobits, so little time—no use getting stuck with ones you don't like.

Chapter 4

Urban Studies Revisited

You frequently deal with the problem of unwanted insectile houseguests in your column, so I thought I would relate my own experience. I have had to fend off cockroaches ever since I began residing in apartments. I have of course tried boric acid, bug bombs, Roach Motels, Raid, etc., with mixed results. One night I turned on the kitchen light and spotted one roach motionless on the counter. As adrenaline raced through our respective bodies, I realized the only artillery I had on hand (besides my hand, yecch!) was a bottle of liquid Ivory Soap. I slowly moved the spout over his suspicious antennae and squeezed. He was hit! He quivered and stumbled as if running into a dense cloud of Black Flag, then flipped over and went on to meet his Maker. I grinned sadistically. But later I wondered: why is such a small amount of this "pure" and "mild" substance so effective? Could it be harmful to humans?—M.B.F., Los Angeles

I think it is high time you were introduced to the concept of "drowning," M., which was most likely the cause of death in the present instance. The soap would also remove the protective oily coating on the roach's exoskeleton, eventually causing it to dehydrate, but that wouldn't result in the scenario of instant death you so graphically describe. The handy Ivory squeeze bottle does have the advantage of providing pinpoint delivery of lethal materials. In addition, the high viscosity of Ivory (as opposed to the runny gloppiness of Brand X) means a little dab will do 'em without your having to flood the room. On the downside, as we say, individually asphyxiating each of the estimated six jillion

roaches at large in this country does present certain practical problems.

Tales from the Front, Part One

Re M.B.F. of L.A., who wondered why putting Ivory soap on his cockroaches offed them: a friend of mine has lived for many years in a small roach-infested apartment deep in the heart of Hollywood. He used to squirt-gun the little beasties, and it seemed to work, but he discovered that they would dry up and walk away. Then he discovered that if he put a little soap in the water it would "stick" better, and they wouldn't dry up and never walked again! So it's not just a question of drowning—the soap itself seems to make a difference.—Jennifer B., Silverlake, California

OK, so maybe I was a bit hasty. Ivory is a detergent, which means it can reduce the surface tension of water, thereby increasing its spreading and penetrating abilities and enabling it to drown cockroaches more dependably. And boy, wouldn't *that* make a hell of an ad campaign?

Tales from the Front, Part Two

I have two additional methods to kill cockroaches: the Quick Kill and the Scare Away. To quick kill, keep a squirt bottle on hand with fresh rubbing alcohol. The "stream" setting is best. With a good aim, you can kill instantly. To scare away, put peppercorns, cinnamon sticks, and bay leaves where roaches enter or like to travel. I put handfuls of spices under the sink and fridge. Every few months I put fresh spices out again. I find these methods to be safe, cheap, and effective. The spice method was at least as effective as using chemicals, and I never had an outbreak like I did when chemicals were used.—Anonymous, Pennsylvania

Just a suggestion on the cockroach issue, although knowing your feelings on cats, I doubt you'll take kindly to it. Friends of mine took an apartment in Boston's cockroach-infested North End this summer. The first night they found three roaches; over the course of that week, a few more; after that, none. When they related this to a colleague at work, she said, "Let me guess. You have a cat." And sure enough, they did. Cats do have their uses.—R.S., Randolph, Massachusetts

Hey, man, whatever works for you.

Is it possible, as a method of pest control, to produce a virus which doesn't kill the critter, but only sterilizes it? That way the little pests could all infect each other and we'd be rid of them in no time. How about it, Cecil?—Have to Know, Chicago

Sounds like the greatest idea since the Black Death, H.—too bad they have laws against this sort of thing. Luckily, a less malign solution to the bug question is at hand: the first practical cockroach contraceptive. I'm serious. We owe it all to Zoecon Industries of Dallas, which has been working on this for 10 years. After numerous false starts (originally they hoped to teach the roaches the rhythm method, but none of the little morons could count to 28), the folks at Zoecon achieved a breakthrough—a miraculous compound called hydroprene, which is innocuously classified as an "insect growth regulator."

Nobody knows quite how the stuff works, but basically you spray it on the roaches when they're little—in the "nymph" stage,

to be precise—and they fail to reach sexual maturity, much like graduates of the University of Notre Dame. Among other things, the wings of the adult roaches don't develop properly, so the males can't fan their pheromones (sex attractants) at prospective mates. Furthermore, the males are stricken with sexual ineptitude in the presence of females, and instead, according to one researcher, prefer to "stand around in a circle and wave [their antennae] at one another." I am reminded of a certain legendary practice once associated with boys-only summer camps, but let's not allow ourselves to get distracted here. Female roaches sprayed with hydroprene will still mate, presuming there are any males around who remember how to do so, but they produce no offspring. A single test spraying conducted at a Florida apartment complex killed off 95 percent of the roaches in eight months.

Hydroprene, which will sterilize any species of cockroach but appears to have no effect on other forms of life, has been approved by the Environmental Protection Agency and most state regulatory agencies, California being a conspicuous exception. Right now it's only available through professional exterminators (under the trade name Gencor), but a consumer version is being tested now, and may be available later this year. The one draw-

back is that the stuff takes several months to work—you have to wait for the sterilized cockroaches to die of old age. To alleviate this problem, the folks at Zoecon are working on a version of their product that combines hydroprene with a conventional quick-kill "adulticide," as they call it. Stay tuned for further developments.

Further Developments, As Promised

American Home Products, maker of Black Flag, has introduced a cockroach contraceptive called Roach Ender. It reportedly was invented by Dr. Carl Djerassi, who helped create the first human birth control pill. (Now we're starting to get *serious*.) A compound called hydramethylnon also has been developed that interferes with roach metabolism. According to one news report, "The roach slowly runs out of gas, falls asleep, and never wakes." Finally there's a new yeast that grows in the roach's blood, goofs up the ability to absorb nutrition somehow, and causes the roach to starve. Ingenious, not to say diabolical, but given the legendary durability of these critters, I'd wait a little while before I marked them down as an endangered species.

A friend of mine has been having some trouble lately with that perpetual pest, the mosquito. He remembers reading somewhere—as do I—about some kind of ultrasonic transmitter used as a mosquito repellent. Do these devices work? Do they have any effect on humans? Are they legal? And where can I get one? I'm just itching for your reply.—Hot to Swat, Chicago

I'm not going to answer your last question, H., because ultrasonic mosquito repellers all have one thing in common: none of them work. At all.

Ultrasonic devices work, according to one advertisement, by "mimicking the sound of the bat—the mosquito's greatest enemy." (They emit sound in the 20–50 kilohertz range, higher than humans can detect.) While it's true that bats eat mosquitoes and that bats make ultrasonic sounds (they navigate through a sort of natural radar), the simple-minded mosquito apparently can't make the connection. The U.S. Environmental Protection Agency conducted two years of tests in the mosquito-ridden area around Chesapeake Bay, trying virtually every type of electronic

repeller they could lay their hands on. Not a one had any noticeable effect on mosquitoes, or, if it's any comfort, on humans (although some say the latter question hasn't been studied in sufficient depth). Subsequent research at various universities has pretty much borne out the EPA's findings. Both the EPA and the U.S. Postal Service have gone after ultrasonic repeller makers for making unsupported claims for their products.

Some ultrasound firms say their products will also repel mice, rats, roaches, bats, fleas, spiders, and the like. The evidence to date suggests these claims are greatly exaggerated. At best they work only when used in conjunction with a concerted antipest program involving traps, improved sanitation, elimination of entry points and nesting places, and so on. So don't throw away that flyswatter yet.

Can you explain why gnats often gather together in large groups in midair, hovering around an imaginary fixed point? Even if you wave your hand through a group of them and confuse their sense of locus, they return to regroup around the same point. —Alan D., Chicago

As you undoubtedly know, Alan, "gnat" is an imprecise term referring to several species of small flies, most often the fruit flies of the family *Trypetidae*. The swarming is part of a mating ritual common to many insect species, wherein the males hover en masse and await the females. It's believed the insects orient themselves over or near some easily recognizable topographical feature—a white object against a field of green, for example, or a tall bush—rather than some "imaginary fixed point." Their uncanny persistence in doing so may be attributed to the fact that they have to propagate the species (and get in what giggles they can) in an extremely short time—gnats only live for a few weeks. Keep all this in mind next time you're tempted to spoil some little fly's fun by waving your hand through his orgy. Creep.

Judging from the number of pigeons inhabiting the city these days, one must assume that either they have very long life spans or they have enormously large numbers of offspring. Yet, although we see our share of baby robins, baby ducks, baby bunnies, and other infant animals, one seldom sees a baby pigeon. Do they emerge full grown from their eggs? Are the squabs simply well hidden, or are they guarded by the parent birds until

they are grown, thus assuring a high survival rate? In short, where are all the baby pigeons?—Birdwatching Commuter, Evanston, Illinois

I must confess that I am mystified by the enduring fascination baby pigeons seem to hold for the Teeming Millions—over the years I have gotten dozens of letters inquiring about their whereabouts. My answer is always the same: the elusive little devils are out there somewhere; you just don't see them because the nests are well hidden and because Ma and Pa Pigeon generally stay with the kiddies for their first few weeks of life. This never seems to satisfy anybody, though, because the letters keep dribbling in. At last, however, I am able to report an *actual sighting* of a bona fide baby pigeon. Read on.

I found two baby pigeons! They are huge, and look just like their mother. The reason you've never seen any is that they stay in the nest until they are old enough to drink, drive, vote, etc. The nest is right outside my office window on a ledge at Arizona State University's Memorial Union. Little does the mother know I could just open the window and snatch the little creatures! Do you want them?—Laura M., Tempe, Arizona

Stifle your murderous impulses, Laura; I get enough nameless horrors in the mail as it is. Nonetheless, I appreciate your insightful report, and hope this puts the pigeon question to rest once and for all.

The Teeming Millions Propose an Alternative Hypothesis

Re your recent comment on baby pigeons: don't be fooled by false sightings from gullible bird lovers. The blunt truth is this: the pigeons you see all over the city are baby pigeons. The adult has a wingspan of 8–12 feet. When they reach adulthood they fly to remote mountain fastnesses and live off the occasional tourist. I do not, however, subscribe to the theory that the adults will one day return en masse to wreak vengeance on us à la The Birds.—Bob W., Melrose Park, Illinois

Cute, Bob. Also amazingly similar to something I saw years ago in *National Lampoon*. If I were you, I'd sue the bastards.

Please identify and state the purpose, if any, of those white squiggles attached to chicken egg yolks. I have either read or been told that they have nothing to do with fertilization. I have been removing them for years because of their appearance and because they are more offensive when found cooked and hard in eggs. Are they found in other types of eggs? Why do some eggs have two?—Myra D., Baltimore

The primary purpose of the squiggles, which are called *chalazae*, is to give the heebie-jeebies to squeamish gentlepersons such as yourself, and secondarily to keep the yolk from sloshing around inside the egg. Normally there are two chalazae, which connect the yolk to either end of the egg and keep it suspended in the middle. They're found in all types of eggs. Sometimes you only see one or none because they stick to the eggshell rather than the yolk. The chalazae are made of semisolid albumen, basically the same stuff that egg white is made of, and are perfectly harmless. Get a grip on yourself.

You're a dog.
The guy you've lived with lo these many years (i.e., me) points out another dog on television. You couldn't care less.
He shows you a photograph of a snarling cur that would normally send you yelping for the hills. You yawn.
Pulling out all the stops, he puts you in front of a mirror to gaze upon your own countenance. Zippidy doo dah.
You prance merrily away, while your guy scratches his head. Is it possible that dogs can't see in two dimensions? If not, why not? And if they can, what kind of brain damage case is my pal?—Christopher A., Los Angeles

Maybe he's just stricken with ennui. From what I can tell, dogs have no problem making out two-dimensional images—in fact, the real problem is they can't tell two-dimensional images from three-dimensional reality. For example, I've heard of one mutt who thought an especially lifelike doggie painting was the real McCoy. Being of a devious nature, the mutt attempted to sidle around to the backside of the painted dog, the better to go for the vitals. Naturally, this caused the mutt to run into the wall, whereupon he discovered that the painted dog had disappeared from view. Baffled, he ran back around to the front of the painting, whereupon the painted dog became visible again. This caused the mutt to totally freak. Another dog of my ac-

quaintance has been known to bark at his canine cousins when they make an appearance on TV, and yet another likes to spend his time scratching away at his image in the mirror. Not too bright, maybe, but they obviously don't suffer from any perceptual disabilities.

This afternoon I was walking my two male dogs in front of a local condominium. As they lifted their legs to a hedge next to the sidewalk, a man in a business suit walked by and said quite loudly, "Don't let your dogs do that! We work hard to keep this property looking nice." Then he just stood there expecting me to reply. I started to walk away and he continued to stand there as if he were guarding the building. Finally, I turned and said, "I really don't think they were hurting anything." Of course, he exclaimed, "Well, I do!" and stamped off toward the building. I then yelled, "Well, you probably don't have dogs!" The point of all this is: scientifically speaking, does dog urine hurt hedges (or bushes and trees, for that matter)? Let me say that I can understand why people object to dogs defecating on sidewalks or in their yards, but what's the harm of a couple squirts of pee-pee?—Etta B., Baltimore

P.S.: Don't bother answering this if you hate dogs and think everything they do is wrong.

Dogs don't bug me, Etta, it's their idiotic owners. It's hard to believe you have gotten through life without noticing that dog urine will cause grass, shrubs, and other plant life to turn brown and wither. This charming phenomenon is called "urine burn," and it's caused by the ammonia and urea contained in doggie water (and, for that matter, in the urine of all mammals). Urea and ammonia are both good sources of nitrogen, an important fertilizer, but they're simple compounds and they break down so quickly that the lawn, hedge, or whatever basically ODs on the stuff. (Similarly, if you use too much inorganic nitrogen fertilizer, you'll get "fertilizer burn.") The urine also makes the soil too acidic. The only cure is to dig up the ruined patch and re-seed.

Well, you say, will just *one dose* wreck the local flora? It depends. One dose is certainly enough to do strange things to the grass. On a lawn where dogs have had free run you'll see numerous funny-looking tufts consisting of brown patches with lush growth around the fringes. (The lush part obviously got the op-

timum dose of fertilizer, while the brown part got too much of a good thing.) Chances are these are the work of female dogs, which like to do their thing out in the open.

Male dogs, by contrast, prefer some vertical landmark, such as a tree or shrub. These are generally hardier than grass, and one jolt won't kill them; unfortunately, you seldom get just one jolt. Male dogs use urine to mark their territories, and they like to return to the same spot again and again. In addition, when other dogs smell a freshly irrigated doggie dump site, they often feel compelled to make a little contribution of their own. Male dogs have been known to do in bushes, hedges, and, in one case at least, a pine tree. So keep your mutts off other people's property.

Is it true that if you pour salt on garden slugs they will dehydrate . . . and scream?—Listener, KING radio, Seattle

Cecil loves fielding calls on the radio, because they enable him to keep his finger on the throbbing pulsebeat of America, disgusting though that experience can occasionally be. Take the subject of regional vermin, for instance. In an era of national homogenization it is amazing to discover the rich variety of crawling things that infests the different corners of the U.S. There are the legendary palmetto bugs of Florida, the killer mosquitoes of Minnesota, and now the giant slugs of Seattle.

This last one in particular has been a real eye-opener. Previously I had always thought of Seattle as charming—but no more. Now I know that beneath those mountains and trees there lies a seething chamber of horrors.

True, there are slugs in other parts of the country. But they are nothing compared to the Seattle variety, which thrives in the region's damp climate. The Seattle slugs (and boy, wouldn't that make a great name for a baseball team?) can be as much as four to five inches long, three-quarters of an inch in diameter, and a ghastly brownish white in color. Hordes of these creatures can descend on your garden and eat all your lettuce overnight. They may turn up in your driveway, your flower box, even—yuck—your basement, leaving a telltale trail of slime behind. Some say that slugs are a leading cause of death in Seattle, owing to the fact that so many people are grossed out of existence. A few slugs

even grow up to become cartoonists for famous newspapers, increasing their power to wreak havoc a thousandfold.

But enough of this scare talk. It's true that slugs will dehydrate if you pour salt on them, although I must say that the thought of standing there watching while the slug shrivels up seems uniquely unappetizing. However, the slugs don't scream, for the simple reason that they don't have any vocal apparatus. No doubt what you hear is your own guilty conscience, which is tormenting you for destroying God's creatures. Or maybe it's the hiss of desiccating slug fluids. I don't know, and I don't want to know.

A better method of dealing with the slug menace is to put out a pie tin filled with a half inch of beer. The slugs drink the beer, pass out, and drown. (Or so they tell me. I did not stick around long enough to see this actually demonstrated.) You can also use a miracle slug killer called metaldehyde, which was originally developed as a solid fuel for camp cookstoves. One day in the 1930s some campers in South Africa left a can of metaldehyde out at night and awoke to discover it surrounded by recently deceased slugs and snails. Aha, said the campers, slugicide!

On the other hand . . . well, maybe you can just learn to love 'em. I'm told that the town of Montesano, Washington, has an annual slug festival, in which the locals dress up the slugs in little costumes and have slug races. Supposedly there are even slug cookbooks. There are those who regard this as tragic evidence of the effect of excessive rainfall on the human psyche, but who knows, maybe you could get into it. I'll tell you one thing, though—next time you're invited to a potluck in Montesano, think twice.

In Defense of Slug City, U.S.A. . . .

As a former Seattleite, I feel obligated to straighten you out in the slug department: (1) Elma, not Montesano, is the home of the infamous slug races; (2) four to five inches long is only average; (3) slugs aren't just brownish white, but come in a rainbow of colors, including green with yellow spots; (4) while some slugs will fall for the ol' beer-in-the-pie-tin trick, salting is much more effective. I once melted 178 in my front yard alone. (Remember that scene in The Wizard of Oz, *the one where the witch melts? Same idea.) (5) Never heard of the slugicide you*

mentioned, but I still vote for salt. No bodies.—Tamara K., Chicago

While the lush and glorious environment of western Washington State does indeed produce many species of the wily slug, Puget Sound's greatest natural wonder is the obscene geoduck (pronounced GOO-ee-duck). A very large (four by seven inches) clam found in Puget Sound, the geoduck has a crude phallus of a neck that is a source of endless wonderment to visiting backeastern swells such as yourself. One find geoducks in Seattle markets—they are quite a delicacy—with the massive neck, six to eight inches long and yellowish in color, hanging out of the shell like a giant uncircumcised penis. Not a sight one soon forgets.

As for slugs, squishing one between bare toes while walking in the postsunset cool of a Seattle evening is unquestionably the grossest experience on earth. Believe me, I know.—Paul O., Chicago

Make That Slug and *Geoduck* City, U.S.A.

My thanks to Tamara K. for clearing up the matter of slugs. As a native Seattleite on a two-year pitstop in D.C., I was appalled at your unsophisticated ignorance of slugs.

But it was Paul O.'s comments about geoducks—those phallic mollusks found only in Puget Sound—that prompted me to write. My alma mater, Evergreen State College of Olympia, Washington, claims the geoduck as its mascot. Our teams—soccer, skiing, swimming—are called the Evergreen Geoducks. Every graduation the 500-odd graduates solemnly sing the geoduck fight song, written by ex-reference librarian extraordinaire Malcolm Stilson:

> *Go geoducks go*
> *Through the mud and slime let's go*
> *Siphon high*
> *Spit it out*
> *Swivel all about*
> *Let it hang out.—Allison G., Arlington, Virginia*

"Five hundred-odd graduates," eh? *I'll* say.

· · ·

The Last Thing You Will Ever Have to Read About This Disgusting Subject

How could you think of addressing the slug question without consulting your faithful Seattle correspondent? Allow me these few comments:

First of all, I concur: slugs are repellent beyond any other life form. Imagine, if you will, hiking up the steep slope of Mt. Baker. This trail is at an 80 degree angle. Suddenly, in front of your nose, appears a huge (we're talking nine inches) yellow-green phallic object, glistening obscenely in the feeble light. Imagine, all the worse, stepping on the aforementioned abomination! How many mysterious hiking deaths could be explained by merely checking the spot on the trail from which the deceased fell for the telltale silver splotch? And then there are the ebony cannibal slugs of Mt. Rainier who devour one another along trailside. I myself was once a patient at the University of Oregon health center when I damaged my knee by falling off my bike, having run over a slug—I was slimed right off the path.

Now, how to kill the little buggers. The beer-in-the-tuna-can method has never been at all effective for me. The slugs hang over the edge and sip at the beer, but very few have ever fallen in. (They do seem quite partial to beer, however.) As for salt, some say it is extremely cruel, a feature that undoubtedly makes it more attractive to many. But the main disadvantage is this: if you salt or otherwise chemically attack slugs, they dump all their slime in their death throes—years' worth at once! The stuff is ineradicable and you are stuck with a yard full of repulsive silvery slime globules.

I once entered the yard of a neighbor and found eight or ten slugs, impaled on a shish kebab skewer, writhing upright in her garden. "A deterrent," she muttered darkly when I questioned her about this grisly spectacle.

Geese and skunks alone among members of the animal kingdom are said to eat slugs, and some keep them for this purpose. To my thinking, the spectacle is too revolting to endure.

My husband, to prove himself manly, has used the following method: he picks them up with his bare hands (geeklike behavior, in my opinion), and when they roll up in a ball (the burnt sienna-and-orange variety that plague my yard change shape from banana to papaya when attacked), he hurls them out into

the street. Then he runs back and forth over them with the car.
Charming behavior which I hope was not genetically transmit-
ted to my children.—Joyce K., Seattle

P.S.: Geoducks are too disgusting even to comment on. If peo-
ple get upset about porno in 7-Elevens, why do they ignore the
spectacle of geoducks at Safeway? Or even worse, the live ones
in Asian grocery stories that squirt at innocent passersby?

· · ·

QUIZ #2

7. Sherlock Holmes's faithful sidekick Watson supposedly took a
Jezail bullet in the _____ during his soldiering days:
 a. arm
 b. foot
 c. all of the above
 d. none of the above

8. Which of the following statements concerning the old "Leave
It To Beaver" TV series is true?
 a. The actor who played Eddie Haskell was later a member
 of Alice Cooper's band.
 b. The actor who played Eddie Haskell is now a renowned
 porno-film star.
 c. Beaver's stand-in was a midget.
 d. Beaver was killed in action in Vietnam.

9. "William B. Goodrich" was a pseudonym for:
 a. Fatty Arbuckle
 b. Eric Hoffer
 c. William B. Goodyear
 d. Howard Hunt

10. Which of the following derives from the Latin word for
"male sex organ"?
 a. pencil
 b. pen
 c. penance
 d. penitentiary

11. "Say it ain't so, Joe." This plea, made by a heartbroken boy after it was learned that the Chicago White Sox had taken a dive in the 1919 World Series (the incident came to be known as the "Black Sox Scandal"), was addressed to the White Sox:
 a. third baseman
 b. left fielder
 c. manager
 d. bookie

12. When Ed Koch was a lad, New York City was divided into five administrative boroughs. They were Manhattan, Brooklyn, Bronx, Queens, and:
 a. Staten Island
 b. Flushing
 c. Richmond
 d. New Jersey

Answers on pages 469–70.

Deep Questions

Please answer this question—I've been lying awake nights just wondering. Why do we drive on the parkway and park in the driveway?—Deidra N., Baltimore

Believe it or not, Deidra, this is the third time I've gotten this question in as many months. It must be the sunspots. Let's get one thing cleared up right off the bat: you *can* drive on the driveway. Indeed, if you'll permit me to wax philosophical for a moment, this is the very essence of drivewayness—to enable you to drive from the street to your garage. Moreover, you can park on the parkway, if you're willing to risk the wrath of the law. I don't know that this clarifies things much, but it seemed like a point worth making. I think the crux of the issue, however—I love using words like crux—is the dual meaning of "park."

Park in the sense of tended greenery and park in the sense of stowing your vehicle, though deriving from the same root, diverged in meaning long ago. In Old French, a *parc* was an enclosure. To this day a military park means an area where vehicles are stored and serviced. As early as 1812 there was a verb "to park," meaning to store one's howitzers in a military park. This carried over to carriages and ultimately to any sort of vehicle. Our notion of landscaped parks, meanwhile, derives from the medieval practice of enclosing game preserves for the use of the aristocracy. The term was later applied to the grounds around a country estate, then to royal parks in London to which the proles were grudgingly admitted, and finally to any landscaped public grounds. The idea of enclosure is still evident in expressions like

"ballpark," for an enclosed playing field. Any more questions, smart stuff?

Thank you for clearing up the driveway/parkway issue. Along the same lines, why is it that kidnapping is a federal offense, while catnapping is merely an enjoyable pastime?—Kathleen M., Washington, D.C.

Don't push it, Kathleen.

Why do left and right reverse in a mirror, but not up and down?—Paul S., Atlanta

I will have you know, Paul, that this question was addressed at length in *The Journal of Philosophy*, May 1974, by N.J. Block. It comforts me to know I'm not the only one goofy enough to spend time on things like this.

What we have here is one of those questions that seems ridiculously obvious at first but gets more and more complicated as you think about it. The answer, simply put, is this: Mirrors *don't* reverse right/left and not up/down, you just *think* they do. The fact is they can reverse either way, as we will see in a moment.

Let's start with the easy stuff. Consider a card imprinted as follows:

THE STRAIGHT DOPE

Now let's turn the card toward the mirror. If we look at the reflection, we now see:

ƎꟼOꓷ THƆIAЯTƧ ƎHT

This image is reversed left to right, but not up and down. However, we can also turn the card so that its mirror image looks like this:

ꓕHE Ꙅꓕᴚ∀IᘔHꓕ ꓷOꟼE

The image is reversed up and down, but not left to right. The difference is that in the first case we turned the card around its *vertical* axis, and in the second case around its *horizontal* axis.

It is even so with all mirror images. Somewhere in the creation or perception of any reflected image, there is always a 180 degree turn involved, and it is around the axis of this turn that the image appears to reverse.

Sometimes the turn is not always obvious. Suppose you come

into the bathroom and look in the mirror. If you shake your head, the mirror image shakes its head. No reversal there. If you wave your right hand, however, the image waves its *left* hand—a clear reversal. But where is the turn? Easy. First we have to ask how we know the image is waving its left hand. The answer is that mentally we have *turned ourselves around and put ourselves in its shoes.* And how we have turned? Through the vertical axis. Ergo, the mirror image also reverses around the vertical axis—i.e., right and left, not up and down.

Now, you may object that this begs the question. Isn't mentally pivoting 180 degrees around the vertical axis the *only* way to look at things from the mirror image's point of view? Not at all. It's just what gravity and the bilateral (i.e., right/left) symmetry of the human body suggest if you want to get the best "fit" with the image in the mirror, the better to look at things from its point of view.

But there are other ways of accomplishing the same thing. Suppose our bodies were symmetrical up and down as well as right and left—like eggs, say. Suppose also that we were floating in space, instead of having gravity to orient us. In that case you could just as easily put yourself in the mirror image's place by doing a mental handstand, i.e., pivoting around the horizontal axis. Having done so, you'd discover your mirror image had reversed up and down, but not right and left.

Having a hard time visualizing this? All I can do is appeal to the example of the cards. Just as there are two ways to flip the cards to produce images that reverse right/left and up/down, there are two ways to flip yourself mentally to judge the orientation of the image in the mirror. Unless you want to spend another two hours at this, let's just leave it at that.

It's 2:30 A.M. It's Friday morning. There's a bluesy tune on KNON. And I'm finally making the big move. Why does my reflection turn upside down in my entire stock of spoons? I have a feeling you're the man with the straight dope.—Monica, Dallas P.S.: Enclosed is Exhibit A.

That was quite a buildup, Monica, but a somewhat disorienting segue. You may want to work on this. Now to business. Touched though I am by the thought, it wasn't necessary for you to enclose the spoon. They all work the same way—the bowl acts as a "parabolic reflector." (It's not a perfect parabola, and

it's not a perfect reflection, either.) Light coming from above is reflected down, light coming from below is reflected up, and the result is an inverted image. We thus have a remarkable thing: a mirror that reverses up and down but *not* left and right. Certainly a pleasant change from the usual humdrum routine.

The whole business of curved reflecting surfaces is pretty interesting, and not just to people in the fun-house mirror business. I'm told that somebody has designed a mirror that uses a complex combination of concave and convex surfaces to produce a "right-reading" image—a mirror, in other words, that allows us to *see ourselves as others see us*. Robert Burns would have been proud.

This question has gnawed at me since I was a young boy. It is a question posed every day by countless thousands around the globe, and yet I have never heard even one remotely legitimate answer. How much wood would a woodchuck chuck if a woodchuck could chuck wood?—R.F.B., Arlington, Virginia

Are you kidding? Everybody knows a woodchuck would chuck as much wood as a woodchuck could chuck if a woodchuck could chuck wood. Next you'll be wanting to know why she sells seashells by the seashore.

Now that you mention it, why does she sell seashells by the seashore?—Agate, Washington, D.C.

Because if, by way of alternative, she simply did seashell shucking whilst she sat, we'd all be in big trouble.

Have you ever considered the puzzle of doubling ancestors? Everybody has two parents, four grandparents, eight great grandparents, and so on back through time, with the number of ancestors doubling in each generation. Go back 30 generations and the number of ancestors tops one billion. Eventually we arrive at a time when we have more ancestors than there could have been people in the world. How can this be? Common sense, not to mention the book of Genesis, suggests the human race started off with a handful of individuals whose numbers steadily increased. What are the implications of these two surging numerical tides, ancestors and descendants, butting head to head? Enclosed is a $10 check for the trouble of a personal reply. —George M., Monrovia, California

You ask a question as cosmic as this one and you think a lousy sawbuck is going to cover it? Keep your money until you can fork over some real cash. The ancestor puzzle has its explanation in what one genealogist has called "pedigree collapse." This occurs when relatives, usually cousins, marry, in effect narrowing the family tree. (Fortunately for the gene pool, most of the cousins are only distantly related.) When this happens you find that many of the "slots" in a given generation of your family tree are filled by duplicates. Consider an extreme case. Mr. and Mrs. Nosepicker have two children, a girl and a boy. These two develop an unnatural yen for one another and marry. Six months later the girl gives birth to an eight-pound horseradish with a lisp. In theory, the horseradish has four grandparents. In reality, its maternal and paternal grandparents are identical. Two of the four grandparent slots are thus filled by duplicates—pedigree collapse with a vengeance. Only slightly less extreme is the case of Alfonso XIII of Spain (1886–1941). Because of inbreeding in the royal family, he had only 10 great-great-grandparents instead of the expected 16.

If you go back far enough, however, pedigree collapse happens to everybody. Think of your personal family tree as a diamond-shaped array imposed on the ever-spreading fan of human generations. (I told you this was cosmic.) As you trace your pedigree back, the number of ancestors in each generation increases stead-

ily up to a point, then slows, stops, and finally collapses. Go back far enough and no doubt you would find that you and all your ancestors were descended from the first human tribe in some remote Mesopotamian village. Or, if you like, from Adam and Eve in the Garden of Eden.

These simple facts have given rise to some remarkable displays of statistical pyrotechnics. Demographer Kenneth Wachtel estimates that the typical English child born in 1947 would have had around 60,000 theoretical ancestors at the time of the discovery of America. Of this number, 95 percent would have been different individuals and 5 percent duplicates. (Sounds like *Invasion of the Body Snatchers*, but you know what I mean.) Twenty generations back the kid would have had 600,000 ancestors, one-third of which would be duplicates. At the time of the Black Death, he'd have had 3.5 million—30 percent real, 70 percent duplicates. The maximum number of "real" ancestors occurs around A.D. 1200—2 million, some 80 percent of the population of England.

Pedigree collapse explains why it's so easy for professional genealogists to trace your lineage back to royalty—go far enough back and you're related to everybody. For that matter, you're probably related to everybody alive today. Some geneticists believe that everybody on earth is at least fiftieth cousin to everybody else. For a fuller discussion of the above, see *The Mountain of Names*, by Alex Shoumatoff (1985).

How many people have lived on the earth since the beginning of time? The reason I'm asking is I want to know if there's going to be enough room in heaven for all those souls.—Listener, Roy Leonard show, WGN radio, Chicago

Boy, for a minute there I thought you were going to say something silly. Estimates of the total roster of humankind rely heavily on guesswork (a state of affairs not entirely unknown to us here at the Straight Dope), and accordingly the numbers vary widely. The more reputable demographers, equipped with the latest tools of science, say there have been between 69 billion and 110 billion humans. This gives us a range of 41 billion, a pretty formidable margin of error. Creationists, who get their data from 900-foot apparitions of Jesus and who believe, among other things, that it all started with Adam and Eve around 6,000

years ago and that a flood in 2700 B.C. killed off everybody except Noah and his relatives, come up with 51 billion. To my way of thinking this is entirely too close to the "real" low-end figure for comfort. Perhaps we should abandon the pretense of science and address future demographic inquiries directly to God.

The problem, of course, is that we have only a vague idea of the birthrate and average life span in ages past. Another complication, among scientists at least, is that we do not know precisely when our primate ancestors became human. Many researchers have arbitrarily settled on 1 million years ago, even though our own subset of the genus *Homo, H. sapiens sapiens*, did not emerge until around 40,000 years ago. If the paleolithic crowd (1 million years to 25,000 years ago) strikes you as too crude for admission to the communion of saints, subtract 36 billion or so from the figures above. Before we start whittling down the eligibility list, though, Les, I have just one question: What makes you think you have to worry about how crowded *heaven* is?

Did the Corinthians ever write back?—Mary and Ted, Chicago

How many times do I have to tell you people—you write the questions, *I'll* write the jokes.

I have utter and absolute trust that the earth is a sphere. And yet I have never had any personal experience that would convince me of this. I have accepted it as a matter of faith. As someone said, "Common sense is what tells us that the world is flat." For all I know from personal experience, the world might be shaped like a frisbee, which is round and has a curved surface, but is not a sphere. Perhaps Magellan, in circumnavigating the earth, sailed in a circle around the North Pole in the middle of the frisbee to get back to his starting point. Taking the word of the astronauts is like taking the word of somebody about his religious experiences—interesting but not convincing.

My unfounded albeit profound faith that the world is a sphere is matched only by my faith that you can come up with some proof I can personally experience to prove that our planet is indeed an orb.—Allan H., Topanga, California

I know you mean this question to seem delightfully impertinent, Allan, but you're about 30 years too late. There are, after all, innumerable photographs of the earth taken from space which reveal it to be spherical. Assuming you are not about to join the Flat Earth Society in proclaiming these a fake, I gather your complaint is that looking at a photo doesn't qualify as "personal experience." Big deal. I've never personally experienced Disney World, either. Most of what we know about anything depends on taking somebody else's word for it.

That said, there are a few home-demonstration-type indications—not proofs—that the earth is a ball. We'll start with the ones you've already thought of:

1. Departing boats gradually sink below the horizon, as do buildings on the shore from the viewpoint of the sailors. Admittedly this only proves the earth is round right where you are—the frisbee hypothesis.

2. "The sphericity of the earth is proved by the evidence of . . . lunar eclipses," Aristotle says. "For whereas in the monthly phases of the moon the segments are of all sorts—straight, gibbous [convex], crescent—in eclipses the dividing line is always rounded. Consequently, if the eclipse is due to the interposition of the earth, the rounded line results from its spherical shape." Of course, a frisbee, properly angled, would make a round shadow too. But if the frisbee rotated while the eclipse was in progress, the curvature of its shadow would change. The earth's does not.

3. The constellations shift relative to the horizon as you move north and south around the globe, something that could only happen if you were standing on a sphere. (You may have to draw a few diagrams to convince yourself of this.) Given sufficient world travel combined with careful observation on your part, the frisbee hypothesis becomes well-nigh insupportable. I suppose this doesn't qualify as a home experiment, but I never said science would be easy.

Chapter 6

Fun with Science

Recently during the occurrence of the vernal equinox I saw a televised report that people had gathered in Central Park in New York City to witness a remarkable sight: eggs that had been balanced on end and then left to stand that way without apparent support. Supposedly this is possible only during the equinox. Is this true? Why?—Philip S., Washington, D.C.

This is a perfect example of the difference between the tough, two-fisted Straight Dope approach to scientific research and the limp-wristed methods practiced by the daily press—e.g., the *New York Times*. The *Times* is not a bad little newspaper in some ways, but when it comes to things like egg balancing, it is out of its depth. When asked about this matter recently, the paper's "Q&A" column copped out by quoting some expert to the effect that hey, maybe it was possible, but only under certain conditions (i.e., at the equator, which the sun crosses during the equinox), although (hedge, hedge) if it was possible during the equinox, it was probably possible at other times too. A classic case of frantic bullshit in action.

Now for the Straight Dope method: We started out with a brutal cross-country manhunt for equinoctial egg balancers and found someone who had actually performed the experiment. His name is Ken Gray, and he is chairman of the art department at the University of Alaska at Anchorage. During the 1985 vernal equinox, he and his friends managed to balance 17 dozen eggs on end. No lie.

Admittedly, the experiment was not conducted under ideal scientific conditions. Ken is more into the aesthetics of the egg ex-

perience than the technical side. Evidently something of a free spirit (his colleagues occasionally have less charitable descriptions), he regularly sponsors art happenings to coincide with the equinoxes, solstices, and other cosmic events. The spring '85 number was called "Egg Zen Trick." (Get it?) The equinox occurred at about 7 A.M. At around 5, Ken managed to get the first egg to stand on end. At 6:45 he got two more, and then another and another until he and his cohorts (about 20 art department groupies) got all 17 dozen upright. The eggs were all the ordinary fresh hen variety. Several types of surfaces were used, ranging from a glass platform to a short-napped rug. Ken reports that balancing the eggs took no special dexterity. You just carefully placed the egg in a vertical position, took your hand away, and it remained standing—in some cases for as long as four days. Some even balanced on the pointy end. Leaving nothing to chance, I even talked to a couple of Gray's fellow faculty members, both of whom are scientists. They confirmed the story and said as far as they could tell the whole thing was legit. They did not, however, examine the eggs closely.

So that settles it, right? Hardly. Cecil has been warning the Teeming Millions for years about their gullible ways, and Cecil means it. After another international manhunt (I casually mentioned on a radio talk show that I was interested in eggs), I got

a call from one Jeff Hartness of Carol Stream, Illinois. This daring pioneer of science volunteered to drive down to the station and demonstrate that he could stand eggs on end at will. He was as good as his word. It was a great moment in radio—five minutes of deathly silence—as we all watched breathlessly while Jeff went to work. To our amazement, he succeeded—and this was the middle of May, you understand. Seeing the evidence before their eyes, the rest of the people in the studio promptly began standing eggs on end too. Later, in the seclusion of his private laboratory, using the strictest scientific procedures, Cecil was able to duplicate Professor Hartness's achievement with his own hands. Moral: You can stand an egg on end any old time; all it takes is *very* steady hands. Also, it seems to work better if you shake up the egg first, but that's cheating.

You guys at the *Times* get stumped again, you just give me a call.

Has anyone and is it possible to compute how many barrels of petroleum are produced by one dinosaur, or how many dinosaurs to make one barrel? Follow me?—Duane S., Los Angeles

Barely, but let's deal with one thing at a time. You obviously haven't been keeping up with the work of maverick scientist Thomas Gold. In a recent book, *Power from the Earth: Deep Earth Gas—Energy for the Future*, Gold presents the startling hypothesis that oil and natural gas may not be fossil fuels after all. In other words, oil and gas may not be derived from the decaying remains of prehistoric critters such as dinosaurs, as scientists have long thought, but rather are the result of inorganic joy juice bubbling up from deep in the earth's crust. If true, there's probably a lot more of the stuff around than was previously believed—in particular, a lot more natural gas. That means good-bye energy crisis, sayonara OPEC, and toodaloo to nukes, air pollution (natural gas burns very cleanly), acid rain, the greenhouse effect, and just about every modern ill except herpes and ho-hum mouth.

Gold's theory faces many obstacles, not the least of which is the almost universal scorn of the petroleum research community. (The Soviets are an exception.) But he presents some interesting evidence. He notes that the oil found in regions such as the Middle East is remarkably uniform, despite great variety in the age

and condition of the rock that holds it, suggesting a common source. Gold believes this source is a crack or cracks in the earth's mantle that extends down hundreds of miles, tapping the primordial hydrocarbons from which the planet was made. Gold believes these deep hydrocarbon reserves may be the cause of volcanoes and perhaps even earthquakes. A well now being drilled in Sweden's Siljan Ring will test this theory. It's expected to go down three to five miles, below the level at which fossils are found. If oil or, more likely, natural gas is discovered in quantity, it'll be strong support for Gold's thesis.

Now, everybody admits that at least some oil is biological in origin. But even in the traditional view, oil doesn't come just from dead dinosaurs, but from whole swampfuls of animal and plant life that got buried and formed the tarlike gunk called kerogen that is the precursor of petroleum. So your question about how many brontos per barrel can't be intelligently answered. As for whether it could be intelligently *asked*—well, that you could work on.

I can hardly believe my Genus Edition ears. My boyfriend has the audacity to claim that his geography professor knows more than I do. In a game of Trivial Pursuit not long ago I correctly answered that the only man-made structure on earth visible from outer space was the Great Wall of China. He has the nerve to tell me that his teacher said this is not true, and worse, he is taking the prof's word over mine. Who's right, the geek from college or the trivia buff?—M.K.M., Los Angeles

Prepare to eat crow, babycakes—those wankers at Trivial Pursuit have screwed up again. Any number of man-made structures can be seen from space, provided we construe "structure" to mean "anything built." Many of these are things that look like long, straight lines when seen from afar, such as highways, railroads, canals, and of course walls. If the orbit is low enough you can see even more. I have here a photo of Cape Canaveral taken during the Gemini V flight in which the big Launch Complex 39, used for the Apollo missions, is clearly visible. Another photo of the Nile delta, taken from a height of 100 miles, shows an extensive road network. Gemini V astronauts Gordon Cooper and Charles Conrad were able to spot, among other things, a special checkerboard pattern that had been laid out in Texas, a rocket-sled test in New Mexico, and the aircraft carrier that

would later pick them up in the Atlantic, along with a destroyer trailing in its wake. Take it from me, honey—Trivial Pursuit is one game I never lose.

Sight-Seeing in Space, Part One

Recently a reader incorrectly stated that the only man-made object visible from orbit was the Great Wall of China. You set him straight—but you may be interested to know the Wall is the only man-made object visible with the unaided human eye from the surface of the moon. The quarter-million miles does make a perceptible difference.—Kenneth L., Chicago

Nice try, Ken, but you whiffed too. According to NASA, the earth as seen from the moon takes up less than one degree of arc in the sky. Basically it looks like a big blue marble. No man-made detail can be seen at all; sometimes even the continents are barely distinguishable.

The NASA folks, I gather, are getting a little tired of hearing about the Great Wall of China. Nobody knows exactly where the story got started, although some think it was speculation by some bigshot during an after-dinner speech in the early days of

the space program. The Teeming Millions are humbly requested to give it a rest.

Sight-Seeing in Space, Part Two

I was greatly disturbed by your blindly taking the word of some NASA goofball who is unable to perform even simple math correctly. Given an earth–moon distance of 239,000 miles and the diameter of the earth as 7,920 miles, the angle subtended by the earth from the surface of the moon is almost two degrees, not "less than one degree." Furthermore, how can you even con-sider that the earth looks "basically . . . like a big blue marble"? The earth is 3.7 times as large in the lunar sky as the moon is from earth, and I can easily see a large amount of detail on the lunar surface, even through earth's polluted atmosphere. The moon, of course, has no atmosphere or city lights to obscure the view.

In fact, the data on visual acuity do not seem to indicate that "no man-made detail can be seen at all." Hugh Davson, in Physiology of the Eye, *4th edition, states that in the com-mon eyechart-type measure, a monocular resolving power of approximately 20 seconds of arc is observed, and when visual acuity is measured by the power to detect a single line on a uniform background, the normal eye can resolve 0.5 seconds of arc. Davson gives an increase in acuity of the square root of two for binocular vision, thus indicating a potential resolution from the moon of objects 0.4 miles across. While the earth may not be a perfect test surface, neither are all eyes "normal." And I can name several man-made details many times larger than 0.4 miles across—the average city, for one. Admittedly, the Great Wall at 12–40 feet in width is much smaller than 0.4 miles, but I think in magnitude of error, it was you, not Mr. L., who really "whiffed on this one."—Rick A., Chicago*

Rick, do you think I just make this stuff up, or what? Tom Burnam, author of *More Misinformation* (1980), quotes a letter from astronaut Alan Bean on the subject:

"The only thing you can see from the moon is a beautiful sphere, mostly white (clouds), some blue (ocean), patches of yel-low (deserts), and every once in a while some green vegetation. No man-made object is visible on this scale. In fact, when first

leaving earth's orbit and only a few thousand miles away, no man-made object is visible at that point either."

You're right about one thing, though. The earth takes up two degrees of arc in the lunar sky, not one.

I have a question about the inability of matter to exceed the speed of light. Suppose I am in a spaceship traveling at the speed of light minus five miles per hour. What would happen if I fired a gun in the direction that the ship is moving? Or tried to run forward at six miles per hour? Would I prove Einstein wrong?—John B., Niles, Illinois

There are two ways we can go about this, John. First there is the Way of the Wimp, wherein I simply tell you no, you wouldn't prove Einstein wrong, and we leave it at that. This avoids distracting complications, but leaves something to be desired from the standpoint of intellectual rigor. Then there is the Way of Righteousness, which requires mental tenacity and moxie. Fortify yourself and we'll give it a shot.

You probably have the idea that if you are standing in a bus moving at speed u, and you walk forward at speed v, your total forward speed w is expressed by the straightforward sum $u + v$. Alas, this is a cruel illusion. In reality, what we might call "addition of velocities" is governed by the awe-inspiring equation

$$w = \frac{u + v}{1 + uv/c^2}$$

where c is the speed of light. (This may give you pause next time you hike to the can on a Greyhound.) At so-called Newtonian (i.e., slow) speeds, the term uv/c^2 is pretty close to 0, and the equation reduces down to the familiar $w = u + v$. However, if we are traveling at, say, $0.9c$ (nine-tenths the speed of light), and we shoot a bullet forward also at $0.9c$, we discover via the above formula that the slug does not attain an overall speed of $1.8c$ (i.e., more than the speed of light), but rather a modest

$$\frac{0.9c + 0.9c}{1 + (0.9)^2} = 0.994c$$

(roughly).

Does this mean the bullet just dribbles out of the gun like a

freaking gumdrop, for Chrissake? Not at all—to you, the space traveler, everything looks normal. However, a stationary observer would note that you were suffering from the unique effects of the Fitzgerald contraction—which is to say, (1) time would slow down for you (although you wouldn't realize it), and (2) you and your spaceship would get compressed like an accordion along your axis of travel. The following poem may help to illustrate this:

> There once was a racer named Fisk
> Who took a considerable risk
>> When his dragster got traction
>> The Fitzgerald contraction
> Reduced his wazoo to a disc.

Sorry, couldn't resist. Anyway, if you ponder this matter awhile, you will inevitably come to the following conclusion: *the faster you go, the slower you go.* Ergo, the speed of light cannot be exceeded. And you wonder why physics is my favorite subject.

Is it true that something carved into the side of a tree will stay the same distance from the ground forever, regardless of how tall the tree grows? If so, why?—Bob B., Dallas

Yup. In yer basic tree, you got yer primary meristems, which are growth areas located at the tips of the roots (below) and shoots (above), and yer secondary meristem (also called the cambium), which is a thin sheath wrapped around the tree between the bark and the wood. The meristems are where all cell division, and thus all growth, occurs. The primaries make the tree taller, the cambium makes it fatter. So when your local sequoia adds a couple stories at attic level, the tree gets taller, but everything at ground level pretty much stays put.

You may have heard the line, "Tornadoes are God's way of telling us there are too many mobile homes." Why is it that mobile homes seem to get damaged by twisters with such regularity? Is it that people who live in mobile homes know when they've been hit, while the rest of us think it was just high winds that blew off those shingles? Or could it be that twisters are deflected by the updrafts in cities with more substantial buildings?—Dave G., Evanston, Illinois

I'm not sure I follow you, Dave. Are you saying that somebody in a nonmobile home could live through a tornado and *not*

realize it? If so, be assured that a tornado is not the sort of delicate phenomenon that easily escapes notice. Nonetheless, you're quite right in noting that mobile homes seem to sustain an inordinate amount of damage from twisters. In late March of 1984, for instance, tornadoes in the Carolinas killed 60 people, 23 of whom, or 38 percent, were mobile-home dwellers—an unusually high proportion by any standard. The main reason for this, of course, is that mobile homes are generally of quite fragile construction. Few can endure winds of more than 100 MPH, which would be generated by a tornado of only moderate destructive power. (By the same token, southern states suffer much greater loss of life during tornadoes than northern states, due to the flimsier construction of their buildings.)

In addition, however, there is some indication that larger cities tend to be tornado-resistant, at least in the sense that they get fewer twisters than would seem statistically likely. I have been communing on this topic with Theodore Fujita, a professor of meteorology at the University of Chicago and one of the world's leading authorities on tornadoes, and he says a big city can whit-

tle down the intensity of a tornado by one or two levels on the "Fujita scale" (and you'll never guess who *that's* named after). Thus an F0 (40–72 MPH winds, light damage) or F1 (73–112 MPH, moderate damage) tornado might be reduced to a mere thunderstorm upon encountering the grand metropolis of, oh, Evanston, Illinois, for instance.

Professor Fujita thinks there are a couple of reasons for this. One is that big cities contain steel or reinforced-concrete high-rise structures that have been shown to be quite durable in the face of tornado-strength winds, and these slow the twister down by sheer force of friction. The warm updrafts that cities create also tend to interfere with tornado formation somehow. Professor Fujita's reasoning on this is a bit difficult to follow—they don't call this guy "Mr. Tornado" for nothing—but in general we can say that tornadoes need an inrush of cool air at ground level, which cities do not provide. Lest you be too comforted by this, city dweller that you are, bear in mind that tornadoes are perfectly capable of ignoring all the preceding and pounding quite sizable towns into flinders. You may recall the sad tale of Kalamazoo, Michigan, much of which was reduced to rubble by tornadoes a few years ago. Going further back, the city of St. Louis has suffered some of the worst tornado disasters in history, including one in 1896 that killed 306 people, and another in 1927 that killed 79. So don't get too cocky.

Cecil, tell me that what I heard about the alternative newspaper business isn't so. I mentioned to a friend one day about the strong smell of my favorite weekly, and he told me the smell is caused by a chemical additive in the ink used to print the paper. This chemical is supposed to last only a few days but the readers become addicted to it, and therefore unknowingly desire to pick up the paper every week. My friend said advertisers are told of this chemical and thus charged more for their ads. Tell me it isn't so.—High on the Straight Dope, Chicago

Heh-heh-heh.

I have a friend who insists that filling an ice cube tray with warm water will cause the cubes to form more quickly than they would if you started with cold water. He said it had something to do with the air circulation around the trays being affected by the temperature. Not knowing much about frigidity myself, but

*being contrary, not to mention skeptical, by nature, I expressed
doubt. Cecil, was I right, or is there indeed some basis in fact
for this foolishness?—Mary M.Q.C., Santa Barbara, California*

You were smart to let me handle this, Mary. God knows
what would happen if you tried to experiment with ice cubes on
your own. Needless to say, I conducted my research in the calm
and systematic manner that has long been the hallmark of
Straight Dope Labs. First, I finished off a half pint of Haagen-
Dazs I found in the fridge, in order to keep my brain supplied
with vital nutrients. Then I carefully measured a whole passel
of water into the Straight Dope teakettle and boiled it for about
five minutes. This was so I could compare the freezing rate of
boiled H_2O with that of regular hot water from the tap. (Some-
how I had the idea that water that had been boiled would freeze
faster.) Finally I put equal quantities of each type into trays in
the freezer, checked the temp (125 degrees Fahrenheit all
around), and sat back to wait, timing the process with my brand
new Swatch watch, whose precision and smart styling have made
it the number one choice of scientists the world over. I subse-
quently did the same with two trays of cold water, which had
been chilled down to a starting temperature of 38 degrees. The
results? The cold water froze about 10 or 15 minutes faster than

the hot water, and there was no detectable differece between the boiled water and the other kind. Another old wives' tale thus emphatically bites the dust. Science marches on.

An Anomalous Situation Arises

Just a few days after I read your column on whether hot water freezes faster than cold water (you said it didn't), I happened to come across an article in Scientific American *entitled "Hot Water Freezes Faster Than Cold Water. Why Does It Do So?" What gives? I hope we will see another column soon resolving the issue.—Ellen C., Chicago*

I know it must unnerve you to find that a supposedly infallible source of wisdom can make mistakes, Ellen, so let me hasten to reassure you: *Scientific American* did not screw up. My results and theirs (specifically, those of Jearl Walker, author of SA's "Amateur Scientist" column) are consistent—we were just working in different temperature ranges. I found that cold water (38 degrees Fahrenheit) froze faster than hot water out of the tap (125 degrees F). I chose these two temperatures because (1) they were pretty much what the average amateur ice-cube maker would have readily available and (2) I couldn't find a mercury thermometer that went higher than 125 degrees.

Jearl, who is not afflicted with miserable penny-pinching editors like some of the rest of us, was able to get his mitts on a thermocouple that could measure as high as the boiling point, 212 degrees F. He found that water heated to, say, 195 degrees would freeze 3 to 10 minutes faster than water at 140–175 degrees. (There were differences depending on how much water was used, where the thermocouple was placed, and so on.) Jearl suggested that the most likely explanation for this was evaporation: when water cools down from near boiling to the freezing point, as much as 16 percent evaporates away, compared to 7 percent for water at 160 degrees. The smaller the amount of water, of course, the faster it freezes. In addition, the water vapor carries away a certain amount of heat. To test this theory, Jearl covered his lab beaker with Saran Wrap to prevent water vapor from escaping. The freezing rate difference was greatly diminished. Conceivably convection (motion within the water) also plays a role.

Fascinating as all this no doubt is, all it basically proves is that very hot water freezes more slowly than very *very* hot water. The ordinary fumbler in the fridge, on the other hand, is dealing with temps more like the ones I was measuring, in which case cold freezes faster than hot. I rest my case.

Yesterday one of the men who works in my company's cafeteria was looking in the milk dispenser (one of those things that has milk in plastic bags inside a cardboard container). He told another worker that the milk was frozen. She replied that she wasn't surprised, because it seemed awfully heavy when she put it in there. My question is, does milk really get heavier when it freezes?—D.S., Wilmette, Illinois

Well, relativistically speaking, there is less molecular motion in frozen milk (or frozen anything) than there is in liquid milk. Less molecular motion (in ordinary terms, less heat) means less energy, and less heat means less mass according to Einstein's famous $E = mc^2$ (energy equals mass times the speed of light squared). But to answer your question, there is no humanly detectable difference in the weight of frozen versus liquid milk.

When I poured myself a cup of coffee this morning I noticed something unusual. As I stirred the hot coffee, the sound of the spoon hitting the sides and bottom of the cup gradually changed pitch. First it was low, then it got higher as, I assume, the coffee cooled minimally. Why?—Thomas B., Chicago

You don't mention whether the coffee was perked or instant, or whether you put sugar or powdered creamer into it. Assuming you poured something into it, my buddy Jearl Walker at *Scientific American* says the pitch changed because tiny air bubbles were released from the powder grains. Sound waves move a lot more slowly through air than they do through liquid. Ergo, the frequency of the standing wave set up inside the cup is lowered, and the sound you hear at first is low in pitch. As the bubbles burst, the pitch rises. If you *didn't* pour anything into your coffee, I haven't the foggiest. Ask Jearl.

Which boils faster—hot (or very hot) water or cold water? —Jane H., formerly of Chicago, now of Washington, D.C.
P.S.: You must have seen this one coming!

I resigned myself to it long ago, buttercup. As any sane and decent person would expect, hot water out of the tap will boil faster than cold water out of the tap. However, water that has been *boiled once and allowed to cool* will boil faster than hot water out of the tap. That's because boiling gets rid of the dissolved oxygen usually found in water, making it easier for the water to boil the second time around. There's money in this somewhere, I'm sure of it.

Whatever happened to the Martian canals? When I was little I distinctly recall seeing pictures of Mars that showed an elaborate network of lines that some thought were the remnants of an irrigation system built by a lost race of intelligent beings. But there was always some disclaimer to the effect that we'd have to wait for further exploration before we could know for sure. Well, NASA has since sent any number of satellites flying by Mars equipped with cameras—and yet I don't remember hearing a peep about the canals. What's the story? Is there something they're not telling us, or was the whole thing a con intended to drum up support for the space program?—Tom L., Madison, Wisconsin

It's important to distinguish between two kinds of silence, Tom—suspicious and embarrassed. We have here, I gleefully

note, a premier example of the latter. The controversy surrounding the Martian canals, probably the most famous episode in the history of astronomy, was not cleared up until the early 1970s, almost a century after it began. It's not clear who initially spotted the canals, but they were first publicized in 1877 by Giovanni Schiaparelli, an Italian astronomer. He called the dim network of lines he saw "canali," Italian for "channels." But the English-speaking world translated "canali" as "canals," which suggested that someone—e.g., a superior civilization—had built them. This idea was taken up a few years later by the amateur American astronomer Percival Lowell, who had built an observatory near Flagstaff, Arizona. Lowell made detailed observations of Mars and published several popular books about the planet, notably *Mars and Its Canals* (1903), which included elaborate maps of the canals and outlined the theory that they were waterways used for irrigation. This notion caught the public fancy, but it was never widely accepted by other astronomers. Some thought the canals were natural features, such as volcanic rift valleys, earthquake cracks, and so on; others doubted they existed at all.

The problem was that even during the best of times the canals could not be seen very distinctly, and many astronomers were never able to see them at all. (Indeed, it was nine years before somebody managed to confirm Schiaparelli's 1877 sighting.) A few wondered whether the whole thing wasn't simply a matter of wishful thinking. In one famous if somewhat casual experiment, a diagram of Mars featuring all of its generally agreed-upon features, but excluding the canals, was tacked up in front of a roomful of schoolchildren, who were asked to copy it. The kids in front, who could see the map clearly, reproduced it accurately. But the kids in the back, to whom many of the fine details on the map were simply a blur, tended to come up with maps that had canal-like lines connecting the smaller landmarks. From this some concluded that the Martian canals were an optical illusion, the result of the psychological tendency to connect indistinct features into some sort of comprehensible whole. Confirming this idea was the fact that on those few occasions when the view of Mars was *exceptionally* clear, the canals could not be seen.

The matter wasn't settled until the Mariner flights of the 60s and 70s, and even then there was some controversy. One photo from an early flyby seemed to show an unnaturally straight fea-

ture that one writer claimed might be a canal. The Mariner 9 flight in 1971, however, photographed almost the entire surface of Mars at fairly close range, and it became clear that not only did no canals exist, the old canal maps provided by Lowell et al. corresponded only rarely with the planet's actual features. Scientists thereupon concluded that the whole thing had simply been an optical illusion. Curiously, the Mariner photographs did reveal what appear to be dry riverbeds and alluvial channels that seem to have been formed by water (or at least liquid), although there is little water to be found on the planet now. How these channels came to be is not known, but they appear to be of purely natural origin.

Oh, while I think of it—the old theory that one of the Martian moons is an artificial satellite is out the window too. Just thought you'd want to know.

Ahem. This is coming several years late, but once I finally get this in the mail I'll be able to rest easier, knowing that another great issue has been laid to rest. I read your column regularly during 1978–1980, and suppose it was during 1979 that the great pigeon controversy appeared in the Straight Dope. It went on for several weeks, and revolved around why pigeons bob their heads as they walk. The proposals included the need to maintain center of gravity over the one foot on the ground, stability of head position for clear vision while the body moved forward, and many other creative and well thought out alternatives. The question was never resolved. I don't propose to resolve it here.

The reason for this letter is a question which followed soon after—that is, why does the shower curtain come inward and cling to your legs when you would expect it to be forced outward by the rushing water? Your answer boiled down to, "I don't know." I was shocked to find that a group intellectually curious and creative enough to debate pigeon head-bobbing for weeks would let you get away with this lame response. In order to rectify this failure of six years' standing, and in the hopes that the original questioner has not pined away and died of intellectual malnutrition in the meantime, I offer the following:

The shower curtain attacks you for the same reason airplanes can fly. You all remember those drawings of airplane wing cross-sections. The air traveling over the top of the wing has farther

*to go, therefore it travels faster, resulting in lower air pressure.
This provides the wing's lift. Similarly, the air inside the shower
is being driven past the shower curtain by the water, resulting
in localized lower air pressure relative to the still air on the other
side. The shower curtain quite naturally flies into your legs. The
result is annoying, but if it didn't happen we would still require
two weeks to get to Europe by boat, so it has its compensations.
In the hopes this puts other troubled minds at ease (and next
time don't give up so easily!), I remain, yours truly . . .—D.C.,
Femont, California*

There are several issues I wish to address here, D.: (1) your
unspeakable impertinence, (2) your whereabouts, and (3) your
question. We will take these one at a time.

1. Your impertinence. You not only think there's a question I
didn't know the answer to, you think this was it? If so, please
disabuse yourself. As you surely know, I have done more to ad-
vance the cause of human knowledge than any single person since
Galileo. Nonetheless, sometimes I am overcome with an exqui-
site languor, causing me to blow off a query. Forgive me.

2. Your whereabouts. Despite the Fremont return address,
your letter is postmarked Brazil. Do you so fear my well-
deserved wrath that you have decided to flee the country, lest I
have you snuffed? Or have you committed some other crime
against nature that has compelled you to take it on the lam? In

any case, now that you're out, have fun trying to get back in. I have friends.

3. Your question. The preceding notwithstanding, the answer you supply is correct. Shower curtains and airplane wings do what they do because of Bernoulli's principle, which says that as the velocity of a fluid (liquid or air) increases, its lateral pressure decreases. Surrounding air (or whatever) moves in to fill the partial vacuum thus created. You can demonstrate Bernoulli's principle by dangling a sheet of paper in front of you so that it's perpendicular to the plane of your face and blowing across it. The paper will be deflected toward, not away from, the airstream. The situation in the shower is slightly more complicated. The falling water pulls air along with it, a process known as "entrainment." The moving air creates a low-pressure area that causes the curtain to fly inward. Similarly, when a truck or car moves at high speed down the highway, it creates a partial vacuum in its wake, whence the expression, "Let's suck his doors off, Elroy."

I hope you have learned something from this, D. Try to be a better person in the future.

More Ravings from the Teeming Millions

Imagine my shock upon learning that you had been fooled by such a ridiculously unscientific notion as the Bernoulli theory to explain why shower curtains are sucked inward when you're taking a shower. The real reason is much simpler. Haven't you ever noticed that hot air rises? The air in your shower stall is being heated by the warm water and therefore rises out of the opening at the top. This air must be replaced by something, so the shower curtain is pushed inward as outside air flows in at the bottom. If you want to prove this, take a cold shower.
—Matthew T., Simi Valley, California

Matthew, did it occur to you to test this idea before you mailed it into the newspapers? If you had, you would have found, as I did, that the shower curtain is sucked in no matter what the temperature of the water. Admittedly the effect is exacerbated by hot water, but the airflow patterns can get pretty complicated. For instance, even when the shower is running with

hot water, air flows *out* at the bottom of the curtain. Try blowing cigarette smoke around and you'll see.

The Crowd Gets Ugly

Cut the crap about shower curtains! Try this—take a cold (100 percent) shower and the curtain goes out; a hot shower and it comes in. Cold air (cooled by the water spray) settles, causing pressure outward, and hot air (as in a hot shower) rises, creating a mild vacuum (suction).—Armadillo, Chicago

You been eating those lead paint chips again, Dillo? I have just spent the last 15 minutes in the bathroom repeating my earlier experiment, and the results are the same. The curtain blows in no matter how cold the damn water is. I have, however, been discussing this question with Jearl Walker, who in addition to writing the Amateur Scientist column for *Scientific American* is chairman of the physics department at Cleveland State University. While agreeing that adherents of the chimney-effect school of shower research are missing a couple bolts below the waterline, he also thinks it unwise to appeal to the Bernoulli principle, which, from the standpoint of explanatory power, he regards as on a par with water sprites. (Jearl is not a man to mince words.)

Jearl says the shower curtain phenomenon is caused by something akin to the *Coanda effect*. Strictly speaking, the Coanda effect is the tendency of a moving fluid to adhere to an adjacent wall—e.g., water clinging to the inside of a pipe as it drains. It seems reasonable to suppose, however, that if the adjacent wall is sufficiently diaphanous, as in the case of a shower curtain, the Coanda effect can work the other way around—the wall will cling to the fluid. What happens is that air is entrained by the turbulent "boundary layers" of the water and pulled along with it. This creates a localized suction, because other air has to rush in to replace the entrained air. The suction is what pulls in the shower curtain. The Coanda effect can also be used to explain the blowing-across-the-sheet-of-paper-held-in-front-of-the-mouth phenomenon.

Cecil is sorry if he initially steered the Teeming Millions wrong on this, but he notes with a certain satisfaction that Jearl and the Cleveland State physics department spent three hours arguing about it before they came up with the right angle. When

you're working on the frontiers of science, you have to expect the occasional wrong turn.

Last evening, after perusing The Straight Dope: A Compendium of Human Knowledge *over a leisurely dinner of canned soup, I spent several hours nursing my apartment full of sick plants. My inquisitive capacities had been piqued by your book, and naturally I fell to wondering: Is it true what Mom used to tell me, that plants enjoy being talked to? My mother taught me all I know about plant care, and I follow all her instructions to the letter (except the talking bit, which I always thought was crazy), yet her plants are infinitely healthier than mine. Is there any scientific evidence that plants respond to the human voice or presence? Do some people (like Mom) give off "vibes" that plants really like, while the other peoples' "auras" (my own, for instance) leave them cold? Might this have anything to do with the fact, known the world over, that babies always cry when held by certain people or that cats are passionately attracted to people who are deathly allergic to them? Help, Cecil.—Gato, Chicago*

Cecil has heard this "vibes" stuff for years, Gato, and with all due respect to your mother, he regards it as mush-brained

bilge. I have never come across any serious study suggesting that your phlox will flourish if you whisper in their little ears, or whatever it is phlox have got. On the other hand, there's a fair amount of research indicating that sound in general (i.e., vibes in the literal sense) can stimulate growth. Admittedly, a lot of this research has been conducted by high school students in New Jersey and whatnot, but hey, we gotta be open-minded about this. Some years ago, for starters, little Evalyn Horowitz won a prize for her science fair project showing that radish seedlings exposed to ultrasonic vibrations of 50,000 cycles per second for a month grew 89 percent taller than a control group. Curiously, the tall radishes were much spindlier than their untreated cousins, which were stubby but sturdy. Evalyn hypothesized that the ultrasonic sound acted somehow on auxins, which are plant hormones that encourage elongated growth.

Other types of sound are also credited with encouraging plant growth. University of Ottawa biologist Pearl Weinberger found that wheat seedlings exposed to 5,000 cycles per second sound (within the range of human hearing) weighed 250 to 300 percent more than untreated controls, and had four times as many potentially grain-bearing shoots. Music will also do the job, although it's not clear what type is best. In 1970, Mrs. Dorothy Retallack, then a 48-year-old housewife-turned-college-student (like I say, the researchers in this field aren't exactly world shakers), attempted to demonstrate that "soft, semi-classical music"— e.g., Mantovani, or one of those cornball "Music to Grow Plants By" records—would cause plants to thrive, whereas hardcore rock and roll would make them wither and die. (She also believed that there was "a link between loud rock and antisocial behavior among college students," which gives you an idea of Mrs. Retallack's level of social insight.)

More recent work by four University of North Carolina scientists casts doubt on Mrs. Retallack's hypothesis. Their research indicates that 100 to 110 decibel noise (the equivalent of standing 100 feet from a 727 jet) will cause 100 percent more turnip seeds to germinate in 10 percent less time than with a control group. This suggests that a healthy jolt of industrial-strength heavy metal, contrary to previous suggestions, may be just the thing to invigorate your rutabagas. Give it a shot and let Uncle Cecil

know what happens. If you'd rather build your own ultrasonic sound generator instead, there's a diagram in the May/June 1984 *Mother Earth News*.

I have noticed that the moon (and the sun, for that matter) appears very large just as it rises and sets. When it is overhead, it seems tiny by comparison. The color is also vastly different, which can be easily explained by the fact that we view the moon through varying "thicknesses" of atmosphere as it makes its way across the sky. But this explanation seems insufficient to account for the change in size. So what's the straight dope?—Frank M., Los Angeles

Believe it or not, Frank, they've been arguing about this for two thousand years now, and it's about time Uncle Cecil got things straightened out once and for all. First of all, let me make it clear that the effect is an optical illusion. If you measure the moon with a ruler held at arm's length (a paper clip bent into the shape of a calipers will also work), you'll find it's always the same size no matter where it happens to be in the sky. If anything, the moon is slightly *smaller* at the horizon than it is at the zenith, mainly because it's 4,000 miles (the radius of the earth) farther away. (If you don't understand why this is so, draw yourself a picture.) Nonetheless, most people are convinced that, area-wise, the moon's at least twice as big when it's near the horizon as when it's overhead.

Numerous theories have been advanced to explain the "moon illusion." At one point people thought it had something to do with the angle at which you hold your head and/or eyes while viewing, while others said it was caused by differences in the moon's brightness when seen at various locations in the sky (a notion first proposed in 1709). Both ideas have long since been discredited. The fact is that the illusion is dependent entirely on the visual cues provided by the terrain when the moon is near the horizon, and the lack of such cues when it's at the zenith. To prove this, try viewing the moon through a cardboard tube or a hole punched in a sheet of paper to mask out the landscape—the illusion disappears.

What's now called the "apparent distance" theory was first advanced by the Egyptian astronomer Ptolemy in the second century A.D. (I told you this goes back a ways). Ptolemy's explanation is a little confusing, but here goes: most people subcon-

sciously perceive the sky to be a flattened bowl—i.e., objects near the horizon seem farther away than objects overhead, due to the abundance of intervening visual cues on the ground. Now, when we see an image of a certain size at what we believe is a great distance, we deduce that it's bigger than an image of the same size seen at what seems to be a lesser distance. (You might want to let this percolate for a minute.) So when we see the moon at the "distant" horizon, we subconsciously conclude that it's "bigger" than when we see it a few hours later overhead, when it's "close." To put it another way, perspective—i.e., the march of visual cues to the horizon—makes the moon look bigger than it does when it's just hanging in space.

This explanation is OK as far as it goes, but it's even better if we combine it with one propounded by psychologist Frank Restle. Frank reasons thusly: You judge the size of something by comparing it to the size of things around it. If it's surrounded by big things, it seems little. If it's surrounded by little things, it seems big. When the moon is overhead you judge its size against the vast expanse of the night sky (the stars are too small and faint to make any difference). Ergo, it looks small. When the moon is close to the horizon, on the other hand, it's usually bigger than many nearby objects (trees, houses, waves on the ocean). In addition, just after moonrise (when the illusion is most compelling), the moon's apparent diameter exceeds the distance from the moon to the horizon. Add in the effect of perspective, and the moon looks huge. That's all there is to it.

The Teeming Millions Aren't Buying It

I know you're not infallible, but just in case you don't realize it, let me point out a small bit of misinformation you published recently. The question was, "Why does the moon sometimes appear much larger when it is near the horizon?" or something to that effect. Your answer was that it appeared *larger because there were earthly objects such as trees, buildings, etc., "near" the moon, giving a false perspective.*

Sorry to disappoint you, but that's completely wrong. The earth's atmosphere is, like the planet, curved. And, as anyone who has ever been in a pool knows, water can distort light. The moon appears larger when near the horizon only when there is

sufficient water vapor (humidity) in the atmosphere, because the curvature of the earth's atmosphere combined with the correct vapor density forms what is essentially a gigantic lens. In this case, a magnifying lens. If you want proof of this, just watch the moon (or the setting sun) on a humid day. Either celestial body will look somewhat pear-shaped when very close to the horizon, since that's where the "lens" is thickest. Trees or no trees. — Tom R., Chicago

Years of dealing with your kind has taught me patience, Tom. Try to pay attention to the following.

The "magnifying" effect you refer to is called *refraction*. It accounts for the fact that the sun, and less often the moon, appears distorted (i.e., vertically elongated, or pear-shaped) just at the point of rising or setting. The elongation lasts only a few minutes, and is *not* what people are talking about when they say the moon looks bigger when it is low in the sky. The so-called moon illusion persists even when the moon is a couple of degrees of arc above the horizon.

The illusion is entirely psychological in origin. The actual size of the moon's image does not decrease as it rises in the sky; you only think it does. To prove this yet again, I got up at several points during the night recently and tried the paper-clip calipers test described earlier to measure the size of the moon's image as it sank toward the horizon. The illusion of great size was compelling toward the end, but it disappeared as soon as I held up the paper clip and confirmed that the size of the lunar image was unchanged.

I have gotten several other letters making a similar argument. None of the writers, apparently, has taken the trouble to go look for himself or herself, which I find exasperating. It is one thing to be mistaken; it is quite another to be willfully ignorant.

Why does the same side of the moon always face the earth? It seems like quite a coincidence that it should rotate so perfectly in sync with us. Is there any slippage, so that parts of the dark side of the moon are slowly being revealed to us? — Trigby P., Northbridge, California

You're right to be suspicious about this, spud, but let's clear up one thing first: there is no "dark side of the moon," the popular expression notwithstanding. All of the moon is illuminated

at some point during the month-long lunar day. It's just that we can't see when it's high noon on the back side.

As for the moon's rotation, you're right in thinking the timing is a little too neat to be coincidental. It was different once upon a time, though. Billions of years ago experts think the moon was much closer to the earth than it is now and rotated much faster, so that over time the entire lunar surface could be seen from earth.

But "tidal friction" slowed the moon down. The earth's gravity caused the side of the moon closest to us to bulge outward, just as the moon's gravity causes our oceans to bulge and create tides. The continual deformation of the lunar crust as it rotated relative to the earth acted as an interplanetary brake, and eventually the moon slowed so that the same side always faced toward the earth. (The moon also got farther away.) The result is called "captured" or "synchronous" rotation, and it's common throughout the solar system.

Eccentricities in the lunar orbit and whatnot periodically do bring some of the moon's back side into view, a process called "libration." In all about 59 percent of the moon's surface is visible at some point. But you'd better look while there's still time—the moon continues to recede from us. Admittedly this occurs at the rate of just four inches per month, so it's not as though you have to rush out right this minute. The pull of the moon also has had a braking effect on the earth, causing our rotation to slow (and thus our day to lengthen) at the rate of one second per hundred thousand years. Good news, at least in the long term, for those who complain there's never enough time in the day.

The other day a good friend of mine (a well-educated man) looked into the sky and announced the next day would be nice because the sky was red. Am I crazy, or is he? Didn't those old weather sayings go out with the Middle Ages or something?
—N.K., Hollywood

Nope. A great many of those old weather sayings date back to the third century B.C., when a student of Aristotle's named Theophrastus set more than 200 of them down in his *Book of Weather Signs*. Most of these adages were based on empirical observation, and it's not surprising that many are fairly accurate.

For example, a red sky at night is, generally, a sailor's delight, because red light is reflected by air with a small amount of moisture in it—pleasant weather, in other words. Since the red sky is necessarily to the west (that's where the sun sets), and since weather systems generally move from west to east in the temperate latitudes, the fair weather may reasonably be expected to arrive by morning.

Similarly, swallows and other birds *do* fly close to the ground when a storm approaches—they seek the highest pressure, or the lowest altitude, to protect their sensitive eardrums in advance of a low-pressure storm system. And you *can* get a fair estimate of the temperature in degrees Fahrenheit by counting the number of times a cricket chirps in 14 seconds and then adding 40—crickets, like crooked politicians, chirp faster when the heat is on.

That said, weather sayings often explain less than they appear to. Take the other half of the "red sky" proverb: "Red sky at morning, sailors take warning." The truth is a red sky in the morning doesn't necessarily mean bad weather; on the contrary, a pink sunrise more often than not means the weather will be fair. It's only a dull red sky that's bad news, as indicated in this version of the proverb from the New Testament (Matthew 16:2–3, to be precise): ". . . When it is evening, ye say, It will be fair weather: for the sky is red. And in the morning, It will be foul weather today: for the sky is red and low'ring. . . ." —threatening, in other words. So the red sky proverb boils down to this: when the western sky is relatively clear at dusk, the next day will be nice; when it looks threatening in the morning, the weather will be bad. All in all, not much of an insight.

Why haven't they found a way to concentrate sound waves the way lasers do with light?—Jim C., Portsmouth, N.H.

This is surely kismet, Jim. Most physicists whom one approaches on this question ramble on about light and sound being fundamentally different phenomena, and say that "stimulated emission of radiation"—the essence of lasers—has no counterpart in the world of audio. However, shortly after your letter arrived, I received a note from Stephen Wilson, Ph.D., of Applied Intelligent Systems in Ann Arbor, Michigan, which holds out some hope. Steve takes issue with the discussion in my book, *The Straight Dope: A Compendium of Human Knowledge*, on

whether, if all one billion Chinese yelled at the top of their lungs at once, we could hear them in the U.S. I thought the question too dumb to be worth answering, but Steve offers the following conjecture:

"Through a cooperative research effort between enthusiastic physicists such as myself and skilled choir directors, we may be able to take the top 10 percent of the best singers in our population and teach them such perfect harmony that we can create *a gigantic biohumanoid coherent acoustic laser*! [My emphasis, his exclamation point.] If they can sing low enough, about thirteen octaves below middle C, we can use the wave guide effect of the captured atmosphere, and I think we could get over 60 thousand miles out of them. Think of the weapons possibilities."

I think he's kidding, but you never know with these Michiganders.

Why does a teapot make progressively louder noises as it heats up, then suddenly go quiet just before the water commences to boil?—Timothy L., physics department, Johns Hopkins University, Baltimore

Jeez, can't you guys at Johns Hopkins figure out *anything*? For starters, a tea*pot* doesn't make noise, a tea*kettle* does. The pot is what the water goes in after it's been boiled. As for the noise, it's caused by cavitation, which is a high-tech way of saying bubbles form and then they pop. When you heat water on the stove, the layer at the bottom is the first to boil, meaning it turns into a gas. The water vapor collects into bubbles, which rise toward the surface, passing through cooler water en route. The lower temperature causes the vapor to recondense into liquid and the bubbles collapse, making a noise. This gets gradually louder, as bubble production increases, until the water is so uniformly hot that the bubbles make it to the top without popping. At this point the noise diminishes. But it takes a moment before the vapor pressure builds up sufficiently in the top of the kettle to make it start whistling. That's why you get a brief period of calm before the steam—an incredibly feeble play on words, but a perfectly adequate description of the event.

When the weather service predicts some percentage chance of rain for the next day, what does this number mean? I always figured they compiled certain parameters about current condi-

tions and compared them to analogous days in the past. The percentage of those days in which it rained is then used as the predicted chance of rain now. In other words, they base the percentages on historical data.

However, a friend who is a pilot (and who presumably should know about these things) claims that the figure is determined by looking at the current conditions of a storm system which is expected to pass over us. The number represents the percentage of the area the storm is now passing over in which it is actually raining. This strikes me as complete bullshit.

Anyway, what's the straight dope on the predicted chance of rain? How can you ever have 100 percent chance of rain? How reliable are these figures?—Ted F., Chicago

You are obviously one shrewd hombre, Ted, no doubt as a result of having been exposed to this column regularly during your formative years. Your guess about what the percentages mean is pretty much on the money.

Here's what happens. The National Weather Service (and various other weather services around the world, under the guidance of the World Meteorological Organization, a UN agency) sends up measuring devices called radiosondes in helium balloons twice a day. These collect weather data continuously as they rise through the atmosphere—wind speed and direction, temperature, barometric pressure, and humidity. The information is radioed to the ground and eventually ends up at the National Meteorological Center near Washington, D.C., where it's fed into a computer. (There are other centers in other parts of the world that do the same thing.) Other data from satellites and ground reporting stations are also fed in, and what you end up with, metaphorically speaking, is a complete three-dimensional picture of atmospheric conditions around the world. The computer program then applies various laws of fluid mechanics to predict future conditions.

Unfortunately, there is only so far you can go with this. While it's possible to predict the temperature, say, with a reasonable degree of certainty, precipitation is much chancier. The best forecasters can do is to give the probabilities, which they do by having the computer compare present conditions with historical data. When you hear there's a 10 percent chance of rain, that means that out of the last 100 times the weather conditions were

just like they are now, it rained 10 times. (More or less—I am obliged to oversimplify a bit, you understand.)

The weather service has been calculating precipitation probabilities for as long as anybody can remember, but it's only been in the last decade or two that the nation's cadre of broadcast weather beings has deigned to convey this to the masses. Why the belated fascination with numbers I don't know; I suppose they feel it gives an aura of precision to a business that, let's face it, is still about one jump ahead of tea-leaf reading. But who can say?

As for your last couple of questions: a 100 percent chance of rain means that out of the last *x* number of times things were just like they are now, it rained damn near every time. (It does not, incidentally, mean it's raining right this second.) On the question of how reliable the figures are, the amazing truth is that they are *absolutely 100 percent reliable all the time*—that is, presuming the raw data were fed in properly and the calculations done correctly. Remember, we're just talking about *probabilities* here. A probability isn't "wrong" if it tells you there's only a 10 percent chance of rain and it rains anyway; it's only wrong if a whole series of such predictions doesn't pan out over the long haul. Not much comfort if your dermis gets damp next time you're out on a picnic, but for the time being it'll just have to do.

Another View

In Washington, Oregon, and British Columbia, we have a different interpretation of precipitation forecasts. If the weatherman says there's a 20 percent chance of rain, that means it will rain 20 percent of the day. If there's a 50 percent chance, it will rain 50 percent of the time, etc., up to 100 percent, which means, of course, a typical January day. This interpretation seems to be quite accurate.—Joyce K., Seattle

While reading an article recently on the coming ice age, I thought of a related apocalyptic myth that happens to be a favorite of mine, namely that the earth is way overdue for its periodic rotation of the poles. This will result in the complete

*destruction of civilization and probably means we won't get to
watch* Wheel of Fortune *anymore either. What's the story—is it
true? Has it started?—David K., Hollywood, California*

Well . . . sort of. But let's take this from the top. "Pole-
shift," as it's called, has been the subject of several books, most
of them by people who think *Close Encounters* was a documen-
tary. A typical one is *5/5/2000—Ice: The Ultimate Disaster*, by
Richard Noone. Noone believes that on May 5, 2000, massive ice
buildup in the Antarctic will cause the earth to shift 90 degrees
on its axis so that what are now the polar regions will end up at
the equator. This will be accompanied by slippage of the crustal
plates, earthquakes, flooding, volcanoes, and probably the most
hellacious rush hour in the history of the universe. A reviewer
has described the book as "without a shred of scientific founda-
tion."

But that's putting it a bit strongly. A few legitimate scientists
believe that the earth, or at least its crust, has shifted on its axis
in the past. Geologist Jean Andrews of Columbia University has
found evidence to suggest that 180 million years ago the poles
were displaced about 22 degrees from their present alignment,
with the North Pole located on the northern coast of what is now
the Soviet Union. The poles have spiraled erratically toward their
present locations in the eons since.

Why this slippage has occurred (if in fact it has occurred) is
not clear, but Andrews points to a theory advanced years ago by
maverick scientist Thomas Gold, who proposed that heavy
regions of the earth's crust would tend to drift toward the equa-
tor due to centrifugal force. This is not that far from Noone's
idea, although Noone is talking about ice, the weight of which
is trivial compared to the continental masses Gold had in mind.
In any case, the concept has many practical applications. Take
vacation travel. Instead of flying off to the tropics, you could just
cram 50 tons of weights in your attic (to maximize your torque,
or course), grab your Coppertone, and wait for the tropics to
come to you. Not exactly express service, maybe, but it can't be
much worse than standby.

•　　•　　•

And Now This Word From Outer Space

How much do the oceans contribute to the density of day-light? Would it be depreciable over a land-filled earth? Or fur-ther, if we were, as the Stones suggest, to paint everything black? But please, Cece, I don't really want this to happen.—Rich D., Los Angeles

Forget to take your lithium again, Rich?

. . .

QUIZ #3

13. A stale egg:
 a. floats in water
 b. sinks in water
 c. spoils the whole dozen
 d. was Beaver's stand-in

14. Who was 53310761?
 a. G. Gordon Liddy
 b. Gregory Peck
 c. Beaver's stand-in
 d. Elvis Presley

15. The "H" in H. R. (Bob) Haldeman stands for:
 a. Henry
 b. Hollister
 c. Harry
 d. Bob

16. Richard Wagner was Franz Liszt's:
 a. lover
 b. illegitimate son
 c. son-in-law
 d. agent

17. The word most commonly used in English language conversation is:
 a. y'know
 b. a
 c. I
 d. the

18. The famous American bluesman who generally started his performances with the statement "I do not play no rock 'n' roll" was:
 a. Mississippi Fred McDowell
 b. Son House
 c. Blind Lemon Jefferson
 d. Elvin "Aberdeen Three-Fingers" Jackson

Answers on pages 470–71.

Chapter 7

Secrets of the Rich and Famous

I'm surprised to have (almost) caught you in an error, viz., your recent discussion of Christ, whom you described as having been "flayed." By extension, "flayed" might mean the same thing as "flogged" (which is what I think you mean), but seems to me it just means "skinned," more or less. We devotees have a duty to keep you on your august toes, Cece. Now for a question. What's the straight dope on the story that J.J. Audubon, the famous naturalist, was really the dauphin who would have become Louis XVII if he hadn't taken up water-colors and stuff? Is there a scholarly basis for this tale? Keep up the good work. —Robert B., New York City

You're a schmuck, B., but at least you're a respectful schmuck. One learns to count one's blessings in these cretinous times. I used "flayed" to mean "flogged to the point where the victim's skin hangs in tatters." No doubt this is an exaggeration, but let's face it, exaggeration is not exactly unknown in this column. Anyway, the usage is sanctioned by the *Harper Dictionary of Contemporary Usage.*

Now, where were we . . . right, the dauphin. "Dauphin," of course, was the title given to the heir apparent to the throne of France. The last one prior to the French Revolution was Louis-Charles Capet, or "Unlucky Chuckie," as we historians poignantly call him, who would have become Louis XVII. In 1792 little Chuck, along with his old man, Louis XVI, and several other members of the royal family, was imprisoned in Paris. During this time he received treatment similar to that inflicted on certain newspaper columnists today—i.e., oodles of undeserved abuse.

His health deteriorated steadily, and on June 8, 1795, he died of what was officially diagnosed as scrofula, or tuberculosis of the lymph glands. An autopsy was performed, the death was duly witnessed and certified, and the body was buried in the cemetery of Sainte-Marguerite.

End of story? Hardly. Even before his death, rumors circulated in France that the real Louis-Charles had been poisoned or spirited out of prison by royalist sympathizers and replaced by a double. These rumors intensified after the prince's alleged demise, and over the next 50 years more than 30 pretenders turned up. These were invariably exposed as impostors, but not before eager royalists flocked around them. Eventually the whole business began to get comical, and it was satirized by Mark Twain in the duke and "dolphin" sequence in *The Adventures of Huckleberry Finn*. I hadn't heard the Audubon twist before, but it's typical of the genre. Audubon was born the same year as the dauphin and lived in France as a child. There were questions about his parentage for many years, and that probably gave rise to the idea that he was the lost Louis XVII. Unfortunately for conspiracy enthusiasts, it's now firmly established that Audubon was born in Haiti, the illegitimate son of a French sea captain.

Several inquiries into the Louis XVII affair were held over the years. The first, a formal investigation conducted shortly after the restoration of the monarchy in 1815, confirmed the official story, but it was suspiciously slipshod—many think the new king,

Louis XVIII, Louis-Charles's uncle, didn't want his right to the throne called into question. In 1846 a priest dug up a body in Sainte-Marguerite cemetery that he believed to be that of Louis-Charles. Investigation showed the victim to have been 14–20 years of age, not 10, as Chuck supposedly was at the time of his demise. This lent credence to the idea that the kid who died in 1795 was a double, a notion that received still more support in the 1950s when researcher André Castelot compared samples of the dauphin's hair with some from the 1846 body and found they did not match. However, despite discrepancies in the official version of events, no hard evidence of a plot has ever been discovered. Most historians believe the 1846 body was just some mope who had been dumped in what was basically a common burial ground, and that Louis-Charles died in 1795 as advertised. Yet another disappointment for intrigue buffs, I guess, but hey, I calls 'em like I sees 'em.

How tall was Frank Lloyd Wright? His autobiography claims he was 5 feet 8 inches tall, but friends say he was only 4 feet 11. The doorways for his houses are only 6 feet 2, which makes me wonder. Was this giant of modern architecture really a midget?—Joseph S., Chicago

My acquaintance with Frank Wright—a charming fellow in many respects, but a tad pushy—was regrettably brief. Still, I seem to recall him as being of middling stature—certainly no dwarf. Photos taken of him in company with others, as well as the memoirs of his associates, confirm this. You're quite right, though, in suspecting that the cramped dimensions of many of his buildings have a lot to do with his none-too-lordly stature. Wright's architectural modus operandi was to build things to suit himself, and to hell with the rest of mankind. He told his students, "I took the human being, at five feet eight and one-half inches tall, like myself, as the human scale. If I had been taller, the scale might have been different." This attitude did not go over real well with a lot of Wright's contemporaries. Someone once said to him, "Whenever I walk into one of your buildings, the doorways are so low my hat gets knocked off." Wright calmly replied, "Take off your hat when you come into a house." Edgar Tafel, a longtime student of Wright's, tells a story about a fellow student named Wes Peters, who happened to be 6 feet 4, the same height as the ceilings at Taliesin, Wright's combination

home/studio/school. Watching Peters's noggin brush up against the rafters once moved Wright to holler out, "Sit down, Wes, you're destroying the scale!" Pretty funny, and an indication how far being a wise guy can take you in this world.

Whatever happened to all of Howard Hughes's money?
—Joe R., Hollywood, California

About what you'd figure. The government got most of it, or at least *will* get most of it, once the legal battles are settled. Conceivably this might happen by the end of 1988, 12 years after the reclusive billionaire's death in 1976. The situation was complicated by the fact that Hughes (1) left no known will (although some 40 alleged wills were considered by the courts and rejected as hoaxes), (2) had no immediate family (an only child, he was orphaned while in his teens, was divorced, and had no children), and (3) was incredibly rich. In fact, it's believed that Hughes is the wealthiest American ever to die without a will. Federal inheritance tax in such cases is an astronomical 77 percent. The states of Texas and California, both of which claimed Hughes as a resident, have already settled for a total of $194 million; Uncle Sam's share is currently under negotiation.

Still, what's left over after taxes is a nice chunk of change. The attorneys won't say how much the estate is currently worth, but the Internal Revenue Service initially valued it at $371 million, and inflation has since boosted that figure substantially. *Forbes*

magazine put the amount at $1.1 billion in 1984. Already more than $100 million has been distributed among 22 Hughes cousins plus their heirs and assigns, a total of maybe 150 people in all. The most any individual has received is somewhere in excess of $6 million—not as much as the Lotto, maybe, but not bad. How much more everybody gets depends on the outcome of the negotiations with the IRS. Ironically, Hughes never met most of his relatives and despised many of those he did know; he also hated paying taxes and would go to great lengths to avoid having to do so. Personally, I think the way the whole thing worked out serves the SOB right.

Why Hughes left no will is something of a mystery. Two he evidently prepared in the 30s could not be found, and later drafts were never signed. In any case, the news that his estate was up for grabs brought every screwball and con artist in the country swarming. Of the many phony wills, the best known was the one giving a sixteenth of the estate to Utah gas station operator Melvin Dummar, who claimed he had once found Hughes in the desert and given him a ride into Las Vegas. The document was shot full of spelling errors, though, and had Melvin's thumbprint on the envelope, so a jury drew the obvious conclusion. The Hughes Medical Institute in Miami, which Hughes established in 1953, said it deserved the money because Howard meant to give it to them, only somebody must have stolen the will. The court said nice try, but no dice.

Several women claiming to be Howard's former wives also got their day in court. "Alyce [Hovsepian Hughes] said she met Hughes in a New Jersey mental hospital," the judge in the case told one reporter. "He had her rehearse a marriage scene with him that she later found out was the real thing. Alma [Hughes] said she was waiting on a gurney in a Dallas hospital to have a hemorrhoidectomy when Howard came along with a preacher and got her to marry him. She was under anesthesia, so he had to twiddle her lips to get a response." Not surprisingly, both claims, along with a third from a psychic who said she was Hughes's daughter, were rejected. A third "wife," actress Terry Moore, was luckier. She had actually had a relationship with Hughes, and says they were married by the captain of Hughes's yacht. Though the claim was dubious, the family settled with her in 1983, reportedly for $390,000.

In addition to the wives, something like 500 distant relatives

of Hughes on his father's side claimed a share of the loot on the basis of several bizarre allegations involving switched identities, mysterious drownings, marital infidelities, and so on, the aim of which was to disqualify the close paternal relatives so the distant ones would have a shot. Implausible though the stories were, they weren't altogether preposterous; the Hughes side of the family apparently had a flair for melodrama. But the court ruled against the distant cousins for lack of evidence. A final resolution, it now appears, is in sight at last.

A few years ago, I read that Joy Adamson, the author of the Born Free *books, was killed by a lion. Then I read that she was murdered by a person or persons unknown who tried to make it look as though she'd been killed by a lion. Did anyone ever find out exactly what happened to her?—Richard N., Los Angeles*

The official word is that she was stabbed to death by a disgruntled former employee. Ms. Adamson, it seems, got along better with four-legged animals than she did with two-legged ones. This seems to be a chronic problem with animal researchers—you may recall the unhappy case of gorilla researcher Dian Fossey, whose relations with others were often hostile and who in 1985 was also murdered.

Adamson's body was discovered by her assistant, Peter Morson (or maybe it was Pieter Mawson—there is a distressing amount of confusion in the press on this point), on the evening of January 3, 1980, on a road near her camp in a remote part of Kenya. Morson/Mawson jumped to the conclusion that she'd been mauled by a lion, and that's how the death was first reported in the American media, always suckers for the cheap ironic twist. (*Born Free*, to refresh your memory, tells the story of one Elsa, a lion that Ms. Adamson and her husband George raised as a cub and then returned to the wild.)

Later, however, police concluded that Ms. Adamson's wounds were too sharp and bloodless to have been caused by an animal, and they decided the 69-year-old naturalist had been murdered with a sharp instrument. They began questioning former employees—Ms. Adamson apparently was in the habit of sacking the help right and left—and eventually a 23-year-old herdsman named Paul Wakwaro Ekai was charged with the crime.

Is it true Albert Einstein's brain is kept in a bottle in a small-town doctor's office near Kansas City?—Listener, Mike Murphy show, KCMO radio, Kansas City, Missouri

You heard right, friend. What's more, for a long time the doctor kept the brain in a cardboard box behind a beer cooler. You'd think the mind that unlocked the atom would rate something a little fancier—a place up there with the bowling trophies, at least—but that's not how things worked out. For 30-some years Big Al's noodle has been in the somewhat casual custody of Thomas S. Harvey, M.D., of Weston, Missouri. Harvey was the pathologist at Princeton Hospital in New Jersey who performed the autopsy when Einstein died in 1955.

Why the brain was preserved at all is not clear; the rest of the body was cremated shortly after death. One biographer says Einstein wanted it to be used for research; the executor of his estate denies this, and says the decision to preserve it was made by his son. At any rate, plans to examine the brain never really got off the ground. One of Harvey's associates blabbed prematurely to the press, and the ensuing publicity antagonized the family. Then Harvey and other researchers couldn't agree on the best way to proceed with the dissection. The brain eventually did get sliced up (it's kept in several bottles today), but after that things just sort of fizzled out. Despite repeated promises, neither Harvey nor any of the other original investigators has published anything about the brain to date.

The whole episode might have been a complete waste of time except for the efforts of two neuroanatomists at UC-Berkeley, Marian Diamond and Arnold Scheibel. Several years ago they learned of the brain's existence and persuaded Harvey to send them some samples. Diamond had done earlier research in which she found that rats who were raised in an intellectually stimulating environment (for a rat) had larger than average brains, and she was curious to see if something similar occurred in humans. Sure enough, she and Scheibel found that one portion of Einstein's brain contained significantly more "glial" cells than a sampling of ordinary brains. (Glial cells perform various support functions for the neurons, which do the brain's thinking.) Ergo, it's possible that if you use your head more, your brain becomes more developed. That may not sound like a real breakthrough, but it sure beats what anybody else has come up with.

Is it true that Thomas Edison's last breath is preserved in a test tube at the Henry Ford Museum outside Detroit?—Listener, Mike Murphy show, KCMO radio, Kansas City, Missouri

What's with you guys in K.C.? Einstein's brain wasn't enough? As a matter of fact, Edison's last breath *is* preserved at the Henry Ford Museum, after a fashion. Ford was a great admirer of Edison's, having once served as chief engineer at the Detroit Edison Company; later the two became fast friends. Ford recreated Edison's Menlo Park workshop in Greenfield Village, the collection of historic buildings next to the Ford museum, and it's possible he wanted to recreate Edison himself, in a manner of speaking. Supposedly Ford asked Edison's son Charles to hold a test tube next to his father's mouth when he breathed his last in 1931. Ford's motive for this odd request is obscure. He is known to have been interested in reincarnation, and some say he thought the spirit exited the body with one's last breath; ergo, what he was collecting was essence of Edison, no doubt for reconstitution at some later date. Others say he just wanted a souvenir of his departed buddy. Whatever the case, it's likely that any Edisonian vestiges, if in fact there ever were any, have long since leaked out. The tube was discovered in the Ford family home in 1950 after both Henry and his wife had died. It's now on display at the Ford museum, just in case you wanted to make any last-minute amendments to your vacation plans.

For some reason the first of the month always seems to unleash a flood of maudlin memories in my aging landlord, particularly memories of World War II. He's a veteran, and I often hear him singing a certain dirty little ditty describing in lurid detail the genital deficiencies of various Axis leaders as he goes about his rounds collecting the rent. The effect is disconcerting, as you can imagine. But now my question: I have heard many versions of this song in the army and often wondered about the validity of the line concerning Hitler. Was he, in fact, fully "endowed," so to speak? Or did he, as the song claims, possess only a single testicle? Was it a congenital defect, or due to some injury? Where did this belief originate? My landlord believes it to this day. Please advise.—B.D., Santa Monica, California

Among conspiracy buffs, D., this is what is know as (ahem) the lone-nut theory. (Note to the Teeming Millions: Hey, I got a million of 'em.) But let's get serious. The case of Hitler's miss-

ing testicle is one of many bizarre twists in the life of one of history's most bizarre hombres. (Another is the never-proven allegation that Hitler's paternal grandfather was Jewish.) The bit of doggerel favored by your landlord probably goes something like the following, originally sung by British Tommies during World War II to the tune of the "Colonel Bogey March":

> *Hitler has only got one ball,*
> *Goering has two, but very small;*
> *Himmler is very sim'lar,*
> *And Goebbels has no balls at all.*

It's customary, of course, for soldiers to impugn the sexual capacities of enemy leaders. (Another verse from the era goes, "Whistle while you work/Hitler was a jerk/Mussolini bit his weenie/Now it doesn't work.") But the troops may have had some reason to believe Hitler really was playing with a short set, so to speak. As a soldier in the German army during World War I, the future dictator was wounded in the Battle of the Somme in October 1916. Sources differ on the precise location of the wound, but some say it was in the thigh or the groin. Conceivably some anonymous poet in the British Army heard this and used it as the basis for the above mentioned ode, although at this late date it's hard to say for sure.

At this point we have to delve into the mystery surrounding Hitler's demise. On May 1, 1945, German radio announced that Hitler had been killed fighting at the head of his troops. But the Russians captured the Fuehrer's bunker, and nobody in the West ever saw the body. Rumors swirled that Hitler had escaped. To resolve the issue, the British assigned H. R. Trevor-Roper, later a well-known British historian, to investigate. After interrogating witnesses, Trevor-Roper concluded that Hitler and his girlfriend Eva Braun had shot themselves on April 30, and that the bodies were cremated shortly afterward.

The Russians, however, maintained that Hitler had managed to escape. At the Potsdam conference in July, Stalin said he believed Hitler was in Spain or Argentina. This was the official line until 1950, when the Soviets unveiled a film called *The Fall of Berlin* that depicted Hitler and Braun snuffing themselves with poison. But they did not say how they arrived at this conclusion.

In 1955 the Russians released several German prisoners who had been present during Hitler's last days, one of whom told of

burying Hitler's remains in a bomb crater. Trevor-Roper interviewed the men, and on the basis of their comments deduced that the Russians had exhumed the bodies and examined them in May 1945. This was confirmed to his satisfaction in the 1960s, when Russian journalists published accounts of the search for Hitler.

One such book published in 1968 was particularly interesting, and it's here we get back to the question of Hitler's missing organs. The book included the report of the autopsy performed on Hitler's bod by Russian pathologists. This contained the startling news that Hitler's "left testicle could not be found either in the scrotum or on the spermatic cord inside the inguinal canal, or in the small pelvis. . . ."

This revelation struck many as suspicious. None of Hitler's doctors or attendants had ever mentioned anything about a missing testicle, and his medical records were silent on the subject. A woman who claimed to have been his lover said he was normally equipped. Moreover, the autopsy report said Hitler's body showed no external wounds, even though all the German witnesses mentioned a shot through the head.

Hitler's World War I company commander, however, offered some support for the Russian finding. He said he'd discovered Hitler's missing testicle as a result of a wartime VD exam.

Questions about the authenticity of the Russian autopsy records were more or less resolved in 1972. Dr. Reidar Sognnaes, a dental expert at the University of California at Los Angeles, compared the Russky data with previous X-rays of Hitler's skull and pronounced the former genuine. (Sognnaes used similar methods to confirm that a body dug up in Berlin was that of Hitler's secretary, Martin Bormann.) So I guess we have to conclude that in some departments, at least, Hitler really wasn't all there.

As you can imagine, historians with a weakness for Freudian woolgathering have had a field day with this news. Perhaps the most elaborate treatment was *The Psychopathic God* by Robert G. L. Waite. Waite believed Hitler's left testicle either failed to descend at puberty or was missing at birth. He regarded the deficiency as one of the formative experiences of Hitler's life, and said it contributed to all manner of psychosexual complications. He stopped short, however, of saying it caused World War II.

Why did the Russians wait so long to reveal the autopsy results? Trevor-Roper thinks Stalin arbitrarily decided that Hitler had escaped and compelled everybody else to go along. Later,

he thinks, the Russians decided to keep things murky lest the Fuehrer's death and/or remains somehow inspire future generations of Nazis. They may have suppressed evidence about the bullet wounds in order to make Hitler's demise seem less heroic.

Others, of course, have their own ideas. They see the missing testicle as evidence that the man who died in 1945 was a double. They think the Russians faked the dental evidence for unknown reasons and that Maria Schickelgruber's grandson ended up leading a life of ease in some South American banana republic.

You never know. After all, Trevor-Roper, the staunchest proponent of the Hitler-is-dead theory, was the same guy who pronounced the so-called Hitler diaries authentic. But the more likely explanation is that your landlord's dirty ditty, in one respect at least, was the simple truth.

You've given us the story on proofs that Jesus Christ actually existed [page 275]. However, there is one rather infamous dude who unquestionably did exist even though I'm having a hard time convincing people of it, namely Dracula. Everyone this side of Transylvania knows about Bram Stoker's book and all the movies spawned down through the decades since about vampires. I personally know the whole story about the real-life guy and how Stoker based his fictional Dracula on him. There's even a real Castle Dracula that still stands. But since I can't convince any of these lazy people to simply go to the library and read (a forgotten art) for themselves, tell them the story and some of the stomach-wrenching things that he did.—Dana C., Baltimore

I haven't heard from you guys in Baltimore for many a moon, Dana; it's nice to see your preoccupations are as wholesome as ever. The real-life fellow you're referring to is Vlad the Impaler (c. 1431–1476), also known as Prince Dracula, who briefly ruled Wallachia, next door to Transylvania, in what is now Romania. Vlad was not a vampire, but that's about the only nice thing you can say about him. He was a vicious tyrant who butchered between 40,000 and 100,000 people during the six years of his principal reign, 1456–1462. His preferred method of execution was to impale people on wooden stakes. Typically this was accomplished by inserting the stake where the sun don't shine, tying the victim's legs to a couple horses, and hollering "giddyup" while holding the stake in place. The corpse would then be put on display for the edification of the public. The

number of rotting bodies hanging outside the Wallachian capital was said to exceed 20,000.

Much of what is known about the Impaler is hearsay, but there appears to be general agreement on several incidents:

- Early in his reign he invited 500 Wallachian nobles, or boyars, to a banquet at his castle. Upon asking how many princes had ruled them over the past few decades, he was told there had been several dozen. He then said something to the effect of, "This is due entirely to your shameful intrigues!" and ordered his attendants to seize many of the boyars, impale them, and hang the bodies outside the city walls. Others were dragged off to rebuild Castle Dracula, the remains of which may still be seen near the border between Transylvania and Wallachia.
- On another occasion Vlad invited the local beggars as well as the old, the sick, and the lame to a feast. Having gotten everybody drunk, he inquired, "Do you want to be without cares, lacking nothing in this world?" Sure, said the assembled multitudes. Vlad then ordered the building boarded up and set afire, killing all inside. "I did this so that no one will be poor in my realm," he supposedly said.
- He raided neighboring Transylvania, slaughtering tens of thousands of people. The most notorious atrocity occurred on April 2, 1459, when he looted the church of St. Bartholomew in the town of Brasov, impaled numerous victims on the nearby hills, and then sat down for a meal amid the bodies. This event was commemorated in several widely circulated woodcuts printed in Germany that are largely responsible for Dracula's enduring infamy.

There are also tales claiming that Dracula had a woman impaled for letting her husband go out in a shirt that was too short; that when some Turkish envoys refused to take their hats off to him he had the hats nailed to their heads; that he forced mothers to eat their children and husbands to eat their wives; that he had various people boiled in cauldrons, fried, or cut up like kraut; and so on ad nauseam. How much of this stuff really happened is not known, but the sheer accumulation of stories suggests that Vlad either had the worst case of bad PR in the history of the universe or else was one brutal SOB.

Debate on this point continues down to the present day. In

the West, Dracula is generally regarded as a monster who killed for the sake of killing. In his native Romania, however, Vlad to this day is considered a national hero, a cruel but just ruler who mightily smote his enemies, notably the Turks, and enforced strict morality at home. Some historians point out that this was the era of Machiavelli, when princes were brutally attempting to consolidate their power all over Europe. In their view, Dracula was merely a product of his times. Cecil, needless to say, regards this as craven bootlicking.

In the end Dracula proved to be too much even for the Romanians. After an inconclusive war in 1462, the Turks set up his brother, Radu the Handsome, as an alternative ruler backed by Turkish troops. Even though it meant losing their independence, the Wallachian boyars abandoned Dracula, who was later arrested and imprisoned by the king of Hungary. Some historians believe the boyars simply feared the superior power of the Turks; I prefer to believe they'd gotten tired of life under a maniac. In 1476 Vlad was restored briefly to the throne, only to be killed under murky circumstances after a few months.

Bram Stoker, who wrote the 1897 horror novel *Dracula*, apparently read about Vlad while doing research in the British Museum. He cheerfully conflated the historical Dracula with the legends about vampirism that had circulated in Eastern Europe for centuries, and the courtly bloodsucker now familiar to all was the result.

But if Stoker had wanted evidence of real vampires, he wouldn't have had to look too far afield. Nearby Hungary boasted Elisabeth Bathory (1560–1614), aka Erzsebet Bathory, a deranged countess who tortured and killed as many as 610 young women for the purpose, tradition has it, of bathing in their blood. The product of a powerful Hungarian family that produced an inordinate number of epileptics and psychotics, Elisabeth allegedly believed that dousing herself regularly in virgin blood would prolong her beauty.

Betsy Bathory apparently was a wild one from her earliest years. There is some evidence to suggest she had a child out of wedlock, and she may have engaged in trysts with a lesbian aunt. What is certain is that she was a sadist. According to sworn testimony, she took pleasure in having her serving maids stripped and beaten for minor infractions. She was married, but her husband was a general who was frequently away on military cam-

paigns, and in any case when he was home he used to encourage her brutalities.

Aided by several trusted servants, most of them old crones, Elisabeth amused herself by torturing girls with pincers, needles, razors, knives, red-hot irons and pokers, and the like. Sometimes she would simply look on while her servants did the dirty work. By and by, it is thought, she took up bloodsucking (although see below), and after the death of her husband in 1604 graduated to murder and midnight bloodbaths. Peasant girls who had been hired to work as servants were sometimes killed their first night on the job. Some were forced to eat the flesh of others; some were forced to eat their own. Some were doused with water in midwinter or plunged into icy streams and frozen to death. Others were starved in the dungeons and torture chambers Elisabeth had installed in her various castles. She ordered the construction of an iron cage fitted with blades so that her victims could be locked in, hauled to the ceiling, and tormented. Later she installed an "Iron Virgin," a lifesize clockwork doll shaped like a naked woman that "embraced" its victims and stabbed them to death.

This went on for a number of years, with the death toll running to five girls or more a week. To keep up the supply, Elisabeth developed a network of procuresses, some of whom delivered up their own daughters. None of this, however, prevented Elisabeth from aging, and in desperation, it is said, she sought out girls of noble birth, whose blood she had been told was of higher quality. After several dozen local debutantes met their end this way, people began to get suspicious. Local ministers had previously been intimidated into burying the bodies, but they finally refused to cooperate any further. Elisabeth's associates thereafter began secretly burying corpses in grain silos and churchyards.

Finally in late 1610 the killers made the mistake of tossing four naked bodies off the ramparts of Csejthe castle to the wolves. This grossed everybody out of existence and convinced them the time had come to call the authorities. One Count Thurzo came down and arrested the servants, who quickly confessed. Elisabeth held out, but after some dithering Thurzo entered the castle and searched it. In the dungeons he found the mutilated body of a torture victim, a couple of girls near death, and several other prisoners.

Three servants were tried and executed, but Elisabeth herself

was never put in the dock owing to her family's influence. While the testimony of her servants left no doubt that she was a mass murderer (610 victims were found listed in a notebook in her room), no evidence was taken regarding her alleged bloodbaths and vampirism. Contemporary accounts, however, indicate that she was universally believed to be guilty on the first score, and more recent historians think she was guilty on the second as well. She is known to have enjoyed biting her victims, and according to one translator a passage in the sentence of her servants refers to her as "a bloodthirsty, bloodsucking Godless woman [who was] caught in the act at Csejthe castle."

Count Thurzo ordered Elisabeth imprisoned in her castle for life. Workmen walled up the doors and windows of her room, with only a food hatch connecting her to the outside world. She died three and a half years later. In a final effort to keep her family's name from being sullied, Count Thurzo left the trial records in the attic of his castle instead of sending them to the court archives. But it was to no avail—a Jesuit priest discovered the papers by accident in the 1720s.

Then there's the case of Gilles de Rais, a French nobleman who was executed in 1440 for killing 800 young boys over the course of . . . but I think we've had enough for now.

Late-Breaking Bulletin: Their Genes Made Them Do It!

No kidding. A Canadian chemist thinks a rare genetic disorder may account for the behavior of vampires, werewolves, and others with an unnatural lust for blood. In a 1985 paper David Dolphin of the University of British Columbia advanced the proposition that vampires suffered from a form of porphyria, a hereditary disease affecting the blood. Porphyria causes the body to fail to produce one of the enzymes necessary to make heme, the red pigment in hemoglobin, a vital component of blood. A common symptom of porphyria is extreme sensitivity to light, the supposed nemesis of all vampires. In addition, the lips and gums may be drawn taught, making the teeth look like fangs. Finally—and here we get to the good part—just about the only way you could treat porphyria in the Middle Ages was to drink large amounts of blood.

Some porphyria victims are so sensitive to light that their skin becomes damaged and they lose their noses and fingers. Hair may also grow on exposed skin. Dolphin speculates that such people, with their animal-like appearance and an inability to go out except at night, would have been considered werewolves. Dolphin also thinks he knows why vampires feared garlic. Eating garlic stimulates heme production, which can turn a mild case of porphyria into a very painful one. A porphyria victim would therefore learn to shun garlic at all costs. Extreme forms of porphyria are rare, occurring only once per 200,000 people. But Dolphin thinks local in-breeding might have produced pockets of the disease during medieval times. Heck, it produced the Chicago city council, didn't it?

It's great to see Prince Andrew doing his part for noblesse oblige, but his decision to become a Royal Navy career man raises a perplexing question: what do his superior officers call him? They can't simply refer to him by his rank and last name, because he doesn't have a last name. And somehow it's hard to picture his squadron commander in the pitch of battle barking out, "If you please, Your Royal Highness, move your bloomin' arse!" Cecil, only you can resolve this question.—Dwight S., Dumfries, Virginia

It probably will not surprise you to learn, Dwight, that the British armed forces have a special office, the Defence Services Secretary, whose solemn duty it is to issue instructions to the troops regarding the proper form of address for members of the royal family. (War may be brutal, the British feel, but there is no reason it has to be impolite.) The DSS's most recent pronunciamento, issued when Andy was still a mere prince, said he was to be introduced as "Lieutenant His Royal Highness, the Prince Andrew." (Naturally, since the British cannot stand to pronounce anything the way it is spelled, they say *lefte*nant.) You, in turn, addressed him as "your royal highness" the first time around and thereafter, assuming you were his superior, as "Prince Andrew," "Lieutenant," "Andrew," or if all else failed, "hey, you."

Recently, however, Andrew was promoted, which naturally changes everything. The consensus among British officialdom is that he must now be introduced as "Lieutenant His Royal Highness, the Duke of York." On second reference, "Duke Andrew"

being decidedly unkosher, "Prince Andrew" remains the preferred form.

Still, what folks are supposed to call him doesn't necessarily have much to do with what they *do* call him. Though one of Andy's old COs avers that everybody said "Prince Andrew," Cecil has it on good authority that the kid is known among his buddies as "H," short for HRH, His Royal Highness. As for the enlisted men—well, that's something else altogether. Cecil was chatting recently with a Royal Navy officer who had served on board the royal yacht when the King of Norway happened to visit. While inspecting the yacht's shipboard telephone directory, the officer was a bit startled to find the king listed under N, for "Norway [King of]." And Rodney Dangerfield thinks *he's* got problems.

The Teeming Millions Think They Know Better

I always enjoy reading your column and was happy to be enlightened regarding the various titles applied to HRH Prince Andrew. However, your dope was not entirely straight. It is true that in the British army the word "lieutenant" is pronounced "leftenant," but in the Royal Navy it is pronounced much as it is in the United States, sounding something like "l'tenant." The Royal Navy hand salute is also similar to that of the U.S. armed forces and is different from the palm-out salute of the British army and air force.—Don B., Yakota, Japan

Time to lay off the sake, Don. A captain with the British naval staff in Washington says the "leftenant" pronunciation is used in all branches of the British armed services, the navy included. You're right about the salutes, though.

I'm amazed that you let slip by DS's comment that Prince Andrew has no last name. The family's last name is Windsor (changed from Hanover during World War I).—Mr. Bill, Waters' Landing, Maryland

Where do I start? For one thing, the royal family name isn't Windsor, it's Mountbatten-Windsor, having been changed from Windsor in 1960. Second, prior to 1917, the family name wasn't Hanover, it was "Saxe-Coburg and Gotha." It was changed be-

cause it sounded too Teutonic for the taste of the British public during World War I.

Finally, while it's true British royals have *family* names, they don't have *last* names in the strict sense, that is, a name you would properly append to your given name(s) in formal usage. Prince Andrew's grandchildren in the male line, assuming no titles are bestowed on them, will be So-and-So Mountbatten-Windsor, but the prince himself is merely Andrew, period. That's the way he signs documents. (His mother signs Elizabeth R, for Regina, "queen".) His passport says Andrew plus all his other given names, followed by "Prince of the Royal Blood."

To some degree this business about titles supplanting last names also applies to nonroyal peers, such as your run-of-the-mill dukes. But it gets pretty complicated, and if it's all the same to you, Cecil would just as soon quit while he's ahead.

The Question That Would Not Die, Round Three

I'm confused after reading your explanation of the changes in British royal family names. Are you sure that before 1917 they used the surname Saxe-Coburg and Gotha? Saxe-Coburg and Gotha is the duchy in Germany where Queen Victoria's husband Albert was born. Prince Albert's father and older brother were known as Dukes of Saxe-Coburg-Gotha, but according to Stanley Weintraub, who published an exhaustive biography of Queen Victoria in 1987, Albert's family name was actually Wettin. Did Edward VII, Victoria's successor, take the name of his father's birthplace as his own family name?—Ms. S., Washington, D.C.

Why I ever got into this I'll never know. I admit I was hasty in saying the royal family name was Saxe-Coburg and Gotha. To tell you the truth, nobody is quite sure what the royal family name was prior to 1917. Certainly not the British, whose befuddlement in these matters has attained the stature of legend. Part of the problem is that royal family names do not necessarily coincide with surnames. Queen Victoria was a member of the House of Hanover, but her family's surname, seldom if ever used, was Guelf, sometimes spelled Guelph.

Her marriage to Prince Albert confused things even more. Prior to 1917 it was generally supposed that Albert had belonged to

the House of Saxe-Coburg and Gotha. This irked the British public during World War I, when Albert's grandson George V was king. The writer H. G. Wells, for one, complained about Britain's "alien and uninspiring court," prompting George's famous remark, "I may be uninspiring, but I'll be damned if I'm alien."

Eventually George agreed to change his family name. No sooner had he done so, however, than it was discovered that one was exactly sure what his family name was. "Was it 'Saxe-Coburg and Gotha'?" one historian wrote. "No, thought the College of Heralds, it was probably 'Wettin' or, even more outlandish, 'Wipper.'"

One giggles with glee at the vile puns one could work up on Wettin and Wipper, but no matter. They were swept out by royal proclamation in 1917 and replaced with Windsor, and for once the royal family name and surname were identical. Elizabeth II, however, could not bear to have this monotonously sensible state of affairs continue. In 1960 she proclaimed that while hers would remain the House of Windsor, her descendants would bear the surname "Mountbatten-Windsor," Mountbatten being the surname of her hubby, Prince Phillip. The traditional muddle was thus restored, and there the matter rests today.

I've read that a respectable number of disrespectable popes in the early Roman Catholic Church had illegitimate children. I understand that many of these children became cardinals in the church, some eventually ascending to the papal throne with infallibility. Does the Catholic Church officially acknowledge these transgressions, and, if so, how does it rationalize them? Also, is there any truth to the scandalous story of an ancient pope's bastard daughter disguising herself as a man, becoming a respected cardinal in the church, and finally getting elected pope by his/her peers—only to be stoned to death by an angry Roman crowd that discovered "him" hiding an advanced pregnancy under those heavy velvet robes?—Jeffrey R., Madison, Wisconsin

A lot of the rumors about the "bad popes" are true, Jeffers, but let's not get ridiculous. The female pope story, for one, is generally regarded as a fabrication. "Pope Joan," who supposedly served from 855 to 858, was said to be an Englishwoman who disguised herself as a monk to be with her cleric boyfriend. She went to Rome, where she so impressed others with her learning that she was elected pope. Her secret was discovered when

she gave birth during a procession, whereupon she was slain. The story is bogus, although it was possibly inspired by actual events, about which more in a moment.

But many other papal horror stories are entirely legit. In many cases, in fact, weaknesses of the flesh were the least of the popes' sins. In the Middle Ages many popes were elevated to office following the murder of their predecessors. During one particularly grim period from 882 to 1046, there were 37 popes, some of whom served only a few weeks.

Leo V (903), for instance, had been pope for only a month before being imprisoned and tortured by one Christophorus, who then enthroned himself. Both men were killed in 904 on the orders of Pope Sergius III (904–911). Sergius later had a son by his teenaged mistress Marozia who became Pope John XI (931–935). In 914, according to one chronicler, Marozia's mother Theodora installed her lover on the papal throne as John X (914–928). (Theodora and Marozia effectively controlled the papacy through their menfolk and may be the source of the Pope Joan legend.) John XII (955–963), who ascended to the papacy at 19, was accused, perhaps falsely, of sleeping with his father's mistress, committing incest with his niece, and castrating a deacon.

Murder gave way to bribery as a route to the papacy in later centuries; some 40 popes are believed to have bought their jobs. But the lax attitude toward celibacy remained unchanged. In large part this was because the Church was an important route to wealth and power. Sons of influential families were pushed into Church careers much as we might send a kid to M.B.A. school, apparently with similar expectations regarding morals. Noblemen with mistresses saw no reason to adjust their life styles just because they had taken vows.

The spectacle of cardinals and popes putting their "nephews" into cushy jobs was a standing joke in Rome for centuries. Innocent VIII (1484–1492) had a son and daughter who lived with him in the Vatican. The notorious Alexander VI (1492–1503), born Rodrigo Borgia, had at least four illegitimate children while still a cardinal, among them the cutthroat Cesare Borgia and the reputed poisoner Lucrezia Borgia. (Actually, she probably never poisoned anybody.) Clement VII (1523–1534), himself illegitimate, had a son whom he attempted to make duke of Florence. Paul III (1534–1539) had four kids; two teen grandsons he made

cardinals. Pius IV (1559–1565) had three children, and the list goes on.

The Catholic Church has been reasonably forthcoming about the bad popes, having opened the Vatican archives to historians in the nineteenth century. The Church acknowledges that the office has been held by unworthy men, but maintains that their spiritual capacities were unimpaired by their temporal failings—a line that may sound familiar to former supporters of Gary Hart. The doctrine of papal infallibility applies only to certain formal pronouncements on faith and morals, so it can be argued that the bad popes did not lead the church permanently astray. But it's not a position I would care to defend before a congressional committee.

More Complaints

There were several errors in your column on the disreputable popes.

You said, "The Church acknowledges that the office has been held by unworthy men, but maintains that their spiritual capacities were unimpaired by their temporal failings." The second part of that statement is false. The Church has always taught that you cannot serve two masters. No one can lead a carnal life of habitual self-gratification and still maintain a healthy spiritual life, not even popes. Those popes who lead lascivious lives, sired bastards, or murdered rivals did so precisely because they lacked spiritual capacities.

That brings me to another incorrect statement: "The doctrine of papal infallibility applies only to certain formal pronouncements on faith and morals." Few Catholics understand that it is not only the Extraordinary Magisterium (teaching authority) that is infallible, but the Ordinary Magisterium also.

The formal pronouncements you said were the only infallible ones are quite rare and exceptional. Pope John Paul II traveling around the globe reminding the faithful of the teachings of the Church is the most dramatic and common exercise of the Ordinary Magisterium today. When he reiterates something the Church has always taught, he speaks infallibly. Just because there

*are no bells and whistles, no pomp and incense, doesn't mean
Catholics can ignore his doctrine.*

*There are some other questionable statements as well. For in-
stance, you said Pius IV had three children, "and the list goes
on." As a matter of fact, that's where the list ends.*

*An important point seems to have escaped you and your ques-
tioner. Despite the bad popes, the Church is still here after two
thousand years. As the Jew in one of Boccaccio's stories said after
returning from Rome to embrace Catholicism, "Any organiza-
tion that can survive such corruption must be the true Church."*

*But for those minor details, it was an interesting article.
—Richard O., Highland, Indiana*

By my count, Richard, you raise three issues, and have man-
aged to boot all of them.

1. By "spiritual capacities" I didn't mean the popes' personal
morals but rather their ability to call down the blessings of God
on the faithful. The bad popes consecrated priests, forgave sins,
baptized babies, and so on. The Church maintains that these acts
were not invalidated by the fact that the pope may have been in
a state of sin at the time.

2. Regarding infallibility, you have confused papal infallibility
with the infallibility of the teachings of the Church as a whole.
While the "ordinary and universal magisterium" of the Church
is infallible, the ordinary teachings of the pope are not. The *New
Catholic Encyclopedia* says, "The ordinary exercise of the teach-
ing office of the pope . . . is an essential element of the ordinary
and universal magisterium of the college [of bishops] but it is not
to be identified with it, and, hence, it is not necessarily infalli-
ble. . . . Just because the pope should express his opinion or show
his approval of something, it is not to be thought that he always
wishes to close the debate."

3. The list of popes with illegitimate children "goes on" in the
sense that I did not mention every single pope who was literally
a holy father. For instance, there's a tradition that Pope Hor-
misdas (514–523) was the father of Pope Silverius (536–537). Ex-
actly how many papal children there were is probably impossible
to determine, due to the lack of documentation for such things.

But for these details, it was an interesting letter.

Chapter 8

Origins

Some years back I recall reading a magazine article to the effect that Robin Hood was not a fictitious character, but a real person. Can this be? The article mentioned him to illustrate the point that recorded history is often modified in popular tales in order to shield the listener from unpleasant truths—i.e., that Robin Hood did not live "happily ever after," but instead was foully murdered. I have forgotten the exact date of death given, except that it was at the end of the eleventh century. Please give us the Straight Dope on this. Also, how about the other characters connected with the story—Little John, Friar Tuck, Will Scarlet, et al.? What about Robin Hood's girl friend, Maid Marian? Did he?—Tom G., Chicago

You're the victim either of journalistic fraud or a typographical error, Tom—as far as I can tell, absolutely nobody contends that Robin Hood punted the pail in the 1090s. Nobody is sure who the real Robin Hood was, or even if there *was* a real Robin Hood, and it's certainly not known when or how he died (although the fictional Robin, in one account, was killed by an evil abbess). The earliest any authority says he arrived on the scene is 1190, and some have him wandering in as late as the 1320s. Two plausible candidates for the historical Robin Hood have been identified: Robert Hood of Yorkshire, aka "Hobbehod," who was recorded in 1228 and 1230 as having been an outlaw and fugitive (which constitutes the sum total of information known about him); and Robert Hood of Wakefield, also in Yorkshire, who lived in the early 1300s.

The evidence adduced in the latter case is as fine a specimen

of rattlebrained historical speculation as you are ever likely to find, so I present it here in all its finery: (1) Robert of Wakefield lived during the reign of Edward II, who visited Nottingham in 1323 after a tour of the forests of Lancashire and Yorkshire (the idea that the king who visited Robin Hood in the forest was Richard I—i.e., Richard the Lion-Hearted—is a relatively modern invention). (2) Robert Hood owned a tenement in a place called Bichill. (3) A tenement in Bichill was seized by the king's agents following a revolt. (4) A Yorkshireman named John le Litel or John Littlejohn was in trouble for housebreaking in 1318, and for poaching in 1323. (5) The sheriff of Nottingham in 1318–19 and 1323–25 was Henry de Faucumberg. He was said to be a nasty dude, admittedly a common characteristic of sheriffs of the day. (6) A Henry Fauconberg was a neighbor of Robert Hood's. (7) In November 1323, one Robert Hood went on the payroll as a porter in the King's Chamber. Payments ceased in 1324 when Hood was let go "because he could no longer work." (8) John le Litel, a sailor, was on the King's Chamber payroll in 1322, 1323, and 1325.

From these pathetic crumbs several historians have concocted the theory that Edward II seized Robert/Robin Hood's property, forcing him into outlawry; that Robin subsequently joined forces with Little John and perhaps others (although Maid Marian and Friar Tuck are postmedieval additions to the clan); that Hood and friends were hassled by de Faucumberg/Fauconberg; that

the king eventually met Robin and the boys in the forest and discovered that they were really OK guys; that after pardoning them he gave Robin and Little John jobs toting suitcases or something in the royal household; and finally that after a while Robin got tired of working for a living and went back to his old program of income redistribution in Sherwood Forest.

The problem with this whole thing, obviously, is that it's based entirely on coincidence, without any solid evidence to back it up. Besides, one spoilsport has already proved incontrovertibly that Robert Hood became a King's Chamber employee *before* Edward II went to Nottingham. In short, it sounds like bunk to me. For more detail, see *Robin Hood: An Historical Enquiry* by John Bellamy.

The Legend of Robin Hood Takes an Ominous Turn

In A Handbook on Witches *by Tyndell, which may not be available in this country, the author puts forth the suggestion that Robin Hood was practicing witchcraft. (I suppose this would make no difference, when evaluated from this century, whether or not he was a real person.)*
The evidence offered:

- *The name "Robin" is a variation of "Puck," who was certainly a "supernatural" personage;*
- *The favorite colors of witches are black, white, and green;*
- *The Merrie Men met under a huge oak tree, which is one of the usual meeting places of covens;*
- *The number of people in Robin's "inner circle" is the same as that in a coven;*
- *In order to hold a Black Mass, one needs a defrocked priest (Friar Tuck) and a virgin (Maid Marian, we assume);*
- *In present-day England, occult groups still have celebrations marking Robin's birthday.*

Furthermore, the author states that King John was the first English monarch to actively declare war on witchcraft, after being goaded into this by church officials. Therefore, Robin's antagonism toward the authorities was not motivated by any share-the-wealth ideas but rather was a matter of survival—Hugh S., La Grange, Illinois

Oh, great. Another one of my childhood heroes brought low. Next you'll be telling me Hiawatha was a drug fiend. Come to think of it, I always did wonder what was in that peace pipe.

Dear Cecil, a question have I/To which I hope you reply.
'Tis a question that over the years
Has really not brought me to tears.
But since it is rapidly approaching, that is, Valentine's Day,
I thought I'd pose this question to you, if I may.
The question regards the shape of the heart, not the one in the bod,
But the two-lobed kind, as on any V-day card.
These stylized hearts bear no resemblance, as far as I can see,
To the real organ of our anatomy.
My guess as to where this shape did arise,
Has to do with a particular slant of one's eyes.
When gazing upon certain portions of a woman's physique,
One sees many roundnesses to a female unique.
It's these curvaceous boundaries that I imagine did inspire
The symbolic heart's shape in someone's imagination to fire.
But who was this person and when did it occur
To create a heart full of symmetric allure?

Thank you, Cecil, for putting up with my verse;
In prose my question would've been much more terse.
But would prose do justice to this heartfelt question of
mine?
Hard to say; nonetheless, Cecil, will you be my valentine?
—Ross Y., Madison, Wisconsin

If you think I'm going to answer this in verse, Ross, you're crazy. I've been able to trace the heart symbol as far back as the 1400s, when it was first used as a suit designation on playing cards, and I'm sure it goes back a lot earlier than that. What inspired the guy who dreamed it up is hard to say, but a lot of people would agree that the biological heart wasn't the portion of the anatomy that was uppermost in his mind at the time. Here's what Desmond Morris, the zoologist who wrote *The Naked Ape*, has to say on the subject in *Bodywatching* (1985):

"The traditional heart symbol, with its deep cleft, looks very little like a real heart. Unconsciously, it seems to have been based more on the shape of the naked female buttocks, as seen by an amorous male approaching from behind. As a symbol of love, this makes much more sense for the human species, bearing in mind the unique and highly characteristic shape of this part of the anatomy, so much the focus of male sexual attention."

Speaking of playing cards, the spade symbol is even more blatant in its sexual suggestiveness than the heart is. Before we get too carried away, though, I should point out that it's not true the heart symbol bears no resemblance at all to the genuine article. The twin lobes of the stylized version correspond roughly to the atria of the anatomical heart.

A friend of mine says she heard from "a reputable source" that Thanksgiving was actually invented by Harper's Bazaar *in the 1800s. Can this be true?—Mindy, Champaign, Illinois*

Right idea, wrong magazine. Thanksgiving as we know it today—at least on the *scale* we know it—is largely the creation of Mrs. Sarah Josepha Hale, editor of *Godey's Lady's Book*, one of the first women's magazines. Mrs. Hale spent 36 years browbeating public officials high and low before finally getting Thanksgiving declared a national holiday in 1863.

But first a little history. What we now think of as the original Thanksgiving took place in the fall of 1621 at the Plymouth col-

ony in Massachusetts, with the Pilgrims and some 90 Wampanoag Indians on hand to chow down, play volleyball, and exchange native diseases. (No joke—an earlier tribe of Indians had been wiped out by European-imported smallpox.) The occasion came to be a semiofficial holiday among New Englanders, one of many such celebrations held throughout the colonies at various times of the year. The idea of holding a national Thanksgiving, however, was slow to catch on. The Continental Congress scheduled the first one for Thursday, December 18, 1777, to celebrate the defeat of General Burgoyne at Saratoga. In 1789 George Washington proclaimed a one-time-only day of thanksgiving for Thursday, November 26, to celebrate the new Constitution. But his successors let the idea drop. Thomas Jefferson, for one, considered proclaiming holidays "a monarchical practice" and paid no attention to Thanksgiving during his term of office.

Enter Mrs. Hale. A native of New Hampshire, she became obsessed with the idea that "Thanksgiving like the Fourth of July should be considered a national festival by all our people." Her opening salvo was her first novel, *Northwood*, published in 1827. An entire chapter was devoted to a detailed description of a Thanksgiving dinner complete with stuffed turkey and pumpkin pie. In 1846, nine years after she became the editor of *Godey's Lady's Book*, she launched a crusade to make Thanksgiving an official holiday. Every fall the magazine would editorialize on the subject, meanwhile running high-cholesterol but no doubt tasty recipes for such things as "Indian Pudding with Frumenty sauce" and "ham soaked in cider three weeks, stuffed with sweet potatoes, and baked in maple syrup." Mrs. Hale also wrote hundreds of letters to influential people urging them to support her cause.

Her efforts continued up through the Civil War. In 1861 she asked both sides to "lay aside our enmities on this one day and join in a Thanksgiving Day of Peace." The appeal failed, but eventually, some believe, she was able to pitch President Lincoln in person. Whatever the case, Abe finally issued a National Thanksgiving Proclamation on October 3, 1863, setting aside the last Thursday of November as the official day.

Thanksgiving continued to be proclaimed annually by the president this way until 1939, when Franklin Roosevelt blithely declared that Thanksgiving that year was going to take place on the *third* Thursday of November. Crass commercialism was the

chief consideration—FDR hoped to woo retailers, who complained that they needed more time to "make proper provision for the Christmas rush" and incidentally cram in a few more shopping days. FDR's move outraged Republicans and quite a few football coaches throughout the country, who claimed that not only was FDR trampling on sacred national traditions, he was screwing up the bowl game schedule. For two years, people celebrated Thanksgiving on one of two different days, depending on their political inclinations. In 1941, however, Congress got into the act by officially declaring that Thanksgiving would thenceforward fall on the fourth Thursday of November. Two weeks later FDR declared World War II. And you thought *Nixon* was a sore loser.

The Teeming Millions Get Huffy

Nice to know from your column that in 1941 "FDR declared World War II." What do you think France, Britain, Germany, Poland, Italy, Norway, Russia, Canada, and Australia had been doing before that date? Arm wrestling?—*Arthur H., Chicago*

Remind me to explain the concept of a "joke" to you someday, Arthur.

I need to know the origin of the peace symbol. Members of the Alliance for Survival will be constructing what may be the world's largest peace symbol on Santa Monica beach, and we want our facts correct. We've heard some pretty strange rumors; perhaps you can clear the air once and for all.—Jerry R., Santa Monica, California

Sorry I'm a little late getting back to you on this, Jer; I see where the world's largest peace symbol was dedicated July 16. However, the pursuit of knowledge cannot be rushed. Incidentally, three rahs on your strategy. Building a gigantic sand castle in La-La Land is sure to make world aggressors think twice.

The design for the familiar crow's-foot-in-a-circle we know as the peace symbol was completed February 21, 1958, by British commercial artist Gerald Holtom. Holtom had been commissioned by the Campaign for Nuclear Disarmament, headed by philosopher Bertrand Russell, which was planning an Easter march to Canterbury Cathedral to protest the Atomic Weapons

Research Establishment at Aldermaston. After doodling around with several versions of the Christian cross set in a circle, Holtom hit on the crow's-foot idea, which had a couple things going for it. First, it was a combination of the semaphore signals for *N* and *D*, standing for Nuclear Disarmament. *N* is two flags held in an upside-down *V*, and *D* is one flag pointed straight up and the other pointed straight down. Second, the crow's-foot has an ancient history as a symbol of death and despair—it looks like somebody spreading his hands in a gesture of defeat. The symbol is shown in a 1955 tome called *The Book of Signs* by Rudolph Koch, a German calligrapher, although it's unclear whether Holtom saw it there. The circle, finally, can mean "eternity," "the unborn child," and so on. From this you can no doubt cook up a suitably apocalyptic interpretation of the symbol as a whole.

During the heyday of the peace movement, other interpretations of the symbol were also offered. A national Republican newsletter noted that it looked a lot like an emblem used by the Nazis during World War II—an apparent coincidence. Another interpretation, widely promoted by the John Birch Society and other right-wing groups, was that the symbol was really the "broken cross," sign of the Antichrist. One Bircher wrote that the broken cross had originally been devised by the Roman emperor Nero, who had Saint Peter crucified upon it upside down.

In the Middle Ages the symbol allegedly was used to signify the devil. I have been unable to discover any good evidence for either of these contentions. The Birchers, you may remember, also distributed bumper stickers featuring the peace symbol with the slogan, "Footprint of the American Chicken." Birchers are noted for their spry sense of humor.

Complaint Department

Your thesis of the design of the peace symbol is for the birds. The symbol was actually derived from the left's attempt to stop the bombing in Southeast Asia. It was an abstraction of the B-52 bombers being used in Vietnam and Cambodia. It was a natural progression to use this symbol, or versions thereof, as a symbol of protest of nuclear arms proliferation, since we all knew from Dr. Strangelove *that SAC B-52 squadrons were poised to ruin every Soviet weekend in the foreseeable future. The B-52 abstraction was encircled as a symbol of containment and also to make a swell medallion. (Medallions were the in thing to wear in that era, generally called* B.C. . . . *Before Cokespoons.)*

The opinions expressed herein were not researched nor documented, but are merely the blissful reminiscences of one . . .
—Born in '48, Chicago

Sorry to confuse you with the facts, partner. Your view was admittedly widespread during the 60s, but here at the Straight Dope, if you'll excuse a touch of self-righteousness, we don't take votes on the facts.

An old friend of mine feels you are the one person who can provide a definitive answer concerning the origin of the popular saucer-shaped champagne glass. His father has always maintained that the original saucers were modeled on the breasts of Diane de Poitiers (1499–1566), the mistress of Henry II. She commissioned the glassblower at their Chateau d'Anet to make them as a present to Henry, who was particularly enamored of her breasts and harbored a fantasy to drink wine from them. (Champagne had not yet been invented.) Imagine my friend's consternation during a recent tour of the Moet & Chandon establishment in Rheims when the Moet staff recounted a close facsimile of this story, only changing the cast of characters to

read Madame de Pompadour (1721–1764), Louis XV, and, naturally, champagne. Cecil, whose knockers are being commemorated?—John D., Washington

Take your pick, Jake. There's lots of versions of this story floating around. A writer by the name of Maurice des Ombiaux bestows the honor on no less a personage than Helen of Troy. Supposedly the gods were so enamored of Helen's chichibangas that they decided to have the shepherd Paris make a wax cast, whence to make goblets. Quoth Maurice:

"Helen appeared with her attendants, looking as radiant as Phoebe among the stars. . . . The veil which covered her bosom was lifted and one of the two globes was revealed, pink as the dawn, white as the snows of Mount Rhodopus, smooth as the goat's milk of Arcadia. . . . With wax provided by the golden daughters of Hymettus, the shepherd Paris . . . took the cast of the breast, which looked like a luscious fruit on the point of falling into a gardener's hand. When Paris had removed the wax cast, the attendants hastened to replace the veil over Helen's gorgeous breast, but not before her admirers had glimpsed a teat whose freshness was as tempting as a strawberry."

Clearly, this was a woman who made a good first impression. I have also heard that four porcelain champagne glasses molded from the breast of Marie Antoinette were kept at the Queen's Dairy Temple at the chateau de Rambouillet, and that one remains today with the Antique Company of New York, Inc. Looking at the question objectively, I think we'd have to agree that the female breast, however interesting *in situ*, would make for a singularly misshapen champagne glass. But you know how it is with these male fantasies.

Who decided, back in the mists of ancient time, that red was the color for "stop" and green for "go"? The commonest form of color blindness makes the colors totally useless, and a warning sign that is near-invisible to a significant portion of the population strikes me as a bad idea.—Barbara T., Los Angeles

Well, now's a fine time to mention it, Barb. Why didn't you bring this up 75 years ago? The present system of color coding was developed by the railroads around the time of World War I, although its roots go back much further. Tradition among railroaders has it that red was chosen for "stop" in commemoration of a farmer who tried to flag down an early choo-choo with his

red shirt. This is cute, but bunk. Red, the color of blood, has been a danger signal since time immemorial. The Roman legions supposedly bore the red banner of the war god Mars into battle 2,000 years ago.

But the other colors have changed over time. When the first primitive railroad signaling devices were developed in the 1830s and 1840s, red meant "stop," green meant "caution," and clear (i.e., white) meant "go." This system had several defects, among them the fact that the white signal could easily be confused with an ordinary white light. What was worse, however, was the fact that the system wasn't fail-safe. This was tragically demonstrated sometime around 1914, when the red lens supposedly fell out of a signal so that it erroneously showed a white indication. This caused a train to sail through the "stop" signal, resulting in a disastrous crash. The railroads subsequently decided to drop white and make green "go" and yellow "caution," the latter presumably because it was readily visible and offered the most striking contrast to the other two colors. When the first electric traffic signals were installed in Cleveland, Ohio, in 1914, they used red and green indications; when the first modern automatic traffic signals were put up in Detroit in the early 1920s, they used red, yellow, and green, and that's what we're stuck with today.

Not to make light of color blindness, but it poses less of a problem for drivers than might at first be imagined. About 8 percent of the population suffers from some color vision deficiency, with difficulty in distinguishing green and red being most common. But it is rare to find someone so color-blind they cannot tell bright red and bright green apart—usually they only have trouble with pastels. (Cecil speaks from personal experience.) If they do have a problem, they can always fall back on the fact that in a vertical stoplight red is on top. Still, people who are totally color-blind do present a risk, and I'm told some European countries have adopted color-vision tests to weed them out during the driver's license testing process. Should some horrifying accident be traced directly to color blindness in this country, no doubt you'd hear calls for such tests here as well.

I hate to see you wasting your time on the insipid questions your readers have been submitting lately. Permit me to pose a question that will have a meaningful impact on today's social problems: Why do clocks that have Roman numerals on the faces

always show the number four as IIII instead of IV?—Jerry M., Hollywood, California

Lord knows I hate to be a wimp about these things, but I'm afraid I'm going to have to fall back on that old standby: they do it that way because that's the way they've *always* done it, at least as far back as 1550, and probably earlier. Clock historians claim that IIII is supposed to provide artistic balance, since you sort of mentally pair it off with VIII on the other side of the dial. (Presumably you see how the otherwise economical IV would have trouble holding its own in this respect.) The only problem with this theory is that the Romans apparently never used IV— it's a modern invention, although how modern is not clear. It's possible, in other words, that old-time clock makers used IIII because it was considered perfectly proper usage for all purposes, horological or otherwise, at the time. Tragically, we may never know the truth. History can be like that sometimes.

A Site for Four I's, Part One

Regarding the use of Roman numeral IIII vs. IV on clocks, I noticed IIII on clocks a long time ago and when I happened to meet a clockmaker, I asked. His conjecture was as follows:

Count the number of X's, V's, and I's on a clock face that has IIII, and you find you have four X's, four V's, and 20 I's, or four identical sets of XVIIIII. Accordingly, if a metal worker in the early days of clockmaking had to make the numerals, it was easier and less wasteful of material to make four slugs for each clock face, each slug containing one X, one V, and five I's. —Peter L., professor of chemistry, Illinois Institute of Technology, Chicago

Could be, but the numbers on many old clocks appear to have been cast in one piece, as opposed to being assembled out of individual characters, as your theory would require. But you— or at least your clockmaker friend—get points for ingenuity.

• • •

A Site for Four I's, Part Two

I was surprised by your wishy-washy answer regarding the rationale for using the Roman numerals "IIII" on clocks instead of "IV." Long ago I read somewhere that the Romans were loath to offend the god Jupiter by daring to place the first two letters of his name (IVPITER in their primitive, pre-U, pre-J script) on a clock face. Hence the four I's. Why the letters would be so offensive I do not recall, but knowing how touchy the gods were, I suppose the clockmakers just figured there was no point taking chances.— E.L.F., San Antonio, Texas

Has there ever been, in the history of civilization, any functional purpose for wearing a tie, or is it merely an inane ritual held over from ancient times, unwittingly followed on a daily basis by hundreds of thousands of grown men as a blazing symbol of conformity to some unspoken norm, bestowing membership in some gigantic, vaguely defined, exclusive club?—Phil S., chairman, Loaded Questions Department, Washington, D.C.

I gather, Phil, that you do not like ties, probably because you are some kind of hippie beatnik who would rather live in the forest eating roots and berries than hold down a job like a man. But hey, no problem, I'm a liberal. The wearing of neck cloths dates back at least to the time of the Roman legions, when soldiers wore a neck band to catch the sweat or block the cold, depending on the season. In the seventeenth century, Louis XIV's Croatian regiment also wore neck cloths, whence we derive our word "cravat," from the French *cravate*, for "Croatian." Cravats, which were cloths wound around the neck and often tied at the ends, gradually evolved into the bow tie, and by the 19th century into the modern long tie.

Cravats were unquestionably an object of fashion, but at least they kept your neck warm, which is more than you can say for most modern neckwear. Regrettably, the trend over the years, in neckties as in all of life, has been to make once functional items increasingly useless. The State Department, for instance. But I digress. First the necktie migrated outside the collar (this was the high collar, I should note), the better to show it off. Then the collar was folded down, thus hiding the necktie and defeating the purpose of putting it outside the collar in the first

place. At the same time the band part of the necktie, which wrapped around the neck, became thinner, until today we have those unbelievably nerdy clip-on jobs with no band at all.

So far as I can determine, the only thing the tie does at present, apart from enforcing corporate discipline, is to hide your shirt buttons. Such a hassle. No doubt we'd all be better off if we could just get naked and frolic with the animals. I look to you, Phil, to show some leadership.

Ties That Blind: A Defense

Your treatment of necktie functionality is more than adequate in tracing the tie's historical descent. But you neglect the psycho-aesthetic value the tie serves. You fail to consider that the tie is the male's one opportunity for textile display as flashy as that permitted the female. Women can splash color from neckline to hem. But male shirtings and suitings are evidently designed by some Protestant soul afraid that any color visible at more than two feet will cause moral degeneracy. The tie is a man's only opportunity to strut his stuff.—James Y., Bethesda, Maryland

Actually, Jimna, people in the clothing biz claim men are so conservative you couldn't get them into colorful duds if you gave the stuff away. More likely, however, this is the result of going at it the wrong way. Cecil, for example, was recently invited to a bash with a nautical theme advertised as "creative black tie." Half the guys showed up in tuxedo jackets and jams, but Cecil stole the show with white Izod shorts, Topsiders, tuxedo shirt, $6 black studs and cufflinks, white tuxedo jacket with black pseudo-velvet trim ($7 from the Salvation Army), all topped off with matching sky-blue bowtie and cummerbund featuring palm trees and sailboats. If I had been any cooler I would have been assumed bodily into heaven. Fashion mavens, take note.

I've noticed that the lobbies of many older buildings are adorned with what appear to be numerous swastikas. Were these an Indian symbol or something before Adolf made them famous?—Scott P., Oak Park, Illinois

You are absolutely right, Scott, an experience you might be well advised to savor. The swastika was employed by various

American Indian tribes, notably the Navahos, for whom it was a sort of good luck sign. I recall once seeing a picture of the young Jackie Kennedy (then Bouvier) wearing a costume decorated with swastikas for some kind of Indian pageant. Or maybe she was going to become a professional wrestler; my memory is somewhat vague. At any rate, the swastika was widespread throughout the ancient world, particularly in India, where it remains in common use by Hindus, Jainas, and Buddhists. Originally it probably symbolized the sun circling through the sky, although many other explanations have also been offered. Up until the twentieth century the swastika's significance was generally benign.

In the 1870s the swastika was greatly popularized by the German archaeologist Heinrich Schliemann, who found many examples of it during his diggings at ancient Troy and Mycenae. Schliemann was fascinated by the swastika and publicized it in his books, referring to it as an Aryan religious symbol. Schliemann himself was not a racist, but the swastika was soon taken up by less principled writers, who were attracted by the Aryan connection as well as by the symbol's strangely compelling appearance. Hitler may have been introduced to it through the work of the fanatical Aryan supremacist Jorg Lanz von Liebenfels, who was using the swastika as the symbol of his cult as early as 1907. Many anti-Semitic and militarist groups had adopted it as well by the time Hitler commandeered it for the Nazis around 1920. Even he was a bit surprised by the impact it had on people. It is undoubtedly one of the most effective political symbols ever devised.

The Misunderstood Swastika

Cecil, you were wrong! I refer to the question concerning the historical roots of the swastika. You informed us that it was an ancient Indian symbol. In reality, however, the Indian symbol was not the Nazi swastika but rather a mirror-image symbol called the Wheel of Life. The Wheel of Life turns in a clockwise ("deosil") direction. Hitler, who was fascinated by the occult, deliberately reversed the ancient symbol of power so that it turned counterclockwise, or "widdershins." Traditionally this is

supposed to give the symbol a "black magic" sort of power. Please, try not to be wrong again—I can't handle the disillusionment.—West M., Atlanta, Georgia

Time to lay off the airplane glue, West. As a glance at a history book would show, the Nazi symbol was oriented in a clockwise direction. So, as often as not, was the ancient good luck/sun symbol sometimes known as the Wheel of Life. It's true that swastikas come in both clockwise and counterclockwise versions, and some scholars maintain that they represent opposing principles—e.g., yin/yang, male/female, and presumably good/evil. On occasion, as you correctly note, the counterclockwise swastika, more properly known as the *sauvastika*, has had black-magical significance, symbolizing night and/or the terrifying goddess Kali. But you can find examples of both types of swastikas being used in what are clearly benign contexts. In any case, the wicked sauvastika was not the Nazi symbol. You got anything else you want cleared up, just let me know.

Cecil Begins to Sympathize with the Misunderstood Swastika

Yin–yang, female–male do not, I repeat, do not represent the good–evil dichotomy. This is a common misperception and shows remarkably faulty and prejudicial logic. Evil results from the imbalance of either opposing force, not the intrinsic "evil" of either. Which sex, by the way, were you stigmatizing with the "evil" label? Against all reason, you would project onto some "dark goddess" what you would rather not face in yourself. It doesn't take Levi-Strauss or a flaming feminist to see the politics in this. Before you enlighten the public on any more opposing forces, read a good book on macrobiotics and at least get that point straight.—Natasha B., Takoma Park, Maryland

Calm down, Natasha. I used male/female and good/evil as examples of opposing forces. I didn't say one was an example of the other.

The Absolute Last Word on this Subject

The Nazi fylfot, known as the swastika or hakenkreuz ("hook-cross"), is actually a Teutonic runic ideograph called "Thorshammarr"—"the hammer of Thor." Although the Nazis emphasized the aggressive, martial implications of this symbol, its primary traditional meaning was the solar wheel and the cycle of life. The Thorshammarr, like many other runes and ideographs, was depicted in reverse (mirror-image) frequently, but its meaning remained constant. The concept of deosil (clockwise)/widdershins (counterclockwise) opposition, which occurs in European magical practice, does not apply to Teutonic runes.

The fylfot occurs frequently in native American symbology, and may be found in Northern Plains beadwork and Southwest pottery, basketry, and sand paintings—usually with a deosil orientation. In Northern Plains symbolism, the fylfot is a representation of the four directions, and embodies the concept that the sacred place of two-leggeds (humankind) is at the center of the world-hoop. Even today the circular solar wheel is reproduced in hair ornaments of rawhide wrapped with dyed porcupine quills, traditional pieces which are still being made by Lakota craftswomen in the manner of their ancestors.—Jean-marie E., Goleta, California

Why is north up? Did the early explorers, mapmakers, astronomers, and the like get together and vote, or did it just sort of happen? Does everyone on earth think of north as up, or could a Northern Hemispherian like myself travel south of the equator and buy a globe with Antarctica on top?—David J., Chicago

By cracky, David, I think you're on to something here. With a few minor exceptions, which we shall attend to directly, mapmakers throughout the world invariably put north on top, even if they were born and raised in Tierra del Fuego. What we are dealing with, in other words, is a case of blatant directionism, the unfairness of which cannot help but rankle any right-thinking person. Why should the big N always be on top when there are hundreds of other directions—thousands, if you get down to seconds of arc—that have an equally legitimate claim on our affections? I grieve to think of the shattered dreams of, say, south-southeast.

People who live in the southern hemisphere, notably our friends the Australians, like to give the impression they could care less about this. But be not deceived. An Aussie friend of mine once showed me a world map printed up by her country-men that had south on top, thereby putting Australia, as she rather ominously phrased it, "in its rightful place." Mark my words, someday the slogan "Down with Yankee imperialism" will have shocking new meaning.

But getting back to your question. The notion that north should always be up and east at the right was established by the Egyptian astronomer Ptolemy (A.D. 90–168). "Perhaps this was because the better-known places in his world were in the northern hemisphere, and on a flat map these were most convenient for study if they were in the upper right-hand corner," historian Daniel Boorstin opines. Mapmakers haven't always followed Ptolemy; during the Middle Ages, Boorstin notes, maps often had east on top—whence the expression "to orient." But north prevailed over the long haul. By the time Southern Hemispheroids had become numerically significant enough to bitch, the north-side-up convention was too well established to change.

How come February only has 28 days (plus an extra day in leap year) when all the rest of the months have 30 or 31? Did

they figure winter would go faster if the months were short?
—Randy Sue C., USA Weekend, *Arlington, Virginia*

You may be closer to the truth than you think, scoop. But let's dispose of the other explanations first. A widely believed—but possibly erroneous—story has it that February is so short because the Romans borrowed a day from it to add to August. August was originally a 30-day month called Sextilis, but it was renamed to honor the emperor Augustus Caesar, just as July had earlier been renamed to honor Julius Caesar. Naturally, it wouldn't do to have Gus's month be shorter than Julius's, hence the switch.

But some historians say this is bunk. They say February has always had 28 days, going back to the eighth century B.C., when a Roman king by the name of Numa Pompilius established the basic Roman calendar. Before Numa was on the job the calendar covered only 10 months, March through December. December, as you may know, roughly translates from Latin as "tenth." July was originally called Quintilis, "fifth," Sextilis was sixth, September was seventh, and so on.

Now, to meticulous persons such as ourselves, Randy, having the calendar run out in December and not pick up again until March probably seems like a pretty casual approach to time-keeping. However, we must realize that 3,000 years ago, not a whole helluva lot happened between December and March. The Romans at the time were an agricultural people, and the main purpose of the calendar was to govern the cycle of planting and harvesting.

Numa, however, was a real go-getter-type guy, and when he got to be in charge of things, he decided it was going to look pretty stupid if the Romans gave the world a calendar that somehow overlooked one-sixth of the year. So he decided that a year would have 355 days—still a bit off the mark, admittedly, but definitely a step in the right direction. Three hundred fifty-five days was the approximate length of 12 lunar cycles, with lots of leap days thrown in to keep the calendar lined up with the seasons. Numa also added two new months, January and February, to the end of the year. Since the Romans thought even numbers were unlucky, he made seven of the months 29 days long, and four months 31 days long.

But Numa needed one short, even-numbered month to make the number of days work out to 355. February got elected. It

was the last month of the year (January didn't become the first month until centuries later), it was in the middle of winter, and presumably, if there had to be an unlucky month, better to make it a short one.

Many years later, Julius Caesar reorganized the calendar yet again, giving it 365 days. Some say he made February 29 days long, 30 in leap year, and that Augustus Caesar later pilfered a day; others say Julius just kept it at 28. None of this changes the underlying truth: February is so short mainly because it was the month nobody liked much—a judgment with which I heartily concur. Frankly, if the Romans had cut it down to 15 minutes, it wouldn't have bothered me a bit.

I've always wondered why there are such widely varying names in different languages for the country between France and Poland. We call it Germany, the French call it Allemagne, and the Germans themselves call it Deutschland. Surely we see in such disagreements the roots of much recent tragic history. Why can't everybody just be sensible and settle on one name?—Listener, Drew Hayes Show, WMAQ, Chicago

You are a good soul, Les, but you lack an appreciation of the philological niceties. There is no necessary correspondence between a nation's name for itself and the name outsiders bestow upon it. This is especially true when the nation or people is very old. In ancient times, when international affairs consisted chiefly of heaving rocks at the tribe over the hill, a people's name for itself was often the local equivalent of "us folks" or "the people," while its name for foreigners was generally some variant on "those frog-faced heathens" or, more kindly, "the gang over yonder." Naturally, the gang over yonder called itself "the people" in its own language while reserving another term for the cretins down the pike.

The various names for Germany are a good example of this. The *deutsch* in *Deutschland* probably derives from the Indo-European root *teuta-* (or *tewt-*, depending on which authority you believe), the source of our word *Teuton. Teuta-* means "the tribe" or "the people," the word the early Germans used to describe themselves.

The Romans, meanwhile, referred to the German-speaking tribes collectively as *Germani.* Where they got this word is not clear. Many authorities believe it was a Celtic term meaning

"neighbors" that the Gauls bestowed on the folks next door. (There's an Old Irish word *gair* meaning "neighbor," although there's also an Old Irish word *gairm* meaning "battle cry." The path of linguistic progress is never easy.) One holdout thinks it was the name of a Celtic people the Teutons conquered and whose name somehow got transferred to the victors.

Moving right along, one of the German-speaking tribes in Roman times was called the Alemanni. They settled in what is now Alsace in the fourth century A.D. and were defeated by the Franks in 496. *Alemanni* may derive from an early German word meaning "all the men," which I suppose is roughly equivalent to "all us guys"—as opposed, naturally, to all *you* guys. The Franks, in a moment of uncharacteristic liberality, apparently decided to call the Alemanni by the name they called themselves. Later, by means of the metaphoric process called synecdoche, taking the part for the whole, the Franks applied the name to all the German-speaking tribes, and thus we have Allemagne. The Spanish, not having any strong opinions on the matter, sensibly simplified the orthography and wound up with Alemania.

The various names for Germany are perhaps the extreme example of diversity in geographical nomenclature. The Italians call Germany *Germania*, but their word for a German is *tedesco*,

which is their quaint attempt to spell *Teuton*. The Polish word for Germany is *Niemcy*, whose meaning is entirely mysterious, at least to me. Given the Polish experience of German manners during time of war, however, I could guess.

The Teeming Millions Clarify the Situation

Regarding your recent column on names for Germany, I once heard a story you may want to verify about how the Russians originated their word for Germany. Seems that in the late Middle Ages the czars invited Westerners, notably Dutch and German craftsmen, to settle in Russian cities because of their skills. The locals found they couldn't make the newcomers understand their language, so they naturally assumed they were deaf and dumb. Hence the Russian term for a German, nyemetz, *which means "mute." This seems similar to the Polish word for Germany*, Niemcy. *Can you confirm?*

More trivia: in Finnish (not related to any of the above), the word for Germany and the German language is Saksa. *Looks familiar, especially since the German word for Saxony, in southeast Germany, is* Sachsen. *Interestingly (or maybe not), the Irish word for a Briton is* sasenach. *It's also an imprecation.—Steve M., Chicago*

You've got the right basic idea, Steveski, but the part about the czars and the craftsmen is apocryphal doodoo—the terms date back to prehistory. *Nyemetz* (often transliterated *nemets*) quite likely derives from Russian *nemoy*, a mute, as in "those guys who are so out of it they are incapable of talking like normal people," a sentiment to which many American tourists abroad can no doubt relate. Variations on this theme occur in virtually all Slavic languages, including Polish *niemiecki*, a German, *niemy*, mute.

Similarly, our word "barbarian" is believed to derive from the Greek *barbaros*—non-Greek, foreign, rude—which many scholars say comes from the Indo-European root *baba-*, a word "imitative of unarticulated speech," my dictionary says. The ancient Greeks evidently thought foreign chitchat all sounded like "ba-ba-ba," baby talk, although I suppose you could also make the case they'd just stumbled across some primeval ancestor of the Beach Boys, as in "Ba-ba-ba, ba-ba-ber Ann." (Guffaw.) *Baba-*,

in any case, is the source of our words "baby" and "babble." Just to extinguish any lingering curiosity you may have on the subject, our word "infant" comes from Latin *infans*, "nonspeaking," incapable of speech.

As for *Saksa* and *sassenach*, both likely derive from the same root as our word Saxon. The Saxons, you may remember, were a German tribe that invaded Britain along with the Angles and the Jutes. By my count this now gives us five entirely independent names for the home of the Volkswagen: Germany, Deutschland, Allemagne, Niemcy, and Saksa. To these we must add a sixth: the Lithuanian Vokietija. I dunno where it comes from, and I don't want to know. This has gone on long enough already.

Department of Offended Sensibilities, Part One

The last paragraph of your column on the various names for the Germans goes off in the wrong direction. The Italians' tedesco is not "their quaint attempt to spell Teuton.*" It is only a slightly modified rendition of the German word* teodisk. *Actually, the Italian is closer to the Old German word than modern German (*Deutsch*) is! Of course, I don't think Italians will mind. They're used to the Americans and English making them look quaint or silly.—Louis R., Department of French and Italian, University of Wisconsin at Madison*

Lighten up, doc. It's my life's dream to make *everybody* look quaint or silly. Just wait till you see the number I do next week on the Uzbeks.

Department of Offended Sensibilities, Part Two

In your item on country names, you seem to reveal a belief that the Franks were some kind of Frenchmen, therefore a cut above the barbarous German hordes. In fact, the Franks were German by any definition one might choose. Most important, they spoke German. This includes Charlemagne, or Karl der Grosse, as he is more properly known. Of course, there was as yet no France or Germany. (Mostly, there was no France.) At the time of ancient Rome, most of Europe consisted of uncouth

barbarians. Barbarians are where you find them. There are still a lot around.—Lee J., Oak Park, Illinois

Let's not get personal, fella. *I'm* not the one who invented Gummy Rats.

Why are there seven days in a week? (Note: this question is not easy. Every other time division is based on natural phenomena but the hour/minute/second group.) The question, expanded, is this: (a) Why have weeks at all? (b) And if weeks, why seven days?—John S., Evanston, Illinois

Thanks, John, but I'll decide which questions are easy, if you don't mind. Is this a test or something?

The most primitive calendar-keeping peoples had no weeks, but as civilization progressed it became apparent that a time period longer than a day and shorter than a month would come in real handy for scheduling certain activities. The primitive equivalent of shopping, for instance. The first "weeks," in fact, appear to have been intervals between market days. The intervals varied—some West African tribes had four-day weeks, and the Egyptian interval was 10 days. The first Roman "week" was the *nundinae*, nine days counted inclusively from one market day to the next.

Many reasons are given for the seven-day week—probably it's the result of several of the following factors taken together: the four phases of the moon are roughly seven days in length; the Babylonians believed in the sacredness of the number seven; in ancient times, seven planets (including the sun and moon) were thought to exist (and indeed the days of the week were named after them). The Mosaic sabbath defined a seven-day period, and the dispersed Jews who observed it may have influenced the establishment of the seven-day week—it first appears in the early Christian era.

The present custom of a five-day work week plus a two-day weekend is a recent invention. Sunday was the only traditional day of leisure from the time of Creation (when, of course, God rested) until the mid-1930s. A "share the work" sentiment during the Depression resulted in codes of fair competition that established the 40-hour, five-day work week. The National Industrial Recovery Act of 1933, under which these codes were adopted, was later declared unconstitutional, but the practice remained. In 1938 the Fair Labor Standards Act renewed the 40-hour

week's basis in law by stipulating that hours worked in excess of 40 were to be compensated at one and one-half times the normal rate.

Don't know whether Baltimore ever had a Bijou movie theater. Don't know if there are too many around the country now. But at one time wasn't Bijou a very popular name for a movie house? Where did the name come from? And how is it pronounced?—F.M., Baltimore

You say it BEE-zhoo, although depending on the neighborhood you can also get away with everything from BUY-joo to BEE-joe—when you start trying to dress up your establishment with a little dimestore French, you take your chances on pronunciation. "Bijou," originally a French word meaning "jewel" or "trinket," was probably one of the five or six most common theater names in the country at one time (the others that occur to me offhand are Rialto, Tivoli, Adelphi, and Odeon). The word entered the English language in the 1600s and has since resisted the most determined efforts to throw it out again. Eventually it picked up an adjectival use as a rough synonym for "charming" or "of intricate design" with reference to architecture—e.g., a bijou cottage. Since theater owners have always like to advertise the attractiveness of their establishments, and since bijou has the added advantage of sounding exotic, Bijou Theater was a natural.

The first such joint that I know of was Hartz's Bijou Theatre, which opened (and closed) in New York in 1870. But the name was probably common before then. It later became quite popular during the vaudeville era. The entrepreneurial team of Albee and Keith, said to have done for vaudeville what Rockefeller did for oil, opened Bijous in Boston and Philadelphia in the 1880s, and thereafter Bijou theaters multiplied like rabbits. Most vaudeville houses, of course, were eventually converted to movie theaters, and many of the latter were eventually torn down, so that today we have precious few Bijou theaters indeed, which doubtless accounts for the present sorry state of the Republic. I could be wrong about this, but somehow I doubt coming generations are going to get nostalgic about the great video stores of their youth.

I'm told the surname "Brewster" comes from the title given to a female brewer. Is this true? I especially wonder since a

brewer was a member of a guild and I didn't think women were allowed to enter the guilds. What's the Straight Dope?—John M., Los Angeles

Hard to say. Many authorities agree that the ending *-ster* was originally feminine, and that terms like "brewster" were applied to female practitioners of various crafts. In addition to "brewster," we have "baxter," a female baker, and "webster," a female weaver. However, this distinction was lost pretty early on. For instance, surname expert Ernest Weekley notes the existence of one Simon le Bakestere (i.e., Simon the baxter, or baker) in a thirteenth-century chronicle. Today we have the term "spinster," originally a woman who spun, but we also have "gangster" and "teamster," both predominantly male callings.

Some guilds did admit women in the early years, mostly the widows of master craftsmen who inherited their husbands' shops. Women members were never very numerous, and restrictions against them increased as time went on. But it's interesting to consider that women may once have enjoyed a state of equality that they are now only gradually regaining.

Where does the name "John Doe" come from? Is Doe some ancient abbreviation or acronym, or a condensation of Dead On Arrival, or what?—G.H., Los Angeles

"John Doe" was the name used by the British to stand in for unknown parties in legal actions. Doe was generally the plaintiff, with his sidekick "Richard Roe" subbing for the defendant. Use of the name goes back at least as far as the fourteenth century; there's even some speculation that the names are as old as the Magna Carta (1215, if it's slipped your mind), which required two witnesses for every legal proceeding. According to this story, when the wily prosecutors of the day found themselves short of witnesses, Doe and Roe were automatically pressed into service. Then, as now, no one much seemed to mind.

I've been told that thousands of years ago mankind recognized the existence of only three colors. For obvious reasons I'm rather skeptical about this piece of historical wisdom. When were additional colors recognized? Did someone "discover" them—e.g., William of Orange? Eric the Red? You just can't find this out in the World Book.—Cary C., Santa Monica, California

In the restaurant of knowledge, Cary, remember this: the *World Book* is a snack, the *Straight Dope* is a *meal*. But enough of this folderol. Anthropologists and classicists have been arguing about color terminology since the nineteenth century, and it's only recently that the situation has begun to clarify. The opening shot was fired by William Gladstone, the British politician and Homeric scholar. He pointed out that abstract color terminology was virtually absent from Homer's work, and claimed that the Greeks had no sense of color at all, having only the ability to distinguish light from dark. He believed ". . . that the organ of color and its impressions were but partially developed among the Greeks of the heroic age"—i.e., the Greeks were physiologically incapable of perceiving color.

Lazarus Geiger, a naturalist, expanded on Gladstone's ideas. Based on his examination of Greek literature, the Vedic hymns, and other ancient writings, he claimed that man's color sense had developed only gradually, in fairly recent times. He thought that man had become aware of colors in the order that they appeared in the spectrum, starting with the longest wavelengths. First, he said, people dimly realized that something was "colored," then they could distinguish black and red, then black and red plus yellow, then white, then green, and finally blue. (I realize white is not a "color" of the spectrum, but this is Geiger's theory, not mine.) He pointed out that "Democritus and the Pythagoreans assumed four fundamental colours, black, white, red, and yellow. . . . Nay, ancient writers (Cicero, Pliny, and Quin-

tilian) state it as a positive fact that the Greek painters, down to the time of Alexander, employed only these four colours."

Later writers conceded the relative poverty of color terminology among ancient peoples, but denied that it reflected a physical inability to distinguish color. A major breakthrough on the question occurred in 1880 when an opthalmologist named Hugo Magnus organized a study involving missionaries working with primitive tribes around the world. Using standardized color samples and a rigorous testing procedure devised by Magnus, the missionaries found that primitive peoples with a limited color vocabulary nonetheless could distinguish colors every bit as well as persons from highly developed cultures—they just didn't have *names* for all the colors.

Not everybody bought this conclusion. As late as 1901 one researcher was arguing that the members of one primitive culture literally could not see any difference between blue and green because their retinas were more strongly pigmented than those of Europeans. But in general anthropologists came to accept the view that physiological differences did not explain the variations in color vocabulary among cultures.

So what does explain the variations? That's still a matter of dispute. The majority view, I would venture to say, is that the designation of colors in different cultures is totally arbitrary. For instance, H. A. Gleason notes, "There is a continuous gradation of color from one end of the spectrum to the other. Yet an American describing it will list the hues as red, orange, yellow, green, blue, purple, or something of the kind. There is nothing inherent either in the spectrum or the human perception of it which would compel its division in this way" (*An Introduction to Descriptive Linguistics*, 1961).

More recent research, however, suggests that color terminology may not be so arbitrary after all. Brent Berlin and Paul Kay (*Basic Color Terms: Their Universality and Evolution*, 1969), to whom Cecil is indebted for much of the preceding discussion, suggest that there is a remarkable degree of uniformity in the way different cultures assign color names. In a study of 98 languages from a variety of linguistic families, they found the following "rules" seem to apply:

1. All languages contain terms for white and black.
2. If a language contains three terms, then it contains a term for red.

3. If a language contains four terms, then it contains a term for either green or yellow (but not both).
4. If a language contains five terms, then it contains terms for both green and yellow.
5. If a language contains six terms, then it contains a term for blue.
6. If a language contains seven terms, then it contains a term for brown.
7. If a language contains eight or more terms, then it contains a term for purple, pink, orange, gray, or some combination of these.

Berlin and Kay also found that the number of basic color terms tends to increase with the complexity of the civilization. They speculated that this explains the sparsity of color terminology among the ancients—e.g., the Greeks had terms only for black, white, yellow and red because theirs was a relatively uncomplicated culture, at least from a technological standpoint. But Berlin and Kay admit they don't know why the "rules" should operate as they do. For more detail, check out their book.

• • •

QUIZ #4

19. In 1945, Chicagoan Frederick Walcher was arrested and convicted (fined $100 plus costs) on a charge of disorderly conduct. The specific nature of his crime was:
 a. being a gross, unsightly, or disgusting object in public
 b. shoving his mother through the skylight of his four-story apartment building
 c. attempting to vote Republican in the 11th Ward
 d. submitting to a public crucifixion

20. The only baseball player to pitch a perfect game in the World Series was:
 a. Don Larsen
 b. Joe Garagiola
 c. Bob Feller
 d. Don Newcombe

21. Several years ago *The New Yorker* published *Ulysses*—a few lines at a time—in the place of reviews of long-running musicals. They similarly published:
 a. *Wuthering Heights*
 b. the Manhattan telephone directory
 c. *Persuasion*
 d. *How to Win Friends and Influence People*

22. In 1966, Hedy Lamarr was arrested for:
 a. murder
 b. shoplifting
 c. disorderly conduct
 d. redundancy

23. The theme song "I'm Your School Bell" was associated with:
 a. Frances Horwich
 b. Bob Keeshan
 c. Pinky Lee
 d. Frances Farmer

24. "Teodor Korzeniowski" is the real name of:
 a. Leon Trotsky
 b. Charles Bronson
 c. Joseph Conrad
 d. Ted Koppel

Answers on pages 471–72.

Chapter 9

Fun and Games

I have three baseball questions, one technical, one histori-cal, and one theoretical. (1) The record books credit about a dozen players with unassisted triple plays. How, exactly, is this done? (2) Has any team ever made nine double plays or more in a game? (3) Which is more elegant, a perfect game accomplished in 27 pitches, each batter hitting into an out, or one accom-plished in 81 strikes, giving the position players nothing to do at all? (Warning: Roger Angell himself refused to answer this ques-tion.)—Peter D., Chicago

Roger is a good fellow, Pete, but when it comes to fine moral judgments, you'd best stick with Unca Cecil. Let's take your questions in order:

1. In your "typical" unassisted triple play (there have been only eight or so in major league history), you've got men on first and second. The batter hits a hard shot to either (a) the shortstop or second baseman, who catches it to put out the batter, touches second, retiring the lead runner, and then tags out the runner arriving from first, or (b) the first baseman, who tags out the first base runner and then runs to second before the lead runner can return.

One of the classic unassisted triple plays (and the only one ever to occur during a World Series) happened in 1920, in the fifth game between the Cleveland Indians and the Brooklyn Robins (Brooklyn used this wimpy nickname during the time the team was coached by Wilbert Robinson). Cleveland was leading when Pete Kilduff and Otto Miller reached base safely to open the fifth for Brooklyn. Clarence Mitchell then drove to right. The im-

mortal Bill Wambsganss, the Cleveland second baseman, made a leaping catch, stepped on second before Kilduff could get back, then tagged the startled Miller. Other notable events during the 1920 Series included the first grand-slam homer and the first homer by a pitcher in Series history. (Cleveland won the game and the Series.)

Then we have *assisted* triple plays such as the one on September 7, 1935, when Boston Red Sock Joe Cronin hit a line drive toward third. It bounced off the head of third baseman Odell Hale and into the hands of shortstop Bill Knickerbocker, who started a TP. I know this is a little off the track, but it just came up on my 365-Days-In-Sports desk calendar, and I couldn't stand not to use it.

2. Not in the majors. The record is seven double plays in a game, which two teams have managed to do: Yankees, August 14, 1942, and Astros, May 4, 1969.

3. The number of pitches thrown during a perfect game is no more relevant than the number of brush strokes used to paint the Mona Lisa. A perfect game is just that: perfect. To cavil about the minor details of such a performance is to proclaim that one has the morals of a newspaper publisher. I need say no more.

This riddle has been bugging me for years now. A man is standing in front of a judge waiting for sentencing, when all of a sudden he excitedly gestures toward a picture of a gentleman hanging on the wall above the judge's head. The prisoner exclaims, "That man's father is my father's son!" Who is the man in the picture? Please solve this.—G.G., Chicago

I'd love to, but unfortunately you goofed up the joke. Usually it goes, "Brothers and sisters have I none, but that man's father is my father's son." Rhymes, you see. Rash and impetuous persons are often inclined to say that the guy in the picture is the speaker himself. However, those who have had their minds toughened by regular exposure to the Straight Dope will see at once that the guy in the picture is the speaker's son. The way you tell it, though, the guy could be either the speaker's son or his nephew. (You may want to ponder this for a while.) Take it from me, sport—humor is no business for amateurs.

I've noticed that crossword puzzles in the newspapers are always symmetrical—that is, if you rotate them 180 degrees

around their centers, they look exactly the same (except, of course, that the little numbers are upside down). Why is this? If we find out, will it help us solve the puzzles? Please investigate!—Matthew S., Chicago

Tranquilize yourself, laddie. Crossword puzzles are symmetrical mainly because (1) symmetrical puzzles appeal to their authors' neurotic love of order (have you ever talked to a crossword puzzle editor?), and (2) the word arrays that crossword puzzles are based on have always been symmetrical, dating back to ancient times, when they were thought to have mystical significance. The first crossword puzzle, devised in 1913 by Arthur Wynne, an editor for the New York *World,* was diamond-shaped with no black squares at all (instead there was a diamond-shaped cutout in the middle), but it was symmetrical nonetheless. Wynne said he based the first crossword on word puzzles he had seen in magazines as a youth in Liverpool. In these puzzles, which were supplied without diagrams, you were asked to construct some sort of symmetrical word array (usually a square or a diamond, but sometimes a star or other shape) on the basis of various clues.

These puzzles had in turn been suggested by two earlier gimmicks: the acrostic (if you solved all the clues the first and/or last letters of the solutions would spell out another word or words),

and the good old word square (the words read the same horizontally or vertically). Acrostics, word squares, and word arrays in general have been around for millennia. One ancient Greek oracle used acrostic verses to spell out prophecies. A version of the famous word square below was found in the ruins of Pompeii:

SATOR
AREPO
TENET
OPERA
ROTAS

This square is unique in two respects: it can be read in four ways (up, down, right, and left), and it also makes a passable Latin sentence, which we may translate as "The sower Arepo holds the wheels at work." (I rely here on Roger Millington's *Crossword Puzzles: Their History and Their Cult.*) Using a bogus word like "Arepo" suggests that Roman puzzle-smiths were as fond of cheating as their modern-day counterparts, although one early writer claims the term meant plow.

Rotational symmetry was one of a number of crossword conventions established by the Amateur Crossword Puzzle League of America in 1924. Nobody seems to remember why, but I'd guess it's because rotational symmetry makes for more compositional flexibility than mirror-image symmetry. (An equally inscrutable convention is that puzzles usually have an odd number of squares on a side, so that there's always a square in the exact center). None of this information, needless to say, will help you in the slightest in solving a crossword. However, if you want a five-letter word meaning "synonymous with brilliance" (Hint: it starts with *C*)—hey, just give me a call.

We recently passed the 100th anniversary of the roller coaster (but you undoubtedly knew that). The first one, called the "Switchback Railway," was built by LaMarcus Adna Thompson at Coney Island (and you know that, too.) Obviously I'm a buff, but an unread one. So please explain: how does a roller coaster work, aside from the fact that they go up and then come down? What keeps them on the track? How can they run several trains simultaneously? How safe are they these days? And finally, which coaster is the biggest, and which the fastest? Great America, Magic Mountain, and King's Island all claim to be the pinnacle

of achievement in certain areas—which is the true winner?
—Lisa O., Chicago

Not to get persnickety about it, kumquat, but 1984 was the centennial of the first *custom-built American* roller coaster, not the first roller coaster period. The first one opened in Paris in 1804. The first U.S. roller coaster (of sorts) started operation in 1870 on a converted mountain railway in Mauch Chunk—great name, huh?—Pennsylvania. However, let's not sweat the details. Here's a rundown on your basic roller coaster technology: (1) *Motive power.* A chain drags you up, gravity gets you down. I assume you do not need this explained in further detail. (2) *Wheels.* Three sets clamp the cars onto the rails from above (the *road* wheels), the side (the *guide* wheels), and below (the *upstop* wheels). The idea here was worked out in 1912. (3) *Ratchets.* OK, you're in the roller coaster being hauled up the first hill by the chain, when suddenly the chain breaks. So you roll back down and make liver sausage out of two dozen cute little tykes in the train behind you, right? Wrong. Ratchets on the track (they're what make that characteristic clicking noise as you go uphill) keep the train from rolling backward. Modern roller coasters often have ratchets or some other antibacksliding device on other hills down the line as well. (4) *Brakes.* At key points along the route there are track brakes, which essentially grab the train and either slow it down (for instance, when it's pulling into a station) or, if necessary, stop it altogether. (5) *Signals.* The train rolls over a sensing device that sends a signal to RC Central

Command. In the old days this consisted of some mope with a couple levers; nowadays it's more likely a computer. Say you've got a roller coaster with two trains on it. You put a sensing device and a track brake at the midpoint on the route. When Train A passes the midpoint, it signals that it's OK to send out Train B. Now suppose Train A gets stuck somewhere short of the station. No sweat—you use the track brake to stop Train B at the midpoint.

In the old days this system did not always work. In 1937 a train on the Pippin (later the Silver Flash) roller coaster at Chicago's late, lamented Riverview Park somehow stopped on the tracks and was subsequently rammed by another train, injuring 60–70 people (no deaths). Nowadays, roller coaster buffs say, technological advances have made such a disaster as inconceivable as . . . oh, an accident at Three Mile Island. On some computer-operated systems you can run as many as five trains at once. If anything goes wrong, the computer stops all the trains automatically.

Actually, most roller coaster accidents are the result of a determined application of stupidity on the part of a rider. But occasionally there are other problems. Cecil has heard tell of one accident on a roller coaster in California in which attendants were unable to get the restraining bar locked around one very fat woman rider, so they let her go up without it. She was thrown out of the car and killed.

Government regulation of roller coasters and amusement parks in general for a long time was quite lax, despite their poor safety record. In May of 1984, for instance (I don't know if this was a typical month), nine people were killed and 34 injured on amusement park rides nationwide. In June of 1986, three people were killed and 15 others were injured when the last car of a triple-loop roller coaster went off the tracks and crashed into a concrete pillar in a crowded indoor shopping center in Edmonton, Alberta. Lately some states have begun to enact more stringent inspection requirements, and the U.S. Consumer Products Safety Commission is authorized to inspect rides in states that do not have inspection programs.

The fastest roller coaster in the world is the American Eagle at Great America in Gurnee, Illinois, with a claimed top speed of 66.21 MPH. Tallest is the 193-foot-high Tojoko Land Loop Coaster in Hyogo, Japan. Longest is the Beast at King's Island

near Cincinnati, Ohio (7,400 feet). As for the *best*—well, I talked to Robert Cartmell, the leading expert on roller coasters (no kidding—last time I talked to him, this guy had ridden 341 of these babies around the world). His top three are: #1—Texas Cyclone, Astroworld, Houston; #2—Mister Twister, Elitch's Gardens, Denver; and #3—Riverside Cyclone, Riverside Park, Agawam, Massachusetts.

I have always played Monopoly with an unstated rule that when a player pays out cash as a result of a Chance or Community Chest card, the money is put into the center of the board. Then, when somebody lands on Free Parking, they get to take all the cash that's accumulated up to that point. No one I know plays by any other rule. Yet the official rules of the game state, "A player landing [on Free Parking] does not receive any money, property, or any reward of any kind. This is just a free resting space." When did this variation begin? Why?—Dan J., Evanston, Illinois

You'd think Parker Brothers would keep track of vital facts like this, but guess again. Here's the sum total of their wisdom on the subject: "It is not known when the practice of collecting money on 'Free Parking' began." However, they do graciously allow that "while the official Parkers Brothers rules followed in tournament play do not allow such variations, you may follow

'house rules' if all players consent before play begins." Thanks a heap, guys. The Free Parking variation is apparently well known in all parts of the country, although an equal number of people play by the official rules. The purpose of the variation, obviously, is to enable financially inept players to scratch up a little extra capital. One of my sources says the kids on his block had worked out an even better scam: whenever you landed on Free Parking, you got one bill of each denomination from the bank— $686, if my addition can be relied upon. Such corruptions make it just about impossible for anybody to go bankrupt, meaning games go on forever. Talk about creeping socialism.

Other interesting board-game rule variations include the blank-tile substitution rule in Scrabble. Under this rule, if somebody puts a blank on the board to signify R, say, and later you wind up with an R in your rack, you can substitute the real letter for the blank and reuse the latter. This keeps the blanks in constant circulation, which can be useful toward the end of the game when everybody is getting down to the nubs, letters-wise. Another variation is the two-rooks rule in chess, which (as I understand it) allows you to move both rooks one square forward from their original spots at the same time. Sort of like castling, I guess. If you guys know of any other interesting variations, send 'em along.

The Teeming Millions Come Through!

Speedily responding to my recent request, Alex M. of Evanston, Illinois, has submitted a list of what appears to be every Monopoly rule variation ever devised by the mind of man, ranging from the mundane to the criminally deranged. Herewith a sampling:

- If you land directly on Go, you collect $400 instead of the usual $200. There's also the "subway" variation—if you land directly on Go, on your next turn you can choose not to roll the dice and move instead directly to any other space on the board.
- If you go bankrupt, you can file for reorganization under Chapter 11, meaning you distribute all your cash on hand to your creditors but continue to play. Next time you go

bankrupt, though, you're out, unless you can convince the government to subsidize you for the good of the economy.

• Players can establish "investment funds" by paying any sum of money into the bank. Subsequently they draw 10 percent interest on their investments (plus $200) every time they pass Go. (A similar variation is the "Florida swamp land" rule, in which the players give all their funds to the Salesman [the player who can talk the fastest], who then disappears without a trace. A good way to end the game quick.)

• If you own all four railroads, you can build "stations" on them. (These stations look suspiciously like houses, thereby demonstrating the monotonous uniformity that is characteristic of modern architecture.) Rent progresses upward until you get to "Grand Central Station," the equivalent of a hotel, which permits you to extort $1,700 from the unlucky sap who lands on it.

• For the ultimate in sybaritic living, we have the concept of "building beyond hotels": an Estate with Gardener's Cottage (a hotel plus a house), an Estate with Gardener's Cottage & Rolls Royce Garage (a hotel plus two houses), and a Palace (a hotel with three houses). These permit rents to be raised to truly astronomical levels—a Boardwalk palace will net its owner a whopping $7,500, resulting in instant ruin for the lessee/victim.

• Then there's the WAHOO card, which you get one of every time you land on Free Parking. Among other things there is the Three Mile Island Contamination card, in which "the color group of properties of your choice is contaminated by leaked nuclear wastes and no owner of a property on that group can collect rent until they have twice passed Go and paid a $500 clean-up charge to the bank." Guaranteed to bring a touch of realistic contemporary angst to the game.

Finally, for those who are truly interested in making Monopoly a spiritually significant experience, hustling Straight Dope managing editor Pat C. suggests a splendid variation called Cosmonopoly. Here, instead of chasing after tawdry commodities like Baltic and St. Charles Place, we aspire to the Platonic virtues, Truth and Beauty. We replace Community Chest and

Chance with Free Will and Predetermination, one of the cards from which may sternly admonish you to "GO DIRECTLY TO THE METAPHYSICAL VOID. Do not pass Being or Essence. Do not collect $200." To get out of the Metaphysical Void, you either have to grasp the meaning of the universe or roll doubles twice. On the Catholic side of the board, instead of collecting all the properties in a color group, your aim is to acquire Wisdom, Understanding, Knowledge, Counsel, Piety, Fortitude, and Fear of the Lord. Playing pieces to select from include the Jean-Paul Sartre piece (comes with blank dice and it's up to you to decide how far you want to go) and the Nostradamus piece (you just sit around and guess who's going to win). Entrepreneurs interested in making a killing on this outstanding concept may write care of this column for a complete prospectus.

Over many years of watching major league baseball, my father and I have observed a peculiar practice. Apparently every team, at the end of their half-inning on the field, has someone in the dugout whose duty it is to throw a ball to the first baseman as he runs off the field. What is the purpose and/or origin of this practice? Why not throw to the shortstop, the right fielder, why throw a ball at all? No one I have ever talked to about this has even ventured a guess as to what is going on. I certainly hope you can enlighten me.—Joe B., Tempe, Arizona

I had always assumed, Joe, that the custom you describe was some old superstition, like not washing your socks during a winning streak. However, various baseball sachems with whom I have conferred on this matter assure me that such is not the case. A baseball *superstition* is some meaningless ritual that you perform for good luck's sake—for example, stepping on third base on the way on or off the field, or not stepping on the foul line. A baseball *tradition*, on the other hand, is some equally meaningless ritual that you perform just because baseball players have *always* done it that way.

Tossing a ball to the first baseman is in the latter category. As you know, one of the first baseman's principal responsibilities is throwing a ball around the horn to warm up the infielders when the team takes the field each inning. Naturally that means the first baseman has to scrounge up a ball somewhere to start with. In the early days of the game, many first basemen were evidently so dense they could barely find the bathroom, much less anything

as inconspicuous as a baseball. Hence the practice of handing them a ball as they entered the dugout, lest they delay the game while they bumbled around looking for one. Today, of course, most first basemen have advanced educational training that renders such precautions unnecessary—but the tradition lives on. Such reverence for the past is what has made baseball great.

I've never been much of a poetry buff, but there are two poems that have been bugging me for years. I've only heard their opening lines on television. The first one is from an episode of "The Honeymooners" in which Ed Norton recites the lines, "As he stepped into the night air, little did he realize the fire escape was not there . . ."—and that was all I heard. The other one is a limerick that has been quoted on various TV shows. It starts, "There was a young (man, girl, woman—I've heard several versions) from Nantucket . . .", and the reciter is always cut off at that point. Knowing the rest of these poems will surely put my mind at ease.—Willie H., Chicago

Willie, I'm trying to fight down the gnawing suspicion that you're the kind of guy who goes around ruining jokes by piping up, "And then what happened?" right after the punchline. As anyone with a sense of literary form has already deduced, the two lines you remember constitute the entire poem (or at least they're all that Norton recited). Here's an accurate transcription: "As he crept into the stealthy night air/Little did he realize the fire escape was not there."

On to limericks, the most sublime and meaningful of all poetic forms. There are innumerable versions of the famous "Nantucket" verse, ranging from the cute to the irredeemably vile. It all started innocuously enough with the following stanza, published years ago in the *Princeton Tiger*.

There was an Old Man of Nantucket
Who kept all his cash in a bucket
 His daughter, named Nan,
 Ran away with a man—
And, as for the bucket, Nantucket

This inspired numerous sequels, the most distinguished of which are believed to be the following, from the *Chicago Tribune* and the *New York Press*, respectively:

Pa followed the pair to Pawtucket
(The man and the girl with the bucket)
 And he said to the man,
 "You're welcome to Nan,"
But as for the bucket, Pawtucket

Then the pair followed Pa to Manhasset
Where he still held the cash as an asset
 And Nan and the man
 Stole the money and ran
And as for the bucket, Manhasset

Nothing like a little good clean fun, I always say. Unfortunately, things have gone downhill since. Out of consideration for the dainty feelings of my readers, I bleeped out portions of the following, but you can probably fill in the blanks yourself:

There was a young man from Nantucket
*Whose dong was so long he could *?@! it*
 Said he with a grin
 As he wiped off his chin
"If my ear was a %$#!! I could ⌐@?! it."

Vulgar, I know, but you asked.

Ever since junior high, when participation in any sport was an occasion for all manner of humiliating failures and verbal and physical abuse from my teammates, I have been insecure, to say the least, about all things athletic. Nevertheless, I couldn't help but get whipped into a frenzy over the 1986 NFL draft. The Super Bowl champion Bears were widely reported to have had the twenty-seventh pick in the first round. As champs, they got stuck with the last pick in each round. But how could the last pick have been the twenty-seventh? It couldn't mean that there are an odd number of teams in the NFL, because every team plays every week, and it's two teams to a game, right? (Don't tell me I don't understand football.) Trades couldn't have had anything to do with it—no matter what teams actually pick, the draft originally calls for one pick per team per round, so we're dealing with a basic universe of 28 picks per round. (I call this the Law of Conservation of Draft Picks. I always did have a scientific bent.) Have I really discovered some secret flaw in

*modern football, or am I in for more snickering in social stud-
ies?—Fred S., Chicago*

Probably the latter, Freddie, but don't feel bad. I had to
apply both lobes to this problem for a full half hour, and I'm
still not sure I've got all the nuances right. Let's get one thing
straight first: there are 28 teams in the National Football League.
The reason only 27 teams picked in the first round in 1986 was
that in 1985 Cleveland traded its first-round '86 pick to Buffalo
so it would get the number-one pick in the '85 supplemental
draft. Supplemental drafts are usually held after graduation for
college players who weren't eligible for the regular draft. They
normally don't attract much notice, but 1985 was an exception.
The top player coming up was Bernie Kosar, a hot quarterback
with the University of Miami (Florida), who had led his team to
the national championship in 1983–1984. In the spring of 1985,
Kosar had only been in school for three years, and thus wasn't
eligible for the regular draft, which is open only to college play-
ers who have (1) been in school four years or (2) graduated. But
being an honor student in addition to a gifted athlete—believe
me, I hate guys like this—Kosar was able to accumulate enough
credits to graduate a year early. Thus he became eligible for the
supplementary draft. Now, here's where the strange part comes
in. Bernie is a native of Cleveland. He had spent several years
in Florida, so he obviously knows how the other half lives. And
we know from his college record that he's no dope. *Yet despite
the fact that he had detailed knowledge of life on Lake Dreary,
he wanted to move back there to play for the Browns.* You figure
it out.

NFL rules prevented the Browns from signing any kind of con-
tract with Kosar before he graduated. But they were so confident
of his intentions that in April of 1985 they traded their first- and
third-round picks in the 1985 draft and their first- and sixth-
round picks in the 1986 draft for Buffalo's first-round pick in the
1985 supplementary draft. (Buffalo, having accumulated the
worst record in the history of the universe, naturally got the first
pick in the first round.) NFL rules say that if you pick somebody
in the supplementary draft, you sacrifice your pick in the corre-
sponding round of the following year's regular draft. The league
has a complicated way of doing the bookkeeping, but the results
are simple: no pick for Cleveland in 1986, and only 27 picks in
the first round overall. Kosar, incidentally, seems to have worked

out just fine. I hope all three of you guys who are still following me appreciate all the effort I put into this. Next week something easy, like home brain surgery.

Being an avid football fan, I spend a few hours each Sunday watching the Redskins during the fall. This season I also watched every "Monday Night Football" game. Every game has been broadcast live from a stadium in a different part of the country—from New York to Seattle to Miami to San Diego. I haven't paid that much attention to it in past years, but on every single game this season I noticed someone in the stands holding an identical card reading "JOHN 3:16." Usually the person is sitting at either end of the stadium so that when a kicker goes to kick an extra point and the camera shot is from his back, the sign being waved is clearly visible. Am I missing out on something? What the hell does John 3:16 mean? Is it a hex on the kicker? Is it a riddle? Is it the same person at every Monday night game? (No way!) Cecil, what's the frequency? I'm as perplexed as Dan Rather! Please rescue me from my ignorance.—Thelonious C., Washington, D.C.

Cecil is conscious at times like this of being a helpless participant in that vast engine known as the Mass Media, which is routinely suckered by shameless publicity hounds looking for a little free air time. It is even so with the John 3:16 man. But what the hell, at least the guy doesn't sell guns to the Ayatollah. His name is Rollen "Rock'n Rollen" Stewart. He's an off-the-wall born-again Christian whose mission in life is to get his signs (and

his mug) on national TV as often as possible, the better to spread the word of the Lord. Only in America.

The business with the signs started in 1980, when Rollen accepted Jesus as his personal savior. Prior to that time his interest was in just generally being famous (or, as he puts it, being "the most famous person in the world no one knows about"). For years he was the guy you used to see on telecasts of golf tournaments with the wild multicolored Afro wig, which earned him the nickname "Rainbow Man." (He has since put the wig aside.) Having scouted the camera angles beforehand, he'd pop out of the crowd at an appropriate moment, waving his arms, making "OK" or "thumbs-up" gestures, and grinning like an idiot.

Rollen's original idea was that he would parlay this shtick into a job as a media pitchman, but his only big score was a role in a Budweiser commercial. Then he got religion. (Fittingly, he saw the light while watching a TV preacher.) He commenced to wearing and/or carrying "Jesus Saves" and "Repent" T-shirts, signs, and whatnot, hitting an average of two major televised events a week. Eventually he graduated to signs with scriptural references, such as John 3:16. ("For God so loved the world, that he gave his only begotten Son, that whosoever believeth in him should not perish, but have everlasting life.") The theory is that you'll start looking things up in the Bible to figure out what's going on, and before you know it, you'll have stumbled into a life of permanent righteousness.

Traveling around to various events is Rollen's only occupation. He lives in his car with his wife, a fellow sign flasher, subsisting entirely on donations. In addition to golf tourneys and football games, he's appeared at numerous World Series, the summer and winter Olympics, the Republican and Democratic national conventions, the Indy 500, the Kentucky Derby, the NBA and NCAA basketball finals, the Stanley Cup, and perhaps most memorably of all, the wedding of Princess Di and Chuck. One summer, he proudly notes, he was down in Mexico hogging the limelight at the World Cup soccer championships, which were viewed by 2.8 billion people worldwide. He estimates that he and his confederates, who help maintain the illusion that he's everywhere, have appeared at more than 1,000 events to date.

Rollen's relations with officialdom are touchy at best. He's been bounced out of numerous joints, and he and another guy are currently suing the managers of RFK stadium in D.C. over the

right to display signs. Yet he refuses to become discouraged. Indeed, he envisions the day when he'll be at the controls of Sign Flasher Central, directing the efforts of evangelical exhibitionists across the U.S. by means of TV monitors and cordless telephones. If ever there was a guy who was a hero for the 80s, Rock'n Rollen Stewart is it.

Walt Kelly's old comic strip "Pogo" had an unusual version of the Christmas carol "Deck the Halls." I've tried to remember all the lyrics, but I'm not convinced I've succeeded. So far I have:

> Deck the halls with Boston Charlie
> Fod-a-rod-a-rol (etc.)
> Nora's freezing on the trolley,
> Walla-walla-bash and Kalamazoo.

Is this complete? Is there more? Am I missing something?—Bill O., Chicago

No doubt, Bill, although whether this is a congenital problem or a tragic consequence of last month's lobotomy column we may never know. According to Kelly's posthumous chroniclers, there were six complete verses for "Boston Charlie":

> *Deck us all with Boston Charlie,*
> *Walla Walla, Wash., an' Kalamazoo!*
> *Nora's freezin' on the trolley,*
> *Swaller dollar cauliflower alley-garoo!*

> *Don't we know archaic barrel*
> *Lullaby Lilla Boy, Louisville Lou?*
> *Trolley Molly don't love Harold,*
> *Boola boola Pensacoola hullabaloo!*

> *Bark us all bow-wows of folly,*
> *Polly wolly cracker 'n' too-da-loo!*
> *Donkey Bonny brays a carol,*
> *Antelope cantaloupe, 'lope with you!*

> *Hunky Dory's pop is lolly gaggin' on the wagon,*
> *Willy, folly go through!*
> *Chollie's collie barks at Barrow,*
> *Harum scarum five alarum bung-a-loo!*

Dunk us all in bowls of barley,
Hinky dinky dink an' polly voo!
Chilly Filly's name is Chollie,
Chollie Filly's jolly chilly view halloo!

Bark us all bow-wows of folly,
Double-bubble, toyland trouble! Woof, woof, woof!
Tizzy seas on melon collie!
Dibble-dabble, scribble-scrabble! Goof, goof, goof!

Fractured Christmas carols were a regular feature of Kelly's holiday strips. Churchy LaFemme once came up with a version of "Good King Wenceslas" that went: "Good King Sauerkraut, look out! On your feets uneven . . ." No question about it, Kelly was a genius. The lyrics to "Boston Charlie" along with many of the strips in which the verses were introduced may be found in *Outrageously Pogo* (1985), edited by Mrs. Walt Kelly and Bill Crouch, Jr.

I knew a woman who would walk through campus Hula Hooping, all the while reading a physics textbook. Ever since then I've been wondering: Does that little ball inside the Hula Hoop do more than provide sound effects? Is it necessary to keep the Hula Hoop going? Please end my sleepless nights!—Lisa S., Washington, D.C.

You can't sleep, Lisa kid, try Sominex. You want to explore the frontiers of knowledge, keep reading. We called up the Wham-O company, maker of the Hula Hoop (as well as the Frisbee and the Super Ball), hoping for a little technical insight. Everybody we talked to said the little ball—actually three or four steel BBs—was just for sound effects. We learned that the original Hula Hoop, which Cecil had known and loved as a child, was silent. But later generations, their senses dulled by constant TV viewing, required more sonic razzle-dazzle. The first noisy hoops, called Shoop Shoop Hula Hoops, had pieces of walnut shell sliding around inside. Later this gave way to the BBs now found in all hoops.

Fine, I said, but are you sure another reason you put in the ball bearings wasn't that you were down-sizing the plastic in order to goose the profit margin and you needed the extra weight to give the hoop some heft? Cross our hearts, they said, and we

believed them. However, the most senior among them, the plant manager, had only 20 years experience with the company, whereas the Hula Hoop was 30 years old. Who knows what chicanery may have taken place in those early years?

So we decided to put the matter to the practical test. We went out to Toys "R" Us and bought a regulation Hula Hoop ($3.69 plus tax). We practiced diligently until we could keep the damn thing going for five minutes at a crack, no small task if you haven't done it for 25 years. (Cecil notes happily that he got the hang of it before Mrs. Adams, who generally delights in humiliating him in matters athletic.)

Then we took out the BBs and tried again. Result: no observable difference, except that we were now free of that godforsaken racket and could concentrate on the Zen of the Hula Hoop experience. My advice to you parents: deep-six the little noisemakers for good. (I mean the *BBs*, silly.) The kids want more stimulation, tell 'em to go see *RoboCop*. The interval between the Terrible Twos and the onset of heavy metal is short enough as it is.

10

Carnal Knowledge

This will no doubt come as one of your more bizarre queries, but why not a little levity in this world of woe? For 16 years, after every orgasm, whether self-caused or by a lover, whether I was happy or sad, and in 30 different countries, I sneeze, often violently and repeatedly. Have you ever heard of such a phenomenon before? I am a 36-year-old female journalist, straight, with no known allergies. Is it simply a relaxation of tension or am I allergic to sex? It's not particularly annoying to myself or others, but it intrigues me. It doesn't matter if the sex is oral or more conventional, the man bald or hairy, the location a beach, an all-satin bed, or a forest. I await your answer with bated . . . achoo!—C.G., Washington, D.C.

Orgasms in 30 different countries, huh? I'm impressed, sweetie—some of this column's hapless correspondents have a tough time getting it on in one. But we can compare notes later. As far as postcoital sneezing goes, you have to realize that in sex, "idiosyncratic reactions are myriad," as one researcher puts it. Having scoured the literature (and in addition having polled the Straight Dope production department, whose sexual eccentricities are legendary), I have compiled the following partial inventory of unusual physiological reactions to sex:

(1) *Sensation of excessive warmth or cold following orgasm*, often accompanied by sweat. Frequently perspiration is localized in the hands and feet. Masters and Johnson say that roughly one-third of both men and women have a sweat reaction on occasion.

(2) *Sexual flush*, a measleslike red rash that starts in the stomach area and spreads to the chest and (in women) the breasts, and

in extreme cases can cover virtually the entire body. Sexual flush usually begins in the latter stages of foreplay and recedes after orgasm. Seventy-five percent of women are said to experience sex flush at least some of the time; the figure for men is smaller. Said to be associated with intensity of the sexual experience. (3) *Itching and/or tingling* following orgasm. (4) *Increased appetite* for food, drink, or a good smoke. Very common. (5) *Uncontrollable laughing, talking, crying, or frenzied movement* at the point of orgasm. Can be very disconcerting for one's partner, believe me. (6) *Urge to urinate or defecate* during or after orgasm. Some women, in fact, emit a clear fluid that, depending on whom you ask, is either urine or an analogue to male ejaculate. (7) *Sneezing fits.* (8) *Headaches.* I got this from Dear Abby. Supposedly this occurs in some men due to accelerated heart rate and increased blood pressure during orgasm. Happily, not a common problem. (9) *Miscellaneous other weird reactions.* One of my interviewees says sex makes his hemorrhoids worse; another says it gives him cramps. We got a real fun bunch around here.

Exactly what causes all these things is not clear. In general, however, they probably result from one or both of the two generalized physiological reactions that occur during sex: *vasocongestion*, i.e., heavy blood flow into various organs (not just

the obvious ones), and *myotonia*, or increased muscle tension. As long ago as 1875 it was known that sex sometimes causes "engorgement of the erectile tissue of the turbinates," i.e., nasal swelling and congestion, often accompanied by sneezing. The sneezing may be caused by some mechanical irritation of the nasal passages triggered by orgasm, or (and I quote) "it can also be initiated by stimuli from the higher cerebral centers such as the psychosexual images which are commonly associated with copulation." Very romantic.

If you ever want to stop the sneezing, some doctors recommend administering a nasal anesthetic before getting into the sack. I have a somewhat boring prescription here calling for 1 percent tetracaine and 2 percent ephedrine sulphate, but I note that in ages past they used to use cocaine. No fooling. Give it a whizz and let me know what happens. If that fails, one remedy in the *Journal of the American Medical Association* requires "cauterization of the Fliess nasogenital areas," which sounds pretty horrible. I'd say you're smart just to leave things alone.

Some of us were sitting around the other night and came up with some questions about a well-known part of the male anatomy. Do they keep, you know, records for the longest and/or widest? If so, what are they (the records, that is)? Also, legend has it that certain ethnic groups are better endowed on average than others. Is there any truth to this?—F.P., Baltimore

I am not aware of any systematic attempt to determine the world's longest male member. Specimens as long as 13 inches (when erect) and as short as 3 inches have been reported. When you get to talking about averages, though, it's another story. The famous sex research pioneer Alfred C. Kinsey kept track of all kinds of weird stuff when he was doing his surveys, and penis length (and girth) were among the things he studied. The results are recorded in a fascinating volume called *The Kinsey Data* (Gebhard and Johnson, editors, 1979), which includes tables on topics like "Which Testicle Lower in Scrotum," "Incidence of Playing Strip Poker," and "Extent of Sexual Contact with Animals." (Like I say, the doc was a mighty curious guy.) Kinsey's data indicated there's a lot more variation in flaccid penis length than there is in erect penis length. Under actual working conditions, in other words, things tend to even out.

The most striking demonstration of this is the comparison be-

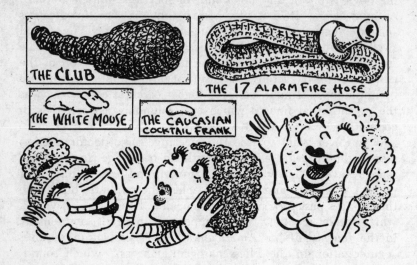

tween whites and blacks. Largely on the basis of furtive obser-
vations in the locker room, white males tend to believe that blacks
are better endowed than they are, and Kinsey's measurements of
flaccid penis length tend to bear this out. White males had an
average flaccid penis length of 4.0 inches, whereas the average
black male's detumescent member measured 4.3 inches. But
when erect, the average white penis was 6.2 inches long, whereas
the average black's was 6.3 inches—still longer, but not by much.
(Average circumference for whites was 3.7 inches; for blacks, 3.8.)
These figures must be regarded with caution: there were more
than 2,500 white male respondents, but only 59 black males.
(Incidentally, for those who wish to pursue this matter on their
own, you measure along the *top*. You'd be surprised how often
this question comes up.)

Kinsey is silent regarding Oriental endowments, but we have
evidence from other quarters—columnist Bob Greene, of all peo-
ple. In his book *Cheeseburgers*, Greene reports that during a visit
to the Trojan prophylactic factory he learned that condoms come
in two sizes—7.1 inches by 52 millimeters for the American mar-
ket, 6.3 inches by 49 millimeters for Japan. A comforting
thought. The Japanese may be smarter and better organized, but
there's one place where we've still got 'em beat.

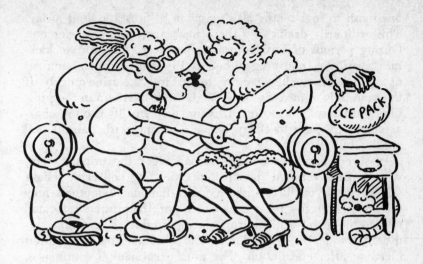

I think my roommate is having sex with his cats. Could you explain the biological reasons why cats can't be impregnated by human beings?—T.S., Chicago

For the same reason you can't park a Cadillac in a closet, you bozo.

After recently engaging in some high school-style sex (prolonged stimulation without orgasm), I experienced the painful phenomenon of, you should pardon the expression, "blue balls." And yet after another similar incident, perhaps even more prolonged no such painful results occurred. Why do one's loins ache sometimes after a bout of non-orgasmic eroticism, and not at other times? Is this a health hazard to be concerned about?— Charles, Los Angeles

Why this happens some times and not others is one of those imponderable mysteries, Chuck. However, the health issue is something else again. Many urologists believe that extended tumescence without orgasm can cause congestive prostatitis, an extremely painful condition of the prostate gland. Among other things, the prostate gland secretes the clear fluid which is the vehicle for the sperm in male ejaculate. When not in a state of sexual excitement, a normal male's prostate will cook up about

one-tenth to four-tenths of a teaspoon of prostatic fluid a day. This ordinarily drains into the urinary tract and gets excreted. During periods of sexual arousal, however, the prostate kicks into overdrive, churning out 4 to 10 times as much fluid as usual—far too much, some say, to pass into the urine quickly. If the man fails to have an orgasm, the stuff backs up in the prostate and causes congestion. In younger men this is often characterized by pain in the pelvic area along with painful and swollen testicles.

In severe cases the congestion can block the urinary tract, which passes through the prostate, meaning you can't relieve yourself and you fill up like a water balloon. Symptoms may include pain in the lower back or rectum (the prostate is located next to the rectal wall), burning sensation during urination, unusually frequent urge to urinate, and sometimes pain and minor bleeding after ejaculation. The usual treatment is continence, perhaps accompanied by ice packs and/or an anti-inflammatory drug.

Other causes of congestive prostatitis include an unusually volcanic session of lovemaking, in which repeated orgasms within a short time overload the system. Some doctors say any sudden change in your sexual habits, whether it's sex followed by abstinence or vice versa, can lead to prostatitis. Still others say long-term abstinence all by itself will do the trick—hence the expression "the priests' disease" (also known, I'm informed, as "the Brandeis University freshmen's disease"). Not everybody buys this, though. Some researchers believe the prostate adapts fairly readily to its owner's requirements, and that prostate problems have some other organic cause.

Prostate problems usually don't become chronic until you're well past 40, but here's something else you can worry about in the meantime. At least one researcher has suggested that pressure in the gonads during sex can cause a back-up of sperm into the prostate, which in turn can lead to prostate *cancer*—further proof that everything fun in this world is bad for you. Presumably a lengthy bout of nonorgasmic sex, in which the pressure never gets relieved, would make cancer even more likely. Sounds grim, but look on the bright side: it offers a valuable addition to the frustrated male's arsenal of can't-miss makeout lines. Now, in addition to "I'm leaving tomorrow on a suicide mission" and "Hey, they might drop The Bomb tomorrow," there's "Cheezit,

honey, you want me to get *cancer?"* Try it, Chas, and maybe next time you'll get past first base.

Recently I saw beaded skirts in an African museum labeled "worn by circumcised girls." Since then I've been wondering (a) how do you circumcise a woman, (b) why would you circumcise a woman, (c) is this practice continued today, and if so, where? Also, if they cut off what I think they cut off, how does it affect a woman's sexual response?—Lauren G., Chicago

The same way having your feet sawed off affects your ability to polka, as any of the estimated 30 to 75 million victims of this barbaric ritual can testify. While some forms of female circumcision merely involve minor nicking of the clitoris or ritual defloration (manual breaking of the hymen), more radical forms require the complete removal of the clitoris and portions of the labia, an operation known as clitoridectomy. (So-called "Sunna" circumcision, regarded as less radical than some forms of clitoridectomy, calls for the excision of the prepuce and/or tip of the clitoris. Many Muslims believe that this practice was recommended by Muhammad.) Even more appalling is infibulation, in which the entire clitoris, the labia minora, and the labia majora are removed and the vulva is fastened shut with thorns or thread, leaving only a small opening for urination and menstruation. The woman has to be cut open before intercourse. In some cultures the clitoris is cauterized or rubbed with nettles to destroy the nerve endings.

Females circumcision is sometimes performed shortly after birth, but more commonly it is done between the ages of three and eight, often without benefit of anesthesia. Infection and other medical and psychological complications frequently result. Numerous justifications for the practice have been advanced: that it "cures" masturbation (which it does, the same way decapitation cures acne), that it ensures chastity and/or purity, and so on. Feminists argue, with considerable justification, that the real reason is patriarchal fear of female sexuality. But in many cultures female circumcision has become so ingrained that women themselves do most of the dirty work. A *Ms.* magazine report on the subject some years ago told the story of a little girl who begged her mother to circumcise her so she could be just like the other girls. (The mother only pretended to comply.)

Female circumcision is most prevalent in Africa and the Mid-

dle East—one survey estimated that 75 percent of Egyptian women had been subjected to it. But it has turned up from time to time in the West as well. In Victorian England, Dr. Isaac Baker Brown established a special hospital to perform clitoridectomies to cure masturbation, although public outrage forced him to shut down after a short while. In the U.S. a band of quacks led by Dr. E. H. Pratt promoted "orificial surgery," which included not only circumcision but also forcible dilation of the anus as a cure for epilepsy, masturbation, and other ailments. No less an authority than Sigmund Freud once wrote, "The elimination of clitoral sexuality is a necessary precondition for the development of femininity." As late as 1936 a standard pediatric textbook recommended cauterization of the clitoris to stop masturbation.

While female circumcision has largely died out in the developed countries, efforts to suppress it in the Third World have met with less success. International health agencies are reluctant to interfere in local customs, ghastly though they may be, and attempts by outsiders to stamp out the practice frequently meet with fierce resistance. In recent years, however, there have been signs that African women themselves are beginning to organize in opposition to female circumcision. African women's groups presented statements opposing genital mutilation to various UN conferences in 1980. In Egypt, Islamic scholars were persuaded to issue a statement that "the Koran does not mention circumcision, nor is there any definite proof that the Prophet either ordered or recommended it." What with the rise of Islamic fundamentalism, though, I'm inclined to think female circumcision may be with us for years to come.

Living in a heavily gay neighborhood as I do, I have seen my share of leather freaks, transvestites, and lesbian couples making out at the beach. My question is, are such carryings-on a uniquely human phenomenon? Do our friends the animals ever get unnatural urges? Do monkeys, cats, dogs, etc., ever frequent gay bars, collect Barbra Streisand records, or speak with a lisp? Please, Cecil, I have a desperate need to know these things.
—The Last Straight in New Town, Chicago

You asked for it, pal. Herewith the contents of my entire file on kinky animal habits. Kinky monkey habits, actually. Warning: it ain't pretty. Read at your own risk.

1. There really are such things as gay monkeys. Animals usu-

ally engage in homosexual behavior only when crowded, deprived of normal heterosexual contact, or otherwise subjected to stress. However, Erwin and Maple (1976) described two male rhesus monkeys who lived together for 19 months and engaged in "reciprocal mounting with anal penetration." When paired individually with females, the male monkeys would exhibit conventional heterosexual behavior. However, when the two were put in a cage together with a female, they would hassle her and direct all their affections toward each other.

2. Monkeys make use of artificial instruments of lust. Ford and Beach (1951) tell of a female chimpanzee of low morals and even lower intelligence who attempted to achieve carnal union with a mango. Her technique consisted of placing the mango upon her external genitalia and awaiting the arrival of sexual bliss. When after some moments it became apparent that this might be a long time coming, the chimp placed the mango on the floor, sat on it, and twisted and rubbed against it with vigor. Bingham (1928) reports a somewhat more imaginative chimp who availed herself of a leafy twig, which she installed below decks and then rubbed against the bars of her cage.

3. Some male monkeys can (and do) lick their own . . . oh, never mind. Spider monkeys also use their prehensile tails to stimulate themselves.

4. Monkeys engage in oral sex, mutual masturbation, and other similar activities. I have a photograph here from a book of sex research (a perfectly sober volume, let me assure you) showing a male gorilla administering oral gratification to his lady. He does this by climbing up on her thighs, leaning down, and perching on his head. The effect is not as graceful as it might be. A younger male gorilla observes with interest from the sidelines. Elsewhere in the book we find detailed renderings of various positions from the monkey Kama Sutra, drawn from life by dedicated researchers. No doubt about it, zoology offers some fascinating career opportunities.

One chilly fall evening recently my girlfriend came over with her cat. She wanted me to take the animal's portrait, since it is very old and nearly dead. So we set up this great Sarah Bernhardt drawing room environment, with a plush oriental rug on the floor, velvet pillows, satin ruffles, potted palms, the whole deal. The cat wasn't impressed. He wouldn't sit still, so my girl-

friend got in the picture to hold the damn beast. It's boring up to here, but now we're starting to get to the point. . . . The cat walked off. My friend didn't. The lights got hot . . . and my friend mellowed . . . and, in the name of art of course, she sort of started posing rather, um, au naturel. . . .

(Wait! It gets better!) Suddenly, a light bulb lit above my head that outshone the 750-watt floods! The camera had a timer and a delayed shutter!

Well, needless to say, I had done a little modeling before and felt right at home in front of the lens . . . so I joined in. And . . . if you know what I mean . . . we got some DYNAMITE SHOTS!

Now here's the problem: where do I get these developed? I mean, this film's so hot I can't even get it in the self-mailer without spontaneously combusting! Even if I put on dark glasses and a Groucho nose when I went to the drugstore to pick it up, it would melt before the nice lady could hand it over the counter.

So where can I get it processed without winding up in county jail? I've spent the past several afternoons squinting over those tiny, hard-to-read ads in the backs of dirty magazines to no avail. I can't even find a sleazy mail-order dirty-little-man-in-his-basement joint! My friend and I would greatly appreciate any ideas. I used 35mm Kodacolor II.—Larry F., Chicago

Seems to me you're getting a little paranoid about this, Lar, but then again these are strange times. Let's start with the law first. So far as I have been able to discover, it is not illegal in any state to take pictures of consenting adults engaging in sex, nor is it illegal to develop them, despite what you may hear from store clerks. It *is* illegal in most states to engage in the sale of pornography. However, it is an "affirmative defense" (I quote here from the Illinois statute) "that the dissemination [of the photos] was not for gain and was made to personal associates other than children under 18." So from a legal standpoint it sounds like you guys are in the clear, no matter how sexy your pictures are.

This is not to say you can just sashay into any corner drugstore and demand that they develop your film. The law notwithstanding, any photo finisher is free to establish its own policies about what kinds of pictures it will or won't handle, as long as they're consistently applied. Most of the big chains, such as Walgreen's

and Fotomat, won't develop pictures of naked people at all, mainly because, as Walgreen's puts it, "we're a family-oriented company." The stores don't actually have somebody in charge of censoring pictures, but the employees who do quality inspections and whatnot are told to cull out the amateur erotica. You'll get the negatives, for what that's worth, but no prints. Walgreen's has even been known to nix pix of kiddies in bathtubs. Eastman Kodak will develop pictures involving nudity, even of the full-frontal variety, if you send the film to them by mail, but they draw the line at overt sexual activities. As with the other processors, you'll get the negatives but no prints, along with a curt little notice saying not to send them this kind of stuff again.

But not to worry. All you've got to do is find an independent photo processing lab, of which most large cities have several. Try looking in the Yellow Pages under "Photo Finishing—Retail." Most of these guys will print anything. "We have no morals at all," one place told me. Bear in mind, however, that the minions at some labs have been known to keep, ahh, family albums of interesting photographic treatments that come their way. If possible, find a place that serves professional photographers and presumably is a little fussier about the folks it employs.

Lotsa luck. I hope the cat enjoyed it as much as you did.

Many years ago—34 to be exact—I was a young man of 20 going with a girl with whom I had, by the standards of the 50s, a passionate relationship. That meant we necked a lot in parked cars. One night as we were kissing, I noticed that my chewing gum, which I had had in my mouth for some time, suddenly disintegrated into many tiny pieces. I was forced to spit them out since all cohesiveness was gone. In the weeks that followed I noted the recurrence of this phenomenon several times, always while similarly engaged. I later broke up with this girl and I don't remember if it ever happened with successor girlfriends. Maybe I stopped chewing gum while kissing, I don't know.

Several years ago, I read an article in Playboy *in which the author described how the same thing had happened to him as a young man. He wrote about the incident as if it had been a phenomenon exclusive to himself, but I knew exactly what he had experienced. My guess is that "disintegrating gum syndrome" is probably caused by a hormonal change in my saliva*

stemming from sexual arousal. I wonder (a) if Cecil has ever heard of this and if so, (b) does he know the cause, and (c) how common is it?—J.M., Bedford, Texas

Cecil's natural reaction, on receiving letters of this kind, is to assume that the writer is nuts. Cecil assumes this because 9 times out of 10 the writer *is* nuts. Remind me to show you the one about the cows and the barbed wire someday. However, vaguely recalling having seen something similar once, I rummaged through the files and came upon the following dusty missive from M.W. of Chicago: "An acquaintance of mine recently told me that if a person chews gum while engaging in sex, the gum will dissolve in the chewer's mouth due to some extraordinary secretion of . . ."

Needless to say, anytime you get the same question twice from different parts of the country, you have to figure something is up. (Or else the Teeming Millions are conspiring against you, a possibility Cecil refuses to even consider.) Not that I'm necessarily eager to do anything about it. It took two years and countless heartfelt pleas before I caved in and answered the one about why asparagus makes your p— well, you remember. Right now I am holding out against an avalanche of maniacs demanding to know about "piss shiver," a mystery that for now I am content to leave unplumbed.

Still, there are some questions that cry out for an answer. Having conducted an informal survey, I would say that the incidence of disintegrating gum syndrome is blessedly low. However, J.M., not that I want to point any fingers, this is probably because most people do not chew gum while making out. (Incidentally, if I might ask, what kind of desperate bimbo were you going out with who not only let you chew gum and spit out the pieces while smooching, but put up with a repeat performance?)

Being devotees of the scientific method, Mrs. Adams and I next retired to the laboratory for a round of experiments. She helped herself to a wad of Big League Chew (she's always been a little butch), while I chose Wrigley's Doublemint—hoping, of course, to double my pleasure. We thereupon commenced a rigorous program of research. I am not at liberty to disclose the details of this, owing to considerations of marital harmony; suffice it to say we were thorough. End result: not a godblessit thing (apart from the usual). I am totally bummed. Obviously we lack, how do

you say, chemistry. (In our defense, I must say that chewing gum during a clinch puts a distinct damper on your ardor.)

In the interest of thoroughness, I have also made a few discreet inquiries, all to no avail. Disintegrating gum syndrome, it appears, is a phenomenon unknown to science. (During sex, that is. I've heard some claim they've had chewing gum disintegrate on them because of some mysterious property of their tooth fillings.) I am thus obliged to throw the matter up to the Teeming Millions, ever willing to give their all in the pursuit of knowledge. Reports from the field are now being gratefully accepted. An anxious world awaits the results.

Notes from the Field, Part One

The enigmatic enzyme that dissolves gum might occur in chocolate. When I was a child, my Double Bubble gum would disintegrate if I ate M&Ms at the same time. I trust you will continue to pursue this matter.—S.M., Seattle, Washington

I experienced distintegrating gum syndrome about three weeks ago. I was watching the movie No Way Out *and my Carefree Sugarless Spearmint disintegrated in my mouth near the end of the film. Regarding hormones, I know that I was turned on by Kevin Costner, but I never made the connection before now. I will experiment some more with this phenomenon and keep you posted.—L.O., Washington, D.C.*

I too have experienced the disintegrating chewing gum phenomenon. Heat or direct sunlight will cause the required results. The preferred method is to place the pack of gum on the dashboard of your car on a reasonably sunny day (you may have to experiment to maximize the loss of cohesiveness/time ratio). Then when the gum is chewed it will quickly devolve into a mass not unlike a spitball or a particularly rotten oyster. This can occur without any foreign saliva or increased hormonal activity.—Joe M., Bethesda, Maryland

The first gum that ever disintegrated in my mouth was Adams Black Jack. Never could figure out why, except that I chew

gum a long time. Black Jack didn't lose its flavor quickly, so you could chew it for days on end. Eventually it disintegrated, though. Then last year they brought Black Jack back after a long absence. I noticed that certain changes in my mental outlook, chiefly nervousness and anger, seemed to change my saliva and caused the gum to disintegrate sooner. I don't chew gum during sex (the fact that a stick of gum lasts for many days may give you a clue to the extent of my sex life), so I can't help much there.—Jim B., Janesville, Wisconsin

It always happens to me at concerts. Maybe it's adrenalin.—A.B., Rockford, Illinois

Your column reminded me of a story my mother told me about her grandmother, a great practical joker, who told her that if she put butter on her chewing gum, she would be in for a treat. She tried it and her gum disintegrated! After reading this, I thought about the composition of lipstick. I don't know exactly what's in it, but I suspect it may have compounds similar to butter and be responsible for the disintegrating gum.—B.J., Chicago; similarly from Ralph B., Evanston, Illinois

This occurs with me but not during foreplay. After several minutes of chewing while on an exercise bike the gum often disintegrates. I think excessive chewing in any kind of hyperactive state may induce DGS.—David D., Santa Monica, California

Cecil has dutifully spent the last hour chewing a stick of Juicy Fruit and then applying a generous dab of Estée Lauder Terracotta Tile Re-Nutriv Lipstick. (To the gum, that is, not me. There are limits to the amount of embarrassment I am going to endure for this job. Also, if I might ask, what kind of name is "Terracotta Tile" for a lipstick?) Then I recommended chewing. Result: a queasy sensation in the stomach, otherwise zilch. Tonight we try lipstick plus exercise bike and M&Ms while reading about nuclear war (to induce nervousness). *Per aspera ad astra.*

• • •

Notes from the Field, Part Two

Cecil, 1,100 lashes for your nonanswer to J.M.'s question about disintegrating gum syndrome. The mundane truth is that gum disintegration is caused by carbohydrate digestion. Saliva contains an enzyme called ptyalin that breaks down the branched polysaccharides of the carbohydrates into oligosaccharides. In other words, if you hold thoroughly masticated gum in your mouth long enough without chewing it, the saliva begins digesting the gum's carbohydrate linkages. Presto, the gum disintegrates! Physiology solves another enigma.—D.M.A., San Antonio, Texas

It's a sad day when I, a lowly member of the Teeming Millions, must pen (word process?) a missive to Cecil Adams to inform him of the facts of science, but a man's gotta do what a man's gotta do. The disintegration of chewing gum while exercising, eating butter or other food, kissing, or engaging in more expressive demonstrations of love or lust is not in the least mysterious. Nor is there any need to invent exotic digestive hormones.

Given time, the enzymes in ordinary saliva at body temperature will cause chewing gum to break down. However, the oral cavity is rarely at body temperature, since it's cooled by the passage of air during breathing. (That's why you put the thermometer under your tongue and keep your mouth closed when checking for fever.) In addition, chewing tends to knock the enzymes loose from the gum before they can do their stuff. So the gum retains its elasticity.

But certain conditions can hasten digestion. Experiment: Leave gum on your dashboard while parking on a hot summer day with the windows rolled up. Start to chew the hot gum and it will immediately begin to fall apart.

Experiment: Chew gum while drinking warm (body temperature) coffee. The gum will start to fall apart. Now breathe through your mouth. The gum will regain its elasticity.

Experiment: Chew gum for several hours. The gum will gradually lost its elasticity as the saliva breaks down the gum.

Experiment: Eat just a little of something greasy while chew-

ing gum. The grease will interfere with the gum's sticking to itself, allowing your saliva to attack it.

Your correspondents must have put old gum into a corner of their mouths or under their tongues and stopped chewing while otherwise occupied. This results in the gum heating up while being kept close to the salivary glands and not being chewed. No wonder it fell apart. If you failed to cache the gum in your check it's clear why you and Mrs. Adams were unable to replicate the earlier writer's experience. Or perhaps you just don't get as heated up as much as you used to when you were first courting. These things happen, you know.—Phil R., Deerfield, Illinois

Sound plausible, Phil, but the folks at the Wrigley gum company, whom I turned to for guidance, are skeptical—they say the gum base, while edible, isn't digestible. (That is, it passes through the body without being broken down by the digestive juices.) On the other hand, I don't know that they've had much experience chewing the stuff for days at a stretch. At any rate, they're looking into the matter. More results when they become available.

Could you please enlighten me as to the latest Straight Dope on pharmones (sp?) and aphrodisiacs?—Your devoted reader, Robin R., Glendale, California

P.S.: Please hurry, I need all the help I can get.

For starters, sweetcheeks, it's "pheromones," not "pharmones." Boys don't get intimate with girls who're illiterate, you know. As for boosting what I take to be your somewhat dismal romantic fortunes, don't get your hopes up. Research on human pheromones (or, more specifically, sex attractants that work via the sense of smell) is still in its infancy, but the results so far have been mostly negative. Ditto for aphrodisiacs in general. But let's take one thing at a time.

The existence of pheromones among your lower forms of life, such as insects, monkeys, and weekly newspaper editors, is well established. The female of the species secretes a chemical known as a copulin (charming, huh?), which instantly drives the male into a rutting frenzy.

Fatty acid materials similar to those that make up monkey copulins have been found in the vaginal secretions of human females, but no one has been able to show that they perform a similar function. One research team had volunteers sniff samples taken from women at various points in the menstrual cycle, with

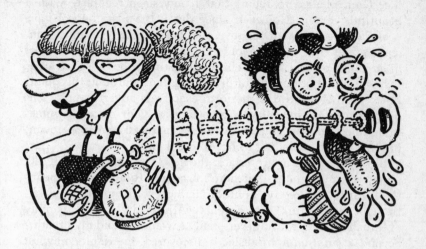

a view toward rating the relative pleasantness thereof. (No smart remarks, please.) While there was a slight decrease in unpleasantness around the time of ovulation, i.e., maximum fertility, the smell never exactly qualified as attractive. Another team isolated the aforementioned fatty acids and told various married female volunteers to dab a little on their bodies every night to see whether it turned their hubbies into howling beasts. Results: ixnay once again.

Still, there is some evidence that pheromones do exist. Cecil has written elsewhere about menstrual synchrony—the tendency of women living in close quarters to menstruate at the same time (see page 306). Studies have shown that one dominant woman can cause others to synchronize with her cycle as a result of smelling her sweat. Furthermore, female volunteers exposed to male sweat found their menstrual cycles, which previously had ranged anywhere from 26 to 33 days in length, tended to stabilize at 29.5 days. These things surely mean something, but God knows what, and they're certainly not going to snag you a man.

Nonetheless, several cosmetics companies have come out with perfumes that supposedly contain pheromones. The folks at Jovan, for instance, have been kind enough to send me a sample of Andron, "the pheromone-based cologne for men." Andron contains alpha androstenol, an alleged pheromone made from tears and sweat. Having daubed Andron liberally about my be-

ing, I am pleased to report that I now sleep regularly with a beautiful woman. However, since this is the same babe I have been sacking out with for several years anyway, we must conclude either that androstenol is so powerful it works *three years in advance*, or else that its efficacy remains to be demonstrated.

Jovan's promotional literature sort of dances around this point. But even if Andron does perform exactly as advertised, it's important to note that all you're getting for your money is something that the body supposedly secretes naturally for free. Jovan, in other words, is selling iceboxes to Eskimos.

Regarding other aphrodisiacs, the news is no better. We'll talk about this more later, but here's a couple things in the meantime. First, no effective aphrodisiac has ever been invented, although some think experiments with brain chemicals may eventually prove fruitful. (Personally I wouldn't hold my breath.) Second, even if an aphrodisiac is discovered, the results may not be exactly what you had in mind. I am reminded of the following sexist joke: Q: What's the difference between a dog and a fox? A: A six-pack. Disgusting, sure, but you see the problem you face.

I know you're not Doctor Ruth, or even an endocrinologist, but can you tell me why men get less horny as they get older? I'm 35 and don't seem to want to boink anywhere near as much as I used to five or ten years ago. Is there some nutritional or chemical substance that can rectify this, such as the much-heralded bee pollen?—J.H., Chicago

Boy, for the baby boomers, the times are definitely a-changin'. Once everybody wanted to know about drugs and how to kill the roaches in their crummy apartments; now I get aging yuppies worried about their fading virility. It's the old story— you start off chasing the Age of Aquarius, you wind up settling for the milk of magnesia.

Ah, well. Despite considerable research, nobody really understands why men gradually lose their sex drive. Most males reach their sexual peak at age 17 or 18, and it's a long, slow slide thereafter, becoming particularly noticeable after the age of 30. It's not uncommon for an 18-year-old male to be able to achieve orgasm four to eight times in a 24-hour period, whereas most 30-year-olds are happy if they manage once.

At one time scientists thought declining sex drive was the result

of decreasing sex hormone levels, but research has not borne this out. Though the data are contradictory, there does not seem to be any clear evidence that testosterone levels decline significantly before the age of 50. In any case there is no positive connection between T-level and sexual activity in normal men. Hormone shots will help a guy with a gland problem, but they will not restore youthful vigor to a normal male who has simply gotten old. It may be that your reduced sex drive results not from lowered hormones but from your body's decreasing sensitivity thereto.

Over the years an amazing array of substances have been proposed as aphrodisiacs. The only ones that really do anything are what we might call quasi aphrodisiacs, notably booze and drugs, which do not increase desire so much as they reduce inhibitions. Some drugs also enhance sex once the show is under way. Amyl nitrate, aka "poppers," is said to intensify and prolong orgasm when inhaled at the point of climax. Amphetamines can produce prolonged erection and multiple orgasm in men, although women usually experience negative effects.

A Food and Drug Administration advisory panel reviewed 15 alleged aphrodisiacs in 1982, including gotu kola, ginseng, licorice, sarsaparilla, cantharides (Spanish fly), nux vomica, Pega Palo, strychnine (!), and yohimbine. The panel declared there was "no substantive evidence whatever to support the claims of aphrodisiac action attributed to these ingredients." In some cases, in fact, they can make things worse—strychnine, for instance. Spanish fly, derived from a southern European beetle that is powdered and then eaten, produces an irritation of the urethra that may mimic sexual arousal, but it can also cause genital damage, impotence, and in extreme cases, death from shock.

Yohimbine, which comes from the bark of a tropical tree, caused a flurry a few years ago when it was shown to increase sexual activity in rats, but tests with humans have been disappointing. A compound related to yohimbine, papaverine, has been shown to produce "impressive erections" if injected directly into the penis. While potentially useful to those suffering from impotence, this doesn't sound like something the average guy would want to fool with.

Other reputed aphrodisiacs include megadoses of vitamin E (studies indicate it has no effect), as well as such things as sea turtle penises, raw bull testicles, and powdered rhinoceros horn, about which I need say no more. And then there's bee pollen.

One quack has called it "a wonderful natural food which tends to increase the body's production of sex hormones." Some believe it also enhances athletic performance, relieves asthma, retards aging, etc. The evidence to date suggests otherwise. While it's legal to sell bee pollen as a food, the FDA frowns on any claim of therapeutic benefit.

But look on the bright side. Most men in their twenties want sex a lot more than women of the same age, resulting in chronic frustration. But while desire declines in men as they get into their thirties, it increases in women, who reach their sexual peak between 35 and 40. Thus you may find the little lady wants you to come thither just about as often as you're prepared to go. Enjoy it while you can; pretty soon she'll be trying to keep you from nodding off halfway through.

Update

It's been reported that the antidepressant drug trazodone increases sex drive in some women. "Some of the women who had not been sexually active during their depression became active with several partners after receiving the medication," it says here. I shudder to think what will happen when singles-bar barracudas get their hands on *that* one.

My boyfriend and I need some answers. You're the only one we can turn to. Please don't think we're weird. (1) Does taking a hot bath (120 degrees) kill sperm? He says he'll be sterile for a month. (2) Can blowing air into the vagina during oral sex really cause an air embolism and sudden death, as per Joy of Sex?—*Francine M., Chicago*

I don't think *you're* weird, sweetie, but you might want to keep an eye on that boyfriend of yours. The mobility of sperm is reduced at temperatures above 104 degrees or so, and "spermatogenesis"—the creation of new sperm—is slowed. But the effect is brief—maybe half an hour, a researcher at the Masters and Johnson Institute guesses—and it certainly doesn't affect *all* the sperm. Remember, it only takes one to get you pregnant. Hot baths are not recommended as a method of contraception, and they certainly won't make a male sterile for a month.

The bathtub *can* be an effective birth-control device when used

properly, however. It can be used for cold showers, for example, and it has been proven beyond reasonable doubt that conception can be prevented when one of the partners lies completely motionless in the tub while the other stays in the bedroom.

This business about blowing air into the vagina is a lot more serious. It definitely can cause embolism and death, particularly if the woman is pregnant. Ten fatalities and one near-miss had been reported in the medical literature as of 1983. During pregnancy the vagina is distended, allowing dangerously large quantities of air to be introduced. The air enters the bloodstream via the vein sinuses of the intrauterine wall and from there finds its way to the heart and the brain. Collapse is usually immediate, and death can occur within minutes. In the one nonfatal case, proper treatment was delayed in part because the victim's male partner didn't tell doctors what had happened until two hours after she was admitted to the hospital. The woman miscarried and, despite treatment in a hyperbaric (high-pressure) chamber, suffered permanent brain damage. How likely such things are if the woman is *not* pregnant is not clear, but if I were you I wouldn't try it under any circumstances.

Since the twenty-year anniversary of Woodstock is looming on the horizon, I would like to inquire about a hard-to-find product that was a result of the hippie movement. Where can a body find body paints (washable, please)?—Interested reader, Chicago

It is a sad commentary on the times—nearly everything is a sad commentary nowadays—but the principal vendors of body paints today are porn shops and sellers of what we politely refer to as "leather goods and rubber novelties." The paints are sold under such names as "Lovin' Hot Body Paints," and apparently you are supposed to smear them on the erogenous regions of your lover(s) during an orgiastic proceeding of some kind. I don't know that this is so much different from what happened during the Age of Aquarius, but presumably people were purer of heart back then. The New York-based Pleasure Chest chain is a good source; failing that, check out the stores in your local gay neighborhood.

What is a jiggle bed?—Curious, Los Angeles
Anything you make it.

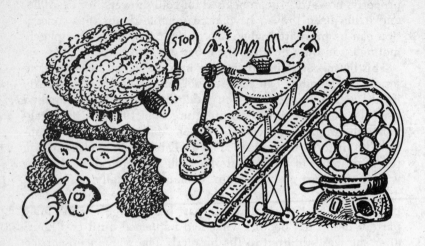

Something's been bothering me about this whole birth control pill thing. If they taught me right back in sex ed, the pill "tells" the ovaries (through the hormonal code) that there's a pregnancy down in the uterus. The ovaries, not wanting to cause a uterine traffic jam, don't send another egg down the fallopian tubes. No egg, no pregnancy. Does this mean that a woman who takes the pill for three years will experience menopause three years later than she naturally would, due to the backlog of unreleased eggs?—B.P., Los Angeles

Lord, give me strength. You're laboring under several misconceptions, B., if you'll pardon the expression. First, the pill doesn't "tell" the ovaries anything. It tells the brain, and the brain tells the ovaries. Next, what the pill says (via the hormones) is *not* that there's a pregnancy in the uterus. Rather, the pill tells the brain that ovulation has recently occurred, causing the brain to hold off sending another egg down the pipe.

Finally, you seem to have the idea that the ovaries are like gum ball machines, containing a relatively small number of eggs, all of which eventually get sent down the fallopian tubes; and that once the last egg is gone, some kind of "empty" light comes on and menstruation abruptly stops. The truth is that the ovaries contain the makings of several hundred thousand eggs, of which only one in a thousand or so ever makes it down the fallopian tubes to the uterus. Menstruation stops not because the proto-eggs get used up, but because they die off.

Only three or four hundred would-be eggs, which are called primary oocytes, develop into full-fledged ova. The rest wither away gradually during the woman's childbearing years. Exactly why this happens nobody knows; one guess is that the oocytes' life span is genetically predetermined. In any case, by the time the woman is in her forties, she's down to a few thousand. The ones that are left become insensitive to incoming hormones, and don't secrete enough outgoing hormones. This disrupts the delicate chemical balance of the menstrual cycle, and menstruation eventually stops. So far as can be determined, using the pill has no effect on the age at which menopause occurs.

My husband and I have an ongoing argument. I say it is possible, though highly unlikely, for fraternal twins to have different fathers. My husband and his friends say this is nonsense. We are relying on you as the final authority in resolution of a $100 bet.—Nancy Ann N., Chicago

We will deal with this vital issue in a moment, Nancy, but first a word. Cecil has been settling bets for as long as he can remember. Yet despite his oft-stated willingness to accept kickbacks and graft, all he has gotten for his trouble is an inflatable Dino the Dinosaur, a bootleg Bob Dylan tape, and a pair of long johns designed for a guy who's built like Santa Claus and hung like a horse. (Don't ask.) A mighty sorry showing for 15 years of selfless service. Well, I've had enough. Since you stand to come into some serious money pretty soon (see below), I expect you to show the proper gratitude. They say Paris is beautiful this time of year. 'Nuff said.

All right, then. Not only is it possible for fraternal twins to have different fathers, it has actually happened. There's even a medical term for it: *superfecundation*. The classic case, which is discussed in *Williams Obstetrics* (1980), was recorded in 1810 by John Archer, the first doctor to receive a medical degree in the United States. According to Archer, a white woman who had sex with a black man and a white man within a short time subsequently gave birth to twins—one white, one mulatto. Other cases have been reported since.

Superfecundation is possible because fraternal twins result from two separate eggs fertilized independently. Some think it happens fairly often, but until recently it was difficult to prove, due to the crudeness of the traditional testing method, which in-

volved comparing blood types. In 1978, however, Dr. Paul Terasaki of the UCLA School of Medicine reported in the *New England Journal of Medicine* that he and his colleagues had conclusively established a case of superfecundation using a sophisticated procedure called tissue or HLA (human leukocyte antigen) testing. This technique can also be applied to more conventional cases. Prospective paternity-suit litigants may wish to take note.

Since clams are bisexual, do you think that's one of the reasons they have a tough time finding an apartment?—Larry L., "Superjock," Chicago

Would you want your daughter to marry one?

Can you give me the Straight Dope on the so-called sex clubs whose ads proliferate in the back pages of weekly newspapers? Many of these ads feature women who claim to crave masculine company. As something of a veteran of the singles scene, it has not been my experience to find sex-starved women overflowing the local bistros. Methinks it's all a front. Probably the prospective member is asked to pay an exorbitant fee which the club uses to hire hookers as dates. This would circumvent the state's prostitution laws as technically the member is paying for an arranged date as in any other dating service, with the sex ostensibly being free. What's the story?—E.T., Chicago Ridge, Illinois

You can't get around the prostitution laws with a scam as transparent as that, friend, although I don't doubt that a lot of escort services try. But that's not what we're talking about here. We're also not discussing "ear sex," in which someone talks dirty to you on the phone. The sex clubs you're referring to are basically in the business of assembling and selling lists of women. It's an interesting racket—sleazy, but interesting. I talked to the owners of a typical operation, D&S Publications of Chicago, in 1983. Here's what I found out.

D&S is run by (and named for) two women, Nanette D. and LaVerne S. They advertise for women in magazines like *Soap Opera Digest*, usually using some noncommittal wording like "meet special friends." The women who respond receive a form letter and an application from an innocuous-sounding organization called Nation Wide Friends.

The application form asks the woman whether she's interested in dating, marriage, or "intimate sexual friendships/encounters."

It also asks for her measurements, and requests that she describe her "special sexual or romantic fantasy." D&S composes a one-paragraph listing for the woman, and adds her name to one or more lists. The woman pays no fee.

D&S advertises for men in such publications as *Hustler*, *Oui*, *Cheri*, and (naturally) various alternative weeklies. In contrast to the women's ads, the men's ads are quite explicit—e.g., "Call Tracy to Contact Her Sex-Starved Girls Next Door." Men who respond to such ads typically are directed to send in $30, for which they receive an eight-page tabloid newspaper entitled "America's Love Clubs." The edition I saw contained listings for 183 women around the country. They also receive a flyer offering additional "specialty" lists for $10–$30 on such topics as "Big Breasted Women," "50 Young Nymphos," and so on. Another flyer offers provocative "photos of the women in our club" (actually they're professional models) for $10.

The women in the Love Club newsletter supposedly all have a desperate craving for sex, but what they're really up to is anybody's guess. D&S promotional material says no "pros" (i.e., prostitutes) are listed, but Nanette and LaVerne admit that beyond a cursory screening they have no real way of keeping hookers out. Many of the women listed in the Love Club are obviously in it for the money, although what exactly the man gets for his bucks is unclear. A typical ad from a "sexy model" reads, "For details on possible meetings and my sample photo, with information on more, send SASE and $5. Faster contacts and more hot moments for those who show how generous they can be in first letter." At the very least, we have here a woman with her own kitchen-table mail-order photography business.

Some of the ads, it's true, have the ring of sincerity to them. Nonetheless we must consider a few straightforward facts. Nanette and LaVerne say they have approximately 1,000 female club members. Of this number, they say, 75 percent are interested in "mating and dating," rather than sex per se. (D&S also publishes a newsletter entitled "Welcome to Club Nice," a conventional lonely hearts listing, which when I checked contained the names of 471 women.) The Love Club newsletter, with its 180-some names, is updated once every three months. At the same time, D&S typically receives an astonishing *13,400 calls per month*, mostly from men. Not all of the callers end up mailing in $30 to receive the Love Club newsletter, of course, but clearly

we have an enormous horde of sex-starved men chasing after a relative handful of available women. Sounds just like your experience in the local bistros, doesn't it?

I have often seen percentages used to compare the effectiveness of various methods of birth control. The pill is 99 percent effective, diaphragms are 98 percent effective, and so on. But what do these numbers mean? If the pill is 99 percent effective, does that mean it prevents pregnancy 99 times out of every 100 times a couple has intercourse, or does it mean that 99 out of 100 couples using the device will remain unexpectant over the course of a year?—L.B., Los Angeles

The effectiveness percentage refers to the number of pregnancies that occur per 100 woman-years of contraceptive use. To put it another way, if 100 women use Coca-Cola as a contraceptive for a year and 20 become pregnant, the effectiveness rate of Coke is said to be 80 percent. I'm skipping some statistical subtleties here, but you get the basic idea.

While discussing a gay acquaintance recently, my friend Mary, a nurse, lauded him by adding, "and he's no damn gerbil stuffer, either." When I protested that she should not perpetuate cruel stereotypes of our homosexual brethren, she informed me that she personally had witnessed a fellow admitted by her hospital to remove a deceased gerbil lodged in his rectum. That gentleman is now doomed to be tied to a colostomy bag through eternity. What I'd like to know is, what are the mechanics and philosophy of gerbil stuffing? How are the gerbils inserted and retrieved? Don't they bite and scratch? Why not hamsters or snakes? Is this a common practice? My curious friends and I await your reply with bated breath.—Shannon O., Chicago

Brace yourself, toots. What follows is not for the weak of stomach. For starters, an awful lot of stuff has been found where that gerbil supposedly turned up. The medical journals list, among other things, the following astonishing array: a bottle of Mrs. Butterworth's syrup, an ax handle, a 9-inch zucchini, countless dildoes and vibrators including one 14-inch model complete with two D-cell batteries, a plastic spatula, a 9-inch water bottle, a deodorant bottle, a Coke bottle, a large bottle cap, numerous other bottles, a 3½-inch Japanese float ball, an 11-inch carrot, an antenna rod, a 150-watt light bulb, a 100-watt

frosted bulb, a cucumber, a screwdriver, four rubber balls, 72 jeweler's saws (all from one patient, but not all at the same time, although 29 were discovered on one occasion), a paperweight, an apple, an onion, a plastic toothbrush package, two bananas, a frozen pig's tail (it got stuck when it thawed), a 10-inch length of broomstick, an 18-inch umbrella handle and central rod, a plantain encased in a condom, two Vaseline jars, a whiskey bottle with a cord attached, a teacup, an oil can, a 6 × 5-inch tool box weighing 22 ounces, a 6-inch stone weighing two pounds (in the latter two cases the patients died due to intestinal obstruction), a baby powder can, a test tube, a ballpoint pen, a peanut butter jar, candles, baseballs, a sand-filled bicycle inner tube, sewing needles, a flashlight, a half-filled tobacco pouch, a turnip, a pair of eyeglasses, a hard-boiled egg, a carborundum grindstone (with handle), a suitcase key, a syringe, a file, tumblers and glasses, a polyethylene waste trap from the U-bend of a sink, and so on. In 1955 one man who was "feeling depressed" reportedly inserted a 6-inch paper tube into his rectum, dropped in a lighted firecracker, and blew a hole in his anterior rectal wall. This changed his mood real quick.

"Insertion of foreign bodies into the rectum," as it is formally known, is by no means confined to gays. Many cases are ascribed to autoeroticism on the part of straights. Leaving aside victims of assault or accident, however, practitioners do have one thing in common: they're incredibly stupid. You don't need to be an Einstein to realize that insertion of objects presents enormous health risks. The rectum can become lacerated, torn, or infected. Long-term effects can include a flaccid sphincter and fecal incontinence.

Which brings us to gerbils. While the examples above are well-documented in the medical literature, live or recently deceased fauna are something else. Rumors of gerbil (and mouse or hamster) stuffing have been circulating since about 1982. In 1984, a Denver weekly said it had a confirmed report of gerbilectomy in a local emergency room. The Manhattan publication *New York Talk* reported several years ago that New York doctors first caught on to stuffing when they started encountering patients with infections previously found only in rodents. But no such case has ever found its way into the formal literature of medicine. Having investigated the matter in some depth, I am inclined to write the whole thing off as an urban legend. (I confess

this represents a change in my thinking since my original column on the subject in 1986.)

Your nurse friend stoutly maintains that a patient was treated for a case of ingrown gerbil at her hospital in Chicago, but she concedes she did not read the patient's chart or see any documentary evidence. A doctor and a nurse at the hospital to whom she appealed for corroboration of her story say they know nothing of any such case, although they had both heard about gerbil stuffing, the nurse from cops in the emergency ward, the doctor at a medical meeting. That's pretty much been the story all over. I have checked with numerous sources in both the gay and medical communities, and though everybody has heard about gerbil stuffing, every attempt to track down an actual case has come to naught.

The whole thing sounds totally nuts, to me, and implausible to boot. Whatever the case, take my advice and stick to mammals your own size.

Just one question. Which came first, the chicken or the egg?—Puzzled in L.A.

There are two answers to this question, P., one serious, one retarded. Let's start with the former. (1) The egg came first. We know that chickens evolved from some earlier, nonchickenoid form of life, e.g., the half-bird, half-reptile *Archaeopteryx*. These nonchickens, however, arrived in eggs. Ergo, eggs were on the scene before chickens. (2) The chicken came first because (sigh) the chicken had to get laid before the egg could. Don't say I didn't warn you.

I heard a weird radio news report a while back about some college medical researchers who had done a study on Coca-Cola being used as a contraceptive. Can this be? The researchers claimed that several Third World countries use it and it works. Also, they did a study of the various Cokes out on the market and found that new Coke was not as effective as old Coke and Diet Coke was better than both. Is this true? What college did the research, and how do you go about using Coke as a contraceptive?—Illinois Smith, Chicago

You would be amazed to find out some of the things people spend their time on in this nation's institutions of higher learning, Smitty. The Coke bulletin was issued by three researchers

at the distinguished Harvard Medical School, and published last November in the equally distinguished *New England Journal of Medicine*, surrounded by articles on such topics as "Retinoic Acid Embryopathy" and "Aldosterone-Receptor Deficiency in Pseudohypoaldosteronism." It consists of a total of four paragraphs plus one table. From these we may glean such nuggets as the following: "Postcoital douching with household substances was a popular form of contraception at the beginning of this century, and Coca-Cola is still said to be used in developing countries for this purpose." The Fugs, if I remember correctly, did a song on this subject once. Great group, the Fugs. Gave new meaning to the expression "seminal influence."

Our authors go on: "There has recently been controversy over the attributes of old-formula ('Classic') Coke and those of 'New Coke.' We therefore compared the effect of various modern formulations of Coca-Cola on sperm motility." (Motility basically means the sperm's swimming ability.) The results were dramatic. "All samples of Coca-Cola markedly reduced sperm motility, whereas [a saltwater control solution] had no spermicidal effect." Old Coke was five times as potent as new Coke, and Diet Coke was the most potent of all, annihilating every living thing

in its path. This may give you pause next time you're tempted to chug down a frosty one.

The Harvard folks conclude, "The effectiveness of Coca-Cola as a spermicidal agent in vaginal douching has been attributed to its acidic pH." However, since the various types of Coke had similar acidity, some other factor must be at work to account for the observed differences. The researchers do not speculate what this might be, but Cecil is sure it had nothing to do with the presence of the artificial sweetener NutraSweet in Diet Coke. Cecil says this because several years ago he intimated in a column that NutraSweet might not be entirely good for you, and he has been besieged with mailings from the G.D. Searle company, maker of NutraSweet, ever since. Cool out, guys.

I should point out that the experiments were conducted in test tubes, rather than *in vivo*, if you follow me. Postcoital contraceptive douching in general is not very effective because the sperm travel pretty fast. Still, I suppose if you were one of today's New Women and you woke up after a particularly rambunctious evening to find the Incredible Hulk snoring beside you . . . well, any port in a storm.

I should also underscore the preliminary nature of the study. The researchers did not test the effectiveness of such common beverages as Mr. Pibb, Mello Yello, or Cherry-Ola Cola, which greatly limits the usefulness of their work. You would not want to be condemned to an unwanted pregnancy simply because of an unfortunate choice of soft drink.

Nonetheless, Harvard has opened up some interesting possibilities here. One can envision the day when the contraceptive properties of a brand might become an integral part of its marketing strategy, e.g.:

<div align="center">

CONTRA-COLA
Kills Sperm by the Million on Contact
. . . and tastes great too

</div>

The potential, I think, is enormous.

Is it true that men with extremely large you-know-whats often pass out when they become aroused, owing to the fact that all the blood rushes from their heads to their groins?—Listener, WBEZ radio, Chicago

I don't know, bub. All I can tell you is it never bothered *me*.

• • •

QUIZ #5

25. Complete this series: O, T, T, F, F, S, S, . . .
 a. A
 b. E
 c. I
 d. O
 e. U

26. The natives of the village of Kuskoy in Turkey communicate through:
 a. touch
 b. smell
 c. whistling
 d. CB radios

27. "Ukelele" comes from the Hawaiian word for:
 a. cat
 b. flea
 c. wind
 d. Pat Boone

28. America owes a tremendous debt to Peter Durand. In 1810 he patented:
 a. the clothes hanger
 b. the nail clipper
 c. the tin can
 d. the bottle opener

29. Who was Edward Carl Gaedel?
 a. Huey Long's assassin
 b. Richard Nixon's father-in-law
 c. the only midget ever to bat in the major leagues
 d. Fred Astaire, before he changed his name

30. Which of the following statements is false?
 a. Mary, Queen of Scots, was the first woman known to have played golf.
 b. Benjamin Franklin founded a national magazine.
 c. Nicolaus Copernicus, the astronomer, was the first man to butter his bread.
 d. Blaise Pascal, the mathematician, invented public transportation.

Answers on pages 472–74.

Chapter 11

Drugs

What's the Straight Dope on nicotine? I know for a fact that nicotine is a stimulant, yet smoking seems to calm people. Can you explain this paradox?—A reader, Chicago

Give me a running start and enough Old Style, pal, and I can explain *anything*. It's pretty generally agreed that smoking is mildly addictive, at least for some people, and that the anxiety smokers feel when they're deprived of weed is actually drug withdrawal. Naturally, as soon as you light up, the symptoms disappear. A study by Columbia University researchers some years ago indicated that the craving for nicotine is related to acid levels in the urine—the more acid, the more you want to smoke. Moreover, stress seemed to make the urine even more acidic, causing you to want to smoke all the more. It was therefore suggested that smokers who are trying to cut down stoke up on acid-killers like bicarbonate of soda or Alka-Seltzer, particularly when they anticipate stressful situations, and at the same time avoid acidic substances like orange juice. I guarantee nothing, you understand, but it's worth a shot.

For the last several years, I've been dipping my lungs into a substance called nitrous oxide—known to dentists as laughing gas, and on the street as whippets. In its most portable form, the gas is packed into handy single-serving cartridges, which are then discharged into a balloon or metal cannister, from which the gas is inhaled. What follows is ninety seconds of euphoria. As a clean-cut all-American boy, I know that anything this enjoyable must be harmful. But how—and how much? A friend showed me an

article which listed four dangers: (1) damage to the brain from lack of oxygen; (2) damage to the lips from "freezer burn," caused by excessively cold equipment; (3) damage to the lungs from inhaling too much too soon; and (4) damage to the head from hitting it during a nirvanaesque blackout. The last three are trivial and easily avoidable (you'll have to take my word on this one, Cece), and the first seems insignificant—you don't go that long without oxygen in this experience. But my question remains. Two questions, actually. (1) How does the stuff work? (2) What's it doing that can't be undone? I don't use it that often, but I'd like to know how soon I can expect to start drooling down the front of my person.—J.B., Iowa City

You know, J., we children of the 60s are supposed to outgrow this stuff eventually. At the rate we're going, though, it's going to be difficult to know whether we should attribute drooling to drugs or the onset of second childhood. You'll be interested to know there's a new book out called *Nitrous Oxide* (Edmond Eger, editor), which I am sure you will want to run out and buy pronto. From this volume we may glean the following useful facts: (1) Despite oodles of scientific experiments, they don't exactly know how nitrous oxide works. "The best surmise," it says here, "is that the gas acts indirectly, perhaps through a pain-inhibiting system in the spinal cord that releases a substance whose effect in turn inhibits a particular neurotransmitter required for pain-signal passage." Check. (2) No short-term nastiness is attributed to nitrous oxide, the experts say, although accidents are an occasional problem. A patient in England died in the 1960s after breathing gas that was contaminated with the lethal higher oxides of nitrogen. Inspection standards supposedly are higher here in the U.S., but that doesn't mean you have nothing to worry about. Barry Kramer, founder of *Creem* magazine, died in 1981 at age 37 of an apparent overdose involving nitrous and unnamed other drugs, according to news reports. So some caution seems to be in order.

You might also wish to be careful if you decide to manufacture your nitrous oxide in the basement. Applying heat to solid ammonium nitrate, which is the customary method of preparation, is a bit tricky, and periodically results in explosions. Two shiploads of the stuff blew up once at Texas City, leveling the town. Fortunately, due to the enormous amount of gas released, no one much cared.

As for long-term effects, nitrous oxide is not a carcinogen or a mutagen. However, chronic exposure can mess up the vitamin B_{12} in your system, which can lead to impaired DNA synthesis and poor cell growth. Chronic users can end up with something akin to pernicious anemia. Those most in peril are hospital operating-room staff who are exposed to small amounts of leaked gas over long periods, although 24-hour exposure to a high concentration will also do the job. This has not prevented med students (not to mention free lance dope fiends such as yourself, J.) from freely indulging—supposedly 20 percent of the pre-docs at one school had tried it. Another interesting factlet is that nitrous oxide is used to pressurize aerosol whipped cream cans. "A resourceful child," I read here, can give him or herself a dose right in the store by simply inverting the can. One last word of warning: if you ever decide to cop a whiff from professional anesthesiology equipment, *don't strap on the mask*, lest you lose consciousness and kill yourself. If you must die laughing, I'd prefer you stuck with the Straight Dope.

It's time us smokers, tokers, and dopers heard the Straight Dope on . . . you guessed it . . . dope! As you know, apathy and lack of ambition are alleged to be the fate of all consumers of the evil weed. However, though I have been smoking for years, I have no lack of ambition, and in fact could be considered quite successful. I know many other marijuana smokers about whom one could say the same thing. What's the scoop? And what are the other long-term effects of marijuana usage, i.e., what are we doing to our lungs, brains, blood, and what have you?—N.R., Phoenix

I'm sure dope hasn't affected your mental faculties in the slightest, N., but I should point out that in this country we usually spell it "marijuana," not "marijuania," which is how you had it throughout your letter. Luckily for you, I made the necessary corrections, and no one need be the wiser.

The last major review of the health effects of dope, *Marijuana and Health*, was issued in 1982 by a panel of scientists working for the National Academy of Sciences. Here's what they said:

- *The "amotivational syndrome"* (i.e., apathy). Sure enough, dopers tend to be apathetic. But it's never been proven that marijuana *causes* apathy. In fact, the panel found, it may

well be the other way around—maybe apathy causes you to use marijuana. On a related subject, the panel noted that atrophy in the brains of 10 heavy marijuana users had been reported some years earlier by a British researcher. Another scientist at Tulane said he found "dramatic" changes in the brains of monkeys subjected to carloads of cannabis. But both studies were sharply criticized for methodological deficiencies. Other scientists have found no brain damage. This led the NAS panel to conclude, predictably, that "much more work is needed."

· *Heart and lungs.* Marijuana smoke contains about 50 percent more carcinogenic hydrocarbons than cigarette smoke. Tests with lab animals and whatnot indicate that marijuana-induced lung cancer is a real possibility. (They also indicate that smoking both marijuana and tobacco is worse than smoking just one or the other.) Still, there has never been a case of lung cancer attributed solely to dope smoking—possibly, according to the panel, "because marijuana has been widely smoked in this country for only about 20 years, and data have not been collected systematically in other countries with a much longer history" of heavy dope use.

Dope smoking places extra stress on the heart, the panel said. This is probably harmless to healthy people, but if you have high blood pressure or hardening of the arteries,

or if you're prone to strokes, you should lay off. Heavy dope users are also prone to respiratory problems such as pharyngitis, sinusitis, bronchitis, and asthma.

• *Reproductive system.* Dope suppresses the production of male sex hormone, shrinks the testes, and inhibits sperm production. Fortunately, the effects don't seem to be permanent. Animal studies indicate that marijuana also inhibits ovulation in females. Dope does not cause chromosome damage, and so far there's no hard evidence that it causes birth defects, but the jury is still out.

Finally, there's no question that smoking does make you, well, stoned—i.e., it's harder to concentrate, your coordination deteriorates, and so on. If you smoke during lunch hour your job performance will suffer. In addition, the panel says, your abilities remain impaired for four to eight hours after the feeling of being stoned passes—much longer than with alcohol. So don't smoke if you're going to drive or do any sort of complex task later in the day.

Help me before my love/sex life becomes even more messed up. When chocolate became a mini-craze not too long ago, I heard several times that "chocolate contains some of the same chemicals that the human brain produces when you're in love." First of all, O all-knowing one, is this true? And if so, what is the practical effect? That is, will chocolate make me more or less horny? And might shrewdly feeding it to my date increase my chances? Please let me know quickly; I've got a hot one lined up for Saturday night.—Tom R., Hollywood, California

So you figure when they talk about Hershey's kisses they're not kidding around, huh? Lord, this is getting too precious for words. It all started a number of years ago with a theory proposed by two doctors at the New York State Psychiatric Institute, Donald F. Klein and Michael R. Liebowitz. They suggested that the brain of a person in love or otherwise feeling groovy contains large quantities of phenylethylamine, a chemical that supposedly produces an amphetaminelike high. Chocolate, it turns out, also contains a lot of phenylethylamine, so Klein and Liebowitz whimsically suggested that maybe people like chocolate so much because it makes them feel like they're in love. Please note that we are *not* talking about an aphrodisiac or sexual stimulant here.

You have fallen prey to the typical male assumption that love equals sex. (Then again, I suppose if you fed your date some Hershey bars before making a pass at her some night she might imagine that she had fallen in love with you, allowing you to cynically violate her maidenhead. Worth a try, I guess.)

Other research has failed to confirm the Klein–Liebowitz hypothesis. At any rate, a couple of years ago another researcher found that phenylethylamine levels in the blood failed to rise after people consumed chocolate, suggesting that most of the chemical is metabolized during digestion and never reaches the brain. Klein and Liebowitz therefore set about doing another study, the results of which I will pass along when they become available.

The preceding notwithstanding, chocolate is still considered to be mildly addictive, in the same sense that coffee, tea, and cola drinks are, because it contains the stimulant caffeine. In *Chocolate to Morphine: Understanding Mind-Active Drugs*, Andrew Weil passes along the testimony of one hapless choco-addict who "could not remember the last time I had managed to get through the whole day without eating chocolate in one form or another. . . . I would think nothing of getting in my car and driving halfway across L.A. for a fix." Eventually she went to a clinic where they gave her electric shocks while she was chewing choco-bits. Not surprisingly, this eventually broke her of the habit. Delighted, she now reports that "the only problem is, I am now addicted to cake." Clearly, this woman has a problem.

I have enclosed an advertisement from a German magazine telling how one can tan easily without the sun by taking a certain product containing "carotin," the chemical that gives the carrot its color. The stuff is sold over the counter, and no doubt has found a sizable market with sun-worshipping Germans. My question is this: if this is such a brilliant idea, why hasn't it made its way over to our side of the globe? With all the talk about how exposure to the sun can cause skin cancer, wouldn't this be a reasonable, safe solution?—James H., Chicago

You gotta be kidding. What's involved here is one of two chemicals, canthaxanthine or beta-carotene, which are synthetic versions of the natural colorants found in carrots and other plants. A day's supply of the pills gives you 10 to 30 times the amount you'd get in an ordinary diet, and the result is that you

give yourself carotenosis—i.e., you turn orange, a condition the Germans inexplicably find alluring. Other ways of doing the same thing include ODing on carrots or getting jaundice. This is not to say that beta-carotene is intrinsically evil. Studies suggest that in moderate amounts it can help prevent cancer. But we're talking about an extra half-cup of carrots (or broccoli, squash, cantaloupe, etc.) a day, not the equivalent of a bushel basket.

During the 1960s, much was made of the impact of hallu-cinogenic drugs, notably LSD, on the genetic makeup of human beings. It was suggested that these drugs would cause users to subsequently produce deformed offspring. Now that the drug-abusing youngsters of the 60s have matured and presumably pro-created on a wholesale basis, one might conclude that a good statistical population exists to test this horrifying theory. But lit-tle now is heard of the genetic effects of drug use. Is there, and was there ever, any truth to the allegations?—Anthony B., Chi-cago

Put your drug-sodden mind at ease, Tonio—the notion that acid causes birth defects was thoroughly discredited years ago. The whole controversy started in 1967 when New York geneticist Maimon Cohen published a paper claiming he'd found an unu-sually high number of broken chromosomes in a 57-year-old man who'd been given LSD as part of a hospital therapy. Cohen also found that human cells dosed with LSD in a test tube showed significant chromosome damage. Not long afterward, another study said that street acid users were found to have scrambled genes in alarming numbers. These reports got big play in the media and soon everybody "knew" that if you did acid your chil-dren would be born looking like kumquats.

Later research pretty much nixed this screwy idea, but unfor-tunately good news never gets as much play as bad. Researchers pointed out that all sorts of things, including milk and undistilled water, can cause chromosome damage in a test tube—such ex-periments just don't prove very much. Others noted that Cohen's 57-year-old man had received regular treatments with Librium and Thorazine, which have since been proved to cause chromo-some damage.

It was also pointed out that "street" acid is rarely pure LSD, often containing such drugs at PCP and STP. And people who do acid often tend to be indiscriminate pill poppers, scarfing

down alcohol, amphetamines, barbiturates, marijuana, cocaine, peyote, psilocybin (a trip down memory lane, ain't it?), etc., in addition to acid, any of which might have contributed to chromosome damage. Amphetamines in particular can be nasty; the illegally manufactured kinds often contain dangerous chemicals like benzene and chloroform. On top of everything else there's the fact that drug users are prone to hepatitis and other viral illnesses, which themselves are suspected of damaging chromosomes.

The upshot is that LSD is no longer considered much of a threat, at least as far as your genes are concerned. A thorough review of all the studies on acid and genetic damage published in *Science* magazine in 1971 concluded that "pure LSD in moderate doses does not damage chromosomes . . . [and] does not cause detectable genetic damage."

Note that we're talking strictly LSD here, not hallucinogens in general—most of the others haven't been studied sufficiently. And it's certainly true that some sorts of drug abuse will cause birth defects, the most notorious example being fetal alcohol syndrome, in which hard-drinking mothers inflict various horrors, such as low IQ, on their unborn children. But LSD at least seems to be in the clear.

The straight dope, s'il vous plaît. Is there any reason to believe that any particular sort of booze will cause a worse hang-

over than any other sort? And what about the old saw that mixing different kinds of booze (gin and beer, say) will guarantee a hangover?—Dean M., Chicago

Most scientists would rather ponder the origins of the universe than do hangover research, Dean—these people just have no sense of priorities—so we still don't have definite answers to these questions. It's widely believed that Scotch, for instance, will cause a worse hangover than vodka, and that red wine will afflict you more than white. But the clinical studies on this point are inconclusive. The problem is that judging the severity of a hangover is highly subjective, and the differences among individuals are enormous. Some folks, supposedly, can quaff Rotgut Red with ease but get sick from white wine. Even mood can play a role.

Numerous substances in alcohol have been suspected at one time or another of making hangovers worse. Some think, for example, that hangover severity is related to substances called congeners, which are certain organic alcohols and salts. These are present in greater quantity in whiskey and other "brown goods," as we say in the trade, than in "white goods" like vodka and gin. By the same token, some think histamines, which are found in greater quantities in red wine than white, account for the suffering differential in vino. Others blame sugar, which is relatively abundant in champagne, widely regarded as the most

lethal of all alcoholic beverages. No firm evidence, however, has been adduced to support any of these notions. For what it's worth, most experts doubt that mixing your liquor makes hangovers worse.

The phenomenon of hangover itself is not clearly understood. Some say you get a hangover because alcohol restricts the flow of blood to the brain; others say you get one because alcohol causes the body to dehydrate. Alcohol also causes your blood sugar to drop and your blood acidity to rise, which may play some role as well. In short, the situation is totally confused.

As long as we are on the subject, I may as well pass along the following tips on hangover relief, which I have culled from sundry dubious sources. I do not have much faith in these things, but shoot, when the situation is desperate, you gotta do something. (1) "Hair of the dog"—i.e., a little nip of whatever it was you had the night before—may actually do you some good on the morning after, many researchers agree. What you're really doing is applying anesthesia, you see. (2) Drink lots of fluids to rehydrate yourself, and make sure they're not acidic. In other words, ixnay on the tomato or orange juice. Whatever you do, don't head for the sauna on the theory that you'll sweat the alcohol out of your system. You'll just give yourself an even worse case of dehydration. (3) Try eating a little honey. (The kind that comes in a jar, smart mouth.) Many experts, such as myself, have their doubts about this, but the fructose in sugar supposedly does help somehow in cases of hard-core alcohol withdrawal, and some claim it helps with hangovers too. Couldn't hurt. (4) Lastly, allow me to pass along a recipe published a while back in *Esquire*. Take the following during or immediately after your next interlude with demon rum: one 100-milligram tablet vitamin B_1, one 100-milligram vitamin B_6, one 250-milligram capsule BHT (butylated hydroxytoluene, a common preservative), one capsule Twinlab MaxiLife multiple vitamin. It's claimed this completely eliminates the effects of light to moderate consumption of alcohol. Naturally, Cecil will be pleased to receive field reports on any and all of the above. We cannot achieve progress unless we are willing to take the occasional risk.

• • •

Late Developments

Steve Paul, a psychiatrist with the National Institute of Mental Health, is testing a drug called RO15-4513 that acts on brain chemicals to block the intoxicating effects of alcohol. So far it works on rats, and in fact seems to produce instant sobriety. An unparalleled boon for mankind if it pans out.

I'm curious about these alcohol rehabilitation centers that claim to "cure" booze and coke addiction, advertising that their programs are "not talk" but special "medical techniques" that help you "lose the craving." What exactly happens during these "two weeks with a couple of two-day follow-ups"? Are you strapped into a chair with your eyes clamped open, fed nauseating drugs, and forced to watch Budweiser commercials over and over?—Don L., Los Angeles

What are you, psychic? Your description actually isn't that far off. You don't mention which outfit ran the ads you quote, but it sounds like we're talking about something variously known as "aversive therapy" or "counter-conditioning." Schick Laboratories, established by the ex-alcoholic who used to run the Schick razor company, runs a typical program. First they feed you a mild nauseant drug called Emetine. Then, at the exact moment the drug takes effect, they have you toss back a jolt of your favorite brew. A couple weeks of this and the mere thought of a martini is enough to make you gag. For smoking or weight control, they give you a little zap of electricity every time you fire up a Camel or eat a Twinkie. The treatment allegedly cures 60 percent of the alkies, 90 percent of the smokers, and a lesser percentage of the fatsos. Pavlov would have loved it.

Update

It seems Cecil was a bit hasty in telling his readers in his first book that MDA, the "love drug" that was popular in the early 70s, "was relatively safe as drugs go." Two researchers at the University of Chicago, Charles Schuster and Lewis Seiden,

have discovered that MDA kills brain cells and may speed up the aging process. Schuster and Seiden also found that another drug in the meth family, methamphetamine, can cause degeneration in the nerve cells responsible for body movement. The MDA research is pertinent because of the similarity of the drug to MDMA (3,4-methylenedioxymethamphetamine), more commonly known as "Ecstasy," which was in vogue a few years ago. Milk and cookies looks better all the time.

Words, Words, Words

Can you tell me the origin of the slang word "cooties," as in "OOOooooh! Melvin touched me! I have Melvin's cooties!" Is this an American vulgarism, or is it a well-known expression in the English-speaking world?—Jolene J., Phoenix

Cooties in the sense of "an intangible profusion of vileness emanating from an especially loathsome individual" is probably peculiar to this country. However, cooties in the original sense of body lice is known to most speakers of English. According to Eric Partridge, whose knowledge of things linguistic is almost as awesome as my knowledge of things in general, the word cooties, and probably the reality as well, was picked up by sailors from the Malayans, who had a similar word meaning dog lice. A possibly related term is *kutu*, a Polynesian word meaning lice of any kind.

What is the origin of the expression "brand-new"? Anything to do with brand names?—Scott S., Chicago

Sort of. Our modern term "brand" comes from the idea of branding cattle with a distinctive ID mark. The word is related to the Old English *baernan*, to burn. "Brand-new" goes back to the Middle Ages, when it referred to pottery or metalwork that had just been pulled from the fire in which it had been hardened. A similar term was *span-nyr*, "chip-new," referring to the fresh-

cut chips made by an axe. That's why you sometimes hear "brand spanking new."

Love Letters from the Teeming Millions

You get "B" on "brand-new," "F" on "spanking new." Although it's true that a newly marked calf is literally "brand-new," it was even earlier that wine bottle corks were "branded" with a manufacturer's mark. As for "spanking-new," you must be wet behind the ears yourself, else you'd know the expression reflects the slap administered by a midwife or other assistant at the birth of a child to provoke crying, hence breathing.—J.P.M., etymologist, Northeastern Illinois University, Chicago

That's very imaginative, J.—I like it when the Teeming Millions show a little creativity—but it's wholly unsupported by authority, unless of course you contend that as an "etymologist" *you're* the authority, in which case Cecil would like to see a little ID. My source on "spanking new" was *Horsefeathers and Other Curious Words* (1958) by the late dictionary editor Charles Funk and his son Charles Junior.

Other sources tend to support the Funks' view. The *Oxford English Dictionary* lists several derivatives of *span-nyr*, such as "span-new," "spanker-new," and "spank span-new," and it seems reasonable to conclude that "spanking new" is more of the same. Then again, the *OED* also lists "spanking," possibly derived from the Danish *spanke*, "to strut," which means big, fine, vigorous, etc. One might make the case that this is the source of "spanking new." William and Mary Morris, authors of the *Morris Dictionary of Word and Phrase Origins*, claim "spanking" comes from a Scandinavian sailors' term used to describe a fresh, lively breeze. One can see how this might reasonably be coupled to the concept of newness in "spanking new." Be that as it may, nobody says anything about spanking babies.

An Australian friend claims that the expression "kangaroo court" was in fact an American invention of the mid-nineteenth century. What's the straight dope? By the way, how do kangaroos court?—Hurst H., Arlington, Virginia

Sorry, amigo, but it's ixnay on your last request. Cecil has been informed that if he favors his readers with one more

essay on lust among the animals his next job will be busting suds at the Dairy Queen. So it's Bourgeois Proprieties 1, the Public's Right to Know 0.

I can offer only the usual speculative mishmash on the origin of "kangaroo court," meaning any extralegal judicial assemblage, such as those established by prison inmates or vigilante committees. There's some argument over whether the term is of American or Australian origin. It appears to have come into common usage around the time of the California gold rush in 1849, when some say miners established kangaroo courts to deal with claim jumpers (get it?). Others argue that the term is a sly metaphorical comment on the frequent leaps of legal logic seen at such conclaves.

Those arguing for the expression's Down Under origins say it sprang up in the Australian outback, where the homesteaders periodically used to convene "hopper's court." This usage derived from the supposed fact that when kangaroos see a man for the first time they typically stop dead and eyeball him for five minutes, then suddenly turn and scoot. The practice of staring idiotically into space for long periods followed by a rash and inexplicable jump to conclusions was thought to closely resemble the behavior of a jury or judicial panel, hence kangaroo court. Trouble is, no published instances of this usage in Australia have ever been adduced. Finally, we should note that kangaroo in English slang at one time meant anything unusual or eccentric, which would obviously lend itself to the application at hand. Take your pick.

You-didn't-ask-but-I'm-telling-you-anyway department: A charming legend has been making the rounds for many years that the word "kangaroo" derives from an aboriginal expression meaning "I don't understand you." Seems the English explorer Captain James Cook was browsing around Australia one day with his naturalist buddy Sir Joseph Banks, when he happened to espy a funny-looking critter with a pouch. Inquiring of a nearby local as to the name of the animal, he received the reply "kangaroo," which was intended to signify "Say what?" Cook somewhat stupidly construed this as the name of the beast, and we have continued to suffer for his ignorance down to the present day. Cute, but is it true? I dunno—the actual aboriginal words for the marsupial in question sound nothing like "kangaroo," which seems to have sprung into existence just about the time of

Cook's explorations. However, slangmeister Eric Partridge declares that kangaroo is in fact of aboriginal origin and means "jumping quadruped." Someday Cecil is definitely going to have to get this straightened out.

We Get It Straightened Out a Little Sooner Than We Expected

I never imagined that the day would come when I would spot an error in your witty and admirably researched column, but your recent discussion of the etymology of "kangaroo," alas, shows you aren't up to date on the research in this area. In the Guugu Yimidhirr language, spoken by the aboriginals of the area where Captain Cook's party recorded the term kangooroo *(the original spelling), this word (more accurately pronounced something like* kang-ooroo*) refers to a particular species of kangaroo, namely the large black kangaroo. The only error Cook's party can be accused of is mistaking the name of one variety of kangaroo for the generic term. I hope you will be able to bring your readers up to date on this question and disillusion them regarding the widespread mythology surrounding it.—Bernard C., Department of Linguistics, University of Southern California, Los Angeles*

As you can imagine, Bernie, keeping track of all the world's knowledge is a formidable task, even for a person of my legendary abilities. So you will just have to forgive me if I messed up on a few details of Guugu Yimidhirr. Perhaps I had best recap the whole controversy. The story is that when the English explorer James Cook and his friend Joseph Banks first espied a kangaroo during an expedition to Australia in 1770, they asked a nearby native what it was. They received the reply "kang-ooroo," which they assumed was the name of the critter in question. A later explorer, however, found that the natives seemed never to have heard of "kangaroos," and the legend grew up that what the native had actually said was the aboriginal equivalent of "I don't understand you"—in other words, that Cook and Banks had made an unbelievably dumb (not to mention comical) mistake. Subsequent research has established, however, that this was not the case. The real problem, apparently, was simply that the later explorers mispronounced "kang-ooroo" (it's *ng* as in *sing*, and I believe there's a roughly equal emphasis on the second and third syllables). The natives were mystified by the European pronunciation "kangaroo," and besides, whoever was asking was probably pointing at a variety of roo other than the large black kind, which, strictly speaking, is the only official "kang-ooroo." Anyway, lexicographers have since made several attempts to convince the world that "kangaroo" isn't merely the result of British incompetence. As usual, however, legend dies hard.

Mistaken Namesakes: The Scandal Widens

I was quite interested in the continuing story of the origin of the word "kangaroo," and confess I was a little disappointed to have the wonderful myth about its origin dashed by the truth—but the straight dope must prevail at all costs! Besides, the kangaroo story isn't history's only case of mistaken namesakes. The Book of Lists #2 *reports that the word "Yucatan," meaning "I don't know," was the response given when a Spanish explorer on the Mexican peninsula inquired what land he was on. "Nome," as in Alaska, also has an interesting origin.—Brad B., Hollywood, California*

Cecil's rule of thumb for these things, Brad, is that the cuteness of the story is in inverse proportion to the likelihood of its

actually being true. The Yucatan = "I don't know" story apparently started with one Gomara, who published *The History of the Indies* in 1554. The explorer involved was Francisco Hernandez, who reached the Yucatan in 1517. Asking some locals about the name of a nearby town, he received the reply, "Tectatan," supposedly meaning "I don't know," which eventually the Spaniards corrupted into "Yucatan." However, other historians say Yucatan was first mentioned in a report by Bartholomew Columbus, brother of Christopher, who had heard about it from some Indians in 1502. Believe who you will.

The origin of Nome, Alaska, is also in doubt. According to the 1943 *Guide to Alaska* prepared by the Federal Writers' Project, the word is the result of a draftsman's error. "When the manuscript chart of the region was being prepared on board the British vessel *Herald*, attention was drawn to the fact that [a certain] point had no name, and a mark (? *name*) was penciled against it. The chart was hurriedly inked in, the draftsman reading ? *name* as *C. Nome*, and Cape Nome and Nome they have been ever since. This story is disputed by other authorities, who say it is a local native name."

I am doubly inclined to disbelieve this story because of a suspicious yarn told by Mary Lee Davis in *Uncle Sam's Attic* (1930). Quoth Davis: "The very name of Nome is an answer to the query, 'Whence came the first American?' 'Ka-no-me,' said the Eskimos, when white men asked what place this was: 'I do not know.' And so the place was called: Ka-no-me, Nome, 'I do not know.' " Having now had the "I don't know" yarn turn up in three different parts of the globe, I can draw one of two conclusions: either explorers are incredible saps, or somebody's been pulling our leg.

A friend and I were wondering where the common suffix "-arama," as in "foodarama" or "motorama," comes from. What does it mean, if anything?—Kimberly J., Baltimore

The suffix *-arama*, as we know it today, is one of many queasy cultural relics from the 50s and early 60s, along with blond wood furniture, Capri pants, and the beehive hairdo. Originally it derived from "panorama" (from the Greek *pan*, all, plus *horama*, view), a word invented in 1789 or so by one Robert Barker to describe his invention, a type of painting showing a wide-angle view of some notable scene. (According to "Ripley's

Believe it or Not," not normally one of my top sources of ety-mological insight, Barker's paintings were 50 feet high, up to three miles long, and weighed up to 8,000 pounds.) In the 1840s and subsequently we find mention of something called a "cyclo-rama," which was a panorama mounted inside a cylinder, with the spectator standing in the center. That was pretty much it as far as vocabulary building was concerned until 1952, which saw the arrival of Cinerama, the beginning of a veritable thunder-storm of *-aramas*. At first the expression was restricted to wide-screen movie processes; later it came to dignify any long, expensive entertainment spectacular, and later still it was ap-plied to virtually any commercial enterprise that looked like it could stand a little goosing, e.g., Liquorama, formerly Al's Tap. The usage has since gone into decline, mercifully, but you still see it around sometimes, usually in places where they use the word "mod" to describe anything that's happened since 1965.

All of us old enough to be allowed to walk down the street by ourselves have experienced that peculiar encounter with an oncoming stroller characterized by dance-like and indecisive movements from side to side, as each participant helplessly fences with the other in an effort to avoid a head-on collision. This raises not one but three questions: (1) is there a word for this type of encounter, and if so, (2) what is it? (3) Whatever hap-pened to "keep to the right" as a guiding principle for pedestrian traffic? Your answers to these questions will help immeasurably in my personal campaign to reeducate the public in the niceties of moving right along. Think how I will impress total strangers if I can emphasize to them the value of keeping to the right in order to avoid "----ing."—J.G., Chicago

Let's keep this talk of "----ing" to a minimum, J.; we're try-ing to run a family column around here. I am pleased to report that at least one attempt has been made to give a name to the little two-step you describe: *shuggleftulation*, "the actions of two people approaching, trying to get around each other, and mut-tering 'thanks for the dance.' " My source here is Rich Hall's *Sniglets* (Collier Books, 1984), a sniglet being "any word that doesn't appear in the dictionary, but should." Other sniglets, as long as we're on the subject, include *elecelleration*, "the mis-taken notion that the more you press an elevator button the fas-ter it will arrive," and *pupkus*, "the moist residue left on a

window after a dog presses its nose to it." Worthy though these efforts may be, I cannot help thinking that "shuggleftulation" does not quite cut the mustard, and accordingly I have been trying to think up something better. The possibilities so far include *sidewaltz, minueticate,* and (my personal favorite) *doing the concrete quadrille.* No sensitive person can fail to be impressed by the poetry of these suggestions. However, if anyone has ideas of his or her own, and is desirous of seeing same immortalized in print, I am inviting you to submit them forthwith.

The Teeming Millions Come Through!

Let me suggest "ambi-ambulation." Catchy, huh? I also like it because the repetition of the letters "a-m-b" verbally recapitulates the actual physical side-to-side movement which typifies this phenomenon.—Bob C., Chicago

When I was in the twelfth grade at Waggener High School in Louisville, Kentucky, my English teacher, Mr. Day, had our class collectively think up a term for the phenomenon in question. The word we invented was "awkstep," or, in the gerund form, "awkstepping." I think it really catches the minor social embarrassment inherent in the act.—Peggy R., Granada Hills, California

Could there possibly be a better word for it than "avoidancing"?—Kenneth Y., North Hollywood, California

William Safire once described the sidewalk dance ("shuggleftulation") as "faux pas de deux." I don't often agree with Mr. Safire, but I like that phrase.—Anne L., Chicago

Impressed as I am with "sidewaltz" and "doing the concrete quadrille," my personal choice to replace "shuggleftulation" is "simuljuke." "Juke," as far as I know, has its origins in American football—the evasive fakes of a running back.—Brent S., Chicago

My slang dictionaries say "juke" means, among other things, "to tour roadside bars, usually with one of the opposite sex," or

"to coit a woman"—maybe not exactly what you had in mind, although it lends an interesting subtext to your word.

I'm sure you've seen those clear plastic or glass containers filled with a liquid and tiny flakes of "snow" or some other material. When you turn or shake them, you create a "snowstorm" inside. My question is, what do you call these things? I feel so inadequate when I'm trying to describe that scene in Citizen Kane.—*Larry R., Richardson, Texas*

Get ready for this, Lar. You call them "shake-'em-ups." You were expecting maybe rhombicosidodecahedron?

No, But They Weren't Expecting "Shake-'em-Ups" Either

Re: "shake-'em-ups." I have over 200 of these things, and I can authoritatively say their name is "snowdomes." I call them "snow." No flea marketer would know definitively what a "shake-'em-up" was.—*S.G., Cabin John, Maryland*

I have subjected countless people to this same question. To this day one friend insists they are called "waterballs." However, based on my extensive data, the correct term is "snowglobes."—*H.G., from D.C.*

They're called "water globes."—*Erika M., Santa Barbara, California*

Great. Till you guys get your act together, I'm sticking with "shake-'em-ups."

For the past year or so, my wife has been after me to find out the origin of the word "hobo." Unfortunately, none of the sources I've checked has been much help. Can you help me out?—*William R., Los Angeles*

As usual, there are various theories: (1) bearing in mind that a hobo traditionally has been a migrant worker, not simply a vagrant, it comes from "hoe boy," a migratory farm worker. (2) It derives from the expression "hey, bo," *bo* being a sardonic corruption of the French word *beau*, a dandy. (3) It comes from "ho, boy," which was apparently what railroad mailhandlers in

the northwestern U.S. felt compelled to yell when they heaved mailbags off the trains.

In a recent note from the British consulate regarding certain weird little interests of mine, I see that Her Majesty's minions are eschewing all punctuation in heading and greeting. Plus, incredibly, complimentary close! Are U.K. civil servants just being ordered to save typewriter ribbon until another North Sea oil gusher comes in? Or are we former colonists in for a bout of creeping depunctuation?—Mr(.) J(.) Stephen H(.,) Chicago

Could be, babushka. British tastemakers decided that the rococo effusion of commas and periods that graces the average business letter was an excess that might well be dispensed with in an age of scarcity. A fair amount of punctuation continues to be used, of course, notably the period at the end of a sentence. But periods are often dropped from abbreviations. The Brits used to make a distinction between a true abbreviation, in which the end of a word is deleted (e.g., Inc. or vol.), and a suspension, in which letters are taken out of the middle of a word (e.g., Mr., Ltd.). A suspnsn did not get a period, but an abbrev. did. Now, however, the tendency is to expunge periods wherever they raise their reactionary little heads, saving typists hours of soul-destroying labor. Show some consideration for the working classes, you creep.

Many people know that a misanthrope is a person who hates all mankind and that a misogynist is a man who hates all women. But to the best of my knowledge, there is no word in the English language for a woman who hates all men. Cecil, here's your chance to go down in linguistic history. How about coining such a word?—Tom M., Chicago

No need, Tomaso—somebody beat me to it. The word is "misandrist," a practitioner of misandry (accent on the first syllable in both cases). We find the latter gem in *Mrs. Byrne's Dictionary of Unusual, Obscure, and Preposterous Words*, by Josefa Byrne. The root *aner*, of course, is Greek for "man." Compare the two varieties of polygamy, or multiple spouses: "polygyny," multiple wives, and "polyandry," multiple husbands. Consider your vocabulary enriched.

I keep hearing and reading about "signifying," e.g., someone calls you a lowlife SOB but means it as a term of endear-

ment. What does signifying mean and where does it come from?
Does this mean that Harold Washington really likes Ed Bradley
(not to mention Ronald Reagan)?—D.W.A., Downers Grove,
Illinois

Let's not jump to rash conclusions, D. Signifying—the ori-
gin of the term is obscure—is the process of semi-witty insults by
which black American male adolescents attempt to reduce their
buddies to psychic mush. Some claim the practice has its origins
in the days of slavery, when blacks had to learn to take abuse
from whites without getting mad, lest the whites whomp the poo
out of them. But Cecil, himself a signifier of legendary ability
(although we used to call it grossing out), is inclined to think
that signifying, under various names, is common among males
of any hue whenever the sap is running. As with any sort of
repartee, whether you really mean it depends on the situation.

The exact definition of signifying (also known, in various times
and places, as sigging, sounding, woofing, wolfing, burning, ic-
ing, joning, etc.) is a bit vague. To some it means any kind of
ritual insult; to others, it must include an element of indirec-
tion—i.e., the victim doesn't realize he's being insulted, you egg
the victim into a fight with somebody else, or in general you just
lay on the BS. In days of yore one of the terms for signifying was
"doin' the dozens," which usually meant making fun of the other
guy's relatives, particularly his momma. Here are a few of the

more printable examples collected by researcher Tom Kochman in his book, *Rappin' and Stylin' Out: Communication in Urban Black America:*

> *Yo momma eat Dog Yummies.*
> *Yo momma raised you on ugly milk.*
> *Yo momma so bowlegged, she look like a bite out of a donut.*
> *Yo momma sent her picture to the lonely hearts club, but they sent it back and say, "We ain't that lonely!"*
> *I walk in yo house and yo family be running round the table. I say, "Why you doin' that?" Yo momma say, "First one drop, we eat."*
> *You so ugly, yo momma have to tie a pork chop to yo neck to make the dog play with you.*

Sometimes there are rhyming dozens:

> *Iron is iron, and steel don't rust,*
> *But yo momma got a pussy like a Greyhound bus.*
> Or: *I hate to talk about yo momma, she a good ole soul*
> *She got a ten-ton pussy and a rubber asshole.*
> Or (this one's from the old days):
> *Yo momma behind like a rumble seat*
> *Hang from her back down to her feet.*

One important element of ritual insults is to always have a snappy comeback, commonly known as cappin' the rap. If somebody says, "Screw you," you say, "Hey, man, we ain't even kissed yet." The story is told of some dude coming out of the john with his fly open. Some women nearby start giggling and pointing. When he finally figures out what's going on, he goes over and says, "Hey baby, you see that big black Cadillac with the full tires waitin just for you?" One woman says, "No, but I saw a little gray Volkswagen with two flats."

In comparison to the distinguished repartee just quoted, you have to admit that the late Harold Washington's remark that Ed Bradley was "the lowest of the low" and "a scurrilous type individual" was pretty weak. Signifying obviously ain't what it used to be.

In elementary school I remember the teacher telling me that the vowels were AEIOU and sometimes Y and W. But I can't

think of a single word where W is used as a vowel. Are there any?—Michael S., Baltimore

Sure. Try "how," which is phonetically equivalent to "hou," as in house. *Ou* and *ow* are diphthongs—that is, two vowel sounds that kind of slide together when you say them. *W* and *Y* are often called semivowels because they go both ways, as it were, depending on the company they keep within the word. (Low morals are obviously a problem at every level of our society.) In "cow," for instance, *W* is a vowel, but make the word "coward" and you can hear *W* working as a consonant. Similarly with *Y* become *I* in "copy" and "copier." I could also expound on the vowel-*likes*, yet another class of letters with an identity crisis, but I think we've had enough angst for one column already.

Letter Writer Claims Telepathic Abilities

Regarding your column on the use of W as a vowel, the word Mr. S. wanted to hear was cwm. There are of course others. Check out your OED. And hey, in general you're OK.— Luis P., Chicago

Don't think that token nicety is going to save you, you skunk. "Cwm," pronounced "koom" and signifying "mountain hollow," is a borrowing from Welsh, in which tongue *W* is a vowel equivalent to *oo* (or perhaps we should say, double-*U*). Use of *W* this way in English is anomalous and is not what linguists have in mind when they talk about *W* being a part-time vowel.

How a mutation like "cwm" got into a nice language like English in the first place is a question that bears some looking into. Except for persons who spend a lot of time prowling around mountain hollows, it's useful chiefly to composers of crossword puzzles and other disreputable amusements, e.g., the "pangram." A pangram is a sentence containing every letter of the alphabet at least once and ideally no more than once. You can see how "cwm" would come in handy in this regard. For example, we have:

Cwm, fjord-bank glyphs vext quiz.

"Carved figures in a mountain hollow and on the bank of a fjord irritated an eccentric person." ("Vext," of course, is an alternate

form of "vexed," and "quiz" means "an eccentric person.") Similarly we have:

Junky qoph-flags vext crwd zimb.

"Trashy flags with a design resembling the Hebrew letter qoph exasperated an Ethiopian fly whose customary habitat was an ancient Celtic stringed instrument (*crwd*)." But it's not like I'm telling you something you don't already know.

Why is the New York borough of the Bronx not simply called "Bronx"? I've consulted encyclopedias, native New Yorkers, and even a linguist at a leading university. So far all I've gotten is a partial explanation. At the turn of the century when the five boroughs were consolidated into one city, the large parcel of land north of Manhattan was owned by a wealthy family named Broncks. When city dwellers wanted to escape suburbia, they went up to the Broncks farm or estate. Later the spelling was changed to Bronx. But I'm sure there's more to it than that. Cecil, if I don't get an answer by August 11, the Lord's gonna call me home.—Norman W., Chicago

I hope you like the Lord's digs better than your previous place of residence, Norm, because I'm a little late. Serves you right—you know how Cecil hates being rushed. You also got a few facts scrambled on the Bronx story. The name of the wealthy family was Bronck (sometimes spelled Bronk). The clan's patriarch, Jonas, settled on 500 acres north of the Harlem River in 1639, and promptly affixed his surname to various features of the local geography, notably the Bronx River. As one of his descendants explained, "The termination of *x* merely indicated the possessive case. Instead of writing Bronk's River or Bronk's farm, the Dutch took the phonetic short cut and made *x* do duty for the fusion of *k* and *s*; extremely simple, and a space saver too. Thus, when Jonas impressed his own family nomenclature on the region he settled, the Aquahung River became Bronk's River— the Bronx, as it remains today, correctly expressed in Dutch."

As far as Cecil can tell, the name "the Bronx" didn't signify the entire area until late in the nineteenth century. In 1874 about 20 square miles of mainland Westchester county was annexed to New York City and known thereafter as the Annexed District of the Bronx. Apparently this referred to the Bronx River, then the district's eastern border. In 1898 the Annexed District became

part of the Borough of the Bronx—presumably still referring to the river. After a while, however, people forgot about the river and began casually referring to the entire borough as "the Bronx." The use of "the," in other words, is simply a historical accident.

What is the origin of the term "story" when applied to a building?—Vaughn C., Scottsdale, Arizona

I hesitate to go into this, Vaughn, but what the heck, you're old enough. A century ago etymologists speculated that "story" came from some lost word "stairy," perhaps related to Gaelic *staidhir*, flight of stairs; or possibly from something along the lines of "stagery," derived from "stage." Others dismissed these as being obviously born of desperation, and for a time the experts settled on Old French *estoree*, a thing built. But doubts arose when researchers dug up such phrases as *una historia octo fenestrarum*, "a story of eight windows," from medieval Latin history books. *Historia* in Roman times meant history or story, and by the Middle Ages had acquired the meaning of "picture." So the charming notion arose that medieval folk were in the habit of installing rows of windows in their buildings called "stories" that were decorated with paintings or sculpture. The theory is that these stories, which for all anybody knows may actually have told a story, eventually came to signify a level of a building. Apparently as evidence of this practice, the authors of the *Morris Dictionary of Word and Phrase Origins* cite the fact that they once visited a Swiss-style hotel decorated along these lines in Lake Placid, New York. (Each floor was tricked out with a large hand-lettered slogan, such as "The only way to multiply happiness is to divide it.") At any rate, conjecture has now hardened into conviction. Believe at your own risk.

Why do we say "a pair of pants" when there is only one article of clothing involved? I have been told it's because there are two legs, but then why isn't it a pair of shirts? Shirts have two sleeves. I'm so confused. Can you help?—Rose M., Chicago

Fret not, my little anchovy. Ann Landers might puppy out and tell you to get professional counseling, but here at the Straight Dope, we deliver. Now for the facts. First of all, let's note that there is a class of objects thought to consist of two independent but connected parts, usually identical or at least

similar to each other. In addition to pants and trousers, there are eyeglasses, scissors, tweezers, shears, pliers, and so on. The terms for these objects are always plural in form, and they are usually referred to as "a pair of . . . ," a usage that goes back to at least A.D. 1297, when we have the expression "a peire of hosen." The implication is that the two parts are separable in some sense, and in fact a pair of hose can often mean two separate pieces. (True, you can't separate tweezers, but I never claimed the English language was rational.) In contrast to trousers, a shirt is thought of mainly as a covering for the torso, and may or may not have sleeves. Hence no pair.

The "pair of . . ." designation is somewhat arbitrarily applied. At one time it was common to speak of a pair of compasses (for drawing), a pair of nutcrackers, or a pair of bellows, but I would venture to say that in the U.S., at least, these expressions are dying out. On the other hand, we do speak of a pair of panties, even though panties aren't really a pair of anything, having (usually) no legs. Further confusing matters is "a dozen pairs of rosaries," even though there are 50-some beads. This harks back to an old use of the word "pair" to mean "a set of more than two like or equal things making a whole." Another example of this, supposedly common in the theater business for many years, is "a pair [flight] of stairs." Finally, there is the familiar male observation, "Jeez, wouldja getta loada that p—" . . . but I think we've had enough language fun for one day already.

This question seems like such an obvious candidate for your column that someone must have asked it before. But on the chance no one has, here goes: What does "OK" stand for, and where does the expression come from? I've heard a lot of different explanations over the years.—Norm, Chicago

I know, and it's about time I got things cleared up. Despite the fact that the origin of OK was conclusively established 25 years ago, few etymological dictionaries, even those of recent vintage, give it accurately, and some persist in giving equal time to explanations that have been discredited for decades. Eric Partridge, in *Origins* (1983), says OK derives from the OK Club, which supported Martin "Old Kinderhook" Van Buren in 1840. This isn't wrong, but it's only half the story. William and Mary Morris, in the *Morris Dictionary of Word and Phrase Origins* (1977), mention the OK Club and give several other theories as

well, including the daft idea that OK comes from "Aux Cayes," a port in Haiti noted for its rum. They imply the matter is still shrouded in mystery.

This is nonsense. The etymology of OK was masterfully delineated by the distinguished Columbia University professor Allen Walker Read in a series of articles in the journal *American Speech* in 1963 and 1964. The letters stand for "oll korrect," and are the result of a fad for comical abbreviations that flourished in the late 1830s and 1840s. Read buttressed his arguments with hundreds of citations from newspapers and other documents of the period. As far as I know his work has never been successfully challenged.

The abbreviation fad began in Boston in the summer of 1838, and spread to New York and New Orleans in 1839. The Boston newspapers began referring satirically to the local swells as OFM, "our first men," and used expressions like NG, "no go," GT, "gone to Texas," and SP, "small potatoes." Many of the abbreviated expressions were exaggerated misspellings, which were a stock in trade of the humorists of the day. One predecessor of OK was OW, "oll wright," and there was also KY, "know yuse," KG, "know go," and NS, "nuff said."

Most of these acronyms enjoyed only a brief popularity, but OK was an exception, partly because it was useful and partly because words with *K* sounds are catchy. It first found its way into print in Boston in March of 1839 and soon became fairly widespread among the hipper element. It didn't really enter the language at large, however, until 1840, when Democratic supporters of Martin Van Buren adopted it as the name of their political club, thereby giving OK a double meaning. ("Old Kinderhook," as Van Buren was known, was a native of Kinderhook, New York.) OK became the warcry of Tammany hooligans in New York while beating up their opponents, and was mentioned in newspaper stories around the country.

Van Buren's opponents tried to turn OK against him, saying that it had originated with Van Buren's allegedly illiterate predecessor, Andrew Jackson, a story that has survived to this day. They also devoted considerable energy to coming up with unflattering interpretations, e.g., "Out of Kash, Out of Kredit, and Out of Klothes." Newspaper editors and publicists around the country delighted in coming up with even sillier interpretations—Oll Killed, Orfully Konfused, Often Kontradicts, etc.—

so that by the time the campaign was over the expression had taken firm root nationwide.

As time went on, though, people forgot about the abbreviation fad and Old Kinderhook and began manufacturing their own etymologies. Here's a sampling: (1) It's a derivative of the Choctaw Indian affirmative "okeh." Andrew Jackson, who figures in many stories about OK, is said to have introduced the word to the white man. Another Jackson story has it that he used to mark OK for "oll korrect" on court documents. In the one example of this that was actually unearthed, however, the OK was found actually to be OR, for "order recorded," a common courthouse abbreviation. (2) It was a telegraphic signal meaning "open key," that is, ready to receive. Others say OK was used for "all right" because A and R had already been appropriated for other purposes. Suffice it to say that the first telegraph message was transmitted in 1844. (3) It stands for O. Kendall & Sons, a supplier of army biscuits that stamped its initials on its product. (4) It comes from Aux Cayes, already discussed. A variant is that it comes from the French *au quai*, "to the dock," said of cotton that had been approved for loading on a ship. (5) It stands for Obediah Kelly, a railroad freight agent, who used to mark his initials on documents to indicate all was in order. (6) It comes from the Greek *Olla Kalla*, "all good." (7) A German general who fought on the side of the Americans in the Revolutionary War used to sign documents OK for *Ober Kommando*.

There are dozens of other interpretations as well, most of them without a shred of documentary evidence. I've got nothing against cute stories, but if one more of the Teeming Millions tries to tell me one of them is the "real" origin, I swear to God I will come out there and strangle you with my bare hands. There are times when only strong measures will do.

Where does the expression "the whole nine yards" come from? Even Walter Payton has to make 10 yards for a first down. Since when does nine yards equal 100 percent effort? I trust your answer is not sexual. No enhancer I've ever seen advertised promises anything like that.—Russell E., Chicago

Don't get smart, Russell, not that there's any great danger. The usual authorities are silent on this topic, so Cecil has been trolling for leads on radio talk shows. This has turned up nu-

merous theories, some of then pretty ingenious, in a demented sort of way.

One guy told me that the expression comes from the nautical term "yard," meaning one of the horizontal poles that hold up the sails on a square-rigged sailing ship. A typical ship, he claimed, would have three masts with three yards apiece, or nine yards in all. A captain who had sent up all the canvas he could in order to squeeze out max velocity would thus be said to be giving it "the whole nine yards." Could be, but I doubt it. For one thing, sailing ships often had 12, 15, or even 18 yards. For another, "whole" in this context is a funny choice of words. "*All* nine yards" would make more sense.

Others have told me that coal trucks in New England originally had three sections that contained three cubic yards of coal apiece. If you anticipated a truly ghastly winter, naturally you asked for the whole nine yards. More commonly, however, you hear that the expression comes from the capacity of ready-mix concrete trucks, which supposedly contain nine cubic yards when fully loaded. This view was recently advanced by William Safire in his "On Language" column in the *New York Times Magazine*. I wrote to Bill inquiring about his sources for this claim, but all I got by way of reply was a postcard congratulating me on my interest in language. This did not strike me as real responsive, somehow, but perhaps there is more to it than meets the eye.

At any rate, I have checked with several ready-mix companies, and they tell me that while drum size on concrete trucks varies (the drum is what holds the concrete), capacity generally ranges from 7 to 10 yards, with 9 a rough average. In short, we could be on to something here. But I'm skeptical. I note that the ready-mix business dates back only to the late 40s and early 50s, so all we have to do to disprove the concrete theory—something disturbs me about that juxtaposition, but never mind—is to find an earlier citation. I shall endeavor to do so, but if the Teeming Millions want to help out, be my guest.

The People Speak, Part One

Not that I am calling you a liar, but I would like to dispute your answer to the question posed in a recent column regarding the origin of the term "the whole nine yards." It is not a nautical,

coal, or ready-mix term but rather relates to the clothing indus-
try. It is a term that tailors used for denoting the extent that one
wishes to invest in a custom-made suit. It takes exactly nine
square yards of material to create a man's three-piece suit. If an
individual desires a suit that is tailored to the "hilt" (double lined,
etc.), he would request that the tailor should proceed with "the
whole nine yards." Anything shy of that would mean various
alterations, thus lessening the overall quality of the suit. My
source: Howell M., father, friend, and personal adviser. His cre-
dentials: Noted sharp dresser and business executive, Michigan
Avenue, Chicago. His experience: 35 years.—Chris M., Tempe,
Arizona

I think I can answer the one about "the whole nine yards,"
though I can't recall my source. The phrase comes from, of all
things, wedding veils. In olden days, any bride who really
wanted to impress the neighbors (and whose father could foot
the bill) simply had to have a veil nine yards in length. Take a
look at the Princess Di wedding pictures and you'll see what I
mean. Anything less was, well, something less. Hence the phrase
originally applied to fancy, blowout weddings—"the whole nine
yards."—Betsy D., Washington, D.C.

It is times like these that Cecil wishes he had gone into a
more respectable line of work, such as numbers running. This at
least lends itself to definite results, which is more than you can

say for freelance etymology. I've looked into both theories outlined above, and while I'm dubious, neither can be flatly ruled out.

The amount of cloth required for a man's three-piece suit varies with the man, but the average is about 4 to 4½ yards measured off a 30-inch bolt. Since cloth for men's suits is generally sold "double-width," meaning it's folded in half before being put on bolts, our actual cloth size is 60 inches wide. This works out to 6⅔ to 7½ square yards of cloth, well shy of the 9 yards we're after, even for a good suit. (The fact that a suit is top quality doesn't mean it uses more cloth than the run-of-the-mill variety; if anything, according to one tailor I spoke to, custom-made suits use less cloth, since there's less waste during cutting.)

I talked to a number of tailors, one of whom had been in business 40 years, and none had heard the expression "the whole nine yards" used in connection with the men's clothing business. However, a seamstress did opine that once upon a time cloth for men's coats had been sold on single-width bolts. Four and a half yards of double-width cloth presumably equals nine yards of single-width, so she cast her vote for Papa M.'s theory. Fine by me. I'd hate to give a boy reason to doubt his old man.

It's pretty much the same story with bridal veils. The longest veil seen nowadays is generally 180 inches, or 15 feet. But a saleswoman at one bridal shop confirmed that years ago your basic last-days-of-Pompeii-type wedding might in fact feature a 27-foot veil. She herself believed that this was the origin of the expression "the whole nine yards." Lady Di's train was 25 feet long; allowing a couple extra feet for the veil (which attaches to the head, as opposed to the train, which attaches to the waist) we come up with nine yards.

We are thus faced with an apparent case of linguistic parallel development—an expression that three different industries (ready-mix concrete, bridal wear, and maybe men's tailoring) claim as their own. With all respect to the Teeming Millions' fathers, the only thing that will settle the issue is published citations—examples of "the whole nine yards" in use in books and periodicals, the earlier the better. You got one, send it in. We'll get to the bottom of this yet.

• • • •

The People Speak, Part Two

The term "the whole nine yards" originally referred to the amount of fabric it took to make an authentic dress for a colonial lady. To this day, ladies who wish to have costumes made can do with no less than nine yards of material, not to mention lace, buttons, snaps and whatever else it takes to complete the outfit. The expression "the whole nine yards" includes all these extras.—Mrs. J.C., Yorktown, Virginia

"The whole nine yards" refers to the last thing a person used to receive in this world. It is the amount of cloth an old-fashioned undertaker used to make a funeral shroud.—Stephen K., Madison, Wisconsin

I submit that the phrase has its origins not in concrete, coal, or sailing ships but in the humble general store of bygone days. These stores sold just about everything a family could need, including fabric. Embedded in the counter were small brass nails three feet apart, which were used to measure yards of material, which usually came in bolts of nine yards. If you needed only a few yards of material, you would "get down to brass tacks" and buy the desired amount. If, however, you needed a large quantity of fabric, then you would just say give me "the whole nine yards." While this answer is speculative, I believe it is more likely than some of the others. How many other phrases have come to us from the ready-made concrete industry?—James M., Pasadena, California

I heard it originated somewhere in England and referred to the difference between a proper burial and a pauper's burial. If you were well-to-do, you could afford to have "the whole nine yards" of dirt removed for your grave, as opposed to the poor who couldn't pay for such a large plot.—Cathy B., Norfolk, Virginia

It is an expression from the sewing circle. To this day all fabric comes in bolts of nine yards. Check it out.—Teresa H., San Antonio, Texas

With regard to the origin of the phrase "the whole nine yards," one must keep in mind the inevitable reduction of the subtle and urbane to the pedestrian and vulgar in the hands of the Teeming Millions. It seems perfectly logical to me that the true meaning of the phrase does indeed spring from football. However, rather than indicating fulfillment of a goal, the phrase probably was originally intended ironically. In an instance of shortfallen achievement where a disdainful comment would be appropriate, it could be said sarcastically that "he went the whole nine yards." For example, then, in answering the original reader's query, Cecil certainly went the whole nine yards.—Rick A., Chicago

Contrary to common belief, cloth does not come in bolts of nine yards "to this day." Twenty to twenty-five yards is more like it. As for the rest of you people, I am not interested in your freaking *opinions*. I want *facts*. Since none appear to be forthcoming, we will declare this discussion closed until such time as I can go investigate myself. This is the last time I ask you guys for anything.

What is a mojo? Do women have them? And what does it mean to have your mojo workin', risin' etc?—Rich R., Madison, Wisconsin

It's not what you think, wise guy. According to my *Supplement to the Oxford English Dictionary*—not, perhaps, the ideal source for a word popularized by semiliterate blues musicians, but bear with me—mojo has two meanings: (1) a narcotic, especially morphine; or (2) "magic, the art of casting spells, [or] a charm or amulet used in such spells." In the first sense mojo may derive from the Spanish *mojar*, to celebrate by drinking; in the second, from an African word, perhaps Gullah, *moco*, meaning witchcraft or magic.

In blues songs mojo almost always refers to meaning number 2. For example, there's "Mojo Blues," recorded by Charley Lincoln in 1927: *Oh the mojo blues mama, crawling across the floor/ Some hard-luck rascal done told me I ain't here no more/ . . . Aw she went to a hoodoo, she went there all alone/Because every time I leave her, I have to hurry back home.* Imponderable though portions of this are, it seems clear that the woman is using a mojo to bring her man back.

Similarly we have "Low Down Mojo Blues," recorded by Blind

Lemon Jefferson in 1928: *My rider's got a mojo, and she won't let me see/Every time I start to loving, she ease that thing on me/She's got to fool her daddy, she's got to keep that mojo hid/But papa's got something, for to find that mojo with/She got four speeds forward, and she don't never stall/The way she bumps over the hill, it would make a panther squall.*

The problem with these damn blues tunes is that just about when you figure you've got something pretty much nailed down, meaningwise, they launch into some off-the-wall digression (e.g., "four speeds forward") that tends to cast doubt on any strictly linear interpretation. However, you get the basic idea. You also see how you might get the impression a mojo has something to do with sex, mainly because nine times out of ten it *does* have something to do with sex, in the form of a love charm or aphrodisiac or something. "Scary Day Blues" by Blind Willie McTell makes this painfully evident:

My good gal got a mojo, she's trying to keep it hid/But Georgia Bill got something to find that mojo with [I know this is repetitive, but it gets better]/*I said she got that mojo, and she won't let me see/And every time I start to love her, she's tried to put them jinx on me/Well she shakes it like the Central, she wobbles like the L and N* [railroads]/*Well she's a hotshot mama, and I'm scared to tell her where I been/Said my baby got something, she*

won't tell her daddy what it is/But when I crawls into my bed,
I just can't keep my black stuff still.

I trust the expression "black stuff" requires no elucidation.

Notes from the Mojo Beat

*Cecil, please, watch your stereotypes—"semiliterate blues
musicians" indeed! One of the musicians you quoted, Blind Wil-
lie McTell, studied at schools for the blind in Mississippi, New
York, and Michigan, and although he sang on the streets for
years he was far from a beggar, traveling extensively throughout
the South and performing many styles of folk and pop, as well
as blues, in a wide variety of venues. Two of our other best-
known "mojo" lyricists—Willie Dixon and J.B. Lenoir—are fa-
mous for their insightful, articulate musical observations on
politic social issues, and a wide variety of other topics. Each,
moreover, was much more than a "mere" musician: Dixon was
A&R man for Chess Records for many years, and Lenoir made
a profitable living for himself in the funeral home business after
he retired from music. The list of blues musicians who've enjoyed
success in other endeavors—politics, business, other performing
arts, the church—requiring both literacy and resourcefulness
would be much too long for this letter.*

*As far as mojo goes, I might be able to contribute two bits of
information: The "mojo hand" often referred to is a variation of
a generic kind of magical "hand" used by root doctors and hoo-
doo doctors in rural folk medicine and magical practices. On one
memorable television broadcast, Dr. John presented Muddy Wa-
ters with one, complete with either the bones or the dried fingers
of monkeys hanging from it. From what I can gather, "mojo" in
this case is an adjective, like the word "magic" in "magic po-
tion."*

*The "mojo rising" the questioner mentioned, however, is the
invention of one Jim Morrison of the famous Delta blues band
the Doors. He took to nicknaming himself "Mr. Mojo Risin' " as
an anagram of "Jim Morrison" toward the end of his life, and
he finally included the phrase in the song, "L.A. Woman," al-
though what Southern folk medicine has to do with Los Angeles
is a secret Morrison carried to his grave (we think).—David W.,
Chicago*

What is the origin of the word Yankee?—Listener, WFBR, Baltimore

We are all familiar with the concept of *yanking*, right? OK, then obviously you have your yank*ers* and your yank*ees*. I can't claim the etymological authorities are exactly lining up to embrace this notion, however.

The origins of "Yankee" have been fiercely debated throughout the history of the Republic, and to this day the *Oxford English Dictionary* says the source of the word is "unascertained." Perhaps the most widely accepted explanation was advanced by H. L. Mencken, the well-known newsman-scholar (and don't tell me *that* isn't an unusual combination), who argued that Yankee derives from the expression *Jan Kaas*, literally "John Cheese." This supposedly was a derogatory nickname bestowed on the Dutch by the Germans and the Flemish in the 1600s. The English later applied the term to Dutch pirates, and later still Dutch settlers in New York applied it to English settlers in Connecticut, who were known for their piratical trading practices. During the French and Indian War the British general James Wolfe took to referring derisively to the native New Englanders in his army as Yankees, and the term was widely popularized during the Revolutionary War by the song "Yankee Doodle." By the war's end, of course, the colonists had perversely adopted the term as their own. Southerners used Yankee pejoratively to describe Northerners during the Civil War, but found themselves, along with all other Americans, called thus by the English during world wars I and II.

The alternative explanations—Mencken lists 16 of them—are that Yankee derives from various Indian languages, or from Scottish, Swedish, Persian, etc. James Fenimore Cooper claimed that Yankee resulted from a fractured attempt by the Indians to pronounce the word "English." But most others think Cooper's skill as an etymologist was about on par with his prowess as a novelist.

Where do we get the stock market terms "bull" and "bear"?—Listener, KMOX, St. Louis

"Bear" is thought to have originated in a proverb that goes along the lines of, "Don't sell the bearskin before you've caught the bear." This is roughly equivalent to "Don't count your chick-

ens before they're hatched," which is precisely what stock market bears do. Anticipating declining market prices, they sell stock they don't own yet, gambling that the price will fall by the time they actually have to buy the stock and deliver it, netting them big bucks. The term had become popular among London stock traders by the early 1700s, when the bearishly inclined were called "bearskin jobbers."

The origin of "bull"—i.e., somebody who buys stock in the expectation that the price will rise—is not as clear. The term appears to have arrived on the scene a bit later than bear, and some believe it was suggested mostly by alliterative analogy to the earlier expression. The usual explanation for the choice is that bulls habitually toss their heads upward, but you could just as easily make the case that bulls get their way by bulling their way ahead—they create a stampede of optimism that prices will rise, and the inevitable result, the laws of supply and demand being what they are, is that prices *do* rise. However, this theory could be a load of you know what.

Did Indians ever really say "how" in formal greeting?—Keath G., Baton Rouge, Louisiana

Not exactly, but you've hit on one of those rare bits of frontier rubbish that actually has some basis in fact. There is no such thing as a universal Indian greeting—the original inhabitants of North America spoke some 500 different languages—but we do find variants of "how" in the native speech of many Plains Indians tribes, who spoke versions of a major language called Siouan. The Tetons said *howo* and *ho*, the Dakota had *hao* and *ho*, and the Omaha had *hau* (and maybe *ho* too, but I didn't find it in my Omaha dictionary.) The precise meaning of these words varies with the ethnographer who recorded them, but from my reading of various ancient Indian tales (rendered in the original, of course) I deduce that they served as a sort of all-purpose introductory adverb or interjection along the lines of "well," "hey," "so," or "now," as in, "Now see here, white-eyes . . ." You can imagine how ignorant pioneers who heard this at the beginning of every injun soliloquy might come to regard it as a greeting, just as there are Anglo employers in the barrio who think the Spanish words for "yes, boss" are *tu madre*. At any rate, the word eventually found its way into the public con-

sciousness. Plains tribes also provided the basis for other popular beliefs about Indians, such as the idea that all chiefs wear elaborate feathered headdresses.

You are my last hope. I need to know the origin of the phrase "etaoin shrdlu." I first encountered it in Walt Kelly's "Pogo" comic strip, where it was the moniker of an irascible bookworm, and it has turned up periodically since. I have searched, in my own pitiful way, for any printed reference to this enigmatic jumble of letters, but to no avail. The nearest thing I have to a lead is the guess of an old pressman. He suggests that "etaoin shrdlu" is what they used to test Linotype typesetting machines with. Apparently the letters, e,t,a,o, etc., were placed in two rows at one end of the keyboard. A typesetter who wanted to test the machine would run his fingers down these rows and rattle out the nonsense phrase. Can you confirm this?—John S., Chicago

You got it, Jojo. Back when newspapers used to be set in "hot" (i.e., cast metal) type, "etaoin shrdlu" would occasionally wind up in print because a careless Linotype operator neglected to throw his test lines away. These unpredictable appearances gave the phrase a certain mythic quality, shall we say, that has beguiled the curious ever since. The letters are arranged thus because that's the order of their frequency of use in English, at least according to one calculation. The full sequence is ETAOIN SHRDLU CMFGYP WBVKXJ QZ.

Since you know how many calories there are in the average male ejaculation, you should also know the answer to a question that follows directly from it. What is the correct wording—"Hell hath no fury as a woman's scorn," or "Hell hath no fury as a woman scorned"? The difference is subtle but profound.—Andrea and Marshanne, Los Angeles

I'll say. The original quote went like this:

"Heav'n has no rage like love to hatred turn'd
Nor Hell a fury, like a woman scorn'd."

The saying is from the closing line of act 3 of William Congreve's *The Mourning Bride*, first produced in 1697. *The Mourning Bride* is your usual king-orders-beheading-of-enemy-prince-upon-finding-he-is-secretly-married-to-king's-daughter-but-gets-it-himself-in-a-case-of-mistaken-identity-resulting-in-another-

mistaken-identity-with-subsequent-suicide-by-poisoning-revolution-and-reunion-of-happy-lovers tragedy. The first line of the play is another oft-misquote: "Music has charms to soothe a savage breast."

Where does the phrase "to read the riot act" come from?—Tim F., Chicago

Believe it or not, there actually was a riot act once, and they really used to read from it. The English Riot Act of 1714 prescribed an official "order to disperse" that was to be read to any crowd of 12 or more persons whom the authorities deemed to be an unruly assembly. If the crowd failed to comply within an hour, they were guilty of a felony and liable to life imprisonment. But the proclamation had to be read word-for-word or it didn't count. At one raucous gathering in 1830, an unfortunate British official omitted the words "God save the king" and the whole bunch got off scot free.

We call the decade from 1910 to 1919 the Teens, from 1920 to 1929 the Twenties, and Lord knows aging baby boomers never tire of talking about the Sixties. But what do you call the first decade of a century? We're going to need something pretty soon, you know.—Joyce S., Evanston, Illinois

This is what we at the Straight Dope call a Damn Good Question, meaning basically that we haven't the foggiest. Let's see now. We always could try the Aughts, as in nineteen-aught-five. With luck and a little sociological cooperation you could end up with the Naughty Aughties, which would definitely be a decade to die for. Assuming youthful nihilism were back (or still) in fashion, you might want to go with the Zeros, the Zips, or the Ciphers. If those don't cut it either, I suppose we could always fall back on the Turn of the Century—pretty lame, granted, but amply supported by precedent.

But while I try to think up some better ideas, let's move on to a related question. When people refer to the dawning of the millennium they always say "the year two thousand." But that's too cumbersome to use on an everyday basis. So what will we use instead? "Two thousand" by itself sounds a bit strange, and "twenty hundred" isn't much better. And how about the following year—will we call it "two thousand and one," as Stanley

Kubrick fans assume, or "Twenty-oh-one"? If you ask me, we'd better get a presidential commission working on this pronto.

"Dishonest" is the opposite of "honest," right? So does that mean the opposite of "disgruntled" is "gruntled"?—D.J., Atlanta

You must have been a great trial to your mother, D. *Dis-* isn't always used to negate; sometimes it's an intensifier. "Gruntle" is an old dialect word meaning "to grumble." So "disgruntled" means you're *really* grumbling. There are times when I can definitely relate.

Does anyone know how to spell the "mad dog's" name? Time spells it Muammar Gaddafi, the TV stations spell it Moammar Khaddafi, and my roommate tells me she's seen it spelled Qaddafi. Now all of a sudden there's a rush to start spelling it Gadhafi. What's the deal?—S.J., Chicago

Lord knows I hate to be critical, but the proliferation of spellings for the name of Libya's head dude has been one of the continuing scandals of American journalism. I mean, come on, we're trying to plumb this guy's psychic depths and we can't even get his *name* straight? Sometimes I shudder for the future of my country.

I count at least 12 different ways to spell the colonel's handle, including Qaddhafi (*New York Review of Books*), Qaddafi (*New Republic*), Gaddafi (*Time*), Kaddafi (*Newsweek*), Khadafy (*Maclean's*), Qadhafi (*U.S. News & World Report*), Qadaffi (*Business Week*), and Gadaffi (*World Press Review*). Libya's UN mission, in an effort to spread further confusion, spells the name Qathafi, and I know I've seen Gadaafi somewhere. To make matters worse, the Library of Congress and the Middle East Studies Association, to whom one would ordinarily look for guidance, have an unaccountable fondness for Qadhdhafi, which is an abomination unto God. I trust you now begin to grasp the dimensions of the problem.

Some publications have used several spellings over the years; unfortunately, the result has not been a stylistic convergence, but rather a prolongation of the dismal status quo. In 1973 *Business Week* started out with Qadafi, which had the advantage of simplicity, at least; unfortunately, almost no one else used it, and *BW* sheepishly changed to Qadaffi. As of December 30, 1985, the usually punctilious *New Yorker* was spelling if Khadafy; by

January 20, 1986, this had inexplicably metamorphosed into Qaddafi. The *Wall Street Journal* initially used Qaddhafi, but now has shifted to Qadhafi. My personal feeling is to chuck all the preceding and just call him Shithead, which is easier to remember and has an undeniable evocative power as well. But to each his own.

Things are only slightly less muddled with Mr. K's (or Mr. Q's or Mr. G's, as you prefer) first name. *Biz Week* originally has it as Muammer, and the *New Yorker* used to say Moammar, but both have changed to Muammar. For a while, in fact, it seemed that Muammar (sometimes written Mu'ammar, but let's not get picky) might become the standard—until the Desert Fox himself threw a monkey wrench into things, as he is wont to do. But more on this anon.

The basic problem here is that (1) there is no generally accepted authority for romanizing Arabic names, and (2) the Mummer's name contains several sounds that have no exact equivalent in English. In standard Arabic, the initial consonant *qaf* is pronounced like a throaty *k*, midway between the English *k* and the German *ch*, as in Bach. The second consonant, *dhal*—two *dhals*, actually—is pronounced like a double *dh*, which is similar to English *th*, only with the tongue pulled back a bit behind the teeth. Regional pronunciation differences further complicate matters. Libyans tend to pronounce *qaf* like a hard *g*, which has inspired a whole different set of spellings.

In most cases where there is doubt about how to spell somebody's name, the usual journalistic practice is to accept the preference of the namee. Until recently, however, the Mummer has been too busy promoting global chaos to devote much time to the niceties of orthography. That changed in May, 1986, when he responded to a letter from some second-graders at Maxfield Magnet School in St. Paul, Minnesota. The colonel signed the letter in Arabic script, beneath which was typed "Moammar El-Gadhafi." This was the first known indication of his own feelings on the subject, and the wire services and many newspapers promptly announced they would switch. But *Time* and the *New York Times* remain holdouts—which is typical, if you ask me. Someday, I swear, we gotta get organized.

• • •

MIKE, AB.MA,PhD.MLS CECIL, P.U. MOE, M.R.

The Federal Government Would Like to Have a Word

You are usually right on the money with your answers to a variety of interesting questions. But I do have to take exception to your remarks concerning the spelling of Muammar Qaddafi. You stated that the Library of Congress has an unaccountable fondness for the spelling Qadhdhafi, "which is an abomination." It is indeed an abominable spelling, but the Library of Congress has no special fondness for it. Rather, as the enclosed Name Authority Record indicates, the Library has chosen the spelling Muammar Qaddafi. To be sure, the Name Authority Record shows many variants, of which Qadhdhafi is one. However, for cataloguing and retrieval purposes the Library uses the spelling at the top of the Authority Record regardless of what variant may appear on the title page of the work being catalogued. For example, if you were to write several more books alternately calling yourself C. Adams, C.A. Adams, C. Adams, Sr. or Cecil Adams, B.A., M.A., Ph.D., all of your works would be catalogued with the authoritative heading as established by the Library's Descriptive Cataloguing divisions—most likely Cecil Adams.

I don't think I have ever come across a Name Authority Record with so many variant (read: unofficial) references as this one. Shakespeare, Lenin, and Tolstoy have as many because their works have been translated into so many languages. Is it Lev Tolsztoj, L.N. Tolstoi, Lyof Tolstoi or Lav Nikolajevic Tolstoj? The Library has settled, you may argue arbitrarily, on Leo Tolstoy as its standardized form.

I have read your book The Straight Dope *and found it highly entertaining and informative. I look forward to many more collections of your best columns.—Michael M., A.B., M.A., Ph.D., M.L.S.—MARC Editorial Division, Miscellaneous Languages Unit, Library of Congress, Washington, D.C.*

I'm glad you folks at the L. of C. are beginning to study the Straight Dope so attentively, Mike. Maybe next I'll make it onto the Gipper's morning news digest and we can really get this country straightened out.

Sorry if I unjustly accused you on the Qadhdhafi business, but you know how dealing with this guy can cloud the mind. For the record, here's the official Library of Congress rundown on how to spell ol' whatsisname: (1) Muammar Qaddafi, (2) Mo'ammar Gadhafi, (3) Muammar Kaddafi, (4) Muammar Qadhafi, (5) Moammar El Kadhafi, (6) Muammar Gadafi, (7) Mu'ammar al-Qadafi, (8) Moamer El Kazzafi, (9) Moamar al-Gaddafi, (10) Mu'ammar Al Qathafi, (11) Muammar Al Qathafi, (12) Mo'ammar el-Gadhafi, (13) Moamar El Kadhafi, (14) Muammar al-Qadhafi, (15) Mu'ammar al-Qadhdhafi, (16) Mu'ammar Qadafi, (17) Moamar Gaddafi, (18) Mu'ammar Qadhdhafi, (19) Muammar Khaddafi, (20) Muammar al-Khaddafi, (21) Mu'amar al-Kadafi, (22) Muammar Ghaddafy, (23) Muammar Ghadafi, (24) Muammar Ghaddafi, (25) Muamar Kaddafi, (26) Muammar Quathafi, (27) Muammar Gheddafi, (28) Muamar Al-Kaddafi, (29) Moammar Khadafy, (30) Moammar Qudhafi, (31) Mu'ammar al-Qaddafi, (32) Mulazim Awwal Mu'ammar Muhammad Abu Minyar al-Qadhafi.

I mean, hey, are we talking a major campaign of Libyan disinformation here or what? Well, I'm not going to fall for it. I say we just call him Duckbreath. It's short, it's easy to spell, and Lord knows it satisfies the soul.

• • •

A Postscript

I just found out that you-know-who's official *title* is "Guide of the First of September Great Revolution of the Arab Libyan Popular and Socialist Jamahirya." Just in case you were thinking of dropping him a line.

I have a somewhat stupid question, but it's been nagging me for a long while. What are you supposed to call your cousin's children? Because I'm Oriental, my family considers my cousin's children my nieces and nephews, but I know that's not right in the Anglo-Saxon system. —James W., Wheaton, Maryland

The simplest thing, assuming your cousin's child's name is Frank, is to call him "Frank." Strictly speaking, the children of your first cousin are your first cousins once removed. (Your first cousin's grandchildren, should it come to that, are your first cousins twice removed. If you have children, your children and your cousin's children are second cousins.) "First cousin once removed" is far too cumbersome to use in casual speech, but for an adult to abbreviate the term and refer to a child as his cousin implies an unseemly generational parallelism—ideally you want to indicate you outrank the little heathens. You could try "my *young* cousin," I suppose, but that sounds a bit patronizing. If you give up and refer to the kiddies as your nieces and nephews, Cecil will understand.

The following question isn't something I could send to Action Line, but I've always wanted to know: what is the origin of the "F" word? A friend told me it's an abbreviation of "For Unlawful Carnal Knowledge," which was supposedly stamped on the foreheads of couples who were locked up in the stocks for fornicating without the benefit of matrimony. Also, whither the expression "fuck you"? I've always agreed with George Carlin, who says"unfuck you" would be a more appropriate curse, indicating you hope the person you're cursing would never enjoy the pleasure of sex again, rather than wishing them the opposite. —Lois S., Mesa, Arizona

This is going to be a little vulgar, folks, but let's try to keep a stiff upper lip. I've heard a number of variations of the "fuck-as-acronym" story, none of which, in my opinion (and that of

most linguists), is even remotely likely: (1) It stands for "fornication under consent of the king," which was supposedly tacked up over the doors of government-approved brothels in early England. (2) It stands for "for the use of carnal knowledge," which allegedly was stamped on condoms, or, alternatively, used the same way as "for unlawful carnal knowledge."

This passion for preposterous acronyms seems to be peculiar to Anglo-Americans, and some believe it started around World War I, about the same time many acronyms began popping up in government. Others I've come across include P.O.S.H. ("port outward, starboard home"), said to have been stamped on the tickets of first class passengers on India-bound British ships who wanted their cabins on the shady side of the boat during the passage through the tropics; C.O.P. ("constable on patrol"); and T.I.P. ("to insure promptness"). All are rubbish. The best guess is that "fuck" comes from the Middle English *fucken*, "to strike, move quickly, penetrate," from the German *ficken*, meaning approximately the same thing. A related word may be the Middle Dutch *fokken*, to strike, copulate with. We get a clue here as to the level of delicacy and tenderness that has characterized the sex act down through the ages, and which is recalled by the charming epithet "fuck you."

Many other possible etymologies have been offered. Some claim the F-word (sorry to have to resort to this lame expression, but you have no idea how tiresome it can be to type "fuck" a million times) is a truncation of "fecund." Richard Spears, author of the splendid *Slang and Euphemism*, says the word may be a disguise of the French *foutre*, same meaning, which comes from the Latin *futuere*. Another possible origin, Professor Spears says, is the Latin "pungo," to prick. Give me a break, doc.

Having totally ODed on gutter epithets, let us move briefly to the cheerful world of euphemism. Professor Spears has amassed an awesome collection of synonyms for the generative act (under "occupy," page 278, in case you're the type who likes to look up dirty words in reference books), including the following, which gives you an idea of the never-ending richness of the English language: bang, batter, beef, bumble, blow off the loose corns, bounce the brillo, dance the buttock jig, do a dive in the dark, flimp, flurgle, foin, foraminate, futz, get one's leather stretched, get one's nuts cracked, get one's oil changed, go bird's nesting, go bush-ranging, go like a rat up a rhododendron, go star-gazing

on one's back, have a bun in the oven, have a game in the cock-loft, have a leap up the ladder, have hot pudding for supper, hide the ferret, hide the salami, hide the sausage, hive it, jazz it, knock it off, lay some pipe, light the lamp, lose the lamp and pocket the stake, make her grunt, mix one's peanut butter, palliardize, pestle, pheeze, pizzle, play cars and garages, plow, plug, plook, ram, rasp, ride below the crupper, shoot between wind and water, strop one's beak, varnish one's cane, wet one's wick, wind the clock, and work the hairy oracle—some 675 synonyms in all. The ingenuity displayed in this, ahh, well-plowed ground is nothing short of awesome.

The Bard Gets Into the Act

I hate to point this out, but you failed to mention something in your recent discussion of the origin of a certain four-letter word. I did some research and found one of the origins in a book called Shakespeare's Bawdy, *which says that the word comes from "foculation," meaning to engage in intercourse. The book I mentioned is a look at sex in Shakespeare.—Melissa Z., Chicago*

Thanks for writing, Melissa, but I'd appreciate it if next time you waited until the drugs wore off first. *Shakespeare's Bawdy*, a comprehensive listing of every dirty word in Shakespeare by language expert Eric Partridge, contains nothing about "foculation." On the contrary, Partridge says the word "f*ck," as he puts it, derives from German *ficken*, to strike, which is what I wrote. Perhaps you were thinking of Partridge's discussion of Shakespeare's pun involving "focative" from *The Merry Wives of Windsor*, act 4, scene 1, lines 42–46, in which the somewhat stupid Sir Hugh Evans is quizzing the even stupider William on his Latin:

EVANS: What is the focative case, William?
WILLIAM: O, *vocativo*, O . . .
HUGH: Remember, William, focative is *caret*.
MISTRESS QUICKLY: And that's a good root.

"Caret" (literally, *it is missing*) equals carrot equals root equals penis equals f*ckative case, get it? They were going to hang

Shakespeare for this pitiful effort, but he pleaded temporary inanity.

What's the origin of the term "Third World"? Some say Jean-Paul Sartre coined the phrase in his preface to Franz Fanon's The Wretched of the Earth. *Others dare to claim that* Newsweek *originated the term. No one seems to know for sure.—P.C., Los Angeles*

The situation is pretty confused, all right, which is about par for the course in matters etymological. I've heard the phrase attributed to the French agronomist Rene Dumont, but the most convincing story credits French demographer Alfred Sauvy, who is said to have coined *tiers monde* in 1952. The archaic *tiers* is used instead of the modern *troisième* to suggest a parallel to *tiers état*, the Third Estate, which came into currency around the time of the French Revolution. The Third World is thought to hold a position vis-à-vis the First and Second worlds (the developed capitalist and Communist countries, respectively) comparable to that of the Third Estate (the commoners) with the First and Second estates, i.e., the clergy and the nobility.

The expression was used at a conference of African and Asian countries in Bandung, Indonesia, in 1955 and was the title of a book published by Sauvy's associates in 1956. It became the title of a journal in 1959 and from there passed into general usage in France. Eventually it made the leap into English. There has since been some suggestion that the Third World ought to be subdivided into the Third and Fourth worlds, the Third consisting of countries that can legitimately be called developing and the Fourth those that are pretty much dead in the water. But the prospective Fourth Worlders have not been embracing this idea with much enthusiasm, for the obvious reason that it makes things sound more desperate than they care to admit.

Where, when, how, etc., did the good-natured word "gay" pass into the vernacular as a designation for all things homosexual? Can one be a homosexual without being gay, and vice versa?—Tom M., Los Angeles

I hate to tell you this, Tom, but the "good-natured word 'gay'" has been leading a double life. Although many people believe "gay" simply meant lighthearted or cheerful until it was shanghaied by the preverts, the truth is the word has long had a

secondary connotation of sexual licentiousness. As early as 1637 the *Oxford English Dictionary* gives one meaning as "addicted to social pleasures and dissipations. Often euphemistically: Of loose and immoral life"—whence, presumably, the term "gay blade." In the 1800s the term was used to refer to female prostitutes; to "gay it" meant "to copulate."

By 1935 the word "geycat," meaning a homosexual boy, had found its way into print, giving a clue as to the direction things were starting to go. Sure enough, by 1955 "gay" had acquired its present meaning, as P. Wildeblood notes in *Against Law*: "Most of the officers had been 'gay' . . . an American euphemism for homosexual." Actually, gays had probably been using the term among themselves long before.

Ghettoization of the term began to occur in the 60s so that today "gay" in the sense of "homosexual" has chased out all other uses of the word. This is more the result of the squeamish attitude of the straight world than any organized campaign on the part of gays, and in any case it's no big deal; there are plenty of other words that cover the same territory that the nonsexual meanings of "gay" did.

At the moment "gay" seems to refer strictly to male homosexuals. Whether all male homosexuals would consent to be called gay—whether, for that matter, all gays would consent to be called homosexual—is a question I will not presume to answer. I am quite certain, however, that most gays would reject the implication that "gay" necessarily implies licentiousness or promiscuity.

Although I'm not what you might call a hard-line feminist, there are some sex-biased features of our language that really bother me. Specifically, how does one head a formal-type business letter to some anonymous person in an office? "Gentlemen" just doesn't make it. After all, in most business offices no gentleman will ever see your letter. "Gentlepersons" is obviously no improvement. "To Whom It May Concern" is the best I've been able to come up with, but it sounds like you tied the letter to a brick and heaved it over the wall. My husband suggests "Howdy!" but I feel this lacks dignity. Got any ideas?—Cindy A., Los Angeles

You could try "Dear Sir or Madam," I suppose. Or "Gentlemen and Mesdames," although it does seem a little redolent of

gaslight and spats. "Dear Folks," maybe? No? Well, then how about "Greetings"? Hmm—we do have a little problem here, don't we?

Time to call in the heavy artillery. Etiquette maven Letitia Baldrige suggests skipping the heading altogether and writing a memo, e.g.:

"Memo to: Ty-D-Bol Corporation

"Re: Infestation of talkative midgets in plumbing"

—following which you launch into your message. If that won't do either (and don't you feel you're being a little difficult about this?), the only solution is to get on the horn and find out specifically to whom your letter should be addressed, and then so address it. A little more trouble, I'll grant you, but not without its practical benefits.

• • •

QUIZ #6

31. In psychoanalytical lingo, a man suffering from an insane fear of Telly Savalas might be called a victim of:
 a. bromidrosiphobia
 b. pteronophobia
 c. pentheraphobia
 d. phalacrespia

32. While we're on the subject, Telly Savalas first shaved his head for:
 a. *The Battle of the Bulge*
 b. *The Birdman of Alcatraz*
 c. *The Greatest Story Ever Told*
 d. Telly Savalas is naturally bald, the tragic result of a childhood disease.

33. "7AA" is:
 a. Coke's secret ingredient
 b. the highest rating given by the *Guide Michelin*
 c. Greta Garbo's shoe size
 d. Pia Zadora's IQ

34. You'll agree, no doubt, that Alfred Hitchcock, John Ford, and Howard Hawks were the three greatest directors ever to work in Hollywood. One actor had the signal honor of appearing in films by all three men. He was:
 a. James Stewart
 b. Walter Brennan
 c. John Carradine
 d. Barry Fitzgerald

35. What do Julia Peterkin, Oliver LaFarge, Margaret Ayer Barnes, and Caroline Miller have in common?
 a. They are all famous authors.
 b. They were all once insulted by Groucho Marx.
 c. They are all famous dancers.
 d. They are all Olympic gold medalists.

36. How's your Latin? If it's good enough, you should be able to come up with a definition for this ridiculous but legitimate English word: *floccinaucinihilipilification*. (Hint: it ain't in Webster's.)
 a. the act of stunning a cow with a large rock
 b. the act of brushing one's teeth with bicarbonate of soda
 c. the act of hiding microphones in the shrubbery
 d. the act of writing to the Straight Dope

Answers on pages 474–75.

The Twilight Zone

I know this is a sticky question, but I'll ask anyway: does any solid evidence exist to prove that a Jesus of Nazareth actually lived? And what about the Shroud of Turin—have scientists concluded anything about it?—Ben C., Chicago

Don't worry about getting me into hot water, Ben. About the only people this column has failed to offend already in its checkered history are left-handed Anabaptists—and just wait till they get a load of next week's blockbuster. If what you're looking for is proof positive that Jesus Christ lived and breathed—e.g., library card, baby pictures, etc.—you're out of luck. The big guy left no written records, and no accounts of his life were written while he was still alive. The earliest Gospels date from maybe A.D. 70, 40 years after his demise.

Still, barring an actual conspiracy, 40 years is too short a time for an entirely mythical Christ to have been fabricated out of (heh-heh) whole cloth. (See below.) Certainly the non-Christians who wrote about him in the years following his putative death did not doubt he had once lived. The Roman historian Tacitus, writing in his *Annals* around A.D. 110, mentions one "Christ, whom the procurator Pontius Pilate had executed in the reign of Tiberius." The Jewish historian Josephus remarks on the stoning of "James, the brother of Jesus, who was called Christ." The Talmud, a collection of Jewish writings, also refers to Christ, although it says he was the illegitimate son of a Roman soldier called Panther. Doubts about the historicity of Christ did not surface until the eighteenth century. In short, whether or not JC was truly the Son of God, he was probably the son of somebody.

As for the Shroud of Turin—well, despite more than 100,000 hours of work by scientists involved in the recent Shroud of Turin Research Project (STURP), nobody can say for sure what it really is. For those unfamiliar with it, the Shroud is one of the most famous Catholic artifacts, shall we say, in the world. It's a piece of ivory-colored linen about 14 feet long and 4 feet wide bearing the imprint of the front and back of a man's body. The image is straw-colored and very faint. The two sides of the figure are set head-to-head, suggesting that the man had been placed on the Shroud and that it was then folded over him. The figure has a beard, long hair, and imposing features, and looks much like traditional representations of Jesus.

There are bloodlike stains at the wrists, feet, and side, as though the figure had been crucified and stabbed. The back bears dozens of contusions characteristic of a type of Roman flail in common use during the time of Christ. Other apparent wounds at the shoulder and knees suggest that the man had been carrying a heavy object and had fallen one or more times. There are puncture wounds around the head, possibly inflicted by thorns. There is just one well-known religious figure who fits all these details, and it ain't Confucius.

The Shroud first turned up in 1357, when it was exhibited in a church that had been specially built for that purpose in Lirey, France, by one Geoffrey de Charny. In 1453 one of de Charny's

descendants sold the Shroud to the Duke of Savoy, whose family later moved its headquarters, and the Shroud, to Turin. The cloth remained in the custody of the Savoys, who eventually became rulers of Italy, until 1983. The exiled King Umberto, the Shroud's last owner, died in that year, and it was subsequently turned over to the Vatican.

Some have conjectured that the Shroud is the Mandylion, another cloth bearing an imprint of Jesus that disappeared during the sack of Constantinople in 1204. From that point they trace it back to an early Christian town in Turkey and from there to the Holy Sepulchre.

But there have always been skeptics. Only a short time after the Shroud was put on display in 1357 the local bishop ordered the exhibition stopped on the grounds that the thing was a forgery. The bishop's successor later claimed in a memo that his predecessor had found an artist who admitted to having painted the image. No independent corroboration of this has come to light, but it's not hard to imagine why people were skeptical— the number of "authentic" shrouds that have been displayed at one time or another totals about 40.

Having been exhibited periodically over the centuries, the Shroud was photographed for the first time in 1898. The negatives caused a great sensation, and are largely responsible for the hold the Shroud has had on the public imagination ever since. While the image on the cloth is faint and difficult to make out, the image on the negatives is instantly recognizable as a man— basically because it looks like a positive print, with normal gradations of tone, i.e., the highlighted areas are white and the shadowed areas are dark. This implies that the image on the Shroud is a negative of sorts. If the image is the work of a forger, Shroud advocates say, it is hard to imagine why he would adopt such an odd technique.

Subsequent inquiries have, if anything, deepened the conviction that the Shroud is, if not the real McCoy, at least not a fake. Researchers were initially puzzled that there were wounds at the wrist rather than the palm, since Jesus has traditionally been depicted as having been nailed to the cross through the latter. However, experiments in the 30s, some involving cadavers, demonstrated that a nail through the palm will not support the weight of a body, whereas a nail through the wrist will. In 1968 an archaeologist in Israel discovered the skeleton of a man who

had been crucified through the wrists, lending credence to the notion that the Shroud is right and two thousand years' worth of paintings are wrong.

In 1976 a researcher at a U.S. government laboratory in New Mexico made an even more startling discovery. Using a computer, he found that the image had a peculiarly three-dimensional quality to it. When a photo of the Shroud was put through a computer analyzer that makes a sort of topographical relief map of an image, with brightness correlated to "height," a remarkable 3-D representation of a man's body resulted. Conventional paintings, and for that matter conventional photographs, don't work that way. Some see this as further proof that the image was not the work of an artist.

Which brings us to STURP. In 1978 a team of American scientists, most of them non-Catholics, was permitted to examine the Shroud round the clock for five days with sophisticated instruments. (One test they were not able to perform, unfortunately, was a carbon-14 dating test, which might have resolved the issue right off the bat. Italian authorities feared, apparently erroneously, that too much of the Shroud would have to be destroyed. However, there have been late-breaking developments in this regard, which we shall discuss anon.) The STURP researchers concluded thusly:

1. The image was the result of "dehydrative acid oxidation of the linen with the formation of a yellow carbonyl chromaphore." What this means in English is that the image is the result of an accelerated aging process: the underlying cloth dried out and yellowed. Some call it a scorch.

2. The Shroud has some dried blood on it, certainly primate, probably human. This took some people by surprise; earlier forensic tests by Italian scientists had failed to find any indication of blood. The STURP conclusion has been vigorously disputed by Walter McCrone, a distinguished microscopist, who thinks the alleged blood is really iron oxide, a common pigment. McCrone's proof, however, seems to reside chiefly in the conviction that he knows blood when he sees it.

The blood does have some odd features about it. It is an unusual color, being a faint carmine rather than the brown one would expect. Moreover, it is difficult to see how it was conveyed from the body to the Shroud. The drip pattern indicates that the blood initially flowed while the body was in a vertical position,

with the arms stretched out from the sides, as though hanging from a cross. So far so good. The blood must then have been imprinted onto the sheet by direct physical contact. Yet the stains have not smeared as much as you would expect, nor are there any traces of crusting. For that matter, no wound debris has been discovered on the Shroud at all.

3. The image was not painted by any known means. The evidence here seems overwhelming. There are no brush strokes, and no sign of any known dye, pigment, or pigment carrier. Moreover, the image did not sink into the cloth at all, as it would have if borne by a liquid. (The blood, on the other hand, did soak through.)

4. None of the explanations for the image proposed over the years is entirely satisfactory. Several early investigators, for instance, had suggested the image was caused by vapors rising off the body that resulted from a mixture of burial ointments and urea-laden sweat. Experiments showed that it was possible to produce such "vaporographs," but they were far more blurred and diffuse than the image on the Shroud.

Other scenarios were even more implausible, the STURP folks felt. Some true believers suggested that the image was made by "radiation scorch"—i.e., by a burst of energy at the moment of the Resurrection. The Shroud showed no significant amount of radioactivity, and researchers felt that speculating on the possibility of some sort of divine light was beyond the purview of science.

More recently, skeptic Joe Nickell has suggested that the image was created by dusting a statue or body with rouge (finely ground ferric oxide) and then "pulling a print" with the linen cloth. This produces a detailed negative image, but the image consists of an applied substance, which the Shroud image does not. Nickell then suggested that if the ferric oxide "print" were moistened, it would cause the underlying cloth to discolor. The oxide might then be washed off, leaving a permanent image. STURP scientists conceded this was a possibility, but said there is no evidence to suggest that such a technique was ever used prior to the nineteenth century. (Nickell, on the other hand, says the technique dates back at least to the twelfth century.)

S. F. Pellicori has proposed a "latent image theory," in which the Shroud was sensitized by contact with a corpse, with the image subsequently "developing" over a period of many years.

Pellicori applied a mixture of myrrh, olive oil, and skin secretions to a piece of linen, which he then baked to produce rapid aging. This produced an image whose color and chemical properties are similar to those of the Shroud image. However, it does not have the Shroud image's three-dimensional shading. The STURP scientists acknowledged, however, that a way might be found to overcome this difficulty, and latent imaging remains a promising avenue of inquiry.

Many aspects of the Shroud remain unexplained. For one thing, it is unlike any other shroud of its era, most of which did not exceed eight feet in length. Moreover, it was not draped or wrapped around the body; there is no imprint of the figure's side. In fact, for the three-dimensional shading of the image to make sense, we have to assume that the Shroud was stretched out flat (more or less) above the body—a strange scenario, and one of the reasons some think the Shroud was purposely created, perhaps by some lost process of thermography.

For a while it appeared we'd have to leave it at that. Then in 1986 the Archbishop of Turin announced that the pope had given his permission to perform carbon-14 tests on the Shroud, which would answer the biggest remaining question: how old is the thing? The archbishop said the results of the tests would be revealed by Easter of 1988. Several labs in the U.S. and Europe are involved, with the British Museum acting as "guarantor" and independent observer. (I am miffed, of course, that the pope didn't ask *me*. See if I ever return his phone calls again.) Never fear, we'll get to the bottom of this yet.

A Rebuttal

I enjoyed your discussion of the Shroud but feel it is necessary to get something straight. My problem is principally the sentence in which you state categorically, "The image was not painted by any known means." I know something about pigments and paintings and have worked with them for most of my life. It is certainly natural for the rest of the world to agree with STURP because they outnumber me about 50 to 1. But none of them were microscopists or microanalysts nor had they any experience with pigments and paintings. I can state to you categorically that the Shroud was painted.

I have enclosed copies of three of my publications on the subject. You may find portions of them interesting, particularly the part on a type of painting that was popular in the middle of the fourteenth century, when I think the Shroud was painted.
—*Walter C. McCrone, McCrone Research Institute, Chicago*

One of Mr. McCrone's publications quotes an old history of painting techniques that discusses the fourteenth-century practice of watercolor painting on linen. Mr. McCrone says he has found traces of such paints on the Shroud, and backs up his claim with an impressive array of data. The STURP researchers say McCrone is wrong and back up their assertions with their own data. Let's hope the carbon-14 tests aren't subject to such widely varying interpretations.

The "whisperized" helicopter in the movie Blue Thunder *called to mind reports of ranchers having seen silent aircraft over areas where mutilated cattle were subsequently found. Do the facts to date point to any conclusions on who could afford to do these strange mutilations for so many years and yet remain so close to committing the perfect crime? Is there any similar crime in history that appears to be so big, widespread, and yet so steadfastly ignored? (Ranchers seem to fall silent out of some feeling that "the walls have ears.")*—*Rob T., Baltimore*

Whenever I start to fret that earthlings are becoming so intelligent and sophisticated that I will soon be out of a job, some-

thing like cattle mutilation comes along to convince me I'm going to be in business for the next two million years. Every year thousands of cattle die on North American ranges, the victims of diseases, parasites, predators, accidents, weirdo pranksters, and Lord knows what else. In most cases the cause of death is obvious, but sometimes it's not. Since everybody loves a mystery, especially if it involves mysto paranormal conspiracies, an incredible legend has sprung up about a strange force that goes around cutting the gonads off the nation's moo-cows. Cooler heads, I think it is safe to say, regard such talk as the nonsense it undoubtedly is.

Cattle mutilations—8,000 to 10,000 have been reported to date—were first noted in Gallipolis, Ohio, in 1963, and have since been regularly reported in major cattle-raising regions throughout the U.S. and Canada. In most cases the modus operandi is the same: the deed is done at night, the deceased bovine is drained of blood, and various body parts, frequently the eyes and sex organs, are missing, having been removed with what is invariably described as "surgical precision." Generally there are no footprints or vehicle tracks to be found in the vicinity.

Innumerable evil agencies have been blamed for cattle mutilation. UFOs were a common target for a while, particularly since reports of mutilations often coincided with reports of unidentified aircraft. Later it became popular to attribute the crimes to gangs of secret marauders in helicopters—maybe even U.S. government helicopters, since several outbreaks occurred near large military bases. Other alleged perpetrators that have been fingered from time to time include: (a) *Satanists*, who use the cattle in some unspeakable ritual; (b) *Big Oil*, which uses the missing cattle organs to detect the telltale signs of nearby petroleum deposits (yeah, I know, it doesn't make sense to me either); and perhaps best of all (c) *the unconscious manifestations of the Mass Mind.* This last theory is the invention of one Thomas Bearden, a retired army officer in Alabama, who believes as follows (I quote from *Maclean's* magazine): "The mutilations are the physical manifestation of the whole human unconsciousness which is somehow aware that the Soviets will, probably within three years, invade and destroy the Western world. . . . Cattle are female symbols representing the U.S., and the surgical precision of the mutilations indicates the precision of the military operations to come. The removal of genitals and organs signifies

the end of children in the Western world and the cutting off of ears and tongues predicts the end of free speech." You bet, Tom.

Sensible people, such as (naturally) readers of the Straight Dope, generally believe that the mutilations are the result of natural predators, aided in a minority of cases by brain-damaged farm boys who get ideas after reading about mutilations in the papers. According to The People's Almanac #3, a couple of Arkansas state cops tried an experiment in which they left a dead cow in a field unattended. Within 33 hours, buzzards followed by blowflies had neatly disposed of the eyes, sex organs, and even the blood, leaving the appearance of "surgical precision" behind them. Other studies have tended to support this scenario. In 1974, for instance, state veterinary labs investigating a rash of mutilation reports in Nebraska and South Dakota reported that every animal brought to them for examination had died of natural causes. Typically, however, many people prefer to believe in the Great Conspiracy. Figures.

I heard a rumor that the people who run Procter & Gamble belong to the Church of Satan, and that the symbol on most P&G products (it looks like the man in the moon surrounded by dots, but it's so small you can't tell for sure) reflects this affiliation. I'm more than happy to let others pursue Satan at their own risk, but I feel a little queasy knowing there's a satanic figure stamped on every box of Puffs, Cascade, and the many other P&G products I've come to like. Is there any truth to this story or has it been concocted by Lever Brothers or some other P&G competitor?—Judy M., Chicago

Judy, I hate to be cruel, but did your mother take thalidomide, or what? You may well be the last person in North America to hear this story, which is taken seriously chiefly by people who talk to themselves on the bus. More to the point, Procter & Gamble decided to phase out its man-in-the-moon logo in May 1985. In other words, not only have you been taken in by a totally idiotic rumor, you have been taken in by a totally idiotic rumor that is three years out of date.

No one knows exactly how the satanism stories got started, but they first attracted attention in the South in the late 1970s. They were inspired by the enigmatic P&G logo, which features the man in the moon in a circle along with 13 stars. The stars and the circle are an outgrowth of an old symbol that was used to

identify cartons of Star Candles, an early P&G product; there are 13 stars to symbolize the 13 colonies. The man in the moon was added around the turn of the century for no better reason than the fact that it was a popular symbol at the time. Somehow people made the leap from this to satanism. Some say that if you hold the logo up in front of a mirror, you can see "666" (the "mark of the beast," symbolic of the Antichrist) in the swirls in the man in the moon's beard. Others say you get 666 if you connect the stars with curving strokes. A minority view holds that the logo merely proves the company is owned by the Moonies.

At any rate, in the early 1980s P&G began getting thousands of phone calls about its links to the forces of darkness—15,000 a month at one point. Many of the calls were inspired by fliers passed hand to hand claiming that 10 percent of P&G's profits went to the Church of Satan, and that the president of the company had admitted P&G's diabolic connection on the Donahue show. All of these rumors, so far as can be reasonably determined, are bunk.

Determined to fight brimstone with brimstone, the company convinced Jerry Falwell and other fundamentalist leaders to proclaim P&G's innocence. P&G also invited reporters down to its corporate headquarters to check the place out, and even sued people it caught spreading the rumor. (Some of these, interest-

ingly, were employed by rival consumer products companies, although there is no evidence that the companies themselves were involved.)

The credulousness some people display about things like this is amazing. Once on a radio talk show I got into a discussion of "dumb things people believe," in the course of which I happened to mention the P&G rumor. Having at the time a childlike faith in the good sense of the populace, I failed to emphasize sufficiently that the dumb things people believed were in fact not true. The P&G switchboards lit up, and the next day a frantic P&G flack was on the phone inquiring why I was spreading horrible rumors about his employer. Had I been so inclined I could probably have parlayed his concern into a lifetime supply of Tide, but as it was I merely promised that I would be more careful in the future.

P&G's efforts succeeded in damping down the rumor for a time, but it flared anew in 1984. At last the company threw in the towel and announced that it would phase out its logo, then 103 years old. Eventually it will appear only on P&G's letterhead and internal publications, and of course at any Black Masses that the company happens to sponsor. But judging from your letter, I'd say the company's problems are a long way from over.

I've saved a newspaper clipping reporting that during the height of a meteor shower on August 11, 1979, three oozing, purple "blobs" were found on a lawn in Frisco, Texas. These blobs were not your ordinary garden variety—they had some very strange properties. Surmising that the blobs fell from space, NASA removed them for testing. I've finally given up waiting for a follow-up on this in the newspapers, and have decided to turn to you. Cecil, what do NASA's secret files say about these blobs? Were they really some sort of smegma from space, or just lumps of grape Jell-O that some kid flung out the window? —Greg T., Chicago

Cecil has gotten to be very chummy with the folks at the National Aeronautics and Space Administration in Houston, and therefore they do not get mad and slam down the phone when he calls up to ask about weird blobs from space. If only some of the other victims of my interrogations would be as considerate. Here's the whole story, as told by NASA geochemist Doug Blanchard:

The blobs were found by Mrs. Sybil Christian on the front lawn of her home in Frisco, a farming town near Dallas. She described them as looking like "smooth whipped cream, [only] purple." The blobs, which were about the size of a telephone and weighed a couple pounds apiece, were warm to the touch and contained small chunks of lead. One melted away on the lawn, but police took the remaining two to the Heard National Space Museum nearby, and eventually one ended up at NASA.

The Perseid meteor shower had reached its height around August 11, and one of Mrs. Christian's neighbors said she had seen a meteor just a few hours before the blobs were discovered. This gave rise to the story about the blobs' extraterrestrial origin. However, an enterprising gent named Ron DiIulio, assistant director of the Fort Worth Museum of Science and History, didn't buy it. Along with a couple newspaper people he commenced prowling around factories near the Christian home. Eventually they came upon a battery reprocessing plant about a mile and a half away, in the back of which they found—voila!—several tons of purple and reddish blobs. The stuff was a caustic soda used to clean impurities out of lead that had been salvaged from old batteries. It was also learned that trucks carrying scrap iron went past the caustic soda dump and the Christians' house every day. The mystery was thus declared to be solved.

But some still have their doubts. The distinguished scientific journal *Fate*, which is a great believer in UFOs and the like,

published a long article claiming the purple blobs were—you had better sit down for this—Star Jelly, also known as *Pwdre Ser*, or "Rot of the Stars." Gelatinous mounds of this stuff supposedly have been found on several occasions following reports of shooting stars. The article goes on to speculate the Pwdre Ser may be "advanced cellular organic matter" that exists in "pre-stellar molecular clouds" floating around in space. In support of this thesis, the story notes that: (1) a simple test that could have conclusively proved the purple blobs were caustic soda was never performed; (2) the one test that *was* performed was inconclusive; (3) the blobs at the battery reprocessing plant were hard, whereas the blobs on the Christians' lawn were soft; and (4) Mrs. Christian herself does not believe the goo she found was the same as the stuff at the plant. In rebuttal, the scientists claim that Mrs. Christian's blobs were soft because they had absorbed water when she squirted them with a hose (Mrs. Christian's notions of an effective planetary defense were a bit quaint). At this late remove it is difficult for Cecil to make a definitive judgment on the whole affair, but I would offer this word of advice to the Teeming Millions: next time you find some cosmic mucus out on the patio, call Unca Cecil first.

Six years ago I witnessed a public demonstration of hypnotism during which, among other things, the hypnotist "regressed" a volunteer from the audience. This volunteer, whom I knew and who clearly was not an associate of the hypnotist, gave a rather startling and chilling description of a past life she said she had lived. While under hypnosis the volunteer spoke differently than normal, exhibited different handwriting, and gave quite detailed information about her supposed past life. What's the scoop, Cecil? How much research has been done on this? Assuming that we haven't discovered proof of reincarnation, what's the psychological explanation for why people would concoct such elaborate lies under hypnosis? Or is the secret to your near-omniscience that you are the Kwisatz Haderach?—John R., Chicago

The secret to my omniscience is hard work, perseverance, and the World Almanac, John, but this is not particularly relevant to the business at hand. I know of no reputable authority who believes that people under hypnosis are recalling actual past incarnations. The consensus is that the subjects who do so are

highly suggestible souls who manufacture their previous "lives" out of bits and pieces of their own past in order to please the hypnotist.

The most notorious example of this is the case of Bridey Murphy, which burst upon the scene in 1956 with the publication of a book by hypnotist Morey Bernstein called *The Search for Bridey Murphy*. In it Bernstein tells the tale of one Virginia Tighe (she was given the pseudonym Ruth Simmons in the book), a young housewife from Pueblo, Colorado whom Bernstein had found to be unusually susceptible to hypnosis. During an attempt to "regress" the patient back to her childhood, a common hypnotic technique, Bernstein decided to go for the gusto and asked Mrs. Tighe to "go back" until she found herself "in some other scene, in some other place, in some other time." The agreeable Mrs. Tighe thereupon began describing herself as a child scratching the paint off her metal bed as revenge for being spanked. As she spoke, her voice started to assume as Irish brogue, and when Bernstein asked her her name, she said "Friday [later clarified as 'Bridey'] Murphy."

In subsequent sessions, "Bridey" claimed she had been born in 1798, the daughter of Kathleen and Duncan Murphy. The family lived outside of Cork, in Ireland; her father was a barrister. Though a Protestant, at 20 she married a Catholic named Brian MacCarthy, also a barrister. They moved to Belfast, where they remained until Bridey's death at the age of 66 following a fall downstairs. Various clues convinced hypnotist Bernstein that Bridey's story was authentic: she used several genuine bits of Irish dialect, she claimed to have patronized a grocer named Carrigan, who had actually had a shop near the neighborhood where she supposedly lived; and so on.

Unfortunately, it wasn't long before skeptics began raising doubts. A *Life* magazine investigation found that few of the checkable details in Mrs. Tighe's story could be verified. Worse, a fellow named Wally White, who said he was a childhood friend of Mrs. Tighe's, said that when she was very young she was in the habit of speaking in an Irish brogue. He also said she was known to have scratched the paint off her bed on one occasion. Next it was learned that metal beds hadn't been introduced into Ireland until the mid-nineteenth century, when Bridey would have been middle-aged. The final blow was the discovery that one of Mrs. Tighe's neighbors in her childhood days was named Bridie Murphy Corkell. Having thus been pretty well discred-

ited, Mrs. Tighe and her associates sank once again into obscurity.

Some researchers doubt that hypnosis can really make you regress to your *own* childhood, much less to that of some earlier avatar. What's really happening, they feel, is that the subjects imaginatively reconstruct their childhoods from memories that hypnosis has helped them recall. Trance states being necessarily subjective, the truth may well be unknowable.

Morey Bernstein Takes Umbrage

Someone was good enough to send me your piece of bovine excrement (a euphemism for plain old bullshit) on Bridey Murphy.

Straight Dope, eh? Dopey, yes. Straight? Like a corkscrew. How the hell could you be such an idiot (or so badly informed)?

Straight Dope, old boy, I can tell you one thing for certain. You did not read the book, nor did you hear the recording of the original Bridey experiment. I am sending these to you, along with a number of clippings which would be of interest to anyone who is open-minded.

You are entirely correct, as Dr. Stevenson points out in the enclosed Journal of the American Society for Psychical Research, *that most of these [past life] experiments are utterly worthless. But you will note that he makes an exception in the case of Bridey Murphy.*

I can understand mistakes of this nature being made by an ordinary horse's ass. But it is positively unforgivable from someone who calls himself the Straight Dope. Jeezus.

You will find that every single item that attacked Bridey was torn to shreds, while even the most recondite facts that Bridey gave forth during hypnosis were 100 percent correct—even though librarians and scholars at first disagreed. They finally admitted they were wrong.

Do you have that much gutz [sic], Straight Dope? Can you write another article, explaining that you did not have the Straight Dope?—Many Happy Lifetimes, Morey Bernstein, Pueblo, Colorado

No offense, Morey, but I didn't realize you were still alive, *The Search for Bridey Murphy* having originally appeared in 1956. Glad

to see you're still getting around. And thanks for the book. It's a paperback edition that includes a new chapter rebutting your critics that wasn't in my hardbound version. I don't find the arguments very convincing, but readers may judge for themselves.

I should explain a few details first. *The Search for Bridey Murphy* appeared in January 1956. In May and June, the Chicago *American* published an exposé of Bridey that made it appear that many of the facts about her "past life" were simply things she had recollected from her childhood in Chicago. The exposé, which was mentioned prominently in *Life* and other publications, pretty much popped the Bridey bubble as far as the general public was concerned. Mr. Bernstein has been struggling to restore Bridey's good name ever since. The new last chapter in his book, written by reporter William Barker, attempts to rebut the *American* stories point by point. Here's a rundown of the more interesting parts:

1. *Exposé:* Bridey knew so much Irish lore because as a child she had lived with her aunt, Mrs. Marie Burns, who was "Irish as the lakes of Kilkenny" and told the girl many stories about Ireland.

Barker: Marie Burns was Scotch-Irish, was born in New York, and spent most of her life in Chicago. She did not have much interest in Ireland. She did not move in with Virginia's family until Virginia was 18, although the two women had known each other earlier. Virginia cannot recall being told any tales.

My comment: Barker's assertions, here as elsewhere, seem to be based primarily on statements by Virginia. There is no evidence that Barker spoke to Mrs. Burns.

2. *Exposé:* Virginia had taken dancing and forensics lessons as a child that included Irish jigs and lengthy recitations in Irish dialect, including one called "Mr. Dooley of Archey Road."

Barker: The teacher, who had been contacted by another newspaper reporter, could remember little about Virginia or what pieces she had recited. She had never heard of "Mr. Dooley of Archey Road." Virginia cannot remember what she was taught, but she says the so-called "Irish jigs" included the Charleston.

My comment: Mr. Dooley of Archey Road was the creation of a well-known Chicago newspaper reporter named Finley Peter Dunne who wrote comic Irish dialect sketches around the turn of the century. Mr. Dooley was supposed to be a garrulous Irish saloonkeeper. Dunne achieved national prominence and his Mr.

Dooley pieces were collected into a dozen books, many of which can be found to this day in branches of the Chicago public library. They are an excellent primer for persons who wish to learn to speak Irish dialect. That said, I do not know of a piece specifically entitled "Mr. Dooley of Archey Road."

3. *Exposé:* A Mrs. Bridie Murphy Corkell, an Irish immigrant, once lived across the street from Ruth and her family.

Barker: Virginia remembers Mrs. Corkell, but cannot remember having heard her first or maiden names. There are seven Bridget Murphys listed in a 1928–1929 Chicago directory.

My comment: Barker is grasping at straws. Bridget Murphy may be a fairly common name, but Bridey (or Bridie) Murphy is not. The fact that it turns up in Ruth's past is a fatal blow to her credibility.

This is not to say that Ruth was intentionally conning Bernstein. From the evidence of the book she was a suggestible sort, and he asked her many leading questions that clearly indicated what he wished to hear. For example, here is what he said to make her "regress" during the very first hypnosis session:

". . . Be looking at yourself when you were one year old. Now go on even farther back. Oddly enough, you can go even farther back. I want you to keep on going back and back and back in your mind. And, surprising as it may seem, strange as it may seem, you will find that there are other scenes in your memory. There are other scenes from faraway lands and distant places in your memory. . . . Your mind will be going back, back, back, and back until it picks up a scene, until, oddly enough, you find yourself in some other scene, in some other place, in some other time, and when I talk to you again you will tell me about it. You will be able to talk to me about it and answer my questions. And now just rest and relax while these scenes come into your mind. . . . Now you're going to tell me, now you're going to tell me what scenes come into your mind. What did you see? What did you see?" Whereupon "Bridey" begins to speak.

These are not the words of a scientist who is dispassionately trying to determine whether people really have previous lives. On the contrary, they're the words of someone who is manipulating his subject into telling him a fairy tale.

There are, admittedly, certain details in Bridey's alleged 19th-century past that check out. The bit about the grocers, for in-

stance. But there are many others that don't. Her attempts to speak a few "Irish" words, as Bernstein requested at one point, were not particularly successful.

Furthermore, in the words of one writer sympathetic to Bridey's cause, "No verification has yet been obtained that a barrister named Duncan Murphy and his wife Kathleen lived in Cork in 1798 and in that year had a daughter, Bridget Kathleen; nor that a Bridget Kathleen Murphy married in Cork a Catholic called Sean Brian McCarthy; nor that she died in 1864 in Belfast; nor that there was in Belfast in her days a St. Theresa's church; nor that it had a priest named John Joseph Gorman who, as Bridey states, performed a second marriage ceremony there."

It may be true, as Bridey proponents point out, that no vital statistics were kept in Ireland prior to 1864. The fact remains that the evidence for Bridey's authenticity consists almost entirely of trivia. If you want anyone besides the New Age crowd to take this stuff seriously, Morey, you're going to have to do better than that.

Umbrage Taking, Round Two

I am writing in reference to your column on past life hypnotic regressions. You stated you "know of no reputable authority who believes that people under hypnosis are recalling actual past incarnations." Well, listen up, Cecil, because I am about to name some names.

In addition to the American Society of Psychical Research and Duke University there is an organization in Riverside, California, called the Association for Past Life Research and Therapy, of which I am a member. The latter organization is composed of physicians, dentists (myself included), psychologists, social workers, etc. We all believe in the accuracy of a properly conducted hypnotic past life regression.

I also qualify as a reputable authority. In addition to my dental degree and four state licenses, I have an M.S. in Counseling Psychology and am a member of the American Psychological Association, as well as many other psychotherapy and dental organizations. Furthermore, I have been a past life regression expert for over 10 years, have conducted over 16,000 past life regressions through hypnosis, and am the author of Past Lives—

Future Lives, *published by Newcastle Publishing Co., I have been interviewed by* Time, *the* Washington Post, *Associated Press, Copley News Service, CBS-TV, etc., and have had articles on past life regressions published in professional journals.*

Cecil, the next time you take a potshot at something, do your research well.—Bruce Goldberg, D.D.S., M.S., Baltimore

Like I said, doc, no reputable authority believes in past lives regression. Not to be insulting, but the fact that you are a dentist, belong to professional organizations, and have managed to get yourself interviewed by talk show hosts and newspaper reporters doesn't give you scientific standing. On the contrary, as you know, mainstream scientists have deprecated your work. Paul Kurtz, a philosophy professor and chairman of the Committee for the Scientific Investigation of Claims of the Paranormal, says you are "typical of the current craze for the paranormal—astrology, tarot cards, past lives—that is sweeping the country. It can be very dangerous, because he is practicing psychotherapy based on untested conjecture. It sounds as if he's abandoned his scientific credentials."

By the way, you might try to avoid getting yourself quoted in any more articles featuring Shirley MacLaine. "MacLaine," quoth *Time*, "says her beheading [by Louis XV] cured her stage fright." 'Nuff said.

I have long been interested in the "Philadelphia Experiment," which was supposedly conducted by the U.S. Navy during World War II as one of the three "city projects." The Manhattan Project, of course, was the development of the atomic bomb; the Philadelphia Experiment supposedly involved the use of magnetism to bend light rays and thus make objects invisible. Legends and sketchy reports have it that objects could be transported from place to place by the use of strong magnetic fields. I grew up around Portsmouth, Virginia, and have long heard rumors that the degaussing facility at the mouth of the western branch of the Elizabeth River was the "receiver" facility for this project, and that a destroyer was briefly transported here before being returned to the Philadelphia Navy Yard. Is this true? —John H., Norfolk, Virginia

Get serious. Even the author of one of the better-known books about the Philadelphia Experiment has backed off on his more outrageous claims, although he still maintains an experi-

ment of some kind did take place. The whole thing first came to light in the mid-1950s, when someone variously identifying himself as Carlos Allende or Carl Allen wrote several strange letters to a UFO writer named Morris Jessup. Filled with misspellings and stylistic eccentricities, the letters told of a U.S. Navy destroyer that in October 1943 had been subjected to a force field in an effort, apparently successful, to make it invisible. Somehow the ship was also teleported from the Philadelphia Navy Yard to Norfolk, Virginia, and back, all within a matter of minutes. Unfortunately, the experiment also had the side effect of rendering half the officers and crew insane, with some of the crewmen unpredictably becoming invisible or bursting into flame years later. Since this had a decidedly negative effect on morale, the Navy halted the experiments and hushed up the whole affair. Or so the letter writer claimed.

The story was taken up by various writers over the years, but received its fullest treatment in *The Philadelphia Experiment* by William L. Moore with Charles Berlitz (1979). The book, which was the basis for a 1984 movie, claimed the ship involved was the U.S.S. *Elbridge*, but offered no hard evidence. The Navy, unsurprisingly, says it has no knowledge of any such experiment.

Cecil recently spoke with William Moore and found he no longer believes the Philadelphia Experiment involved invisibility or teleportation. Instead, further research has convinced him it was part of an effort by the Navy to make ships radar-proof, supposedly in an effort to foil radar-guided torpedoes that the Germans were believed to be developing. The idea was to feed a high-power, low-frequency current into the ship's hull, in effect making it into a radar antenna that would jam incoming radar. But the initial experiment had unintended side effects on the crew, ranging from nausea to hallucinations and loss of consciousness. The hallucinations were the basis for the wild tales that later arose.

This version is a lot less implausible than the original yarn, but it's still got some holes in it. A Navy historian sensibly points out there's no such thing as a radar-guided torpedo—radar doesn't work underwater, something people understood even back in 1943. (The Germans used acoustic torpedoes, which homed in on the sound of a ship's engines.) And Moore still doesn't have much documentary evidence. If it exists, both he and the Navy agree it's in the National Archives in Washington.

But Moore says R&D records take up "a mile and a half of shelf space" and aren't indexed, so finding the right stuff could be a bit of a project. I might get around to it one of these days, but in the meantime you can purge yourself of any thoughts of teleported warships.

This may sound off the wall, but how about the straight dope on the Trilateral Commission? All my life I've heard about this "secret" organization that supposedly actually runs the world. What's the real story?—Alton F., San Antonio, Texas

Alton, you wound me. You should know by now the only person remotely together enough to run the world is . . . well, modesty forbids, but you just wouldn't believe what you can accomplish with a home computer these days. (Sorry about that blip in the stock market, by the way—I definitely gotta keep those floppies out of the taco sauce.)

But on to the Trilateral Commission, or TLC, as it's often coyly referred to. For starters, unless you're a lad of very tender years, it's a safe bet you haven't been hearing about the commission all your life, inasmuch as it was founded in 1973. Second, as you probably already recognize, an organization that everybody already knows about hardly qualifies as "secret." They're in the New York phone book, and if you ask they'll send you a bunch of literature about the organization. Third, while it's your constitutional right to be paranoid, you might at least try to be paranoid about something reasonably up-to-date. The TLC-as-world-conspiracy theory peaked during the early 80s, and has now pretty much gone the way of the hula hoop.

The Trilateral Commission is based on the quintessentially American notion that if we could just get together and talk about stuff, we could solve all the world's problems. Accordingly David Rockefeller, chairman of the Chase Manhattan bank, got together several hundred opinion leaders from North America, Western Europe, and Japan (hence the *tri* in trilateral), who meet annually to hear speeches, participate in seminars, and exchange idle gossip. In between times the commission puts together task force reports on pertinent issues and publishes a magazine.

The TLC's first executive director was Zbigniew Brzezinski, and such well-known figures as Walter Mondale, Caspar Weinberger, and Paul Volcker have been members. Also on the rolls

at one time, mainly because the commission needed some representation from the South, was the then-governor of Georgia, Jimmy Carter. The prospect of spending hours cooped up with the likes of Walter Mondale would probably send most of us screaming for the exits, but Carter was an impressionable sort who found both the commission's meetings and its members deeply fascinating. He got chummy with many of the latter and appointed more than a dozen to posts in his administration, including Cyrus Vance, Michael Blumenthal, and of course the redoubtable Brzezinski.

All of this was noted with great interest by the conspiracy buffs, but what really got their juices flowing was the revelation during the 1980 presidential campaign that not only was Carter a member of the commission, so were two of his potential opponents, John Anderson and George Bush. Holy Illuminati, they screamed, the power elite is conspiring to enslave us! They heaped poo on Jimmy and friends and flocked to nonmember Ron Reagan. But then Ron went and signed up Bush and Weinberger, which set off the howling anew.

Among true believers, opinions about what the Trilateral Commission is up to fall roughly into two categories: the merely dubious and the totally insane. The John Birch Society and its confreres see the commission as the latest manifestation of the international conspiracy that is trying to create a one-world totalitarian state, or at least a New World Economic Order. (Before the TLC it was the Council on Foreign Relations and an annual meeting of Western business leaders called the Bilderberg Conference.) The less extreme view is that while the Trilateralists may be well intentioned, the clubby atmosphere tends to create a climate of opinion (either socialist or fascist, depending on whether you're on the far right or far left) that is inimical to America's real interests. The controversy died out after a short time; Reagan even had a reception for commission members in the White House in 1984. But obviously in a few dark corners the anti-Trilateral flame still burns bright.

Report from Baltimore

Twice in recent weeks you have mentioned the Illuminati in your column. In your answer to the question about the Trilateral Commission, you stated that "an organization that everybody already knows about hardly qualifies as secret." If you know anything at all about the workings of the Illuminati, you must surely know that they virtually always hide their "secrets" in plain sight. They do this as a sign of their power, and also as a great cosmic joke at the expense of the public (or "robots," as they condescendingly refer to them) because they know that the vast majority of people are too dim to pick up on it.

All the clues are right under our noses and always have been. We just have to open our eyes. An example is the very "3172" you referred to at the end of the question about marks on money [see page 341]. It's a numerical anagram of the 17/23 correlation.

This is an ideal way for the Illuminati to protect themselves. Anyone who is perceptive enough to figure out what is going on is immediately branded a crackpot and censured by the public or worse, a paranoid schizophrenic, and is thereby censured by the state, i.e., hospitalized, where Illuminati-trained operatives have special techniques designed to actually drive the person insane.

It puzzles me that a man of your intelligence and knowledge could scoff at the Illuminati and compare the TLC conspiracy to a fad like the hula hoop. Have they gotten to you too?

Just in case, and to avoid any further attention from the Secret Chiefs of the Order, I'll sign this . . .—Adam Kadmon, Baltimore

The 17/23 correlation?

Update

Readers of *The Straight Dope,* volume one, may remember our discussion a while back of spontaneous human combustion (SHC), a mysterious phenomenon blamed for hundreds of gruesome fire deaths. The victims typically are found burned to a

crisp for no apparent reason, often leaving nothing but ashes. Yet other flammable objects nearby are undamaged.

The classic case involved Mary Reeser of St. Petersburg, Florida. On the morning of July 2, 1951, her landlady attempted to deliver a telegram but found the doorknob too hot to touch. When rescuers finally entered the smoke-filled apartment, they found only a blackened circle where Mrs. Reeser's easy chair had been, along with some blackened seat springs, a portion of her backbone, a shrunken skull, some ashes, and one foot encased in a black satin slipper. Little else in the apartment was damaged.

What happened in this case and others like it? Past researchers have blamed everything from excessive alcohol consumption to "geomagnetic fluctuations." Now Joe Nickell and John Fischer, the former a well-known investigator of the paranormal, have analyzed the evidence in 30 cases and concluded that SHC may not be so inexplicable after all. Here's a quick rundown of their findings, recently published in the *Skeptical Inquirer:*

- *In most cases combustion probably wasn't spontaneous.* Candlesticks, oil lamps, pipes, and the like were found near the victims. Mrs. Reeser when last seen alive was smoking a cigarette.
- *The victims tended to be slow to react.* Many were alcoholics; others were elderly, overweight, or handicapped in some way. Mrs. Reeser was 67, weighed 175 pounds, and had a bad leg. The evening before her demise she told her son she had taken two sleeping pills and expected to take two more.
- *Bodies can be totally consumed at temperatures much lower than previously believed.* Proponents of paranormal explanations for SHC often point out that crematoriums use temperatures of 2,000 degrees or more, much hotter than the usual household fire. But experts say high temps are necessary only if the body must be destroyed in a short time. Smoldering fires can consume an entire piece of furniture (and presumably the body within it) if given long enough. Yet they often leave nearby objects undamaged. Twelve hours passed between the time Mrs. Reeser was last seen alive and the time her remains were discovered.
- *In cases where the body was completely destroyed, there was often a nearby source of combustible material to feed*

the fire. The floorboards beneath a number of victims were found burnt through; Mrs. Reeser was wearing a flammable nightgown and housecoat and was sitting in an overstuffed chair.

In addition—this gets pretty gross—the fuel sources may have served to catch melting body fat which then added to the flames: the "candle effect." A quantity of "grease," Nickell and Fischer note, was found where Mrs. Reeser's chair had stood.

"In the Reeser case, what probably happened was that the chair's stuffing burned slowly, fueled by the melted body fat and aided by partially open windows," Nickell and Fischer conclude. "What has been described as 'probably the best-documented case' of alleged spontaneous human combustion is actually attributable to the deadly combination of a lit cigarette, flammable nightclothes, and sleeping pills." Grisly stuff, but I thought you'd want to know.

Chapter 14

The Body Eclectic

How is it that people often wake up moments before their alarm goes off? I know this isn't just me. I thought maybe the body gets accustomed to a set number of hours of sleep or maybe it responds to something like the sun being at a certain place. But that isn't possible because you'd have to go to sleep exactly at the same time every night, and besides, the sun is in a different position each day. I could see that the body would rather wake up on its own than have a loud noise jarring it out of sleep, but that doesn't explain how a sleeping person can know when to wake up. Help, Cecil.—David D., Chicago

We can chalk this up to two things, Dave: your natural body rhythms plus some classic Pavlovian conditioning. Scientists have long been interested in what are called "circadian rhythms"—i.e., cyclic fluctuations in various bodily functions, such as memory and manual dexterity, over the 24 hours of the day. Many of these rhythms are endogenous—i.e., controlled internally rather than by external factors like the sun. (Interestingly, if you're isolated from the outside world and don't know what time it is, oftentimes your body will adjust to a 25-hour cycle.) For our purposes, the most important function to be concerned with is body temperature, which is highest at midday and lowest in the early morning hours. (That's why if you pull an all-nighter you'll feel chilly around 4 A.M., even if room temp stays constant.) Studies by Harvard researcher Charles Czeisler indicate that waking is strongly linked with a rise in body temperature, and that body temperature rises at about the same time each morning regardless of what time you got to bed. In other words,

300

your internal alarm clock will wake you up even if you aren't fully rested—which may account for the fact that people on irregular schedules sometimes complain they wake up tired.

But your biological alarm clock doesn't instantly jolt you to a state of full alertness when morning comes around. Rather, your sleep becomes progressively lighter, and alternates with brief periods of wakefulness. Here's where the Pavlovian conditioning comes in. You may not be consciously aware of this, but in virtually all mechanical and many electric clocks there's a faint click or some other change in rhythm a short time before the alarm goes off. You're quite capable of hearing this in your semiwakeful predawn state, and over time you associate it with the alarm that invariably follows. Since the alarm itself is so unpleasant, you unconsciously learn to snap to a state of full wakefulness as soon as you hear the click so you can shut the damn thing off. If you were to buy a clickless electronic clock or clock radio, however, you'd be more likely to sleep straight through till the alarm sounded.

What is the greatest volume of blood that any one blood donor has donated in his/her life? Just imagining the amount sends shivers up and down my aorta.—Billy Rubin, Chicago

"Billy Rubin"? Goodness, you med students are a caution. From the 1987 *Guinness Book of World Records* we learn that

the champ blood donor is Allen Doster, who donated 1,800 pints—a staggering 225 gallons—at Roswell Park Memorial Institute, New York, from 1966 through April 1986. On the next page we note that the largest tumor ever recorded was an ovarian cyst weighing 328 pounds removed from a woman in Texas. She recovered fully. Fascinating book, *Guinness.*

Re "Billy Rubin": Huh?—M.M.Q., Los Angeles
It's a pun, such as only a med student could possibly love, on *bilirubin*, the end product of red blood cell breakdown. See page 381.

Why do we have sinuses? Why, more specifically, do I have a body part that causes me to live on Sudafed for months at a time and still occasionally causes headaches so severe I throw up? Are sinuses the upper respiratory equivalent of tonsils, or what?—Julie P., Tempe, Arizona
The real purpose of sinuses, I suspect, is to remind you of your sinful nature and prevent you from being overcome with happiness. That explanation, at any rate, is no dumber than any of the dozens of others that have been proposed, none of which is very convincing. Here's a quick rundown:

- *Resonance,* i.e., they make your voice more piercing. Unfortunately, cats, which have no unfilled sinuses, can howl like banshees, whereas giraffes, which have quite large sinuses, are silent.
- *Reduced weight in the skull.* Sounds plausible, but some researchers have estimated that if the sinus cavities were filled with porous bone instead of air, the head would be just 1 percent heavier. Also, many heavy-headed mammals have absent or rudimentary sinuses.
- *Protects the brain against blows to the face,* apparently by deflecting the force of the blow to the sides, after the manner of an arch. There's little evidence one way or the other here, although I would venture to say, having watched a few boxing matches, that the face's primary shock absorber is the nose.
- *Heat insulation for the base of the brain.* Dubious. Some of the sinuses do not adjoin the brain; others which do

adjoin the brain are not present in all mammals. In any case, most warming of breathed-in air is done by the primary nasal passages, not the sinuses.

- *Having hollow spaces in the head facilitates the growth of the face*, somehow. Why it's so important to have your face grow rapidly I dunno. In any case, baboons get along fine without maxillary sinuses simply by having their cheeks curve in.

- *An aid in smelling and/or breathing.* The idea here is that the sinuses warm and moisten breathed-in air. (Moistness is known to be important to smelling.) Some believe that sinuses provide a sort of reservoir of smellable molecules, giving the nose more opportunity to sample a transient scent. In some keen-scented mammals, the sinuses contain smell-sensing organs, but this is not true in man. Moreover, it's been calculated that sinuses contribute perhaps $1\frac{1}{2}$ percent of the moisture in inspired air.

In sum, medical science has failed again. And we expect these guys to cure cancer?

Ever since I was a tiny infant, I have sneezed when going out into the bright sun. My momma confirms this fact, but can't give me a more satisfactory cause than the empirical statement that I've always done it. Three decades later, I still produce the obligatory two or three sneezes seconds after walking into bright sunlight. (It doesn't happen on a cloudy day or at night.) I remember several years ago reading in the paper that some percentage of people experienced sun-induced sneezing fits, but they didn't say why. What's the deal?—Alan C., Dallas

What you're talking about is the "photic sneeze reflex," which occurs in something like one-sixth to one-quarter of the population. According to a Johns Hopkins medic named Stephen Peroutka, the trait is passed along genetically, with a 50 percent chance of inheritance. Researchers in Sweden found that out of 460 subjects, 24 percent sneezed in bright light, and 40 percent had at least one sneezing parent. Sixty-four percent of children with one sneezing parent were themselves sneezers, but two non-sneezers never produced a sneezer. (Isn't it amazing how I can make these things so easy to understand?) Nobody's exactly sure what causes photic sneeze reflex. But you've got a lot of nerves

crammed together in the front of your head, and some researchers guess that there can be leakage of sorts from one nerve pathway to another. So maybe the reflex is just a case of congenitally crossed signals.

From the Teeming Millions

Re "photic sneeze reflex": When we cry, we need to blow our noses. Therefore, there is a passage from the tear ducts to the nose. Photic sneeze reflex is caused by tears (our eyes water to protect the unadjusted irises from bright lights) moving into the nasal passages, tickling the hairs within. The result: ker-choo!—Peter R., Decatur, Georgia

As a matter of fact there *is* a passage connecting the tear ducts to the nose called the nasolacrimal duct. It enables tears to drain out of the eye. According to an ear-nose-and-throat specialist who experiences photic sneeze reflex himself, however, the sneeze occurs immediately upon emerging into the light, too quickly for tears to work their way down the duct.

Is there any truth to the claim that if you hold your eyelids open while sneezing, your eyes will pop out? I have never mustered the courage to try this, but I'm curious to know.—Trevor R., San Antonio

If you want to know something about courage, Trevor, try asking this question of your typical straight-ahead physician. Fortunately, years of practice at this have rendered me immune to embarrassment. The chances of postsneeze deoculation, I'm happy to say, are approximately zip. The truth is it's just about impossible to keep your eyes open during a sneeze—they snap shut by reflex. The reflex serves no purpose, so far as anybody knows; it's just the way you're wired up. The nerves serving the eyes and the nose are closely intertwined, and stimuli to the one often trigger some response in the other. We've already discussed photic sneeze reflex. Similarly, sneezing (or yawning or vomiting) can cause not only blinking but tears. Some beauticians claim that if your eyes start to water while you're applying make-up, you can stop it by blowing your nose. There is something about this arrangement reminiscent of a Three Stooges-play-

plumber routine, but I don't justify these things, I just lays out the facts.

Why do oriental and occidental eyes differ?—J.B., Chicago

The question I think you are dimly trying to ask here, J., is what the function is of the epicanthic fold, the extra flap of skin that gives Orientals a sort of double upper eyelid. Anthropologists aren't sure, but their best guess is that it's an adaptation that protects against cold and glare. The theory is that the people who eventually became the Mongoloid race were trapped in Siberia by the glaciers during the last ice age, from 50,000 to 25,000 years ago. During that time, when life was truly survival of the fittest and evolution was rapid, the proto-Mongoloids developed a number of physical traits that helped them cope with the bitter weather. For one thing, their noses became flattened, which minimizes exposure to the elements and thus reduces the risk of frostbite. The nostrils got narrower, enabling inhaled air to be warmed up more efficiently and preventing cold air from reaching the lungs. Their faces gradually became round and flat and lined with fat, which acts as an insulator. The eyelids picked up a layer of fat as well.

The epicanthic fold was the crowning touch. Not only did it help make the eyelid thicker, it also acted as a barrier to the elements. If you had icicles hanging off your outer eyelid (the fold), at least your inner one might remain unencumbered. Some say the epicanthic fold also cut down on glare off the snow. Not exactly polarized Ray-Bans, but arguably the next best thing.

Every time I crack my knuckles the kids in my classes wince and gleefully inform me that I will get arthritis. My yoga book, on the other hand, informs me that the practice is beneficial. Who's right? I once read that the cracking sound was due to gas bubbles being exploded inside the joints. Is this true? When I was a grotty child I used to crack not only my finger joints but my toe joints also. I used to consistently reach 30 cracks, but have always wondered whether there was a maximum possible number of cracks or whether there is a standing world record. Uncle Cecil, put me out my misery and give us the straight dope.—Clive G., Baltimore

Cecil would love to put you out of your misery, Clive, since he regards knuckle-cracking as a crime against nature, but once again we find that justice is obstructed by the law. Be that as it may, you're pretty much on the money with this business about gas bubbles popping, although actually they don't *explode*, they *implode*, a matter of some importance to us scientists.

Here's the deal. The knuckle (M.D.s call it the *metacarpophalangeal joint*) is surrounded by the synovial fluid, a clear liquid that lubricates the joint. This fluid contains about 15 percent carbon dioxide in solution. When you crack your knuckles, you tug or twist the finger or toe with a steady effort, creating a low-pressure zone within the synovial fluid. According to the most likely hypothesis (Unsworth, Dowson, and Wright, 1971), the low pressure draws CO_2 and water vapor out of solution, creating a bubble. This collapses almost instantly, and the fluid crashing in from all sides makes the noise.

Once the big gas bubble has popped, a little one remains behind for about 15 or 20 minutes until the CO_2 inside it is totally redissolved. During that time, any further finger-tugging simply causes the micro-bubble to expand a bit, like a tiny shock absorber. That's why you can't crack the same knuckle twice in rapid succession. (The fact that the knucklebones also remain at maximum extension for a while is also a factor.) This leads me to conclude that the theoretical ceiling for knuckle-cracking is . . . let me get my shoes off here . . . 56. Sounds like you've still got a ways to go with your 30. Incidentally, not all cracking noises produced by stretching—e.g., in the backbone—are the result of gas bubbles popping. Sometimes the noise is caused by a ligament snapping over some bony projection.

Will cracking your knuckles cause knobbiness and arthritis, as some claim? Not necessarily; genetics undoubtedly plays a much more important role. But some clinicians believe chronic knuckle-cracking can make things worse. And it certainly doesn't do much for your standing in civilized society. Knock it off before it's too late.

Are the workings of the female half of our species always to remain a mystery? One of my lady acquaintances recently relayed the following piece of physiological trivia, which I won't believe unless I get confirmation from a higher source. She said that when a group of females live together, their menstrual cycles begin to coincide. Even harder to believe, she tells me this

is because of a scent women react to. Is this true? Is this phenomenon observed in women's prisons and schools? How come I never heard about this before? What else don't I know about women's bodies?—Mark D., Washington, D.C.

What you don't know about women's bodies is something you'd better take up with your girlfriend, Marko. But you heard right about "synchronous menstruation," as it's called. This amazing phenomenon was first described in 1971 by researcher Martha McClintock, now with the University of Chicago. Having asked around a bit, I'd say it's common knowledge among women, but I'll bet not one male in 50 has ever heard of it. Women *do* have their little secrets.

Synchronous menstruation has been observed among mothers, sisters, and daughters who live together, and sometimes among women who simply work together. McClintock tells of seven female lifeguards who started out one summer with widely scattered periods. Three months later they were all menstruating within four days of one another.

A study of 135 residents of a women's college dorm confirmed the effect. Most of the cycle shifting occurred within the first four months and was usually complete after seven months. Fortunately for the dorm's plumbing, the whole building didn't synchronize, just roommates and close friends. As often as not, the women were unaware of what had happened.

Later research has suggested that synchrony is caused by some sort of scent cue, or pheromone. Scientists at the Sonoma State Hospital Brain Behavior Research Center in California identified several women who were believed to be menstrual pacesetters— they made other women conform to their cycles. The scientists placed cotton pads under the dominant women's arms for a day, and then wiped the pads on the upper lips of five female subjects three times a week. (One wonders how much the subjects got paid for this.) Within five months, four of the recipients were menstruating at the same time as their donors.

Interestingly, men also have an effect on women's menstrual cycles—and not just because they make women pregnant, either. Women who associate with males frequently find that their periods become shorter and more regular. One woman told McClintock that she had a six-month cycle length until she began hanging out with guys, at which point her periods began occurring every 4.5 weeks. When she resumed her solitary ways, her

cycle lengthened again. Another round of cotton pad experiments, this time using males as donors, confirmed this. Having sex with a man at least once a week will also do the trick.

Why synchrony occurs is pretty much a total mystery. The only published theory I've seen treats it as an evolutionary holdover from prehistoric times, when it was common for men to take multiple mates, and efficient reproduction was essential to the survival of the species. The author of this theory conjectures that women in their brief monthly phase of peak fertility give off some pheromonic signal that drives males wild with desire. (The author, I'd be willing to bet, was either the owner of a dog or the parent of a teenage girl.) If his wives are on different cycles, hubby has a good chance of picking wrong when his nose tells him it's time to go into action, thus wasting precious bodily fluids. On the other hand, if his wives are all on the same cycle, he can't miss. The problem with this theory is that surveys show sex occurs most frequently around the time of menstruation, when women are *least* fertile. Back to the drawing boards, I guess.

Menstrual Synchronicity in Action

Your informational bursts usually don't blow me away, but the piece you did on "synchronous menstruation" sure did. Quite by coincidence it meshed with a conversation I had the prior week with a computer company middle management type.

I manage technology transfer for a university in Illinois. One of our most successful recent inventions is an innovation in computer monitors known as plasma display. Their high resolution, soft orange color, and versatility are well suited for those who must stare at computers on a daily basis, i.e., engineers, designers, bank functionaries, etc.

A company (which shall remain nameless other than the designation "Big Blue") has been utilizing this invention in their product line for the past eight years or so. Not long after production geared up, Big Blue management noticed that the junk bins were filling up with rejected screens at an inordinately high rate at a certain time of the month. Plasma displays involve the chemical bonding of electronic circuitry to the inside of the screen's glass face. Prior to the recent introduction of automated production equipment, the bonding process was done by hand

by female assembly workers. Yes, Cecil, you guessed it. When Big Blue's efficiency experts got done number-crunching, they found that the workers' menstrual periods were collectively peaking at around the same time the junk bins were running over. Why? It seems that the perspiration on the fingertips of the assemblers became more acidic at their collective "time," which quite effectively screwed up the chemical bonding process.

When people tell me the world runs on sex, I now understand what they mean.—Robert C., Chicago/Champaign

On the assumption that the Big Blue you're talking about is more commonly known by the initials I-B-M, I called up to check on your story, Bob. Nobody at IBM can recall anything about it, but they admit it might have happened. Makes a good yarn, in any case.

Why is it that when I yawn, everyone around me yawns too? Am I so boring that I put even myself to sleep? Or is yawning just the latest STD (socially transmitted disease)?—Daniel C., Washington, D.C.

Not being personally acquainted with you, Danny, I am not in a position to say just how tedious the experience of your company really is. But I should note that yawning isn't always a sign of boredom. Adélie penguins, for instance, employ yawning as part of their courtship ritual. The happy couples face off amid the ice floes and the males engage in what is described as an "ecstatic display," their beaks open wide and their faces pointed skyward. It may be, therefore, that when your entry upon the scene inspires a round of uncontrollable yawning, you have merely stumbled onto a gaggle of Adélie penguins in disguise, who are signaling their powerful erotic longing for you. A slim hope, admittedly, but any port in a storm.

As for the larger question of why yawns are catching, the fact is that nobody really knows. In general you yawn when there's too much carbon dioxide and not enough oxygen in your blood. A part of your brain called the brain stem detects this and triggers the yawn reflex. Your mouth stretches wide and you inhale deeply, shooting a jolt of oxygen into the lungs and thence to the bloodstream. Subsequently, you exhale a lot of CO_2. Often you'll stretch while yawning, which seems to temporarily improve circulation.

Yawning typically occurs when you get tired and your breath-

ing slows down, or else when you're in a crowded room and the air gets stale. Since most people keep roughly the same hours and thus get tired around the same time, we may theorize that toward the end of the evening everybody is on the verge of yawning anyway, and that the power of suggestion from seeing one person do it is enough to push everybody else over the edge. Similarly, when you're in a room full of stale air, everybody else there is in the same boat, so you all tend to yawn together. (My yawn-expert colleagues say this theory sounds plausible but despair of proving it.)

Adults rarely catch a case of the yawns from a child or animal, which tends to corroborate this idea. Children usually have different sleep schedules and respiration rates from adults, so you would expect them to yawn at different times. Animals, on the other hand, often yawn not for physiological reasons but as a display of hostility, to which humans are evidently unresponsive.

Given that yawning does have a communicative function among animals, I suppose I could concoct an even more complicated theory about how social yawning is an evolutionary holdover from man's prelingual past. Frankly, however, I think we've had enough BS for one column already.

Breakthrough in Yawn Research!

It may be true that adults rarely catch a case of the yawns from an animal, but I have proof of contagious yawning in cats. One evening my sister and I discovered we could make the cat yawn by looking it in the eye and yawning. Naturally, this made us a hit at parties. We have achieved a 1:1 ratio of human yawns to animal yawns.—Mary W., Chicago

Science, Mary, will be forever in your debt.

I have wondered about this for years—my friends now only roll their eyes when I wonder aloud. What are dreams like for people who have been blind from birth? Are there any kinds of images, or are they strictly sound, smell, and touch dreams? —Jane M., Chicago

Many great minds have wondered about this, Jane. Of course, so have many total prune pits, so don't jump to any rash conclusions. The dreams of the congenitally blind contain no

visual elements and consist predominantly of sound plus smell, touch, and the sense of movement. Plotwise they tend to be reality-based—e.g., a reprise of the events of the day—with less of the fantasy you find in the dreams of sighted people. There's also more conversation. Persons who become blind *after* birth often see in their dreams, although it depends on (a) how old they were when they became blind and (b) how long it's been since. If you're blinded before the age of six or seven you generally see little or nothing in your dreams, since you haven't fully "learned" to see. (No kidding. The sad story is told of a man born blind due to congenital cataracts who had surgery on his eyes as an adult. Though physically cured, he found himself totally unable to see properly, due to the inability of the brain to learn to process visual information past a certain age.) Dreams of people who become blind when older are often indistinguishable from those of the sighted, but as time goes on they "see" less and less. To some extent, I gather, this can be counteracted by force of imagination. Helen Keller, who became blind at the age of 19 months, claimed to have "visions of ineffable beauty," which mostly involved things like pearls and whatnot. To my mind this betrays a certain want of ambition; personally I'd want to see what I could work up along the lines of Jacqueline Bisset. But at least we know there's hope.

Sometimes when I'm lying on my back looking at the sky or the ceiling or some other light-colored background, I swear I can see specks and what looks like little threads floating by. They seem to move when I move my eyes, leading me to believe they're actually on my eyes. Is there some optical phenomenon that allows us to focus that close? Is there a name for this effect?—Mike P., Dallas

Those little specks and threads aren't *on* your eyes, you silly, they're *in* your eyes. Doctors call them floaters, *muscae volitantes* (Latin for "fluttering flies"), or, if they're in a prosaic mood, spots. The specks are variously described as particles, soot, spiders, cobwebs, worms, dark streaks, or rings. Just about everybody experiences them, although they're most common in people who are nearsighted. Usually—but not always—they're harmless.

The little threads are believed to be the sad remnants of the hyaloid artery, which nourishes the lens and other parts of the

eye during fetal development and then withers away. During its brief life the artery floats in the vitreous humor, the goo that fills the eyeball behind the lens. Running from the lens to the back of the eye where the optic nerve comes in, the artery reaches the high point of its existence around the third month of development, then starts to atrophy. By the seventh month blood stops flowing through the artery and it gradually disintegrates. Most of the debris disappears by the time you're born, but some of it remains on the scene indefinitely.

As you get older, the number of floaters in your eyes tends to increase due to the formation of fibrous clumps and membranes in the vitreous fluid. If things really start to slide, the vitreous material may even pull away from the inside of the eyeball, in which case what you're seeing may be crudniks *stuck to the back side of your eyeball jelly.* Disgusting, sure, but more or less normal, they tell me. Your vision remains unimpaired.

But floaters aren't always benign. Sometimes they're errant blood cells resulting from hemorrhage of the delicate vessels inside the eye. This can be caused by a good whack to the head or by a variety of ailments. A sudden shower of spots, for instance, often accompanied by flashes of light, can signal that you're about to suffer a detached retina.

Floaters can also be debris resulting from an eye infection—or worse. I note here in my ophthalmology handbook, which need-

less to say I keep with me always, that sometimes floaters can be "intraocular parasites"—meaning that what look like flies may actually *be* flies, after a manner of speaking. Fortunately, these are rare.

Assuming your floaters aren't caused by some ongoing disease or other problem, they'll generally go away or at least settle out of your line of vision eventually. If not, and if your sight is seriously impaired as a result, the vitreous fluid can be surgically drained and replaced with an inert substitute. This is called a *vitrectomy*, and it's a bit delicate. If you're checking out surgeons and the guy says, "Sure, I'll take a stab at it"—think twice.

We've heard that when you're cold, your basal metabolism kicks into high gear and your body burns up calories faster. Does this mean you can lose weight by keeping the thermostat turned down? Also, is there a "good" time of day for stoking up on more munchies? In other words, is there a point during the day when your metabolism is really cranking and the calories from an extra dessert will just go up the flue rather than around your waist?—T. and S., Chicago

If half the ingenuity the Teeming Millions waste on trying to avoid dieting and exercise could be devoted to something constructive, we'd cure cancer in a week. Let me start by laying down the two basic axioms of fat science. *Axiom 1:* There is no good way to lose weight that does not involve eating less or exercising more. *Axiom 2:* If the choice is between eating less and exercising more, choose the latter.

Now for the specifics. You do burn up calories faster when it's cold, although after a while your body adapts and the effect is reduced. Not that it matters much. Unless you exercise at the same time, you're not going to be burning the *right* calories. When your metabolism is in "rest" mode, you burn mostly glucose, the simple sugar that's found in your blood. Your fat cells remain untouched, and you don't lose any weight. But when you engage in sustained, strenuous (i.e., aerobic) exercise, your system shifts gears and you start metabolizing body fat. This typically occurs about 15 or 20 minutes into your workout, when you experience the familiar phenomenon known as "hitting your stride." Suddenly, things seem easier. That's because fat is a more efficient fuel—it provides 18 times more energy than glucose. Working out in the cold (within safe limits, of course) will burn

even more fat, although curiously enough so will working out in the heat—your body uses up a lot of calories trying to keep you cool too. Once fat metabolism gets started, it takes at least an hour, and maybe as long as four or five hours, before your body switches back to "rest" mode. So you can safely eat a big meal after working out and be confident you'll burn it off pretty fast.

Which brings us to question two. Your metabolic rate does fluctuate during the day, peaking out around midday. Studies indicate that a load of calories taken at night will result in more weight gain than the same amount taken in the morning. So if you must make a pig of yourself, do it before noon. Morning is also the best time to exercise if you want to lose weight. One study indicated that two-thirds of the calories you burn up in the morning come from fat, whereas less than half come from fat in the afternoon.

A couple other interesting factettes: Whatever you do, don't try to lose weight by simply knocking off eating altogether. If you do, your bod simply shifts into "starvation" mode. Your metabolism slows down in order to conserve your energy supply and you work off fat very slowly. Also, the act of eating itself kicks up your metabolic rate 5 to 30 percent. This has led some nutritionists to suggest that you ought to eat lots of little meals during the day rather than one or two big ones. Knowing human nature as he does, however, Cecil fears the Teeming Millions will regard this as license to munch out all day on Snickers bars, which

needless to say is not the idea. Try Cecil's Experimental Do or Diet instead. 7 A.M.: Fruit on high-fiber cereal with low-fat milk. Gets the blood sugar up, increases mental alertness. *10:30 A.M.*: Half an hour of vigorous exercise, e.g., running, cycling, swimming, handball, etc. *11 A.M.*: The big meal of the day. Preferably it shouldn't be that big, but if you must pork out, now is the time to do it. Include fish several times a week. *3 P.M.*: Optional snack, such as fruit, veggies (raw carrots especially recommended), trail mix. For a change, try popcorn (lightly salted, no butter), a good fiber source. *7 P.M.*: Light supper. Cecil prefers salad with French bread and candles. *8 P.M.*: Vigorous lovemaking with the party(s) of your choice. Good for the disposition, and burns off ugly fat too. *Three months from now:* Report your results to Cecil, especially if this whole things works. You'll have the satisfaction of contributing to the betterment of mankind, and I'll get the Nobel prize.

We were watching Spartacus *the other day and the age-old question came up again. How does someone with a real deep chin dimple shave it? Does he just shave straight over it, leaving the beard in the dimple? Is there a special type razor? Or what?—Ted O., Arlington, Virginia*

Kirk and I aren't speaking these days, so I called up my brother John, who has a hole in his chin so deep you can hear an echo when he talks. John avers that shaving a chin dimple is no problem at all—it just flattens out under the pressure of the razor. (He uses an electric, but says it worked the same way when he used blades.) He attributes the malleability of the dimple to the fact that it isn't underlaid by bone or cartilage but simply subcutaneous fat. (Actually, John did not say "subcutaneous"; I'm the intellectual in the family.) He sternly advises not smiling while shaving; this tautens up the skin and makes the dimple harder to get into. "No special curved tools are required," says John. "We people with handicaps, we just want to be treated like everybody else."

We have a question that has been plaguing us ever since "Ask Andy" declined to answer it some 30 years ago. Can hair turn white overnight from fright? We recall reading somewhere that during stressful events the few remaining dark hairs in a salt-and-pepper head can loosen and come out so that a person

appears to be very much whiter. Is this true? We have been let
down before, Uncle Cece, so please come through for us.—Susan
K., M.D., Los Angeles, and N.W.B., Seattle

I'm not saying you lack initiative, doc, but if this question
had been bugging me for 30 years, it might have crossed my
mind to head down to the library. Doing so would have turned
up a delightful essay on the subject by J. E. Jelinek, a dermatol-
ogy professor at NYU. Overnight graying or whitening of hair
has been reported for centuries, and for almost as long doctors
have been arguing about whether it actually occurs, and if so,
how. The hair of Thomas More, for one, is said to have become
entirely white the evening before his execution in 1535. Henry
of Navarre, later Henry IV of France, supposedly went suddenly
white following his escape from the Saint Bartholomew's Day
Massacre in 1572.

But the evidence for such stories is often suspect. Legend has
it, for instance, that Marie Antoinette's hair turned white the
night before she was beheaded. Several writers clearly state,
however, that in fact her hair had lost its color long before. (One
claims it turned white following her failed attempt to flee France
in 1791.) Even in modern times reports of rapid graying often
turn out to be secondhand or to have originated with doctors
who examined the patient months after the supposed event.

The problem with sudden whitening, of course, is that hair is
dead tissue, and thus, one would think, incapable of becoming
entirely white until it grows out from the roots, a process that
takes weeks. Still, as you indicate, there does seem to be one way
that hair can appear to turn gray in a very short period of time.
What happens is that a condition called "diffuse alopecia areata"
may occur in somebody with a mix of normal and gray hairs.
Alopecia can result in sudden, substantial hair loss, but for un-
known reasons seems to affect mostly pigmented hairs, leaving
white ones untouched. The impression one gets, therefore, is that
the patient has become suddenly gray. The precise sequence of
biological events resulting in alopecia is unknown, but it's
thought emotional stress can contribute to it. No doubt this ex-
plains the fate of Cecil's own once-vigorous mop, now largely
gone the way of the passenger pigeon due to the constant trauma
of calling up total strangers and asking where the baby pigeons
are. Hope you appreciate it.

Can you please tell me why your fingers and toes wrinkle in the bathtub, but the rest of your body doesn't?—Rachel F., Chevy Chase, Maryland

What my body does or does not do in the bathtub is no business of yours, Rachel. However, speaking in generalities, I might note that the top layer of the skin is composed of toughened, scaly cells collectively known as the stratum corneum. On most of the body, this layer is quite thin, just .015 of a millimeter, but it's 40 times as thick, or 0.6 of a millimeter, on the soles and palms. Normally the stratum corneum is relatively dehydrated, but it absorbs moisture and swells up when soaking. This swelling occurs throughout the soles and palms, but it's most noticeable in the fingers and toes because of their restricted dimensions. In extreme cases, e.g., so-called immersion foot syndrome, which sometimes occurs among soldiers whose feet stay wet for prolonged periods, the entire sole can wrinkle up and become painful to walk on. The principle is the same in any case: since the underlying tissue doesn't absorb water, the stratum corneum can't spread out, so it buckles like asphalt on the highway in the summer sun.

Why is it that the sound of fingernails scraping a chalkboard is so godawful annoying?—Andy L., Syracuse, New York

In these days when so many scientists are panting after research grants from Star Wars, Andy, it's good to know there are still a few people around who know what's really important. People like Lynn Halpern, Randy Blake, and Jim Hillenbrand of Northwestern University, for example. These daring pioneers of science recently conducted an investigation into the "psychoacoustics of a chilling sound"—in laymen's terms, why the sound of fingernails scraping a chalkboard is so godawful annoying. What's more, according to their scientific paper on the subject, the work was "supported" by the National Science Foundation. Cecil immediately jumped to the conclusion that not only were Halpern et al. studying blackboard scraping, *they had gotten the government to pay for it*, which would put them in the running for research scam of the year. Unfortunately, further inquiry reveals that this was not exactly what happened. The National Science Foundation grant actually paid for some equipment Blake was using for more, ahem, "serious" research, which he was then able to put to disreputable ends. This does not make as good a story, I suppose, but it shows spunk all the same. Good work, gang.

In the aforementioned scientific paper (which appeared in a publication sternly entitled *Perception & Psychophysics*, and is not to be confused with a vulgar and sensationalized, if entertaining, article that appeared subsequently in *Psychology Today*), the authors note the antiquity of human curiosity on this subject. No less an authority than Aristotle acknowledged the "aversive quality" of scraping sounds. Our heroes even dug up the archaic English verb *gride*, which means to make hellacious noises by means of scraping or cutting.

Getting down to business, Halpern and friends subjected 24 adult volunteers to various noises with a view to determining whether blackboard scraping was really as excruciating as it was made out to be. Generally speaking, they found, it was. (For purposes of reproducibility, the scraping was conducted not with fingernails but with a three-pronged garden tool, solemnly described as a "True Value Pacemaker model.") Interestingly, "rubbing two pieces of styrofoam together," the sound that results when you pry two styrofoam cups apart, ranked second on the irritation index.

Next, by means of the magic of high tech, the researchers filtered out the most high-pitched portion of the scraping sound.

To their great surprise, what remained was as unpleasant as ever. However, when they filtered out just the lower frequencies (particularly 3.0 to 6.0 kilohertz, for you weens), they found that what was left was relatively bearable—"quaint" or "tinkly," in Blake's description. In other words, it was the low-to-middle frequencies, not the high ones, that really set people's nerves on edge.

So much for science; now for the woolgathering. Knowing that the preceding research by itself would not get them on many talk shows, Halpern and her associates set about considering just why, in the philosophical, Big Picture sense, humankind was so susceptible to scraping noises. (Actually, Blake says, they did not do this to get on talk shows. They *hate* talk shows. Sure.) Guessing that the whole thing may have had something to do with our monkey ancestors—looked at in the proper light, just about everything has something to do with our monkey ancestors—the researchers compared the waveforms of the scraping noise with those of the warning cries of macaque monkeys. The two sounds, they decided, closely resembled one another. Ergo, Blake writes in *Psychology Today,* "we speculate that our spine-tingling aversion to sounds like fingernails scraped over a surface may be a vestigial reflex" inherited from our primate forebears.

Well, maybe. But by a similar application of logic, it seems to me, we might just as plausibly conclude that the reason our hair is brown (most people, anyway) is that it enabled our monkey ancestors to hide amongst the coconuts. But hey, *I* didn't get a research grant.

Why are women athletes always flat-chested? It's easy to understand that being stacked might not be too helpful in many Olympics-type sports, but how do those gals get rid of 'em? Do they strap themselves down, like Julie Andrews did in Victor Victoria? *Can you shrink them through diet and exercise? Or are they such a disadvantage that competition selects against them? Is it impossible to excel in such events as track and field and gymnastics if you are well endowed? When this first occurred to me, I naturally assumed that good grillwork was just not part of the well-toned athletic female body. However, this past summer I have put this notion to the empirical test, and I don't think it holds up, if you'll pardon the expression. So I turn to you, wise*

*one. What gives? And WHY WAS THERE NO OFFICIAL SUP-
PORT-GARMENT MANUFACTURER FOR THE LOS AN-
GELES OLYMPICS?—Leg Man, Chicago*

Cool your jets, Jasper. As I'm sure you can appreciate, it's
difficult to come up with a definitive answer to a question like
this, partly because Uncle Cecil has an aversion to getting
punched out by female track stars, and partly because the U.S.
Olympic Committee's records on chest size are woefully inade-
quate. However, trainers and coaches confirm that women ath-
letes do tend to be on the small-breasted side, particularly long-
distance runners.

A number of reasons for this have been suggested. According
to a report by Dr. Christine Haycock, a trauma surgeon and
associate professor of surgery at the New Jersey College of Med-
icine, "a trainer who has worked more than 10 years with track-
and-field athletes noted that he has seen only one or two girls
with large breasts in sports, and this tends to confirm that the
discomfort of running without adequate breast support has kept
many potential athletes from competing." As it happens, Cecil
has a well-endowed woman friend who intends to run in a mar-
athon this fall, and pursuant thereto has been doing training runs
of as much as 14 miles a day. These often leave her with a ghastly
collection of abrasions where her bra rubs. It seems safe to say,
therefore, that the low incidence of big-breastedness among run-
ners is to some extent a matter of self-selection. We might further
speculate that since the female breast, whatever may be said for
it from an aesthetic standpoint, can do nothing for an athlete
except slow her down, competitive pressures would tend to favor
small-breasted women. Unfortunately, little research seems to
have been done on this topic.

As for your other theories on small-breastedness, women ath-
letes do not go to any extraordinary lengths to "strap themselves
down." Diet and training, however, may play a role. Female
runners carry about 15 percent body fat, and long-distance run-
ners about 12–13 percent, compared to 18–22 percent or higher
for an ordinary healthy young woman. There is a widespread
belief among female athletes and their coaches that breasts are
"mostly fat," and thus will decrease in size as overall percentage
of body fat declines. (There's some speculation that low body fat
also causes menstruation to stop, a common phenomenon in
women athletes.)

But others have their doubts. Dr. Victor Katch, a PE prof at the University of Michigan, and Dr. Frank Katch, of the department of exercise science at the University of Massachusetts, say that breasts are 80 percent glandular tissue and only 20 percent fat. They claim their studies show there is no statistical correlation between body fat and breast size. Whatever the truth of the matter, there's no doubt that distribution of body fat varies widely from one woman to the next, and certainly *some* women find that their breasts become significantly smaller when they're in training. In any case, the Straight Dope research program in this vital area is continuing. Stay tuned.

Is there any mammalian species where the males breastfeed the young? The reason I ask is that the external mammary features of male homo sapiens *might be a vestige from a time when men actively participated in childrearing. Needless to say, if men once had milk-producing capability this would have far-reaching socio-sexuo-political ramifications, to say nothing of the gossip value.—Genuinely Concerned, Washington, D.C.*

Sorry to put the kibosh on this idea, Gene, which exhibits the sort of deranged inspiration that Cecil so dearly loves, but as far as anybody can tell, there is not now and never has been a mammalian species in which the males suckle their young. You bring up an interesting subject, however, and Cecil must say that in studying up on it he has been pleased to find confirmation for one of his pet epistemological theories, to wit: *For any conceivable question, no matter how bizarre, there is some twisted genius somewhere who has devoted his life to researching the answer.* It is even so with male lactation. The genius in this case is one Martin Daly, a psychology professor at McMaster University in Canada. In 1977 he wrote a monograph entitled "Why Don't Male Mammals Lactate?" which I heartily commend to all serious students of the subject.

Daly notes that there is nothing about male physiology that "appears to present an insurmountable barrier to the evolution of male lactation." In fact, there are a couple cases on record in which elderly men treated with estrogen for prostate cancer were induced to lactate. The reason lactation hasn't evolved naturally, Daly thinks, has to do mostly with the way male/female roles among mammals have developed. Males don't make much "parental investment" in their chilluns—that is, they don't spend

much time with them like mama mammals do. Instead (I blush to report this, but scientific objectivity demands it), the males spend all their time trying to get laid. This evidently is the most efficient way to perpetuate the species, which should be comforting news for all you studs trying to romance bimbos in the local bistros.

Interestingly, there are some nonmammalian species in which the males do suckle their young, notably pigeons and doves, who feed their kiddies "crop milk," which is vaguely similar to human breast milk. And who knows, what with the Mr. Mom scenario becoming more common all the time, we ultramacho he-men may yet find ourselves in the restaurant business, so to speak. I personally am not looking forward to this—hell, I'm still trying to warm up to the idea of changing diapers—but since it's probably 75 jillion years down the road at the earliest, I've got a little while to reconcile myself to it.

Please speak out on this disturbing occurrence: each day when I clean my ears with Q-tips I start coughing. Why?—Glenn F., Chicago

Probably because the Q-tip is tickling your tonsils, fogbrain. Try not to worry about these things.

The Earbone Connected to the Throatbone, Part One

You bill yourself as a modern-day journalist and you don't even bother to research your answers? You should be ostracized by competent fellow professionals and never allowed to print again for your answer to Glenn F. The reason Mr. F. coughs when he sticks a Q-tip in his ear is because his head is attached correctly, unlike yours. Two cranial nerves supply sensation to the oral cavity, throat, larynx (voice box), and trachea as well as the external ear canal. When a Q-tip is inserted, it stimulates these nerves, causing a discharge of signals to the brain. The nerves are not completely separated, so the brain senses an irritation in the throat, triggering the cough reflex. This same association of nerve impulses causes many people to feel they have an earache in addition to a sore throat when in fact their ears are free of infection.

In the future, lazy "reporter," if you don't know the answer to the question, look it up.—Paul J., M.D., Chicago

P.S.: I enjoy your column immensely.

Thanks for the vote of confidence, doc. Having looked into this matter in greater depth, I can now report that the two nerves in question are actually branches of one big nerve, the vagus. This transmits impulses from both the throat and the ear canal, triggering the cough/gag reflex. Med student M.Z. tells me the vagus nerve can also slow the heart rate. "A legend handed down by medical instructors," he reports, "has it that some unhappy physician once induced a cardiac arrest by performing a routine ear exam. Farfetched, but not impossible." Reflex slowing of the heart (bradycardia) also occurs when doctors stick tubes down somebody's throat. No wonder people get jumpy about going to the hospital.

· · ·

The Earbone Connected to the Throat Bone, Part Two

Regarding your recent discussion of the vagus nerve, be advised that the tickle in the throat as a result of cleaning your ears is a variation of the Bartender's Reflex. Old bartenders learned that if they stuck a finger in their ear it would facilitate eructation (medical talk for make them belch).—T.S., Studio City, California

Let's see if I've got this straight. You poke your finger in your ear to make yourself belch, and you blow your nose to make your eyes stop watering. Brilliant. Obviously the problem with stuff made the day before the weekend goes back a whole lot earlier than we thought.

A couple years ago a friend of mine who owns a small recording studio mentioned that a client wanted to record a bunch of different subliminal messages on separate tracks and then mix them all down into one hodgepodge under ocean waves or some other masking sound. The idea was that the unconscious mind could sort out and soak up all this knowledge, reprogramming your brain for better golf scores, better relationships, an end to smoking or procrastination, financial independence, enhanced sex, and anything else they felt like including.

More recently, while flipping through the UHF channels, I discovered some success motivation lecturer types offering their own subliminal tapes with hundreds of multilayered, multi-tracked affirmations to improve every aspect of your life. It all smacks of snake-oil salesmen selling rose-colored water from the back of a medicine wagon to me. What's the straight dope on the unconscious mind's ability to absorb even one subliminal message, much less hundreds at one time? Is it really possible to reprogram my head?—Ken, Panorama City, California

Having once participated in a four-year study of the unconscious mind's ability to absorb subliminal messages (in those days it was called "going to college"), I can assure you the technology ain't what it's cracked up to be. However, things have come a long way in the last few years. While it's doubtful that subliminal cassette tapes do much besides lighten your wallet, there's a

considerable body of evidence to suggest that subliminal messages can improve performance under some conditions. A couple years ago researchers Lloyd Silverman and Joel Weinberger published a paper summarizing numerous experiments, the gist of which was that if you flashed a certain message before and after some other, more conventional training technique (e.g., anti-smoking therapy), you greatly enhanced the therapy's effectiveness.

Now we get to the weird part. The most effective message is said to be "Mommy and I are one." This is supposedly because "there are powerful unconscious wishes for a state of oneness with 'the good mother of early childhood' . . . and gratification of these wishes can enhance adaptation," according to Silverman and Weinberger.

The general reaction to this on the part of the scientific community (to the extent that it noticed at all) was yeah, right. But S&W pointed out the following facts: (1) psychologically neutral messages, such as "People are walking," have no effect; (2) disturbing messages, such as "Destroy mother," have a negative effect, at least on psychiatric patients; and (3) in areas such as the South where the usual term of affection is "mama" rather than "mommy," "Mommy and I are one" has no effect.

A typical case of "mommy therapy" in action involved a weight-watcher's program. For two months subjects participated in weekly half-hour sessions of conventional therapy involving calorie counting and whatnot. Before and after each session subjects were asked to imagine a situation in which they would overeat. A four-millisecond subliminal message was then flashed, with half getting the "mommy" message and half a neutral message. Both the "mommies" and the controls lost weight during the program. However, a month after the therapy ended, it was found the "mommies" continued to lose weight, whereas the controls were starting to inch back upward.

In another study, Israeli high school students who were exposed to the "mommy" message four times a week for six weeks did better in a math course than a control group. Similar results from other classroom experiments have also been reported.

To be sure, there have also been studies that failed to replicate the "mommy" effect. Also, the research to date involves visual stimuli, not audio ones. And nobody is claiming that just any

old subliminal message—e.g., the infamous "Drink Coke"—will cause behavior changes. So I wouldn't waste my dough on tapes just yet. But you never know.

Upon rare occasions when there is a funny commercial on TV, if I give in to laughter I experience a short-term case of retrograde amnesia, just long enough to make me forget what the product was. This has also been the fate of some of the funniest jokes and scenes that have come my way. It seems that the harder I laugh, the less info I can retrieve. It turns out I'm not the only one, which brings me to ask, JUST WHAT IS THE LAUGHTER NEUROTRANSMITTER??? It derails the habitual circuit patterns of the brain, alleviates stress, lowers blood pressure, and gives the brain a buzz. How and where is this transmitter synthesized? What cofactors and nutrients have to be present to make it? Is there a humor enzyme?—Shan G., Venice, California

If it's knowledge you hunger for, lad, chew on this from the December 7, 1984 *Journal of the American Medical Association:*

"Although there is no known 'laugh center' in the brain, its neural mechanism has been the subject of much, albeit inconclusive, speculation. It is evident that its expression depends on neural paths arising in close association with the telencephalic and diencephalic centers concerned with respiration. Wilson considered the mechanism to be in the region of the mesial thalamus, hypothalamus, and subthalamus. Kelly and co-workers, in turn, postulated that the tegmentum near the periaqueductal gray contains the integrating mechanism for emotional expression. Thus supranuclear pathways, including those from the limbic system that Papez hypothesized to mediate emotional expressions such as laughter, probably come into synaptic relation in the reticular core of the brain stem. So while purely emotional responses such as laughter are mediated by subcortical structures, especially the hypothalamus, and are stereotyped, the cerebral cortex can modulate or suppress them."

I hope this clears things up.

· · ·

Update

In *The Straight Dope*, volume one, Cecil reported that "virtually all mammals . . . have umbilical cords and hence navels, the principal exceptions reportedly being our distinguished forebears Adam and Eve, for reasons that a moment's thought will make obvious." Further research has turned up the fact that two other species of mammal also do not have belly buttons. Platypuses and echidnas, both found in Australia and New Guinea, come into this world ensconced in eggs, and thus are navel-less.

• • •

QUIZ #7

37. What is four feet, six inches long?
 a. a whale's penis
 b. the world's largest cigar
 c. the Statue of Liberty's nose
 d. the longest beard ever grown by a woman

38. Back in the 60s, the secret agents of popular culture made a habit of picking peculiar names for their organizations. What do these well-known—and infinitely tortured—acronyms stand for? (I'll count the question if you get four out of five.)
 a. UNCLE
 b. SPECTRE
 c. THRUSH
 d. KAOS
 e. ICE

39. *Ontogeny recapitulates phylogeny.* This famous (well, relatively famous) sentence might best be described as:
 a. succinct but overstated
 b. recondite but accurate
 c. imposing but meaningless
 d. wrong

40. J. R. R. Tolkien, author of the *Lord of the Rings* trilogy, was a philologist who based many of the fictional languages in

his books on actual human tongues. The language of the elves, for instance, most closely echoes:
a. Welsh
b. Gaelic
c. Danish
d. Yiddish

41. The phrase "hocus-pocus" harks back to some medieval conjurer's parody of the act of:
a. transfiguration
b. transubstantiation
c. transmigration
d. transvestitism

42. If one day you were overcome by a shimmering vision in which it almost seemed that you were about to look at Cecil Adams face-to-face, you'd be experiencing the classic psychic phenomenon of:
a. déjà vu
b. jamais vu
c. presque vu
d. inebriation

Answers on pages 476–78.

Chapter 15

Folktales

This question is for my friend Irene. Were ship's captains ever allowed to marry people while cruising the deep blue? If not, can you tell me where this rumor emerged?—Magenta, Washington, D.C.

This being a free country, Magenta, ships' captains are allowed to marry anybody they want to. *Performing* marriages, however, is a different story. So far as I can tell, sea captains in the U.S. cannot now and have not ever been able to perform marriages at sea or anywhere else, unless they also happen to be recognized ministers or JPs or something. The same goes for sea captains in Britain and the Soviet Union. However—and this is the interesting part—this myth is so widely believed, not only among the general public but among sailors, that both the U.S. Navy and the British Mercantile Marine Office have taken the extraordinary step of *explicitly forbidding* captains to do freelance weddings. Let me quote from the Code of Federal Regulations, Title 32, Subtitle A, Chapter VI, Subchapter A, Part 700, Subpart G, Rule 716, also known as 32 CFR 700.716:

"The commanding officer shall not perform a marriage ceremony on board his ship or aircraft. He shall not permit a marriage ceremony to be performed on board when the ship or aircraft is outside the territory of the United States, except: (a) In accordance with local laws . . . and (b) In the presence of a diplomatic or consular official of the United States."

Similarly, the official logbook supplied to ships' captains by the British Mercantile Marine Office warns that shipboard mar-

riages performed by the captain are not legal. If the ship is registered in New York state, the captain can be fined or imprisoned.

So where did the idea arise? We can only guess. Sailors have it drummed into them that the captain (more properly known as the master) is the supreme authority on the ship, and one might easily jump to the conclusion that said authority extends to civil matters. In some jurisdictions, in fact, it does. The Soviet Union allows its masters to attest wills and draw up documents concerning births and deaths (although not to perform marriages). Furthermore, many merchant services, including those in Britain and the U.S., require masters to note marriages, births, deaths, collisions, etc., in the ship's log. The master thus becomes the *registrar* of any marriages. Finally, we know that in days of yore ships might be at sea or at least beyond the reach of civilization for two years or more. It thus seems reasonable to suppose that a master would be empowered to officiate at a marriage rather than have some local heathen do it. Nonetheless—and I've checked out seaman's guides going back to 1850—it does not appear that this has ever been the case. Another myth cruelly shattered. If anything further turns up, however, I'll let you know.

I have been puzzled for many years about clocks, specifically why all clocks shown in catalogs are set to 8:20. Some goof once told me they were set that way because that was the time John Kennedy was shot, a notion I dismissed in a hurry as being sev-

eral hours off. I guessed on my own that they set the hands that way to show the manufacturer's name, often imprinted below the 12:00 position, but it seems setting the clocks at 8:15 or 10:15 would do just as well.—James D., Evansville, Indiana

If you'd continue along the promising line of reasoning you've just described, James, it would have dawned on you sooner or later that 8:20 makes for a pleasingly symmetrical arrangement of the hands. So does 10:10, an arrangement that shows up almost as often. Relative to the vertical axis they both make a sort of equiangular tripod, if you follow me, that strikes most people as more attractive than, say, 9:15. The practice dates back at least to the 1920s, judging from the ads in (appropriately) *Time* magazine; the illustrations in a Sears Roebuck catalog from 15 years earlier show no such arrangement. You were right to reject the JFK story as bogus; it's simply a modern update on the old yarn that 8:20 (or, more commonly, 8:18) is the time Lincoln died. Actually Abe was shot a little after 10 P.M. and died at 7:30 A.M. In England they say 8:20's the time Guy Fawkes had planned to blow up the House of Parliament. Gullibility obviously knows no country.

During a recent chat about freezing the body after death—cryogenics, I believe it's called—somebody said Walt Disney's body was frozen until they develop a cure for lung cancer. Disney supposedly is still technically alive, though terminally ill. I said freezing somebody alive is probably illegal, and if they waited for Uncle Walt to actually die, it would take too long to get him from hospital bed to Kelvinator—if you're dead more than five seconds they can't bring you back, right? Finally, how can cryogenics work at all?—Ted L., Los Angeles

Your skepticism gladdens my heart, Ted; obviously my years of patient effort are starting to pay off. First things first: (1) Walt Disney, as near as can be determined, was cremated on December 17, 1966, two days after his death. Admirable work in this regard was done by William Poundstone, author of a groundbreaking volume called *Big Secrets*. Poundstone heard not only that Walt was on ice, but that the body was stashed below the Pirates of the Caribbean exhibition at Disneyland. Disney was known to have been preoccupied with death, his funeral services were held in secret, and the cause of his demise was never formally announced. Poundstone, however, was able to get a copy

of the death certificate, which says Walt died of cancer of the left lung and was cremated at Forest Lawn cemetery. The certificate was signed by an embalmer named Dean Fluss, a real guy who really worked at Forest Lawn. Forest Lawn would not disclose the location of the remains, but after a search Poundstone found the grave site in the cemetery's Court of Freedom section. There is nothing remarkable about it. Conclusion: Walt was fried, not frozen.

(2) To date, as many as 40 people have had their bods frozen after death in hopes that new technology would someday be able to restore them to health. The first was James Bedford, a 73-year-old psychologist from Glendale, California, who got the Big Chill in 1967—not long after Disney's demise, interestingly. Many of the 40 were thawed after their estates ran out of money; allegedly only 11 are still in "cryonic suspension," as it's called. The chances that they will ever be revived successfully are slim. Currently there is no known way to freeze an entire body and revive it. The problem is twofold: when the body is frozen, ice crystals form in the cells and destroy them; and when it's thawed, whatever cells are left die for lack of oxygen and nutrients.

Still, science has made mighty strides in this field of late, and eventually—well, who knows? For the last ten years or so animal husbandry experts have been freezing cow embryos for later implantation. In 1983 Australian doctors froze a human embryo, then thawed it and implanted it in a woman's womb, resulting

in an otherwise normal pregnancy; the procedure has since become fairly common. There's also a brisk business today in frozen body parts for use in transplants. An antifreeze like dimethyl sulfoxide (DMSO) is used to prevent ice crystals from forming. Right now body-part freezing is mostly confined to durable items like bones and arteries, but some predict they'll be transplanting frozen hearts in 10 years.

Given the relatively primitive state of the art, is it worth spending $80,000 to get yourself frozen? I doubt it, but cryonics advocates disagree. "We're preserving information, the genetic code carried in the DNA and the memories and personality imprinted in the weave of macromolecules in the brain," says Arthur Quaife, president of Trans Time, a cryonics outfit based in Oakland, California. He admits reviving people isn't going to be easy. "It's going to require more sophisticated techniques than simply warming people up. There's going to have to be a significant amount of reconstruction." Fine by me. I always hated the idea of heat 'n' serve.

What is this story I hear about manufacturers putting blood plasma into hair shampoo? Supposedly this is the source of the protein in all those shampoos and conditioners that promise to put protein back in your hair. Is this true? Is our hair so dead that we must pump new blood into it?—Kat, Dallas

This is one of the great modern folktales, pumpkin, and believe me, what you've heard so far is strictly the PG version. One of the more baroque elaborations has it that the protein comes from blood drained from starving Haitians. Another claims it comes from—get ready for this—aborted babies. The latter story may derive from the fact that face creams offered by European clinics occasionally include cells from sheep placentas and the like. Horrified spokesbeings for several American cosmetic companies, however, assure me that no U.S. manufacturer would dream of using such a thing.

This is not to say the origin of hair shampoo protein isn't a bit on the grisly side. Much of it comes from what are euphemistically described as "food industry by-products," i.e., boiled animal leftovers. In Revlon's Flex Balsam & Protein Body Building Conditioner and Body Building Shampoo, for example, we find such ingredients as "hydrolyzed animal protein" and "keratin amino acids." The former is derived from the hooves of moo-

cows (mostly) whose other components wound up on some-body's dinner table. Keratin, on the other hand, is derived from animal hair. Sounds pretty gross, but animal by-products are used in a great many household products, so try to steel your-self.

Did the French queen, Marie Antoinette, ever actually utter the phrase, "Let them eat cake"? I have a friend who claims that Crazy Marie actually said something in French that, in phonetic spelling, merely sounded like "Let them eat cake." Is the line in a class with Humphrey Bogart's "Play it again, Sam"—i.e., bo-gus?—Willie H., Chicago

I have a dream that someday one of these alleged facts of history is actually going to pan out. Alas, that day has yet to arrive. While Marie Antoinette was certainly enough of a bub-blehead to have said the phrase in question, there is no evidence that she actually did so, and in any case she did not originate it. The peasants-have-no-bread story was in common currency at least since the 1760s as an illustration of the decadence of the aristocracy. The political philosopher Jean-Jacques Rous-seau mentions it in his *Confessions* in connection with an inci-dent that occurred in 1740. (He stole wine while working as a tutor in Lyons and then had problems trying to scrounge up something to eat along with it.) He concludes thusly: "Finally I remembered the way out suggested by a great princess when told that the peasants had no bread: 'Well, let them eat cake.' " Now, J.-J. may have been embroidering this yarn with a line he had really heard many years later. But even so, at the time he was writing—early 1766—Marie Antoinette was only 10 years old and still four years away from her marriage to the future Louis XVI. Writer Alphonse Karr in 1843 claimed that the line originated with a certain Duchess of Tuscany in 1760 or earlier, and that it was attributed to Marie Antoinette in 1789 by radical agitators who were trying to turn the populace against her.

As for your friend's suggestion, I suppose it's possible that one day, while under the influence of powerful hallucinogens, Marie said *Le theme est quete* ("The theme is quest"), and was over-heard by an English-speaking tourist—thus giving rise, as your friend suggests, to the "Let them eat cake" legend. But frankly I doubt it.

Thank you, Cecil, for so nobly coming to the defense of the much-maligned Marie Antoinette, just as you did a few years ago with the equally vilified Catherine the Great. And now, as Paul Harvey would say, here's the rest of the story . . .

At the time that whoever-she-was uttered the infamous quotation "Let them eat cake," the word "cake" did not refer to the familiar dessert item that modern-day French call le gateau. The operative term was brioche, a flour-and-water paste that was "caked" onto the interiors of the ovens and baking pans of the professional boulangers of the era. (The modern equivalent is the oil-and-flour mixture applied to non-Teflon cake pans.) At the end of the day, the baker would scrape the leavings from his pans and ovens and set them outside the door for the benefit of beggars and scavengers. Thus the lady in question was simply giving practical, if somewhat flippant, advice to her poor subjects: If one cannot afford the bourgeois bread, he can avail himself of the poor man's "cake."

However, by the time Marie Antoinette ascended the throne, brioche had acquired its current meaning—a fancy pastry item which, like le gateau, was priced far beyond the means of any but the wealthiest classes. The anti-Marie propagandists were well aware that their compatriots, most of whom were uneducated in either history or semantics, would swallow the story whole, so to speak, and not get the joke. Bon appetit!—N.D.G., Chicago

That's very interesting, N., but wrong. Brioche is a sort of crusty bun, typically containing milk, flour, eggs, sugar, butter and whatnot. It's considered a delicacy, and as far as I can determine (which is pretty far), has been since the Middle Ages. According to one cooking historian, brioche originally contained brie cheese, whence the name. Nicolas Bonnefons, writing in *Delices de la campagne* in 1679, gives a recipe for brioche that calls for butter and soft cheese, plus a glaze containing beaten eggs and (if desired) honey. Sounds pretty tasty, and in any case certainly not something bakers would line pots with.

I'm a big fan of the old Pacific Electric, the sprawling electric railroad known as the "Big Red Cars" that once covered much of southern California. Strangely, when I mention the old PE, many times someone within earshot says something to the effect of, "You know, back when they built the freeways, GM and the oil companies got together and forced them to tear up

the tracks." Cecil, is there any truth to this rumor? If not, why do so many natives believe it?—Tom R., Los Angeles

If you think trashing the L.A. trolleys was the extent of GM's alleged crimes, Tom, you ain't heard nothin' yet. In 1974 one Bradford Snell, a staff attorney for the U.S. Senate antitrust subcommittee, advanced the startling proposition that GM had (1) sabotaged energy-efficient electric transit systems in 45 cities around the country, including L.A., in order to sell more fuel-guzzling buses and autos; (2) forced the railroads to replace nonpolluting electric locomotives with GM-built diesels by threatening to withhold lucrative auto shipments; and, most astonishing of all, (3) treasonously built armaments for the Nazis during World War II through Opel, its German subsidiary. Not surprisingly, Snell's charges were widely publicized.

Snell lavished particular attention on the case of the Pacific Electric. Though it's difficult to believe today, Los Angeles once boasted the largest system of "interurbans" (heavy-duty intercity trolleys) in the U.S., carrying some 80 million passengers a year in the late 1930s. According to Snell, all this went out the window starting in 1939, when GM got together with Standard Oil of California (now Chevron), Firestone, and other auto-related firms to set up a holding company that bought up trolley lines, dismantled them, and replaced them with buses. "The noisy, foul-smelling buses turned earlier patrons of the high-speed rail system away from public transit and, in effect, sold millions of private automobiles," Snell said. "Largely as a result, Los Angeles today is an ecological wasteland."

In a stinging counterattack, GM argued that Snell's accusations were off the wall from start to finish. The company said it relinquished day-to-day control of Opel in 1939 following the German invasion of Poland, and severed all relations with the firm when Germany declared war on the U.S. in 1941. It denied trying to strong-arm the railroads, pointing out that an earlier government investigation into the matter had produced nothing. Finally, it said its investments in various transit holding companies were small, that it exercised no managerial control, that many of the PE lines the California holding company bought had already been converted to buses, and that in any case the conversion to buses was part of a nationwide trend that was well under way before GM had made any transit investments at all.

Now, you may or may not believe GM's professions of inno-

cence concerning the holding company. But most authorities agree that trolleys bit the dust in L.A. and elsewhere not because of a conspiracy but because they were slow and inconvenient compared to autos, and in the long run just couldn't compete. Los Angeles is typical in this respect. It has neither the high population density nor the concentrated downtown necessary to support rail transit. The PE, which was owned by the Southern Pacific railroad, made a profit in only 8 of the 42 years it was in business under its own name. The problem was exacerbated by the fact that many PE lines in L.A. proper operated on city streets, and as more cars crowded those streets, service got progressively slower. (The average speed on the run to Santa Monica was only 13 MPH.) Buses were looked on as the transit industry's salvation because they were cheaper to operate and maintain than trolleys, with no tracks or wires. In fact, the PE had begun to convert to buses in 1917, and had changed over 35 percent of its system by 1939. A state commission in the late 30s urged that busification continue, and by the early 1950s most of the tracks were gone. The last line gave up the ghost in 1961. It's too bad— some think the PE could have been the nucleus of a decent, if heavily subsidized, modern rail system—but blaming GM is like blaming the inventor of gunpowder for war.

For years I've heard cops and emergency room nurses say things really get crazy out there when the moon is full. Is there anything to this? I mean, I've never bought into astrology, because it seems like the stars are too far away to have any effect on us. But the moon is another story—look at the tides. What do you say, Cecil?—Listener, WJR radio, Detroit

You're not the first person to wonder about this. There have been lots of studies over the years, some of which have purported to show that there really is such a thing as a "lunar effect." For example, one study claimed that an unusual number of traffic accidents occurred during the evenings right around the full and new moons (Templer, Veleber, and Brooner, 1982). But later researchers showed that during the time period studied, a disproportionate number of full and new moons fell on weekends, when traffic accidents are *always* higher.

That's pretty much been the story with all lunar-effect claims— when you look at them closely, they fall apart. Another study of homicides in Dade County, Florida (Lieber and Sherin, 1972)

claimed to have found there was an upsurge in killings in the 24 hours before and after the full moon. Other researchers, however, found that the Dade County researchers had used dubious statistical methods. When the figures were reevaluated using proper methods, the alleged pattern disappeared.

But many people remain convinced that the moon must do *something*. After all, they say, the earth's surface is 80 percent water and we all know about the tides; the human body is 80 percent water, so why shouldn't there be a human tidal effect? But this reasoning doesn't take the the question of scale into account. The tides are only noticeable in the oceans, where the vast distances act as a multiplier. Even so, tidal variation in most coastal areas seldom exceeds 10 feet. In smaller bodies of water, such as lakes and presumably the human body, tides are negligible.

Besides, when it comes to exerting any influence on humankind, the moon has a lot of competition. Researchers have calculated that a mother holding her baby exerts 12 million times the tide-raising force on the child that the moon does, simply by virtue of being closer.

Another thing to remember is that the tides don't occur just once or twice a month; they occur once or twice a *day*. What happens at full and new moon is that the earth, moon, and sun are lined up, resulting in higher tides than usual. (At full moon the earth is between the moon and the sun; at new moon the moon is between the sun and the earth.) So when we talk about the influence of the full moon, we're really talking about the additional influence of the sun. But small though the moon's pull on the earth is, the sun's is only half as much.

Just to make sure about all this, a pair of admittedly skeptical scientists (Rotton and Kelly, 1985) did what they called a "meta-analysis" of 37 studies of the moon's effect on things like psychiatric admissions, suicides, crime, etc. They found that the moon accounted for no more than 3/100 of 1 percent of the monthly variation.

A new twist was recently given to lunar-effect theorizing by the discovery that positive and negative ions in the atmosphere have an effect on behavior (negative ions usually favorable, positives the opposite). It turns out that positive ions are more abundant when the moon is full. However, the effect is slight

compared to major sources of positive ions like air conditioning and air pollution.

So how do we explain all those cops and emergency room nurses who believe in the lunar effect? Easy. Nobody notices when there's a full moon and nothing happens—you only notice when something *does* happen. In other words, heads I win, tails don't count. Case closed.

Three desperate B-school students and I need to know: are there really alligators living in the sewers of New York? If so, why? If not, how did this vicious rumor get started?—Baby Needs New Shoes, Chicago

New York is home to a great many reptiles, babe, but nowadays most of them hang out on 42nd Street. At one time, however, things were different. On February 10, 1935, the *New York Times* carried an astonishing report that several teenagers had dragged a live eight-foot alligator out of a sewer in Harlem the previous evening. The kids supposedly found the gator while shoveling the remains of a recent snowfall into a manhole—a project that strikes me as suspiciously civic-minded, given the reputation of Big Apple youth, but never mind. The boys first

saw the alligator thrashing in the sewer 10 feet below street level, and decided to drag it up with a clothesline. Once on dry land, however, the frightened animal began snapping about with its mighty jaws. The teenagers promptly beat it to death with shovels, foreshadowing the fate of countless unwilling visitors to Harlem in the years to come.

It's questionable whether the alligator could actually be said to have "lived" in the Enwye sewers. The locals at the time speculated that the animal had fallen from a boat passing through the nearby Harlem River and had swum 150 yards up a storm conduit.

But at least one expert claims (or claimed, at least) that alligators really did thrive in the pipes during the 1930s. According to *The World Beneath the City* (1959), a book by Robert Daley about New York's underground utilities, a former sewer superintendent named Teddy May said he had seen alligators with his own eyes during an inspection tour around 1935. May had heard repeated reports of subterranean gators from sewer workers, and was startled to find that his men weren't kidding. The animals averaged about two feet in length, and apparently hung out in some of the smaller branch pipes where the water flowed relatively slowly.

Though nobody knew for sure how the alligators got there, the most plausible theory was that they had been dumped into the sewers by parents who had originally bought them for their children and later grew tired of them. (Giving your kid a genuine baby Florida alligator apparently was quite the rage for a while.) But the pitiless May was no animal lover either, and he ordered the gators exterminated. Sewer workers used poison and a few zealots even tried rifles and pistols. In a few months they were all gone.

Alligators in the sewers have since become part of the lore of New York, and references to them turn up all over the place, including Thomas Pynchon's novel *V.* The more rococo versions of the legend claim that the animals are blind and white—blind because it's too dark to see, and white because they don't get any sunlight. The whole business is recounted in more detail in Jan Brunvand's *The Vanishing Hitchhiker: American Urban Legends and Their Meaning.*

I was in the fourth grade when the first Kennedy half-dollars came out. My friend Dominic Riccutti (who supposedly knew

everything about everything) told me those little markings on Kennedy's neck were there because some Communist agents had broken into the mint and engraved the hammer and sickle on the original mold and it hadn't been caught in time before the new coins were struck. Well, that was over 20 years ago and I recently got a new Kennedy half-dollar at the 7-Eleven and the markings are still there! In all this time they've kept changing the dates but they've never cleaned up Kennedy's neck. Is this all part of some pinko plot to subvert America by secretly marking our coins?—Andy H., Arlington, Virginia

I think after 20 years, Andy, the hypothesis might have formed in my mind that maybe this Riccutti kid was putting me on. The alleged commie graffito is really the initials of the man who designed the front side of the coin—GR, for Gilroy Roberts, former chief engraver at the U.S. Mint. Gil's monogram looks like two stylized *G*'s set back-to-back, and under the influence of liquor or bad companions I suppose you could make it out to be a pair of hammers and sickles. The other side of the coin was designed by Frank Gasparro; his *FG* can be found just under the eagle's left thigh—not the place I'd choose to put *my* monogram (when was the last time you saw an eagle take a bath?), but I guess Frank wasn't one to make a fuss. You want a real scandal, check out the "3172" in the bushes on the $5 bill. If that isn't the handiwork of the Illuminati, my name ain't Cecil Adams.

The Saboteurs Return!

Cecil was recently shocked to learn that a tiny Star of David had been etched into the portrait on a U.S. stamp by a rogue government engraver. The star, which is too small to be seen with the naked eye, can be found in the beard of Hebrew educator Bernard Revel, who is pictured on the $1 stamp. Officials said the star is the work of engraver Kenneth Kipperman, who has since been arrested for threatening to blow up the site of the planned U.S. Holocaust Memorial Museum. What exactly the point of this little stunt was has not been disclosed.

Chapter 16

Consumer Reports

> *If you're going to have to eat someone from "The Flint-stones" TV show, it's gotta be Betty. Why, then, is Betty Rubble the only character missing from bottles of Flintstones chewable vitamins? They've got Dino, they've even got Fred's car, for Chrissake, but no Betty! Wilma? Ecch! I've had to resort to Pebbles and I feel a little guilty about it. I ask you, what in God's great name am I to do?—Randy S., Hawthorne, California*

I'm not sure what your problem is, Randy, but I strongly suspect is isn't a vitamin deficiency. As near as anybody at Miles Laboratories, the maker of Flintstones vitamins, can remember at this late date (the product was introduced in 1969), Betty was left out because she was a subsidiary character who could not readily be distinguished from Wilma when reduced to tablet size. Her husband, Barney, made the cut, however, as did adopted son Bamm Bamm, along with Fred, Wilma, their daughter Pebbles, pet dinosaur Dino, and yes, Fred's car.

. It's clear Betty is a tragic victim of second-woman syndrome, which also afflicted Trixie Norton in the old "Honeymooners" TV show. The main character in both cases is a loudmouthed male, and the plot revolves primarily around his dealings with his wife and/or his buddy. He just doesn't have much opportunity to interact with his buddy's wife (remember, this is a family show), so she doesn't get much airtime.

Still, you have to wonder what kind of warped moral values you'd need to bump Betty to make room for Fred's car. Miles Laboratories says it's gotten a few complaints, but evidently not enough to make them put this injustice right. Clearly a concerted

effort is called for. If you're not up for the torchlight rally or the hunger strike, the least you can do is write Miles at P.O. Box 40, Elkhart, Indiana 46515.

Enough with the cheesebrain questions about eggs and gerbils and slug salting already. I want the facts. Why do they call Q-tips Q-tips?—Peter S., Montreal, Canada

The official explanation, which is not altogether satisfying, is that the name stands for "quality tips." I get this from the folks at Chesebrough-Pond's, the manufacturer. It all started back in 1926. Until then the company's cotton swabs were called Baby Gays, mainly because you were supposed to poke them into the orifices of helpless infants. Apparently having an inkling that the name Baby Gays might strike certain persons as humorous in years to come—one recalls the sad fate of Fairy Soap, whose ads once said, "Do you have a little Fairy in your home?"—the company decided to segue seamlessly into a new era by changing the name to Q-tips Baby Gays, and eventually just to Q-tips. Another reason for the change was the realization that the whole family could use cotton swabs, not just babies.

Cecil does not find this very convincing, however. My guess is that this "quality tip" business was invented after the fact to justify a name that was already being casually used by the boys out at the factory. If we examine a typical Q-tip in profile, we note that the cotton part is oval-shaped, with the stick poking out the bottom. Now what well-known letter of the alphabet

does this resemble? You got it. Admittedly this is only speculation, but hey, "quality" tips? Come *on*.

I recently came across a book by researcher Wilson Bryan Key in which he claims to find subliminal images of sex, death, and the occult stuck into photos in print advertisements. They range from screaming skulls airbrushed into ice cubes to an orgy depicted in a plate of fried clams. My major impression is that Key is a crackpot (he can find the letters S-E-X spelled out anywhere there are squiggly lines), but some of his findings seem a little too real to be coincidental. What's the truth, Cecil? Do advertisers really hide these images (while denying all, of course), or does Key just have an active imagination?—Jay S., Chicago

I won't claim no eager beaver account executive ever slipped a subliminal message into an ad, Jayzie, but Wilson Bryan Key is the kind of guy who could find something suggestive in a dial tone. Revealing testimony on this score comes to us from the *Skeptical Inquirer*, one of the nation's leading antifruitcake journals. Psychologist Tom Creed reports attending a college lecture in 1986 in which Key decribed in detail the subliminal images he'd found in a picture of a martini. In the middle there was a man with an erect penis, in the upper left a woman scolding the man for drinking, and in the lower right another man, who Key somehow determined was the woman's henpecked husband.

Creed thoughtfully includes the suspect photo with his article, and by jiminy it looks like there *is* a man with an erect penis in the middle. (All I see in the upper left is something that looks vaguely like a face, and I can't make out the alleged husband at all.) Aha, you think. Maybe there's something to this after all.

Key went on to tell the students he first saw this photo on the cover of the paperback version of one of his own books with the headline, "Are You Being Sexually Aroused by This Picture?" At first he assumed the publisher had taken the photo from an ad. Naturally he was consumed with guilt, since the publisher was using (perhaps inadvertently) the same sleazy techniques to seduce people into buying the book that Key himself was condemning in others. So he called up to protest. The folks at the publishing house informed him they hadn't taken the photo from an advertisement, they'd merely had a photographer set a martini on a table and take a picture of it, without bothering to stick in any subliminal stuff. The apparent image of the man with the

erect penis was just happenstance, the equivalent of seeing a face in the clouds.

At this point a rational person might have said to himself, boy, I been on this job too long. Not Key. He immediately concluded that *his own publisher* was part of the subliminal seduction conspiracy. "I guess it's my word against theirs," he told the students cheerfully.

Also in the martini photograph, Key claimed, there was an image of a man's face that could be discerned only with an "anamorphoscope," a mirrored cylinder that works sort of like a fun-house mirror. Through some miracle of photography, the face had been superimposed on top of the image of the man with the erect penis. Why go to all the trouble of putting in something that no reader could recognize without special instruments? Because, Key says, your subconscious brain doesn't *need* special instruments. And how is a man's face (or, for that matter, a scolding woman or a henpecked husband) supposed to seduce you into buying something? I don't know, and as far as I can tell neither does Key, but his view seems to be that if it's in there, it's in there for a reason.

This is a guy who also claims that every Ritz cracker has the word "sex" embedded on it 12 times on each side; that on April 21, 1986, *Time* magazine published a picture of Moammar Gadhafi with the word "kill" embedded on the face; and that once at a Howard Johnson's he felt compelled to order fried clams, even though he hates fried clams, because (he later discovered) the place mat had a picture of fried clams containing subliminal images of an orgy including oral sex and bestiality with a donkey. This guy doesn't have sex embedded in his pictures, he's got sex embedded in the brain.

In Defense of Wilson Bryan Key

In your recent column on Wilson Bryan Key and Subliminal Seduction, *you stated that Key "doesn't have sex embedded in his pictures, he's got sex embedded in the brain." Before dismissing Key as a crackpot, take a look at the attached article from* Consumer Behavior: Concepts and Strategies *(1978) by Berkman and Gilsen:*

"[In] *Subliminal Seduction* . . . Key . . . offered numerous

examples of sexual symbols, four-letter words, and pornographic pictures buried in the otherwise bland content of various ads. He concluded that such 'hidden persuaders' were carefully contrived by major advertisers and their agencies to seduce consumers at a subliminal level.

"But to people who have worked in ad agencies, there would seem to be a simpler explanation. Much photography for advertising art is sent to professional retouching studios, where artists set to work correcting photographic imperfections and adding visual effects not captured by the camera. Ice cubes in ads, for example, are completely the work of retouching artists, since real ice cubes would melt under the hot lights of the photographer's studio. Retouchers, like most artistic people in commercial fields, want to add something of their own creativity to their work. Some even find it humorous to introduce carefully designed sexual elements to an ad that must be puritanically straitlaced for the mass market. . . . Concealed symbols and words in ads . . . are most likely the work of individual creativity, boredom or mischievousness rather than the cunning and insidious strategy of marketing decision makers that Professor Key suggests."— *Jerome J., Chicago*

You have defamed a very astute and responsible person in your attack on Wilson Bryan Key. It appears from your column that you relied completely on second-hand data from a notoriously unreliable source—a psychologist. Of course a pyschologist is going to try to smear Key. Psychs are among those who try to figure out the unconscious motivations of alcoholics and smokers so that ad agencies can sell them harmful products. They did most of the research from which subliminal ad techniques were developed.

I enclose an ad from the July 1987 Life *containing a pretty good example of a subliminal "embed." Once you've seen the man with the erection on the Camel cigarette pack he will be clear to you ever after.—Faxon B., Los Angeles*

Let me deal with you first, Jerome. Cecil's aim was to discredit the notion that there is some organized conspiracy to seduce the public through subliminal techniques. He is perfectly willing to concede that practical jokers have occasionally snuck dirty words and the like into print. One notorious example appeared in a 1980 Montgomery Ward catalog entitled "999 Price

Cuts." On page 122 one could find—and many shocked home-makers *did* find—the F-word etched faintly into the background of a shot of a bedspread. (All Ward's catalogs at the time were identified by letter; perhaps coincidentally, this was the X cata-log.) The incident caused quite a stir around Ward's. It was traced to an employee of a retouching studio used by Ward's who evidently got mad one day when a piece of artwork was sent back for what he considered to be trivial changes. His editorial emendation, which was done with bleach on the negative, was his way of expressing his feelings on the matter. He and the re-touching studio parted company soon thereafter.

As for the alleged Camel embed . . . well, judge for yourself. People have been claiming to see mysterious figures in the illus-tration of the camel virtually since the day the brand was intro-duced nationally in 1913. (The drawing is based on a photo of Ol' Joe, a camel in the Barnum & Bailey Circus.) The man with the erection is sometimes identified as a woman, and there's sup-posedly a lion lurking near the camel's hindquarters. An R. J. Reynolds spokesman claims it's all just coincidence. Unfortu-nately, we can't ask the original artist—his name has been lost, the company says, and he's probably long dead anyway. Rey-nolds has never bothered to modify the drawing because it only gets about 10 letters on the subject a year. Or so they tell me. Believe what you like.

While We're on the Subject . . .

In your recent column on "subliminal sex," Jerome J. states: "Ice cubes in ads, for example, are completely the work of re-touching artists, since real ice cubes would melt under the hot lights of the photographer's studio." Let's not give more credit to the retouchers than they deserve. As someone who has built many "ice cubes," I would like to share my recipe: take one acrylic cube, round of all sharp edges, carve all flat sides with random hollows and bulges, polish on wheel with emery and jeweler's rouge. The Set Shop, a photo supply house where I worked, sold these faux "ice cubes" for $20 apiece or $7 per day rental, no retouching necessary.

The reason for not using real ice is not so much the melting factor, but that real ice is seldom crystal clear. A well-polished

acrylic cube is flawless. I hear, by the way, that most ice cubes come from the Japanese now. They are the Zen masters of fake foods.—Michael B., Hoboken, New Jersey

I often receive sweepstakes notices offering spectacular prizes like trips around the world, Rolls-Royces, houses, and the like. But I notice the contest rules usually allow grand-prize winners to take either the prize or a cash equivalent, which often appears to be worth more than the prize. I always wonder why anyone would take the prize over the money if they had a choice. Does anyone? And why?—Kent R., Van Nuys, California

There are probably some contest winners who take the prize instead of the money, but not many, and that's just the way the sponsors like it. They'd much rather write out a check than go to all the hassle of actually delivering on some of their gaudier offerings, and fortunately most people would rather take the dough than try to fit a pink Cadillac (or whatever) into their life styles. Publishers Clearing House, for instance, says that every single winner of the $250,000 custom-built homes it used to offer opted for the money instead. So why offer noncash prizes at all? Because offering only cash would be boring—you want to give people something tangible they can fantasize about. This isn't to say the whole thing is a fraud; contest sponsors are fully prepared to deliver on their promises if they have to. They just hope they never do.

What does the "K" in K-Mart stand for?—Ron T., Atlanta

It's K mart, Ron, not K-Mart. You know what these details mean to me. The K stands for Kresge, as in Sebastian S. Kresge, founder of the S.S. Kresge dime store chain. Sebastian—a man so cheap he gave up golf because he couldn't stand to lose the balls—retired as president of the company in 1929, long before there was any such thing as a K mart. But his name continued to grace the firm's stores. Then, in 1959, one Harry B. Cunningham took over. Harry was a former newspaper reporter and, like many of that breed, a man of subtle (if unappreciated) genius. Sensing that the dime store concept was a bit dated and apparently having cornered the market on blue light bulbs, he decided the time had come for a bold new concept. K mart, with the Kresge name sensibly boiled down to the bare essentials, was it.

The first K mart opened in a Detroit suburb in 1962, and shortly thereafter they were sprouting like dandelions nationwide.

By 1977 more than 1,200 of Kresge's 1,600 outlets were K marts, so management proposed changing the company's name to K mart Corporation. This did not sit well with Kresge's son Stanley, who felt the younger generation was insufficiently appreciative of his father's legacy. But he went down to stunning electoral defeat at the annual meeting, 89 million shares to 11 million. People these days just have no respect.

Last night I inserted a new blade cartridge in my modern safety razor. This A.M. my true love used said instrument (unbeknownst to me) to remove unwanted hair from her lower extremities. Now, a half hour later, I am trying to figure out how to apply a tourniquet to my upper lip after using the same blade for my morning ablutions. My question is, how can delicate female down so completely ravage a blade that regularly stands up to my hard-bitten stubble?—Bill S., San Antonio

It's simple, compadre. While the little lady's leg hair tends to be finer than your face hair, she's got a whole lot more shaving acreage than you do, particularly if she decided to shave her underarms too. So she wears the blade out a lot faster. (Remember, it's not just hair that clogs up a razor, but dead skin cells as well.) If she's not wetting her legs sufficiently it'll make things even worse.

The blade companies wimpishly decline to speculate on what the female-to-male wear-per-shave ratio might be, saying individual variation makes averages meaningless (which certainly ought to come as news to people in the statistics business), but let's say it's 4:1. You put in a new blade and experience the silky smoothness of shave number 1. Your inamorata comes along and thoughtlessly scrapes her gams with the selfsame razor, using up the equivalent of shaves #2, #3, #4, and #5. The next morning you pick up the razor expecting shave #3 and instead what you get is the equivalent of shave #6. Being psychologically unprepared, you gouge divots out of your face, straining the bonds of affection and causing you to wonder whether this relationship is really worth it. The obvious solution is separate-but-equal shaving equipment. Sounds reactionary, but there are times when the liberal impulse has to give way to the instinct for survival.

Ever since I was a kid, I've been annoyed at the fact that hot dogs come 10 to a package while buns come in either 8- or 12-packs (usually 8 around here). My girlfriend says it's because kids often eat wieners without buns, and it's just thoughtful packaging by the meat packers. I think she's suffering from a sodium nitrite overdose, and that what we have here is a conspiracy between Oscar Mayer and Mrs. Karl to keep us endlessly buying either hot dogs or buns to use up the leftovers. What's the story?—Bjorn B., Madison, Wisconsin

Your mistake, Bjorn, is in assuming that business people always have some rational basis for their actions. On the contrary, my experience is that many corporate decisions are arrived at by a process not far removed from consulting sheep entrails. Things are further complicated in this instance by the fact that the principal players are suffering from a case of collective amnesia. Nobody at any of the major hot dog companies can offer a convincing rationale for why things are packaged the way they are. Nonetheless, by a system of anthropological inquiry not unlike Margaret Mead's researches among the Samoans, I have been able to construct the following hypothesis: you get 10 hot dogs and 8 buns per package because meat packers like things that come in pounds and bakers hate things that come in tens.

The meat-packing side of this is easiest to understand. Your standard-issue hot dog, a product that generations of consumers have found to be convenient, comes 10 to the pound. Jumbo hot

dogs come 8 to the pound, and occasionally you'll see some symptom of wretched excess that comes 4 to the pound. If you've got 10,000 pounds of hot dogs, therefore, you know you've got 10,000 packages. A few packers deviate from this rule and give you, say, 8 standard dogs per 12-ounce package, but they're in the minority.

The situation with bakers is a bit murkier. Here are some of the "explanations" you'll hear: (1) We do it that way because everybody else does. If we started doing 10 to the package we'd have to charge more, consumers wouldn't notice they were getting more, and we'd lose business. Fine, but why did the *first* guy start packing 8? (2) There is something inherent in baking tray or oven design that makes 10 impractical to produce. Not true. Continental Baking, maker of the Wonder brand and one of the largest companies in the industry, sells both 8-packs and 10-packs, depending on "consumer preferences and local market conditions." What this means is that if enough people want 10-packs and everybody else is selling them, Continental will too. St. Louis, for one, is said to be a big 10-pack town. (3) Ten-packs are a clumsy shape and tend to get broken up when they're tossed around on supermarket shelves. This is close to the truth, I think (see below), but obviously not that close, since Continental somehow manages to cope.

The true explanation, in my opinion, is that bakers just don't like 10s. They prefer dozens, or more generally, multiples of 3 and 4, notably 4, 6, 8, and 12. These quantities lend themselves to compact packaging—three rows of four, two rows of three, two slabs of two by two (e.g., hamburger buns), and so on. Ten lends itself only to one row of 10 or two rows of 5, which are seldom compact shapes. Therefore, the baking mind-set—and here's where we start getting into anthropology—is such that you instinctively regard 10 as an unwieldy number. When the pioneers of bun baking were trying to figure out how to package their product, they probably figured what the hey, 8 makes a squarish package, so that's what we'll go with, without even considering the unique circumstances that made 10 more appropriate. The situation has been allowed to continue because the Teeming Millions meekly submit to it. Oscar Mayer says that of the 50,000 or so consumer letters they get each year, only 10 or 15 complain about the hot dog/bun mismatch.

There are a few cynics, some of them employed in this office,

who do not buy the preceding analysis, and indeed regard it with something approaching scorn. I pray for these people every night. Some of us, I guess, are capable of daring leaps of imagination; the rest, sadly, just pick nits.

*I never drink and drive but I swear every Chevy Nova (pre-1985) and Olds Omega (same car—different label) I see is driving down the road sideways. Well, not quite sideways but at an acute angle. Was this the product of foresighted GM engineers trying to provide a more panoramic view for drivers and passengers alike, or merely a flashback from my chemical abuse days?
—H.B., Chicago*

I don't know where you young people learned to be so sarcastic—certainly not from *me*. For your information, the peculiarities of the Nova have nothing to do with either your mental state or GM's desire to simplify angle parking. Older Novas and Omegas, as well as Pontiac Venturas and Buick Apollos, are vulnerable to an embarrassing defect that involves misalignment of the rear axle. The axle, you see, is attached to the car by a couple of leaf springs, the things under the car that look like a horizontal parenthesis. (Cecil loves these homely metaphors.) In the center of each spring there's a locator pin that's supposed to fit into a hole in the axle assembly and keep it lined up properly. Unfortunately, the pins have an annoying tendency to shear off, whereupon the axle slips out of parallel and the car heads around in a circle. To overcome this, the driver has to keep the front wheels turned in the opposite direction, with the result that he heads down the road sidesaddle. This problem was most common in Novas from the mid-70s; supposedly some cars were already goofed up when they left the factory. GM, for its part, says, "We don't consider this a manufacturing problem." In other words, sucker, it's *your* problem. Happy motoring.

Today, again, I found myself out shopping without my checkbook. Only this time, I vaguely recalled once hearing that a person can write a check on any old piece of paper. Is or was this true, or is my memory failing? If true, what are the requirements as to what must be written, besides the amount and your signature—account number? Bank? Am I paying for blank checks I don't really need?—John G., Laurel, Maryland

Don't throw out those puppies yet, Jack. It's true you can write a "negotiable instrument," which is bank talk for a valid check, on just about anything. According to the Uniform Commercial Code, the body of law that governs these things, all you have to include are the name of the payee, the dollar amount, the name of your bank, your signature, the date, and some suitable words of conveyance, such as "pay to the order of." You don't need the account number or the bank ID number you find on preprinted checks.

The trick is that you have to find somebody willing to *accept* such a check. Merchants and the like are free to reject any sort of payment they don't cotton to, checks included. Needless to say, if you try to write a check on the back of an old grocery list, the average checkout clerk is going to tell you to take a hike. However, if the clerk does accept it, the bank will honor it.

Charlie Rice, a columnist for the old *This Week* Sunday newspaper supplement, once wrote about various goofy checks that had been successfully cashed over the years. Here are a few of the choicer examples:

- Eben Grumpy of Iowa was a little slow in paying John Sputter $30 he owed him. (The names are genuine, Rice claimed.) Sputter threatened to sue, so Grumpy painted a check on a door and dropped it on him from a third-story window next time Sputter came over. A court ruled the door was legal payment.
- Albert Haddock of England once paid his taxes by whitewashing a check for 26 pounds, 10 shillings on the side of a cow. The check was ruled legal.
- A participant in an arc-welding contest in Cleveland (Ohioans obviously know how to have a good time) won first prize for a steel check that he hand-lettered. The check was cashed by officials at a cooperative bank. "The canceling holes," Charlie says, "were applied by a bank guard with a submachine gun." Right.

Many nonstandard checks are publicity stunts, such as the 21-by-7-foot check cashed for a charity drive in Fort Worth. Most others are intended as nuisances. As a rule, I would venture to say, checks in the latter category get sent through the mail, for the obvious reason that they're a lot harder for the payee to reject. Just about any large company can tell you stories about

comedians who send in checks written on underwear, bricks, and other inconvenient media. One common stunt is to write your annual tax check to the IRS on a shirt (the shirt off your back, get it?). Swiftian satire it ain't, but I'm sure some find it amusing.

Could you tell me who gets the profit from the stamp machines located in stores—the store or the post office?—K.J., Chicago

The stores purchase the machines from private manufacturers; they purchase the stamps from the postal service at regular price, and they keep all the profits. It's perfectly legal. Once you buy a stamp from the postal service, you can do whatever you like with it—put it on a letter, use it to paper your bathroom walls, or sell it for a profit.

I am in the process of moving from Baltimore to Washington, and I've been sending out change-of-address cards to magazines. Three of these went to post office boxes in Boulder, Colorado, all at the same zip code. None of the magazines is published in Colorado. This can't be a coincidence, can it? —Robert L., Washington, D.C.

Nothing is a coincidence, Booboo, as my previous writings on this subject have already made clear. The arm of the international terror conspiracy you've unearthed here is the Neodata Services Group—and doesn't *that* have an ominous ring to it? But fear not. Actually, it's a company that processes subscriptions for 115 or so magazines ranging from *Playboy* to *House & Garden* out of an office at Boulder plus several satellite locations. The firm gets between 100,000 and one million pieces of mail per day from 44 million subscribers. It's handled by a total of 1,500 employees, including 600 in Limerick, Ireland. All of them, I am sure, are absolute sweethearts. (Hey, I subscribe to magazines too, you know.)

Neodata mails out 202 million pieces a year (subscription renewal notices and so forth) and spends $36 million on postage per year. The company guesses it generates about 1 or 2 percent of the annual volume of mail handled by the U.S. Postal Service. It prints up mailing labels for each issue of the periodicals its clients produce and ships them out to the publishers to be affixed to the actual magazines. It also handles two million complaint calls per year—listen, I can go on like this for hours. For its

services the company charges publishers about a dollar per subscriber per year.

The company was founded in 1949 to handle subscriptions for *Esquire* and eventually began taking on other clients. It was bought in 1963 by A. C. Nielsen, the television ratings company, which was in turn bought by Dun & Bradstreet (The tentacles of the Great Combine are *everywhere.*) Neodata's chief competitor (which actually is larger) is Communications Data Services of Des Moines, Iowa. CDS is owned by the Hearst Corporation and processes subs for Hearst mags like *Cosmopolitan* and *Good Housekeeping* as well as many independents. Needless to say, these companies keep *up-to-date computer files* on all you guys. Not to alarm you unnecessarily, but forewarned is forearmed.

On every commercial airliner, the little "card in the seat pocket in front of you" warns you not to use AM or FM receivers because they might interfere with navigation equipment. How so? I could understand not operating a transmitter, *since any aircraft has a large number of radio receivers, but why would a simple portable radio be a problem?—Curious in Chicago*

You probably have the idea that radio receivers are passive, vegetable-like devices incapable of making trouble for anybody, and at one time, I suppose, you would have been right. But technology has made great strides over the years. Today a receiver can wreak every bit as much environmental havoc as a transmitter—and not just in the form of boom boxes on the subway, either.

Most modern receivers use something called a "local oscillator," which is sort of an internal transmitter. The oscillator generates signal A, which is mixed with the somewhat raw (if entertaining) incoming signal B to produce nice, easy-to-work-with signal C. There's usually some sort of shielding around the oscillator, but it's not always real effective and sometimes errant signals leak out to make life difficult for other radio equipment nearby. If the other equipment happens to be an aircraft navigation device, somebody could wind up digging furrows with a $25 million plow. So do your bit for air safety and bring a tape player instead.

Interesting digression department: Radios aren't the only gizmos spewing electrical graffiti into the ozone—so do lots of other things, such as electric typewriters. Typewriter static isn't a

threat to airplanes, but it did get the Pentagon to thinking: jeez, what if the Russians figure out how to pick up that stuff and *translate* it? So the National Security Agency set up a program called TEMPEST to test "information processing systems" to see if they give off "compromising emanations," the better to spy-proof government offices. If you want to do the same for your office, Uncle Sam can send you its official list of TEMPEST-tested products. Who knows, it could be the status symbol of the 90s.

I read a lot of my "junk mail" with interest, so I'm not trying to end it all. But there are some junk mailers that annoy me enough to make me want to make them pay, and pay, and pay. What's the best way to do this? The easy way, of course, is to send back their reply envelope ("no postage necessary if mailed in the United States") with no signature, address, etc., which makes them pay the business reply postage. But I keep wishing there was a better way. What if I stuff all the junk material that came with the mailing into the reply envelope, so that it weighs more than will go for the standard 25-cent rate? What if I enclose a sheet of scrap iron, or paste the envelope cover onto a brick? Surely there must be a legal method to make some of these villains think twice before they buy just any mailing list.—Winfield S., Chicago

It is obvious, Winfield, that you are a person who is consumed with cunning and wickedness. In short, you are my kinda guy. Come on over sometime and I'll buy you a brew. Unfor-

tunately, your bricks-for-business scheme, admirable though it is in theory, won't work in practice. According to rule 917.243(b) in the *Domestic Mail Manual*, when a business reply card is "improperly used as a label"—e.g., when it's affixed to a brick—the item so labeled may be treated as "waste." That means the post office can heave it into the trash without further ado.

Once upon a time, they tell me, things were different. Years ago, it seems, postal regulations required that all business reply mail be delivered, whether the cards were affixed to bricks, 2×4s, or hand grenades. Furthermore, the recipient was required to pay full first-class postage (a good buck, in the case of a brick) plus 18 cents handling per piece. However, the direct-mail firms usually worked out a deal with the local postmaster whereby unwanted building materials and whatnot (believe it or not, Win, you're not the first person to think of this) somehow became "lost" (heh-heh), getting the mailing firm off the hook.

The current regulation has made it largely unnecessary to resort to this subterfuge (although something of the sort probably still occurs with gray-area items such as envelopes containing scrap iron). But most people don't realize the mailing firms won't get stuck with the tab, so a fair amount of oddball junk still finds its way into the nation's mailboxes. The postal service regards this as a major pain in the neck, and therefore I have been implored to convey to the Teeming Millions the following message: *Putting bricks in the mail could bring American civilization to its knees.* (That's the impression I came away with, anyway.) Also you might be charged with "abuse of the mails."

The postal service suggests the following course of action instead: write the offending mailer and respectfully request that the SOB take you off his mailing list. If that doesn't work, write to the Mail Preference Service of the Direct Marketing Association, 6 East 43rd St., New York NY 10017, and tell them you don't want to get any more unsolicited (i.e., junk) mail. Every three months the DMA makes up a computer tape that they send around to the major mailing-list companies with all the people who want their names deleted. The drawbacks here are that you can't be selective, you can't do anything about local small-time operators, and if you ever subscribe to another magazine in your life (or, for that matter, buy anything through the mail), your name goes back into circulation.

Incidentally, Win, of the 161,000 people who wrote to the

DMA last year, 116,000 wanted *more* junk mail. They were sent a booklet entitled "How To Get More Interesting Mail" (as God is my witness, I am not making this up), which tells you various key catalogs that you can send for to guarantee you'll be deluged with stuff. Just in case you have a change of heart.

I've enclosed the brochure of a company calling itself "Business Research, Inc.," which purports to offer easy money for stuffing envelopes for them—$1.40 per envelope. Supposedly you can "easily mail 300 a week by working one or two hours daily," all in the comfort of your home. Sounds unreal, doesn't it? What do you know about these places? Do they just pocket the $20 "registration fees" of gullible housewives and disappear from the planet? If so, why doesn't anyone do something about it?—Elisa G., Baltimore, Maryland

Goodness, Elisa, where is our faith in our fellow man? Your attitude is going to prevent you from cashing in on many golden opportunities—most of them involving swamp land in Florida. The fact is, envelope-stuffing offers, also known as "work-at-home" schemes, are almost always fraudulent. In 1979 the Council of Better Business Bureaus in Washington looked at 55 work-at-home ads and found every single one misleading.

You are never asked simply to stuff envelopes. Instead, you're told to place ads of your own getting other suckers to send you stuff. Then *those* suckers find *other* suckers, till eventually everybody in the world has ripped off everybody else. This kind of thing is also called a "pyramid" scam, since it depends for its success on an ever-widening pool of victims.

Just to show you how this works, and save you a couple bucks besides, Cecil mailed $20 to the aforementioned Business Research, which has its offices in Inglewood, California. (Right now, that is. Businesses of this type are prone to sudden changes of address.) What I got was some flyers plus some instructions telling me to place an ad in a weekly newspaper offering free details on "selling information by mail." The respondents would mail me a self-addressed stamped envelope, into which I was supposed to stuff the flyers. Then I was to send all the envelopes to Business Research, which supposedly would pay me $1.40 per envelope. Naturally, I would have to pay for the ads and hope that (1) I got enough response to cover my costs, and (2) Business Research actually paid me. Further complicating things would

be the fact that most (ahem) reputable papers won't run such ads.

Placing ads was a little more than I was prepared to do for the sake of participatory journalism, but I was intrigued by the flyer I was supposed to stuff. For $10 it offered "70 Money Making Reports," which I was free to reproduce and sell to people by mail order using classifieds ads. (You see how this racket perpetuates itself indefinitely.) I sent off some more bucks and got a grand total of six (6) sheets covered with tiny print on both sides. Each "report" consisted of a single paragraph proposing some stunt ranging from the simpleminded to the possibly illegal. Here's a typical one: "AMAZING PROSPERITY PLAN. Make extra money by running the following ad over your name: 'AMAZING PROSPERITY PLAN . . . Pays eight ways—up to 16. All profit. Rush $1.00 for your copy today.' Fill orders with a copy of this same plan." The whole thing is so ridiculous, after a while you just have to laugh.

The beauty of these schemes is that the amount each pigeon loses is small, so nobody's going to sue you. And there's a virtually limitless supply of pigeons. One work-at-home promoter snookered 25,000 people; another bagged 9,800. Since there are thousands of hustlers trying to pull the same con, the chances of actually getting prosecuted are slim. Instead the U.S. Postal Service and various state consumer protection agencies will usually try to get you to knock it off voluntarily. Then again, they may decide to make an example of you and nail you for mail fraud.

Getting back to Business Research, Cecil was interested to learn that the firm's operator, Mel Hayes, had signed a consent agreement in August following an investigation by postal authorities. I was interested to learn this mainly because I got my stuff from BR in October. Naturally, I notified the postal inspectors. I am always eager to help my fellow citizens be virtuous.

When we are fortunate enough to discover someone willing to visit our excruciatingly drab apartment, a topic which invariably comes up is the nature and origin of our vintage red lava lamp. Just what is a lava lamp and how does it work? Is it the result of some ghastly industrial accident, or did someone create it on purpose?—Jim G., Brian R., Tim R., Lindor H., Greenbelt, Maryland

As you know, boys, we at the Straight Dope strive at all times to be cool. However, nothing we have ever done even approaches the coolness of our latest feat, namely, *visiting the actual lava lamp factory*, the source—nay, the *font*—of all the world's lava lamps. (Actually, all the lava lamps sold in the Americas, but what's a couple continents among friends?) It's located in a funky old neighborhood in Chicago, has a front office staffed largely by little old ladies, and goes under the fittingly grandiloquent name of Lava-Simplex Internationale.

As Cecil's more venerable readers know, the lava lamp was one of the three indispensable components of the properly furnished 60s apartment, the other two being a black-light poster and a waterbed. The lamp consists of a glass jar (technically known as a "globe") filled with a colored liquid, at the bottom of which is a glob of the mystic lava lamp lava. When you turn the lamp on, the lava gradually extrudes into a long, obscene column that shimmies around suggestively and finally breaks into gigantic globules. The effect is bizarre, and as many veterans of the 60s can verify, is best appreciated under the influence of mind-altering drugs.

The lava lamp (properly known as the "Lava Lite") was invented in the early 60s by an Englishman named Craven Walker. History does not record what sort of twisted impulse inspired Mr. Walker, although when you've got parents who would give you a name like "Craven," we can probably guess. An entrepreneur named Adolph Wertheimer spotted the lava lamp, then called the Astrolight, at a Hamburg trade show in 1965, and immediately heard destiny calling. Together with partner Hy Spector, he bought the American manufacturing rights, set up a factory, and began cranking out Lava Lites by the boatload.

The timing could not have been better. The lava lamp immediately became one of the icons of the Age of Aquarius. Unlike many relics of that lost era, however, it never entirely disappeared. It reached something of a low point during the recession of the early 80s, but now things are on the upswing, apparently because the children of the baby boomers are rediscovering the things that made the 60s great. Indeed, you can now get a lava lamp whose base is painted trendy matte black, the better to fit in with your halogen lighting and Bang & Olufsen stereo. Some may feel this is at odds with the inspired tackiness that is at the heart of the lava lamp experience, but such is progress.

The principles of Lava Lite operation are simple. The lava is basically a specially compounded wax. When heated from below by a 40-watt bulb, it expands until it becomes less dense than the liquid above, causing it to rise. When it gets to the top of the globe, the wax cools and starts to sink again, and the cycle repeats. Convection currents in the water presumably add to the effect.

Sounds simple, but Lava Lite president Jack Mundy tells me that manufacturing the things is actually an exacting process. The wax and the water are composed of 11 secret ingredients mixed in giant (well, relatively large) vats. Dedicated technicians measure the specific gravity of the various components to the ten-thousandth. The specific gravities of each batch of wax and water must be individually matched or the wax will break up into tiny bubbles, crawl up the side of the globe, or just float about an inch above the bottom of the lamp.

The custom mix-and-match involved in each batch explains why you can't just go out and buy some replacement goo if the fluid in your lamp gets low or if the lava gets sick. But fear not—the Lava Lite folks will sell you a new globe for about $22 or so, depending on the size. (New lava lamps cost anywhere from $35 to $75.) If your lava lamp is so old that the right size globe isn't available anymore, they'll sell you a new lamp at a discount. Call (312) 342-5700 or write Lava-Simplex Internationale, 2321 N. Keystone, Chicago IL 60639.

• • •

QUIZ #8

43. Complete this sequence: square, circle, waves, cross, . . .
 a. star
 b. triangle
 c. pyramid
 d. dagger

44. If legend is to be believed, the English poet Samuel Taylor Coleridge probably had a special antipathy for the residents of what unfortunate town?

 a. Ozone Park
 b. Porlock
 c. Shrewsbury
 d. Nether Stowey

45. "Ring around the rosie/A pocket full of posies/Ashes, ashes/ All fall down!" Authorities believe this seemingly innocuous bit of doggerel actually commemorates what grim event?
 a. the Great Fire of London
 b. the Black Death
 c. the St. Bartholomew's Day Massacre
 d. nothing special

46. Three of the following alleged facts about baseball are false. Name the one that isn't.
 a. You cannot bat from both sides of the plate during a single time at bat.
 b. Home plate and the bases on a baseball diamond form a perfect square.
 c. You mark a K for a strikeout because the player has strucK out.
 d. Only catchers are permitted to wear mitts.

47. In the English version of Monopoly, what are the equivalents of Kentucky, Indiana, and Illinois avenues (the red color-group)?
 a. Pall Mall, Whitehall, and Northumber Land
 b. Regent, Oxford, and Bond streets
 c. Strand, Fleet Street, and Trafalgar Square
 d. the Angel Islington, Euston Road, and Pantonville Road

48. Three of the following American towns share an unusual feature. Name the one that doesn't.
 a. Yonkers, New York
 b. Norridge, Illinois
 c. Hamtramck, Michigan
 d. Beverly Hills, California

Answers on page 478–80.

Chain Letter

I am seriously thinking about getting one of my nipples pierced. Are there health risks involved? Also, should I go to a doctor and have it done or don't they do that sort of thing? Do guys think it's sexy, or am I just weird?—Lisa, Los Angeles

Whatever guys may think about it, Lisa, you are definitely weird—and increasingly, so is this job. When I started writing the Straight Dope 15 years ago, I used to get maybe two or three truly pathological questions a month. Now I'm getting double handfuls of them in every mail. Here's a sample of what the postman brought this morning:

If a person has a pacemaker implanted in his body, and that person dies, what becomes of the pacemaker? Is it removed? If so, is it inspected and repaired, then sold again? If so, is it sold at full price, or at a discount rate? Who gets the money, the hospital or the survivors of the deceased? And is the purchaser told that his pacemaker is used, and may have contributed to the death of its previous owner? (Sunland, California)

It is nearly autumn again here in Los Angeles, and this week I was once again assaulted with what is, for me, my primary autumn experience here in L.A. As I was cycling down Willoughby going east near Spaulding, I was enveloped by the pungent and erotic smell of semen. What causes this? In years past I have noted this smell at Third near Curson and also at Fernwood near Bronson. But by October it should be a very general experience throughout Los Angeles. Any ideas? (Los Angeles)

I am 29 years old, and have been hearing a lot about my "bi-

ological time clock." As I understand it, some kind of alarm will go off if I reach the age of 30 without having conceived. What I am worried about is the possibility of this alarm going off while I am in some public place. What if I'm at a restaurant or something? Will it go beep, braaaaap, or tingalingaling? Please answer quickly, as it may affect my birthday plans. (Alexandria, Virginia)

If I cross the street in the middle of the block, I cross at an angle to the right or left or else straight across. If anything, it's "I" walking. SO HOW COME THEY CALL IT "J" WALK-ING? (Los Angeles)

After a recent session of cunnilingus, I began to wonder what produces that one-of-a-kind vaginal taste. After talking it over with some friends, connoisseurs all, I found that there are three basic tastes: good, no taste, and really bad—the mustard-gas variety. Why this clear-cut division? (No address)

Did God put us here for a purpose? If so, what? My landlady tells me that our purpose is to pay the rent. My girlfriend agrees. She says there is no intrinsic meaning to life, but that we can create meaning for our lives by setting goals—such as paying the bills and doing the laundry—and striving to attain them. But that seems too shallow. So please, Cecil, why are we here? —(Chicago)

Needless to say, I am not going to answer any of these questions, because they are offensive to my sensitive nature, not to mention nuts. For you, though, Lisa, I am going to make an

exception. The medical authorities I have chatted with on the subject of nipple piercing advise me that, to put it bluntly, you are out of your mind. For one thing, the scar tissue that normally forms around a pierced hole might block the milk ducts, making it difficult or impossible for you to nurse. Second, if the hole became infected, as occasionally happens in ear piercing, the infection could travel up the milk ducts and affect the entire breast. In men, the milk-duct system is vestigial, so guys can get away with this kind of thing, should they be so inclined. For you, however, I'd recommend looking into something a little more wholesome in the way of bodily adornment. A buttock tattoo, maybe. I understand they're all the rage in Washington these days.

Reports from the Fringe, Part One

Abhorrent as it is to speak of such matters, I must corroborate your reader's recent observation about certain trees in Los Angeles that smell like semen in the fall. I have two of these funky-smelling (in the original sense of the word meaning "bitch dog in heat") trees in my backyard in Laurel Canyon. They are ugly, have grotesque hairy blossoms, and smell so bad that bees and flies both share the nectar. It is disconcerting for me, and I'm glad I'm not the only one to notice it.—R.H., Los Angeles
P.S.: I have no idea what they're called.

I can see it's going to be one of those weeks. Due to the press of business, I have not had a chance to go hunt down the sperm trees of Los Angeles myself. However, David Lofgren, a botanical information consultant at the Los Angeles State and County Arboretum, speculates that the plant in question is the carob tree, *Ceratonia siliqua*, source of the well-known chocolate substitute. The tree, which grows only in Mediterranean climates like L.A.'s, typically is around 30 feet tall and has bluish green leaves that are rounded on the end. At blossom time it has many little flowers, which may give the appearance of hairiness. In the fall and winter it produces sweet, juicy pods that conceivably could produce the smell of semen when they rot. However, if one of Cecil's devoted readers will be so kind as to send him a sample of the offending tree's leaves, blossoms, pods, or whatever, we will get to the bottom of this matter once and for all.

The Sperm Trees of Los Angeles: The Search Continues

I am writing in regard to the identity of the "semen tree" discussed recently in your column. May I suggest that what the writer was talking about was the female ginkgo tree? In the fall it drops many small apricot-colored fruits. When the fruit ripens, it smells more like vomit *than semen. Orientals (I lived in Japan for 10 years) consider the nut within this fruit (the ginkgo nut) to be a delicacy. In the early morning old people put Baggies over their hands, push the smelly fruit away from the nut, drop the nuts into a bag, and take them home. They are washed and dried (during which they lose their smell), cracked open, and the nut meat boiled or baked. Ginkgo nuts are great, but the fruit is still disgusting.—Elyse A., Evanston, Illinois*

Considering I ran the original letter as an example of a question so stupid that nobody could possibly be interested in it, the sperm trees of L.A. have generated an extraordinary response. In addition to vomit, I have heard about trees that smell like . . . well, like shit, to be blunt about it. Another tree supposedly smells like a certain well-known female orifice. I had no idea botany was such a fascinating field. A recent graduate of Vassar College in lovely Poughkeepsie, New York, reports that while on campus she too noticed certain trees that smell like vomit. However, another former Vassar inmate—believe me, I check this stuff out—says the indicated trees are definitely not ginkgoes. Knowing the party-hearty predilections of college women these days, I'm not sure the smell is entirely botanical in origin. Similarly, Cecil's longtime buddy and spiritual adviser Uncle Pat suggests that the smell of the L.A. tree may be the result of the city's notorious deve community having its way with the local plant life. I have taken this under advisement. Gratz Beehler of Washington, D.C.—a fine fellow despite his dubious moniker—says there is a tall (50 to 60 feet) and spindly (6 to 10 inches in diameter) plant in Florida known as the "punk tree," which has "very spikelike flowers" (hence the name, presumably). It blooms in March and October, smells "like rotten stuff" (if not necessarily semenlike), and is known to grow in L.A. Gratz promises to try to rustle up a sample so we can get a positive ID. Meanwhile, I am still waiting patiently for somebody to send me a specimen

of sperm-tree foliage. C'mon, kids—there's a Nobel Prize in this somewhere.

More Opinions

Regarding the "sperm trees" of Los Angeles, I've checked with several people, and they all agree. California privet (sorry, I don't know the scientific name) is your culprit. I've seen it in hedge and tree form. I've seen its hairy flowers bloom in spring and fall; however, it only smells for a few weeks in the spring. That's when swarms of bees are attracted to it.—C.H., Glendale, California

. . . carob trees. Said trees abound, for example, in the Los Feliz area north of Franklin near Edgemont. The trees smell like sperm, or Clorox on some days, and have nothing to do with appearing or acting like sperm.—Frank W., Thousand Oaks, California

. . . the carob tree. These trees emit this odor only in the fall when they show a hairlike pollen-tipped fuzz growing from the bark near the tips of narrow branches—Tom K., Los Angeles

. . . the carob tree. We had a small one growing in our schoolyard in Arizona. One of the reasons it may be hard to identify is that it does not always smell. It seems to have a cycle, but not a yearly one.—M.N., Long Beach, California

The mail at this point is running about 2-to-1 carob tree, so I guess we'll declare it the winner. Unfortunately, the one sample of sperm tree blossom we received had been dumped into an ordinary envelope (rather than, say, a baggie), giving it time to dry out and disintegrate before we could get it to an expert for analysis. Let's use our *heads* out there, gang.

Reports from the Fringe, Part Two

Regarding the enclosed: now you know!—Susan M., Billerica, Massachusetts

Susan has sent the following clipping:

PACEMAKERS FOR PETS

If your dog has a heart problem, you'll be glad to know that

more and more vets are implanting pacemakers in their canine patients. Pacemakers help dogs with blocked hearts and impaired cardiac function, which often causes fluid buildup in the lungs, coughing and wheezing.

Some of the pacemakers being used for dogs are recycled or outdated human models *[my emphasis] that originally cost as much as $4,000. These must be recalibrated for a dog's faster heart rate—generally 80 to 100 beats per minute, compared to the resting human pace of 70 beats per minute. A reconditioned unit—sterilized and rewired by the pacemaker manufacturer—costs between $400 and $700. The surgical procedure is not dangerous, complicated or very expensive, but I advise you to use a veterinary cardiologist recommended by your animal doctor.*

Taken from Dr. Michael W. Fox, scientific director of the Humane Society of the U.S., Understanding Your Pet.

We live in an amazing age. Cecil has also seen news reports of a pacemaker implanted in a cat at the New York State College of Veterinary Science, Cornell University. The pacemaker used in the $600 operation had been designed for humans but was donated by the manufacturer after its recommended shelf life had elapsed. However, the device's lithium battery is expected to last beyond the cat's lifetime.

Reports from the Fringe, Part Three

(Warning: It gets pretty strange from here on out)

Re: Your answer to the woman who was thinking about getting her nipples pierced.

Hey, don't rush to judgment without at least taking into account the historical perspective. Stephen Kern in his book Anatomy and Destiny: A Cultural History of the Human Body *(Bobbs-Merrill, 1975) says:*

"In the late 1890s the 'bosom ring' came into fashion briefly and sold in expensive Parisian jewelry shops. These anneaux de sein *were inserted through the nipple, and some women wore one on either side linked with a delicate chain" (p. 97).*

Kern cites as his source Eduard Fuchs, Illustrierte Sittengeschichte vom Mittelalter bis zur Gegenwart *(Munich: Erganzungsband, 1912), p. 68.—Monty J., Evanston, Illinois*

Listen, I don't doubt there are people who've *done* it. I just said it's *weird*.

Your objectivity seems to have been thrown off a bit by "Lisa." This is not an uncommon reaction to a first-time experience with nipple or genital piercing. The first pierced nipple I saw I thought the man was nuts! I now love the look and am an avid devotee of body piercing, but it is a very hidden subject in this society.

It sounds like the doctors you spoke with have no experience with the subject. You would get the correct answers from a store called the Gauntlet on Santa Monica Boulevard (right next to Herotica). They deal only in body-piercing jewelry. They also publish a magazine devoted to this subject.

No body piercing should ever be attempted by anyone who does not know what they are doing, including a doctor. There are many variables and it is an exact technology.

The "pluses" are enhanced sensitivity in the area and, for those of us who like the slightly barbaric look, heightened sexual response. The "minuses" are that more men are initially turned off than turned on, and in a woman a milk duct can be pierced requiring the removal of the rings and healing before repiercing. More than one woman has nursed a baby with nipple rings intact.

I feel the "minuses" are worth the heightened pleasure sexually. I love the look and feel of rings through nipples, and no, I am not a drugged-out biker. I'm 36, a mother, fairly monogamous, and don't even indulge in caffeine or nicotine. Sex and weightlifting are my two main vices, and I like my sex with different spice than you like yours with. That doesn't make me weird, just different.

Keep on, you're basically still doing great!—Debbie, Rosemead, California; similarly from Christie, Reseda, California

Reports from the Fringe, Part Four

Wouldn't want you to not answer one of those pathological questions just because you didn't have the answer, so I am enclosing a couple of articles from the Journal of Pharmaceutical Sciences. *They don't answer the question, but they do show that scientists are on the trail.—Dan P., Carrollton, Texas*

P.S.: Please note the last author listed for the 1970 article.

Sheesh. The two articles are "Odor Threshold and Gas-Chromatographic Assays of Vaginal Odors: Changes with Nitrofurazone Treatment" and "Vaginal Odors: GLC Assay Method for Evaluating Odor Changes." I will spare you a summary of the contents; suffice it to say they are perfectly sober treatments of the topic. The author Dan refers to is one I. M. Bush.

This is the last time I am ever going to run a collection of nutball questions in hopes of discouraging people. Obviously, the Teeming Millions have no shame. You think this column is bent, don't blame Cecil, blame *society*.

Chapter 18

The Bathroom

During the coverage of Super Bowl XXI, I read something about New York City officials being concerned that people watching the game on TV might all go to the bathroom during the commercials and flush the toilet at the same time, causing a catastrophic pressure drop. Was this for real? Did anything really happen?—Listener, Paul Brian show, WGN radio, Chicago

The thing you have to understand, friend, is that New York is a giant media circus, and everybody feels like they have to get into the act. The Friday afternoon before the Super Bowl, Harvey Schultz, commissioner of the New York City Department of Environmental Protection, issued a "bowl warning" (get it?) urging Super Bowl viewers, particularly those who planned to drink a lot of beer, to stagger (as it were) their trips to the bathroom so as not to put too much of a strain on the city's water system. A city spokesperson cheerfully concedes that the whole thing was done tongue in cheek, and that it was specifically timed so that it would make a cute weekend story for the media.

As it turns out, there was no noticeable "super flush effect" during or after the game. The city spokesperson speculates that this may have been due to one of two things: (1) New Yorkers actually cooperated with the government for the greater good of the city—admittedly an unlikely possibility; or (2) the game was such a laugher in the second half, and there were so many commercials, that the flush effect sort of, you should pardon the expression, dribbled away.

Media stunt or not, there really have been occasions when the super flush effect did occur. The most recent, according to the

city, came at the end of the much-touted last episode of "M*A*S*H," which aired in 1983. People were apparently glued to their seats during the entire two-and-a-half-hour show and then all headed off to the *pissoir* at once. The resultant pressure drop caused a pronounced surge in the two huge tunnels that bring water into New York each day from the Catskills. Similar surges have been observed during the Academy Awards, the first moon walk, and so on.

How much of a threat these surges pose is debatable; they only last for a few minutes. But what the hell, New Yorkers always seem to get a big kick out of contemplating impending disaster, and let's face it, living in Enwye, sometimes you need all the cheap laughs you can get.

What is it about smoking a cigarette that will sometimes send me to the bathroom for a number two?—C.B.M., Washington

During my foolish youth (i.e., last month—see question on Q-tips, page 323), this is the kind of question I would kiss off with some totally uncalled-for if nonetheless desperately funny remark. Now that I am mature, however, I know that behind many seemingly inane queries there lie deep scientific truths. It is even so in the present case. The reason smoking makes you feel like heading for the john is that your body has been specially programmed to respond to the products of the R. J. Reynolds company. No fooling. Your guts are crammed with "nicotinic receptors," which are part of the parasympathetic nervous system that controls your digestion, among other things. When

you use tobacco, these receptors are stimulated and your innards commence to churning. If you were pretty full already, you may well feel the need to visit the john.

Some people become dependent on this odd phenomenon. Cecil has heard of a case involving an old coot who used to spend every waking moment with a chaw of tobacco between cheek and gum. One time he had to go into the hospital for prostate surgery. While he was stretched out in the recovery room, a nurse noticed that his abdomen was swelling up. The attending physicians feared that they had pierced his intestine during the operation and infected him. But then another doctor strolled in and remarked, "Hey, that's the first time I've ever seen old Charlie without his wad." Remembering the nicotinic receptors, the physicians immediately guessed that old Charlie had become so accustomed to tobacco that his intestines wouldn't work without it. His abdomen was swelling because his bowels were filling up with air like a balloon, an event known as an ileus. They promptly sent out for a family-size can of Red Man and administered a double dose. (I presume they woke Charlie up first.) The swelling soon subsided. Another triumph for modern pharmaceutical technology, and a damn good reason to think twice about abandoning your bad habits.

This is entirely on the level. It is also the kind of question only you can answer. What did people use before toilet paper was invented?—Name withheld, Baltimore

You should thank your lucky stars you live in the twentieth century, bucko. Let me tell you about . . . corncobs. You may not believe this, but it was once common practice in rural America to leave a corncob hanging from a string in the outhouse for purposes of personal hygiene. The string, I gather, was to permit the cob to be reused. For those who were punctilious in these matters, or else blessed with an abundance of corncobs, a box of disposable cobs might be provided instead. In coastal regions, the cob might be replaced by a mussel shell.

For those who had access to it, paper from discarded books or newspapers was often preferred to either of the foregoing. The meteoric growth of the Sears Roebuck company, for instance, is thought to be partly attributable to the protean nature of its catalogs, which might serve a family of regular habits for an entire season. As with the cob, the catalog would be hung in the outhouse on a string and pages torn off as needed. It is said the use of coated stock, which was nonabsorbent, was a source of great consternation to farm families when Sears began printing color pictures in the catalog earlier in this century.

English lords, in attempting to teach their sons to be cultivated gentlemen, often advised purchasing an inexpensive volume of verse for use in the loo. The idea, of course, was that while you were sitting there in a contemplative state you would be able to

read a few stanzas, subsequent to which the paper could be put to other ends, so to speak. It has not escaped my notice that my magnum opus, *The Straight Dope: A Compendium of Human Knowledge*, is also well suited for this purpose. Indeed, in the next edition we are thinking about perforating the pages, for maximum convenience.

For more data on this fascinating topic, see *An Irreverent and Almost Complete Social History of the Bathroom* (1983), by Frank Muir.

Fun with Corncobs, Part Two

Re your column about substitutes for toilet paper: I do not know how much comment you want to spare on this topic, but if you would like to read one of the most hilarious discussions ever written on the best thing to cleanse oneself with, you should go straight to Rabelais. He has a whole chapter devoted to the subject, with a very surprising Number One choice.—Steve S., Los Angeles

You refer to chapter 13 of *Gargantua*, the cockeyed epic by François Rabelais (1483?–1553). Frank's reputation as a comic genius is proof that if you tell enough dirty jokes, write in French, and wait 400 years, posterity will proclaim you one of the leading lights of civilization. In the chapter in question, the giant Gargantua tells of his efforts to find the ultimate in sanitary comfort:

"Once I did wipe me with a gentlewoman's velvet mask, and found it to be good; for the softness of the silk was very voluptuous and pleasant to my fundament. Another time with one of their hoods, and in like manner that was comfortable; at another time with a lady's neckerchief, and after that some ear-pieces made of crimson satin; but there was such a number of golden spangles in them that they fetched away all the skin of my tail with a vengeance. This hurt I cured by wiping myself with a page's cap, garnished with a feather after the Swiss fashion. Afterwards, in dunging behind a bush, I found a March-cat, and with it daubed my breech, but her claws were so sharp that they grievously exulcerated my perineum. Of this I recovered the next morning thereafter, by wiping myself with my mother's gloves, of a most excellent perfume of Arabia. [He continues in

this vein for several pages.] But to conclude, I say and maintain that of all arse-wisps, bum-fodders, tail-napkins, bunghole-cleansers and wipe-breeches, there is none in this world comparable to the neck of a goose, that is well downed, if you hold her head betwixt your legs: and believe me therein upon mine honour; for you will thereby feel in your nockhole a most wonderful pleasure, both in regard of the softness of the said down, and of the temperate heat of the goose; which is easily communicated to the bumgut and the rest of the intestines, insofar as to come even to the regions of the heart and brains. And think not that the felicity of the heroes and demigods, in the Elysian fields, consisteth either in their Ambrosia or Nectar, but in this, that they wipe their tails with the necks of geese." And you guys think *I'm* a kink.

Fun with Corncobs, Part Three

Your recent response to the question, "Was there life before toilet paper?" was not quite the rest of the story. Perhaps you've gotten a little behind in your research, but there are at least a billion folks in South Asia and elsewhere who have never had their tushes in contact with Charmin, Cottonelle, or for that matter page 207 of the old Sears catalog.

I became aware of these cultural differences on an early morning trip to Santa Cruz airport north of Bombay, India, many years ago. In dawn's first faint glow, and half-asleep, I peered out the window of the airport bus to view a vast field covered with what appeared to be thousands of storks, or possibly giant egrets, apparently waking. A closer inspection, however, revealed not birds but thousands of white-clad citizens, clutching their dhotis and saris as they stooped to perform an act common to all humankind. They had, as far as I could see, no folded pieces of paper, no catalogs, no half-rolls of toilet paper, such as I prudently carried in my briefcase. Rather they carried with them small brass pitchers filled with water. These folks, I might add, were inhabitants of tiny, makeshift hovels clustered around Bombay's outskirts—squatters' settlements, so to speak.

Later in my trip I sought the services of an Indian physician for a persistent problem of an alimentary nature. After I described my symptoms, he wanted a sample for microscopic in-

spection. *Observing my furtive glance for a handy roll of tissue, he sternly lectured me on the unhygienic way we Westerners tend to these matters in contrast to the Asian way of using water and the left hand. Thank heavens, since I am somewhat ambidextrous, I remembered to use my right hand while fishing in my billfold for some rupees to pay him and in shaking hands while leaving.*

More could be added, particularly on the muscular coordination and dexterity required to perform in the middle of an open field without, for example, rocking back on your heels or worse. Practice, I gather, makes perfect. For further insight on this question, consult Paul Theroux's The Great Railway Bazaar. *—Philip T., Fairfax, Virginia*

Another example of the brutal indignities heaped upon us long-suffering left-handers. For now we bear it quietly—but we do not forget.

*Do you know the origin of the squeamish American attitude regarding, shall we say, "sanitary facilities"? I refer specifically to waste elimination, one of the most important of the human physiological functions. Yet it's swept under the rug, as it were, in a manner suggesting it doesn't even exist. Why is a toilet never called that? Rooms that contain no tub or shower are referred to as "bathrooms." Toilet paper is bath tissue. With no intention of making any alteration to her makeup, a lady visits the "powder room." Or maybe the "vanity." Apartments featuring 1¹/₂ baths have one room with a tub but the other has only a toilet. When the astronauts go into space, a vivid description is given of their living quarters and their every move—except one. Maybe it's like Hawkeye once said on "M*A*S*H," when asked if the officers had a latrine—oops, I mean bathroom: "No, we just hold it in till we explode."—Flushed With Curiosity, Chicago*

I'm glad you bring this up, F., because there have been startling etymological developments in this area which you Teeming Millions should know about. But first a few facts. Americans certainly aren't the first to use euphemisms to refer to the toilet. According to bathroom historian Frank Muir, the toilet and/or the outhouse have at one time or another been called the House of Honor (by the ancient Israelites), the House of the Morning (by the ancient Egyptians), the garderobe (literally, "cloakroom"), the necessarium, the necessary house, the rere-

dorter (literally, "the room at the back of the dormitory"), the privy (that is, the private place), the jakes, the john, the loo, the W.C. (for water closet), room 100 (in Europe), the lavatory, the closet of ease, and many other things. In addition to euphemisms, needless to say, there is also an abundance of vulgar expressions. Curiously, however, there is no "real" word for the place where one deposits one's bodily wastes. "Toilet," which is now thought of as the "official" term, is itself a euphemism— originally, toilet was the process of dressing, as in, "the lady has just completed her toilet." Before toilet assumed its present meaning in the early twentieth century, the accepted technical term for the john was the vaguely disgusting but still euphemistic "bog-house." We thus have a thing for which there are polite terms and impolite terms, but no simply *correct* term—a situation which may well be unique in the English language.

Now for the startling developments. You may be aware that certain persons of indifferent breeding refer to the john as the "crapper." You may also be aware that in 1969 British writer Wallace Reyburn published a book entitled *Flushed With Pride: The Story of Thomas Crapper*, which purported to tell the story of the inventor of the flush toilet. Reyburn followed this up in 1971 with another volume entitled "Bust-Up: The Uplifting Tale of Otto Titzling and the Development of the Bra." The latter effort was obviously a spoof, and it has been widely assumed that the story of Thomas Crapper was a joke as well.

In recent years, however, Ken Grabowski, ace researcher at the Field Museum of Natural History in Chicago, has gone to great lengths to prove that Crapper actually existed. Grabowski has made several trips to England and collected hundreds of documents, including baptismal and death records, photos, magazine write-ups about Crapper's plumbing company, advertisements, and so on. Having inspected the evidence, Cecil must say Grabowski makes a compelling case. Thomas Crapper (1836–1910), an English sanitary engineer, apparently founded a plumbing fixture company in London in 1861, and his products became well known throughout the British Isles. While Crapper did not actually invent the flush toilet, he did come up with certain improvements. Moreover, his equipment, with his name prominently displayed, was installed at military barracks where it may have been seen by U.S. troops stationed in England during World War I. Does this mean that Mr. Crapper's name is

the origin of the word "crap"? Not exactly. There was crap before there was Crapper (you should pardon the language), but big-C Crapper quite possibly gave rise to little-C crapper, meaning "toilet." That's the Straight Dope, friends. Accept no substitutes.

As an avid reader of your column, I thought I would write in hopes of obtaining an answer to a perplexing question posed to me at work today. My colleague, Dorothy, said she had to go to the "john," then paused a moment to ask, "Why do they call it a 'john'?" Well?—Michele M., Chicago

This is one of those questions for which there isn't a good answer, Michele, but let's face it, many is the time Cecil has had to cobble together an answer for which there wasn't a good question. "John," along with an older term, "cousin John," is probably related to "the jakes," which goes back to 16th-century England and apparently is a shortened form of "Jake's house." "Jake" was a generic term for a yokel, but that's about all I can offer in the way of etymological wisdom. Basically, "john" is just another euphemism for an appliance that, as I have pointed out before, is one of the few things for which there is no simple descriptive term in the English language, i.e., one that resorts neither to euphemism nor vulgarity. The redoubtable Joyce K., a regular contributor to this column, reminds me of the etymology of the word "toilet" that I alluded to earlier. Initially toilet derived from the French *toile*, cloth, then came to mean a bureau or vanity (which the "toile" covered), then a grooming ritual ("toilette") that took place at the bureau, then the *room* in which this took place, and finally the current usage—another piece of furniture in the same room. Mankind's genius for avoiding queasy realities just slays me sometimes.

From the Teeming Millions

I was quite surprised by your reply to Michele M. Surely some source could have told you "john" derives from the name of Sir John Crapper, inventor of the modern (and highly unsanitary) flush toilet. Obviously, this is also the source of "crapper" and "crap."

I mention the unsanitary nature of this beast simply because

using it requires one to place one's naked flesh thereon. Compare the oriental, or "bombsight" device, which is touched only by the soles of your shoes, and at worst can only be accused of transmitting athlete's foot.

If you want a real toughie to find rhyme or reason for, why do the British refer to this device as the "loo"? I have spent at least 13 years trying to find the source of this word!—Ray C., Pasadena, California

Why do I get the feeling you people aren't paying attention? The legendary inventor of the flush toilet was *Thomas* Crapper, not John. See above.

As for "loo," did it occur to you to look in, say, a book? Just about every etymological dictionary I've ever seen has a theory. Frank Muir, bathroom historian par excellence, offers five: (1) it's short for "Waterloo," which in turn is slang for "water closet." (2) It's short for "gardy-loo," a warning shouted by natives of Edinburgh in the days when it was still customary to empty your slops out the window. (3) It's short for "Lady Louisa," Louisa being the unpopular wife of a nineteenth-century earl of Lichfield. In 1867 while the couple was visiting friends, two young wiseacres took the namecard off her bedroom door and stuck it on the door of the bathroom. The other guests thereafter began jocularly speaking of "going to Lady Louisa." In shortened form this eventually spread to the masses. (4) It comes from the French *lieu*, "place," meaning, of course, *that* place. Some seventeenth-century English architectural plans call the bathroom "le lieu." Similarly, Germans sometimes call it *der Locus*. (5) It comes from the Continental practice of referring to the bathroom as "Room 100"—"100," when written hastily, looks like "loo." Take your pick.

You haven't had an intestinal-gas question for months now, so . . . how does gas affect one's weight? After a prolonged episode of expulsion, will one weigh less?—Just another anal compulsive, Van Nuys, California

Your question undoubtedly arises from a deep-seated spiritual sickness, Annie. However, you have opened up an interesting line of inquiry, inasmuch as there is some reason to believe that after a good toot you weigh *more*—slightly. Two of the principal components of flatus are hydrogen and methane, which are both lighter than air. Thus it is conceivable that when you

deflate, as it were, you lose buoyancy and add poundage. On the other hand, it is not clear what the ambient pressure of gas in the intestines is—a critical factor, since even a light gas under sufficient compression weighs the same as or more than air. In hopes of expanding the pitiful reaches of human understanding, therefore, Cecil offers the following proposition to the research community: you provide a practical experimental design and a willing vict—er, subject; I'll supply the beans.

The other day, a friend of mine asked me a question which left me speechless. I could not begin to come up with an answer. You are my only hope. Why is shit brown?—Dave A., Lemont, Illinois

I am answering this question, friends and neighbors, not out of any low motives, but because I wish to demonstrate that there is an answer for everything, if we merely apply ourselves industriously to the problem. The thing that makes (ahem) fecal matter brown is a potent brownish-yellow pigment called bilirubin, which is found in the bile. It's what is left over when red blood cells die off and decompose, as they normally do throughout your life. Bilirubin is taken out of the blood by the liver, where it's concentrated and shunted around some until it winds up in the intestines and gets excreted. Isn't that interesting? Wouldn't it be a great way to liven up dinner at Mom's next week? You want

to be a more fascinating conversationalist, you just keep reading the Straight Dope.

Why do outhouses have half-moons on their doors? Perhaps it's related to the great high school custom of "mooning"?—Joyce K., Seattle

This is no time for buffoonery, Joyce. Level with me: you've never actually *seen* an outhouse with a half-moon cut into the door, have you? Neither have I, despite several decades of camping trips, and I'll bet the same goes for just about everybody else. The idea that outhouses always have moons on them has been perpetuated largely by several generations of cartoonists (e.g., Al Capp), probably none of whom ever saw one either.

The only reference I can find to the practice is in Eric Sloane's *The Little Red Schoolhouse: A Sketchbook of Early American Education.* Discussing eighteenth- and nineteenth-century schoolhouses, Eric writes: "The woodshed was often a lean-to attached to the schoolhouse, but the most accepted arrangement was to place it between the schoolhouse and the privy, with a fence separating the boys' entrance from the girls'. The ancient designation of privy doors was to saw into them a sun (for boys' toilet) and a moon (for girls' toilet)." Eric has supplied a sketch of both versions, showing the familiar crescent moon for the girls and a radiant sun for the boys.

By way of corroboration, I note here in my manual of semiotics that the moon "is usually represented as the feminine power, the Mother Goddess, Queen of Heaven, with the sun as the masculine." Which is just great. All this time you thought you were just in there doing your business and now it turns out you were participating in a pagan ritual.

Why cartoonists picked up on the moon rather than the sun as the universal symbol for outhouse is hard to say, although knowing cartoonists I'd guess it has something to do with the fact that the radiant sun is hell to draw. The reason there's a hole in the first place is a lot simpler: it provides ventilation.

· · ·

From the Teeming Millions

How old are you—12? And do you only hang out with other 12-year-olds? I've seen REAL outhouses with moons on them! I'm originally from Green Bay, Wisconsin, and they had them all over. (I've been out here since '58 and have never gone back. I LOVE Santa Barbara, and I have indoor plumbing.) All you may have seen are the ones on construction sites or in campgrounds. These, of course, don't have cute little moons on them. I can't believe you didn't ask around to find out this important information.—Gini M., Santa Barbara, California

You're smart to stay in Santa Barbara, Gini; they say the indoor plumbing there is one of the wonders of the world. But I still say all those guys in Green Bay were just borrowing from Al Capp.

This devoted fan (teem as I may, I can hardly imagine 999,999 more like me) has been reading your book, The Straight Dope: A Compendium of Human Knowledge, *and finds she must take you to task for your woefully inadequate discussion of terminology for animal excrement. Surely you can appreciate the importance of thoroughness in this regard. Imagine how mortifying for an educated person to have to refer to a pile of animal leavings as "poop" or "doodoo" for lack of the proper term. I enclose copies of a couple pages on the subject from Cyril Hare's* Language of Field Sports, *which is the locus classicus for this stuff: Hart and all deer—fewmets; hare—crotiles, crotisings; boar—lesses; fox—billitting; other vermin (Hare's term)—fuants; otter—spraints; hawk—mutes. Let me also add scumber for dogs.—Avise N., Mt. Rainier, Maryland*

Really now, Avise. "Poop"? "Doodoo"? I'm trying to run a respectable column here. All the terms you mention check out in the *Oxford English Dictionary*, allowing for some variation in spelling. The *OED* also offers *buttons*, sheep droppings, and suggests that *lesses* may issue from a bear or wolf as well as a boar. Be that as it may, you have helped to expand the pitiful reaches of human knowledge. I'll send you a six-pack as soon as I start collecting on the tankload the Teeming Millions owe me.

My faith in you remains unshaken and my respect for the sagacity of your judgment undiminished. However, I am afraid

that, as Mitzi Malone might say, your interlocutors have gotten pretty weenie. What you need are some good questions, such as the following: Why does my urine smell funny after I've eaten asparagus?—F.K., Dallas, Texas

I have probably been asked this question a dozen times since I started this job, F. The first 10 times I dealt with it as you might expect—I took it out to the backyard and beat it to death with an ax, owing to the fact that it was morally reprehensible. This week, however, I have gotten the question twice *in the same mail*, which leads me to believe that this is something the Teeming Millions truly yearn to know, God help us. So here's the story:

Many sagacious persons have noted the peculiar effect of certain products on human urine. For example, Benjamin Franklin, in a wide-ranging discussion of bodily discharges, once noted, "a few stems of asparagus eaten shall give our urine a disagreeable odor; and a pill of turpentine no bigger than a pea shall bestow upon it the pleasing smell of violets." It is said that in a venerable British men's club there is a sign reading, "DURING THE AS-PARAGUS SEASON MEMBERS ARE REQUESTED NOT TO RELIEVE THEMSELVES IN THE HATSTAND."

Serious scientific research in this field dates back to 1891, when M. Nencki tentatively identified a compound known as metha-nethiol as the culprit. The odor appears within an hour after eating just a few spears of the offending vegetable. According to Allison and McWhirter (1956), the ability to produce the odor is controlled by a single autosomal (i.e., non-sex-related) dominant gene. In a sample of 115 persons, 46 were rendered fragrant by asparagus and 63 were not (which leaves 6 mysteriously unaccounted for—urology is an inexact science, I guess).

In 1975 one Robert H. White, then with the chemistry department at the University of California at San Diego, found that the odor-causing chemical was not methanethiol after all. Instead, using gas chromatography-mass spectrometry (Bob was obviously not one to screw around), he found that the aroma was in fact caused by several S-methyl thioesters, specifically S-methyl thioacrylate and S-methyl 3-(methylthio)thiopropionate. (Thioesters are compounds that result from the reaction of an acid with a sulfur-containing alcohol. They tend to be smelly.) I know you are very interested in all this stuff and are following me closely, F., so I am going to give you the exact chemical

formulation for these chemicals, in case somebody asks you at some fancy social soiree. The thioacrylate recipe is:

$$CH_2 = CHC\overset{\overset{\displaystyle O}{\|}}{}SCH_3$$

The thiopropionate is:

$$CH_3SCH_2CH_2C\overset{\overset{\displaystyle O}{\|}}{}SCH_3$$

I know you are grateful for this information. Anyway, sez Bob, the "metabolic origin [of the compounds—i.e., how and why they end up in the urine] remains an open question." I can't exactly say that research is continuing, but if anything develops I'll let you know.

My mother has always told me that the real way to spell relief is f-a-r-t. I have always been a person closely attuned to what is truly natural in myself and others and would appreciate an answer to a problem that has haunted me since childhood. If gas pains are caused by intestinal gas, then how come I never feel better when I fart? All I ever feel is embarrassed.—Lauran P., Washington, D.C.

Clearly, Lauran, you are one of the millions of innocent victims of a taboo that has tyrannized mankind since the dawn of time. As early as the fourteenth century we find a "Boke [Book] of Curtasye" sternly warning, "Beware of thy hinder parts from gunblasting." Yet the truth of the matter is that farting is a natural—nay, a beautiful—process by which we bring our inner being into harmony with the universe. The real question we ought to ask is, what irreversible physical and psychic traumas do we inflict upon ourselves by our prejudice against gas? We can but speculate. The doctors at the medical school at Salerno in the eleventh century wrote that "those who suppress [farts] risk dropsy, convulsions, vertigo, and frightful colics." The famous essayist Montaigne sagely observed, "God alone knows how many times our bellies, by the refusal of one single fart, have brought us to the door of an agonising death." In fact, the Roman emperor Claudius is said to have been so alarmed at the prospect of expiring while attempting to stifle one's natural im-

pulses that he considered issuing an imperial decree making it permissible to fart at the dinner table.

Today, with the advent of modern research methods, we know that few deaths can be attributed directly to this problem. But at least one researcher (G. Wynne-Jones, *Lancet*, 1975) has suggested that (ahem) "Flatus Retention is the Major Factor in Diverticular Disease." This ailment involves the formation of diverticula, which are sacs or pouches that develop at weak points in the intestines. In other words, by holding your wind, you may be causing your innards to blow up like a balloon. Admittedly this is a minority view. Most people think that diverticular disease results from constipation caused by lack of roughage and too much sugar in the diet.

Still, intestinal gas is clearly a force to be reckoned with. Dr. Michael Levitt, a Minneapolis gastroenterologist who is probably the world's leading expert on flatulence, tells of a somewhat gassy patient who was having a rectal polyp cauterized one day and unexpectedly exploded on the operating table. No fooling. An electric spark caused the hydrogen in the patient's bowels to detonate, blasting the surgeon backwards against the wall and slamming the patient's head into the table. The explosion also ripped a six-inch hole in the patient's large intestine. Luckily, the poor guy recovered. In view of the potentially dire consequences, therefore, my advice is simple: when in doubt, by all means let it out.

Is it possible, practically or theoretically speaking, for a person to eat in such a way that he or she would not excrete? How?—Mark G., Oakland, California

Not really. No matter what or how you eat, you'll always urinate at fairly regular intervals—that is, unless your kidneys fail, in which case death is not far off. On the other hand, it's possible to minimize if not entirely halt defecation by availing oneself of a liquid diet of what amounts to predigested nutrients—amino acids instead of proteins, glucose instead of carbohydrates, and so on. Conceivably you could avoid defecating for weeks or months this way, although I don't think you'd be in a position to enjoy what we would call an energetic life-style. As long as you have any sort of material moving through the digestive tract, however, you're eventually going to have to unload. That's partly because you never get 100 percent absorption

in the intestines, given the limitations of processes like osmosis, and partly because the liver routinely secretes a brownish-yellow liquid called bilirubin, composed of the end products of red blood cell breakdown. A certain percentage of this gets reabsorbed in the intestine, but the rest is destined for the nether darkness— and believe me, to deny nature's call in this regard is to court serious trouble.

· · ·

QUIZ #9

49. Pick the one that's false:
 a. The Waring blender was invented by Fred Waring, the 1930s society band leader.
 b. Benjamin Franklin invented swim fins.
 c. Dr. Joseph Guillotin invented the guillotine.
 d. Frank Lloyd Wright's son John invented Lincoln Logs.

50. Complete this sequence: Washington, Jefferson, Lincoln, Hamilton, Jackson, . . .
 a. Monroe
 b. Grant
 c. Adams
 d. Douglas

51. Pick the word that best describes the Straight Dope (your old college dictionary won't be much help, but there's another one that might):
 a. idioticon
 b. cacafuego
 c. adoxography
 d. acrocephalic

52. Pick the one that does not belong:
 a. cellophane
 b. zipper
 c. nylon
 d. xylophone

53. Which of the following gets the best mileage per gallon?
 a. Saturn V rocket with Apollo capsule, average over one-way trip from Earth to Mars
 b. Honda Civic
 c. Ultralarge Crude Carrier (supertanker)
 d. moped (using motor)

54. Three of the following famous alleged movie lines are actually misquotations or fabrications. Pick the one that isn't:
 a. "I want to be alone."
 b. "Play it again, Sam."
 c. "Why don't you come up and see me sometime?"
 d. "You dirty rat."

Answers on page 480–81.

High Tech, Low Tech

I've always wanted to know why there are holes in the prongs in electrical plugs. My guess is that a small rod, inserted through the holes, could lock an appliance into the socket. This could prevent such domestic disasters as having to get behind the fridge to plug it back in when the plug falls out. However, I have never seen this put into practice. What's the straight dope?—Daniel S., Chicago

You will be distressed to learn this, Dan, but I dunno. Engineers have been sticking holes in the prongs of plugs for so long—there is an undercurrent of sexual imagery here that I am studiously going to ignore—that they have forgotten why they started. An expert at Underwriters Laboratories says the holes are a by-product of the manufacturing process: they're needed to hold the prongs in place while the plastic part of the plug is molded around them. A guy from General Electric, however, says the purpose of the holes is to dissipate the heat generated by the flow of electricity. The UL guy says the GE guy is nuts. A third engineer from a smaller electrical manufacturing firm agrees with the UL guy. He says originally there were little nubbins inside the—ahem—"female" connector (i.e., the socket) that clicked onto the holes when the plug was shoved in to keep it from pulling out. (UL won't OK a socket if a plug comes out with a pull of less than three pounds.) But nubbins aren't needed anymore because of improved socket design, and now the holes are just a manufacturing convenience. Two-thirds of the voters thus opt for convenience, so I guess we'll have to go with that.

I've heard of Heisenberg's uncertainty principle before, but this is ridiculous.

The Teeming Millions Stick in Their Two Cents' Worth

Just to set you straight when you're stumped: the holes in the prongs of electrical plugs are a safety feature. They are there so you can slip a small lock through one of them and keep the key, thus preventing unauthorized persons from plugging in the appliance, e.g., small children from using an electric carving knife, iron, or dangerous power tool.

Simple logic tells me that the GE guy is nuts. Prongs of electric plugs used in other countries, with sometimes higher voltages (e.g., 220 volts in Germany), do not have holes. Hope I have made your day.—Sibylle A., Tempe, Arizona

I don't know the engineering of this, but isn't it the case that punching holes in strip metal increases its strength? I seem to remember from my model carmaking days that the holes in dragster frames, in addition to reducing weight, increased the frame's rigidity.

Theory #2: Can one melt and reuse the punched-out slugs, thus saving about one-quarter the raw materials cost per unit, which, multiplied by the krillions of plugs made each day, would result in substantial savings? Just a thought.—Bob M., Riverside, Illinois

Both of your "thoughts," Bob, reduced my engineer buddy to hysterics. 'Nuff said.

As for you, Sibylle, you're a little closer to the mark. It is in fact possible to buy a little locking gizmo that slips over an electrical plug and engages the holes, thus preventing the appliance from being used. But that's not why the holes are there in the first place. The holes have been around as long as anybody I've talked to on this subject can remember—at least 20 or 30 years. The earliest anybody can remember the locks appearing on the scene is about 10 years ago.

If you're riding in an airplane and sitting in the seat next to the wing exit and the sign on the door says "Push lever to open in emergency," can you just push the lever to open at any old

time around 30,000 feet up? If so, shouldn't they carefully screen the people they put next to the wing exits? We need to know.
—*Byron, Greg, Janice & Paula, Chicago*

Don't panic, gang. If you'll look closely next time you're on a plane, you'll notice that the emergency exits—they're not so much doors as removable window plugs—open *in*, not out. When the plane is on the ground (which is when you're supposed to use the exits), that doesn't matter much, because the air pressure is equal on both sides. But when the plane is at cruising altitude, the inside (cabin) pressure is so much greater than the outside pressure that you'd have to have superhuman strength to pull the exit open. Let's say the window plug measures 18 by 36 inches. The cabin pressure in a typical commercial aircraft is about seven pounds per square inch. At 35,000 feet atmospheric pressure outside is about three and a half pounds per square inch. This means that to get the exit open you'd have to overcome a net outward pressure of more than 2,200 pounds, or more than a ton. Fat chance. The same thing applies to the plane's regular doors. In most commercial aircraft the doors open outward, but they're designed in such a way that they have to be popped in a smidge before they can be swung out. As with the emergency exits, cabin pressure prevents the doors from being opened when the plane is at cruising altitude.

You may recall that in 1971 a hijacker named D. B. Cooper

with $200,000 in his mitts parachuted out of the rear exit of a Boeing 727 flying over Washington state, never to be seen again. How'd he do it? Turns out the plane was flying at a low enough altitude—7,000 to 10,000 feet—to enable D. B. to get the door open. Boeing says the exit has since been modified to prevent its being opened while the plane is in the air, no matter what the altitude. Just as well. When somebody pulls off one of the all-time great exits, you don't want some copycat spoiling the effect.

Does adding more Heet gas-line antifreeze than the label recommends help? Does it hurt?—Mike L., Chicago

We must learn, Mike, to resist the notion that if a little is good, a lot is better—a typically American idea that has given us megavitamin therapy, expansion-team baseball, and the Vietnam War. Adding more Heet (or any gas drier) won't help much. If you've got more than an ounce or two of water in your gas tank, which a 12-ounce bottle of Heet will sop up adequately, you'd better take your car to a garage to have the fuel system drained. On the other hand, a little more Heet won't hurt all that much either. It's basically methyl (wood) alcohol, which is heavier than gasoline and consequently sinks to the bottom of the gas tank. There it mingles with any water in the tank, which also sinks to the bottom. The resultant mix is combustible, although just barely, so when it gets pumped through your engine you car may sputter a bit. In the absence of water all Heet does is raise the octane of your gas slightly (although see next question). Bear in mind that antifreeze is a *preventive* measure—if your gas line is already frozen, all you can do is wait for a thaw.

Stopping at a local gas station and seeing a large banner announcing "Alcohol Free!" reminded me that there was some controversy surrounding the use of ethanol versus methanol in gasoline. What are the differences between these two octane boosters?—Danglin' Dave, Garland, Texas

It may be OK to dangle out there in Garland, Dave, but here in the big city we'd prefer that you buttoned up. As for alcohol, there are some differences between ethanol (made from grain) and methanol (made from methane). But the real question is whether you want to use gasoline laced with alcohol at all, since it tends to screw up your engine.

Many refiners began putting up to 10 percent alcohol (usually

ethanol) in their gasoline in the 70s, producing what's known as gasohol. It's most commonly available in the Midwest, particularly in Farm Belt states where it's subsidized in the form of lower taxes, but you can also find it in the West and South and occasionally elsewhere. Alcohol has two advantages: it's a renewable resource, unlike petroleum, and it boosts octane, meaning you'll get less pinging and knock. Methanol has the added advantage of being quite cheap.

In fact, alcohol would be just about perfect were it not for the fact that it can soften hoses and gaskets, dissolve your carburetor float and other plastic parts, and corrode metal. It can also cause vapor lock and hot-weather restarting problems, and it tends to lower your gas mileage. Methanol is the more serious offender, but ethanol will give you trouble too.

Unfortunately, it's not always easy to tell whether gas contains alcohol. Amoco used to put decals on some of its pumps saying "Pure Lead-Free, No Alcohol Added," but now the no-alcohol line is being dropped, in part due to protests from gasohol advocates. Amoco pumps that do have gasohol are prominently labeled, but this is not necessarily the case with all retailers.

Most major refiners that sell gasohol use ethanol rather than methanol. ARCO (Atlantic Richfield) for a long time was the exception, but the company now says it has discontinued the sale of its methanol blend, at least for the time being. You may still wind up with some of the stuff, however, because unscrupulous service station operators have been known to cut their gas with methanol in order to chisel a few extra bucks. If you've been having inexplicable problems with your ride lately, try filling your tank at a different joint.

No doubt this query won't have the same mass appeal as some of your other columns, i.e., sneezing after orgasm, but I feel it merits a moment of your time. On a recent excursion across the highways of this state, my traveling companion posed a perplexing problem. She contends that the average automobile is much more efficient with the windows down and the air conditioner off. I, on the other hand, maintain that the aerodynamic drag created by having the windows down makes the savings marginal at best. Help us, Cecil, as our discussions are getting rather . . . heated.—Maintaining My Cool, Phoenix

You'd think it would be pretty easy to get to the bottom of a question like this. Just call up Detroit and ask, right? Guess again. All you get for your trouble is loads of contradictory doubletalk.

But never fear. Cecil recently arranged (at no little expense, I might note) a cross-country expedition for the express purpose of determining which gives you the better gas mileage: having the air conditioner off and the windows down, or the AC on and the windows up. For purposes of comparison, we also checked the mileage with the AC off and the windows up, which theoretically would give you the best mileage of all. In between these tests, we spent some time contemplating the Atlantic in lovely Rehoboth Beach, Delaware.

The car was a four-door Pontiac 6000 LE with 1,600 miles on it at the start. We drove 300 miles in each of the combinations described above, maintaining a 60 MPH speed on more or less level interstates throughout. Here's what happened:

> *Windows up, AC off:* 35 MPG
> *Windows up, AC on:* 34.4 MPG
> *Windows down (all four), AC off:* 33.8 MPG

These figures are preliminary, of course, but interesting all the same. We got slightly better mileage running the AC with the windows up than we did with the fresh-air method—a surprising result, some may feel, but there you have it. Still, the difference was slight, and in my humble opinion, statistically insignificant. I should point out that it wasn't very hot outside, and we didn't have the air conditioning on at full blast. If we'd run it at arctic maximum, I suspect the mileages would have turned out to be identical.

Unfortunately for you, M., I ran out of vacation before I was able to prove this idea conclusively. Pending further investigation, the best I can do is declare your argument a draw.

I have an old apartment complete with old pipes, and I've noticed an annoying phenomenon when I turn on the hot water. At first it comes blasting out, but within a short time it slows to a trickle, as though a poltergeist were under the floor squeezing the pipe. What gives? The pipe stays the same and I assume the water pressure does too. Is there some law of fluid dynamics that causes this? It doesn't seem to happen to cold water pipes.
—Mike P., Dallas, Texas

Cecil would love to tell you there's some mind-boggling phenomenon at work here involving gravitons and the strong nuclear force, Mike, but, unfortunately, no can do. According to my *Plumbing Repairs Made Easy*—I love books with titles like this—the hot water slows to a trickle because the washer in the faucet expands when it gets hot. Solution? "Replace with a proper, nonexpanding washer." Short, simple, and unlikely to inspire much backtalk from the troops. Sometimes I think I went into the wrong line of work.

When President Reagan makes speeches you often see two squares of glass mounted on stands on either side of the podium. What are they for?—Jim L., Phoenix

They're teleprompters—you didn't think Ron actually memorized all those speeches, did you? The glass squares, which are called "beam splitters," are coated in such a way that they act as mirrors for the person at the podium while appearing transparent to people in the audience. They're carefully angled so that they pick up the text of the speech off TV monitors lying face up on the floor and reflect it toward the speaker.

The whole business is orchestrated offstage by a technician who slowly reels a typed copy of the speech past a closed-circuit TV camera, which transmits it to the TV monitors and thence to the beam splitters and the speaker. This enables you to read your speech directly off the glass without having to glance down at the lectern, thus giving the impression that you're a bold, dy-

namic kinda guy who can maintain eye contact with the audience. (Remember, the glass looks transparent from their side.) The fact that you can shift your gaze from one glass to the other adds to the illusion. The audience seldom tumbles to what's going on and figures the beam splitters are bulletproof shields or something. (They're not.)

Ron's teleprompters are supplied by a New York outfit called Q-Tv, which also does business with many other politicians and corporate executives. The firm makes a similar gimmick for use on the cameras found in TV studios. Years ago, when the teleprompter was mounted above or to the side of the lens, you had to look slightly off camera to read the script, making it appear you couldn't stand to look anybody in the eye. Nowadays a beam splitter is mounted right in front of the lens, enabling you to read your script while gazing directly into the camera like a man (or a woman, if that is what you happen to be). The glass is transparent when seen from the back and thus does not interfere with the normal operation of the camera. And here you probably thought all those ex-jocks-turned-commentator were geniuses because they never consulted notes when doing a stand-up intro. Ha. With most of those guys you'd have better luck getting an ad-lib out of Pinocchio.

Q-Tv Update

Thank you for your comprehensive report on our Q-Tv prompting system. To update your story, the system is now computerized. The text or "copy" is prepared on a word processor and stored on a floppy disc. At performance time, the text is then fed into a computer, which transmits it to the beam-splitter glasses mounted at the speaker's podium or in front of the lens. Flow of the text is regulated by a technician via a variable-speed hand control, to keep it synchronized with the speaker's delivery. Use of the computer results in a text image brighter and more sharply defined than in earlier generations of the system. More important, it greatly facilitates copy revision. Instead of retyping or hand-lettering copy changes, the technician can make instantaneous revisions via the computer keyboard.—John K., Q-Tv, Hollywood, California

I recently heard that spy satellites can read the headlines off the newspaper of a person sitting on a park bench. How powerful are these satellites? Can they see through walls?—Todd S., Columbus, Ohio

Give me a break. Though the Pentagon isn't exactly bubbling over with details about things like this, we are fortunate enough to have in this country that great institution known as a Free Press, which can ferret out stuff that would take the KGB years. Defense reporter Jay Peterzell, writing in the *Columbia Journalism Review*, of all places, says that the "resolution" of both U.S. and Soviet spy satellites is six inches and perhaps even less. That means if you have two objects six inches square and they're placed at least six inches apart, they'll show up as two distinct items in the photos, rather than one big blur. That's not bad; the resolution of commercial satelites ranges from 10 to 30 meters. But it still pretty much rules out reading the headlines in the newspaper, unless of course you're talking about something on the order of the *New York Post*, whose headlines you can read from Mars (which seems only fitting). For anything else in the way of reading material, the Russkies have to go out and plunk down a quarter like everybody else.

Recently while inspecting the innards of an old pocket watch I noticed the most beautiful dancing swirls on the inside of the back cover. Obviously no one but the watch repairman would ever see these swirls. So what purpose do they serve?—L.B.B., Dallas

What, you think watch repairmen don't appreciate the finer things in life? This is the kind of attitude that plays right into the hands of the Sandinistas. The effect you refer to is probably what is known as "engine turning," a decorative finish commonly applied to metal surfaces with a special lathe. You used to find it quite frequently in fine watches and clocks and even, I am told, on the dashboards of vintage autos. In its simplest form it's cheaper to apply than the high-gloss finish or other decorative treatment you find on the outside of the watch, but it still beats the appearance of rough metal.

At a recent jazz festival I bought a length of hollow plastic tubing about a foot and a half long filled with a green liquid that gave off an eerie neon glow bright enough to read by. It

cost $1, but in three hours the glow had gone. Various treatments (light, extreme heat and cold) have not brought the light back. What gives?—O.T.M., Chicago

Listen, kid, just be grateful you didn't put a down payment on the Brooklyn Bridge. Light tubes are intended to amuse the masses for a few hours, not light up the rest of your life. The ingredients are made by American Cyanamid Corporation of New Jersey in the form of something called a light stick or glow stick. Each light stick contains two chemicals separated by a plastic barrier, which the user must break to get things started. It's thought that many light-stick and light-necklace entrepreneurs drain the chemicals out of the original tubing into smaller tubes in order to boost the profit margin. Naturally they have to do this several hours before the start of the show, which may explain why American Cyanamid light sticks glow for 12 hours and yours only went for three.

Although the precise chemical formulation in light sticks is secret, in general you have a substance called luciferin that oxidizes and glows when catalyzed by an enzyme called luciferase. It's the same principle used by lightning bugs. Cold will slow down the reaction, which is why light-stick vendors store their wares in freezers, but once the chemicals are used up, the show's over and no amount of effort will bring the glow back. Light sticks are mostly intended for boaters, campers, and the like, but a fair number of them end up in the hands of innocent guppies such as yourself. Look at the bright side, so to speak—$1 is a small price to pay for a short course in reality.

What are the ingredients in soap that make it clean? Does soap ever get dirty? What will soap not clean?—John S., Chicago

You wanted the facts here, John, and that's what you're going to get. The active ingredient in soap is a sodium fatty acid salt, produced by the action of a hot caustic alkali solution on a natural fat or oil (most often, vegetable oil or tallow). This compound has two vital components—a water insoluble (hydrophobic) part, consisting of a fatty acid or a long-chain carbon group, and a water soluble (hydrophilic) part, generally an alkali metal. The hydrophobic part attaches to the fabric or dirt, the hydrophilic part snuggles up to the water. The result is that you force an electrically polar wedge of soap and water between the fabric

and the dirt. The slime is then removed by mechanical action—
"scrubbing," to put it in layman's terms.

By this time it should be obvious that soap *always* gets dirty—
if it didn't, it wouldn't work. The whole idea of soap is that
grease and dirt feel a more powerful attraction toward it than
they do toward your clothes. But protein stains—blood, milk,
egg, etc.—are inherently immune to soap's charm. Insoluble in
water, the complex protein molecules adhere too tightly to the
fabric to let the soap get a foothold. Enzymes—compounds whose
only role in life is to break down protein molecules—must be
added to the detergent to make it effective.

*I am enclosing an inflatable Dino the Sinclair Dinosaur out
of gratitude for your putting two of my questions in your recent
book. (You mentioned that you "had one" of these as a child and
found it "inexplicably charming.") Now I have another question:
my step-dad tells me that many years ago there was a fellow
who invented a pill that, when put in a tank of water, would
turn the water into gasoline. After publicly demonstrating this,
he then disappeared forever, his secret formula gone with him.
The yarn goes on that the big oil companies felt threatened and
were responsible for his demise. A good friend of mine confirms
that he read this story in an old Farmer's Almanac. Any truth to
this?—Mike J., Chicago*

Thanks for the dinosaur, Mike, as well as the opportunity
to work in yet another plug for my book, which is selling like
hotcakes, mainly due to my relentless program of self-promotion.
As for your question, I believe you're referring to the legendary
Guido Franch, who was the subject of a story some years ago by
former Straight Dope editor Mike Lenehan. Over the course of
three decades, Guido, who's now 74, convinced dozens, maybe
hundreds of people that he could turn ordinary water into high-
test gasoline (he called it "Mota fuel," Mota being "atom" spelled
backwards) by dumping some mysterious green powder into it.
The cost? Just eight cents a gallon.

Guido, a blue-collar worker with a seventh-grade education,
explained that Mota fuel had been developed by a German sci-
entist named Dr. Alexander Kraft, who had settled in Guido's
hometown of Livingston in downstate Illinois between the world
wars. Guido claimed he learned the formula for the powder,
which was made from coal, while working part-time in the doc-

tor's lab. After the doctor died, Guido spent his spare time trying to scrounge up cash to build a pilot plant to make the Mota fuel powder in quantity, but without much success. The problem, Guido claimed, was that the big corporations (supposedly companies like Ford, Phillips, Sinclair, and others have looked into this) wanted him to hand over his formula first. He refused, suspecting they'd rip him off.

Instead, Guido signed up small investors, who had perhaps read about him in the *National Tattler* or some equally reliable publication. Guido would give them a backyard demonstration in which he'd take a gallon of water, mix in the green powder, and use the resultant concoction to operate, say, a lawn mower. Frequently he'd convince them to cough up some dough—typically $1,000 in return for 1 percent of the profits—so he could make more powder and give additional demonstrations. Unfortunately, nothing ever came of these investments—Guido would claim he'd run into unexpected problems, there was an illness in the family, etc. Occasionally Guido would fork over a vial of the green powder, but it would always turn out to be ordinary green vegetable dye.

As a result of such shenanigans, Guido was hauled into court a couple times, once in 1954 and again in 1979, on charges of fraud. He was acquitted the first time—the prosecution's expert witness admitted it was *possible* Guido's Mota fuel really worked. But he wasn't as lucky the second time. A witness testified that Guido had once admitted that he'd substituted aviation fuel for the water by sleight-of-hand, and prosecutors showed that he'd

taken $20,000 from various parties and given nothing in return. Guido was convicted and given five years probation. He did not "disappear forever," however. I chatted with him just the other day at the barbershop where he hangs out, and he still claims he can make gasoline out of water. He says if you're willing to put up a $25,000 "loan," he'll make you rich beyond your wildest dreams. Send me a ten-spot (chuckle, snort) and I'll give you his phone number.

Recently, while watching a weekend TV news program, I saw a short report which was treated as a light human interest piece by the reporter. It seems to me, however, that if the thrust of the story were to prove true, it would have revolutionary implications—maybe even affect the fate of civilization. On the other hand, it could also be a big scam.

Here are the facts. Mr. Joseph Newman is a self-proclaimed country boy and inventor from Georgia. Using ordinary materials and basic magnetics as a catalyst, he claims to have designed and built a machine that produces more power than it consumes. The result is said to be pure, nonpolluting energy at almost no cost. Mr. Newman believes a machine of the same design, weighing about 300 pounds, could satisfy all the energy needs of an average home. However, Mr. Newman's application for a patent was rejected by the patent office because it "smacks of perpetual motion," which scientists declare is impossible. Mr. Newman claims to have made a new discovery which disproves currently held theories of magnetics and which might even necessitate a change in our understanding of physics. Cecil, please enlighten your loyal readers—G.K., Washington, D.C.

Love to, G., but some days it's like trying to light up the Grand Canyon with a flashlight. Take you, for instance. Your parents probably spent 60 grand to send you to college, and the first time you see some crackpot on TV you're ready to believe the laws of the universe have been suddenly repealed. And they wonder why I get depressed.

Here's the story. Joseph Newman of Mississippi (not Georgia) sued the U.S. Patent and Trademark Office in 1984 for refusing to give him a patent for his "energy output machine." He also hired a publicist to get him on TV shows to demonstrate his machine, enabling him to sucker the gullible on a mass-production basis. "Country boy," my arse.

Fortunately for the cause of knowledge, the court ordered the National Bureau of Standards, a division of the U.S. Department of Commerce, to test Newman's contraption to see if it worked as advertised. Not surprisingly, it didn't. Researchers found the machine generates only 27 to 67 percent as much energy as it consumes.

The director of the bureau's National Engineering Laboratory said Newman's invention, which operates on 116 nine-volt batteries, basically converts direct current into alternating current. Commercially available devices that perform a similar function operate at 90 percent efficiency or higher.

Newman, naturally, claims the tests were fixed. "I have no respect for the National Bureau of Standards," he says. "This is a conspiracy against me." He wants the court to order the testing of the test equipment. If that doesn't work, no doubt he'll demand the testing of the test equipment that tested the test equipment. These guys are so predictable.

I bought some crystal prisms at a crafts fair and was going to hang them in a window on the west side of my house. Then I got to thinking about an experiment we did in school, which consisted of having sunlight go through a magnifying glass onto paper. The paper started to smolder. Now I'm worried that if I hang the prisms in the windows, I may come home to a smoldering heap of charred wood. At a shop that sells crystal prisms, I asked about the likelihood of this happening. The shop owner assured me sunlight coming through a prism would not start a fire, even if it hit a stack of newspapers. But I figured, of course he would say that, he sells prisms. So I turn to you, Cecil. Do I have anything to worry about?—Robin S., Dallas

Relax. Magnifying glasses *concentrate* light, prisms *scatter* light. That's why you see those bands of color—the prism has caused the different wavelengths of the light to separate. Interesting, yes; dangerous, no.

Whilst driving around recently a friend and I got stuck at a railroad crossing waiting for a freight train to go by. To pass the time, we began speculating on the meaning of a sign we saw on some of the cars saying DO NOT HUMP. We conjectured that this might be some sort of safe-sex campaign organized by the railroads in the wake of the AIDS crisis, but eventually rejected

the idea. So we put it to you, Cecil—what is the meaning of this odd instruction?—Gene W., Dallas

I am saddened to report that DO NOT HUMP does not have any of the off-color significance that seems to give many of the Teeming Millions their principal reason to go on living. It refers to a common method used to sort freight cars known as "humping," which involves the use of a man-made hill, or hump. A track heads up the hill and branches into numerous parallel tracks on its way down the other side. To make up new trains, a switch engine pushes a string of cars to the top of the hump, where the cars are uncoupled one at a time. Having determined the car's destination, a worker in a nearby tower pushes buttons or throws levers or whatever to get the track switches (you know, those things where one track divides into two) lined up properly. The car is then given a nudge, causing it to roll down the hump and onto the right track.

The advantage of humping is that it's a lot faster than having switch engines shuttle back and forth all day making up trains. The disadvantage is that it's sometimes a little rough on the freight cars and their contents. Occasionally a car derails going down the hill, meaning the crew has to stop working and horse around trying to get the wheels back on the rails, which is a million laughs, particularly in the middle of winter. What's

worse is the possibility that the car may roll down the hill too fast and crash into the car in front of it, jostling or damaging both the cars and what's inside them. Special gimmicks on the rails called "retarders" are supposed to slow things down and prevent this, but they have been known to fail. Accordingly, cars with especially delicate contents are marked DO NOT HUMP, which tells the yard crew to set the car aside for special handling. This applies particularly to the tank cars used to haul hazardous chemicals, many of which have DO NOT HUMP stenciled permanently on their sides.

The railroad business, I note with some nostalgia, is one of the few fields where a guy without advanced training can still precipitate a major disaster. An old high school teacher of mine once told me about the time he worked in the steel mills helping switch coal cars. During his first week on the job, he was asked to participate in a semirisky maneuver known as a "flying switch." The idea was that the locomotive would head toward a switch pulling a single coal car behind it. At the right moment, somebody would uncouple the car and the locomotive would scoot ahead through the switch onto the main line. Once the locomotive was clear, my high school teacher was supposed to throw the switch so the coal car would roll onto the side track.

Everything worked great until they got to the part where the teacher was supposed to throw the switch. For reasons that time has mercifully expunged from his memory, he waited to throw the switch until after the coal car's front set of wheels had headed out toward the main line. The back set, however, was now headed onto the siding. You see the obvious problem this presents. My teacher had the privilege of watching a magnificent slow-motion disaster in the making as the coal car sort of rolled sidesaddle down the line until the tracks got too far apart, whereupon it toppled over and spilled 50 tons of coal all over creation. A great moment in railroading—nearly as funny as the time I almost knocked out the side of a building with an overhead crane. But we'll get to that story some other day.

You know those high-voltage power lines you see on towers? They're big and thick and they're hung on big insulators. But at the very top of the towers I also see one or two thin wires that aren't on insulators. What are they for?—Mike P., Dallas

Lightning protection. Called "static lines," the wires are grounded at intervals and basically function as continuous lightning rods, attracting lightning bolts and conveying them around the current-carrying wires to the earth. Static lines are also used on telephone poles sometimes. The wire you see running down the pole, often sheathed in wood or some other insulator for the bottom 10 feet or so, is the ground connection. Mess with it at your peril.

Most pianos have just two pedals—one for loud, one for soft. But sometimes you see a piano with three *pedals. What does the third one do—make the music more . . . middle of the road, somehow? And why don't all pianos have one?—Greg, Phoenix*

Silly boy. Let's start at the beginning. The right-hand pedal is the "forte" pedal, also called the sustain or loud pedal. In ordinary piano playing, dampers plop down on the piano strings after you let up on the keys, stifling the earlier notes and making the new notes sound more distinct. On occasion, however, you want a richer, more resonant sound, so you depress the forte pedal. This prevents the dampers from falling, and all notes continue to resound until the pedal is released.

The left-hand pedal is called the "una corda" or soft pedal. Most notes in a piano are produced by two or three parallel strings tuned in unison. The una corda pedal shifts the piano's innards over so that the hammers only strike two strings rather than three (or one rather than two), reducing the volume. In many upright pianos, the una corda is replaced by the "piano" pedal, which shortens the distance traveled by the hammers, another way of reducing volume.

The mysterious third or middle pedal is usually the "sostenuto." When you press down a key or keys, then depress the sostenuto pedal, it will sustain those notes—and *only* those notes—until you let the pedal up. This allows you to play a note in the bass, for instance, and then move both hands up to the treble for a few bars while the bass note continues to sound. In effect you have an extra hand to work with. But it's the sort of thing you only need with keyboard-spanning music like that of Debussy or Ravel. For the average Saturday night tinkler, two pedals will do just fine.

Piano making being an idiosyncratic business, there are many variations on the preceding. Sometimes there's a modified sosten-

uto that only works for the bass notes. Sometimes it's replaced by an alternative soft pedal called the "celeste." And sometimes . . . but let's quit while we're ahead.

> *Please confirm or refute my suspicions. Does the "Close Door" button on an elevator actually do anything, or is it provided merely as a tension-releaser for us harried yuppies? I await an uplifting answer.* — *Leonard V., Silver Spring, Maryland*

Spare me the pathetic puns, Lennie; this is serious business. The grim truth is that a significant percentage of the close-door buttons in this world, for reasons that we will discuss anon, don't do anything at all. Naturally, this is not something the elevator companies wish to have widely known, lest there be social unrest. When I talked to the folks at the Otis Elevator company in Farmington, Connecticut, they were all innocence. Among other things, I was told that the close-door buttons at Otis HQ (which, the views of the cynics notwithstanding, is not located in a one-story building) always work like a charm.

This is comforting news, needless to say, and I would suggest that any harried city dweller who has never seen a close-door button that actually did anything might want to make a field trip out to Farmington to inspect the genuine article. In the meantime, having consulted with various elevator repairmen, I would say that apparent CDB nonfunctionality may be explained by one of the following: (1) The button really does work, it's just set on time delay. Suppose the elevator is set so that the doors close automatically after five seconds. The close-door button can be set to close the doors after two or three seconds. The button may be operating properly when you push it, but because there's still a delay, you don't realize it. (2) The button is broken. Since a broken close-door button will not render the elevator inoperable and thus does not necessitate an emergency service call, it may remain unrepaired for weeks. (3) The button has been disconnected, usually because the building owner received too many complaints from passengers who had somebody slam the doors on them. (4) The button was never wired up in the first place. One repair type alleges that this accounts for the majority of cases. In other words, the whole thing is a total fraud. Shocking, but in an era of E. F. Hutton-style Yupscams, it's about what you'd expect.

Observations from the Field

Your source at the Otis Elevator company seems not to have been entirely forthcoming, or perhaps only Brand X elevators have "close door" buttons that function in yet a fifth way. At my grade and high school in New York (the building opened in 1966), the elevators usually operated in automatic mode—you pushed the button for your floor, and eventually the doors closed and the elevator took you where you wanted to go. But for special occasions it could be keyed into "operator" or manual mode. The doors would stay open until you pressed and held the "close door" button. (If you released it before they were completely shut, they would just slowly open up again, and you couldn't do a thing about it until they were finished. That could be real embarrassing when you were, say, ferrying visiting parents to their teacher conferences.) "Open door" always worked, but "close door" didn't seem to have any other effect.—Peter D., Chicago

Just a comment on your recent investigation of "close door" button operation. I visited Otis Elevator HQ last spring and had to walk up to the second floor because the elevator was out of order. The "close door" buttons may work there, but the rest of the equipment is a little chancy.—S.G., Chicago

Chapter **20**

The Doctor Is *In*

One night as I was about to nod off to sleep, I felt a lot of energy hitting me. It felt great. As I was lying there enjoying it, I saw a small black cloud in the corner of the ceiling. It slowly came down and landed on my chest. I couldn't move. I tried desperately to struggle but was completely paralyzed. After what seemed an eternity, the "cloud" was gone and I was able to move. I was scared witless and stayed up the rest of the night with the light on. The same thing has happened several times since, with slight variations. I am able to avoid any paralysis by lying on my side or stomach. Every time this has happened except once I've been alone in the room. The one time someone else was sleeping in the room they didn't notice anything. Cecil, what's going on?—P.S., Washington, D.C.

Jeepers, P., I dunno. Could be it's a relatively harmless phenomenon called "early sleep paralysis," which occurs in about 15–20 percent of the population. On the other hand, it could be a symptom of narcolepsy, epilepsy, or, for that matter, dietpepsy, which results from excessive consumption of sugar-free beverages. (Sorry, couldn't help it.) Signs of narcolepsy include sleep paralysis and "hypnagogic hallucinations"—"extremely vivid dreamlike experiences that occur as the individual is falling asleep [e.g., descending black clouds, one supposes]. Such dreams are often difficult to distinguish from waking experiences" (W. C. Orr, in *The Sleep Disorders*, 1982). Also sez here that "normal subjects may have an occasional sleep paralysis when awakening; [sleep-onset-only] paralysis suggests narcolepsy." By far the most common symptom of narcolepsy, however, is excessive daytime

sleepiness, including frequent "sleep attacks." If you've got that too, you poor guy, hustle your buns over to a sleep-disorder specialist for a confirmed diagnosis. Not that it's going to help you much; narcolepsy has no cure.

On the other hand, maybe what you've got is epilepsy. Epileptic seizures are often preceded by a brief period of altered consciousness called an "aura," which could be the "energy" you claim you feel prior to the arrival of the cloud. Terrifying hypnagogic hallucinations are also a sign of this disease. Again, find a sleep-disorder specialist. Call a university medical center if you don't know where to start looking.

The Teeming Millions Want a Second Opinion

Shame on you, Cecil! How dare you tell that poor fool to see a doctor! This man was obviously experiencing astral phenomena resulting from the projection of the astral body! Epilepsy, huh? Where the hell did you get that? You're liable to worry the poor fellow to death! When someone comes to you with a question about the unexplainable you've gotta realize that science and medicine, no matter how modern and up to date they are, cannot explain that stuff! Next time before you tell

some unsuspecting slob to blow his life savings on somebody's couch, go to the nearest spiritualist bookstore and find out what it's all about! The best book I've found on this subject is The Projection of the Astral Body *by Muldoon and Carrington. It will explain most if not all of this curious phenomenon.—K.M., West Hollywood, California*

"Poor fool"? "Unsuspecting slob"? Hey, at least I didn't *insult* the guy.

A Definite Alternative Diagnosis Begins to Emerge

Why do we insist on believing the myth of "scientific" explanations, especially when such explanation teach us to fear? P.S. began his letter by saying that initially he "felt great"! The black cloud he saw frightened him, but it didn't hurt him, did it? If I were responding to P.S., I would tell him not to fear these experiences, and certainly not to struggle to escape from them. Instead I would simply let them happen and observe. These nascent "astral projections" (one of many names given to them outside the "scientific" community) may eventually lead to a lot more exciting, and more pleasant, experiences than ominous black clouds.—Robert M., Washington, D.C.

Yeah, and they could lead to an outright seizure, too. I don't want to exaggerate the danger, but several members of Cecil's family suffer from epilepsy, and one once had a seizure while cruising down the highway at 60 MPH. He was saved from disaster only by the quick action of a passenger. He takes medication now to prevent a recurrence. P.S. may well be perfectly healthy, but I'd rather give him the facts than fill him full of nutty ideas about astral projection.

A Word from Someone Who's Been There

In your recent column concerning paralytic dreams, you suggested that the cause might be narcolepsy, which has the additional symptoms of daytime sleepiness and frequent sleep attacks. You also said that even if the poor fellow or gal does get

a narcolepsy diagnosis, it wasn't going to help much because narcolepsy has no cure.

I am not a doctor or medical authority. However, I have been a longtime experiencer of paralytic dream states. From childhood, I have experienced excessive daytime sleepiness and frequent sleep attacks. It is not true that nothing can be done for victims of this condition.

After three decades of a low-energy, indolent life-style, I have found relief. I hopped on down to my local sleep-disorder center and was told to have a sleep test to see if I had narcolepsy. The test involves being wired up and measured as you sleep. Being the nervous type, I was not able to get a good sleep during the test. I was told I didn't have narcolepsy, and I thought I was doomed to a life of paralytic dreams and frequent sleep attacks as well as extreme nervousness if I didn't get my naps in.

I asked my doctor if he could provide me with whatever he would have prescribed if I had tested positive on the sleep test. He prescribed Ritalin, a drug that is used not to cure narcolepsy but to control the symptoms. I'll tell you, it really made a difference in my life. I am actually able to work a full day now without nodding off during work or at lunch. I can watch a movie without falling asleep. I mean, I have fallen asleep during rock concerts and left the place with my ears ringing because of the loud sounds and yet not remembered the performance because I had nodded off.

Cecil should suggest his reader get his doctor to prescribe Ritalin even if the test for narcolepsy is negative. I know the reader didn't complain about sleepiness, but if he or she is experiencing sleepiness along with paralytic dreams, this would be the route to try.—Eugene S., Evanston, Illinois

There are some of us, Eugene, for whom a low-energy, indolent life-style doesn't sound half bad, but I suppose this is no time for levity. Ritalin, a nonamphetamine stimulant, is probably the most common drug prescribed for narcolepsy. As you note, it does not cure the condition; it only alleviates the symptoms. My medical sources tell me it does not have much effect on paralytic dreams. For people suffering from such dreams, doctors often prescribe from a class of drugs known as "tricyclic antidepressants." The American Narcolepsy Association announced the other day that a new drug made by Stuart Phar-

maceuticals called Vivalan is now being tested which also promises to help.

Linus Pauling and others speak of the marvelous curative powers of vitamin C. I take it myself with superstitious regularity and virtually never get a cold. Yet others say there isn't one shred of evidence that vitamin C prevents colds, cancer, or any other disease. Your answer will be an inestimable service to mankind.—CC Writer, Chicago

All in a day's work, bubba. The evidence for vitamin C as a cold preventative is positive if not overwhelming. One researcher, using data from eight separate studies, concluded that vitamin C freaks averaged about one-tenth fewer colds per year than other people, and their colds lasted one-tenth less time. Another study was recently conducted by researcher Elliot Dick at the University of Wisconsin. Of 24 subjects, one-third were exposed to a cold virus, one-third received vitamin C, and one-third received a placebo. After a week of living together, seven of the eight placebo patients had colds, compared with six of the eight vitamin C patients. The difference was that the symptoms of the vitamin C patients, as indicated by the number of coughs, sneezes, nose blowings, and so on, were only half as severe. The study will be repeated, but so far things look promising.

As for vitamin C and cancer, the American Society has issued guidelines suggesting that consuming C-rich foods might reduce the risk of certain types of malignancies. But once you have cancer, vitamin C won't help. A study recently published by researchers at the Mayo Clinic decisively rejects the contention of Pauling and others that megadoses of vitamin C can cure cancer. In addition, too much C can cause undesirable side effects. If you must take supplements, don't take more than 60–100 milligrams extra per day.

Is it healthy to literally "lick one's wounds"? Does human spit contain any chemicals that are antibacterial or antiseptic? Would you recommend the practice if, for example, a Bactine-less camper had the misfortune to be mauled by a bear?—Judy H., Chicago

Cecil is of two minds about this. On the one hand, researchers at the University of Florida at Gainesville have discovered a protein called Nerve Growth Factor (NGF) in the saliva of mice.

Wounds doused with NGF healed twice as fast as untreated, unlicked wounds. So in a few species, at least, spit does have some curative powers. NGF has not been found in human saliva, but researchers do note that human spit contains antibacterial agents such as secretory IgA, lactoferrin, and lactoperoxidase. It has not yet been shown that licking your wounds actually disinfects them, but on the other hand it probably won't do you any harm.

At least I think it won't. See, the one problem is that your mouth also contains "anaerobic" bacteria, which thrive in airless environments such as the nooks and crannies of your teeth and gums. Normally these don't find their way into your saliva, but if they do, you'd be better off throwing yourself on a punji stake. So virulent are the anaerobic microbes that hospital emergency room personnel consider human bites to be among the most serious types of trauma. If not treated promptly this kind of wound can result in severe infection, sometimes so bad that the affected finger, or even the hand or arm, has to be amputated. The danger exists even if the spit in question is your own. Cecil knows of one case of a woman who managed to infect herself by chewing obsessively on her fingernails.

So in other words, licking your wounds either isn't so bad or it'll kill you. If you're one of those types with a low tolerance for ambiguity, maybe you should just forget it and try the old Boy Scout method—namely, letting the wound bleed briefly before

bandaging it, thus allowing any contaminants to be washed out of the damaged area.

Remember those fluoroscopes we used to wiggle our toes under in shoe stores? We treated them as toys! Overnight they were snatched out of circulation as health hazards. Are my feet a walking time bomb? Am I doomed?—Solly H., Chicago

If your feet are a walking time bomb, Sol, it's probably because of your daredevil attitude toward changing your socks. At this late date (shoe store fluoroscopes were outlawed in most states in the late 50s), whatever bad is going to happen to you due to youthful X rays probably already has. Studies suggest that cases of radiation-induced leukemia tend to peak 7–15 years after exposure. So if you've made it through this far, you're probably OK.

Count yourself lucky. The nation's 10,000 shoe store fluoroscopes were notoriously poorly regulated during their heyday in the 40s and 50s. The U.S. Public Health Service said the average device emitted between 7 and 14 roentgens per dose, but one study found that some machines emitted as much as 116 roentgens. (For comparison, a person standing within 1,500 meters of ground zero at Hiroshima got hit with 300 roentgens or more—admittedly throughout their entire bodies, not just their feet.) There is a predictable relationship between X-ray exposure and excess cancer deaths. So we can safely say that some people died ahead of their time due to what was basically a sales gimmick.

Shoe store fluoroscopes were typical of the careless and in some cases frivolous attitude toward X rays that prevailed for decades. X rays were once used to treat benign enlargements of the thymus, tonsils, and adenoids, for instance, triggering many cases of thyroid cancer. Pregnant mothers and babies were routinely fluoroscoped by pediatricians, causing leukemia.

In shoe stores, the people really at risk weren't the customers but the salespeople, who were exposed to radiation on a daily basis. (Both customer and salesperson, you may recall, had to lean over the cabinet of the fluoroscope to look in through viewports.) A cursory check has failed to turn up any studies on this score. But when they talk about an old shoe flogger having a certain glow, they probably aren't talking about his tan.

The enclosed clipping from Glamour *talks about a miraculous headache cure involving something called "auto-acupres-*

sure." Supposedly there's this special spot located at the base of the web between the thumb and the forefinger, and if you squeeze it long enough your headache disappears. Well, I had a mild headache the other night, so I did like it said, and sure enough, the pain seemed to go away, for a little while, anyway. What's the deal? Is this just another example of the power of suggestion? Or is it like when you go to the dentist and you pinch yourself to distract yourself from the pain? Or is there actually some remote control switch in your thumb that turns off headaches? Which brings up another topic—do I correctly deduce that there's some connection between "auto-acupressure" and acupuncture? And why does acupuncture work, huh, Cecil? —Ramona F., Los Angeles

Ramona, if you ask any more questions, I'm going to be in dire need of a headache cure myself. No entirely satisfactory explanation for acupuncture has yet been offered, but studies have shown that the needles somehow stimulate the production of brain chemicals called endorphins, which are natural opiates that the brain generates to numb itself out to pain. Other research indicates there may be some sort of nervous connection between internal organs and various areas on the skin surface. Acupuncture expert Dr. C. W. Liu theorizes that nerves from different parts of the body enter the central nervous system at common junction points, and that the acupuncture needles blow the fuse, so to speak, for a particular collection of nerve fibers. (This is hilariously oversimplified, you realize.) Thus needles stuck in your fingers, for instance, may knock out sensation in your face. This notion has yet to be proven; but fortunately it doesn't make any difference as far as you're concerned—few doubt that acupuncture actually works, and that it involves far more than the power of suggestion or mere distraction.

Dr. Howard Kurland, the fellow who came up with the treatment mentioned in the *Glamour* article, has written a book entitled *Quick Headache Relief Without Drugs*, which explains how to apply auto-acupressure at a variety of points on the head and hands. For the Ho Ku point (or, for those who insist on spelling Mao Tse-tung Mao Zedong, "Hegu point") on your thumb, you're supposed to feel for a spot in the muscle mass near the bone leading from the forefinger that tingles or feels unusually tender when pressure is applied. Having found the right location, you

firmly pinch it with your other thumbnail (not the fleshy part of the thumb) as hard as you can stand without breaking the skin for 15–30 seconds. (Note: If this doesn't hurt like hell, you're not doing it right.) Do the same with the other hand; repeat as necessary.

Of two friends who have tried the technique, one claims it did in fact make her headache go away, while the other says she's damned if she can find the spot. Then again, the latter woman has never been able to find her G-spot either, so maybe she's just some sort of abnormal genetic mutant. At any rate, the Teeming Millions are invited to try for themselves.

An Acupuncturist Wishes to Make a (Heh-Heh) Point

As a practicing acupuncturist I would like to add something to your recent discussion of acupuncture. First of all, it is not completely correct to say that "no entirely satisfactory explanation for acupuncture has yet been offered." Traditional acupuncture theory, which involves the body's intricate meridian system and regulation of qi/energy flow, is a very satisfactory and usable explanation of the therapy's effectiveness.

Second, while endorphin release or nerve junction theories may explain some aspects of acupuncture mechanics, they cannot account for the broad spectrum of illnesses which have been found to respond well to acupuncture treatment, including such diverse problems as bronchitis, menstrual irregularities, depression, and high blood pressure, to name but a few. Hopefully future research will enable us to integrate traditional acupuncture theory with modern medical concepts to the satisfaction of health care practitioners in both East and West.

Also, for what it's worth, "Hoku" is the Japanese name for the headache-relieving point you mentioned. "Hegu" is Chinese and "Hopku" is Korean.—Dan P., AcT., Chicago

"Traditional acupuncture theory" is a quaint patchwork of folklore with about as much relevance to current medical practice as medieval European notions about the four bodily humors. While it may be useful as a guide to future research, no scientist would regard it as satisfactory as it stands.

As for Ho Ku/Hegu, I was following Dr. Kurland's usage. You want to argue about it, take it up with him.

And Now This Just In

Applying ice to the Ho Ku point can reduce toothache or jaw pain, according to a recent study. Two researchers at McGill University in Montreal found that "acu-ice" cut the pain in half for 24 of 36 patients studied. You're supposed to wrap an ice cube in cloth and use it to massage the web of skin between thumb and index finger for five minutes or so, or until you get a "deep achy feeling." The treatment is good for half an hour. It's believed the intense stimulus causes the brain to produce pain-killing chemicals that swamp the jaw pain.

Let's see if you can deliver as promised. I'm obsessed with the idea of having interesting cheekbones, and I'm wondering if cheekbones can be implanted, like a prosthesis for a weak chin. If so, what doctor should I see about this?—Cameron E., Dallas

Funny you should mention this, Cameron, but a recent edition of the distinguished medical journal *Self*, available at finer grocery counters everywhere, discusses just such a procedure. It's part of something called "interface" surgery, which permits, and I quote, "the creation of an idealized version of the face you were born with. . . . A too-wide jaw can be narrowed; a long face shortened or a short one lengthened; cheekbones can be built up; a jutting chin can be trimmed back, a weak one given more projection; eyes that droop downward can be tilted up . . ." —you get the picture.

Interface surgery is basically a combination of cosmetic surgery, which deals with soft tissue like skin, and reconstructive surgery, in which bones are reshaped or rebuilt. Reconstructive surgery used to be limited to car-wreck victims and the like, but modern techniques, along with the desperate need of doctors for enough money to support their Maserati habits, have put it in reach of garden-variety uglies such as you and me. The most radical forms of interface surgery involve grafting bone from the skull, hip, or rib, but usually things don't get that drastic. Cheekbone implants, for instance, can be inserted through an incision in the mouth so the scars don't show.

Seeing as you're in Dallas, you might try calling one of the superstars of the plastic-surgery biz, Dr. Fernando Ortiz-Monasterio, a professor of plastic surgery on the Faculty of Medicine at the National University of Mexico City. If that's out, you can get referrals from the following: the American Society of Plastic and Reconstructive Surgeons, 233 N. Michigan, Suite 1900, Chicago, Illinois 60601; the American Academy of Facial Plastic and Reconstructive Surgery, 1101 Vermont Avenue NW, Suite 404, Washington, D.C. 20005; or the American Association of Oral and Maxillofacial Surgeons, 211 E. Chicago, Suite 930, Chicago, Illinois 60611. One word of warning—a full-scale job of cheek rebuilding could cost you five grand. You might want to think about cheaper alternatives: a little rouge, a darkened room, and a couple double Scotches for your date. My sister always told me it worked wonders.

A few months ago my boyfriend started cracking my back. I lie on the floor and he applies brute force up and down my spine, which produces horrible crunching and cracking noises. After this ritual is over, my aching back feels much better. The only trouble with this procedure is that I need it done every night or my back hurts while I lie in bed. My question is, what causes the Rice Krispy noise in my back? Is it harmful over the long run? And why do I seem to need to have my back cracked

nightly? Is this how chiropractors stay in business? Your wisdom on this matter will be greatly appreciated.—Karen K., Evanston, Illinois

Cecil has heard many variations on this basic line of treatment, each one more revolting than the last. I know of one fellow, for instance, who has his wife walk on his back, producing a sensation he claims is on a par with orgasm. Clearly this guy has kinks in places other than his spine. At any rate I should point out that his wife is somewhat on the petite side. This is not something I would want to try with Oprah Winfrey.

You're right in suspecting that what your boyfriend is doing to you is basically amateur chiropracting, more commonly known as spinal manipulation. Many people claim it can produce miraculous results, and while claims of permanent cures are almost certainly exaggerated, the medical establishment has begun to come round to the view that manipulation can help. A 1981 study published in the *Journal of the American Medical Association* found that "rotational manipulation" (a twisting maneuver favored by osteopaths that is performed with the patient on his or her side) definitely appeared to provide short-term relief. The chances for long-term improvement, however, are doubtful.

Why the treatment works is unclear. According to one writer, "the chief benefit is to stretch shortened muscles and tendons, or those that are in spasm, or adhesions or scar tissue that tend to

otherwise tighten." Some osteopaths and chiropractors also claim they're helping unclog blocked nerve impulses somehow. Sounds bogus to me, but who knows.

Cracking noises are common in such treatments. It's not known exactly what causes them, but most suspect they're the result of bony projections or ligaments sliding by one another, or bubbles forming in stretched joint capsules (as with cracking your knuckles). The noise, while unsettling to listen to, is generally harmless. But there is some danger. Spinal manipulation, even when performed by qualified practitioners, remains a controversial technique, and there have been cases of people who have been severely hurt during treatment. For instance, if the cause of your back problems is a protruding disk, manipulation could cause the disk to break open and herniate. If your man *really* throws himself into his work, you could end up with cracked bones, torn ligaments, or worse. Your back is one place where finesse counts for more than youthful enthusiasm. If you plan to keep this treatment up for a while (or hang on to the same boyfriend), it'd probably be wise to have what you're doing checked out by a back doctor or physical therapist.

A few weeks ago a friend of mine had a motorcycle accident and tore himself up a bit. He was unconcious for about a week. During this time his parents signed away his organs in case of death. A few days after that, the doctors lost all hope for recovery and suggested that he be removed from life support. He was removed, then he died, then he was gutted.

My question is, how dead do you have to be before the M.D.'s start eyeing your organs? I refuse to donate my organs for fear that I might be salvaged for parts before I've been given a sporting chance at recovery. Also, who all can sign a person's organs away?—Les W., Dallas, Texas

Sorry about your buddy, Les. Can't say as I blame you for being a little queasy about "organ harvests," as doctors call them. Even a surgeon friend of mine says they're weird.

This isn't going to make you feel any better, but chances are parts of your friend weren't very dead at all when they began dissecting him. Most likely, in fact, his heart was still beating and he was still breathing with the aid of a ventilator. If he were stone cold, his organs would have deteriorated too much to be usable.

What was dead was his brain. The classic transplant donor is an accident victim who has suffered severe head injury while the rest of him remains intact. Brain death can be determined several ways: a "flat line" EEG (little or no electrical activity in the brain), "doll's eyes" (eyes remain fixed straight ahead when the head is moved), no response to ice water squirted in the ear, etc. A neurologist and/or neurosurgeon is almost always consulted before the declaration of brain death is made.

What keeps doctors from deciding you're worth more dead than alive is the fact that the ones who determine you're transplant material aren't the same ones who stand to benefit financially from your demise. The attending physician notifies the organ bank only after he or she has decided your case is hopeless. The organ bank then notifies the transplant team, which sends surgeons out to collect the goods.

It's fairly common to notify the organ bank of a potential donor before the patient is legally declared dead because of the time that's required for transplant preparation. But once in a while people in the organ procurement business really jump the gun. One of Cecil's sources recalls getting a call from a transplant coordinator who was shopping around a potential donor's parts. When asked how soon the donor would be ready, the coordinator replied, "I don't know, he's still breathing"—that is, without the aid of a ventilator. This brought the conversation to an abrupt halt. You can't declare somebody dead if he's still breathing on his own. Fortunately transplant coordinators aren't the ones who decide about these things.

If you don't agree in advance to become an organ donor, either by signing a donor card or the back of your driver's license, donation can be authorized by your next of kin. Right of priority is set by the Uniform Anatomical Gift Act: (1) your spouse, (2) a son or daughter over the age of 18, (3) either parent, (4) any adult brother or sister, or (5) the party who will take custody of your body at death. As a practical matter, even if you signed a donor card, virtually no organ bank will take you without the unanimous consent of your immediate family.

An organ harvest ain't pretty. Time is of the essence; there may be several surgical teams, each waiting to remove a different part. So the body is simply sliced open. The blood vessels for each organ are tied off, preservative solution is pumped in, and the organ is removed. Depending on what's needed, the liver,

kidneys, pancreas, corneas, heart, and even bones and other items may be taken out. When everybody is done, the anesthesiologist switches off the ventilator, and you watch what's left of the patient die. The process is brutal, but the alternative is to do nothing. In that case not only does the potential donor die, so do the would-be recipients.

In Defense of Organ Harvests

In response to your column on organ donation, it amazes me that someone who knows virtually nothing about a sensitive medical issue like this feels compelled to disseminate such biased information. Especially when that information is neither accurate nor appropriate.

In case of irreversible brain death, organ donation is offered to grieving families as an alternative which creates some solace and comfort in an otherwise abominable situation. It turns a senseless death into life. The families are approached by skilled medical professionals trained in the process and sensitive to their grief. The donor, in all cases, has been declared clinically brain dead (legally deceased) before any procurement activities are carried out. And finally, when the procurement takes place, it is done in the operating room under sterile conditions with the utmost respect afforded to the donor.

The reward to the grieving families is the knowledge that otherwise terminally ill patients suffering from end-stage organ failure can receive a second chance at our most precious commodity—LIFE.—Ricky R., RN, technical director, Midwest Region, Musculoskeletal Transplant Foundation, Chicago

I know this is a touchy issue, but it's simply not true that no "procurement activities" take place before the declaration of death. The former transplant coordinator for a major university medical center tells me that in a significant percentage of cases he got word about a potential donor before the donor was actually declared dead. He did not regard this as particularly scandalous, and neither do I. Apart from saving time, calling ahead saves doctors the trouble of having to bother the family if it turns out the potential donor's organs aren't suitable for transplant.

Physically taking charge of the body is a different matter. Most transplant coordinators won't even go to the hospital until the donor is officially dead for fear of looking like vultures.

I'm sure transplant surgeons are respectful, but an organ harvest is one event where neatness is not a priority, at least when it comes to opening up the body. Instead of making, say, a six-inch incision in order to minimize scarring, the donor is "peeled wide open," says a surgeon who's been there. (See "An Improved Technique for Multiple Organ Harvesting" by Starzl et al., *Surgery, Gynecology & Obstetrics*, October 1987, for a technical description.) It has to be that way—there's no time for the aesthetic niceties. The organs themselves, of course, are treated with TLC. You get stitched back together for the funeral, same as with an autopsy.

I am not opposed to organ donation or organ harvests. I think everybody should sign the back of their driver's licenses. But I decline to deal in euphemism when discussing the subject.

Why do theaters put signs in their lobbies warning the audience when a strobe light is used in the performance of a play?
—*C.G., Chicago*

Because they're afraid it might induce a seizure in an epileptic, of whom there are maybe 2,000,000 in the U.S. today. The phenomenon is called a "photoepileptic seizure," and it most often occurs when the light source has a frequency of 15 to 20 cycles per second. Why it happens is not well understood, but it's quite common, and in fact strobes are often used to diagnose epilepsy. In extremely sensitive individuals seizures can even result from the play of light through the trees or on water. Photoepileptic seizures often result from TV viewing, particularly when you get close to the screen to change the channel. It may be going a bit far to say that TV causes brain damage, but it sure doesn't help things any.

Sometimes when I am sleeping I will jerk and wake myself up. My friends say that I am dreaming about falling, and that if I hadn't jerked and woke myself up I would have died. Is this true? I mean, the only thing I could fall off of when I am sleeping is my bed. But I don't believe I could die. Uncle Cecil, is this an old wise tail?—Sandy K., Phoenix

An "old wise tail," whatever that is, no. An old wives' tale, quite likely. However, there's a slim chance you have a serious problem, so listen up.

Many people, when they're drifting off to sleep, experience something called "hypnagogic myoclonus," which we've discussed in this column in the past. This basically consists of sudden full-body twitches, and often it's preceded by a sensation of falling. It's not clear why myoclonus occurs, but it's nothing to worry about.

On the other hand, there's another nocturnal phenomenon called "sleep apnea" that isn't so benign. During apnea you stop breathing for periods up to 20 seconds, and sometimes even longer—in extreme cases, permanently. Apnea is caused by a relaxation of the muscles that keep your airways open when you're awake. To some extent it's normal, and may happen 8–10 times a night. People with severe cases, though, have what's called "obstructive apnea," in which the tongue or even the tonsils can block the air passages. This can cause you to stop breathing as often as twice a minute, or perhaps 1,000 times a night. At best this means you get a terrible night's sleep and go through the day exhausted; at worst you stop breathing altogether and die.

Could this be your problem? Maybe—it's estimated that a million Americans suffer from obstructive apnea. (Apnea is also thought to have something to do with Sudden Infant Death Syndrome, but that's a whole different subject.) You wake up every time apnea occurs, but usually you fall back to sleep almost immediately and remember nothing the next morning. Other symptoms include bedwetting and morning headache. The treatment is pretty grim. They can cut a hole in your windpipe, or else give you a tongue-restraining device that you wear while sleeping.

Sounds pretty bad, huh? Well, don't panic just yet. Most obstructive apnea victims are hypertensive middle-aged men who snore and possibly drink too much. Usually I never miss a chance to be an alarmist, but this is one time I'd say you needn't get too concerned.

Last year I signed up at one of those tanning centers where you lie on a bed surrounded by fluorescent tanning bulbs. I tanned nude in order to get that "glow all over" look, but lately it has dawned on me that I was exposing the family jewels to ultraviolet radiation for 30 minutes at a crack, three times a

week. Did I rearrange my genetic heritage by tanning my pri-
vates—or worse? I don't want to wake up some night with two
little night-lights between my legs.—R.J., Chicago

For Chrissake, R., we're talking about *ultraviolet* radiation
here, which is basically a form of light, not *ionizing* radiation,
e.g., nukes. No matter what happens, your pubes aren't going
to glow in the dark, useful though this phenomenon might be
under some circumstances. But that doesn't mean you should
needlessly expose yourself, so to speak. The skin in the pubic
region is very delicate, and you could be letting yourself in for
sunburn, wrinkling, or worst of all, skin cancer. In other words,
what started out as grapes could wind up as raisins, if you catch
my drift. I trust I need say no more.

In medicine, what's the difference between an -ectomy, an
-ostomy, and an -otomy? My wife believes they mean "hack it
off," "bite it off," and "pinch it till it drops off."—J.W., Chicago

Very funny, J.W., and actually, not all that far off the mark.
According to my *Taber's Cyclopedic Medical Dictionary*, which
for an old deve like me is a constant garden of delights, an
-ectomy is the cutting out of something, as in "tonsillectomy." In
other words, hacking it off. This may be what accounts for the
lingering squeamishness about another well-known operation, the
vasectomy. (In reality, of course, only a tiny portion of the vas
deferens is removed.) An *-ostomy* (actually, *-stomy*) means you
cut a hole in it, or more precisely, furnish it with a mouth or
outlet, as in "colostomy," wherein an opening cut into the colon
creates an artificial anus. (Seems like a waste, considering how
many real ones there are already.) Finally, there's *-otomy* (or
-tomy), which means to slice it up, i.e., an operation in which
cutting is involved. Thus we can distinguish a lobectomy, in
which a lobe, typically of the brain, is removed, from a lobot-
omy, in which they merely jab an ice pick in there and chop
things up a bit.

I'm not kidding, either. You might want to check out a fun
volume entitled *Great and Desperate Cures: The Rise and De-*
cline of Psychosurgery and Other Radical Treatments for Mental
Illness, by Elliott Valenstein. Valenstein quotes a letter written
in the mid-1940s by one prominent lobotomist, Walter Freeman:
"I have also been trying out a sort of half-way stage between
electroshock and prefrontal lobotomy [to treat mental pa-

tients]. . . . This consists of knocking them out with a shock and while they are under the 'anesthetic' thrusting an ice pick up between the eyeball and the eyelid through the roof of the orbit [the bony cavity that contains the eye] actually into the frontal lobe of the brain and making the lateral cut by swinging the thing from side to side. I have done two patients on both sides and another on one side without running into any complications, except a very black eye in one case. There may be trouble later on but it seemed fairly easy, although definitely a disagreeable thing to watch. It remains to be seen how these cases hold up, but so far they have shown considerable relief of their symptoms, and only some of the minor behavior difficulties that follow lobotomy. [That is, prefrontal lobotomy, which typically involved boring holes through the front of the skull. The ice pick operation is called a "transorbital lobotomy."] They can even get up and go home within an hour or so. If this works out it will be a great advance for people who are too bad for shock but not bad enough for surgery."

Freeman went around the country in the late 1940s demonstrating this technique in mental hospitals. These exhibitions reportedly went well for the most part, except on those occasions when the patient bled too much or the ice pick broke off within the orbit or inside the skull. To remedy this problem, the ice pick was later replaced with a sturdier tool and an ordinary carpenter's hammer was used to drive it into the brain.

The first lobotomy in the United States took place on September 14, 1936. By August 15, 1949, the number of victims had reached 10,706. (To be exact, the operation had been performed 10,706 times. I presume you did not need to have it performed on you twice.) In the mid-1950s the popularity of the operation began to decline due to the availability of psychotropic drugs, which offered similar benefits without the trauma. One hopes that today the practice is entirely extinct, but you never know.

Truly, an amazing business. Out on the street, you stick a knife into some guy's brain and they'll give you the chair, do it in your office wearing a lab coat and they'll proclaim you a hero of medicine. And they wonder why people don't like doctors.

I was told my local hospital was home to the practice of one of the nation's leading experts in, catch this, penile fractures. This has me worried, Cecil. How might it happen that I would,

*you know, break it? Is this a hazard of everyday life? Are there
any preventive measures I might take?—M. Toulouse-Lautrec,
Chicago*

Cecil has heard about some stupid injuries in his day, but
penile fracture takes the cake. Offhand you'd think the penis
would be immune to fracture, since it contains no bones. It does
get rigid, however, and things that get rigid can break. At risk
are the *corpora cavernosa*, the two tubelike masses of tissue that
run through the penis. They become engorged with blood during
sexual arousal and cause the penis to become erect. Each corpus
cavernosum is covered with a fibrous sheath, which during erec-
tion gets stretched pretty thin. A sudden jolt in the wrong place
and you could pop like a balloon. In severe cases, the urethra
(through which urine passes) and the outer sheath of the penis
can also be damaged.

Most men recognize their vulnerability and take appropriate
precautions, but a few meatballs evidently don't. As of 1985,
about 180 cases of penile fracture had been reported. In about a
third, fracture occurred as a result of what is called—and leave
it to the French to have an expression for this—a *faux pas des
coit*. Here are some typical cases:

- "A 31-year-old man was having sexual relations approxi-
 mately 1½ hours before admission to the hospital. He
 missed the introitus [and] hit the perineum [the area be-
 hind his partner's genitals]," causing his penis to fracture
 (my italics).
- A 67-year-old minister, obviously taking the parable of the
 good seed to heart, was having intercourse when his "penis
 rammed [the] mattress." He began to bleed profusely and
 experienced pain and swelling.
- "A 26-year-old male . . . experienced sudden acute pain
 and prompt detumescence during vigorous coital activity.
 The episode was associated with an audible cracking sound
 [and] his penis became grossly swollen."

Now, far be it from me to add insult to injury, but how could
you be so klutzy that you "missed the introitus"? Admittedly the
target is small and the visibility isn't the best, but we're talking
point-blank range here.

The other cases are just as goofy. Frequently the victim suffers
the injury while kneading his member in order to reduce an erec-

tion, a technique that in my experience usually has the opposite effect. One moron "awoke during the night with a desire to urinate," whereupon he "hit his erect penis with his hand in order to alleviate this desire." Other reported causes: rolling over in bed, hitting the bedpost, getting caught in your pajamas, falling out of a tree, being thrown against the knob of a motorcycle saddle, and so on.

Fracture always occurs during erection, making you wonder what some of the victims were up to. Consider one case involving a 38-year-old ranch hand. "The [medical] history was vague and difficult to obtain," the reporting physician writes. "The injury had occurred in the corral. It was impossible to get the exact details. . . . His family was of the opinion that he had been kicked by one of the horses." Tell it to Catherine the Great, buddy.

In the old days treatment consisted of splinting, ice packs, insertion of a catheter (sometimes), and rest, augmented by drugs to suppress erection while the injury healed. However, such treatment sometimes resulted in permanent deformation and inhibited sexual performance. Accordingly, many doctors today recommend repairing the damage surgically—not a pleasant thing to watch, judging from the pictures. The operation is fairly straightforward, but there's obviously not much room for error. One thing's for sure: if this ever happens to you, make sure you get a surgeon who's more coordinated than you are.

My neighbor has been advised by her holistic dentist that she needs to have her silver alloy fillings replaced with gold ones. The dentist claims that the mercury in her fillings is leaching out and poisoning her. This sounds like bullshit to me, but now I'm beginning to wonder. Should I worry? Is mercury carving divots in my brain?—M.M., Pasadena, California

Hard to say. On the one hand, looking strictly at the facts, I'd say the only leaching your neighbor has to worry about is her "holistic dentist" leaching bux out of her wallet. On the other hand, they say mercury causes severe brain damage, which would certainly account for some of the mail I've been getting lately. So you're just going to have to decide for yourself.

Most people have the foolish idea that silver fillings are made out of silver. In reality, they're made from an alloy called "amalgam," which is about half mercury, plus some silver and other

stuff. Mercury is poisonous, but until recently scientists thought it stayed put in the filling. Then in 1979 some researchers found that chewing can release small amounts of mercury from old fillings. The question is whether enough of it winds up in your system to do you any damage. Some dentists say it does, and they claim the only solution is to replace the silver fillings with gold or composite resin. The price? Probably several hundred dollars—which strikes some as suspicious. Times have been tough for dentists lately because of the success of fluoridation, which has cut the number of cavities in half. So you have to wonder whether dentists aren't exaggerating the mercury danger to drum up a little business.

Consumer Reports, which ran a long article on this subject in its March 1986 issue, sent a volunteer out to have his teeth tested by an antiamalgam dentist. The dentist took some readings with a mercury-vapor analyzer and said the guy's mercury levels were so high he was lucky he wasn't drooling already. His "highly acidic saliva" was allegedly making things even worse. The volunteer then hiked over to a doctor, who did some more tests, only to discover that the guy's mercury levels were well within normal limits and that his saliva was neutral. So either we have a remarkable case of spontaneous recovery, or the dentist was selling a crock. *Consumer Reports* also found that some of the leading antiamalgam dentists were . . . well, I don't want to get into name-calling, but let's say that with some of these guys, you have to wonder whether "D.D.S." isn't Latin for "student of Donald Duck."

Still worried? Then keep an eye out for these telltale symptoms: tremors, incoherent speech, difficulty in walking, and feeblemindedness. If you got 'em, you've got one of two problems: either you've been poisoned by mercury, or you've had one hell of a Saturday night.

A Dissent

I read your column on amalgam fillings with interest. However, I must tell you that if you had spoken to individuals who had actually had their mercury amalgam fillings replaced you would have written a completely different story.

With 20–20 hindsight I can pinpoint the date when I started

to act like a senile old man. It was immediately after I had a root canal on one of my molars that involved lots of silver. I became absent-minded to a fault, had a poor memory, and suffered frequent bouts of mental confusion. For example, I would be driving home as usual and somewhere en route I would look around and not remember where I was or where I was going. It was so bad I thought seriously about taking early retirement because I was not performing on the job to my standards.

Out of frustration I had my silver fillings replaced with something other than amalgam, in the hope that my mental health would be restored. Immediately afterward I stopped acting like an old man. My long- and short-term memory improved. I became more assertive in my relationships with other people. (Before-and-after handwriting analysis tends to bear this out.)

From my youth I had had a 2–3 second delay in responding to a normal conversation, and my response to a question was always "what?" Both these traits have vanished. It has been two years since I had the silver removed and I have no problem carrying on a normal conversation. I have dismissed any thought of early retirement because I can now meet the requirements of my job with no difficulty.

What a lot of people fail to realize is that having toxic metals in your body in any amount is not good for you. The medical world deals with this in clinical tests by comparing your results to the average, and if your reading is average or less, you're home free. This is wrong. Any toxic metal, no matter how small the amount, should be dealt with as the poison it is, including mercury fillings.—Frank M., Hampton, Virginia

QUIZ #10

55. *Deft, first, calmness, canopy, stupid, laughing, hijack.* These words have a common characteristic. Pick a word from the list below that shares it.
 a. spaghetti
 b. crabcake
 c. violin
 d. larynx

56. Imagine a card game in which there are three cards. Number one is red on both sides, number two is white on both sides, and number three has one red side and one white side. The cards are placed in a hat and thoroughly mixed up. While your back is turned, one card is plucked from the hat and placed on the table. When you turn around, you see that the top side is white. What are the chances that the bottom side is also white?
 a. 1 in 2
 b. 1 in 3
 c. 1 in 4
 d. 1 in 6
 e. 2 in 3
 f. 2 in 5

57. Pick the one that does not belong:
 a. Dione
 b. Phoebe
 c. Miranda
 d. Rhea

58. Another one for baseball buffs. (Cecil likes baseball.) A blessed autumnal event has occurred in three of the following cities. Pick the odd one.
 a. Los Angeles
 b. St. Louis
 c. Chicago
 d. New York

59. Complete this sequence: M, X, Y, Z, P, T, L, . . .
 a. A
 b. K
 c. R
 d. Q

60. According to Scrabble fanatics, what six letters (which conveniently form a word) are the best ones to keep in your rack if you want to score a "bingo"—that is, use all seven letters in one turn for a 50-point bonus?
 a. SATIRE
 b. INSERT
 c. OATERS
 d. RATION

Answers on page 481–82.

Chapter 21

Odds and Ends

I'm disturbed to my Saxon roots each time I see a news item showing the British prime minister's residence at 10 Downing Street. It looks like the entrance to a three-story walk-up. Her Majesty and the family have palaces galore, but it seems the PM has to make do with a "railroad flat." What's the scoop? And while you're at it, who lives at 8 and 12 Downing? Are they the kind of folks who improve the property values, or do they talk trash and play the stereo all night?—R. Lee H., Evanston, Illinois

The situation is definitely scandalous, R. Lee, and I'm glad you bring it up, because I've been meaning to say something to Mrs. Thatcher about it. Ten Downing is unquestionably a dump, and don't think the Brits don't know it. Although a few of them go on about how the prime minister's low-rent abode exemplifies the U.K.'s egalitarian ways, others aren't afraid to call a hovel a hovel. One writer describes the neighborhood as a "narrow, dingy street"; the most charitable term another can come up with is "nondescript." Yet another says the prime minister's residence "can hardly be regarded as consistent with the dignity of his high office on the one hand, or the capital of the British Empire on the other." The last remark, I should note, was made at a time when one could safely refer to the prime minister of England using the masculine pronoun and to the British Empire without smirking. There are some who would say that Downing Street's unprepossessing appearance is all too consistent with the state of the empire today.

It is a tribute to England's long tradition of public service that

433

its citizens continue to run for office knowing full well that they may have to spend five years in a tenement if they get elected. (You may think I am exaggerating about this, but think again. A Labor member of Parliament named Austin Mitchell was recently quoted as saying, "This is a lousy, undoable job which ruins family life, which you can never live up to, but which is done mainly out of dumb, depressing duty." Until 1987 MPs made less than $30,000 a year. Now it's $36,000.) Ten Downing looks like a three-story walk-up because that is basically what it is, with an attic floor set back on top. Its exterior design can only be described as severe, incongruously so in view of the rococo ornamentation of some of the other government buildings in the area.

Fittingly located on a dead-end street, 10 Downing was built in the late seventeenth century by Sir George Downing on what turned out to be a peat bog, which over time caused many of the buildings on the street to settle and crack. King George II, knowing a lemon when he saw one, tried to unload the place on the first modern British prime minister, Robert Walpole, in 1732. It was meant to be a personal gift, but the canny Walpole, fearing he might be stuck with the joint for the rest of his mortal existence, begged the king to make it one of the perquisites of the First Lord of the Treasury, a post traditionally held by the prime minister. It has been the PM's official residence ever since, and is also used for things like cabinet meetings.

The British government made a few concessions to the twentieth century in the early 60s, when the interior of the home was gutted and rebuilt and the whole thing added on to considerably in the back. Nonetheless, during Harold Wilson's second term his wife Mary refused to spend another night in the place, and they wound up finding lodgings elsewhere. Margaret Thatcher, who is no fool, stays elsewhere when she can. To prevent the public from finding out any more about this sorry state of affairs than they already have, the police have barricaded the end of the street. Ostensibly this is to guard against assassins, but you can't fool me.

Ten Downing does have the advantage of being convenient. It's across the street from the Foreign Office and just a few steps from Whitehall, the street where many government offices are located. The neighborhood also isn't what you could call overcrowded. Number 10 is one of only three remaining houses on

Downing, the other two being numbers 11 and 12 (all of which adjoin—having even and odd numbers on opposite sides of the street is an American practice). Number 11 is occupied by the Chancellor of the Exchequer, and number 12 is the office of a personage called the Chief Government Whip. I tremble to contemplate the latter's duties, but given the penitential nature of everything else in the vicinity, I can't say his job seems inappropriate.

Two questions: (1) More than once I have heard that World War III could be started by a flock of migrating geese showing up on a radar screen. Is this true? (2) Is it true that the average hurricane has more energy than the average hydrogen bomb?— Curious, Chicago

1. You refer to one of the great legends of the nuclear era. The story, which may be apocryphal, is that in the 1950s a flock of Canadian geese showed up one day on radar screens in the DEW (Distant Early Warning) Line, the string of radar pickets maintained by the Pentagon above the Arctic Circle. Jumpy technicians supposedly interpreted the blips as Russky bombers, and until cooler heads prevailed several trembling fingers were poised above the buttons that would have reduced the Soviet Union to a puddle of molten glass.

Whether or not this actually happened, there are several well-documented instances of nuclear near-misses that really did occur. In 1960, for instance, nuclear alerts were reportedly triggered by meteor showers and lunar radar reflections. Perhaps the most notorious incident occurred on June 3, 1980. At 2:26 in the morning, alarms went off in the Strategic Air Command's underground command post in Omaha as display screens showed two Russian sub-based missiles heading toward the Land of the Free from the North Atlantic. Klaxons awakened bomber and missile crews, and 76 B-52s were prepared for takeoff. Meanwhile, headquarters checked with remote radar stations to see if they could confirm the enemy contact. For 60 seconds things looked tense, but by then the radar stations were reporting that they could find no sign of the Russian missiles. Command post honchos quickly concluded that there was a malfunction in the computer system that relayed battle data, and the bomber crews were ordered to shut off their engines. The alert was terminated at 2:29, 3 minutes and 12 seconds after it began. Engineers even-

tually traced the problem to a 46-cent computer chip that had shorted out.

There was a great flurry in the media about the close call, but a Senate inquiry later concluded that the nation hadn't really come all that close to war. Still, investigators also found that false alarms of one kind or another were a constant occurrence, 3,703 having been reported in the 18 months prior to June 1980. Most of these were minor, but a few weren't. For example, on November 9, 1979, some hapless minion inadvertently fed a training tape into the main computers at the North American Aerospace Defense Command, giving a false indication of a massive missile attack and scaring the poo out of U.S. military men the world over. Pentagon officials admit that equipment failures cause two or three false alarms every year. Like their counterparts in the nuclear power industry, the officials also claim that the fact that these scares have yet to result in World War III proves the system works. But other say it all shows that the U.S.

defense computer network is dangerously unreliable. The question has yet to be satisfactorily resolved.

2. The average hurricane generates energy roughly equivalent to 400 20-megaton bombs exploding in one day—the equivalent of all the electrical energy used in the U.S. for six months. The biggest known H-bomb, you may remember, is less than 100 megatons. Incidentally, the word "hurricane" comes from *huracan*, the name of the ancient Mayan storm god. But you probably already knew that.

For a good many years, Spain had a virtual monopoly on the importation of gold from the New World. Although some of it wound up on the ocean floor (witness recent discoveries near Florida), we know that an awful lot actually made it to the mother country, helping to make Spain one of the richest and most powerful nations in Europe at the time. Today, of course, it is neither. My question is, what happened to all that gold? I've considered some of the possibilities, but I'm not convinced: (1) The ship captains stole it. (2) The kings of Spain made lousy investments. (3) The Portuguese (or the French or the Italians or the North Africans or somebody) stole it. (4) It was buried somewhere, and the folks who buried it forgot where. Since I assume the Spanish have not developed a gold-fueled nuclear device, thereby converting matter into energy, I think I've run out of possibilities. Qué paso?—Joseph M., Los Angeles

The average person reading this question would probably figure you've got filings in the brain pan, Joe, but in fact you have asked a question that baffled Spaniards at the time and has fascinated historians since. A couple things to keep in mind: first, while the flood of gold into Spain in the sixteenth century seemed like a big haul at the time, by modern standards it was a fairly trivial amount. Total world gold production during the 1500s is estimated to have been around 36 tons; from 1900 to 1976 it was 76,428 tons. (Which still isn't all that much, incidentally. It's claimed that all the gold that's ever been mined would fit into a cube 18 yards on a side.) Second, you're right in guessing that a lot of the gold was stolen. One researcher estimates that 10 to 15 percent of the New World gold intended for Spain never got there due to theft, piracy, or other mishap.

Nonetheless, that leaves 85 to 90 percent that did make it, along with tons of silver, which began to be mined in quantity

toward the end of the sixteenth century. Where did it go? The answer has to do with the slippery nature of money. The importation of New World gold into Spain coincided with a corrosive inflation that has come to be known as the "price revolution." Although prices had dropped steadily during the 1400s, after 1500 they began to rise dramatically—300 percent by 1600, according to economist Earl Hamilton, who wrote a well-known book on the phenomenon. The reasons for this are complex, but it seems clear that at least in part it was a matter of a sharply increasing amount of money (in the form of silver and gold) chasing a relatively fixed output of goods and services, thus bidding up the price. Among other things the higher prices meant Spanish goods became uncompetitive on European markets. Even the Spanish themselves began buying foreign products, resulting in a lot of cash leaving the country. In addition, inflation stifled local investment, with the grandees spending their dough on conspicuous consumables instead.

For the latter part of the 1500s and on into the 1600s Spain was a debtor nation, spending more abroad than it took in. The result was a net outflow of gold and silver. Attempts were made to restrict the export of precious metals, but without much success. In the end it all simply dribbled away. The problem was

that the conquest of the New World left Spain with a lot more *money*, but not that much more *wealth*, if you follow me. They didn't realize that until too late, and suffered centuries of poverty as a consequence.

Spanish Gold Today: Still Dribbling

Your article on what happened to Spain's gold left out some recent developments. During the Spanish Civil War the Republican side was supported by socialist volunteers from many countries, including Russia. As the war deepened it looked like the Republicans might lose. So the Russians came up with a brilliant suggestion: why not send the Spanish treasury of gold, silver, and precious stones to Papa Stalin where it would be safe? After all, weren't the Russians laying down their lives for Spain? The Spaniards bought it. Today the treasury of Spain is safe in the hands of the Soviet Union. I cannot prove this but I believe it.— Ralph F., Washington, D.C.

There are lots of apocryphal stories like this floating around, Ralph. In *Treasures of the World* (1966), Robert Charroux claims the treasure of the Spanish Republicans, or at least *a* treasure, is buried on a beach near the town of Argeles, France. Says Charroux, "it is a big, indeed very big treasure, originally intended for the maintenance of a Communist *maquis* force. Only eight people knew of its existence and where it was deposited. Then came the 1939–45 war: several holders of the secret were killed and those who returned were never able to find the hiding place again." Though the treasure supposedly lies only seven feet underground, the site is subject to frequent flooding that has altered natural landmarks. Postwar construction in the area has further confused matters. Charroux says "hundreds of thousands of people, including the French minister Monsieur Jules Moch" have sought the treasure, all in vain. I take that as a pretty good sign there's nothing there, but you're welcome to go look for yourself.

People are probably all worn out hearing about the Statue of Liberty, but isn't it true you could once go up into the arm and come out by the torch? Wasn't there a lookout there? After all the publicity during the centennial, I began to realize they're hiding something from us about this. Thanks. And I've always

loved your column. Keep it up.—Michael S., Hollywood, California

No problem, Mike, that's why I eat oysters. As for the S. of L., you're right—in the early days the torch was open to the public. However, only a minority thereof was able to take advantage of the opportunity. The platform around the torch could accommodate just 12 people, and was reachable only by a single 54-rung ladder. By 1917 crowding had gotten to be such a problem that the authorities decided to end public access, opening the torch only to journalists, photographers, and others with friends in high . . . well, you know what I mean.

The closing gave rise to a rumor that the statue had been damaged the previous year by a massive explosion in a nearby Jersey City ammo dump that had been touched off by German saboteurs. The rumor was apparently untrue, but another event in 1916 did result in a serious weakening of the arm. Sculptor Gutzon Borglum, the same guy who carved the Mount Rushmore memorial, rebuilt the existing copper flames of the torch by inserting 250 panes of amber glass, which were then illuminated from within. Whatever might be said for this from an artistic standpoint, it was a practical disaster. Water leaked in past the improperly sealed glass and severely corroded the iron armature inside. The upraised arm had been installed about 18 inches out of true to start with, for reasons that have never been entirely clear, and by the time restoration began in the 1980s, Ms. Liberty was in serious danger of going the way of Venus de Milo. The rehabilitation rectified the problem, but the park service has not been tempted to open the arm again.

Can you tell me why they changed the name of the U.S. space center from Cape Kennedy back to its original name, Cape Canaveral?—S.M.J., Atlanta, Georgia

Sure, but let's get our facts straight first: they didn't change the name of the space center, they changed the name of the *cape*—i.e., the land under the space center (or under part of it, anyway). The NASA launch facility continues to be known as the John F. Kennedy Space Center. The whole confusing business got started back on November 27, 1963, shortly after JFK's assassination, when Lyndon Johnson was casting about for a suitable memorial for the slain president. Jackie Kennedy suggested it might be appropriate to rename Cape Canaveral—after

all, her husband had been a big space-exploration buff, and had launched the Apollo program that would eventually put a man on the moon. Now, your average president would have taken "Cape Canaveral" to mean merely "the Cape Canaveral launch facility," which at the time consisted of two installations—Station Number 1 of the Atlantic Missile Range (operated by the Department of Defense) and the NASA Launch Operation Center. LBJ, however, was never one for halfway measures. In an exhibition of his legendary arm-twisting skills, he got the Department of the Interior's Board of Geographic Names to agree to changing the name of the *cape itself* in a record three hours, enabling him to announce the rechristening of both cape and center in his Thanksgiving Day message.

Nobody objected to renaming the space center, but quite a number of Floridians were peeved about changing the name of the cape, which had been called Canaveral for more than 400 years. It had been sighted by Ponce de Leon in 1513, was named by other Spaniards not long after that, and appears as Cape Canaveral on the earliest French and Spanish maps of the area. ("Canaveral," incidentally, is supposedly Spanish for "place of tall reeds.") The nearby towns of Cape Canaveral and Cocoa promptly sent resolutions protesting the change to LBJ and the governor of Florida, but in the hysterical atmosphere following the assassination nobody paid much attention. Nonetheless, state historical groups and others persevered in their efforts to get the old name back, and eventually a resolution to that effect was introduced in the U.S. Senate. Witnesses at a committee hearing on the matter were uniformly in favor of resurrecting the name, but Congress was reluctant to act, presumably because it might appear disrespectful to the late president. Finally, having gotten fed up with waiting for Uncle Sam to do anything, the Florida legislature passed a resolution stating its intention to try to get the name changed on maps regardless of what Congress did. What sort of behind-the-scenes scrambling followed this declaration is not clear, but on October 9, 1973, the Board of Geographic Names unanimously agreed to restore the old name. Ted Kennedy wrote a brief letter saying his family "understand[s] the decision," and that was that.

I need the true story on the buried treasure on Oak Island, Nova Scotia. From what I have read it was buried in a deep

shaft beneath layers of wood, concrete, and other materials. As if that wasn't enough, there are also booby traps, with two different underground streams flooding the shaft whenever someone tries to dig up the treasure. Has anyone finally succeeded in getting the treasure out? Who put it in there so ingeniously? And how the hell did the owner ever expect to retrieve it?—J.P., Washington, D.C.

The short answer to your letter, J.P., is no, beats me, and good question. Despite the loss of at least six lives and the expenditure of millions of dollars, virtually nothing of value has ever been recovered from Oak Island, the setting for one of the most famous and arguably one of the most bungled treasure hunts in history. Although searching continues sporadically, the site has been so thoroughly blasted, tunneled, and flooded out that the chances of anything substantial being found are remote. Which is too damn bad. There was almost certainly something there at one time, and even if it wasn't necessarily doubloons and pieces of eight, the cache as a whole nonetheless had enormous historical interest which is now lost forever.

What is now called the "money pit" was first discovered in 1795 by three boys. While exploring the island one day, they noticed a huge oak tree with a big forked branch from which hung an old tackle block. Directly beneath this was a shallow depression in the earth. Recalling the local legend that pirates had buried treasure in the area, the boys immediately com-

menced digging. About two feet below the surface they found a tier of flagstones. When they removed it, they saw they had uncovered an old shaft that had been filled in with loose dirt. Ten feet down they found another obstruction, this time a platform of oak planks. They patiently pried this up, only to find additional platforms at the 20- and 30-foot levels. (Some accounts differ on these details.) Recognizing that they were onto Something Big, the boys decided to knock off until such time as they could get more help.

In 1803 or 1804, the boys, now men, let a well-to-do friend in on the secret. He rounded up some investors, hired laborers, and began digging anew. Every 10 feet the searchers found additional wooden platforms and/or layers of coconut fiber, putty, charcoal, and so on. At 80 or 90 feet—nobody is quite clear which—the workers found a flat stone about 3 feet by 16 inches marked with mysterious characters. At 95 feet somebody jabbed an iron bar three feet into the earth, which had become very soggy, and struck something solid. But rather than keep digging, the men decided to knock off for the day.

Big mistake. When they came back the next morning, they found the shaft filled with 60 feet of water. Bailing proved fruitless. A primitive pump was equally unhelpful. So the following spring the men decided to sink a parallel shaft, on the off chance that the water was coming from an underground spring that they could bypass. The workers dug down 110 feet without incident, but shortly after they started tunneling horizontally toward the money pit water burst in and flooded the second shaft to the same depth as the first.

The search was abandoned until 1849. A new company then returned with more money and another crew. Having consulted with the surviving veterans of the original search, the workers reexcavated the money pit down to 86 feet. Predictably, it flooded again, so they began drilling with an auger. At 98 feet the auger went through a layer of wood, dropped a foot, and then went through more wood, 22 inches of loose material, wood again, 22 more inches of loose material, two last layers of wood, and finally clay. When the drill was brought up workers found three small gold links like those of a watch chain. Hot dog, the searchers exulted, buried treasure!

The following spring the searchers dug another parallel shaft, which flooded like the others. After efforts at pumping failed,

they discovered (somewhat tardily, in my opinion) that the water in the shaft was seawater, which rose and fell with the tides. They concluded that the original builders had dug a special flood tunnel from the money pit to the sea as a booby trap. Upon checking a nearby beach, they found an elaborate network of stone channels buried under tons of coconut matting between the high- and low-tide lines. Five feeder channels converged on a main tunnel, which then headed inland. The matting evidently acted as a giant sponge to keep the channels filled with seawater.

An attempt to build a cofferdam to keep the sea out failed. The searchers then dug a couple shafts in between the beach and the money pit in an effort to block the main tunnel. No luck. Finally they decided to dig another parallel shaft back at the money pit. God knows what they expected to accomplish, but the result was another fiasco. The workers got down to 118 feet and began to tunnel toward a point directly underneath the money pit. Before they got there, though, there was a tremendous crash and a massive cave-in. Apparently the bottom of the money pit had collapsed into the new shaft, scattering whatever goodies had been stored there. Later—it starts to get a little intricate here—some came to believe there had been a large open chamber beneath the stash, and that the treasure might have fallen another 40 or 50 feet farther down.

Things got even more scrambled in the succeeding decade. Several more shafts were dug—there have been 37 to date, by one count—along with a number of tunnels and boreholes. These succeeded mainly in destroying the structural integrity of the original pit. The workers also kept very poor records of their excavations, greatly complicating matters for later searchers. At one point workers dug out the money pit to the 108-foot level, and then began digging sideways. One laborer felt the earth give beneath his feet, and when he probed with a tool, found a large cavity below. But incoming water prevented him from exploring further.

Work ceased in 1867 but resumed in 1893. In 1897 diggers working in the money pit found a 2-½-foot-wide tunnel at 111 feet filled with stone, gravel, and sand, through which seawater flowed. They believed that this was the original pirate flood tunnel. Efforts to block it were, as usual, unsuccessful. Later, while drilling in the pit, searchers found oak and iron at 126 feet, iron at 138 feet, cement (possibly man-made) at 153 feet, and iron

again at 171 feet. At one point the drill went through several feet of what seemed to be loose metal in pieces. (Cecil has his doubts, frankly.) A tiny piece of parchment with parts of the letters *ui*, *vi*, or *wi* written on it in India ink was also found. Evidently the money pit was much deeper than anyone had previously supposed.

But getting to the treasure remained as problematic as ever. At one point red dye was dropped into the money pit. Instead of seeping into the ocean on the north side of the island where the stone channels had been found, it came out at three places on the south side, indicating the existence of a second flood tunnel.

More attempts followed in later years. Even Franklin Roosevelt invested in one venture in 1909. (It turned up nothing new.) In 1931 a shaft was sunk to a depth of 163 feet in the general vicinity of the money pit, whose original location by this time had been lost. But all that was found were various tools, an anchor fluke, and other odds and ends.

Finally in 1936 a semiretired American businessman named Gilbert Hedden decided to get serious. He ran power cables out to the site and installed modern pumps and other equipment. He then reexcavated the 1931 shaft to a depth of 170 feet and found—zip. The next year he dug a new shaft a short distance away down to 125 feet. The discovery of debris from previous expeditions convinced him that he had now found the site of the original money pit, but nothing even remotely treasure-like turned up. Hedden abandoned the search, concluding that in all the digging and flooding and whatnot over the years, the treasure had sunk down to 160–175 feet below ground and no doubt was thoroughly scattered about. That is, if there were ever any treasure at all.

Ah, but hope springs eternal. Over the last 50 years searchers have continued to sacrifice their money and in some case their lives in pursuit of Oak Island's chimerical riches. In 1965 three or four men (accounts vary) were killed in an accident.

Since 1971 exploration has been conducted by a Montreal-based outfit called the Triton Alliance, which has been operating on the theory that the money pit was some sort of pirate savings bank, with side tunnels containing the loot of individual buccaneers leading off from the main shaft. I know of no evidence to support this view, but as of early 1985 they were still at it. What

is going on today at the site I frankly don't know; a spokesperson for the Alliance declined to answer any questions.

The area around the money pit today is basically a huge mess of abandoned shafts and boreholes. The precise location of the pit is no longer known. (The oak tree with the old tackle block disappeared long ago.) The stone tablet with mysterious markings discovered in 1804 disappeared sometime in the early twentieth century after kicking around for years; typically, no photos or rubbings were preserved. After it was gone someone claimed the markings meant, "forty feet below two million pounds are buried." It's a shame, but we'll probably never know for sure.

Cecil, O Font of Inestimable Wisdom, please tell me about the christening of ships. If a world-famous celebrity (say, Cecil Adams) is about to christen the USS Straight Dope, but at the last moment, a dangerous psycho runs up and grabs the Dom Perignon, hits the ship, and christens it the USS Dear Abby, does that mean the vessel is really named after the world's lamest advice column? Can it be rechristened, or was it ever truly christened in the first place? I need to know soon, Cecil—my prankster cousin pulled this stunt with my new 90-foot yacht, now called the Heavy Brick.—Zeke K., Evanston, Illinois

Zeke, you are surely old enough to realize—and in any case Ronald Reagan has made it abundantly clear—that what you *say* in this world has little or nothing to do with reality. It's what you write down on the official government form. We're talking federal government now, you understand. Most states do not care what you dub your tub as long as you pay the registration fee. In such cases the name of the boat depends entirely on the whim of the mope wielding the paintbrush and stencil kit.

The naming process is more formal for boats registered with the Coast Guard, as is required for certain commercial vessels. Among other things you have to fill out Form CG-1258, Application for Documentation or for Surrender, Replacement, or Redocumentation, wherein you state the proposed name of the boat, along with various other things that we need not go into right now. You send this in with the appropriate fee and the Coast Guard sends you back another form assigning you an official number and telling you to affix it to the boat, along with the name and hailing port. That done, you send in yet another form and the gummint sends you back Form CG-1270, Certifi-

cate of Documentation, which officially declares the name of the boat to be whatever you wrote down on Form CG-1258.

If you want to celebrate this momentous occasion with a champagne christening, or for that matter with a druidic rite involving public fornication and drunkenness, well, that's strictly up to you. If you want to change the name of the boat later on, you have to fill out even more forms, the details of which I will mercifully spare you. Bureaucracies being what they are, however, the official boat *number* is unalterable forevermore. In short, you can tell your prankster where he can cram his Heavy Brick.

I taped a "Moonlighting" episode that ABC broadcast in D.C. on either September 23 or 30 of 1986. When I finally got around to watching it, I noticed that a frame of letters had been inserted into the footage of an explosion. These are the letters:

<div align="center">

VTILT URKTC VFCFI
VTILO VTOIL ZZTT
XIGVSSO BL?

</div>

What does it mean? Is the "Moonlighting" production company responsible for this or was it done later? What's the dope on this subliminal message?—Mark S., Alexandria, Virginia

The wheels of the Straight Dope grind slow, friends, but they grind exceeding fine. By dint of Herculean investigative effort, punctuated by frequent car chases, gunfire, and snappy asides to the camera (I like to get in the mood for these things), I have solved the mystery of the secret message. Here's the whole sordid story:

At my request, Mark S. supplied a videotape copy of the message, which appeared in an eppisode entitled "The Man Who Cried Wife." Sure enough, during an explosion, we noticed an odd flicker. Reviewing the tape in slo-mo, we found the message described above. It consisted of white letters on a black background, and lasted just a single frame.

Cecil was initially sure this was going to turn out to be some publicity stunt dreamed up by the ratings-hungry moguls at ABC. The ABC people, however, claimed they had no idea what was going on. We sent them a copy of the cassette. They said it was damaged in transmit—a likely story. We sent them another one. Hmm, they said.

Meanwhile, the Straight Dope production department endeav-

ored to decode the message—in vain. The problem was ZZTT. No four-letter English word, so far as we could tell, consists of consecutive pairs of double letters. We refused to even consider the possibility that the message was written in Maltese.

After a considerable passage of time, and no doubt following many frantic conversations with highly paid crisis-management consultants, ABC declared as follows: 'twarn't us. The message, they said, had been inserted into the show after being transmitted by the network.

Convinced that ABC was trying to cover up some fiendish plot, I asked the Teeming Millions to check their own copies of the episode, figuring that if the same message had appeared in several cities, I would have enough evidence to petition the Justice Department to appoint a special prosecutor. The Teeming Millions responded with enthusiasm. It soon became apparent that the message had not appeared in any city outside the nation's capital. Jeepers, we thought, spies!

Then we checked with a reader in D.C. and made a devastating discovery: the message hadn't appeared in Washington either. In fact, it was now clear, it hadn't appeared anywhere except on Mark S.'s tape. Was it a visitation by aliens? Or, worse, was Mark putting his Unca Cecil on? He assured us he would rather be boiled in oil and die horribly. (Actually, he did not use quite those words, but the thought ran through our mind.)

Enlightenment came from Jack Blessing, the actor who plays the character MacGillicuddy on "Moonlighting" and, as befits a major figure in the entertainment industry, a devout reader of the Straight Dope. In addition to confirming that there was no message, Jack noticed something else: a few minutes after the alleged message, there was a commercial for "Project Literacy U.S." While a voice intoned, "Imagine that if you can't read this, you won't make a good living. . . ," there appeared four lines of scrambled letters. Three of the lines constituted the message on Mark S.'s tape.

We called Mark. By and by we established that (1) when he first viewed the show, he noticed nothing unusual; (2) he recorded the show as he watched, blipping out the commercials; (3) a friend first saw the message during a later viewing of the tape. We were forced to conclude that the message was nothing more than an incredible technical glitch.

I am, needless to say, inconsolable. I thought sure there was a

Pulitzer in it for me, to say nothing of the thanks of a grateful nation. Now it turns out the Republic was safe all along. What a bummer. Then again, what if those creeps at Project Literacy . . . but I refuse to even consider the thought.

I have worried for some time about what city in the U.S. houses the largest park. My worries began when I moved to Philadelphia, and a city map said Fairmount Park was the largest city park. Then when I came to Los Angeles, another guidebook told me that Griffith was the largest municipal park. Finally, I gave my organizational communication class at USC the assignment of finding out the Truth, and they told me it was Golden Gate Park in San Francisco. We have called park services, geography professors, and chambers of commerce, and are truly stumped. How about the straight dope?—Eric E., Professor of Communication, University of Southern California, Los Angeles

Your class said the largest park was *Golden Gate*? Golden Gate Park (either 1,107 or 1,017 acres, depending on who you think made a typographical error) is not only not the largest city park, it isn't even in the top 10. (Remember, we're talking city parks—Golden Gate National Recreation Area, which is federally administered, is 24,000 acres.) If the feebs in your class had bothered to check with the L.A. parks and recreation commission—which, for Chrissake, is a *local call*—they'd have found that Griffith Park comprises 4,107.87 acres. Still, Griffith can't beat out Philly's famed Fairmount Park, which boasts 4,618 acres, according to the Fairmount Park Commission. Admittedly 379 acres of this consists of the Schuylkill, which happens to be a river. Even deducting this, however, we have 4,239 acres of dry land, enough to beat out Griffith.

But Fairmount isn't the biggest city park either. It isn't even second biggest. The largest city park in the U.S. is South Mountain Park in Phoenix, Arizona, which presently comprises 16,169 acres and eventually will encompass 16,455 acres. Second place goes to another Phoenix park—Phoenix Mountain Reserve, now 7,358 acres, eventually to be 7,750 acres.

If it makes you feel any better, park acreage is probably second only to city population when it comes to exaggeration, misinformation, and fraud. The one comprehensive list I've seen, put out by the National Recreation and Parks Association, is filled with

gross inaccuracies and omissions, skipping not only the two Phoenix parks but two of the largest parks in New York City. It does include N.Y.C.'s Pelham Bay Park (2,117 acres), probably the nation's fifth-largest city park, and D.C.'s Rock Creek Park (1,754 acres), probably sixth. FYI, Chicago's Lincoln Park has 1,185 acres, which probably puts it around twelfth, and New York's Central Park, at 840 acres, comes in around fifteenth.

I am curious about what it is that makes someone legally married. Is it the purchase of a license? Can two people be married without a third party "marrying" them? Do ministers, etc., have some number somewhere that makes it legal when they sign the certificate? Is there a copy filed somewhere that tells the world you are married?—Patricia A., Chicago

The license is just permission to get married, normally within three to nine days after issuance. Actually getting married means performing whatever ritual is prescribed by your sect, Indian tribe, or native group, or, should none of the preceding be relevant, exchanging vows before a judge or authorized public official. Usually some third party solemnizes the proceedings, but if your church happens not to require one, you and your prospective spouse can simply marry each other, fill out the marriage certificate, and mail it to the county clerk. Ministers and the like aren't licensed; should the officiant in fact be bogus, the marriage is still valid, as long as you believed his/her credentials to be genuine. Wherefore do not inquire too closely into such matters. The county clerk mails a copy of both license and certificate to the state department of health, which I suppose tells the world you're married, after a fashion.

Why do we nod our heads for "yes" and shake them for "no," instead of the other way around? Are there any peoples who reverse the gestures?—Have to Know, Chicago

You may not believe it, H., but there are a lot of people out there right now who think this is the silliest question they have ever heard. Little do they know. No less a personage than Charles Darwin looked into the matter and wrote up his findings in a book called *The Expression of the Emotions in Man and Animals* (1872). Chuck was interested in finding out whether there were universal gestures and expressions, so he sent out a questionnaire to missionaries and whatnot that, among other things, asked

what gesticulations the locals used to convey "yes" and "no." Nodding and head-shaking turned out to be pretty common, but there were some striking exceptions. For example, certain Australian natives, when uttering a negative, "don't shake the head, but holding up the right hand, shake it by turning it half round and back again two or three times." One Captain Speedy—I cannot say the name inspires much confidence—told Darwin that the Abyssinians said "no" by jerking the head to the right shoulder and making a slight cluck, while "yes" was expressed by the head being thrown backwards and the eyebrows raised for an instant. The Dyaks of Borneo supposedly raised their eyebrows for "yes" and slightly contracted them, "together with a peculiar look of the eyes," for "no." Eskimo nodded for "yes" and winked for "no."

I don't know of any culture that completely reverses the meaning of our nod and head-shake gestures, but the Turks come close—they say "yes" by shaking their heads from side to side, and "no" by tossing their heads back and clucking. Head-tossing for "no" is also common in Greece and parts of Italy, such as Naples, that were colonized or heavily influenced by Greeks in ancient times.

Still, cultures ranging from the Chinese to the natives of

Guinea nod and shake their heads like we do, leading Darwin to believe that the gestures were innate to some extent. He noticed that when babies refused food they almost always turned their heads to the side, whereas when they had worked up an appetite they inclined their heads forward in a nodding gesture.

Other gestures are much more arbitrary. One of the most notorious of these is making a circle with thumb and forefinger, which to Americans and most Europeans means "OK." In Brazil, however, and some other places, it means something on the order of "screw you." (The actual term is more pungent, you understand.) Cecil learned this to his sorrow on a little jaunt he made to São Paulo some years ago. I seldom make the OK gesture at home, but once I got down south and learned its obscene significance I felt a sudden compulsion to make it 20 or 30 times a day, thus antagonizing Brazilians by the thousands. It was only with the most determined effort that I was able to stifle this low impulse and make the thumbs-up sign that, in Rio as in the U.S., signifies everything's copacetic.

Which reminds me. You probably think we make the thumbs-up gesture because that's what the Romans used to do when they wanted to spare a fallen gladiator, right? Wrong—that's a myth based on a succession of mistranslations. The truth is when the Romans were feeling merciful they *hid* their thumbs in their clenched fists (symbolically sheathing their swords, some historians believe). To have a guy offed they didn't turn thumbs down but rather extended their thumbs in a stabbing gesture. For whatever reason, though, thumbs-up today means OK just about everywhere—except in Sardinia or Greece, where it means "screw you." I'm told that for rookie travelers this makes hitchhiking in Athens a pretty lively experience. *Caveat viator.*

And Now This Message of Moral Uplift

With reference to your column on gestures, did you leave out or just not know that in Greece the five fingers spread out and thrust forward at someone means "shit in your face"? I learned it as a child while living in Greektown and it really came in "handy" at times.—Had to Tell You, Chicago

Thank you for sharing that with us, H. Just shows you how the Greeks continue to enrich civilization.

Crossed Signals, Part One

FYI regarding gestures—Bulgarians nod when they mean "no," shake their heads to signify "yes." Very confusing customs, leading to many problems in matters social, amatory, etc. Maybe something that they picked up, like assassins, from Turkey. —Dick L., Chicago Tribune

Not to knock your romantic prowess, Dick, but when those Bulgarian girls shook their heads "no," they probably *meant* "no." R.R. of Chicago reports the same phenomenon. Maybe you guys should invest in a little Aqua Velva.

Crossed Signals, Part Two

I'd like to add some info to your column on gestures. The misunderstanding regarding the thumbs-up, thumbs-down gestures and ancient Rome began with a nineteenth-century French artist named Jean Leon Gerome and his painting Pollice verso. *Gerome isn't a household word today, but he was a painter of international renown in his time, the leading academic artist of the period. He was also a learned classicist who specialized in archaeologically correct history paintings. The Jenney Latin textbooks of my misspent youth used to use Gerome's work to illustrate Roman customs. His* Pollice verso, *in which a gladiator stands astride a fallen foe and looks up to the Colosseum's bleachers for the crowd's verdict, was a tremendous hit back in 1874, and called forth considerable scholarly debate on whether the thumbs up and down he painted amidst the crowd were the correct interpretation of the Latin phrase* pollice verso, *"with turned thumb." Alexander Stewart bought the painting from Gerome, brought it to America, and published a pamphlet about the work in which he proved to the satisfaction of his contemporaries that* pollice verso *was a matter of turning the thumb up or down. Gerome's artistic reputation went into eclipse after his death, but his gladiator paintings had considerable influence on early Hollywood's epics about pagan Rome, and that's how we got our current interpretation of thumbs up and thumbs down.*

My young lady is Philippine, and she says that when Filipinos want to signal agreement or approval they raise their eyebrows.

They have no analogous gesture to signal disapproval, however, shaking their heads instead.—F.J.R., Lawrence, Kansas

It is still not totally clear what gestures the Romans used to indicate go/no go at gladiator contests. *Pollice verso* has been translated to mean "with thumbs turned inward," "with thumbs turned outward" (in both cases as a stabbing gesture), and "with thumbs bent back" (i.e., thumbs up). Hardly anyone contends that the phrase meant "thumbs down." On the contrary, some say thumbs down meant "spare him." Our opposite interpretation is largely Gerome's invention. For a fuller discussion of the preceding, see *Gestures* by Desmond Morris (1979).

I can recall considerable chat about John Wayne Gacy having murdered a record number of individuals, but I'm curious about the official statistics on another famous Chicagoan—Herman Webster Mudgett, aka "Dr. Henry Holmes," who supposedly murdered around 200 women at the time of one of Chicago's world's fairs. Yet his name is not mentioned with Manson, Starkweather, or Corona as one of the nation's leading mass murderers. He first came to my attention in Jay Robert Nash's Bloodletters and Badmen. *I doubt Nash's facts, however, and I'm wondering whether any official account of Mudgett's crimes exists.—Steven L., Chicago*

There are several stirring accounts of Mudgett-Holmes's activities, not the least of which is the doctor's own, a lurid confession written in 1896 while he awaited execution. He admitted 27 murders, most of which, he said, occurred in his infamous "castle" on what is now Chicago's South Side. Holmes was a psychopath and a compulsive liar, though, so there's no telling how many he really did away with. On the gallows he claimed he'd only slain two persons, both of whom he had carved up on the operating table in his macabre basement. Frank Geyer, a Philadelphia police detective who later wrote a book on the case, unearthed (in a regrettably literal way) enough evidence to pin four killings on Holmes: those of a onetime business associate named Benjamin Pitezel and three of Pitezel's children. Holmes—who really was a doctor, with a degree from the University of Michigan—destroyed or hid the bodies of the rest of his victims; conjecture puts the toll as high as 200.

Holmes was a handsome, intelligent man of great personal

charm. By the time he took a job as a drugstore chemist in 1888, he'd already abandoned two wives and committed a variety of felonies, such as defrauding one of his in-laws. In 1890 the proprietress of the drugstore disappeared and Holmes took over the business, selling patent medicines of his own invention by mail order. He also began to build a "hotel" across the street, a gaudy three-story building with shops on the first floor and a bizarre labyrinth of windowless rooms, false floors, secret passages, trapdoors, and chutes above. He changed contractors several times and shuffled the workers around frequently so that no one ever got a clear idea of the floor plan or what the building was for.

In fact it was a death house. Most of the rooms had gas vents that could only be controlled from a closet in Holmes's bedroom. Many were soundproof and could not be unlocked from inside. A few of them were lined with asbestos, presumably so the victim could be incinerated. Chutes and passages led to the basement, where Holmes had installed an oven for cremating the bodies as well as several lime pits for disposing of whatever evidence remained. He also had a well-equipped surgery area equipped with the usual medical apparatus as well as several instruments of torture, such as the rack. Human fragments, including several complete skeletons, were discovered here and throughout the premises.

Holmes was quite the ladies' man, and his victims seem to have been mostly female. He hired dozens of young women from the outback to work as secretaries, many of whom he seduced and many of whom subsequently disappeared. Perhaps as many as 50 visitors to his hotel were also slain. It was the era of the World's Columbian Exposition (1893), the entrance to which was only a few blocks from Holmes's establishment; the thousands of untraceable transients who passed through town in those years may explain how he got away with it for as long as he did.

In late 1893 Holmes left Chicago and traveled around the country, murdering anybody who was handy. He was finally caught in 1895 by the Philly police when he neglected, through some oversight, to dispose of the previously mentioned Pitezel's body.

Holmes was hanged on May 7, 1896. Students of the occult may wish to note that within a few years of his death a great number of people associated with the case—prison officials, lawyers, relatives—died suddenly, some of them under unexplained

circumstances. The castle, by the way, burned down on August 19, 1895. The cause of the fire was not determined. Just a few fun facts to help you digest your Cheerios.

Over two years ago I was forced to leave my home, and thus The Straight Dope, in order to take the job at Yale that I had been preparing for for more years than I would care to tell you about. Besides these losses, I also had to leave behind some of my oldest and most precious friends, such as Ms. Giudi W. Now, on the occasion of my thirty-fifth birthday, Giudi has sent me a gift so spectacular, so appropriate, that only Cecil Adams could think to match it. It is, need I say, The Straight Dope: A Compendium of Human Knowledge. *Cecil, Giudi is a regular reader of your column. I need your advice. How can I ever thank her adequately and appropriately for this gift?—Barnett R., assistant professor, Yale University, New Haven, Connecticut*

Easy. Buy about 900 more copies of the book and give them to everybody you know at Yale—in Giudi's name, of course. She'll be touched, the intellectual atmosphere at Yale will be noticeably improved, and I'll be able to pay the rent.

Chapter 22

Feedback

Franz Liszt was not a Hollywood composer as you stated in your book, The Straight Dope. *He was a Hungarian whose life spanned 1811–1886.—Tom H., Atlanta*

Glad we could get *that* cleared up.

Your answer regarding courtroom oaths for atheists is correct but deficient. I have been a court reporter for 16 years, and one of my daily duties is to swear in witnesses. I enclose a copy of some "special oaths" that was given to me by a counsel general before a deposition some years ago. Hope this is of use to you. —Kevin D., Oakland, California

The special oaths include the following:

- *Buddhist.* "I declare, as in the presence of the Buddha, that I am unprejudiced, and if what I shall speak shall prove false, or if by colorful truth others shall be led astray, then may the three Holy Existences, Buddha, Dhama, and Pro Sangha, in whose sight I now stand, together with the Devotees of the Twenty-Two Firmaments, punish me and also my migrating soul; and I accordingly swear that this is my name and handwriting (or mark) and that the contents of this your affidavit are true."
- *Muslim.* A copy of the Koran is handed to the deponent. He places his right hand flat upon the book and his left hand upon his forehead and brings his head down to the book and into contact with it. He then regards the book for some moments. The deponent is asked: "What is the

457

effect of the ceremony you have performed?" Deponent should reply, "I am bound by it to speak the truth, and I swear (or declare)," etc. Some Arabs will only take the oath on the Koran in the original Arabic language and will refuse to be sworn upon an English translation.

- *Chinese.* Formerly a saucer was handed to the deponent who took it in his hands and kneeling down broke it into fragments, whereupon he repeated after the consular officer the following: "I tell the truth and the whole truth; if not, as that saucer is broken, may my soul be broken like it." At present a similar procedure is used in which a lighted candle is extinguished.

In your excellent book you revealed the complete libretto of that infamous mini-opera "Louie Louie." If you had done nothing else in your lifetime, this alone would qualify you for a nice comfy chair on Garage Band Parnassus. But listen. You said the song was sung by a homesick sailor to a sympathetic bartender named Louie. Perhaps so. However, I recently discovered the following entry in a slang dictionary: "Louie Louie (military slang)—short for lieutenant." In view of this, doesn't it seem plausible that our sailor was crooning not to a barkeep but to a shipmate pal of lieutenant rank?

And examine the lyrics. He is voicing his longing for the gal he left ashore, and affirming his intent to return to her. Maybe he was confiding a plan to go AWOL, yes? Note in particular the tortured pathos in the dramatic refrain, "Louie Louie, me gotta go." Clearly the man is torn between his loyalty to the navy and the siren call emanating from shore. This conflict is eating him alive, yet abandon his post he shall, for he is first a man and only secondly a patriot. It's a scene as fully poignant as anything in Bizet's Carmen.

Richard Berry might interpret the song differently, but what does he know? He only wrote it. Recently I've taken to playing Kiri Te Kanawa's recording of "Louie Louie" at top volume, the better to ferret out subliminal nuggets. The Kingsmen's version was OK, but Dame Kiri blows 'em away.—David E., Somerville, Massachusetts

The hallmark of all great art, David, is that each generation is able to interpret it anew.

Your book is great. What makes it even better is that there is a mistake in it that I will now proceed to bring to your attention. On page 323, you state that "Happy Birthday" is the first song performed in outer space, on March 8, 1969. I'd like to believe you, as that happens to be my birthday, but I know better. According to a variety of impeccable sources, on December 15, 1965, the crew of Gemini VI performed a stirring rendition of "Jingle Bells" on harmonica and bells. Sorry to have to correct you, but you're in my area of expertise now.—Mark S., Cambridge, Massachusetts

Your discussion about presidential succession prompts me to write. You're right that David Rice Atchison was not "president for a day," but you sound a little unsure why. [There was a gap of a day in between the time James Polk's term expired and Zachary Taylor was sworn in, and Atchison, as president pro tem of the Senate, was next in line of succession.—C.A.] *The truth is that a president of the Senate cannot become [chief executive] between Congresses because he is chosen for a particular session, and his position ends with the final adjournment of that session. Atchison's term as senator expired at midnight on March 3, and his term as president pro tem expired at the same time.*

Some may then ask, if Atchison wasn't president, how about the next person in line of succession? In 1849 that would have been the Speaker of the House. But again, outgoing Speaker Robert C. Winthrop's term of office ended on March 3, and incoming Speaker Howell C. Cobb's term began on March 5, so he wasn't "president for a day" either.

So who comes after the Speaker? The act of succession in effect at the time provided that if all the above offices were vacant, the states were to send electors to choose a new president. Needless to say, this never happened. Thus we have the amazing fact that from noon, March 4, to noon, March 5, there was no president, no vice-president, and no Congress either. And the sky didn't fall in. Anarchists and libertarians everywhere should declare March 4 a national holiday.—Steven D., Madison, Wisconsin

I think I may have found a flaw in one of your answers. The question was what the distance to the horizon was for someone five feet tall. Your response was 2.3 statute miles. I think this

number is a bit on the low side. Using an old surveyor's equation, h = 0.574m² *(h being eye level in feet and m being the distance in miles to the horizon, I get 2.95 miles. How did you come up with 2.3 miles? Did you take refraction into account? What about curvature? Is your distance chord length or is it along the curve of the earth?—Tye B., Richardson, Texas*

I cannot tell a lie. It was the work of Soviet disinformation specialists. I meant to use this formula: the distance in miles to the horizon is approximately equal to the square root of 1.5 times the height of your eyes above the ground in feet. Answer: 2.7 miles and some change. Close enough.

An error appears in The Straight Dope. *You recommend to a reader that he treat his marijuana plants with Diazinon rather than Malathion in order to rid of an aphid infestation. You characterize Malathion as "the strontium-90 of aphid control." Contrary to what you say, it is an established fact that Diazinon is a far more toxic compound than Malathion. Diazinon is described by Metcalf and Flint* (Destructive and Useful Insects) *as a persistent, general purpose insecticide with an oral LD_{50} of about 125 milligrams for rats.* ["LD_{50}" means the lethal dosage necessary to kill 50 percent of the target population.— C.A.]

Malathion is the safest of all insecticides with an oral LD_{50} of between 1400–5800 milligrams for rats. Supposing your correspondent weighed 72 kilograms (160 pounds), he would need to ingest approximately 216 grams of Malathion as compared to 9 grams of Diazinon to have a 50 percent chance of killing himself.

Lastly, you should know that by following your recommendation an individual would be in direct violation of federal law, which states that an applicant may not use any pesticide in a manner not permitted by the labeling. As the crop in question is not listed on the label, using it would be a violation which could result in civil penalties of as much as $5,000. Stick to calorie counting.—David D., Whiting, Indiana

If you were to get busted for growing 40 tons of hemp out in your back yard, David, I would venture to say that improper pesticide use would be the least of your problems. As for Malathion, my characterization admittedly was extreme, but it's not without support in the scientific literature. Melvin D. Reuber, a former pathologist at the Frederick Cancer Research Center in

Maryland, concluded in a 1985 article in *Environmental Research* that Malathion was carcinogenic. The Environmental Protection Agency plans to request new studies on Malathion-induced birth defects and chromosome aberrations from manufacturers of the pesticide in 1988. So there.

You missed the boat on what the H stands for in Jesus H. Christ. It stands for Hallmark, because God cared enough to send the very best. — Walter A., Chicago
Everybody's a comedian these days.

Your piece concerning the anatomy of pigs was a minor masterpiece. [The question was whether pigs have corkscrew-shaped penises. They do. — C.A.] *However, it astounds me to learn that you, Cecil Adams, found it impossible to find a picture showing the private parts of a boar, domesticated or otherwise. You were obviously looking in the wrong places.*
The enclosed Xerox was taken from The Illustrated Presidential Report of the Commission on Obscenity and Pornography. *The original report, as you might recall, was published by the Nixon administration in 1970 and not illustrated. This illustrated version, also copyright 1970, was brought out by Greenleaf Classics, a San Diego-based publisher, and was released to the public right before Christmas. I apologize for the fact that this Xerox is not in color like the original photograph. Also for being unable to find an illustration uncluttered by the blond. — Saint Alice of Hollywood, Los Angeles*
The photo depicts a tumescent pig being . . . urk . . . ministered to by a young woman. I am speechless.

While it may be true that there is a scientific explanation for the expression "once in a blue moon," a more commonly circulated understanding of the term is a month in which two full moons occur. This happens every year or two, and radio "personalities" gleefully point out the fact when it does. — Stuart S., Madison, Wisconsin
I don't doubt that a lot of people believe this, Stuart, but it's a recent interpretation, and it certainly waters down the meaning of the term. According to the *Morris Dictionary of Word and Phrase Origins*, the first appearance of "blue moon" is in a work entitled *Rede Me and Be Not Wroth* (1528): "Yf they say

the mone is blewe/We must believe that it is true." From this we deduce that blue moons are a patent impossibility. I was willing to concede that they occur once in a great while, but "every year or two"—forget it.

I was looking around in your book yesterday, and ran across an answer you gave to someone regarding time zones. As part of the reply, you mentioned that the clocks in Saudi Arabia are reset every day. [Actually, I said they're reset to midnight every day at sunset.—C.A.] *As I have just returned from working in the Kingdom for the past two and a half years, I may be able to shed some light on this issue.*

In fact, the clocks there are not reset every day, at least, not anymore. I believe this information was correct at one time, but as it became necessary for the Saudis to deal with the outside business community on a daily basis, resetting was no longer practical. The most likely reason that it used to be done is the requirement that all Muslims pray five times every day, at sunrise, noon, midafternoon, sunset, and 90 minutes after sunset. If the clocks were reset every day according to the sun, prayer would always be at the same time.

The system now, however, is to leave the clocks alone and change the prayer time every day. These times are listed daily in the newspapers, both in Arabic and English, and adhered to as official for purposes of closing shops and offices during prayer time. I hope this sheds some light on the topic.—John S., Chicago

For what it's worth, I'd like to set the record straight on where the legend about creatures being microwaved in ovens got started. One of the biggest box office successes of the year 1970 (right around the same time that microwave ovens were beginning to become popular) was a low-budget exploitation flick staring Elliot Gould called Getting Straight. *Toward the end of the year, an even lower budget exploitation flick entitled* Getting Wasted *(an obvious parody of the title, although I believe the two plots had absolutely nothing to do with one another) appeared in maybe one or two theaters around here for a week or so. An extremely crude quasi-documentary on the hippie move-*

ment of the time, the only even slightly famous personality in the entire picture was Peter Alsop (nowadays much more well known as a recording artist of considerable stature in the way of folk and children's records).

Approximately midway through the film, there is an amazingly tasteless scene in which the family poodle meets its premature demise in (as if you couldn't guess by now) the family's brand-new microwave oven. As far as I know, this is absolutely the earliest documentation of the phenomenon in existence. Just thought you might like to know.—Dan H., Los Angeles

This may well be the earliest known instance of a *microwave* oven being used, Dan, but there are earlier versions of the legend that involve gas ovens. Jan Brunvand discusses the subject in detail in *The Vanishing Hitchhiker: Urban Legends and Their Meanings.*

While we're on the subject of modern legends, I came across a few jewels collected by Dwight Conquergood, an associate professor of performance studies at Northwestern University. The first one I think is peculiar to Northwestern, which I attended years ago, but the other one is universal:

THE SINKING LIBRARY. The newer part of the Northwestern campus is built on landfill in Lake Michigan that was created in the 1960s. For years the ground was very spongy. The first major structure to go up on the landfill was the new library, the lower floors of which have oozed water ever since day one. The university claims the water comes from a leaking overhead plaza, but this is bullshit. The fact is that the library is sinking back into Lake Michigan, an inch or so every year. The problem is that when the architect designed it, *he forgot to take the weight of the books into account.*

No one who has ever had any dealings with Northwestern has any trouble believing this at all.

THE PHILOSOPHY 101 EXAM. Your grade depends entirely on your score in the final. Professor comes in, hands out the blue books, and says there is going to be exactly one question, which he writes on the blackboard:

"Why?"

Everybody breaks into a cold sweat. Two students in particular are sitting there with intense looks on their faces, when suddenly the light dawns. They scribble briefly in their blue

books, then bring them up to the professor and leave. Curiously, they are the only two to get A's.

The first student wrote, "Why not?"

The second student wrote, "Because."

In the tradition of your loyal readers bailing you out when the heavy responsibility of having to know everything *starts to sink you, I hereby offer a list of the usable two-letter Scrabble words:*

AA	AW	DO	FA	IT	MY	OP	SH	WE
AD	AX	EF	GO	JO	NA	OR	SI	WO
AE	AY	EH	HA	KA	NO	OS	SO	XI
AH	BA	EL	HE	LA	NU	OW	TA	XU
AI	BE	EM	HI	LI	OD	OX	TI	YA
AM	BI	EN	HO	LO	OE	OY	TO	YE
AN	BO	ER	ID	MA	OF	PA	UN	
AR	BY	ES	IF	ME	OH	PE	UP	
AS	DA	ET	IN	MI	OM	PI	US	
AT	DE	EX	IS	MU	ON	RE	UT	

This 86-word list comes from Scrabble Players, *which has competitive clubs throughout the United States.—Bruce D., Scrabble Players Club Number 44, Los Angeles*

I have just finished reading your book, The Straight Dope: A Compendium of Human Knowledge. *In exchange for the wisdom you have imparted me, allow me to broaden your understanding of Muzak.* [The question was whether Muzak was created by an army of heavily sedated Orientals.—C.A.] *You know that in most places Muzak is on for 15 minutes and off for 15 minutes, which the company says is "better" in some undefined way. Actually, "15 minutes on/15 minutes off" is the result of some early technical limitations.*

Until recently, Muzak programming was distributed in large reels of tape to franchises around the world. Tapes were programmed with music appropriate to the time of day, but early tape players were not terribly accurate at holding constant speed over an 8-hour period (the length of one tape). Slow or fast machines would start to creep the "dayparts" backward or forward,

and after several days, lunchtime music might be heard at breakfast time.

To prevent this, the tapes were programmed in 14-minute segments, and a 25-cycle tone after the last tune made the playback machine "park." The next 14-minute segment started when a 15-minute clock closed a switch. A slow machine might play the segment in 14¹/₂ minutes, while a fast machine might get through it in only 13¹/₂ minutes. A fast machine would "park" longer than a slow machine, but overall 8 A.M. music would be heard at 8 A.M. worldwide.

Three Muzak programs are offered: an "office" program, an "industrial" program, and a "public area" program. The first and third segments of each hour's tape were uptempo; the second and fourth segments were more relaxed. Office subscribers had their feeds switched on only for the second and fourth segments, while the industrial subscribers received only the first and third segments. (The originators of this system loved clock switches.) "Public area" subscribers received all segments.

In some larger cities a separate playback machine with all uptempo segments fed "industrial" subscribers during the second and fourth segments (assembly line workers are more productive with bouncy music), but in most places 15 minutes of silence was fed on your line if your program segment wasn't being played by the master tape. There were some complaints about the long periods of silence, so the advertising department "discovered" through "psychological tests" that music interspersed with periods of silence was more beneficial than continuous music.—Jerry M., Hollywood, California

You really didn't answer G.'s question about gaffers. The gaffer gets his name from the early days of motion pictures when lights were considerably larger units than they are now and were often placed, like today, in unlikely, hard to get at positions. The gaffer used the gaff, a long stick, to trim or adjust the lights. Now, 'best boy' is even more obscure. . . .—Bruce H., Venice, California

Your flip and condescending answer to whatever happened to Dooley Wilson was full of shit. [Dooley was "Sam," the piano player in Humphrey "Rick" Bogart's club.—C.A.] *Even had the*

man lived to be a hundred, he still couldn't have "played it again" no matter what course he might have chosen to follow— for you see, all-wise one, he never played it in the first place. Though Wilson's Armstrong-like voice may be heard warbling the lyrics of "As Time Goes By" on the sound track of Casa-blanca, the piano accompaniment was played by my good friend, Jean Plummer, a staff musician at Warner Brothers at the time. (Note the lack of sync between Dooley's tickling of the ivories and the sound that issues forth.)—Hutch M., Los Angeles

"Flip"? "Condescending"? "Full of shit"? I sense a lot of hostility here, Hutch. But thanks for the information.

Quiz Answers

1. The odd one out is D, the coronation of Victoria. The other three events all coincided with appearances of Halley's comet. You may recall reading about the Bayeux tapestry, which commemorates both Hastings and comet. Interestingly, Mark Twain was born during one appearance of the comet in 1835, and speculated that he might depart this vale of tears during the next. "I came in with Halley's comet . . . and I expect to go out with it," he is reported to have said. "It will be the greatest disappointment of my life if I don't. . . . The Almighty said, no doubt: 'Now here are these two unaccountable freaks; they came in together, they must go out together.' " They did. Twain died in 1910, one day after Halley's reached its perihelion.

2. The only state that has never had a foreign flag flying over it is A, Idaho. The explanation for this is a little complicated, so get ready:

In the latter eighteenth century, Idaho was part of a mostly unexplored region west of the continental divide known as the Oregon country, which also included modern-day Washington, Oregon, British Columbia, and part of Montana. While Britain, Spain, Russia, and the U.S. all laid claim to Oregon, only Spain ever took formal possession of any of it—the Pacific coast, in 1775. Spain's efforts at settlement failed, though, and as a practical matter control of the territory fell into the hands of the British, through the agency of the North West and Hudson Bay trading companies. Although the companies established a number of trading posts in what later became Idaho, they were private corporations and never took official possession on behalf of the British crown.

Spain and Russia eventually relinquished their claims on Oregon, but the U.S. and Britain were unable to settle on a division of the region, so in 1818 they signed a covenant essentially postponing the issue. Finally, in 1846, faced with an influx of American settlers into the southern portion of the territory, the British agreed to give up their claims on the portion of Oregon below the 49th parallel. In subsequently annexing the area, the U.S. became the first nation to establish formal sovereignty over the inland part, thus enabling Idahoans to claim that no foreign flag has ever flown (legitimately, anyway) over their state.

3. A. Believe it or not, you were supposed to say "ahoy, hoy" when answering the phone in the early days. This was gradually supplanted by "hello," a word that had not previously been in common usage.

4. The unusual river is B, the Humboldt River, which possesses the peculiar characteristic of ending in the middle of nowhere instead of emptying into an ocean, lake or another river. The Humboldt is the principal waterway flowing through the Great Basin, that odd region in the American West from which no flowing water ever escapes. At one time it emptied into the Humboldt Sink, basically a big dry lake, from which the water either soaked into the ground or evaporated. A dam was built upstream in 1936, and now the water collects in the Rye Patch reservoir. The Willamette River, one of the other choices, is one of the few U.S. rivers that flows predominantly north, but it does manage to get to the sea eventually.

5. D. Roger Kahn explained it this way in *The Boys of Summer*: "As far as anyone knows, the nickname proceeded from benign absurdity. Brooklyn, being flat, extensive, and populous, was an early stronghold of the trolley car. Enter absurdity. To survive in Brooklyn one had to be a dodger of trolleys. After several unfortunate experiments in nomenclature, the Brooklyn National League Baseball Team became the Dodgers during the 1920s, and the nickname endured after polluting buses had come and the last Brooklyn trolley had been shipped from Vanderbilt Avenue to Karachi."

6. C. Doc Holliday was a dentist.

7. Sorry, guys, trick question. The correct answer is D, none of the above. As any Holmes fanatic (and there are an alarming number of them) can tell you, this is one of those instances where Conan Doyle screwed up—he had Watson getting shot in two different places in two separate stories. Unfortunately for those of you who picked C, all of the above, neither of them was the arm or the foot. In *Study in Scarlet*, Watson was alleged to have taken the slug in the shoulder; in *Sign of the Four*, the leg.

While we're at it, a "Jezail" is not an Afghan tribe, as many assume, but rather a heavy stand-mounted musket in fairly common use among Asians in the nineteenth century. I'm glad to be able to clear up the widespread confusion on this subject.

8. This question isn't as tough as it used to be, since Jerry Mathers (Beaver) and Ken Osmond (Eddie Haskell) have made periodic appearances on talk shows and whatnot in recent years. If you saw them, you know that Osmond is neither rock nor porno star, and that reports of Beaver's death were premature. As of a few years ago, Osmond was a policeman in Los Angeles, and Mathers was some sort of management trainee. The correct answer is C: Beaver's stand-in was a midget. The studio used this ploy to avoid paying tutoring fees for another child actor.

9. A. William B. Goodrich was the pseudonym under which Roscoe "Fatty" Arbuckle directed two films (*The Red Mill* and *Special Delivery*) in 1927. He used it because he had been black-balled from moviedom six years earlier, when he was accused in the death of 23-year-old actress Virginia Rappe of Chicago. It seems that Fatty, the lovable devil, was holding a party in a San Francisco hotel suite when, lo and behold, there appeared in the bathtub the naked and bruised body of Ms. Rappe, a guest. According to Fatty and the male guests at the party, she had complained of feeling ill, so they ripped her clothes off and placed her in the water for relief. The female guests told a different story—that Fatty and Virginia had been alone in a bedroom, and that Virginia had cried out for help. In any case, the actress died shortly thereafter of peritonitis (which can be induced by beating). Arbuckle was first held for murder, then indicted for manslaughter. After two hung-jury trials, he was finally acquitted, but there was some decidedly negative PR associated with the whole affair, and Fatty never got his real name or his face

on the screen again until 1933, the year of his death. Some film historians shorten the pseudonym to "Will B. Good" (get it?), but I've found no evidence that it ever appeared in the official credits that way. William and Goodrich were, respectively, the first and middle names of Arbuckle's son.

10. A. The word that comes from the Latin for "male sex organ" is "pencil," which derives from *penis* ("penis" or "tail") via *peniculus*, "brush," *penicullum*, "paint brush," and Middle English *pensel*, among others. "Pencil" and "pen" are unrelated etymologically—the latter comes from the Latin *penna*, "feather."

11. B. The Joe in "Say it ain't so, Joe" was Shoeless Joe Jackson, who was the White Sox left fielder in the 1919 World Series.

12. C. You saw this one coming, didn't you? The fifth borough of New York City, popularly known as Staten Island, was officially known as Richmond until January 8, 1975, when it was formally changed to Staten Island. While this may have made life easier for New Yorkers, it sure ruined a good thing for us quiz compilers.

13. A. A stale egg floats in water.

14. D. Number 53310761 was Elvis Presley. That's not his mug number in *Jailhouse Rock*, as many people assume, but his U.S. Army serial number.

15. C. The "H" stands for Harry.

16. C. Franz Liszt, the greatest piano virtuoso of all time, some say, was no slouch in the rack, either—he had a legion of illegitimate virtuosi. But Richard Wagner wasn't one of them. Wagner became Liszt's son-in-law when Liszt's second daughter, Cosima, left her first husband to wed Mrs. Wagner's *magnum opus*.

17. C. The most commonly used word in English conversation is "I," as you probably know if you've ever spent any time talking

to rock critics. The most common *written* word is "the," followed by "of" and "and."

18. A. The late Mississippi Fred McDowell, thought by some to be the greatest of the bottleneck blues guitarists, was the man who used to say, "I do not play no rock 'n' roll." The line is the title of one of McDowell's albums on Capitol.

19. D. Seems old Fred, in an attempt to round up some publicity for his extreme-right "American Industrial Democracy" plans, had himself affixed to a wooden cross with three-inch spikes through the hands. (Ropes supported his body weight, and he came through the experience in pretty good shape.) Walcher was found making odd noises beneath a train trestle and was fined $100 plus costs, proving once again that you can get in a lot of trouble for hanging around the wrong places.

20. A. Don Larsen of the New York Yankees pitched a perfect game against the Bums of Brooklyn in the fifth game of the 1956 World Series, and so far nobody has been able to equal his feat.

21. C. Starting in 1967, the people who do the "Goings On" section in *The New Yorker* began to substitute for reviews of long-running plays (*The Fantasticks*, *Fiddler*, etc.) all kinds of garbage, including copyright lines, favorite quotes, and excerpts from *Ulysses* and Jane Austen's *Persuasion*. The foolishness faded with the dawn of 1972.

22. B. In 1966, Hedy Lamarr was arrested for shoplifting. She was leaving the May Company department store in Los Angeles when an eagle-eyed security guard spotted some merchandise in her handbag that she had neglected to pay for. The case against Hedy was eventually dismissed, but the scandal cost her the lead in the horror movie, *Picture Mommy Dead*, that was supposed to be her comeback. This historic episode later served as the basis for an Andy Warhol film, *Hedy* (aka *Shoplifter*), a movie so boring that at one point the cameraman loses interest in the action entirely and begins to film the crack on the wall.

23. A. The theme song "I'm Your School Bell" was associated with Frances Horwich, once known to millions of kiddies as "Miss

Frances" on NBC's "Ding Dong School." The show, which also attracted a sizable number of adult viewers, premiered on October 3, 1952, and ran for some 10 years on the network and in syndication. The complete, unexpurgated lyrics to the theme song are: "I'm your school bell,/Ding, dong, ding,/Boys and girls all hear me ring." And no, in answer to your next question, she did *not* spice it up in the studio.

24. C. "Teodor Korzeniowski" is the real name of Joseph Conrad. This one was supposed to be easy, but for some reason a lot of people guess Charles Bronson. Wrongo. Bronson's real name is Charles Buchinsky.

25. B. This one's cute, if a trifle old. The letters stand for words, and the words stand for numbers, i.e., *O*ne, *T*wo, *T*hree, *F*our, *F*ive, *S*ix, *S*even. So the next letter is *E* for *E*ight. Bet you could just kick yourself, huh?

26. C. The natives of Kuskoy communicate through whistling. This unique language allows the Kuskovians to communicate over distances of up to one mile. Their courtship rituals—whistled, of course—are reported to be breathtakingly beautiful, although not without their hazards. I mean, jeez, over all that distance, you could wind up betrothed to a freaking *canary*.

27. B. "Ukelele" comes from the Hawaiian word for "flea." Just why the Hawaiians should have made the arcane connection between fleas and miniature guitars is lost in the mists of history, but it has been suggested that the ukelele player, caught up in the frenzy of his art, seems to be scratching the instrument rather than strumming it. To the eternal chagrin of Don Ho, the Hawaiians did not invent the ukelele. It was introduced to the islands in 1879 by Portuguese sailors—one of the few gifts of the white man you didn't have to treat with penicillin.

28. C. In 1810, London merchant Peter Durand took out a patent for packaging food in cans made of tin and other metals for the purpose of preservation. The tin can—which, by the way, has always been made of steel with a tin coating—reached America nine years later. (And you think the mail service today is crappy.) Unfortunately, Durand never figured out a convenient

way to *open* his cans, which were filled through a hole in the top and then soldered shut with a disk of sheet metal. For 40 years housewives were forced to resort to hacksaws, crowbars, and psychokinesis. Finally J. Osterhoudt of New York came to the rescue by putting a lip on the topside disk, so it could be grasped by a pair of pliers and deftly torn free.

29. C. Edward Carl Gaedel—height 43 inches, weight 65 pounds—pinch hit for the St. Louis Browns in a 1951 game against Detroit. Gaedel, sporting the uniform number 1/8, came in for Frank Saucier. The umpire tried to throw him out, but after Browns manager Zack Taylor produced a signed contract proving that Gaedel was a full-fledged member of the team (owned in those days by the fun-loving Bill Veeck), he was allowed to bat. Bob Cain, Detroit's pitcher, was visibly shaken. Gaedel walked and was replaced at first by a pinch runner, outfielder Jim Delsing. Gaedel never came up in the big leagues again. He died, brokenhearted, in 1961.

Fred Astaire's real name, incidentally, is Frederick Austerlitz.

30. B. Another trick question. I'm so sly. Most people guess C because it sounds so ridiculous, never suspecting the truth. "How could this be?" you ask. "Everyone knows that Ben Franklin founded *The Saturday Evening Post*. It says so right on the cover." Well, I hate to spoil your faith in a treasured American institution, but that line on the masthead—"Founded A.D. 1728 by Benjamin Franklin"—is nothing more or less than a deliberate, damnable lie.

Franklin's connections to the *Post* are very vague indeed. In 1729, he bought a nearly bankrupt newspaper, the *Pennsylvania Gazette*, and eventually made it a success—the paper continued to publish for 25 years after his death, going out of business in 1815. Six years later, Charles Alexander and Samuel Atkinson took over the *Gazette*'s abandoned print shop and began to turn out the weekly *Saturday Evening Post*. The *Post* was purchased by Cyrus H. K. Curtis in 1898, its masthead still carrying a modest and truthful "founded 1821." But in the first issue to appear under Curtis's ownership, January 29, 1898, the masthead suddenly and unaccountably read, "Founded A.D. 1728"—a year before Franklin took over the *Gazette*, even if you want to grant that tenuous link. The coup de grace came

in September, 1899, when George Horace Latimer was installed as the *Post*'s editor, bringing with him the nefarious Franklin lie, which was promptly emblazoned across the front cover.

As for the other choice, Copernicus discovered the magic of buttered bread when he was put in charge of defending the besieged castle of Allenstein in Prussia, where he was nominally employed as a canon of the Cathedral of Frauenberg. This being the early sixteenth century, Copernicus found he was losing as many soldiers to the plague as he was to the enemy. Turning his powerful mind to the problem, he hypothesized a link between the plague and the vile food the soldiers were eating. (Apparently they had Cheez Whiz even then.) To control contamination, Copernicus experimented with buttered bread. Amazingly, it seemed to work—and it tasted real fine too. Copernicus had a hit on his hands; buttered bread quickly became a dietary staple.

31. D. This should have been no sweat to anyone with a medical dictionary, but a dirty mind and a rudimentary knowledge of Latin roots would have gone a long way. A man suffering from an insane fear of Telly Savalas might be called a victim of *phalacrespia*, the fear of bald men, particularly if they resemble (if you squint your eyes) a gigantic penis, or phallus. For the record, *bromidrosiphobia* is the fear of body odor; *pteronophobia* is the fear of being tickled with feathers; and *pentheraphobia*, believe it or not, is the fear of one's mother-in-law, a condition that has proved fatal to more than one Las Vegas comedian.

32. C. Contrary to popular belief, Telly did not shave his head first for *The Birdman of Alcatraz*, in which he played an egg. Savalas's upper epidermis made its debut in George Stevens's immortal *The Greatest Story Ever Told*, a film best remembered for its closing line. (John Wayne, a centurion, looks up at Christ [Max von Sydow] hanging on the cross and declaims, with the lumbering eloquence that only Wayne could muster, "Truly, he wuz the Son of Gawd.") Savalas played Pontius Pilate, with the bald pate as a gesture toward historical accuracy. Telly, by the way, finds it necessary to shave twice a day in order to maintain his noggin in all its gleaming glory.

33. C. "7AA" was the subject of one of the most famous press releases in Hollywood history—it was, of course, Greta Garbo's shoe size, revealed by the MGM publicity department in order to combat a rumor that was sweeping the country, namely, that Garbo had big feet. She didn't.

34. D. The only actor to work for each of Hollywood's Big Three was little Barry Fitzgerald. He appeared in a number of Ford films, beginning with *The Plow and the Stars* in 1936. He did his only work for Hawks in the classic *Bringing Up Baby* (1938), playing an Irish gardener with a fear of leopards. The Hitchcock film is the tricky part: Fitzgerald appeared in *Juno and the Paycock*, an adaptation of the O'Casey play that Hitchcock made in England in 1930. Because of copyright problems, it's never been shown on American television, so don't feel too bad if you missed it.

35. A. All four were Famous Novelists—with Pulitzer prizes to prove it. Julia Peterkin won in 1929 for the unforgettable *Scarlet Sister Mary*; Oliver LaFarge knocked 'em on their fannies with *Laughing Boy* in 1930; Margaret Ayer Barnes brought home the bacon in 1931 with *Years of Grace*, and Caroline Miller earned immortality in 1934 for *Lamb in His Bosom*. Seeing all the mopes who've gotten Pulitzers makes me feel better about being passed over. I mean, who wants a dumb old Pulitzer, anyway? Not *moi*. Sniff.

36. D. A look in the *Oxford English Dictionary* would have revealed the answer. "Floccinaucinihilipilification" is the longest word the *OED* certifies as legitimate, Sir Walter Scott having once dropped it into one of his lapidary paragraphs, which is good enough for them. Some sources, though, consider it to be a humorous fabrication perpetuated by a gang of fun-loving Latin students. The words breaks down thusly: *flocci*, meaning "trivia," plus *nauci*, "consider worthless," plus *nihili*, "nothing," plus *pili*, "particle." Adding it all together, we come up with a mouthful meaning "the act of judging a bit of information to be utterly worthless"—in short, the act of writing to the Straight Dope.

37. The question "what is four feet, six inches long" is multiple choice, not fill-in-the-blank, as some of you relentless self-promoters out there seem to assume. Idle braggadocio aside, the correct answer is C, the Statue of Liberty's nose. Fascinating, no? Did you know that her index finger is eight feet long, and that it sports a fingernail measuring 13 by 10 inches? Now you do. And they say this column isn't educational. The world's largest smokable cigar (answer B), as certified by the *Guinness Book of World Records*, measures 16 feet, 8½ inches in length and weighs 577 pounds 9 ounces. It is currently housed in the Tobacco Museum in Kampen, the Netherlands. By contrast, the longest beard ever grown by a woman, answer D, measured a paltry 14 inches. It belonged to Janice Deveree, of Bracken County, Kentucky. I knew a Delta Zeta like that once. As for answer A, the length of a whale's penis is his business, not yours.

38. It's amazing how many people have their minds clogged up with junk like this when they could be remembering important things, like the meaning of existence and why they ever voted for Jimmy Carter. UNCLE, of course, stands for United Network Command for Law and Enforcement, the outfit that unleashed Ilya Nickovetch Kuryakin (David McCallum) and Napoleon Solo (Robert Vaughn) on THRUSH, aka the Technological Hierarchy for the Removal of Undesirables and the Subjugation of Humanity. (I told you these things were tortured.) SPECTRE was James Bond's foe—the Special Executive for Counter-Terrorism, Revenge, and Extortion. ICE was featured in the Matt Helm movie series—Intelligence Coordination and Exploitation. KAOS was a trick question (remember, you only needed to get four out of five). It was the evil organization on "Get Smart," but none of the show's creators—among them, Mel Brooks—ever bothered to work out what the initials were supposed to stand for.

39. A. Hey, kids, it's Heavy Duty time! "Ontogeny recapitulates phylogeny" is succinct but overstated. (I got into a discussion on this very topic out in Montana once. Things could get pretty weird in Montana at times.) The expression is known in biological circles as "the biogenetic law of Mueller and Haeckel," who were two nineteenth-century German embryologists. Basi-

cally it says that during fetal development (ontogeny), an embryo passes through all the evolutionary stages that led up to the modern version of whatever species the embryo happens to be (phylogeny). Human embryos, for instance, start out as one-celled creatures, then develop into simple invertebrates, later into sea critters (you have gill slits at one point), and so on up the ladder to the primates and finally *homo sapiens*. Interesting, huh? Unfortunately, it's not strictly accurate. While as a fetus you do bear a resemblance to some of your long-departed ancestors at certain points, you skip a lot of intermediate steps. Also, you pick up a lot of uniquely human characteristics pretty early on. So while "ontogeny recapitulates phylogeny" is true in a loose sense, at best it's an exaggeration of what's really happening.

40. A. Actually, there are two Elvish languages in the Tolkien books: Quenya (High Elven), which is based on Finnish, and Sindarin (Gray Elven), which is based on Welsh. Since Finnish was not offered as an option, you were compelled to choose Welsh. I failed to note this fine but critical distinction when I first asked the question in the newspaper years ago, and I caught no end of grief for it.

Books have been written on Tolkien's linguistic inventions, which contribute a great deal to the verisimilitude of his work. (One of the better ones is *The Languages of Tolkien's Middle-Earth* [1980], by Ruth Noel, from which the preceding is drawn.) The results can be eerily beautiful, if occasionally a bit melodramatic:

> *A Elbereth Gilthoniel!*
> *Silivren penna miriel*
> *O menel aglar elenath!*
> "O Star-Queen, Star-Kindler!
> Your glory sparkles down like gemstones
> From the firmament of the star-host!"

41. B. The phrase "hocus-pocus" is generally thought to be some ancient mummer's corruption of the Latin sentence *hoc est enim corpus meum*, "for this is my body." As every good Catholic knows, these words signal the transubstantiation of bread and wine into the body and blood of Christ during the Sunday liturgy. No mean feat, which explains why people thought the formula had magical powers during the Middle Ages.

42. The answer is clearly C, presque vu, "almost seen," in which it seems to the subject that he or she is about to experience absolute truth. Modesty forbids me to continue. The other choices were the familiar déjà vu, "seen before," and jamais vu, "never seen," in which common objects take on an utterly strange aspect.

43. A. As any parapsychology buff can tell you, the five symbols constitute the Zener series, used to test for psychic abilities. You shuffle the deck, give each card the old eyeball one at a time, and attempt to transmit the info to your partner telepathically.

44. B. We refer here to one of the most famous legends in literature. Coleridge claimed to have composed the poem "Kubla Khan" (who in Xanadu did a stately pleasure dome decree) while nodding out on drugs one afternoon, a circumstance with which many of this column's readers can no doubt identify. Coleridge managed (or so he said) to record just 54 of the two or three hundred lines he had dreamed up before being interrupted by "a person on business from Porlock," at the conclusion of which the poet found he had completely forgotten nearly everything else he wanted to write. Many of Coleridge's biographers are disinclined to believe this yarn, but that need not concern us here. "A person from Porlock" has since become an epithet for any sort of distracting busybody, to the great distress of the Porlock Chamber of Commerce, I should think. But fame can be like that sometimes.

45. D. Permit me to quote from *The Annotated Mother Goose:*
"As recently as November 1961, Mr. James Leasor was writing in his book *The Plague and the Fire* that this rhyme 'had its origin in [The Great Plague]. Rosy [roses] refers to the rosy rash of plague, . . . the posies were herbs and spices carried to sweeten the air; sneezing . . . was a common symptom of those close to death.' And 'We've all tumbled down' was in a way exactly what happened.
"This is an interesting theory, but 'If you consult *The Oxford Dictionary of Nursery Rhymes*' (as Charles Poore noted in his *New York Times* review of *The Plague and the Fire*) 'you will find, in place of corroboration, the somewhat frosty notation that: "The invariable sneezing and falling down in modern ver-

sions has given would-be origin finders the opportunity to say that the rhyme dates back to the Great Plague." ' Actually— surprising in a rhyme that has become the accompaniment to one of our most popular nursery games—['Ring-around-the-rosy'] first appeared in print as late as 1881."

By means of this triple-barreled quotation we learn that three out of four experts agree: the correct answer is D, the rhyme signifies nothing in particular. Some yo-yo, incidentally, had the nerve to call up and tell me the preceding *supported* the Black Death theory.

46. Another trick question. I'm so ashamed. The correct answer, remarkably enough, is C: You *do* mark a K for strikeout because the player has strucK out. The scoring system was invented in 1858 by one Henry Chadwick, sometimes known as "the father of baseball." D stood for a ball caught on the first bounD, which was an out at the time, and L stood for fouL ball. Why Chadwick chose this odd arrangement I don't know, but there you have it. As for the other possible answers, most baseball fans know you can change sides of the plate while at bat, subject to some restrictions; and first basemen as well as catchers wear mitts. Now for the tricky part. The fourth choice was: home plate and the bases form a square. According to the diagram in my handy baseball rule book, the plate and bases *don't* form a square; they form an irregular tetragon. The base *paths* form a square. First, third, and home line up with the base paths along their *edges*, while second base is placed with its *center* at the intersection of the base paths. Thus second is seven and a half inches out of alignment with the others, hence no square. QED.

47. C. I gather that Strand, Fleet Street, and Trafalgar Square are considered thoroughly middle-class locales in London, much like Kentucky, Indiana, and Illinois avenues in Atlantic City. (I'll admit I haven't visited either city recently.) The equivalents of Park Place and Boardwalk are Park Lane and Mayfair, and the counterparts of Mediterranean and Baltic are Old Kent Road and Whitechapel. Try mentioning *that* next time there's a lull in the conversation.

48. A. A good map question is a thing of beauty and a joy forever. Yonkers excepted, the towns are all completely sur-

rounded by much larger cities—Norridge by Chicago, Hamtramck by Detroit and Beverly Hills by Los Angeles.

49. You were asked to pick which of four implausible-sounding propositions was false, the correct answer being (naturally) the least implausible, namely choice C, "Dr. Joseph Guillotin invented the guillotine." Actually, the Doc only argued in favor of the use of the device; it had been invented some centuries before. Amazing as it may seem, Fred Waring, for many years the proprietor of the well-known society band Fred Waring and the Pennsylvanians, was indeed an inveterate tinkerer who invented the blender that today bears his name. Frank Lloyd Wright's son John really did invent Lincoln Logs, and Benjamin Franklin did in fact invent swim fins of a sort (they're described in a letter he wrote in 1773; see *Benjamin Franklin's Autobiographical Writings*, page 3).

50. B. The names indicate the portraits appearing on U.S. currency now in circulation in ascending order of denomination. Ulysess Grant's picture graces the $50 bill.

51. C. *Adoxography* is defined as "good writing about a trivial subject" by *Mrs. Byrne's Dictionary of Unusual, Obscure, and Preposterous Words* (1974), a volume no aspiring omniscient dare be without. An *idioticon*, Mrs. Byrne further informs us, is a glossary of idioms; *cacafuego*, literally "shit-fire," means spitfire, and *acrocephalic* means pointy-headed. We nattering nabobs of negativism are lucky Spiro Agnew didn't get his mitts on *that* one.

52. D. The other three are coinages for commercial products that have since entered the language as generic terms. Aspirin is the example most often cited in this line; Coke and Xerox are perennially threatened with the same fate.

53. A. The Saturn V burns about a million gallons of fuel during lift-off and coasts the rest of the way; the various Mariner probes to Mars traveled between 250 million and 325 million miles en route, giving us an admirable 250–325 MPG for the Apollo capsule. (The round trip from Earth to the moon, incidentally, is 700,000 miles, meaning you only get a miserable .7

MPG on lunar voyages.) A moped gets about 120 MPG, a Honda Civic gets 51 (highway), and an Ultralarge Crude Carrier gets about 31 feet to the gallon. Reminds me of an old Rambler I used to have.

54. A. The movie line that is *not* a misquotation or fabrication is A, "I want to be alone." According to *The Oxford Companion to Film*, Greta Garbo actually said it in *Grand Hotel* (1932). As is well known, the line in *Casablanca* is not "Play it again, Sam," but "Play it, Sam," said by Ilsa Laszlo (Ingrid Bergman) to piano player Dooley Wilson. Rick Blaine (Humphrey Bogart) later says, "You played it for her, you can play it for me. . . . If she can stand it, I can; play it." The line Mae West as Lady Lou actually said to Captain Cummings (Cary Grant) in *She Done Him Wrong* (1933) was not "Why don't you come up and see me sometime" but "Why don't you come sometime 'n' see me." The line "You dirty rat" is commonly attributed to the late Jimmy Cagney, but Cagney declared he never said it in any film.

55. B. As a moment's study ought to have made clear, *crab-cake* is the only choice that contains three consecutive letters in alphabetical order.

56. E. This is not a trick question, but it is certainly a sucker question, and most people fall for it like a ton of bricks. The correct answer is E, 2 in 3. The tendency is to choose A, 1 in 2. The reasoning seems to be as follows: There are three cards. Since we see that there is one white side showing, we can eliminate the red/red card from consideration. That leaves two cards remaining—one white on its back side, and one red. Therefore the chances of the other side being white are 1 in 2. A seductive line of thinking, but wrong. We must consider not the *cards themselves*, but the *faces* thereof. In our deck of three cards, there are three white faces—call them A, B, and C. Each of these has an equal chance of turning up in a random draw. Sides A and B are the two sides of the white/white card; side C is one side of the white/red card. The reverse side of A is white, the reverse side of B is white, and the reverse side of C is red, giving us a grand total of two white and one red reverse sides. Ergo, the chances are two in three that the underside of the card on the table is white. For a more complete discussion of this seeming

paradox, formulated in 1950 by mathematician Warren Weaver, see *The Paradoxicon*, by Nicholas Falletta.

57. C. Miranda is a moon of Uranus; the others are moons of Saturn. There are other ways to arrive at the same result. Some say Miranda is the only non-Greek name; others say she was the only non-Titan, Titans being the Greek mythological figures for whom certain of the moons were named. Actually, Dione was the *daughter* of a Titan, but let's not sweat the details.

58. The unlucky city is A, Los Angeles. The others have all had the good fortune to host a "city series"—that is, a World Series in which both teams came from the same town. It happened in Chicago in 1906, in New York on many occasions, and in 1944 in St. Louis. The St. Louis series, in which the Cardinals played the Browns, is particularly interesting. Over the years the Browns had compiled one of the worst records in the history of baseball, but in 1944 they managed to win the American League pennant, owing in part to the fact that many top players from other teams were serving in the military. The Browns gave the Cards a good fight, but eventually went down to defeat four games to two. All six games were played in the same ball park, Sportsman's Park, which had been home field to both clubs since 1920. It was the first pennant for the Browns, and also their last. In subsequent years the team's performance returned to its customarily putrid state, until finally in 1954 the club skulked out of town and moved to Baltimore, where it was reincarnated as the Orioles.

59. B. Comix buffs immediately recognized that they were being asked to come up with the last letter in the name of Mr. Mxyzptlk, the imp from the fifth dimension who was Superman's nemesis. To get the little dude to return whence he came, Superman had to persuade him to pronounce his name backwards—no small task for either party.

60. A. According to *The Official Scrabble Players Handbook*, the magic word is SATIRE, which lends itself to more combinations that any other six letters. A close runner-up is RETINA or its anagram, RETAIN.

Index

A

ABC (network), 42, 447–48
acid (drug). *See* LSD
acidity, of urine, and desire to
 smoke, 223
acrostics, 175–76
acupuncture and acupressure, 414–17
Adamson, Joy (*Born Free* author),
 slaying of, 126
additives: in food, 47, 48; in ink of
 alternative newspapers, 98
age, of dogs, compared to human,
 10–11
air conditioning, effect of on auto gas
 mileage, vs. keeping windows
 down, 393–94
air embolism, resulting from air
 blown into vagina during sex, 210–
 11
air pressure, and shower curtain
 motion, 104–8
aircraft: commercial, prohibition of
 passenger radios on, 355; exit doors
 in, possibility of opening while in
 flight, 390–92
airfoil (explained), 104–5
alarm clock, why you wake just
 before it goes off, 300–301
alcohol, 54; effect of on autos when
 used in gasoline, 392–93; and
 hangover severity, 230–32; wood,
 in Heet gas drier, 392. *See also*
 beer; wine
Alexander VI (pope), 140
Alfonso XIII of Spain, 84
alligators, in sewers of New York,
 339–40
amalgam, in tooth fillings, alleged
 danger of, 428–30
amphetamines, 230; as sex enhancer,
 209
amyl nitrate, as sex enhancer, 209
Anatomy and Destiny, 368
ancestors, "doubling" of, 83–85

Anderson, John, 296
Andrew, Prince: how addressed in
 Royal Navy, 136–37; last name of,
 137–38
Andrews, Jean (geologist), 118
animals: deviant sex practices of,
 198–99; excrement of, terms for,
 383; testing of color vision in, 4–5
anisakiasis (parasite infestation), 60
antifreeze, gas-line (Heet), 392
apatosaurus, name mix-up regarding,
 11–14
aphrodisiacs, 227; and human sexual
 response, 206, 208–10
apnea, sleep, 424
apple juice, difference vis-à-vis cider,
 48–50
apple skins, nutritiousness of, 57–59
"-arama," origin of suffix, 240–41
Arbuckle, Fatty, accusations
 regarding, 470–71
Archer, John, 213
Aristotle, 113; and proofs of earth's
 sphericity, 87
Armendariz, Pedro, 18
arthritis, and knuckle-cracking,
 306
"As Time Goes By," who played it in
 Casablanca, 465–66
asparagus, effect of, on smell of
 urine, 383–85
Astaire, Fred, real name of, 473
astral projection, and sleep paralysis,
 409–10
Atchison, David Rice, 459
atmosphere, effect of on apparent
 size of moon, 110–12
atom bomb tests, and movie *The
 Conqueror*, 16–18
Audubon, J.J., and rumor that he
 was Louis XVII, 122–23
Australia: 332–33; and "kangaroo,"
 "kangaroo court," 237, 238; and
 perennial location at bottom of
 map, 160

Satanists: and cattle mutilation, 282;
and Procter & Gamble symbol,
283–85
satellites: and determination of
existence of canals on Mars, 102–4;
and weather forecasting, 116; spy,
visual resolving power of, 397
Saturday Evening Post, origin of,
473–74
Saudia Arabia, resetting of clocks in,
462
Sauvy, Alfred (originator of term
"Third World"), 271
Savalas, Telly, when first shaved
head, 475
Saxe-Coburg and Gotha (royal last
name), 138–39
Scheibel, Arnold, 127
Schiaparelli, Giovanni (astronomer),
103
Schick Laboratories, 233
Schliemann, Heinrich, and
popularization of swastika, 157
Schultz, Harvey, 371
Schuster, Charles, 233–34
Scientific American, 100, 101, 107
Scrabble (game): best way to get 50-
point bonus in, 482; list of two
letter words in, 464; variant rules
in, 180
Search for Bridey Murphy, The, 288
seashells, why she sells by seashore,
83
Seattle, giant slugs of, 73
secret message, in "Moonlighting"
TV show, 447–49
Secret Word Is Groucho, The, 25
Seiden, Lewis, 233–34
semen trees. *See* sperm trees of Los
Angeles
Sergius III (pope), 140
sewers, of New York, alligators in,
339–40
sex: and "blue balls" syndrome, 195–
97; desire for, effect of graham
crackers on, 53–55; and
"disintegrating gum syndrome,"
201–6; effectiveness of
aphrodisiacs, 208–10; effectiveness
of pheromones, 206–8; legality of
photos of persons engaged in, 199–
201; penile fracture during, 426–
28; sneezing and other unusual
reactions following, 191–93; and

subliminal suggestion, 344–47. *See
also* contraception; pregnancy;
gerbil stuffing, 216–18
sex, oral: and monkeys, 199; danger
of blowing air into vagina during,
210–11
"sex clubs," theory and operation of,
214–16
sex habits: of ants, 9; of gnats, 69; of
praying mantis, 7–8
sex practices, deviant, of monkeys,
198–99
Shakespeare's Bawdy, 270
Shakespeare, William, and
"foculation," 270–71
shaking head for "no," nodding for
"yes," universality of, 450–54
shampoo, protein, alleged use of
human blood in, 333–34
shaving: of chin dimple, 315; why
woman uses up razor blade faster
than man when, 349–50
ship christening, procedure for, 446–47
ships' captains, and alleged ability to
perform marriages, 329–30
shit, why brown, 381–82
shoe store fluoroscopes, and cancer,
414
Shoumatoff, Alex, 85
shower curtain, why it blows in
during shower, 104–8
Shroud of Turin, debate regarding
authenticity of, 275–81
"shuggleftulation," term for
impromptu dance when meeting
someone head-on, 241–42
sidewalk "dance" (attempt to avoid
oncoming walker), terms for, 241–
42
"signifying," black insult game, 244–
46
Silverman, Lloyd (subliminal
researcher), 325
Silverius (pope), 142
sinuses, purpose of, 302–3
Skeptical Inquirer, 298, 344
Slang and Euphemism, 269
sleep: and why you awaken just
before alarm goes off, 300–301;
paralysis during, causes of, 408–
12; twitches during, 423–24
sleep apnea, 424
Sleep Disorders, 408
Sloane, Eric, 382

ABOUT THE AUTHOR

One of the world's legendary recluses, Cecil Adams, author of *The Straight Dope* and reputedly the world's smartest human being, has never been photographed or interviewed. In fact, only a handful of people have ever met him, giving rise to his reputation as the Howard Hughes of American journalism.

All Cecil's dealings with the public are handled by his editor and confidant, Ed Zotti, who has been sworn to secrecy. Consequently, little is known about Cecil's private life. Even Zotti says he doesn't know where Cecil managed to learn so much stuff.